Post-Biblical Saints Art Index

ALSO BY MERCEDES ROCHELLE

Historical Art Index, A.D. 400–1650:
People, Places, and Events Depicted
(McFarland, 1989)

Mythological and Classical World Art Index:
A Locator of Paintings, Sculptures, Frescoes,
Manuscript Illuminations, Sketches, Woodcuts and
Engravings Executed 1200 B.C. to A.D. 1900,
with a Directory of the Institutions Holding Them
(McFarland, 1991)

Post-Biblical Saints Art Index

A Locator of Paintings, Sculptures, Mosaics,
Icons, Frescoes, Manuscript Illuminations,
Sketches, Woodcuts and Engravings
Created from the 4th Century to 1950,
with a Directory of the Institutions Holding Them

by Mercedes Rochelle

McFarland & Company, Inc., Publishers
Jefferson, North Carolina, and London

To Michael Alexander,
my dearest friend and helpmeet

British Library Cataloguing-in-Publication data are available

Library of Congress Cataloguing-in-Publication Data

Rochelle, Mercedes, 1955–
 Post-Biblical saints art index : a locator of paintings,
sculptures, mosaics, icons, frescoes, manuscript illuminations,
sketches, woodcuts and engravings created from the 4th century to
1950, with a directory of the institutions holding them / by
Mercedes Rochelle.
 p. cm.
 Includes bibliographical references (p. 343).
 ISBN 0-89950-942-8 (lib. bdg. : 50# alk. paper) ∞
 1. Christian saints in art — Indexes. 2. Art — Indexes. I. Title.
N8079.5.R63 1994
704.9′4863′074 — dc20 94-10155
 CIP

Manufactured in the United States of America

McFarland & Company, Inc., Publishers
Box 611, Jefferson, North Carolina 28640

Table of Contents

Abbreviations

add. always found as part of an "assigned" manuscript number in British institutions

anon. anonymous

att. attributed

Biblio. Bibliothèque, or library in French

BL British Library

BM British Museum

BN Bibliothèque Nationale, Paris

BS Bayerische Staatsgemaldesammlung, Munich

c. circa

canon. canonized

cat. catalogue

CCC Corpus Christi College, Cambridge

cent. century

Cod. always found as part of an "assigned" manuscript number

Coll. Collection

colorpl. colorplate

d. died

Dict. Dictionary

Encyclo. Encyclopedia

f. always found as part of an "assigned" manuscript number designating "folio"

fig. figure

Flem. Flemish

fo. always found as part of an "assigned" manuscript number as an abbreviation for "folio"

fol. always found as part of an "assigned" manuscript number as an abbreviation for "folio"

Guelf. always found as part of an "assigned" manuscript number

illum. illumination

illus. illustrated

Inst. Institute

Int'l International

Ital. Italian

KM Kunsthistorisches Museum, Vienna

lat. always found as part of an "assigned" manuscript number

mart. martyred

min. miniature

ms. manuscript

Met Museum Metropolitan Museum of Art, New York

Musées des B/A Musée des Beaux-Arts (in several cities)

Musées Royaux des B/A Musées Royaux des Beaux-Arts (in several cities)

Nat'l National

NGA National Gallery of Art, Washington, D.C.

NGI National Gallery of Ireland

NGS National Gallery of Scotland

nouv. acq. always found as part of an "assigned" manuscript number in a French library

NYPL New York Public Library

ON Österreichische Nationalbibliothek, Vienna

p. page

pl. plate (referring to the book plate where the picture can be found)

r. reigned

RA Royal Academy of Arts, London (see preface)

Regin. always found as part of an "assigned" manuscript number

Ren. Renaissance (always used as part of an abbreviated book title)

S. Saint. Always used in an Italian proper name for a physical location, such as S. or Sta Church. The unabbreviated Italian word for saint as used may be San or Santa

SS. Saints

Sect. Section

Univ. University

V & A Victoria and Albert Museum, London

Vol. Volume

Preface

When searching for illustrations, what does one do without a starting point — without even knowing whether a person has ever been represented? Indexes of artwork are almost always listed alphabetically by the artist's name; this kind of guide does little good if one is searching for a subject, rather than a work by a particular artist.

What the researcher requires is a subject index, listing relevant artworks under the names of the individuals depicted. This book is my attempt to fill that need for those researching post–Biblical saints.

Not only is this volume a subject index, it is also intended to serve as a locator of the artwork itself. I have attempted in each instance to point the researcher toward the appropriate institution or church, so that, for instance, permission can be obtained to reproduce a piece from its collection.

Post-Biblical saints are listed alphabetically as boldfaced headings. I have excluded Biblical saints because the saints directly associated with Jesus would fill another volume all by themselves (i.e. the apostles, the Holy Family, Mary Magdalene, John the Baptist, Veronica, and Lazarus). This book features saints who lived after the time period covered by the Bible. There are nevertheless a few saints included who are mentioned in the Bible but only briefly (Saints Gamaliel and Nicodemus, Saint Longinus, and St. Simeon of Jerusalem) or whose association with Jesus was indirect (Saint Stephen, the first martyr, died for his faith but never met Jesus).

Whenever possible I have given a brief description of the saint's title or lineage, significant role or contribution, priestly order, method of execution (if martyred), date of death, and feast day (in parentheses). The deeds and relevant celebrations of some saints may have been confined to a small area, even one community. These saints were so obscure that no reference to them could be found in literature. Such saints have no descriptive line under their entry heading.

The Middle Ages are filled with references to saints implored for intercession against the plague and other afflictions. It is interesting to note that saints regularly performed miracles more famously attributed to Jesus Christ: raising the dead, walking on water, multiplication of food, etc. A great many depictions of events in a saint's life can be found in the predella panels supporting an altarpiece.

It is important to know that in art, a saint's martyrdom did not always end in death. Some saints were martyred over and over again (unsuccessfully) until the persecutor found a guaranteed method — usually decapitation. St. Sebastian, for example, is most often shown tied to a tree or a column, filled with arrows, but he actually survived this martyrdom, only to be beaten to death at a later time; the fatal beating is rarely depicted.

As one studies the altarpieces, one can begin to recognize individuals by attributes they carry; sometimes, this is the only way a saint can be identified. St. Catherine of Alexandria, for example, is invariably depicted with a broken wheel — the symbol of her martyrdom — or with a sword, the instrument of her death. One can recognize St. Jerome because he is nearly always shown (mistakenly) with a cardinal's hat and with a lion (he was never a cardinal, but he did serve as papal secretary); he is usually depicted as an older man, and balding. Because these attributes are so critical to the understanding of religious art, I have included an *Index of Attributes and Events* as an appendix.

In this volume, I have included paintings, sculptures, mosaics, icons, frescoes, manuscript illuminations, drawings, sketches, woodcuts, and engravings. Unless it is otherwise stated, a work may be assumed to be a painting. I have noted where a sketch or woodcut is in color; engravings are in black-and-white. Under the saints' names, the pieces are listed chronologically by date of creation (as far as such date could be determined), starting with contemporaneous art and continuing through the early part of the twentieth century. Each entry is assigned a number, and will always be referenced as such; to avoid duplication, there is a "see also" section following each saint's listing if that person is depicted along with one or more other saints.

Information given for each work follows this pattern: description of the piece (or, more rarely, a title); artist's name when known; date of work when known. This information is followed by the collection in which the original is held (when known). The longest and most frequently used names have been abbreviated and are listed below:

BL: British Library
BM: British Museum
BN: Bibliothèque Nationale, Paris
BS: Bayerische Staatsgemaldesammlung, Munich
CCC: Corpus Christi College, Cambridge
KM: Kunsthistorisches Museum, Vienna
Met Museum: Metropolitan Museum of Art, New York
Musées des B/A: Musée des Beaux-Arts (in several cities)
Musées Royaux des B/A: Musées Royaux des Beaux-Arts (in several cities)
NGA: National Gallery of Art, Washington, D.C.
NGI: National Gallery of Ireland
NGS: National Gallery of Scotland
NYPL: New York Public Library
ON: Österreichische Nationalbibliothek, Vienna
RA: Royal Academy of Arts, London
V & A: Victoria and Albert Museum, London

(If the source of the painting is given as the Royal Academy of Arts, "RA," there could well be a problem locating the piece. These works of art were on exhibition at the Academy, but were generally placed there for sale by the artist. The Academy did not keep records of each painting after it was sold.)

Whenever possible, following the location I have listed a book or books in which the artwork is reproduced. For sake of convenience, I have listed the

books by author's last name and a short form of the title; complete information for these may be found in the *Bibliography*. In the case of a manuscript, whenever possible I have given its particular catalogue number from the library listed as the source. This does not necessarily mean that another library does not have a copy of this manuscript. But there is a possibility that a different edition will contain other illustrations.

My choice of books was simple: I used as many books as I could discover. If one is looking for a particular book and does not find it listed in the *Bibliography,* it was most likely unavailable to me. Initially, it was my intention to use books most readily available in one's local library. But because the general interest titles tend to repeat the same paintings over and over again, I had to abandon this plan in favor of more specialized books that give access to lesser-known works; it has been my intent to discover as many pieces — both obscure and well-known — as possible.

Because of the depth of my search, I was obliged to use some reference libraries not easily accessible to the general public. Even if the researcher cannot locate the book with the reproduction, I have tried to give enough of a description in each entry so that the researcher will known what the piece is about. The researcher can still write to the institution for further information; I have found that the museums and churches tend to be receptive to that kind of letter.

This leads us to the *Directory* at the back of this book. The *Directory* contains the names and addresses of art museums and libraries and some churches mentioned in the subject listing. I could not locate the mailing addresses for many of the churches, but I discovered that the letter will reach its destination with only the name of the church and the city on the envelope.

An *Artist Index* is also provided, listing truncated titles under alphabetically arranged artists' names (where known), and referencing it to the assigned entry number. When an identically named piece is found in more than one location, I have listed them separately, including the name of each city in parentheses.

This volume does not claim to be comprehensive; locating every piece of artwork related to the saints could easily come to be a lifelong project. But the Index is nevertheless quite substantial, covering over 4,200 saints and nearly 5,000 artworks, and years have gone into its compilation.

Post-Biblical Saints

Abbâ Macarius
1 Abbâ Macarius assaulted by the devil while drawing water for hermits, by Tuscan School, 1440–50. Christ Church, Oxford; Shaw, *Old Masters.*
2 Scenes from the life of St. Benedict, Abbâ Macarius and others: Abbâ Macarius, living in a tree-trunk, fed by angel; Abbâ confronted by a devil carrying a scythe; a monk lowers food to St. Benedict by a rope attached to a bell; Benedict lay penitent in bed of thorns, by Tuscan school, 1440–50. Christ Church, Oxford; Shaw, *Old Masters.*

Abdon and Sennen, Roman martyrs, mart. 303 (July 30)
3 Saints Abdon and Sennen (both hold a sword; they stand on a tiled floor), retable of Saints Abdon and Sennen by Jaime Huguet, 1459–60. Tarrasa, Santa Maria Church; Bentley, *Calendar*; Book of Art, *German & Spanish*; Erlande-Brandenburg, *Gothic Art*; Lassaigne, *Spanish*; McGraw, *Encyclo.* (Vol.XIII, pl.129).

Abercius, Bishop of Hieropolis, d. 300 (Oct. 22)
4 Madonna and Child adored by SS. Peter, Abercius, Stephen, and Benedict, by Corrado Giaquinto. Vassar College Art Gallery, NY; *Paintings 1300–1900*; Yale Univ., *Taste* (cat.46).

Achatius or Acacius, Bishop of Antioch, one of the 14 Holy Helpers, invoked against headaches (Mar. 31)
5 St. Achatius (holding both hands on his head; both are pierced through with blades) and St. Pantaleon, by the Bavarian School, c. 1455. BS, Munich; Bentley, *Calendar.*
6 St. Achatius (in armor) with a train of knights and nobles, after Lucas Cranach the Elder, c. 1520. Coll. Baron R. von Kuffner, Diosek; Friedländer, *Cranach.*

7 The baptism of St. Achatius and his companions, by Bacchiacca, 1540. Uffizi, Florence; Maison, *Art Themes.*
8 St. Achatius (crucified, with six standing figures at his feet), wood sculpture with water-based paints by José Benito Ortega, c. 1875–90. Museum for Southwest Studies, CO; Wroth, *Images of Penance.*

Ache *see* **Adrian (16)**

Achilleus *see* **Nereus and Achilleus**

Adalbert, Bishop of Prague; speared with a lance; mart. 997 (Apr. 23)
9 Archbishop Jan Očko of Vlašim kneeling between SS. Vitus and Adalbert, votive picture, c. 1371–75. Prague, Nat'l Gallery; Bachmann, *Gothic Art.*
10 Bust of St. Adalbert, embossed silver, before 1500. Prague, St. Vitus Cathedral; Korejsi, *Ren. Art in Bohemia.*
11 St. Sigismund (with orb and scepter) and St. Adalbert (with Bishop's crosier), by Bartholomaus Spranger. Zámecká Galerie, Duchcov; Kaufmann, *School of Prague.*
12 St. Adalbert (in bishop's robes), statue by Michael Johann Josef Brokoff, 1709. Charles Bridge, Prague; Štech, *Baroque Sculpture.*
13 St. Adalbert, polychromed wooden statue att. to Anton Braun, c. 1730. Benešov, Collegiate Church; Štech, *Baroque Sculpture.*
14 St. Adalbert, polychromed wooden statue by František Ignác Weiss, c. 1741–43. Prague, St. Catherine's Church; Štech, *Baroque Sculpture.*

Adalbert of Magdeburg, Missionary, first Archbishop of Magdeburg, 10th cent. (June 20)
15 St. Adalbert of Magdeburg (in bishop's regalia, pointing at an open book), by the Tyrolese school, c. 1500. V & A, London; Bentley, *Calendar.*

Adrian or Hadrianus, Roman Officer; dismembered; mart. 309 (Sept. 8)

16 The martyrdom of St. Adrian (they cut his feet off as Emperor Maximian looks on); the martyrdom of two saints thought to be Ache and Acheul (martyred with wooden swords) by anon. French painter, c. 1480. Met Museum; Bentley, *Calendar.*

17 St. Adrian (astride a white prancing horse, holding a model of his city, with a kneeling donor in lower left corner), from a triptych by Francesco di Gentile. Matelica, Museo Piersanti; Kaftal, *Central and So. Ital.*

18 St. Adrian (resting a hammer on an anvil), limestone statue by the School of Troyes, Champagne, c. 1500. Wadsworth Atheneum, Hartford CT; *Handbook.*

19 St. Adrian of Nicomedia (in armor, holding a sword and an anvil), stained-glass window, probably South Lowlands, 1510–25. John Higgins Armory Museum, Worcester MA.

20 St. Adrian martyred in the presence of his wife Natalia (he sits, supported, on an anvil, partially disemboweled, while executioners strike his legs with halberds), illum. by Jean Bourdichon from the Great Hours of Henry VIII, 1514–18. Coll. Duke of Cumberland; *Great Hours.*

21 The martyrdom of St. Hadrianus (they are about to cut off his feet) oil sketch by P.P. Rubens, 1621–22. Ruben-shuis, Antwerp; Held, *Oil Sketches.*

22 The martyrdom of St. Adrian (they are about to cut his foot off; his discarded armor lies on a step below him), by Adrien Sacquespée. Rouen, Musée des B/A; *La Peinture d'Inspiration*; Schnapper, *Jouvenet.*

23 Martyrdom of St. Adrian (executioner holds up the hand he had just severed, while a companion points to heaven; cherubs descend with a wreath), by Theodore Van Thulden, 1656. Ghent, St. Michel; Hairs, *Sillage de Rubens*; Larsen, *17th Cent. Flem.*

24 St. Adrian (in his Roman armor, holding a sword; cherubs crown him with a laurel wreath) by Pierre Thys the Elder. Ghent, St. Peter and Our Lady; Hairs, *Sillage de Rubens.*

Afra, Roman matron, converted by SS. Faustinus & Jovita; beheaded; mart. 304 (Aug. 5)

25 Saints Afra (in a nun's habit) and Margaret, by Pietro Lorenzetti. San Francesco, Assisi; DeWald, *Lorenzetti.*

26 St. Afra (holding a book and a palm, with a leopard and lion at her feet), fresco by Antonio della Corna. Asola, S. Andrea; Kaftal, *North West Italy.*

27 St. Afra (wearing a veil), poly-chromed wooden bust statue, 16th cent. BS, Munich; Bentley, *Calendar.*

Agatha, Patron of Catania and of bell-founders; patron of nurses; breasts cut off; died in prison after torture, mart. 251 (Feb. 5)

28 St. Agatha (holding a crucifix, giving a blessing), icon by the Tuscan School, 13th cent. Florence, Museo dell'Opera del Duomo; Kaftal, *Tuscan.*

29 St. Agatha brought to the brothel of Aphrodisia with her nine daughters; St. Agatha being whipped; St. Agatha's breasts are shorn; St. Peter visits Agatha in prison to cure her wounds; St. Agatha rolled naked over burning coals; an earthquake destroys the palace; from an altarpiece by the Paduan School, 13th–14th cent. Cremona, Sant'Agata; Kaftal, *North East Italy.*

30 St. Agatha (holding a palm and an upright lamp), fresco by the Lombard School, c. 1345. Castel San Pietro, S. Pietro; Kaftal, *North West Italy.*

31 St. Agatha (holding her severed breast and a palm), fresco by the Lombard School, 14th cent. Bellinzona, S. Biagio; Kaftal, *North West Italy.*

32 Scenes from the life of St. Agatha: she is sent to a brothel; she refuses to worship idols, and is lit by a celestial beam coming through the roof; her breasts are cut off; frescoes by the Tuscan School, 14th cent. Valdarno, S. Agata in Arfoli; Kaftal, *Tuscan.*

33 Scenes from the St. Agatha Cycle: kneeling in prayer; refusing to marry the provost; sent to the brothel of Aphrodisia; refusing the provost a second time; refuses to sacrifice to the idols; as she hangs by her hands, her breasts are cut off; visited by St. Peter and an angel in prison; praying to God; panels from an altarpiece by an unknown Sicilian artist, c. 1420. Castroreale, S. Agata; Kaftal, *Central and So. Ital.*

34 Scenes from the St. Agatha Cycle: rolled naked over live coals; funeral of St. Agnes; the provost, stealing Agatha's property, is thrown into the river by his

horses; Agatha's veil, carried in procession, stops the eruption of Mt. Etna; panels from an altarpiece by an unknown Sicilian artist. Castroreale, S. Agata; Kaftal, *Central and So. Ital.*

35 St. Agatha (standing in a brocaded robe, holding up her skirt with her left hand, and holding a palm with her right; blood seeps from her breasts), by the Marchigian School, 15th cent. Fermo, Archbishop's Palace; Kaftal, *Central and So. Ital.*

36 Torture of St. Agatha (her right breast is cut off as a consul watches), initial D from an Antiphonary painted by Sano di Pietro, 1456-76. Met Museum; Christiansen, *Siena.*

37 Initial with martyrdom of St. Agatha, by Bartholommeo della Gatta from an Antiphonal, ms.Cor.6, fo.40v. Urbino, Chapter of the Metropolitan; Salmi, *Ital. Miniatures.*

38 St. Agatha (sitting with a book and holding a breast with pincers), drawing by Bernhard Strigel, 1496-97. Fogg Art Museum, Cambridge MA; Mortimer, *Harvard Univ.*

39 Saints Peter and Agatha (holding a chalice with a host) with three kneeling donors, by Jakob Schick. Snite Museum of Art, IN; *Guide to the Snite Museum.*

40 St. Agatha wearing a circlet of flowers, by Bernardino Luini. Borghese Gallery, Rome; Coulson, *Saints.*

41 The martyrdom of St. Agatha (executioners clench her breasts with pincers), by Sebastiano del Piombo, 1520. Pitti Palace, Florence; Denvir, *Art Treasures.*

42 Saint Agatha holding a flaming staff, panel from an altarpiece by Master of Messkirch, c. 1530-43. Philadelphia Museum of Art, PA.

43 The burial of St. Agatha (priests perform funeral services, while an angel holds a marble tablet next to her head), fresco by Giulio Campi, 1537. Cremona Cathedral; Moir, *Caravaggio.*

44 The martyrdom of St. Agatha (soldiers being instructed, as her followers watch from top of stairs), by Giulio Campi. Cremona, Sant'Agata; Berenson, *Ital. Painters*; McGraw, *Encyclo.* (Vol.IX, pl.302).

45 St. Peter and an Angel (holding a candle and a bottle of salve) appearing to St. Agatha in prison, by Alessandro Turchi. Walters Art Gallery, Baltimore; *Ital. Paintings* (Vol.II).

46 St. Peter visiting St. Agatha in prison (he brings a bottle of salve and points to her, as an angel holding a large candle looks at him), by Simon Vouet, c. 1625-26. Hamilton Smith Estate, III; Spear, *Caravaggio.*

47 St. Agatha (holding a palm and pincers, looking off to her right) by Francesco Furini. Walters Art Gallery, Baltimore; *Ital. Paintings* (Vol.II).

48 St. Agatha (holding a platter with two breasts), by Francisco de Zurbaran, 1631-40. Fabre Museum, Montpellier; Gállego, *Zurbaran.*

49 St. Agatha (looking up, holding a hand over her wounded breast), by Bernardo Cavallino. York City Art Gallery; *Catalogue.*

50 St. Agatha (holding a bloodied linen to her chest), by Francesco Guarino, c. 1637. Capodimonte, Naples; RA, *Painting in Naples.*

51 St. Agatha (in an orange dress), by Bernardo Cavallino, 1640-45. Detroit Inst. of Art, MI.

52 St. Agatha (holding a platter with breasts and a palm) by Francisco de Zurbaran, 1641-58. Coll. Elosegui, Bilbao; Gállego, *Zurbaran.*

53 St. Agatha (bust portrait, looking heavenward, with her right hand on her chest), by Massimo Stanzione, 1640-60. Prague Castle; Neumann, *Picture Gallery.*

54 The Trinity adored by four female martyrs: St. Ursula (with a banner), St. Catherine of Alexandria, St. Agatha, and St. Barbara, by Francesco Cozza, 1670's. Picture Gallery, Berlin; *Catalogue.*

55 The martyrdom of St. Agatha (one executioner stabs her in the chest, while the other, standing behind her, draws his sword from its scabbard), by Giovanni Battista Tiepolo, c. 1734. Courtauld Inst. of Art, London; *Catalogue.*

56 St. Agatha (holding a plate with breasts, while an angel descends with a flower wreath and a palm), by Antonín Kern, c. 1736. Prague, Loreto Church; National Gallery, *Baroque.*

57 The martyrdom of St. Agatha (executioner sheaths his sword as friends support her), by Giambattista Tiepolo. Coll. Broglio, Paris; Morassi, *Catalogue* (pl.125).

58 The martyrdom of St. Agatha (helmeted man holds dagger point down, as friends support her), oil sketch by

Giambattista Tiepolo. Coll. Broglio, Paris; Morassi, *Catalogue* (pl.123).

59 The martyrdom of St. Agatha (helmeted man holds dagger point down, friends support her as God looks on), by Giambattista Tiepolo. Santo, Padua; Morassi, *Catalogue* (pl.124).

60 The martyrdom of St. Agatha (boy holds her breasts on a platter, and girl wraps her chest) by Giovanni Battista Tiepolo, c. 1750. Picture Gallery, Berlin; *Catalogue*; *Masterworks*; McGraw, *Encyclo.* (Vol.XIV, pl.56); Morassi, *Tiepolo*; Praeger, *Great Galleries*; Redslob, *Berlin*.

See also 75, 3433, 3457, 3471, 4475

Agatho, Pope, r. 678–681 (Jan. 10)
61 St. Agatho holding a staff, by the Umbrian School. Subiaco, Monastery of St. Benedict; Brusher, *Popes*.

Agnellus, Abbot of St. Gaudiosus, Naples, d. 596 (Dec. 14)
62 St. Agnellus (standing in monk's robes, with a walking stick; two tiny goats at his feet), by an unknown artist of the Neopolitan school, late 14th–early 15th cent. Naples, S. Genaro al Vomero; Kaftal, *Central and So. Ital.*

Agnes, Roman virgin, patron of Salerno and Rome; stabbed to death; mart. 304 (Jan. 21)
63 St. Catherine of Alexandria (in a fur-lined cloak, holding a palm) and St. Agnes (holding a lamb), panels from an altarpiece by Pietro Lorenzetti, 1329. Siena, Pinacoteca Nazionale; Van Os, *Sienese Altarpieces* (Vol.I pl.107 & 108).

64 St. Agnes holding a lamb, wood statue att. to Spoletto, 1350–1400. Isabella Stewart Gardner Museum, Boston MA.

65 St. Agnes, with a plaid lined cloak, holding a lamb and a scroll, by an unknown artist of the Sienese school, 14th cent. Worcester Art Museum; Edgell, *Sienese Painting*; *Handbook*.

66 St. Agnes, led to the brothel, covered only by her long hair, fresco by the School of Cavallini. Naples, S. Maria Donnaregina; Kaftal, *Central and So. Ital.*

67 St. Lucy (holding a tiny dagger and a boat-shaped bowl with eyes) and St. Agnes (holding a lamb), att. to Turino di Vanni, c. 1400. Birmingham Museum of Art, AL; Shapley, *Samuel H. Kress.*

68 Scenes from the life of St. Agnes:

St. Agnes refuses to marry the son of the pagan prefect, who fell ill; the father tries to persuade her to change her mind; Agnes is stabbed in the chest with a sword; frescoes by the Bolzano School, 1414. Caldaro, S. Caterina; Kaftal, *North East Italy.*

69 St. Agnes in glory (flanked by angels), illum. miniature from ms. add.18196. BM, London; Verdon, *Christianity.*

70 St. Bartholomew and a donor before St. Agnes (holding a palm and reading, with a lamb at her feet) and St. Cecilia, by Master of the Altar of St. Bartholomew, c. 1450–1510. Munich, Pinakothek; Bentley, *Calendar.*

71 St. John the Evangelist and St. Agnes (reading, as a lamb puts its front hooves against her dress), from a triptych by Quentin Metsys, 1518–22. Wallraf-Richartz Museum, Cologne; Bosque, *Metsys.*

72 Madonna and Child (with musician angels), flanked by SS. Catherine (holding an open book) and Agnes (showing her ring to a lamb), triptych by Mabuse and workshop, 1520's. Joslyn Art Museum; *Paintings & Sculpture.*

73 St. Agnes (sitting by a tree with an open book; a lamb paws at her dress), woodcut by Hans Sebald Beham. Fogg Art Museum, Cambridge MA; Geisberg, *Single Leaf.*

74 St. Agnes (sitting before a window with a lamb, holding a palm and looking up), by Andrea del Sarto, c. 1528. Pisa Cathedral; Padovani, *Andrea del Sarto.*

75 The Four Great Virgins of the Church (Agatha holding her breasts, Agnes with her lamb, Lucy holding a plate with eyes, Cecilia holding a pipe organ) and St. Barbara (leaning on a wall), by Moretto. Brescia, San Clemente; De Bles, *Saints in Art.*

76 The miracle of St. Agnes (she gestures to a man lying on the ground), by Tintoretto. Venice, Madonna dell'Orto; Tietze, *Tintoretto.*

77 Madonna with Saint Martina (with a lion) and St. Agnes (with a lamb), by El Greco, 1597–99. NGA, Washington DC; Gudiol, *El Greco.*

78 The martyrdom of St. Agnes (executioner, standing behind her, stabs Agnes in the neck), by Domenichino, c. 1619–22/25. Bologna, Pinacoteca Nazionale; Spear, *Domenichino.*

79 St. Agnes (standing next to a table with a lamb, holding a palm), by Alonso Cano, c. 1635–37. formerly Kaiser Friedrich Museum, Berlin; Wethey, *Alonso Cano* (pl.43).
80 St. Agnes with a lamb on a pedestal, by Alonso Cano, 1635–37. Picture Gallery, Berlin; Book of Art, *German & Spanish*; Wethey, *Alonso Cano* (pl.43).
81 St. Agnes (holding a book and a lamb), by Francisco de Zurbaran 1641–58. Seville, Museum of Fine Arts; Gállego, *Zurbaran.*
82 St. Agnes (an angel covers her nakedness in a brothel), by Jusepe de Ribera, 1642. Picture Gallery, Dresden; Bentley, *Calendar*; Book of Art, *German & Spanish*; New Int'l Illus. *Encyclo.*
83 St. Agnes on the pyre, marble sculpture by Ercole Ferrata, 1660. Sant'Agnese, Rome; McGraw, *Encyclo.* (Vol.II, pl.167); New Int'l Illus. *Encyclo.*
84 St. Agnes in glory with worshippers below, fresco by Gismondi, c. 1664. Rome, S. Agnese in Piazza Navona; Waterhouse, *Roman Baroque.*
See also 1066, 1517, 1579, 1722, 1841, 3525, 3647, 4252, 4276

Agricolus, Bishop, patron of Avignon, 7th cent. (Sept. 2)
85 The Man of Sorrows standing in the tomb, with St. Agricolus presenting a donor, known as the Retable of Bolbon, by the School of Provence, 1457. Louvre, Paris; Gowing, *Paintings.*

Aidan, Irish missionary and Abbot, protector of animals, d. 626 (Jan. 31)
86 St. Aidan (in ecclesiastic robes, holding a crosier), drawing by Sir Edward Burne-Jones; window design for St. Mary Virgin, Speldhurst, Kent. Bentley, *Calendar.*

Alban, first British martyr; decapitated; mart. 304 (June 22)
87 Martyrdom of St. Alban (they cut off his head and hang it from a tree), from Matthew Paris, "Life of St. Alban" ms.E.i.40, fo.38r, c. 1240. Trinity College, Dublin; Read, *Great Art.*
See also 181

Albert of Liege, Cardinal Bishop; killed with sword; mart. 1192 (Nov. 21)
88 St. Albert of Liege (holding a book and a palm), oil sketch by P.P. Rubens.

Chicago Art Inst.; Held, *Oil Sketches* (pl.27).
89 Archduke Albert with Saint Albert de Liege, engraving after Rubens by F. Harrewijn. Rooses, *L'Oeuvre.*

Albert of Trapani *see* **Albert Sicilus**

Albert Sicilus or Albert of Trapani, Carmelite monk, invoked against fever, d. 1307, canon. 1457 (Aug. 7)
90 St. Albert of Trapani (trampling the devil, holding an open book and a picture of the Virgin and Child), fresco by the Lombard School, 1472. San Felice del Benaco; Santuario del Carmine; Kaftal, *North West Italy.*
91 St. Albert Siculus (holding a book and a lily), from a polyptych by a follower of A. Gaddi. Yale Univ., New Haven CT; Kaftal, *Tuscan.*
92 St. Albert Siculus (standing with a book and a lily), fresco by Taddeo di Bartolo. Siena, Palazzo Pubblico; Kaftal, *Tuscan.*

Albert the Great, or Albertus Magnus, Dominican and bishop of Ratisbon and Regensburg, d. 1280, canon. 1931 (Nov. 15)
93 St. Albert the Great (sitting in his study, his right elbow against a book, looking at the viewer), fresco by Tomaso da Modena, 1352. Treviso, Dominican Seminary; Kaftal, *North East Italy.*
94 St. Thomas Aquinas studies in the school of St. Albert the Great at Cologne; fresco by the School of the Abruzzi, late 14th cent. Loreto Aprutino, S. Maria del Piano; Kaftal, *Central & So. Ital.*
95 Albert the Great, about to turn the page of his book, by Justus van Ghent. Barberini Palace, Rome; Coulson, *Saints.*
96 The School of Blessed Albert the Great (he sits at a desk, flanked by students), by Beato Angelico. Florence, Galleria Antica & Moderna; Bentley, *Calendar.*

Albertus Magnus *see* **Albert the Great**

Albinus, Bishop of Angers, d. 550 (Mar. 1)
97 Scenes from the life of St. Albinus from "Lives of the Bishops of Angers," ms. Regin. lat.465, f.74v, first half of 11th cent. Vatican; Porcher, *Medieval French Min.* (fig.4).

98 St. Albinus blesses the bread and wine, from "Vie de Saint Aubin," ms. nouv. acq. lat.1390, f.2, late 11th cent. BN, Paris; Porcher, *Medieval French Min.*

Aldebrandus *see* **Hildebrand**

Alexander, Thebian soldier; patron of Bergamo; beheaded; mart. 303 (Aug. 10 & 26)
99 St. Alexander (astride a galloping horse, in armor), fresco by the Lombard School, 1325-50. Bergamo, S. Maria Maggiore; Kaftal, *North West Italy.*
100 St. George (smiting a dragon) and St. Alexander (in armor, holding a pennon), by the school of Master of the Martyr Apostles, c. 1490. Esztergom Christian Museum; *Christian Art in Hungary* (pl.XI/222).
101 Martyrdom of St. Alexander (he kneels in prayer as executioner raises his sword), by Lorenzo Lotto, c. 1515. North Carolina Museum of Art, Raleigh; Shapley, *15th-16th cent.*
102 Martyrdom of St. Alexander of Bergamo (executioner sheaths his sword after decapitating the martyr), pen and brown ink drawing by Lorenzo Lotto, early 1520's. NGA, Washington DC; Walker, *NGA.*
103 St. Alexander led to martyrdom (he kneels, as the executioners try to tug him along), by Giuseppe Maria Crespi, 1729. Bergamo, S. Paolo d'Argon Parish Church; Merriman, *Crespi.*
See also 2329, 2533

Alexander I, Pope; pierced with nails; mart. 117 (May 3)
104 Reliquary head with an effigy of Pope Alexander, chased and gilded silver, cloisonné, att. to Godefroy of Huy, 1145. Brussels, Musées Royaux des B/A; Batselier, *Benedict* (p.178); Pirenne, *Belgique*; Souchal, *Early Middle Ages.*
105 Alexander I (in papal robes, holding a book, flanked by angels in upper corners and donors in lower corners), fresco by School of the Abruzzi, 15th cent. Pentima (Corfino), S. Alessandro; Kaftal, *Central and So. Ital.*
106 St. Alexander I, fresco att. to Fra Diamante in the Sistine Chapel. Vatican Museums; Brusher, *Popes.*
107 St. Alexander (conquering a fallen enemy with his crosier), by Ignatius

Platzer, c. 1750. Prague, Saint-Nicolas-de-la-Mala-Strana; Boone, *Baroque.*
See also 2531

Alexander Sauli, "Apostle of Corsica," bishop of Aleria and Pavia, d. 1592 (Oct. 11)
108 Saint Alessandro Sauli (in ecstasy), terracotta statue by Pierre Puget, c. 1662. Aix, Museum; Held, *17th & 18th cent.*

Alexander Svirskii, Russian monk
109 St. Alexander Svirskii in brown cloak and green robe, giving a blessing and holding an open scroll, embroidered funeral shroud with pearls in halo, Moscow, 1644. State Russian Museum, St. Petersburg.

Alexis, Lorraine hermit saint
110 St. Alexis meets his father, who, not recognizing him, takes Alexis into his house, fresco from the Roman School, late 11th cent. Rome, S. Clemente; Kaftal, *Central & So. Ital.*
111 Scenes from the life of St. Alexis: Pope Boniface finds the dead Alexis with the scroll in his hand; Boniface and Alexis's parents weep over his body; frescoes from the Roman School, late 11th cent. Rome, S. Clemente; Kaftal, *Central & So. Ital.*
112 Death of St. Alexis (Emperors Arcadius and Honorius and Pope Innocent I examine biography, while Alexis lies dead behind them), by Cornelius Buys, 1490-1520. Philadelphia Museum of Art, PA.
113 St. Alexis (dressed as a nobleman) giving alms, by Prospero Fontana. Bologna, S. Giacomo Maggiore; Bentley, *Calendar*; Boschloo, *Carracci.*
114 Madonna and Child with SS. Francis, Louis of Toulouse, Clare, John the Baptist, Catherine of Alexandria, and Alexis, by Annibale Carracci, c. 1587-88. Bologna, Pinacoteca Nazionale; *Age of Correggio.*
115 The discovery of the body of St. Alexis (by a young boy holding a torch), by Georges de la Tour. Nancy, Musée Historique Lorrain; McGraw, *Encyclo.* (Vol.IX, pl.95).
116 St. Alexis (boy holding a torch discovers his body), by Etienne de la Tour. NGI, Dublin; Wright, *Reality.*
117 The death of St. Alexis Falconieri

at Monte Senario (surrounded by monks), drawing by Bernardino Poccetti. Met Museum; Bean, *15th & 16th cent.*

Alexius, Metropolitan of Moscow
118 St. Alexius, Metropolitan of Moscow, with scenes from his life (discovery of his remains; birth of Elevfery–Alexius), icon by Dionysius, late 15th cent. Tretyakov Gallery, Moscow; Knopf, *The Icon* (p.287).

Almachio, Eastern monk, in the time of Emperor Onorio
119 St. Almachio Monk (standing with a hand on his chest and holding a palm, looking at a celestial light in upper right corner), etching by Teresa Del Po. Illus. Bartsch; *Ital. Masters of the 17th Cent.* (Vol.45).

Alò see Eligius

120 Virgin and Child (above) with Saints Alò and Petronius, by G. Cavedone. Bologna, Pinacoteca Nazionale; McGraw, *Encyclo.* (Vol.VIII, pl.219).

Aloysius Gonzaga see Luigi Gonzaga

Alphonsus Rodriguez, Jesuit monk, d. 1617 (Oct. 30)
121 Ecstasy of Alphonsus Rodriguez (he kneels, arms outspread, looking to heaven, supported by an angel), from a panel by Michael Pacher from Novacella Convento. Alte Pinakothek, Munich; Bentley, *Calendar.*
122 St. Alphonsus Rodriguez in ecclesiastical cope, looking up as cherub crowns him with flower wreath, by Bartdomé Esteban Murillo. Picture Gallery, Dresden; Coulson, *Saints.*

Alto, Irish hermit, founded a monastery near Augsberg, d. 760 (Feb. 9)
123 St. Alto, St. Bridget, and the founders of the Mariamünster, colored woodcut by anon. German 15th cent. artist. NGA, Washington DC.
124 St. Alto cutting down trees, handcolored woodcut by anon. Bavarian artist, c. 1500. NGA, Washington DC.

Amadour, first hermit of France, date unknown (Aug. 20)

125 SS. Amadour and Veronica displaying the Holy Face to the Gauls, min. by the Master of Claude from a Prayer Book of Queen Claude of France, fo.27v, c. 1515–16. Coll. H.P. Kraus, NY; Sterling, *Master of Claude.*
126 St. Amadour preaching to the Gauls (from a pulpit in a church), min. by the Master of Claude from a Prayer Book of Queen Claude of France, fo.27r, c. 1515–16. Coll. H.P. Kraus, NY; Sterling, *Master of Claude.*

Amand, French missionary and bishop of Maestricht, founded monasteries, d. 675 or 679 (Feb. 6)
127 Scene from the "Life of St. Amand" (he saddles a bear; he prays at an altar), ms.500, f.61, late 12th cent. Valenciennes Library; Porcher, *Medieval French Min.*
128 St. Amand (sitting, with a quill and a crosier) and St. Baudemond (writing), from the "Vie de Saint Amand," ms. 501, 2nd half of 12th cent. Valenciennes, Biblio. Municipale; Batselier, *Benedict* (p.205).
129 The conversion of St. Bavo (he is met on the steps by St. Amand, bishop of Maestricht), oil sketch by P.P. Rubens, 1611–12, etc....
See also 4089, 4725, 4871

Amandus of Burgundy, Bishop of Boreaux, d. 431 (June 18)
130 Scenes from the "Life of St. Amandus," ms.502, fo.29 (fig.35), second half of 11th cent.; St. Amandus baptizing a man, ms. 500, fo.54 (fig.38), second half of 12 cent. Valenciennes Library; Porcher, *Medieval French Min.*
131 Saints Amandus and Saint Walburga facing Saint Eligius and Saint Catherine of Alexandria, by P.P. Rubens, 1610–11. Antwerp, Cathedral; White, *Rubens.*

Ambrose, one of the four Latin fathers of the Church, Bishop of Milan, d. 397 (Dec. 7)
132 Mosaic of St. Ambrose, c. 400. S. Ambrogio Cathedral; Grant, *Western Civ.* (254.30).
133 St. Ambrose writing, from "Egino Codex," Phill. 1676, fo.24r., Verona, 796–99. Deutsche Staatbibliothek, Berlin; Rothe, *Med. Book Illum.* (pl.5).

134 St. Ambrose, holding a book and giving a blessing, mosaic with his name in background, 12th cent. Palermo, Cappella Palatina; Kaftal, *Central & So. Ital.*

135 St. Ambrose falls asleep at mass (when he awakens, he claims that he had been officiating at St. Martin's funeral), fresco by Simone Martini, 1328. San Francesco, Assisi; Kaftal, *Tuscan.*

136 St. Ambrose (enthroned, holding a crosier and a scourge), by Vitale da Bologna. Pesaro, Museo Civico; Gnudi, *Vitale.*

137 The four church fathers of 1363: Ambrose (holding a book and crosier), Gregory I (holding an open book, with a dove whispering in his ear), Augustine (holding an open book and crosier) and Jerome (holding an open book and plume), panels of a polyptych by Giovanni del Biondo, 1363. Santa Croce, Florence: Offner, *Corpus* (Sect.IV, Vol.IV, part I, pl.XV).

138 Saints Gregory I, Jerome, Augustine, and Ambrose (each in a quarter of a page), manuscript illum. from ms. 3004 B 10, fol.121v, c. 1400. Hessisches Hauptstaatsarchiv, Wiesbaden; Dogaer, *Flemish Min.*

139 Four church fathers: Ambrose, Jerome (reading), Augustine (in left profile), and Gregory I, by Sassetta. Siena, Pinacoteca Nazionale; Christiansen, *Siena.*

140 St. Ambrose (in a green cloak), from the "Book of Hours of Catherine of Cleves" by the Master of the Hours of Catherine of Cleves, c. 1434–40. Pierpont Morgan Library, NY; Snyder, *Northern Ren.*

141 St. Maurizio Altarpiece; Virgin and Child flanked by SS. Ambrose and Jerome (in cardinal's robes), by Master of the Osservanza, c. 1436. Osservanza, Siena; Van Os, *Sienese Altarpieces* (Vol.II pl.182).

142 St. Ambrose's miracle of the bees (as a new-born, when a swarm of bees flew in and out of baby's mouth without stinging him), by Filippo Lippi, c. 1441–47. Picture Gallery, Berlin; *Catalogue*; Redslob, *Berlin.*

143 Ambrose, Cecilia, and Augustine, with the donor Heinrich Zeuwelgyn, by Stephan Lochner, c. 1445. Nat'l Gallery, London; Dunkerton, *Giotto to Dürer.*

144 St. Jerome and Gregory and SS. Augustine and Ambrose flank the Virgin and Child in the Four Fathers of the Church triptych by Antonio Vivarini and Giovanni d'Alemagna, 1446. Accademia, Venice; Burckhardt, *Altarpiece.*

145 St. Ambrose baptizes St. Augustine (Augustine kneels semi-nude, as Ambrose pours water on his head, and others watch), fresco by Ottaviano Nelli. Gubbio, S. Agostino; Kaftal, *Central & So. Ital.*

146 St. Augustine (in bishop's regalia, reading a book), St. Jerome (standing in cardinal's robes), and St. Ambrose (in bishop's regalia), three panels by an unknown Provencal painter, c. 1480. Louvre, Paris; *L'Ecole d'Avignon.*

147 St. Ambrose (in his study, deep in thought as he writes), fresco by Domenico Ghirlandaio, c. 1480. Ognissanti, Florence; Andres, *Art of Florence* (Vol.II, pl.468).

148 St. Ambrose (writing, with a dove above him and a child in the cradle at his feet), from "The Four Latin Fathers" altarpiece by Michael Pacher, c. 1483. Alte Pinakothek, Munich; Bentley, *Calendar*; Janson, *Picture History*; McGraw, *Dict.*; Piper, *Illus. Dict.* (p.87).

149 Birth of St. Ambrose (witnesses watch while a swarm of bees lands on the infant's face without causing harm), predella panel by Ambrogio Bergognone, 1490. Kunstmuseum, Basle; Kaftal, *North West Italy.*

150 SS. Augustine (holding an image of the Holy Trinity) and Ambrose, panel of a polyptych by Vincenzo Foppa and Ludovico Brea, 1490. Savona, S. Maria di Castello; Kaftal, *North West Italy.*

151 St. Ambrose chastises the Arians with his whip, allegorical episode, fresco by Bonifacio Bembo. Monticelli d'Ongina, Cappella della Rocca Pallavincino; Kaftal, *North West Italy.*

152 St. Ambrose consecrated as bishop; St. Ambrose preaching, in the presence of St. Augustine and St. Monica, predella panels by Ambrogio Bergognone, 1490. Turin, Galleria Sabauda; Kaftal, *North West Italy.*

153 St. Ambrose in his study, woodcut att. to Albrecht Dürer from "Ambrosii Opera," 1492. Strauss, *Woodcuts* (p.653).

154 A count of Hainault (dressed as a Cistercian monk) with his patron saint Ambrose, by Flemish school, late 15th–early 16th cent. Nat'l Gallery, London; Poynter, *Nat'l Gallery.*

155 St. Ambrose baptizes St. Augustine (in the presence of his mother, St. Monica), panel by Antonio Vivarini. Bergamo; Kaftal, *North East Italy* (fig. 979).

156 St. Ambrose on horseback (cracking a whip), fresco by Bernardo Zenale. Milan, S. Pietro in Gessate; Sedini, *Marco d'Oggiono* (p.28).

157 St. Ambrose enthroned with other saints, by Alvise Vivarini and M. Basaiti, c. 1503. Venice, S. Maria Gloriosa del Frari; Burckhardt, *Altarpiece*; McGraw, *Encyclo.* (Vol.XII, pl.45).

158 St. Ambrose (standing on a cloud, holding a book), by Martin Freminet. Orléans, Musée des B/A; O'Neill, *L'Ecole Francaise.*

159 Dispute between SS. Ambrose and Augustine (they discuss doctrine, in a crowded church), by Camillo Procaccini, 1618. Milan, San Marco; Fiorio, *Le Chiese di Milano.*

160 The Emperor Theodosius refused admission into the church by St. Ambrose, by P.P. Rubens, c. 1618. KM, Vienna; Larsen, *17th Cent. Flem.*

161 The Emperor Theodosius refused admission into the church by St. Ambrose, by Anthony van Dyck after a painting by Rubens, 1618. Nat'l Gallery, London; Larsen, *17th Cent. Flemish*; Larsen, *Van Dyck* (pl.110); Poynter, *Nat'l Gallery.*

162 St. Ambrose (leaning on a table, with his left hand on the spine of an open book), by Claude Vignon, 1623-25. Minneapolis Inst. of Art, MN; *European Paintings.*

163 St. Ambrose (in bishop's robes, holding a crosier), by Francisco de Zurbaran, 1626-27. Seville, Museum of Fine Arts; Gállego, *Zurbaran.*

164 St. Ambrose dissuading Maximus, by Anthony van Dyck KM, Vienna; Daniel, *Encyclo. of Themes.*

165 St. Ambrose (in left profile), by P.P. Rubens. NGS, Edinburgh; *Illustrations.*

166 St. Ambrose (standing before a balustrade, in bishop's robes), by Gaspar de Crayer. Prado, Madrid; *Peinture Flamande* (b/w pl.93).

167 The four doctors of the Latin Church (Jerome, Augustine, Gregory the Great, and Ambrose) in discussion before the Holy Sacrament, by Erasmus Quellin, 1646. Liège, St. Paul Cathedral; Hairs, *Sillage de Rubens.*

168 St. Ambrose (in bishop's regalia, pointing at an open book), marble sculpture by Johann Mauritz Gröninger. Münster, St. Martini; *800 Jahre.*

169 St. Ambrose welcoming the delegates of a procession, by Agostino Sant'Agostino. Virginia Museum of Fine Arts; *European Art.*

170 St. Ambrose (sitting in right profile, giving a blessing), by Subleyras. Stanford Univ. Museum of Art; *Subleyras.*

171 St. Ambrose giving absolution to Emperor Theodose (died 394) after the massacre of the citizens of Thessalonique (the emperor kneels before the sitting Ambrose, who blesses him), by Subleyras, 1745. Pérouse, Galleria Nazionale dell'Umbria; *Subleyras.*

172 St. Ambrose giving absolution to Emperor Theodose (died 394) after the massacre of the citizens of Thessalonique (the emperor kneels before the sitting Ambrose, who blesses him), by Subleyras, 1745. Pinacoteca, Munich; *Subleyras.*

173 St. Ambrose giving absolution to Emperor Theodose (died 394) after the massacre of the citizens of Thessalonique (the emperor kneels before the sitting Ambrose, who blesses him), by Subleyras, 1745. Louvre, Paris; *Subleyras.*

174 St. Ambrose (sitting in ecclesiastic robes, writing in a book and looking up), by Goya, 1781-85. Cleveland Museum of Art, OH; *European 16-18th Cent.*

See also 486, 495, 522, 530, 1929, 3514, 3598, 3607, 4745, 4921

Ambrose of Siena or Ambrose Sansedoni, patron of Siena; Dominican, d. 1286 (Mar. 20)

175 St. Ambrose of Siena (sitting in his study, writing in a book), partially ruined fresco by Tomaso da Modena, 1352. Treviso, Domenican Seminary; Kaftal, *North East Italy.*

176 St. Ambrose of Siena (writing, as a dove flies over his right shoulder), by Francisco de Zurbaran, 1631-40. Córdoba, Provincial Museum of Fine Arts; Gállego, *Zurbaran.*

Amicus or Amico, hermit monk, patron of woodcutters, invoked against hernia, d. 1045 (Nov. 2 & 3)

177 Amicus (as a monk, holding a

pruning hook, and holding a small wolf on a leash), fresco by the Umbrian School, 15th cent. Rasiglia, Santuario della Madonna; Kaftal, *Central & So. Ital.*

178 St. Amicus (holding a hatchet and holding a small wolf on a leash), fresco by the Umbrian School, 15th cent. Rasiglia, Santuario della Madonna; Kaftal, *Central & So. Ital.*

179 St. Amicus (holding a hatchet over his right shoulder, and holding a small wolf on a leash), fresco by the Umbrian School, 15th cent. Campi (Norcia), S. Salvatore; Kaftal, *Central & So. Ital.*

Ampelius
180 Christ appearing to St. Ampelius (as angels support him, applying ointment to his feet), by Pompeo Batoni, c. 1748–50. Museum of Art, Rhode Island School of Design; Clark, *Batoni.*

Amphibalus, Clerk of St. Alban; scourged while bound to a tree by his bowels; mart. 303
181 Alban watching Amphibalus kneeling before the cross, from "Lives of Saints Alban and Amphibalus" by Matthew Paris, mid-13th cent. Trinity College, Dublin; Rickert, *Painting in Britain.*

Anastasia, The poison curer, patron of agriculture; burned at the stake (Oct. 29)
182 Saint Anastasia the poison curer (holding a vase) with the donor Anastasia, fresco, 14th cent. Church of Panagia Phorbiotissa of Asinou, near Nikitari; Stylianou, *Painted Churches* (p.139).
183 Icon of St. Anastasia (in green, holding a six-armed cross and a vase), second half of 14th cent. Hermitage, St. Petersburg; Bank, *Byzantine* (pl.285).
184 SS. Paraskeva (in a red cloak) and Anastasia (holding a vase), tempera on wood icon, Novgorod, 1450–1500. State Russian Museum, St. Petersburg.
See also 4085

Anastasius, Christian soldier in Persia, later monk; beheaded; mart. 628 (Jan. 22)
185 Virgin and Child flanked by SS. Anastasius and Vincent, by Andrea di Niccolò. Siena, Contranda dell'Istrice; Kaftal, *Tuscan.*
186 St. Anastasius (sitting at a round

table before a window, reading from a large book), anon. copy after a lost original by Rembrandt, 1631. Stockholm National Museum; Schwartz, *Rembrandt.*

Anatolia, sister of St. Victoria; stabbed with a sword; mart. 253 (July 10)
187 St. Anatolia, standing with a sword in her breast, holding a palm in her right hand, and a book and serpent in her left hand, fresco by the Umbrian School, 15th cent. Subiaco, S. Scholastica; Kaftal, *Central & So. Ital.*

Andrea Avellino or Andrew Avellino, Theatine monk, invoked against sudden death and apoplexy; d. 1608 (Nov. 10)
188 God the Father appearing to Saints Gaetano and Andrea Avellino, by Domenichino, c. 1629–30. Rome, S. Silvestro al Quirinale; Spear, *Domenichino.*
189 Episode from the story of SS. Cajetan and Andrea Avellino (they exorcise a possessed woman), by Sebastiano Ricci. Milan, Sant'Antonio Abate; Fiorio, *Le Chiese di Milano.*
190 Virgin with Saints Philip Neri and Andrea Avellino, by Giuseppe Maria Crespi, c. 1688–90. Bologna, Sant'Andrea Avellino; Merriman, *Crespi.*

Andrea Corsini or Andrew Corsini, Carmelite archbishop of Fiesole, d. 1373, canon. 1629 (Jan. 30 & Feb.4)
191 St. Andrea Corsini surrounded by cherubs (as he prays, three cherubs appear in a celestial light, and behind him, two cherubs play with his attributes), by Guido Reni, c. 1629. Corsini Palace, Florence; *Guido Reni.*
192 St. Andrea Corsini (standing in bishop's regalia, looking heavenward), by Guido Reni, c. 1635. Bologna, Pinacoteca Nazionale; *Guido Reni.*
193 Glorification of St. Andrew Corsini (raised to heaven with other saints), by Luca Giordano. Florence, Carmelite Convent; Bentley, *Calendar.*
194 Miracle of Saint Andrea Corsini (he looks down on a battle), marble relief by Giovanni Battista Foggini. Florence, S. Maria del Carmine; New Int'l Illus. *Encyclo.*

Andrea of Ireland *see* **Andrew of Ireland**

Andrew Avellino *see* **Andrea Avellino**

Andrew Corsini *see* **Andrea Corsini**

Andrew of Ireland or Andrea, deacon of St. Donatus, brother of St. Brigid of Ireland, ninth cent. (Aug. 22)
195 Scenes from a life of St. Andrew of Ireland: he cures a paralytic girl at her bedside; St. Donatus points to the ruined church of St. Martino and tells Andrew to repair it; death of St. Andrew (poor and sick surround his bed), painted casket from the Late Orcagnesque period. S. Martino A Mensola (near Florence); Kaftal, *Tuscan.*

Andrew Yorodivy, the "Holy Fool," beggar and preacher, 10th cent.
196 St. Andrew Yorodivy in the Protecting Veil icon, where the Holy Mother appears to him in the church of Blachernae in Constantinople, surrounded by prophets and apostles under a veil held by angels, Novgorod, mid-16th cent. State Russian Museum, St. Petersburg.
197 St. Andrew Yorodivy with scenes from his life, icon from Moscow, mid-16th cent. State Russian Museum, St. Petersburg.

Angela Merici, founder of Ursuline nuns, d. 1540, canon. 1807 (Jan. 27)
198 The mystic marriage of Saint Catherine, with Saints Lawrence, Ursula, and Angela Merici, by Romanino, c. 1530–35. Brooks Memorial Art Gallery, Memphis TN; New Int'l Illus. *Encyclo.*

Angelique
199 Reliquary bust of St. Angelique, repousse copper with polychrome and gilt, Italian, 15th cent. Snite Museum of Art, IN; *Guide to the Snite Museum.*

Angelo or Angelus, Carmelite monk; stabbed to death; mart. 1220 or 1225 (May 5)
200 St. Angelo (standing with a palm and a book, with a dagger in his chest and a knife in his head, crowned by two angels) panel by the Sicilian School, late 15th cent. Palermo, Carmine; Kaftal, *Central & So. Ital.*
201 St. Francis prostrates himself before St. Angelo predicting his martyrdom, in the presence of St. Dominic and another monk, fresco by the Lombard

School, 1488. S. Felice del Benaco; Kaftal, *North West Italy.*
202 Madonna and Child in glory with SS. Angelo and Clara of Montefalco, by Francesco Solimena. Naples, Santa Maria Egliziaca a Forcella; Yale Univ., *Taste* (fig. 69).

Anicetus, Pope, mart. 168 (Apr. 17)
203 St. Anicetus (holding a closed book), fresco by Botticelli in the Sistine Chapel, 1481. Vatican Museums; Brusher, *Popes*; Lightbown, *Botticelli.*

Ansano *see* **Ansanus**

Ansanus or Ansano, first apostle and patron saint of Siena; beheaded; mart. 304 (Dec. 1)
204 St. Ansanus (kneeling with a hand upraised), from the Maestà by Simone Martini, 1315. Siena, Palazzo Pubblico; Bachmann, *Gothic Art.*
205 St. Ansanus (in half-view, holding a banner and a palm), panel att. to Lippo Vanni. Lehman Coll., NY; Edgell, *Sienese Painting.*
206 Nativity Polyptych, with SS. Ansanus and Victor, by Giovanni di Paolo. Petit Palais, Avignon; Van Os, *Sienese Altarpieces* (Vol.II, pl.118).
207 Four patron saints: Victor (with a sword), Ansano (with a banner), Savino (in bishop's robes) and Crescenzio (holding a severed head, standing on a sword), by Sassetta. Siena, Pinacoteca Nazionale; Christiansen, *Siena.*
208 St. Ansanus holding a banner, from an Antiphonary illus. by Giovanni di Paolo, ms. codex G.I.8, fo.25r. Siena, Biblio. Communale degli Intronati; Christiansen, *Siena.*
209 St. Jerome in the desert with St. John the Baptist and St. Ansanus by Fra Filippo Lippi and Fra Diamante. Fogg Art Museum, Cambridge MA; *Med. and Ren. Paintings*; McGraw, *Dict.*
210 The mourning St. John the Evangelist, the Assumption of the Virgin, and St. Ansanus, by Giovanni di Paolo, 1445. El Paso Museum of Art, TX; Christiansen, *Siena.*
211 Nativity Polyptych, with SS. Ansanus and Augustine, by Pietro di Giovanni d'Ambrogio, mid-15th cent. Asciano, Museo d'Arte Sacra; Van Os, *Sienese Altarpieces* (Vol.II, pl.119).
212 St. Ansanus (holding a heart and a

palm) and St. Apollonia (holding pincers), by Maestro di Signa. Florence, Museo della Collegiata di S. Andrea; Pierleoni, *Denti e Santi* (fig.64).

213 St. Ansanus performs baptisms outside the city gates (three men kneel on the ground, while others remove their clothes), by Giovanni di Paolo. Esztergom Christian Museum; *Christian Art in Hungary* (p.59); Kaftal, *Tuscan.*

214 Scene from the life of St. Ansanus: he is beheaded (kneeling before soldiers), predella from a dispersed altarpiece by Giovanni di Paolo. Bargello, Florence; Kaftal, *Tuscan.*

215 Scene from the life of St. Ansanus: he is boiled in a cauldron of oil (he stands, unharmed, as soldiers stoke the fire), predella from a dispersed altarpiece by Giovanni di Paolo. Coll. Du Luart, Paris; Kaftal, *Tuscan.*

216 St. Ansanus (as a young man, standing with a palm and his own viscera, with a city in background), by School of Lazio, late 15th cent. Viterbo, Museo Civico; Kaftal, *Central & So. Ital.*

See also 2322, 3248

Anselm, archbishop of Canterbury, d. 1109 (Apr. 21)

217 St. Anselm (kneeling before a group of monks), from "Le Miroir Historial" by Vincent de Beauvais, 15th cent. Condé Museum, Chantilly; Bentley, *Calendar.*

218 St. Anselm enthroned, surrounded by other saints, terracotta altarpiece by Luca della Robbia. Empoli, Galleria della Collegiata; Coulson, *Saints.*

219 Virgin and Child with SS. Anselm (in bishop's robes) and Sebastian (holding a crown), by Bernardino Fungai. Virginia Museum of Fine Arts; *European Art.*

220 St. Anselm (in friar's robes, reading a book), by Francisco de Zurbaran, 1637–39. Cadiz, Provincial Museum of Fine Arts; Gállego, *Zurbaran.*

221 Saint Anselm (conquering heresy in the guise of contorted men), by Giuseppe Maria Crespi, 1735–40. Louvre, Paris; Merriman, *Crespi.*

Anselm of Nonantola, Benedictine monk and founder of Abbey of Nonantola, d. 803 (Mar. 3)

222 St. Anselm of Nonantola (standing in robes of abbot, holding a book and a crosier), panel of a polyptych by Michele di Matteo. Nonantola, Abbey; Kaftal, *North East Italy.*

Anterus, Pope, r. 235–236 (Jan. 3)

223 St. Anterus, holding a book and quill, fresco by Fra Diamante in the Sistine Chapel. Vatican Museums; Brusher, *Popes.*

Anthelm, Carthusian Prior, first minister general of the order, Bishop of Belley, d. 1178 (June 26)

224 St. Anthelm (in a hooded robe, reading a book), painted for the Carthusian Monastery at Jerez de la Frontera by Francisco de Zurbaran. Cadiz, Provincial Museum of Fine Arts; United Nations, *Dismembered Works.*

Anthony Abbot, or St. Anthony of the desert, founded first monastery, 4th cent. (Jan. 17)

225 St. Anthony Abbot blessing the camels sent by the king (he stands at left, inside an archway with his boar, blessing the camels who are behind a building; the king stands inside the building at right), att. to the school of Ottaviano Nelli. Coll. Corsi, Florence; Kaftal, *Central and So. Ital.*

226 St. Anthony holding the Christ Child in one arm, carved and painted wooden statue from Lithuania. Paris, Musée de l'Homme; McGraw, *Encyclo.* (Vol.V, pl.353).

227 Temptation of St. Anthony (bitten by wild animals), from a Book of Offices, ms. lat. 757, fo.289v. BN, Paris; Salmi, *Ital. Miniatures.*

228 St. Anthony Abbot (standing with a crutch and two pigs) with fourteen donors and an infant, votive panel by the Master of the Fabriano Altarpiece. Fabriano, Pinacoteca Civica; Offner, *Corpus* (Sect.III, Vol.V, pl.XXXVI).

229 Miracle of St. Anthony (above, he is rescued from a tower; below, he discovers two men lying in a hole), by Vitale da Bologna. Bologna, Pinacoteca Nazionale; Gnudi, *Vitale*; McGraw, *Encyclo.* (Vol.VI, pl.352).

230 St. Anthony Abbot (in black robes, holding a book) and St. James, by Vitale da Bologna. Bologna, Collezioni Communali d'Arte; Gnudi, *Vitale.*

231 St. Anthony Abbot brings the camels for the sick king (in bed, in a house above the praying saint), by Vitale da

Bologna. Bologna, Pinacoteca Nazionale; Gnudi, *Vitale.*

232 The ill are cured at the tomb of St. Anthony, by Vitale da Bologna. Bologna, Pinacoteca Nazionale; Gnudi, *Vitale.*

233 Coronation of the Virgin, with kneeling SS. Anthony Abbot and Louis of Toulouse (and a tiny kneeling female donor), by Giovanni del Biondo. San Donato in Poggio, Parish Church; Offner, *Corpus* (Sect.IV, Vol.IV, part I, pl.XXXIV).

234 St. Anthony Abbot, by a follower of Pietro Lorenzetti, c. 1350–1400. Bridgeport, Museum of Art, Science, and Industry, CT; Shapley, *Samuel H. Kress.*

235 The miracles of St. Anthony Abbot (he stops a man from hanging) by Vitale da Bologna. Bologna, Pinacoteca Nazionale; Gnudi, *Vitale*; Gowing, *Biog. Dict.*

236 St. Anthony Abbot in a cloak, holding a bell and crosier, by Giovanni da Milano. Univ. of Georgia, Athens GA; Ferguson, *Signs*; Shapley, *Samuel H. Kress.*

237 St. Anthony Abbot (half-view, holding a crutch and a book), by a follower of Nardo di Cione. Coll. Berenson, Ponte A Mensola; Offner, *Corpus* (Sect.IV, Vol.II, pl.XXIII).

238 Crucifixion with St. Anthony Abbot; on the reverse, St. Anthony Abbot (with a crutch and bell) and St. Eligius (with a hammer and horse hoof) with two kneeling donors, by Barnaba da Modena, c. 1370. V & A, London; Bentley, *Calendar* (p.6); Dunkerton, *Giotto to Dürer.*

239 St. Anthony Abbot beaten by devils (before the mausoleum where he lives; at right, he prays to Christ, who comforts him), fresco by A. Gaddi, 1385. Santa Croce, Florence; Kaftal, *Tuscan.*

240 St. Anthony Abbot teaching his disciples, by Martino di Bartolommeo. Vatican Museums; Kaftal, *Tuscan.*

241 Scenes from the life of St. Anthony Abbot: Anthony leaves his sister with some pious virgins; the devil tempts Anthony by appearing as a woman next to a bed, then appearing as a black boy who is the spirit of fornication; frescoes by the School of the Veneto, late 14th cent. Bassano, S. Francesco; Kaftal, *North East Italy.*

242 St. Anthony Abbot (standing in a circle of flames; coats of arms in background), from the "Boucicaut Hours" painted by the Boucicaut Master, ms.2,fo.35v. Jacquemart-André Museum, Paris; Meiss, *French Painting.*

243 St. Anthony Abbot in black robe holding a red book, flanked by angels, by Gerini, c. 1400. Isabella Stewart Gardner Museum, Boston MA.

244 St. Anthony Abbot and the devils (he sits in a chair in a circle of fire, flanked by demons), by the workshop of Boucicaut, ms.Douce 144, fo.138, c. 1407. Bodleian Library, Oxford; Meiss, *French Painting.*

245 St. Anthony's vision of hell (he kneels amidst a group of burning sinners, looking up at demons carrying more sinners), fresco by the Umbrian School, 14th–15th cent. Montefalco, S. Francesco; Kaftal, *Central & So. Ital.*

246 St. Anthony Abbot (as a pilgrim, with a "tau" embroidered on his cloak, standing with his crutch, a bell, a rosary, and a boar), min. by the Rohan Master from a Book of Hours, ms. Latin 9471, f.218, c. 1415–16. BN, Paris; *Rohan Master* (pl.95).

247 St. Anthony Abbot exorcising a woman (before a cave), by The Master of 1419. NGS, Edinburgh; *Illustrations.*

248 St. Anthony feeding the poor (who are seated at a long table), by Bicci di Lorenzo, c. 1423. Vatican Museums; Cleveland Museum of Art, *European before 1500.*

249 St. Anthony Abbot (reading a red book, holding a staff with a bell attached), by the Master of the Osservanza Triptych, after 1425. Louvre, Paris; Gowing, *Paintings.*

250 St. Anthony Abbot tempted by a lump of gold (he is running away from it) by Fra Angelico, c. 1430. Houston Museum of Fine Arts, TX; *Guide to the Coll.*; *Permanent Legacy.*

251 Anthony Abbot, standing with a walking stick, wolf at his feet, by Giovanni dal Ponte, c. 1430. Baltimore Museum of Art, MD.

252 St. John the Baptist and St. Anthony Abbot (with a "tau" on his robe, leaning on a walking stick), by Giovanni dal Ponte. Fitzwilliam Museum, Cambridge; Catalogue, *Italian.*

253 Death of St. Anthony (surrounded by monks holding candles) by Sassetta, c. 1440. NGA, Washington DC; Christiansen, *Siena*; Shapley, *Samuel H. Kress*; Walker, *NGA.*

254 Scenes from the life of St. Anthony Abbot (he has a vision of angels ascending to heaven; he buries St. Paul the hermit with the help of two lions, who dig a grave), by Tuscan School, 1440–50. Christ Church, Oxford; Shaw, *Old Masters.*

255 St. Anthony Abbot at mass (dressed as a nobleman), att. to Sassetta or Master of the Osservanza, c. 1429–36. Picture Gallery, Berlin; *Catalogue*; Christiansen, *Siena.*

256 St. Anthony beaten by devils (as another devil flies down with a snake), by Sassetta or Master of the Osservanza, c. 1440. Yale Univ., New Haven CT; Christiansen, *Siena*; Pope-Hennessy, *Sienese.*

257 St. Anthony distributing his wealth to the poor (before an orange building) by Sassetta, c. 1440. NGA, Washington DC; Christiansen, *Siena*; Newsweek, *Nat'l Gall.*; Shapley, *Samuel H. Kress*; Walker, *NGA.*

258 St. Anthony leaving his monastery, by Sassetta, c. 1440. NGA, Washington DC; Christiansen, *Siena*; Shapley, *Samuel H. Kress*; Walker, *NGA.*

259 St. Anthony tempted by the devil in the guise of a woman, by Sassetta or Master of the Osservanza. Yale Univ., New Haven CT; Christiansen, *Siena*; Pope-Hennessy, *Sienese*; Yale Univ., *Selected Paintings.*

260 The meeting of St. Anthony and St. Paul (they embrace) by Sassetta, c. 1440. NGA, Washington DC; Christiansen, *Siena*; Newsweek, *Nat'l Gall.*; Phaidon, *Art Treasures*; Pope-Hennessy, *Sienese*; Shapley, *Samuel H. Kress*; Walker, *NGA.*

261 St. Anthony presenting a pilgrim to St. John, by Giovanni di Francesco, 1442–59. Dijon, Musée des B/A; Georgel, *Musée des B/A.*

262 St. Anthony Abbot tempted by gold (he is running away from it), part of a predella by Master of Fucecchio, c. 1444–50. Birmingham Museum of Art, AL; *Samuel H. Kress Coll.*; Shapley, *Samuel H. Kress.*

263 Death of St. Anthony (he lay on his deathbed, attended by monks and nuns; a frantic woman is helped by two others), by the Umbrian School, 15th cent. Cascia, S. Antonio; Kaftal, *Central & So. Ital.*

264 St. Anthony Abbot (walking down the road in the wilderness), att. to the Master of the Osservanza, mid-15th cent. Lehman Coll., NY; McGraw, *Encyclo.* (Vol.XII, pl.372).

265 St. Anthony appoints the hermit Paphnutius as abbot (they stand at the door of the monastery), fresco by the Umbrian School, 15th cent. Cascia, S. Antonio; Kaftal, *Central & So. Ital.*

266 St. Anthony chases a dragon away from a well (while his monks look on), fresco by the Umbrian School, 15th cent. Cascia, S. Antonio; Kaftal, *Central & So. Ital.*

267 St. Anthony given bread by a deacon, who climbs a ladder and slips it through a window in his cell, fresco by the Umbrian School, 15th cent. Cascia, S. Antonio; Kaftal, *Central & So. Ital.*

268 St. Anthony Abbot (kneeling before a wall) and St. Michael, by Fra Filippo Lippi, c. 1457–58. Cleveland Museum of Art, OH; *European before 1500*; *Selected Works.*

269 St. Anthony Abbot (seated with a walking stick and an open book, a pig at his feet), by Neri di Bicci, 1460–90. Denver Art Museum, CO; Shapley, *Samuel H. Kress.*

270 St. Anthony Altarpiece; Virgin and Child enthroned with angels, flanked by SS. Anthony Abbot and Bernardino of Siena at left, and Francis and Catherine of Siena at right, by Giovanni di Paolo, c. 1463. Pienza, Cathedral; Van Os, *Sienese Altarpieces* (Vol.II, pl.204).

271 Temptation of St. Anthony (woman brings him a covered urn, as he sits before a thatched hut), by Simon Marmion from the Huth Hours, add.ms. 38126, fo.133v, c. 1480. BL, London; *Ren. Painting in MS*; Snyer, *Northern Ren.*

272 St. Anthony Abbot enthroned, holding a book and crosier, by Juan de la Abadia, before 1473. Fitzwilliam Museum, Cambridge; Catalogue, *Dutch.*

273 Virgin and Child with St. Anthony Abbot and a donor, by Hans Memling, 1472. National Gallery of Canada; Hubbard, *Canadian Collections.*

274 St. Anthony Abbot (in the wilderness; demons attack him in the sky), by Master of the First Prayer Book of Maximilian, from the Hours of William Lord Hastings, add.ms.54782, fo.50v, late 1470's. BM, London; BL, *Ren. Painting in MS.*

275 St. Anthony beaten by devils (one

devil pulls his hair), by Sassetta. Siena, Pinacoteca Nazionale; Christiansen, *Siena.*

276 St. Anthony beaten by devils and wild beasts, while lying in a mausoleum, fresco by the Umbrian School, 15th cent. Cascia, S. Antonio; Kaftal, *Central & So. Ital.*

277 St. Anthony decides to dedicate his life to God (after hearing a sermon), fresco by the Umbrian School, 15th cent. Cascia, S. Antonio; Kaftal, *Central & So. Ital.*

278 St. Anthony gives his belongings to the poor (they line up outside his door), fresco by the Umbrian School, 15th cent. Cascia, S. Antonio; Kaftal, *Central & So. Ital.*

279 Temptation of St. Anthony (a woman taps him on the shoulder as he sits in the wilderness), pen and ink drawing by Fra Bartolommeo. Windsor Castle; Fischer, *Fra Bartolommeo.*

280 Temptation of St. Anthony (surrounded by demons), engraving by Martin Schongauer, 1480-90. Met Museum; Book of Art, *German & Spanish*; Gardner, *Art thru Ages*; Hibbard, *Met Museum*; Janson, *History* (pl.483); Snyder, *Northern Ren.*

281 St. Anthony Abbot presenting a hooded flagellant to the Virgin and Child, fresco att. to Maestro Paroto. Berzo Inferiore, S. Lorenzo; Kaftal, *North West Italy.*

282 St. Anthony Abbot, enthroned, giving a blessing, with the city of Pavia in the background, fresco by Bernardino Lanzoni. Pavia, S. Teodoro; Kaftal, *North West Italy.*

283 St. Anthony in the wilderness (reading, with his pig), by Simon Marmion from the Louthe Hours, ms.A2, fo.101v. Louvain-La-Neuve, University Library; BL, *Ren. Painting in MS.*

284 Posthumous episodes from the life of St. Anthony Abbot: Anthony resuscitates three men killed by wild beasts; Anthony sustained a soldier named Effron for eight days, holding him so that he would not hang; Sophia, daughter of Constantine, is cured of her madness at the shrine of St. Anthony; panels by Vitale da Bologna. Bologna, Pinacoteca Nazionale; Kaftal, *North East Italy.*

285 Scenes from the life of St. Anthony Abbot: Anthony's monks lower him on a rope from a window; Anthony

resuscitates two men who are killed by a dragon in a well; a pilgrim tells the ailing king of Palestine to send camels with food and water to Anthony in the desert, so he will be cured; panels by Vitale da Bologna. Bologna, Pinacoteca Nazionale; Kaftal, *North East Italy.*

286 St. Anthony (sitting, leaning against his staff, next to a stream; grotesques appear in various postures around him), by Hieronymus Bosch. Prado, Madrid; Châtelet, *Early Dutch* (pl.151).

287 St. Anthony Abbot (standing with his staff, hands clasped in prayer), by Girolamo di Benvenuto, 1490's. Walters Art Gallery, Baltimore; *Italian Paintings* (Vol.I).

288 Scenes from the life of St. Anthony Abbot: Anthony invokes the devil, who makes him the doorkeeper of hell; Anthony refuses to let anyone in or out of hell, and the devil releases him and sends him away; frescoes by Dionisio Baschenis, 1493. Pelugo di Vigo Rendena, S. Antonio; Kaftal, *North East Italy.*

289 Scenes from the life of St. Anthony Abbot: his parents go on pilgrimage; having broken their vow of chastity on the pilgrimage, the parents travel in a ship to Compostella, where a storm is raised by the devil; the mother tells Anthony about his birth, and Anthony leaves his parents in search of expiation; frescoes by Dionisio Baschenis, 1493. Pelugo di Vigo Rendena, S. Antonio; Kaftal, *North East Italy.*

290 Scenes from the life of St. Anthony Abbot: Anthony gives his possessions to the poor; Anthony is surrounded by three men, who tempt him with gold; panels by Bernardo Parentino. Doria Pamphili Palace, Rome; Kaftal, *North East Italy.*

291 Temptation of St. Anthony (he is bargaining with the devil to cure the donor of St. Anthony's Fire), by Master of the Violets, c. 1500. Coll. Fürstenberg, Donaueschingen; Cooper, *Family Collections.*

292 The temptation of St. Anthony (demons attack him in a river) by a follower of Bosch. Picture Gallery, Berlin; *Catalogue.*

293 Temptation of St. Anthony (he leans on a table, hands clasped in prayer; a building with a woman's face dominating the front in right background), copy after Hieronymus Bosch. Prado, Madrid; *Peinture Flamande* (b/w pl.39).

294 Temptation of St. Anthony (he sits inside a rotted tree trunk beside a stream, surrounded by grotesques), att. to Hieronymus Bosch. Prado, Madrid; *Peinture Flamande* (b/w pl.37); Gaunt, *Pictorial Art.*
295 The temptation of St. Anthony (in background, a barn with huge head filling the door), after Hieronymus Bosch. Rijksmuseum; *Paintings.*
296 St. Anthony Abbot (with a boar at his feet), by Monaldo, c. 1505. Walters Art Gallery, Baltimore; *Italian Paintings* (Vol.I).
297 Temptation of St. Anthony (kneeling before a ruins containing a crucifix, while several creatures dine at his side) by Hieronymus Bosch, 1505-06. Lisbon, Museu Nacional de Arte Antiga; Guratzsch, *Dutch*; Larousse, *Ren. & Baroque*; Murray, *Art & Artists.*
298 Temptation of St. Anthony (demons lift him off the ground), woodcut by Lucas Cranach the Elder, Munich, 1506. Geisberg, *Single Leaf*; Schade, *Cranach*; Strauss, *The Illus. Bartsch* (Vol.II no.56).
299 St. Anthony Abbot, lindenwood statue att. to Tilman Riemenschneider, c. 1510. Busch-Reisinger Museum, Cambridge; Mortimer, *Harvard Univ.*
300 The temptation of St. Anthony (praying as grotesque creatures creep up on him) by Lucas Van Leyden, 1511. Brussels, Musées Royaux des B/A; *Peinture Ancienne.*
301 Temptation of St. Anthony (he bends toward his pot cooking over an open fire, looking back at a horned woman standing before his cave), illum. by Jean Bourdichon from the Great Book of Hours of Henry VIII, 1514-18. Coll. Duke of Cumberland; *Great Hours.*
302 Meeting of St. Anthony and the Hermit Paul (in a dress made of leaves, reaching out for the bread brought by a raven), from the Isenheim Altarpiece by Matthias Grünewald, 1515. Colmar, Musée d'Unterlinden; Benesch, *German*; Levey, *Giotto to Cézanne*; Snyder, *Northern Ren.*
303 Temptation of St. Anthony (on his back, attacked by demons pulling his hair, biting him, beating him), from the Isenheim Altarpiece by Matthias Grünewald, 1515. Colmar, Musée d'Unterlinden; Benesch, *German*; Rowling, *Art Source Book*; Snyder, *Northern Ren.*

304 Temptation of St. Anthony (running from grotesques and a burning city in the background), by Giovanni Girolamo Savoldo, 1515-20. Timken Art Gallery, San Diego CA; *European Paintings.*
305 Temptation of St. Anthony (as he kneels beside a thatched hut, he is tempted by the seven mortal sins personified as grotesques and a wanton woman), by Jan de Cock. Esztergom Christian Museum; *Christian Art in Hungary.*
306 Landscape with the temptation of St. Anthony, by Joachim Patenir, c. 1520. Mauritshuis, The Hague; Hoetink, *Mauritshuis.*
307 The temptation of St. Anthony, (pampered by three women as an old hag laughs at him), by Joachim Patiner and Quentin Metsys, 1520-24. Prado, Madrid; Bosque, *Metsys*; La Peinture Flamande; Larousse, *Ren. & Baroque*; McGraw, *Dict.*; Newsweek, *Prado*; Snyder, *Northern Ren.*
308 St. Anthony the Hermit (in a blue tunic, leaning against a rock from which hangs a bell), by Lorenzo Lotto. Wilton House, Salisbury; Berenson, *Lotto; Catalogue.*
309 The temptation of St. Anthony (on his back as demons beat him with sticks), by B. Parentino. Doria Pamphili Palace, Rome; McGraw, *Encyclo.* (Vol.IV, pl.179).
310 Temptation of St. Anthony (woman with an urn kneels before him, in front of a brick doorway shaped like a circle), by Jan Gossaert. Nelson-Atkins Museum, Kansas City MO; Bosquet, *Mannerism; Handbook.*
311 The temptation of St. Anthony (nude woman, rising out of the ground, holds out to him an open urn, with grotesques all around) by Pieter Coecke van Aelst. Prado, Madrid; *Guide to the Prado.*
312 St. Anthony (in red, holding a scroll), by Michael Damaskinos, 1550-1600. Byzantine Museum, Athens; Knopf, *The Icon* (p.355); McGraw, *Encyclo.* (Vol.IV, pl.51).
313 The temptation of St. Anthony (surrounded by grotesques), by Jan Mandijn, mid-16th cent. Frans Hals Museum, Haarlem; Van Braam, *Benelux.*
314 Holy Family (raised on a marble platform) with SS. Catherine and Anthony Abbot (with a pig), by Paolo

Veronese, 1551. Venice, S. Francesco della Vigna; Rearick, *Veronese*.

315 Temptation of St. Anthony (beaten by a satyr and a seductress, who pulls his hand away from his face), by Paolo Veronese, 1552. Caen, Musée des B/A; Rearick, *Veronese*.

316 Temptation of St. Anthony (pulled by a Satyr and a seductress), drawing by Paolo Veronese, 1552. Louvre, Paris; Rearick, *Veronese*.

317 The temptation of St. Anthony (sitting under a rude shelter), by Pieter Bruegel the Elder, 1555–58. NGA, Washington DC; Newsweek, *Nat'l Gall.*; Phaidon, *Art Treasures*.

318 St. Anthony Abbot and a donor, by Paolo Veronese. NGS, Edinburgh; *Illustrations*.

319 Virgin and Child enthroned with Saints Thomas and Anthony Abbot (with his boar), by Nosadella, c. 1560. Coll. Richard L. Feigen, NY; *Age of Correggio*.

320 Madonna and Child in glory (in the clouds) with SS. Anthony Abbot and Paul the Hermit (in the wilderness), by Paolo Veronese, 1562. Chrysler Museum, Norfolk VA; Rearick, *Veronese*.

321 Temptation of St. Anthony (surrounded by horned, semi-nude women, he looks up as Christ descends), by Tintoretto, 1577. Venice, S. Trovaso; Tietze, *Tintoretto*.

322 The temptation of St. Anthony (as he is engrossed in a vision, demons attack him; even his lion bares his teeth), by Annibale Carracci. Nat'l Gallery, London; Book of Art, *Ital. to 1850*; Boschloo, *Carracci*; Poynter, *Nat'l Gallery*.

323 Scenes from the life of St. Anthony Abbot (he crosses a river; he protects the door of a fort; he emerges from his solitude; he performs miracles of healing; he is tempted by the devil in the guise of a monk); drawing by Giovanni Battista Lombardelli, mid-1580's. Met Museum; Bean, *15th & 16th cent.*

324 Temptation of St. Anthony (face down in a landscape with grotesques and exploding houses), by follower of Hieronymus Bosch, early 17th cent. Walters Art Gallery, Baltimore.

325 Sylvan scene with the temptation of St. Anthony (woodland, mythical, and grotesque figures surround him), by Gillis van Coninxloo. Christie, London; Briels, *Peintres Flamands*.

326 Woodland scene with the meeting of St. Anthony and St. Paul the Hermit (they talk at right, as demons look on), by Gillis van Coninxloo. Coll. Sidney R. Clarke III, Shawnee OK; Briels, *Peintres Flamands*.

327 Woodland scene with the meeting of St. Anthony and St. Paul the Hermit (as Paul reads, Anthony approaches in center of painting), by Alexander Keirincx, 1630's. Coll. Johnny Van Haeften, London; Briels, *Peintres Flamands*.

328 St. Anthony Abbot (walking, with a stick), by Francisco de Zurbaran, 1631–40. Coll. Contini-Bonacossi, Florence; Gállego, *Zurbaran*.

329 St. Anthony Abbot (resting, leaning against a rock outcropping), by Francisco de Zurbaran 1641–58. Lima, Monastery of St. Camillus de Lellis; Gállego, *Zurbaran*.

330 Landscape with Saints Anthony and Paul (receiving bread from the raven), by Micco Spadaro, 1642–46. Capodimonte, Naples; RA, *Painting in Naples*.

331 Temptation of St. Anthony (sitting at a table, as a horned lady taps him on the shoulder and points to a beautiful girl who approaches holding up a glass of liquid), by David Teniers the Younger. Ponce, Museo de Arte; Held, *Catalogue*.

332 Temptation of St. Anthony (he lies on his back, holding a cross against a demon on tall, spindly legs), by Salvator Rosa. Pitti Palace, Florence; Bentley, *Calendar*.

333 The temptation of St. Anthony (sitting at a table before a cave, surrounded by grotesques, women at his back, man riding a monster) by David Teniers, c. 1670. Prado, Madrid; *La Peinture Flamande*; Levey, *Giotto to Cézanne*.

334 Temptation of St. Anthony (demons hang him from a scaffolding, as broom-riding witches look on), drawing by Claude Gillot. Crocker Art Gallery, Sacramento CA; *Catalogue*.

335 Temptation of St. Anthony (he wards off a woman with his crucifix), by Sebastiano Ricci, c. 1708. BS, Munich; Daniels, *Ricci*.

336 Temptation of St. Anthony (sitting with chains around his neck, he is attacked by demons), by Sebastiano Ricci. Formerly Galleria Sestieri, Rome; Daniels, *Ricci*.

337 St. Anthony tempted by demons (they surround him with chains and bones as he looks toward the heavens), by Giuseppe Maria Crespi. San Nicolò degli Albari, Bologna; *Age of Correggio*; Merriman, *Crespi*.

338 Madonna with Saints George and Anthony Abbot (sitting in white), by Giambattista Tiepolo. Coll. Spalletti-Trivelli, Rome; Morassi, *Catalogue*.

339 Temptation of St. Anthony (by a woman and a winged man), by Giovani Battista Tiepolo. Brera, Milan; McGraw, *Encyclo* (Vol.XIV, pl.55); Morassi, *Tiepolo*; Praeger, *Great Galleries*.

340 Temptation of St. Anthony (a woman with horns pulls his corded belt as he prays), by Anthelme Trimolet, c. 1833. Dijon, Musée des B/A; Georgel, *Musée des B/A*.

341 The temptation of St. Anthony (he sits against a wall, knees drawn to his chest, next to a nude woman), by Domenico Morelli, 1878. Rome, Galleria Nazionale d'Arte Moderna; New Int'l Illus. *Encyclo*. (see Symbolism).

342 The temptation of St. Anthony, watercolor by Gustave Moreau, c. 1890. Gustave Moreau Museum, Paris; Hahlbrock, *Gustave Moreau*; Mathieu, *Aquarelles*.

343 Temptation of St. Anthony (he kneels in lower left corner, warding off the visions with a crucifix; huge, spindly-legged horses and elephants carry buildings and treasures on their backs), by Salvador Dali. Coll. Salvador Dali; Jacobs, *Color Encyclo*.

See also 372, 396, 444, 461, 573, 597, 606, 777, 841, 913, 965, 1116, 1351, 1356, 1529, 1531, 1540, 1550, 1588, 1803, 1835, 1925, 2091, 2389, 3183, 3238, 3320, 3451, 3679, 3707, 3791, 3918, 3923, 3924, 3925, 3927, 3928, 3929, 3930, 3931, 3935, 3939, 3940, 4013, 4100, 4162, 4299, 4448, 4453, 4905

Anthony of Egypt *see* **Anthony Abbot**

Anthony of Florence or Antonius Pierozzi, Archbishop of Florence, Dominican, d. 1459, canon. 1522 (May 10)

344 St. Antonius Pierozzi (kneeling, with a hand around the cross with crucified Christ), by the Florentine school, mid-15th cent. Florence, San Marco; Kaftal, *Tuscan*.

345 St. Antonius Pierozzi blessing the hospital of the Innocenti, predella panel by Bartolommeo di Giovanni. Florence, Spedale degli Innocenti; Kaftal, *Tuscan*.

346 St. Antonius Pierozzi founds the congregation of the Buonomini di S. Martino, predella panel by Bartolommeo di Giovanni. Estensische Kunstsammlung, Vienna; Kaftal, *Tuscan*.

347 St. Antonius Pierozzi (standing in bishop's regalia), panel by the school of Nice. Taggia, S. Domenico; Kaftal, *North West Italy*.

348 St. Antoninus overturning a gaming-table (as the players argue with him), fresco by Fabrizio Boschi. Florence, San Marco; Bentley, *Calendar*.

349 St. Antoninus of Florence giving alms (as he sits, enthroned with angels, reading a scroll, monks below him hand out alms), by Lorenzo Lotto. Venice, SS. Giovanni e Paolo; Berenson, *Lotto*; Huse, *Venice*; McGraw, *Encyclo.*; (Vol. IX, pl.213).

350 Gilt tomb effigy of Antonius of Florence, by Portigiani. Florence, San Marco; Coulson, *Saints*.

351 The youthful St. Antonius kneeling before a crucifix in Orsanmichele, drawing by Bernardino Poccetti. Met Museum; Bean, *15th & 16th cent.*

Anthony of Padua, Franciscan Friar, disciple of St. Francis, d. 1231 (June 13)

352 St. Anthony of Padua dons the Franciscan habit (he kneels before his superiors), by Giovanni di Paolo. Vatican Museums; Kaftal, *Tuscan*.

353 Story from the life of St. Anthony of Padua (he is standing in flames), by the Florentine School, 15th cent. Vatican Museums; Francia, *Vaticana*.

354 St. Anthony of Padua serves dinner to noblemen, by Bicci di Lorenzo. Vatican Museums; Francia, *Vaticana*.

355 St. Anthony of Padua (holding a book and a flame), from a triptych by Giovanni dal Ponte, 1435. Vatican Museums; Kaftal, *Tuscan*.

356 St. Anthony healing the young man's foot (in a large city-scape, as people are running down the steps to see better, St. Anthony lifts the man's foot while he is supported by his friends), high altar bronze relief by Donatello. Padua, S. Antonio; McGraw, *Encyclo. of Art* (Vol. IV).

357 The miracle of Saint Anthony (preaching before a litter containing a

dead man) att. to Pesellino, c. 1440. Uffizi, Florence; New Int'l Illus. *Encyclo.*

358 Anthony of Padua rescues the infant who has fallen into a boiling cauldron; Anthony among the sick and crippled; Anthony saves a ship in distress; wall murals by unknown artist. Embrun, Eglise des Cordeliers; *Peintures Murales.*

359 The miracle of the infant given back to his father by St. Anthony of Padua, wall mural by an unknown artist, mid-15th cent. Embrun, Eglise des Cordeliers; *Peintures Murales.*

360 St. Anthony Altarpiece; Virgin and Child enthroned with angels, flanked by SS. Anthony of Padua and Bernardino of Siena, by Matteo di Giovanni, 1460. Siena, Museo Opera dell'Duomo; Van Os, *Sienese Altarpieces* (Vol.II, pl.188).

361 St. Anthony of Padua cures two cripples (one kneels, one stands on crutches before his ruined monastery; hilly landscape in background), panel by Bartolommeo Caporali. Brooklyn Art Museum, NY; Kaftal, *Central & So. Ital.*

362 St. Anthony of Padua exorcises a man (as a monk holds the man's arm behind his back, a small demon flies from the man's mouth), fresco by P.A. Mezzastris, 1461. Montefalco, S. Francesco; Kaftal, *Central & So. Ital.*

363 St. Anthony of Padua in a friar's robe before an archway, holding a book and flower, by Vincenzo Foppa. NGA, Washington DC; Ferguson, *Signs*; Shapley, *15th-16th cent.*

364 St. Anthony of Padua (holding a lily and a book), by Carlo Crivelli. Rijksmuseum, Amsterdam; Zampetti, *Crivelli.*

365 St. Anthony of Padua and the miracle of the miser's heart (he preaches at the miser's funeral, that "Where is your treasure there is your heart"—Luke 12: 34—we see that the dead miser's heart is in his coffer of gold); St. Anthony of Padua raises a man from the grave, to protest the innocence of his father (the dead man stands up from a hole in the ground, while Anthony's father waits with a guard, hands tied behind his back), frescoes by the Umbrian School, late 15th cent. Deruta, S. Francesco; Kaftal, *Central & So. Ital.*

366 St. Anthony of Padua, holding a book and knotted belt, from polyptych by Giorgio Schiavone. Nat'l Gallery, London; Bentley, *Calendar*; Coulson, *Saints.*

367 Scenes from the life of St. Anthony of Padua: the miracle of the mule (who kneels before the Host in worship, rather than accept food); St. Anthony preaches to the fish (who come to listen, as the men who rejected him watch); miracle of the miser's heart; St. Anthony restores the leg of a man who has severed it in remorse; frescoes by Lorentino d'Angelo, 1482. Arezzo, S. Francesco; Kaftal, *Tuscan.*

368 St. Anthony of Padua witnesses the martyrdom of Franciscan friars in Morocco, posthumous episode; panel from the "armadio" door from the sacristy in St. Croce, by Taddeo Gaddi. Accademia, Florence; Kaftal, *Tuscan.*

369 St. Anthony of Padua (standing in an archway, holding a book and a lily), by Cosimo Tura, c. 1484. Estense Gallery, Modena; Lloyd, *1773 Milestones* (p.107); Ruhmer, *Tura.*

370 A miracle of St. Anthony of Padua (the miracle of the mule), by the Master of the Brugeoise passion. Prado, Madrid; *Peinture Flamande* (b/w pl.177).

371 St. Anthony of Padua (standing in a friar's robe, reading), by Cosimo Tura. Louvre, Paris; Gowing, *Paintings*; Larousse, *Ren. & Baroque*; Ruhmer, *Tura.*

372 St. Roch, St. Anthony Abbot, St. Peter, and St. Anthony of Padua, from thirteen panels of a polyptych, by Guidoccio Cozzarelli, 1490. Columbia Museum of Art, SC; Shapley, *Samuel H. Kress.*

373 SS. Augustine, Catherine of Alexandria, and kneeling Anthony of Padua, right panel of the detached Bichi polyptych by Luca Signorelli, 1498. Picture Gallery, Berlin; United Nations, *Dismembered Works.*

374 St. Anthony of Padua (holding an open book with a tiny Christ), from St. Michael altarpiece by Gerard David. KM, Vienna; Miegroet, *David.*

375 St. Anthony of Padua preaching to the fishes (as nobles look on in amazement), by Gerard David, 1500-10. Toledo Museum of Art, OH; *A Guide.*

376 Madonna and Child with Saints Anthony of Padua and Roch, by Giorgione, c. 1505. Prado, Madrid; Wethey, *Titian* (pl.203).

377 St. Anthony of Padua preaching at the funeral of a miser (at right, the heirs open his treasure, only to find the miser's

bleeding heart; at left, Anthony preaches to a sitting crowd, but stops when demons carry off the miser, with chains around his wrists), by Hans Fries, 1506. Fribourg, Church of the Cordeliers; Deuchler, *Swiss Painting*.

378 St. Anthony of Padua and a donor, Giulia Trivulzio, by Marco d'Oggiono. Brera, Milan; Sedini, *Marco d'Oggiono* (p.116).

379 Anthony of Padua and the miracle of irascible son (he replaces the foot the son severed in remorse for kicking his mother), fresco by Titian, 1510–11. Padua, Scuola del Santo; Wethey, *Titian* (pl.142).

380 Anthony of Padua and the miracle of the jealous husband (he restores life to the murdered wife when the husband repents and begs his help), fresco by Titian, 1510–11. Padua, Scuola del Santo; New Int'l Illus. *Encyclo.*; Wethey, *Titian* (pl.141).

381 St. Anthony and the Miracle of the speaking infant (he hands the child to his mother, as the crowd exclaims at the miracle), by Girolamo da Carpi. Ferrara, Pinacoteca Nazionale; Ricci, *Cinquecento*.

382 St. Anthony of Padua (standing with a book and a lily, looking over his left shoulder), from the Colonna altarpiece by Raphael. Dulwich Picture Gallery, London; Murray, *Catalogue*.

383 St. Anthony of Padua and the miracle of the speaking infant (who speaks to assure his father that his mother is innocent of adultery), fresco by Titian, c. 1510. Padua, Scuola del Santo; McGraw, *Encyclo.* (Vol.XIV, pl.89); Wethey, *Titian* (pl.139).

384 St. Anthony of Padua and the mule (he holds up the host and chalice, and the white mule kneels before him), illum. by Jean Bourdichon from the Great Hours of Henry VIII, 1514–18. Coll. Duke of Cumberland; *Great Hours*.

385 Anthony of Padua and the miracle of the mule (the mule kneels as he stands with a chalice and the Eucharist inside of a courtyard), min. by Jean Bourdichon, c. 1515. Paris, Ecole des B/A; Sterling, *Master of Claude*.

386 St. Anthony of Padua (standing three-quarters to the left, holding a book), att. to Marco Basaiti, c. 1516. Bucknell University, Lewisburg, PA; Shapley, *15th–16th cent.*

387 Saints Anthony of Padua (holding a book with a tiny baby sitting on it) and Nicholas of Tolentino (holding a platter from which birds eat), right panel from "Crucifixion with the Virgin, Saints Paul and John the Evangelist and kneeling donor" triptych by Joos Van Cleve, 1520–30, Met Museum.

388 St. Anthony of Padua taking the habit of the Franciscan order, by the Romagna School, early 16th cent. Walters Art Gallery, Baltimore; *Italian Paintings* (Vol.I).

389 Madonna and Child with SS. Anthony of Padua and Jerome, by Lorenzo Lotto, 1521–22. Boston Museum of Fine Arts; *Illus. Handbook*.

390 Anthony of Padua (holding a book and a tiny Christ, dressed in a friar's robe), by Pieter Coeck. Evora Museum; Marlier, *Coeck*.

391 St. Anthony of Padua (holding a lily and reading), etching by Guercino. McGraw, *Encyclo.* (Vol.IV, pl.430).

392 St. Anthony of Padua and the miracle of the mule (it kneels as he walks up), by Domenico Beccafumi. Louvre, Paris; Gowing, *Paintings*.

393 St. Anthony of Padua (half-view, with a book and an hourglass on the table, placing his right hand on his chest, with a lily in the upper right corner), att. to Giovanni Cariani, c. 1540. Carrara Academy, Bergamo; Pallucchini, *Cariani*.

394 Virgin and Child with SS. Elizabeth, the Infant Baptist, St. Anthony of Padua, and a female martyr, drawing by Giacomo Pontormo. Met Museum; Bean, *15th & 16th cent.*

395 St. Anthony of Padua (as he looks at a book, a baby Christ appears on the page), by El Greco, 1576–79. Prado, Madrid; Gudiol, *El Greco*.

396 St. Anthony of Padua enthroned with Saints Anthony Abbot and Nicholas of Tolentino, by Moretto. Brescia, Pinacoteca Tosio-Martinengo; Boschloo, *Carracci*.

397 Vision of St. Anthony of Padua (the Virgin stands behind him as he kneels, holding the Child), by Ludovico Carracci. Rijksmuseum, Amsterdam; Freedberg, *Circa 1600*; McGraw, *Encyclo.* (Vol.II, pl.175).

398 A miracle of St. Anthony of Padua (revives a dead man to attest to his father's innocence), by Giovanni Battista

Caracciolo, c. 1620–23. Colnaghi & Co., London; RA, *Painting in Naples*.

399 St. Anthony of Padua (holding a Christ Child standing on a book), by Francisco de Zurbaran, 1625–30. Coll. Emile Huart, Cadiz; Gállego, *Zurbaran*.

400 St. Anthony of Padua (in prayer, as a tiny Christ Child appears in upper left corner), by Francisco de Zurbaran, 1625–30. São Paulo, Museu de Arte, Brazil; Gállego, *Zurbaran*.

401 The miracle of St. Anthony of Padua (the miracle of the mule); the mule bends his knees to the host that Anthony holds out, by Anthony van Dyck, c. 1631. Lille, Musée des B/A; Larsen, *Van Dyck* (pl.203).

402 The vision of St. Anthony of Padua (he sees angels playing musical instruments), by Vincenzo Carducci, 1631. Hermitage, St. Petersburg; Eisler, *Hermitage*.

403 Vision of St. Anthony of Padua (he embraces the Christ Child), by Alonso Cano, c. 1638–42. Madrid, San Francisco el Grande; Wethey, *Alonso Cano* (pl.49).

404 Vision of St. Anthony of Padua (the Virgin lets him hold the Christ Child), by Alonso Cano and assistants, 1645–52. Alte Pinakothek, Munich; Wethey, *Alonso Cano* (pl.92).

405 St. Anthony of Padua (kneeling, holding an open book, looking over his shoulder toward the viewer and gesturing to heaven), by Guercino. Bob Jones Univ. Art Gallery, Greenville, SC; Pepper, *Ital. Paintings*.

406 The Immaculate Conception with the Virgin flanked by kneeling St. Francis of Assisi and St. Anthony of Padua, by Giovanni Battista Castiglione, 1650. Minneapolis Inst. of Art, MN; *European Paintings*.

407 St. Anthony of Padua holding the Christ Child, polychromed wooden statue by Alonso Cano. Murcia, San Nicolás; Wethey, *Alonso Cano* (pl.130).

408 St. Anthony of Padua holding the Christ Child, polychromed wooden statue by Alonso Cano. Manuel Gomez-Moreno, Madrid; Wethey, *Alonso Cano* (pl.129).

409 St. Anthony of Padua holding the infant Christ, by Francisco de Zurbaran, 1650's. Prado, Madrid; Random House, *History* (p.208).

410 St. Anthony of Padua resuscitates a dead boy (to save his father, who was falsely accused of the child's murder; Anthony's father is enthroned above the scene, and judges look on), by Jacob Van Oost the Elder. Bruges, State Museum; Pauwels, *Musée Groeninge*.

411 St. Anthony of Padua with the Christ Child (he embraces the Child, who stands on a cloud), by Jacob Van Oost the Elder. Bruges, State Museum; Pauwels, *Musée Groeninge*.

412 St. Anthony of Padua embracing the Christ Child, painted wood statue by Alonso Cano and P. de Mena, 1653–57. Granada, Museo Provincial; McGraw, *Encyclo*. (Vol.XIII, pl.142).

413 Vision of St. Anthony of Padua (cherub angel speaks to him), by Bartolomé Esteban Murillo. Birmingham City Museum & Art Gallery; *Foreign Paintings*.

414 The Holy Family with St. Anthony of Padua, by Felice Cignani, c. 1680. Bologna, Santa Maria della Caritá; Merriman, *Crespi*.

415 St. Anthony resuscitating a dead man (he holds the man's hand, pointing up, as witnesses stare in surprise; a cherub hovers overhead with a book and a lily), by Giuseppe Chiari. Rome, S. Silvestro in Capitre; DiFederico, *Trevisani*.

416 Vision of St. Anthony of Padua (he is visited by cherubs and angels), by Francesco Trevisani, 1719. Rome, Stimmate di S. Francesco; DiFederico, *Trevisani*.

417 Miracle of St. Anthony of Padua (he reattaches a man's severed foot), by Francesco Trevisani, c. 1734. Venice, S. Rocco; DiFederico, *Trevisani*.

418 A miracle of St. Anthony of Padua (he stands beside a prone man, holding the man's severed foot), oil sketch by Giambattista Tiepolo. Coll. E. Modiano, Bologna; Morassi, *Catalogue* (pl.131).

419 A miracle of St. Anthony of Padua (he stands beside a prone man, holding the man's severed foot), altarpiece by Giambattista Tiepolo. Mirano Parish Church; Morassi, *Catalogue* (pl.132).

420 Madonna with Saint Anthony of Padua (he is resting his chin on the Christ Child's arm), by Giambattista Tiepolo. Coll. Cini, Venice; Morassi, *Catalogue* (pl.103).

421 St. Anthony of Padua with the Christ Child (a monk looks in the doorway as he holds the Child), by Giambattista Tiepolo. Coll. Rodriguez Bauza, Madrid; Morassi, *Catalogue* (pl.179).

422 Apparition of the Virgin to St. Anthony of Padua (she appears in a cloud as he kneels by a table), by Francesco Fontebasso, 18th cent. Bordeaux, Musée des B/A; *Peinture Ital.*
423 The Virgin and Child with St. Anthony of Padua (inside a hall, the Virgin hands the Child to Anthony), by Lorenzo Masucci, mid-18th cent. Bob Jones Univ. Art Gallery, Greenville, SC; Pepper, *Ital. Paintings.*
424 St. Anthony of Padua (holding the Christ Child), pine retable with water-based paints, gesso, att. to José Benito Ortega, c. 1875–90. Taylor Museum for Southwest Studies, CO; Wroth, *Images of Penance.*
See also 891, 1527, 2276, 2296, 3268

Anthony Percherskii, Father of Russian Monasticism, d. 1074 (July 10)
425 St. Anthony Percherskii holding a scroll, embroidered funeral shroud, late 15th–early 16th cent. State Russian Museum, St. Petersburg.

Anthony the Roman, Russian monk, d. 1147
426 St. Anthony the Roman, holding an open scroll, gilded wooden reliquary tomb lid, Novgorod, 1573. State Russian Museum, St. Petersburg.

Antonia of Florence, Poor Claire nun, founded Convent of St. Eucarestia, d. 1472 (Feb. 28)
427 St. Antonia of Florence (kneeling in prayer before an altar and a crucifix, with a divine flame around her head), fresco att. to Saturnino de'Gatti. Aquila, Chiesa della Beata Antonia; Kaftal, *Central & So. Ital.*

Antonin
428 St. Denis, urging St. Saintin and St. Antonin to write the story of his life, from "The Life of St. Denis" ms. fr.2090–2092, Vol.II, fo.125, c. 1317. BN, Paris; Avril, *MS Painting*; Sterling, *Peinture Médiévale.*

Antoninus, Thebian knight, companion of St. Maurice, patron of Piacenza (Sept. 2)
429 Scenes from the life of St. Antoninus; Antoninus and Maurice leave the city of Piacenza (on horseback); Antoninus preaches in Piacenza (before sitting peasants); Antoninus beheaded by pagans; his body is placed in a boat, watched over by angels; St. Savinus instructs men to dig for the body of Antoninus; St. Savinus officiates at funeral; predella panels by Emilian School 1420–30. Piacenza, S. Antonio; Kaftal, *North East Italy.*
See also 4267

Antonius of Florence *see* **Anthony of Florence**

Antonius Pierozzi *see* **Anthony of Florence**

Apollinaris of Ravenna, first bishop and patron of Ravenna, mart. 75 (July 23)
430 St. Apollinaris (wearing a chasuble, standing amid rocks and flowers), mosaic, 6th cent. Ravenna, S. Apollinare in Classe; Coulson, *Saints*; Kaftal, *North East Italy.*
431 St. Apollinaris of Ravenna (standing in bishop's robes, holding a crosier and giving a blessing), by the Venetian school, c. 1600–50. Ravenna, Accademia di Belle Arti; Frabetti, *Manieristi.*
432 St. Apollinaris resuscitates the daughter of Rufino (as angels hover overhead, holding the Eucharist), by Gaspare Venturini. Ferrara, Chiesa di S. Cristoforo della Certosa; Frabetti, *Manieristi.*
See also 4227

Apollonia, invoked against toothaches; daughter of Christian martyr Apollonius; had teeth pulled out then stabbed; mart. 249 (Feb. 9)
433 St. Apollonia (standing in a brocade dress before a brocade hanging, holding a book in her right hand and pincers in her left hand), att. to the Umbrian School, 15th cent. St. Louis Art Museum, MO; Kaftal, *Central & So. Ital.*
434 St. Apollonia (in a nun's habit, holding a book and pincers), by Vitale da Bologna. Coll. Lanckoronksy, Vienna; Gnudi, *Vitale.*
435 Martyrdom of St. Apollonia (she is bound to a column, and executioner balances himself against her, holding pincers), illum. by the Rohan Master from a Book of Hours, ms. Latin 9471, fo.234v, c. 1415–16. BN, Paris; *Rohan Master* (pl.122).
436 St. Apollonia (daughter of

Emperor Eusebius), destroying idols (she climbs a ladder, carrying a large hammer), panel att. to Antonio Vivarini. Kress Coll., Wash. D. C. ; Kaftal, *North East Italy*.

437 St. Margaret of Antioch (dragon at her feet) and St. Apollonia of Alexandria (with tongs and extracted tooth), by Rogier Van der Weyden, 1445–50. Picture Gallery, Berlin; *Catalogue*.

438 Martyrdom of St. Apollonia (one man bends her backwards by the hair, while another pulls out her teeth with pincers, while the emperor watches), by Neri di Bicci. NGA, Wash. D. C. ; Kaftal, *Tuscan*.

439 St. Apollonia (holding a book and pincers), by Master Gandolfino. Turin, Pinacoteca; Pierleoni, *Denti e Santi* (fig.73).

440 St. Apollonia (holding a palm and a pincer, standing on a tiled floor), by Giovanni Barcels. Cagliari, Museo Civico; Pierleoni, *Denti e Santi* (fig.55).

441 Martyrdom of St. Apollonia (she is tied to a litter, pulled backward by her hair, as executioner shoves huge pincer in her mouth), by Jean Foucquet from "Hours of Etienne Chevalier," 1452–60. Condé Museum, Chantilly; Fouquet, *Hours*; Puppi, *Torment*; Snyder, *Northern Ren.*

442 St. Apollonia holding pincers, by Piero della Francesca. NGA, Washington DC; Clark, *Piero* (fig.57); Ferguson, *Signs*; Shapley, *15th–16th cent.*

443 The martyrdom of St. Apollonia (pulled backwards by her hair, while torturer shoves pincers in her mouth), by Neri di Bicci, c. 1460. Pomona College, Claremont, CA; Shapley, *Samuel H. Kress*.

444 Madonna and Child (enthroned) with SS. Apollonia, Catherine of Alexandria, Anthony Abbot, and a bishop saint, by Cosimo Tura. Picture Gallery, Berlin; Pierleoni, *Denti e Santi* (fig.81).

445 St. Apollonia (holding her tooth in pincers), by Ercole de'Roberti. Louvre, Paris; Gowing, *Paintings*.

446 Saint Apollonia (with a book and pincers) and St. Sebastian (tied to a tree), by Le Pérugin, c. 1495. Grenoble, Musée de Peinture et de Sculpture; Chiarini, *Tableaux Italiens*; Lemoine, *Musée*.

447 St. Apollonia, a warrior saint, and a kneeling donor, by Defendente Ferrari. Sforza Castle, Milan; Pierleoni, *Denti e Santi* (fig.125).

448 St. Apollonia (holding a palm and a pincer, looking to her left), by Francesco Granacci. Munich, Staatsgemäldesammlungen; Pierleoni, *Denti e Santi* (fig.3).

449 Madonna and Child with Saints Apollonia and Sebastian (in armor) by Ghirlandaio. Philadelphia Museum of Art, PA.

450 Crucifixion with SS. Jerome and Apollonia, by Parmigianino. Parma, S. Giovanni Evangelista; Pierleoni, *Denti e Santi* (fig.129).

451 St. Apollonia (holding pincers with tooth), woodcut by Hans Sebald Beham. Geisberg, *Single-leaf*.

452 Martyrdom of St. Apollonia (she is tied to a column, and the torturer approaches with the pincers), by Guido Reni, c. 1614. Bob Jones Univ. Art Gallery, Greenville, SC; *Guido Reni*.

453 The martyrdom of St. Apollonia (executioner shoves pincers in her mouth), by Jacob Jordaens, 1628. Antwerp, Augustinian Church; d'Hulst, *Jordaens*.

454 The martyrdom of St. Apollonia, preparatory drawing for the painting in the Augustinian Church by Jacob Jordaens, c. 1628. Stedelijk Prettenkabinet, Antwerp; d'Hulst, *Jordaens*.

455 St. Apollonia (in gold and pink dress, holding pincers with a tooth and a palm), by Francisco de Zurbaran, 1631–40. Louvre, Paris; Bentley, *Calendar*; Gállego, *Zurbaran*; United Nations, *Dismembered Works*.

456 St. Apollonia (holding a plate with teeth) with an angel (pointing to the plate), by Marco Liberi. Bordeaux, Musée des B/A; *Peinture Ital.*

See also 212, 2334, 2532, 3457, 4921

Arduinus or Ardovinus, confessor and hermit near Rimini, d. 1009 (Aug. 15)

457 St. Arduinus (a young tonsured priest, standing and holding a book), fresco by the Marchigian school, 1467. Urbino, Galleria Nazionale delle Marche; Kaftal, *Central & So. Ital.*

Arigius or Erigius or Isicius, Bishop of Gap, d. 604 (May 1)

458 Scenes from the life of St. Arigius: he kneels before Pope Gregory the Great; he washes the feet of lepers; he is singing with angels; he received communion from St. Isicius; funeral of St. Arigius, drawn

on a cart by a bear and an ox, and blessed by St. Isicius, frescoes under Piedmontese influence. Auron, Chapel of St. Erigius; Kaftal, *North West Italy.*
See also 458

Arsenius or Arsenio of Scete, Roman hermit monk, d. 450 (July 19)
459 Saint Arsenius (holding a bible, giving a blessing), c. 1350–1400. Rila Monastery; Paskaleva, *Bulgarian Icons.*
See also 3697, 4649

Artaldus *see* Arthold

Arthold or Arthaud or Artaldus, Carthusian bishop of Belley, d. 1206 (Oct. 7)
460 St. Arthold (reading), from a dismembered series painted for the Carthusian monastery at Jerez de la Frontera by Francisco de Zurbaran, 1637–39. Cadiz, Provincial Museum of Fine Arts; Gállego, *Zurbaran*; United Nations, *Dismembered Works.*

Athanasius the Great, Bishop and patron of Alexandria, d. 373 (May 2)
461 St. Antony and St. Athanasius (kneeling), from St. Athanasius, "Life of St. Antony," ms. 1 Da/6, fo.1a, French, late 15th cent. Halle, Universitätsbibliothek; Rothe, *Med. Book Illum.* (pl.120).
462 St. Athanasius (in ecclesiastic robes, writing on a scroll, with an open book on his lap), by Luca Signorelli. Uffizi, Florence; Bentley, *Calendar.*
463 St. Athanasius holding an open book, fresco by Domenichino, 1608–10. Grottaferrata Abbey; Spear, *Domenichino.*
464 St. Athanasius the Great of Alexandria overcoming the heretic Arius (standing over him, jabbing him with a crosier), oil sketch by P.P. Rubens. Gotha, Schlossmuseum; Held, *Oil Sketches* (pl.28).
465 Saint Athanasius of Alexandria (giving a blessing), 17th cent. icon. Bulgaria, National Art Gallery; Paskaleva, *Bulgarian Icons.*
466 St. Theodore Tyron, the Archangel Michael, St. Athanasius, and St. Nicholas, icon from the Church of the Holy Archangels in Arbanassi, 1843. District History Museum, Veliko Turnovo; Paskaleva, *Bulgarian Icons.*

Audomarus *see* Omer

Audrey *see* Etheldreda

Augusta, Virgin martyr, patron of Serravalle; beheaded, 100 (Mar. 27)
467 Augusta (holding a palm), fresco by the Venetian School, early 15th cent. Vittorio Veneto, S. Lorenzo; Kaftal, *North East Italy.*

Augustine, one of the four Latin Fathers of the Church, founded Augustinian Order; son of St. Monica; d. 430 (Aug. 28)
468 St. Augustine and Christ; Alardus presents his book to St. Vedastus from "Confessions" of St. Augustine, ms.548, fo.1v, first half of 11th cent. Arras Library; Porcher, *Medieval French Min.*
469 St. Augustine disputes against Felicianus, from "Oeuvres diverses des saints Jerome, Augustin, et Ambroise," ms.72,fo.97, second half of 11th cent. Avranches Library; Porcher, *Medieval French Min.*
470 St. Augustine, from Augustine's "De Civitate Dei," early 12th cent. Medicea Laurenziana Library, Florence; Kidson, *World*; Rickert, *Painting in Britain.*
471 St. Augustine enthroned, from "Enarrationes" MS 250, fol.2. Douai Library, BN; Horizon, *Middle Ages*; Porcher, *Med. French Min.*
472 St. Augustine, page from "De Civitate Dei" MS, Plut. XII, 17, f.3v, early 12th cent. Florence, Biblio. Laurenziana; Kidson, *World.*
473 St. Augustine handing his rule to the monks (who kneel around him, while he gives them a book), detached fresco by the Marchigian school, 13th cent. Fabriano, Pinacoteca; Kaftal, *Central & So. Ital.*
474 St. Augustine with book and crosier, by Simone Martini. Fitzwilliam Museum, Cambridge; Coulson, *Saints.*
475 St. Augustine (holding a book and the Trinity), alabaster bust, English, c. 1350. Hyde Coll., Glens Falls NY; Kettlewell, *Catalogue.*
476 St. Augustine and St. Peter, fragment of an altarpiece by Paolo Veneziano, c. 1350. Chicago Art Inst.; Maxon, *Art Institute.*
477 St. Paul and St. Augustine, from a dismembered polyptych by Giusto de'Menabuoi, c. 1363. Univ. of Georgia, Athens GA; Shapley, *Samuel H. Kress.*

478 Madonna and Child enthroned, flanked by SS. Augustine and Paul, by Master of the Fiesole Epiphany, 1450–1500. Bob Jones Univ. Art Gallery, Greenville, SC; Pepper, *Ital. Paintings.*

479 St. Augustine (standing with crosier and miter before a wall painted with coats of arms), from the "Boucicaut Hours" painted by the Boucicaut Master, ms.2,fo.32v. Jacquemart-André Museum, Paris; Meiss, *French Painting.*

480 St. Augustine holding a book, giving a blessing, by Taddeo di Bartolo. Isaac Delgado Museum of Art, New Orleans LA; Ferguson, *Signs.*

481 Death of St. Augustine (a monk holds a book open to him as he lies in bed), from "Trésor des Histoires" illus. by the Boucicaut Master, ms.5077,fo.295v. Paris, Biblio. de L'Arsenal; Meiss, *French Painting.*

482 St. Augustine reading from "De Civitate Dei" (on a platform for a group of men outside the city), by the School of Van Eyck, ms. 9015, fol. Ir. Biblio. Royale Estampes, Brussels; Dogaer, *Flemish Min.*

483 The Virgin giving her girdle to St. Thomas and Saints Michael, Augustine, Margaret, and Catherine, by Neri di Bicci, 1419–91. Philadelphia Museum of Art, PA.

484 Madonna and Child with St. Augustine, from a triptych by Leonardo Boldini. Correr, Museo Civico; Herald, *Ren. Dress.*

485 Scenes from the life of St. Augustine: an angel speaks to him while he meditates on the epistles of St. Paul; he shows the book to Alypius; frescoes by Guariento. Padua, Eremitani; Kaftal, *North East Italy.*

486 Scenes from the life of St. Augustine; St. Ambrose baptizes St. Augustine in 387; vestition of Augustine by St. Ambrose; frescoes by Guariento. Padua, Eremitani; Kaftal, *North East Italy.*

487 St. Augustine rejects the doctrine of the Manicheans, predella panel att. to Girolamo dai Libri. Avignon, Musée Campana; Kaftal, *North East Italy.*

488 Conversion of St. Augustine (in the wilderness outside of a house) by Fra Angelico. Cherbourg Museum; Keller, *20 Centuries.*

489 Madonna and Child with SS. Dominic and Jerome on the left, and SS. Augustine and Francis on the right, known as the "Gesuati Polyptych" by Sano di Pietro, 1444. Siena, Pinacoteca Nazionale; Van Os, *Sienese Altarpieces* (Vol.II, pl.29).

490 St. Jerome appears to Sulpicius Severua and to St. Augustine, panel from an altarpiece by Sano di Pietro, 1444. Louvre, Paris; Gowing, *Paintings.*

491 St. Augustine in glory (enthroned, flanked by monks), from ms. Magl.II, i 122 (B.R.18), fo.96v. Florence, National Central Library; Verdon, *Christianity.*

492 The vision of St. Augustine (comes across the Christ Child ladling a river into a hole), by Fra Filippo Lippi, late 1450's. Hermitage, St. Petersburg; Eisler, *Hermitage*; Hermitage, *Western European.*

493 Petrarch and St. Augustine (in discussion before Margaret of York), ms. illum. by The Master of Margaret of York, ms. 113/78, fol. Ir. Groot Seminarie, Bruges; Dogaer, *Flemish Min.*

494 Vision of St. Augustine (as he writes, St. Jerome and St. John the Baptist appear to discuss doctrine; they are espied by a monk), by Matteo di Giovanni. Chicago Art Inst.; Christiansen, *Siena.*

495 Scenes from the life of St. Augustine: he is received at the Univ. of Carthage; St. Monica blesses and prays for him; Augustine teaches at the Greek academy at Rome; he leaves for Milan; he greets the Prefect Symmachus and St. Ambrose; SS. Monica and Augustine listen to Ambrose preaching; Ambrose blesses St. Monica; frescoes by Benozzo Gozzoli, 1465. St. Gimignano, S. Agostino; Kaftal, *Tuscan.*

496 St. Augustine (child) given to the grammar master, fresco by Benozzo Gozzoli, 1465. San Gimignano, S. Agostino; Hartt, *Ital. Ren.*; Jacobs, *Color Encyclo.*; Kaftal, *Tuscan* (fig.100).

497 St. Jerome appears to St. Augustine in his study, by Giovanni di Paolo, c. 1465. Picture Gallery, Berlin; *Catalogue.*

498 St. Augustine (sitting and reading), fresco by Alesso Baldovinetti, 1466-67. Florence, San Miniato al Monte; Hall, *Color and Meaning.*

499 SS. Jerome and John the Baptist appear outside St. Augustine's door, while Augustine writes to Jerome, not knowing that he is dead, fresco by Ottaviano Nelli. Gubbio, S. Agostino; Kaftal, *Central & So. Ital.*

500 St. Augustine arrives in Carthage (he steps out of a boat and enters the city

gate), fresco by Ottaviano Nelli. Gubbio, S. Agostino; Kaftal, *Central & So. Ital.*

501 St. Augustine presented at school by his mother and father (his teacher welcomes him, while the other students discuss their books among themselves), panel from the School of Lorenzo Salimbeni. Vatican Museums; Kaftal, *Central & So. Ital.*

502 SS. Augustine (in bishop's robes) and Jerome (in cardinal's robes, holding a model of a church and books), by Carlo Crivelli. Accademia, Venice; Zampetti, *Crivelli.*

503 St. Augustine (in bishop's robes, facing the left), by Carlo Crivelli. Rome, Casa Colonna; Zampetti, *Crivelli.*

504 St. Augustine in miter and gloves with crosier, by Sano Di Pietro, c. 1470. Birmingham Museum of Art, AL; *Samuel H. Kress Coll.*

505 Virgin and Child enthroned, flanked by SS. Jerome and Augustine, by Perugino, c. 1471. Bordeaux, Musée des B/A; *Peinture Ital.*

506 St. Augustine, with left hand on an open book and right hand in the air, panel from the Famous Men series commissioned by Federigo da Montefeltro and painted by Justus of Ghent, 1473–74. Louvre, Paris; United Nations, *Dismembered Works.*

507 Consecration of St. Augustine (he is crowned by two bishops, as several other bishops look on), by Jaime Huguet, 1480. Catalan Museum, Barcelona: Int'l Dict., *Art.*

508 St. Augustine in his study, by Sandro Botticelli, 1480. Ognissanti, Florence; Andres, *Art of Florence* (Vol.II, pl.467); Argan, *Botticelli*; Berenson, *Ital. Painters*; Hay, *Renaissance*; Lightbown, *Botticelli.*

509 St. Augustine with a kneeling donor; St. Peter the Martyr with a kneeling donor, panels from a polyptych by Il Bergognone. Louvre, Paris; Gowing, *Paintings.*

510 St. Augustine with a small child, from the Altarpiece of the Church Fathers by Michael Pacher, 1483. Alte Pinakothek, Munich; Bentley, *Calendar*; Janson, *History of Art* (pl.568); Janson, *Picture History*; Lassaigne, *Fifteenth Cent.*; Piper, *Illus. Dict.* (p.87); Praeger, *Great Galleries.*

511 St. Augustine writing in his cell (with discarded quills on the floor, and a

curtain pulled aside), by Sandro Botticelli, c. 1490–94. Uffizi, Florence; Lightbown, *Botticelli.*

512 St. Augustine's first vision of St. Jerome (as he sits in his study), predella panel of the San Marco Altarpiece by Sandro Botticelli, c. 1490–93. Uffizi, Florence; Lightbown, *Botticelli.*

513 St. Augustine in his study, turned to the left, woodcut from "Soliloquii," Florence, 1491. Hind, *Woodcut.*

514 Madonna and Child, with St. Augustine and other saints, with Ludovico il Moro, the Duke of Milan and family, by Master of the Sforza Altarpiece, c. 1496. Brera, Milan; Newsweek, *Brera.*

515 Birth of St. Augustine (nurse hands the wrapped child to St. Monica), panel by Antonio Vivarini. Courtauld Inst. of Art, London; Kaftal, *North East Italy* (fig.976).

516 St. Augustine (in a red robe and bishop's miter) with members of the Confraternity of Perugia, by Perugino, c. 1500. Carnegie Inst., Pittsburgh PA; *Catalogue of Painting.*

517 St. Jerome and St. Augustine (both in their cells, facing each other), by Botticelli, c. 1500. Pallavicini-Rospigliosi Palace, Rome; Cooper, *Family Collections.*

518 St. Augustine in his study at a table, before an altar, fresco by Vittore Carpaccio, 1502–08. Venice, Scuola di S. Giorgio degle Schiavoni; Lloyd, *1773 Milestones* (p.106); Rowling, *Art Source Book.*

519 St. Augustine (reading in his study), stained glass window by the workshop of Veit Hirschvogel the Elder, c. 1507. Germanisches Nationalmuseum, Nuremberg; Met Museum, *Gothic Art.*

520 Madonna and Child, flanked by SS. Jerome and Augustine, by Giovanni Cariani, c. 1509–10. Formerly coll. Sir Holman Hunt, London; Pallucchini, *Cariani.*

521 St. Augustine (standing in bishop's robes, holding a crosier), by Marco d'Oggiono. Blois, Musée des B/A; Sedini, *Marco d'Oggiono* (p.98).

522 Baptism of St. Augustine (he kneels before St. Ambrose, as a crowd looks on), by Aspertini. Lucca, San Frediano; Ricci, *Cinquecento.*

523 St. Augustine giving the habit of his Order to three Catechumens (their discarded clothes lay on the floor), by

Girolamo Genga, c. 1516. Columbia Museum of Art, SC; Shapley, *15th–16th Cent.*

524 St. Augustine at the seashore, (watching the child ladle water into the sand), by Giovan Pietro Birago from the Hours of Bona Sforza, add. ms. 34294, fo.199v, c. 1517–21. BM, London; BL, *Ren. Painting in MS.*

525 The vision of St. Augustine (watching a child, who tries to ladle the ocean into a hole, demonstrating the futility of describing the Divine mystery), by Benvenuto Da Garofalo. Nat'l Gallery, London; Poynter, *Nat'l Gallery.*

526 Virgin and Child with SS. Catherine (kneeling next to a large wheel hub), Augustine (leaning toward the Child), Mark, and John the Baptist, by Tintoretto, c. 1549. Lyon, Musée des B/A; Durey, *Musée.*

527 St. Augustine (standing in a niche, draped in a red cloak), by Paolo Veronese, 1568–69. Burghley House, England; Rearick, *Veronese.*

528 St. Augustine (standing on a cloud, reading from a book which he rests on his knee), by Martin Freminet. Orléans, Musée des B/A; O'Neill, *L'Ecole Francaise.*

529 St. Augustine (in bishop's regalia, holding a church), by El Greco, 1597–1603. Santa Cruz Museum, Toledo; Gudiol, *El Greco.*

530 Baptism of St. Augustine (St. Ambrose stands above Augustine, who kneels, half-nude, while a roomful of other convertees wait and talk), by Il Cerano, 1618. Milan, San Marco; Fiorio, *Le Chiese di Milano.*

531 St. Augustine (with a child ladling the ocean into a hole), att. to Gerard Seghers. Prado, Madrid; *Peinture Flamande* (b/w pl.308).

532 St. Augustine, oil sketch by P.P. Rubens. Coll. Emil G. Bührle; Held, *Oil Sketches* (pl.32).

533 St. Augustine (struck by a vision as he writes in a book), by Francisco de Zurbaran, 1625–30. Private coll., Barcelona; Gállego, *Zurbaran.*

534 St. Augustine writing at a table, from a series of ten lunettes depicting the founders of religious orders by Paolo Domenico Finoglia in the Sala del Capitolo, c. 1626. Naples, S. Martino; RA, *Painting in Naples.*

535 St. Augustine in ecstasy (supported by angels, he looks up at Christ in heaven), oil sketch by Anthony van Dyck, c. 1628. Yale Univ. Art Gallery, New Haven, CT; Larsen, *Van Dyck* (pl.206).

536 St. Augustine in ecstasy, grisaille study for an altarpiece, by Sir Anthony van Dyck, 1628. Ashmolean Museum, Oxford; Larsen, *Van Dyck* (pl.205); Piper, *Treasures.*

537 The ecstasy of St. Augustine (supported by angels as he looks up at Jesus), by Anthony van Dyck, c. 1628. Antwerp, Augustinian Church; Gaunt, *Pictorial Art*; Larsen, *17th Cent. Flem.*; Larsen, *Van Dyck* (pl.204).

538 St. Augustine (in bishop's robes, preaching), by Francisco de Zurbaran, 1631–40. Félix Valdés, Bilbao; Gállego, *Zurbaran.*

539 St. Augustine, by P.P. Rubens, from Augustinian church of St. Thomas Prague, c. 1637. Prague Nat'l Gallery; Novotny, *Prague.*

540 St. Augustine (talking to a child, who is holding a spoon, standing next to a collection of sea shells) by Gaspar de Crayer. Prado, Madrid; *Peinture Flamande* (b/w pl.92).

541 St. Augustine (in bishop's miter, holding a book), by Francisco de Zurbaran, 1641–58. Convent of the Capuchin Nuns, Castellón de la Plana; Gállego, *Zurbaran.*

542 St. Augustine, meditating on the Holy Trinity, is interrupted by the Child, by Guercino. Prado, Madrid; *Guide to Prado.*

543 St. Augustine washing the feet of Christ (who is dressed as a pilgrim, while three monks and a youth look on), by Jacob Van Oost the Elder. Bruges, State Museum; Pauwels, *Musée Groeninge.*

544 St. Augustine, reliquary with the chair of St. Peter, sculpture by Gianlorenzo Bernini, 1656–66. Rome, St. Peter's; Calvesi, *Vatican.*

545 St. Augustine (holding a church, in bishop's regalia), by Francisco de Zurbaran, 1658–64. Juan de Córdoba y Mirón, Madrid; Gállego, *Zurbaran.*

546 St. Augustine (in bishop's regalia, holding a heart, looking up over his right shoulder), marble sculpture by Johann Mauritz Gröninger. Münster, St. Martini; *800 Jahre.*

547 St. Augustine surrounded by child angels, drawing by Giovanni Antonio

de'Sacchis called Pordenone, c. 1664. Royal Collection; Roberts, *Master.*
548 Triumph of St. Augustine, by Sanchez Coello, 1664. Prado, Madrid; Book of Art, *German & Spanish.*
549 The blessed Alessandro Sauli as St. Augustine, terracotta sculpture by Pierre Puget, 1665-67. St. Louis Art Museum, MO.
550 St. Augustine curing the sick (in the wilderness, the sick are carried up to him while he kneels, pointing at them and looking heavenward), by Joseph Parrocel. Nantes, Musée des B/A; Cousseau, *Musée.*
551 St. Augustine in glory (raised to heaven on a cloud), by Pittoni. Venice, S. Giovanni Elemosinario; Boccazzi, *Pittoni* (pl.15).
552 St. Augustine (holding out a burning heart), statue by Andreas Philip Quitainer, 1720-21. Prague, St. Thomas Church; Štech, *Baroque Sculpture.*
553 St. Augustine in flowing cloak, left hand pointing up, right hand pointing down, marble statue by Permoser, c. 1725. Bautzen, Stadtmuseum; Murray, *Art & Artists*; Murray, *Dictionary.*
554 St. Augustine (enthroned) and other saints, by Giambattista Tiepolo. Nat'l Gallery, London; Morassi, *Catalogue* (pl.110).
555 St. Augustine (looking down), terracotta bust by Augustin Pajou, 1761. V & A, London; Burton, *V & A.*
556 St. Augustine (sitting in ecclesiastic robes, writing in a book and looking up), by Goya, 1781-85. Coll. D. Manuel Monjardin, Madrid; Cleveland Museum of Art, *European 16th-18th Cent.*
See also 137, 138, 139, 143, 144, 145, 146, 150, 152, 155, 159, 167, 211, 373, 1208, 1213, 1268, 1622, 1731, 1801, 2316, 2330, 2532, 2658, 3123, 3225, 3238, 3405, 3483, 3713, 3715, 3717, 3721, 3722, 3723, 3828, 3833, 3835, 3975, 4652

Augustine or Austin Archbishop of Canterbury, First Archbishop of Canterbury, Apostle to the English, d. 604/5 (May 28)
557 St. Austin preaching Christianity to King Ethelbert and Queen Bertha in the Isle of Thanet, by Samuel Wale, 1769. RA.
558 St. Austin preaching the gospel to King Ethelbert and Queen Bertha, in the Isle of Thanet, by Henry Singleton, 1799. RA.

559 St. Augustine's mission to King Ethelbert, by Henry Tresham, 1806. RA.
560 St. Augustine preaching to the Saxons, by Stephen B. Carlill. RA; Parrott, *British.*
561 The interview of St. Augustine and King Ethelbert, by Charles Goldie, 1869. RA.

Augustine Novello, Augustinian friar, d. 1309 (May 19)
562 Posthumous scenes of St. Augustine Novello: he resuscitates a child who was killed, falling out of a broken hammock; he resuscitates a child who is mauled by a dog; he saves a man who is thrown from his horse; from an altarpiece by Simone Martini. Siena, S. Agostino; Kaftal, *Tuscan.*

Aurea, drowned with a millstone around her neck (Mar. 11)
563 Virgin and Child with SS. Dominic and Aurea, triptych by Duccio di Buoninsegna, c. 1315. Nat'l Gallery, London; Dunkerton, *Giotto to Dürer.*

Auxentios, horse-guard of Theodosius the Younger, hermit monk, d. 473 (Feb. 14)
564 Martyrs Mardarios, Eugenios, Eustathios, Auxentios, and Orestios, by a Greek painter working at Chilandari, 1350-1400. Chilandari Monastery, Mt. Athos; Knopf, *The Icon* (p.177).

Averkius
565 Saint Averkius, holding a scroll, icon fresco, second decade of 16th cent. Palaeochorio, Church of the Transfiguration of the Savior; Stylianou, *Painted Churches* (p.286).

Babylas, Bishop of Antioch; beheaded after torture; mart. 2nd cent. (Jan. 24)
566 SS. Romanus and Babylas (giving a blessing, with a kneeling donor at his feet), panel by G. A. Bevilacqua. Waddesdon Manor, Rothschild Coll.; Kaftal, *North West Italy.*

Bacchos, Roman officer; martyred 303 (Oct. 7)
567 St. Sergius of Radonezh and St. Bacchos (both are riding horses, dressed in chain maille), reverse of a two-sided icon, 1275-1300. Sinai, Monastery of St. Catherine; Manafis, *Sinai.*

Barbara, Virgin-martyr, patron of artillery; invoked against lightning, fire, explosion, and sudden death; beheaded; mart. 235 (Dec. 4)
568 Silver reliquary of St. Barbara (half of her figure, with a hand over the tower), 13th cent. Rome, Museo Diocesano; *Tresori d'Arte.*
569 St. Barbara, fresco from central Greece, early 14th cent. Euboea, St. Thekla; Knopf, *The Icon* (p.166).
570 St. Barbara (holding a model of a tower), from a polyptych by Cecco di Pietro, 1386. Pisa, Museo Civico; Kaftal, *Tuscan.*
571 St. Barbara holding the steeple of a tiny church, from "Book of Hours" ms. 170, fo.172v. Walters Art Gallery, Baltimore; Panofsky, *Early Nether.*
572 Martyrdom of St. Barbara (tied to a post, one man whips her while another cuts her breast off), by Master Francke, c. 1415. Kansallismuseo, Helsinki; McGraw, *Encyclo.* (Vol.VI, pl.375).
573 Madonna and Child in the enclosed garden, with Saints Catherine (in a pink robe), John the Baptist (holding a lamb), Barbara (in orange) and Anthony Abbott (in green cloak), by studio of Master of Flémalle. Kress Coll., NY; Ferguson, *Signs*; Phaidon, *Art Treasures.*
574 St. Barbara in a green cloak, reading before a fire, by Master of Flémalle, early 15th cent. Prado, Madrid; Bentley, *Calendar*; *Guide to Prado*; Levey, *Giotto to Cézanne*; Newsweek, *Prado*; *Peinture Flamande.*
575 Scenes from the life of St. Barbara: they are building her tower; cripples are cured at her tomb; by the Florentine School, 15th cent. Vatican Museums; Francia, *Vaticana.*
576 St. Barbara (sitting, open book in her lap, before a cathedral), drawing by Jan van Eyck, 1437. Antwerp, Musée Royal des B/A; *Eight Centuries*; Pischel, *World History.*
577 SS. Mark, Barbara, and Luke, shutter of an altarpiece by Stephan Lochner, c. 1445. Wallraf-Richartz Museum, Cologne; Dunkerton, *Giotto to Dürer.*
578 St. Barbara (sitting in a castle courtyard with a book in her lap), ms. illum. by Horae Beatae Maria Virginis, ms. I, B.51, fo.341v. Naples, Biblio. Nazionale; McGraw, *Encyclo.* (Vol.V, pl.283).
579 St. Barbara (towering over a church, on which she rests her arm),

polychromed oak sculpture, English or Flemish, 1450–1500. Walters Art Gallery, Baltimore MD.
580 St. Barbara directs the building of her tower (adding a third floor for the Trinity); martyrdom of St. Barbara (father cuts off her head; in upper right demons carry off his soul), by Master of the Legend of St. Joseph, c. 1470–1500. Walters Art Gallery, Baltimore.
581 Episode from the life of St. Barbara (stripped to the waist and tied to a column, she is whipped by moors), by Guidoccio Gozzarelli. Vatican Museums; Francia, *Vaticana.*
582 Flagellation of St. Barbara (a man with a flail pulls a lock of her hair as she kneels with her hands clasped, in a landscape), by the workshop of the Younger Master of the Schotten Altarpiece, late 15th cent. York City Art Gallery; *Catalogue.*
583 SS. Barbara (holding her tower by the roof) and Roch (pointing to his plague wound), fresco by Giovanni da Marone. Zone, S. Giorgio a Cislano; Kaftal, *North West Italy.*
584 Saints Catherine of Alexandria (holding a sword and reading a book) and St. Barbara (before a tower), wings of a triptych by Master of Frankfurt. Mauritshuis, The Hague; Hoetink, *Mauritshuis.*
585 St. Barbara (sitting with a book before a tower), by Master of Frankfort. Prado, Madrid; *Peinture Flamande* (b/w pl.181).
586 St. Barbara, polychromed wooden statue, Swabia, Germany, 1490–1500. Philadelphia Museum of Art, PA.
587 St. Barbara, reading beside a small tower, min. from "Breviary of Isabella of Castile," add. ms. 18851, fo.297, before 1497. BL, London; Miegroet, *David*; *Ren. Painting in MS.*
588 St. Barbara (standing near her tower, holding a chalice), by Antonio Giovanni Boltraffio, 1502. Picture Gallery, Berlin; Fiorio, *Le Chiese di Milano*; Murray, *Art & Artists.*
589 St. Barbara (standing next to her tower with the chalice and Eucharist and an open book, next to a kneeling penitent), woodcut by Hans Baldung Grien, Hamburg, 1505. Geisberg, *Single-Leaf.*
590 St. Catherine (holding a sword and a fragment of a wheel) and St. Barbara (holding a chalice with a host), wings from an altarpiece by Hans Baldung

Grien, 1505-06. Schwabach, Evgl. Lutheran Stadtpfarrkirche Sankt Martin; Met Museum, *Gothic Art.*

591 St. Catherine of Alexandria, St. Barbara (with a tower on the front of her hat) and other saints in Virgo Inter Virgines (Madonna is feeding Christ a bunch of grapes) by Gerard David, c. 1506. Rouen, Musée des B/A; Miegroet, *David.*

592 St. Barbara (sitting on a chair holding a chalice and host, small castle at her feet), woodcut by Hans Baldung Grien, Coburg, c. 1508. Geisberg, *Single-Leaf.*

593 Beheading of St. Barbara, woodcut by Lucas Cranach the Elder, Munich. Geisberg, *Single-Leaf.*

594 St. Barbara (in a red robe and green dress, standing next to a small square tower), by Marco d'Oggiono. Condé Museum, Chantilly; Sedini, *Marco d'Oggiono* (p.lll).

595 Pope Sixtus II and St. Barbara kneel before the "The Sistine Madonna," by Raphael. Picture Gallery, Dresden; Ettlinger, *Raphael.*

596 SS. Catherine of Alexandria (leaning on a wheel) and Barbara (wrapped in a mantle, holding a chalice), wings of an altarpiece by Lucas Cranach the Elder, c. 1510. Cassel, Gemäldegalerie; Friedländer, *Cranach.*

597 St. Barbara Altarpiece, with subsidiary panels of SS. Sebastian, John the Baptist, Anthony Abbot, and Vincent Ferrer, by Palma Vecchio, c. 1510-25. Venice, S. Maria Formosa; Int'l Dict., *Art.*

598 The martyrdom of Saint Barbara (kneeling); her father holds her hair, sword upraised, by Lucas Cranach the Elder, c. 1510-15. Met Museum; Friedländer, *Cranach.*

599 Madonna and Child with SS. Barbara (reading) and Catherine of Alexandria (holding a sword), by a Flemish master of the early 16th cent. Rhode Island School of Design; *Handbook.*

600 St. Barbara murdered by her father (she kneels, while he holds out her hair and raises his sword to strike), illum. by Jean Bourdichon from the Great Hours of Henry VIII, 1514-18. Coll. Duke of Cumberland; *Great Hours.*

601 SS. Catherine of Alexandria (holding a long-sword) and Barbara (holding a chalice in her apron), by Lucas Cranach the Elder, c. 1516. Picture Gallery, Dresden; Friedländer, *Cranach.*

602 St. Barbara standing with a chalice above which rises a host, from the Altarpiece of St. Sebastian by Hans Holbein the Elder, 1516. Alte Pinakothek, Munich; Benesch, *German.*

603 St. Barbara standing with a chalice, woodcut by Lucas Cranach the Elder, Munich, 1519. Geisberg, *Single-Leaf*; Schade, *Cranach.*

604 Saints Catherine of Alexandria (holding a ring) and Barbara (holding a green bird), by anon. French Picardy artist, early 16th cent. Philadelphia Museum of Art, PA.

605 Barbara in left profile, by Parmigianino. Prado, Madrid; *Guide to Prado.*

606 Madonna with Saints Anthony Abbot and Barbara (angel sits between saints, playing the lute), fresco by Luini, 1521. Brera, Milan; Murray, *Art & Artists.*

607 St. Barbara in a rocky landscape with firs, by Lucas Cranach the Elder, c. 1525. Frauenfeld, Thurgau, Switzerland, Kunstmuseum; Friedländer, *Cranach.*

608 St. Barbara sitting before a green velvet drape (reading), by Lucas Cranach the Elder, c. 1525. Coll. J. Rosenbaum, Frankfurt; Friedländer, *Cranach.*

609 Madonna in glory (with the Child and angels in the clouds) with SS. Barbara and Ursula (holding a banner; the two saints kneel on clouds above the 10,000 virgins), by Bastarolo. Ferrara, Direzione Orfanotrofi e Conservatori; Frabetti, *Manieristi.*

610 St. Barbara, half portrait in left profile, copy after Il Parmigianino. Mauritshuis, The Hague; Hoetink, *Mauritshuis.*

611 The decollation of St. Barbara (executioner is holding up her hair, and is about to cut off her head with a curved sword), from the Osek altar by the Master I.W., after 1540. Prague, Nat'l Gallery; Korejsi, *Ren. Art in Bohemia.*

612 Virgin and Child with St. Barbara and a Carthusian Monk (before a window with a city in background), by Petrus Christus. Picture Gallery, Berlin; *Gemäldegalerie; Masterworks.*

613 St. Barbara (leaning on a castle), marble sculpture att. to Germain Pilon. Nelson-Atkins Museum of Art, Kansas City MO; *Collections.*

614 St. Barbara (close view, sitting before a window holding a book; her tower is lit by a celestial light in background), by Bartholomaus Spranger. Budapest, Museum of Fine Arts: Haraszti-Takács, *Masters of Mannerism*; Kaufman, *School of Prague*.

615 St. Barbara, her right hand supporting an angel, by Cavaliere d'Arpino, c. 1597. Rome, Santa Maria in Transpontina; Moir, *Caravaggio*.

616 The flight of St. Barbara (holding a palm, she runs from her father across a roof), oil sketch by P.P. Rubens. Dulwich College Picture Gallery, London; Held, *Oil Sketches* (pl.31); Murray, *Catalogue*; Rowlands, *Rubens, Drawings*.

617 St. Barbara (kneeling before a fortress wall, beneath an angel reclining on a cloud), by Carlo Bononi, c. 1620. Matthiesen Fine Art Ltd., London; *Age of Correggio*; *Around 1610*.

618 St. Barbara (in ecstasy, holding a book), by Francisco de Zurbaran, 1641–58. Seville, Museum of Fine Arts; Gállego, *Zurbaran*.

619 St. Barbara (bust portrait, with a hand on her breast, looking up in ecstasy), by Luca Giordano. Bob Jones Univ. Art Gallery, Greenville, SC; Pepper, *Ital. Paintings*.

620 St. Barbara (kneeling on a cloud with cherubs), pear wood statue by Ignác František Platzer, after 1750. Prague, Nat'l Gallery; National Gallery, *Baroque*.

621 St. Barbara (with blood coming from her head), pine wood retable with water-based paints, gesso, Retablo Style I, late 19th cent. Taylor Museum for Southwest Studies, CO; Wroth, *Images of Penance*.

See also 54, 75, 1032, 1054, 1065, 1067, 1342, 1384, 1829, 2532, 3544, 3545, 3546, 4740, 4792

Bartholomew, abbot of Grottaferrata, d. 1050 (Nov. 11)
622 The Virgin appearing to Saints Nilus and Bartholomew, by Domenichino, 1608–10. Grottaferrata Abbey; Spear, *Domenichino*.

Barulas, child saint *see* **Romanus (4222)**

Basil the Great, archbishop of Caesarea; Doctor of the Church; founded Basilian Order; d. 379 (Jan. 1 & June 14)
623 Saint Basil, reading a scroll, fresco, 1110–18. Koutsovendis, Monastery

of St. Chrysostom; Stylianou, *Painted Churches* (p.461).

624 St. Basil the Great holding a book, mosaic, 1148. Duomo, Cefalù, Sicily; Coulson, *Saints*.

625 St. Basil the Great (reading from a scroll), mosaic by the Venetian School, 14th cent. Venice, S. Marco; Kaftal, *North East Italy*.

626 St. Basil the Great, icon by Theophanes the Greek, 1405. Kremlin, Cathedral of the Annunciation; Knopf, *The Icon* (p.264).

627 SS. Paul, John Chrysostom, and Basil (standing in three trompe l'oeil arches, looking to their right), by Carlo Crivelli. Jacquemart-André Museum, Paris; Zampetti, *Crivelli*.

628 Dormition of Saint Basil the Great (a priest kisses him as they say the last rites), icon, early 16th cent. Sinai, Monastery of St. Catherine; Manafis, *Sinai*.

629 St. Basil holding a scroll, fresco by Domenichino, 1608–10. Grottaferrata Abbey; Spear, *Domenichino*.

630 St. Basil (sitting on a cloud, with a cherub overhead), oil sketch by P.P. Rubens. Gotha, Schlossmuseum; Held, *Oil Sketches* (pl.33).

631 St. Basil dictating his doctrine (to other saints and monks), by Francesco de Herrera the Elder. Louvre, Paris; Boone, *Baroque*; Gowing, *Paintings*.

632 St. Basil (standing and reading, in right profile) by Francisco de Zurbaran, 1641–58. Convent of the Capuchin Nuns, Castellón de la Plana; Gállego, *Zurbaran*.

633 Mass of St. Basil (the heretical emperor Valens is so overcome by Basil's mass that he nearly faints; his offering of bread, carried by servants at left, is ignored by Basil who is immersed in the mass), by Subleyras, c. 1748. Akademie der Bildenden Künste, Vienna; *Subleyras*.

634 Mass of St. Basil (the heretical emperor Valens is so overcome by Basil's mass that he nearly faints; his offering of bread, carried by servants at left, is ignored by Basil who is immersed in the mass), by Subleyras, c. 1748. Hermitage, St. Petersburg; *Subleyras*.

635 Mass of St. Basil (the heretical emperor Valens is so overcome by Basil's mass that he nearly faints; his offering of bread, carried by servants at left, is ignored by Basil who is immersed in the mass), copy after Subleyras. Paray-le-Monial, Musée du Hiéron; *Subleyras*.

636 Mass of St. Basil (the heretical emperor Valens is so overcome by Basil's mass that he nearly faints; his offering of bread, carried by servants at left, is ignored by Basil who is immersed in the mass), by Subleyras. Louvre, Paris; *Subleyras.*

637 Mass of St. Basil (the heretical emperor Valens is so overcome by Basil's mass that he nearly faints; his offering of bread, carried by servants at left, is ignored by Basil who is immersed in the mass), by Subleyras, c. 1748. Rome, Church of Saint Mary of the Angels; *Subleyras.*

638 Mass of St. Basil (the heretical emperor Valens is so overcome by Basil's mass that he nearly faints; his offering of bread, carried by servants at left, is ignored by Basil who is immersed in the mass), copy after Subleyras. Granet Museum, Aix-en-Provence; *Subleyras.*

639 St. Basil before the prefect Modestus (Basil stands, at the foot of the steps, holding out a document to the prefect), by Hoël Halle, c. 1762. Orléans, Musée des B/A; O'Neill, *L'Ecole Francaise.*

See also 2594, 3116, 3743

Basilissa *see* **Julian and Basilissa**

Basilius
640 St. Basilius (saving a man from the devil), woodcut by Günther Xanier from "Leben der Heiligen, Winterteil,"Augsberg, 1471. The Illus. Bartsch; *German Book Illus.* (Vol.80, p.71).

Bassian, Bishop and patron of Lodi, mart. 413 (Jan. 19)
641 St. Bassian (standing in bishop's regalia, holding a book), fresco by the Lombard School, 1300-25. Lodi, S. Bassiano; Kaftal, *North West Italy.*

Bassus or Basso, bishop of Nice or Nicea; transfixed with spears; mart. 250 (Dec. 5 or 6)
642 St. Bassus, standing in bishop's regalia, holding a book and the two spears with which he was transfixed from foot to head, by a Marchigian follower of Crivelli. Cupra Marittima, Parish Church; Kaftal, *Central & So. Ital.*

Bathilde or Bathildis, wife of Clovis II, founded Abbey of Corbie, d. 680 (Jan. 30)
643 St. Bathilde (sold as a slave by her captors), by Guy-Louis Vernansal, 1700. Orléans, Musée des B/A; O'Neill, *L'Ecole Francaise.*

Baudemond *see* **128**

Baudime
644 Reliquary of St. Baudime, enameled copper on oak bust and torso by the Limoges workshop, 12th-13th cent. St. Nectaire Church, France; Lloyd, *1773 Milestones*; McGraw, *Encyclo.* (Vol.XII, pl.379).

Bavo (Allowin), hermit, patron of Ghent and Haarlem d. 655 (Oct. 1)
645 Nativity with St. Francis (receiving the stigmata) and St. Bavo (standing with a hawk), by Rogier van der Weyden. Brussels, Musées Royaux des B/A; Bentley, *Calendar.*

646 St. Bavo (enthroned, with a book and scepter), ms. illum. by Nicolaas Spierinc, ms. 1857, fol. 123r. ON, Vienna; Dogaer, *Flemish Min.*

647 St. Bavo (half-view in a landscape, wearing armor and holding a sword and a hawk), by Geertgen Tot Sint Jans. Hermitage, St. Petersburg; Eisler, *Hermitage.*

648 St. Bavo (holding a hawk and a sword), from diptych of the St. Anne Trinity by Jacob Jansz, c. 1490-1500. Herzog Anton-Ulrich Museum, Brunswick; Châtelet, *Early Dutch* (pl.107); Miegroet, *David.*

649 St. Bavo of Allowin holding a falcon, right outer shutter of "The Last Judgment" by Hieronymus Bosch. Vienna, Academy of Fine Arts; Coulson, *Saints.*

650 St. Bavon (holding a falcon and bag, appealed to by a number of beggars), by Hieronymus Bosch. KM, Vienna; Daniel, *Encyclo. of Themes.*

651 The conversion of St. Bavo, oil sketch by P.P. Rubens, 1611-12. Nat'l Gallery, London; Baudouin, *Rubens*; McGraw, *Encyclo.* (Vol.XII, pl.328).

652 Conversion of St. Bavo, by P.P. Rubens, 1623-24. Ghent, St. Bavo; Baudouin, *Rubens.*

653 St. Bavo about to receive the monastic habit at Ghent, by P.P. Rubens. Nat'l Gallery, London; Bentley, *Calendar* (detail).

See also 4903

Becket *see* **Thomas Becket**

Bede the Venerable, doctor of the Church, d. 735 (May 27)
654 St. Bede writing, from Bede's "Life of St. Cuthbert" ms., late 12th cent. BM, London; Coulson, *Saints.*

Begga, mother of King Pepin of Heristal, founded seven churches, d. 693 (Dec. 17)
655 St. Begga (as a witness) in "St. Bavo About to Receive the Monastic Habit at Ghent" by P.P. Rubens. Nat'l Gallery, London; Bentley, *Calendar.*

Benedict of Nursia, founder of Benedictine Order, d. 547 (Mar. 21)
656 St. Benedict healing a leper, fresco, 10th cent. Rome, S. Crisogono; Batselier, *St. Benedict* (p.55).
657 Christ between SS. Benedict and Gregory, from "Homilies on Ezechiel," ms.175, p.150, 10th cent. Orléans Library; Porcher, *Medieval French Min.* (fig.12).
658 St. Benedict and monks of Canterbury, from a Psalter, Arundel ms. 155, c. 1012–23. BM, London; Gowing, *Hist. of Art* (p.411); Rickert, *Painting in Britain.*
659 St. Benedict giving the rule to Abbess Aeilika in the Abbey of Ringelheim, ms. theol. lat.qu.199, c. 1025. Berlin, Staatsbibliothek; *Benedict* (p.408).
660 St. Benedict, half view with an open book, holding a crosier, fresco, mid-12th cent. Salzburg, Benedictine Abbey; Batselier, *Benedict* (p.113).
661 St. Benedict writing his rule, from a Codex of Zwiefalten, ms. cod. hist. fo.415, c. 1138–47. Wurttembergische Landesbiblio., Stuttgart; Batselier, *Benedict* (p.123).
662 Initial "A" with St. Benedict, from "Rule of St. Benedict," ms.15, fo.113r, Posa, mid-13th cent. Sankt Marienthal Convent Library; Rothe, *Med. Book Illum.* (pl.44).
663 St. Benedict at Enfide (he repairs the sieve dropped by his nurse) and at Subiaco (withdrawing to a cave), fresco by Master Conxolus, 13th cent. Sacro Speco, Subiaco; Batselier, *St. Benedict* (p.18).
664 St. Benedict giving a blessing, mosaic, 13th cent. Venice, S. Marco; Batselier, *St. Benedict.*
665 St. Benedict with a book and crosier, icon fresco by the Romano-Byzantine school, 13th cent. Sacro Speco, Subiaco; Batselier, *St. Benedict* (p.59).

666 St. Benedict, St. Maurus and St. Placidus in the cave, with the miracle of the poisoned bread (carried by ravens), fresco by Master Conxolus, 13th cent. Sacro Speco, Subiaco; Batselier, *St. Benedict* (p.95).
667 St. Benedict (half-length, pointing at an open book), left leaf of a polyptych by Bernardo Daddi, c. 1320–25. Coll. Sig. Marco Brunelli, Milan; Offner, *Corpus* (Sect.III, Vol.VIII, pl.I).
668 A priest (sitting at a table below the cave) shares his Easter meal with St. Benedict (the priest talks to an angel), fresco by the school of Giotto, mid-14th cent. Santa Croce, Florence; Batselier, *St. Benedict* (p.89).
669 St. Benedict holds the ladder of humility as his monks climb the wall to the celestial city, from Guillaume de Deguileville, "Pèlerinage de la vie humaine," ms. 10176, 14th cent. Biblio. Royale, Brussels; Batselier, *St. Benedict* (p.33).
670 Presentation in the temple, flanked by St. John the Baptist and St. Benedict, triptych by Giovanni del Biondo, 1363. Accademia, Florence; Offner, *Corpus* (Sect.IV, Vol.IV, part I, pl.XVII).
671 St. Benedict leaving his home for the desert; an angel appears to a monk, instructing him that Benedict needs food, while at right Romanus lowers food to Benedict in a cave, panels by Giovanni del Biondo, 1364. Coll. Acton, Florence; Offner, *Corpus* (Sect.IV, Vol.IV, part I, pl.XVIII).
672 St. Benedict restores life to a young monk (who has been killed by a collapsed building), by Giovanni del Biondo, 1364. Toronto, Art Gallery of Ontario; Eisenberg, *Monaco* (pl.307); Offner, *Corpus* (Sect.IV, Vol.IV, part 1, pl.XVIII).
673 St. Benedict's vision of the whole world (he stands outside his building shielding his eyes against the vision inside of the sun), by Giovanni del Biondo, 1364. Toronto, Art Gallery of Ontario: Offner, *Corpus* (Sect.IV, Vol.IV, part I, pl.XVIII).
674 St. Benedict (in a black robe, holding an open book), by a follower of Nardo di Cione. Coll. Berenson, Ponte A Mensola; Offner, *Corpus* (Sect.IV, Vol.II, pl.XXIV).
675 Funeral of St. Benedict (surrounded by monks, as an angel looks on

from above), by Giovanni del Biondo, 1356–99. Colonna Palace, Rome; Cooper, *Family Collections*; Offner, *Corpus* (Sect.IV, Vol.IV, part 1, pl.XVIII).

676 St. Benedict (standing in a white robe and a red brocade cloak), by Spinello Aretino, c. 1385. Hermitage, St. Petersburg; Eisler, *Hermitage.*

677 Death of St. Benedict (as he dies, surrounded by monks, the angels pull him to heaven along a carpet), by Spinello Aretino, 1387. Florence, San Miniato al Monte; Eisenberg, *Monaco* (pl.303); Kaftal, *Tuscan* (fig.156).

678 St. Benedict expels the devil from one of his monks, fresco by Spinello Aretino, 1387. Florence, San Miniato al Monte; Berenson, *Ital. Painters*; Gowing, *Biog. Dict.*; Kaftal, *Tuscan* (fig.160).

679 St. Benedict predicts the death of Totila (Benedict points at the King, who shies away), fresco by Spinello Aretino, 1387. Florence, San Miniato al Monte; Batselier, *St. Benedict* (p.100); Kaftal, *Tuscan* (fig.166).

680 St. Benedict raises a young monk (after a demon has broken a stairway on the monk's body), by Spinello Aretino, 1387. Florence, San Miniato al Monte; Eisenberg, *Monaco* (pl.304); Kaftal, *Tuscan* (fig.160).

681 St. Benedict restoring the Goth's sickle (he pulls it from a stream), fresco by Spinello Aretino, 1387. Florence, San Miniato al Monte; Batselier, *St. Benedict* (p.92).

682 St. Benedict blessing the stone (his monks raise the a large flat stone with levers, while Benedict blesses it and a demon flies away), predella panel from Coronation of the Virgin polyptych by Cenni di Francesco, 1410. J. Paul Getty Museum, Malibu CA; Fredericksen, *Catalogue.*

683 The Monte Oliveto Altarpiece, with Saints Benedict, Thaddeus, John the Baptist and Bartholomew, by Lorenzo Monaco, 1410. Accademia, Florence; Eisenberg, *Monaco* (pl.22).

684 St. Benedict raises a young monk tempted from prayer, by Lorenzo Monaco, c. 1414. Vatican Museums; Eisenberg, *Monaco* (pl.186).

685 Death of St. Benedict (surrounded by monks in an open room under a roof), by Lorenzo Monaco, c. 1414. Nat'l Gallery, London; Eisenberg, *Monaco* (pl. 187).

686 Incident from the life of St. Benedict of Nursia (he rescues St. Placidus), by Lorenzo Monaco, c. 1414. Nat'l Gallery, London; Book of Art, *Ital. to 1850*; Coulson, *Saints*; Eisenberg, *Monaco* (pl.184).

687 Scenes from the life of St. Benedict (saves a man from drowning by walking on water; preaches to nuns), predella of the "Coronation of the Virgin" altarpiece by Lorenzo Monaco, 1414. Uffizi, Florence; Batselier, *St. Benedict*; Denvir, *Art Treasures.*

688 St. Benedict admitting St. Placidus and St. Maurus into the order, from St. Benedict Altarpiece by Lorenzo Monaco, c. 1414. Nat'l Gallery, London; Eisenberg, *Monaco* (pl.183).

689 St. Benedict in the Sacro Speco (he stands before a cave as a monk lowers food to him), by workshop of Lorenzo Monaco. Rome, Galleria Pallaviknci; Eisenberg, *Monaco* (pl.196).

690 St. Benedict visits St. Scholastica, from an altarpiece by Lorenzo Monaco, c. 1414. Nat'l Gallery, London; Book of Art, *Ital. to 1850*; Coulson, *Saints*; Eisenberg, *Monaco* (pl.184).

691 St. Benedict (in robe and cowl, holding a book), by Gherardo Starnina. Stockholm, Nat'l Museum; Eisenberg, *Monaco* (pl.290).

692 St. Benedict and the miracle of the Easter meal (the devil tries to intercept the hermit's Easter meal which is lowered on a rope, but is foiled when another monk brings food from a different direction; story is explained with scrolls), by Thomas de Coloswar, 1427. Esztergom Christian Museum; *Christian Art in Hungary.*

693 St. Benedict miraculously breaks the poisoned cup (offered to him and his monks at dinner), by Pisanello. Uffizi, Florence; Batselier, *St. Benedict* (p.91).

694 St. Benedict punishing a monk who was led astray by the devil, fresco by Giovanni di Consalvo, 1435–40. Badia, Florence; Batselier, *St. Benedict* (p.40).

695 St. Benedict (standing over a blue puddle, holding a staff and a blue book), by Fra Angelico. Minneapolis Inst. of Art, MN; *European Paintings.*

696 Conversation between SS. Benedict and Scholastica (at dinner), fresco by the School of Umbria and the Marches, 15th cent. Sacro Speco, Subiaco; Batselier, *St. Benedict* (p.22).

697 Saint Benedict (in a blue robe) between two angels, by Bertoldo di Giovanni, 15th cent. Bardini Museum, Florence; Batselier, *St. Benedict* (p.73).

698 St. Benedict (standing on a tiled floor dressed in monastic robes, holding a crosier), from Catherine of Cleve's Book of Hours, ms. 917, c. 1440. Pierpont Morgan Library, NY; Batselier, *St. Benedict* (p.21).

699 St. Benedict and the young man who had concealed a flask of wine, from "Vita Beati Benedicti" by Jean de Stavelot. Condé Museum, Chantilly; Batselier, *St. Benedict* (p.22).

700 St. Benedict receiving (kneeling) Totila (as the army watches), by Neroccio de'Landi. Uffizi, Florence; Pope-Hennessy, *Sienese*.

701 St. Benedict (standing in a white robe, leaning on a crutch), from the polyptych of the Virgin of Mercy by Piero della Francesca, 1450-60. Borgo San Sepolcro, Comunale Palace; Batselier, *St. Benedict* (p.34); McGraw, *Encyclo.* (Vol.XII, pl.376).

702 St. Benedict punishes a monk who has been led astray by the devil, fresco by the School of Umbria and the Marches, 15th cent. Sacro Speco, Subiaco; Batselier, *St. Benedict* (p.90).

703 St. Benedict talks to his sister St. Scholastica (who kneels at his side; in background he sends a soul to heaven), from Vincent de Beauvais "Speculum Historiale," ms.722, ex.1196, 15th cent. Condé Museum, Chantilly; Batselier, *St. Benedict* (p.48).

704 St. Benedict (standing with a finger to his mouth in a gesture of silence), fresco by Mariano di Matteo da Roma, second half of 15th cent. Monte Oliveto Maggiore; Batselier, *St. Benedict* (p.37).

705 St. Benedict with a white beard in a black habit, by Sano Di Pietro, c. 1470. Birmingham Museum of Art, AL; *Samuel H. Kress Coll.*

706 St. Benedict tormented (he kneels amid boulders, while a demon flies up from behind; above him, a man lies on top of a boulder), by Francesco di Giorgio. Uffizi, Florence; Edgell, *Sienese Painting*.

707 Alms of St. Benedict (he stands at the doorway of the monastery, giving bread to beggars), by Ambrogio da Fossano. Sforza Castle, Milan; Bentley, *Calendar.*

708 St. Benedict instructing his order (two rows of several monks sit before him; they don't seem to be paying much attention), engraving by Benedetto Montagna. Illus. Bartsch; *Early Ital. Masters* (Vol.25).

709 The prayer, the miracle of the broken sieve, and the departure of St. Benedict for Subiaco, by Bergognone, 1481-1522. Nantes, Musée des B/A; Cousseau, *Musée.*

710 St. Benedict reading, wing of a triptych by Hans Memling, 1487. Uffizi, Florence; Batselier, *St. Benedict* (p.64); Praeger, *Great Galleries.*

711 Saint Benedict (holding a crosier and an open bible), right panel of a triptych by Giovanni Bellini, 1488. Venice, Church of the Frari; Batselier, *St. Benedict* (p.76).

712 St. Benedict (wearing a cope and bishop's miter), by Vittore Crivelli, c. 1490. Walters Art Gallery, Baltimore; *Italian Paintings* (Vol.I).

713 St. Benedict cures Emperor Henry II of a kidney stone, from the tomb of Emperor Henry II and Empress Cunegund by Tilman Riemenschneider, 1499-1513. Bamberg Cathedral; Batselier, *St. Benedict* (p.121).

714 St. Benedict and the miracle of the sieve (he miraculously repairs the sieve, and the inhabitants of Effida hang it above the entrance to their church), fresco by Antonio Solario. Naples, SS. Severino e Sosio; Kaftal, *Central & So. Ital.*

715 St. Benedict leaves Rome with his nurse, then arrives at Effida (or Offida; he shakes hands with an elder, outside the city), fresco by Antonio Solario. Naples, SS. Severino e Sosio; Kaftal, *Central & So. Ital.*

716 The vision of St. Benedict (as he looks from a window), pen and ink drawing by Albrecht Dürer, c. 1500. Picture Gallery, Berlin; Batselier, *St. Benedict* (p.130).

717 St. Benedict leaves school, fresco by Sodoma, 1505-08. Monte Oliveto Maggiore; Batselier, *St. Benedict* (p.84).

718 St. Benedict and the miracle of the sacks of flour (at left, while the monks eat at right), fresco by Sodoma, c. 1505-08. Monte Oliveto Maggiore; Batselier, *St. Benedict* (p.39).

719 St. Benedict explaining the rule to a monk, from Jean de Stavelot's "Règle

de Saint Benoît," ms.1401, c. 1437. Condé Museum, Chantilly; Batselier, *St. Benedict* (p.30).

720 St. Benedict restoring the Goth's sickle by fishing it from the water (p.25); St. Benedict giving the rule to his monks (p.29); St. Benedict instructs the sleeping monks of Terracina how to build their abbey (p.24); frescoes by Sodoma, c. 1505-08. Monte Oliveto Maggiore; Batselier, *St. Benedict*.

721 St. Benedict leaving his parents by riding away on a rearing white horse (p.17), fresco by Sodoma, c. 1505-08. Monte Oliveto Maggiore; Batselier, *St. Benedict*.

722 St. Benedict (in a black robe, standing before a garden wall), from dismembered "God Between Two Angels" altarpiece by Gerard David, c. 1507. Bianco Palace, Genoa; Miegroet, *David*; United Nations, *Dismembered Works*.

723 Four scenes with St. Benedict, min. from the Mayer van den Bergh breviary, ms. cat.946, c. 1510. Mayer van den Bergh Museum, Antwerp; Batselier, *St. Benedict* (p.32).

724 St. Benedict absorbed in his devotions outside the cave of Subiaco, by Master of Mondsee, c. 1515. Osterreichische Galerie, Vienna; Benesch, *German*.

725 A monk shares his Easter dinner with St. Benedict (on a cloth spread before the cave), panel of an altarpiece by Jan II van Coninxloo, 1525-50. Brussels, Musées Royaux des B/A; Batselier, *St. Benedict* (p.86).

726 St. Benedict and the miracle of the broken sieve (in the kitchen, he kneels as the nurse cries; the sieve lies broken on the floor), panel of an altarpiece by Jan II van Coninxloo, 1525-50. Brussels, Musées Royaux des B/A; Batselier, *St. Benedict* (p.87).

727 St. Benedict (holding a crosier), from dismembered High Altar of Santo Domingo el Antiguo, Toledo, by El Greco, 1577-79. Prado, Madrid; Gudiol, *El Greco*; United Nations, *Dismembered Works*.

728 St. Benedict drives the demon from a possessed monk, relief by Albert ven del Brulle, 1596-98. Venice, S. Giorgio Maggiore; Batselier, *St. Benedict* (p.105).

729 Saints Benedict and Mark, drawing on blue paper by P.P. Rubens, c. 1605. BM, London; Batselier, *St. Benedict* (p.76).

730 Virgin in Glory with Saints Benedict (kneeling in a black robe, with miter and crosier on the ground), John the Baptist (pointing up) and Francis, by Bartolommeo Cesi, c. 1612. Bologna, S. Giacomo Maggiore; *Age of Correggio*.

731 St. Francis in ecstasy and St. Benedict (with an angel playing the violin), by Guercino. Louvre, Paris; Merriman, *Crespi*.

732 St. Benedict with a raven and angels, from a series of ten lunettes depicting the founders of religious orders by Paolo Domenico Finoglia in the Sala del Capitolo, c. 1626. Naples, S. Martino; RA, *Painting in Naples*.

733 Miracles of St. Benedict (he comes out onto a staircase, as armies wait for him, as well as the sick and dying), by P.P. Rubens, 1630-35. Brussels, Musées Royaux des B/A; Batselier, *St. Benedict* (p.139).

734 St. Benedict (holding out a pottery bowl), by Francisco de Zurbaran, 1641-58. Kleinberger & Co., New York; Gállego, *Zurbaran*.

735 St. Benedict's vision of Glory (he looks to heaven, while before him, three tiny angels support a sphere), by Alonso Cano, 1657-60. Prado, Madrid; Wethey, *Alonso Cano* (pl.132).

736 St. Benedict fed by brother Romain (as he prays near his cave), by French School, 17th cent. Orléans, Musée des B/A; O'Neill, *L'Ecole Francaise*.

737 Last communion of St. Benedict (he is supported by the other monks), by Daniel Hallé, c. 1660. Rouen, Saint-Ouen Church; *La Peinture d'Inspiration*.

738 St. Benedict presents the rule of his order (to monks and nuns who hold out their hands), by an unknown Rouen artist. Rouen, Monastery of Benedictines of Holy-Sacrament; *La Peinture d'Inspiration*.

739 The supper of St. Benedict (he sits at a table, while a monk stands opposite holding a candle), by Fray Juan Rizi, Prado, Madrid; Larousse, *Ren. & Baroque*.

740 St. Benedict receiving donations of food from the villagers (while he stands before his cave), copy by Giovanni Mari Viani, 1689, after an original by Guido Reni. Bologna, San Michele in Bosco; *Guido Reni*.

741 St. Benedict destroys the statue of Apollo at Monte Cassino, pen and ink

drawing by Engelbert Fisen, end of 17th cent. Liège, Musée des B/A; Batselier, *Benedict* (p.131).

742 St. Benedict reviving a dead child (he breathes into its mouth while monks look on), by Pierre Subleyras. M. H. de Young Memorial Museum, San Francisco CA; *European Works.*

743 St. Benedict in glory (raised to heaven on a cloud, supported by cherubs), from the altar of St. Benedict by G.A. Borroni, 1740. Cremona, Cathedral; Voltini, *Cremona.*

744 St. Benedict resuscitating a child (as monks look on; a man with a basket stands at right), by studio of Subleyras. Ackland Art Museum, Chapel Hill; *Subleyras.*

745 St. Benedict resuscitating a child (as monks look on; a man with a basket stands at right), by studio of Subleyras. San Francisco, Fine Arts Museum, CA; *Subleyras.*

746 St. Benedict resuscitating a child (as monks look on; a man with a basket stands at right), by Subleyras. Pérouse, Pinacoteca; *Subleyras.*

747 St. Benedict resuscitating a child (as monks look on; a man with a basket stands at right), by Subleyras. Louvre, Paris; *Subleyras.*

748 St. Benedict resuscitating a child (as monks look on; a man with a basket stands at right), by Subleyras. Munich, Pinacoteca; *Subleyras.*

749 St. Benedict reviving a child (as monks look on), by Pierre-Hubert Subleyras, 1744. Rome, S. Francesca Romana; Held, *17th & 18th Cent.*; McGraw, *Dict.*; *Subleyras.*

750 St. Benedict, standing with a cup, marble statue by Laurent Delvaux, 1753. Brussels, St. Michel Cathedral; Batselier, *Benedict* (p.116).

751 St. Benedict receiving the last communion, by Jean-Baptiste Deshays, 1761. Orléans, Musée des B/A; O'Neill, *L'Ecole Francaise.*

752 St. Benedict presents the rules of his order to the Pope, by Jerome Preudhomme, 1779. Orléans, Musée des B/A; O'Neill, *L'Ecole Francaise.*

753 St. Benedict (sitting, with book and crosier), marble statue by P. Tenerani, c. 1845. Rome, S. Paolo fuori le Mura; McGraw, *Encyclo.* (Vol.XI, pl.303).

See also 2, 4, 756, 771, 1176, 1641, 1983,

2525, 2541, 3259, 3320, 3430, 3526, 3558, 3690, 3982, 4069, 4070, 4114, 4229, 4271, 4272, 4273, 4499

Benedict I, Pope, r. 575–579

754 St. Benedict I, mosaic. Rome, St. Paul-Outside-the-Walls, Rome; Brusher, *Popes.*

Benedict XI (Nicholas Boccavino), pope, General of the Dominican Order

755 St. Benedict XI (reading at a desk in his study), fresco by Tomaso da Modena, 1352. Treviso, Domenican Seminary; Kaftal, *North East Italy.*

Benedict the Martyr

756 The Trinity with Saints Mauro, Placidus, Benedict, Romualdo, Benedict the Martyr, and John the Martyr, fresco by Raphael, c. 1508. Perugia, Monastery of San Severo; Raphael, *Complete Works* (1.79).

Benefactus

757 St. Benefactus (with miter and crosier) with Christ and a (tiny) supplicant, by an unknown Sicilian Master, mid-14th cent. Bob Jones Univ. Art Gallery, Greenville, SC; Pepper, *Ital. Paintings.*

Benvenuto, bishop of Osimo, c. 1282 (Mar. 22)

758 St. Benvenuto (half-portrait in bishop's robes, holding a book and giving a blessing), wing of a polyptych by Pietro da Montepulciano, 1418. Osimo, Cathedral; Kaftal, *Central & So. Ital.*

Bernard, Cistercian Abbot of Clairvaux, called Doctor Melli Fluus, d. 1153, canon. 1174 (Aug. 20)

759 Virgin (two angels) appears to St. Bernard (as he is writing), from Rinuccini Triptych by the Rinuccini Master, 1350–75. Accademia, Florence; Andres, *Art of Florence* (Vol.I, pl.140).

760 Legend of St. Bernard (as he kneels, the Virgin squirts her nursing milk into his mouth), Majorcan design, 14th cent. Palma, Museo Arqueologico; Meiss, *Painting in Florence* (pl.158).

761 Madonna and Child with SS. Catherine and Bernard at left, and SS. Margaret of Antioch and Paul at right, retable by Antonio Veneziano, 1370–90. Ponce, Museo de Arte; Held, *Catalogue.*

762 St. Bernard, sitting and reading, from "S. Augustini Soliloquia. S. Bernardi de Conscientia. S. Anselmi Orationes," Italian, c. 1375. Coll. C. W. Dyson Perrins; Burlington, *Illum. MS.*

763 Scenes from the life of St. Bernard: Bernard greets his five brothers, who are also Cistercian monks; while preaching at Sarlat, he blesses a loaf of bread and offers it to the brethren, telling them that if they eat of it, they will be cured of earthly ills; predellas of an altarpiece by the Master of the Runiccini chapel. Accademia, Florence; Kaftal, *Tuscan.*

764 St. Bernard venerated by the owner of the Book of Hours, ms. Linel 11. Frankfurt, Museum fur Kunsthandwerk; Panofsky, *Early Netherl.*

765 St. Bernard's "Vision of the Virgin" (as he reads at his desk, she appears before him with angels), by Filippo Lippi, 1447. Nat'l Gallery, London; Coulson, *Saints*; Hall, *Color and Meaning.*

766 Saints Jerome, Bernard, and Roch (hands clasped in prayer), by Fra Angelico. Lindenau Museum, Altenburg; Pope-Hennessy, *Fra Angelico* (fig.27).

767 St. Bernard teaching (to eight monks in a monastery; below, the devil tempts St. Bernard, beckoning to him while Bernard is at his prayers), illum. by Jean Fouquet from the Hours of Etienne Chevalier, c. 1453. Condé Museum, Chantilly; Fouquet, *Hours*; Horizon, *Middle Ages.*

768 St. Bernard (standing in white robes, and reading a green book), by Carlo Crivelli. Picture Gallery, Berlin; Zampetti, *Crivelli.*

769 Vision of St. Bernard (Virgin appears to him as he sits at his writing table), by Perugino, 1483–92 Munich, Pinacoteca; Larousse, *Ital. Painters*; McGraw, *Ren. & Baroque*; McGraw, *Encyclo.* (Vol.XI, pl.111).

770 The Madonna appearing to St. Bernard (as he is writing outside), by Filippino Lippi, 1486. Florence, Badia Church; Andres, *Art of Florence* (Vol.II, pl.497); Berenson, *Ital. Painters*; Book of Art, *Ital. to 1850*; Hartt, *Ital. Ren.*; Int'l Dict. of Art; McGraw, *Dict.*; McGraw, *Encyclo.* (Vol.IX, pl.149); Random House, *Paintings* (p.117).

771 St. Benedict and St. Bernard flank the Virgin in Coronation of the Virgin by Jan Provoost, late 15th cent. Hampton Court, Royal Coll.; Batselier, *Benedict* (p.119).

772 St. Bernard of Clairvaux receiving the stigmata from the Virgin (the Virgin supports a standing Jesus, while Bernard stands at their side, hands clasped; a ray of light emanates from Mary's hand), by the Flemish School. Crocker Art Gallery, Sacramento CA; *Catalogue.*

773 St. Bernard praying (as monks reap a harvest of wheat), by Jörg Breu the Elder, 1500. Monastery of Zwettl, Lower Austria; Benesch, *German.*

774 The Virgin and Child with St. Bernard, central panel of the "Universal Judgment" altarpiece by Hans Fries, 1501. Neue Pinakothek, Munich; New Int'l Illus. *Encyclo.*

775 Madonna appears to St. Bernard as he kneels, by Fra Bartolommeo, 1507. Accademia, Florence; Book of Art, *Ital. to 1850*; Fischer, *Fra Bartolommeo*; Hartt, *Ital. Ren.*; McGraw, *Encyclo.* (Vol.VIII, pl.209).

776 St. Bernard of Clairvaux (kneeling with his monks, blessed by an enthroned bishop saint), by Cotignola, called Marchesi. Formerly Kaiser Friedrich Museum, Berlin; Ricci, *Cinquecento.*

777 Carondelet Madonna, with a kneeling Ferry Carondelet gesturing to the Madonna and Child (on a cloud before a door), flanked by SS. Sebastian, John the Baptist, and Stephen at left, and SS. Anthony Abbot and Bernard at right, by Fra Bartolommeo, c. 1511. Besancon, Cathedral; Fischer, *Fra Bartolommeo* (fig.139).

778 St. Bernard (pointing up) and a holy bishop, by Bartolomeo Montagna. M. H. de Young Memorial Museum, San Francisco CA; *European Works.*

779 The vision of St. Bernard (Virgin and angels appear to him as he sits at a desk before a landscape), by Domenico Puligo, c. 1520. Walters Art Gallery, Baltimore; *Ital. Paintings* (Vol.II); Zafran, *50 Old Master Paintings.*

780 St. Bernard (bestriding a demon, holding a chain wrapped around its neck), by Sebastiano Luciani. Vatican Museums; Francia, *Vaticana.*

781 St. Bernard (holding a book and crosier) by El Greco, 1577–79. Unknown; Gudiol, *El Greco.*

782 St. Bernard (pausing at his writing, to look over his right shoulder toward a light source), by Philippe Quan-

tin. Dijon, Musée des B/A; Nicolson, *Caravaggesque Movement*.

783 St. Bernard of Clairvaux (at the gates of a monastery, greeted by monks), by Vicente Carducho. Louvre, Paris; Gowing, *Paintings*.

784 Christ embracing St. Bernard, by Francisco Ribalta, 1620-28. Prado, Madrid; Boone, *Baroque*; Gowing, *Biog. Dict.*; *Guide to Prado*; Random House, *Paintings* (p.208).

785 St. Bernard (kneeling, holding three nails, resting a plank and a lance against his shoulder), from a series of ten lunettes depicting the founders of religious orders by Paolo Domenico Finoglia in the Sala del Capitolo, c. 1626. Naples, S. Martino; RA, *Painting in Naples*.

786 St. Bernard of Clairvaux (holding a book and crosier), by Francisco de Zurbaran, 1641-58. Lima, Monastery of St. Camillus de Lellis; Gállego, *Zurbaran*.

787 The Holy Trinity, the Virgin and St. Bernard (Jesus squirts him with blood from the hole in his side, and the Virgin squirts him with milk from her breast), by Theodore Van Thulden, 1657. Zichem, St. Eustace; Hairs, *Sillage de Rubens*.

788 Vision of St. Bernard (as he prays to the Virgin, a ray of light shoots from her hand to his mouth), by Alonso Cano, 1658-60. Duque de Hernani, Madrid; Wethey, *Alonso Cano* (pl.133).

789 The miracle of St. Bernard in a garland of flowers, by Daniel Seghers and Erasmus Quellinus the Younger. Birmingham City Museum & Art Gallery; *Foreign Paintings*.

790 The vision of St. Bernard (kneeling, he greets the Holy Family), by Pierre Le Tellier. Rouen, Musée des B/A; *La Peinture d'Inspiration*.

791 St. Bernard of Clairvaux carrying the instruments of the passion, by Jerónimo Jacinto Espinosa. Vassar College Art Gallery, NY; *Paintings, 1300-1900*.

792 The apparition of the Virgin to St. Bernard of Clairvaux, by Luca Giordano, 1681-83. Columbia Museum of Art, MO; *Illus. Handbook*.

793 The Holy Trinity with SS. Bernard and Catherine of Siena, by Francesco Trevisani, 1684. Cetinale, Siena, Church of La Cetina; DiFederico, *Trevisani*.

794 The Antipope Victor IV submits to Innocent II in the presence of St. Bernard,

by Carlo Maratta. Gerusalemme, Santa Croce; Boudet, *Rome*.

795 St. Bernard's vision of the crucified Christ (he helps Christ down from the cross), by Odazzi, c. 1710. Rome, S. Bernardo alle Terme; Waterhouse, *Roman Baroque*.

796 Holy family with St. Bernard, oil on copper by Giuseppe Maria Crespi, 1735. Ascoli Piceno, Pinacoteca Comunale; Merriman, *Crespi*.

797 Apotheosis of St. Bernard (carried to heaven by angels), fresco by Giambattista Tiepolo. Milan, S. Ambrogio; Morassi, *Catalogue* (pl.149).

See also 1607, 1859, 2525, 3138, 4820

Bernard of Traversères, Dominican Inquisitor General in Catalonia, martyred by heretics

798 St. Bernard of Traversères, sitting at his desk, pointing to a book, fresco by Tomaso da Modena, 1352. Treviso, Domenican Seminary; Kaftal, *North East Italy*.

Bernardino of Fossa, Franciscan monk, d. 1503 (Nov. 27 or 29)

799 St. Bernardino of Fossa (halfview, hands clasped in prayer before a city landscape; crutches and a book propped under his left arm), att. to a follower of Cola dell'Amatrice, early 16th cent. Aquila, Museo Nazionale; Kaftal, *Central & So. Ital.*

Bernardino of Siena, Franciscan apostle and missionary, d. 1444, canon. 1450 (May 20)

800 Madonna and Child enthroned, with SS. John the Baptist and Bernardino of Siena, triptych by the School of Pietro Lorenzetti, c. 1328. Siena, San Pietro in Ovile; Edgell, *Sienese Painting*.

801 St. Bernardino of Siena preaching (men and women kneel before him, separated by a white cloth barrier; the nobles sit at right), by Neroccio di Landi. Siena, Palazzo Pubblico; Kaftal, *Tuscan*; Pope-Hennessy, *Sienese*; Van Os, *Sienese Altarpieces* (Vol.II, pl.30).

802 St. Bernardino of Siena (holding an open book and a blazing disc) by Pietro di Giovanni d'Ambrogio. Siena, Pinacoteca Nazionale; Christiansen, *Siena*; Edgell, *Sienese Paintings*.

803 St. Bernardino of Siena resuscitating a drowned child (he flies overhead as

the child lies in a barrel); a possessed woman is exorcised (near the deathbed of St. Bernardino) by Sano di Pietro. Private coll.; Christiansen, *Siena*.

804 St. Bernardino preaching before the church of San Francesco in the Piazza del Campo, by Sano di Pietro. Siena, Cathedral; Christiansen, *Siena*; Edgell, *Sienese Paintings*; Enciclopedia Bernardiniana, *Iconografia*.

805 St. Bernardino resuscitates a dead child (he pulls the child from a river), by Sano di Pietro. Coll. Lady Catherine Ashburnham, Ashburnham; Christiansen, *Siena*; Pope-Hennessy, *Sienese*.

806 St. Bernardino preaching in the Piazza del Campo in Siena, in the 1420's, by Sano di Pietro. Siena, Museo dell'Opera del Duomo; Christiansen, *Siena*; Enciclopedia Bernardiniana, *Iconografia*; Horizon, *Elizabethan* (p.19); Oxford, *Medieval Europe*.

807 Bernardino of Siena in left profile, wearing a hood, by school of Squarcione. Carrara Academy, Bergamo; Coulson, *Saints*.

808 St. Bernardino of Siena (holding an open book and his emblems), by Pietro di Giovanni, 1444. Siena, Chiesa dell'Osservanza; Enciclopedia Bernardiniana, *Iconografia*.

809 St. Bernardino of Siena preaching (holding a large disk inscribed with IHS) from a predella by Master of Fuecchio, c. 1444-50. Birmingham Museum of Art, AL; *Samuel H. Kress Coll.*; Shapley, *Samuel H. Kress*.

810 Ascension of St. Bernardino of Siena (carried up to heaven on a gold cloth by two angels), by Giovanni di Pietro. Coll. Mr. and Mrs. Nereo Fioratti, NY; Christiansen, *Siena*.

811 St. Bernardino of Siena (holding an open book, with angels at his feet), by Sano di Pietro, c. 1450. Siena, Fine Arts Academy; Bosque, *Metsys*; Enciclopedia Bernardiniana, *Iconografia*.

812 St. Bernardino with Confraternity emblem, polychromed wooden statue by Lorenzo di Pietro, 15th cent. Florence, Museo Nazionale; McGraw, *Encyclo.* (Vol.IV, pl.401).

813 St. Bernardino, holding up a blazing disc with IHS, by follower of Lorenzo Vecchietta, 1450-1500. Walker Art Museum, Bowdoin College, Brunswick ME; Herald, *Ren. Dress*; Shapley, *Samuel H. Kress*.

814 St. Bernardino of Siena (pointing up; above, two angels hang a brocade drape behind him), by Benozzo Gozzoli, c. 1452. Montefalco, S. Francesco; Enciclopedia Bernardiniana, *Iconografia* (fig.45).

815 St. Bernardino of Siena flanked by SS. Louis of Toulouse and Clare, triptych by Giovanni da Gaeta, 1456. Pesaro, Museo Civico; Enciclopedia Bernardiniana, *Iconografia* (fig.62).

816 St. Bernardino of Siena leads a procession to the pagan fount (he carries a cross); destruction of the pagan fount; St. Bernardino preaches next to the destroyed fount, which has the cross erected in its place; predella panels from the Madonna della Misericordia altarpiece by Neri di Bicci, 1456. Arezzo, Pinacoteca Nazionale; Enciclopedia Bernardiniana, *Iconografia* (fig.62).

817 Madonna and Child, flanked by SS. Francis (with a donor) and Bernardino of Siena, by Benozzo Gozzoli, c. 1457. KM, Vienna; Enciclopedia Bernardiniana, *Iconografia* (fig.40).

818 Madonna and Child between Saints Jerome and Bernardino of Siena, with six angels, by Sano di Pietro, 1406-81. Fogg Art Museum, Cambridge MA.

819 St. Bernardino curing a paralyzed woman (she sits on the floor, hands clasped in prayer, while he cures her; above, a man and a woman hand the afflicted woman down a flight of steps), fresco by P. A. Mezzastris. Montefalco, S. Francesco; Kaftal, *Central & So. Ital.*

820 St. Bernardino meets Pope Celestine V (on his way to Apuila, he shakes hands with the pope, standing between the mountains with two monks), fresco by P. A. Mezzastris. Montefalco, S. Francesco; Kaftal, *Central & So. Ital.*

821 St. Bernardino of Siena (holding a panel with the confraternity emblem), fresco by Pietro di Giovanni, c. 1460. Siena, Palazzo Pubblico; Enciclopedia Bernardiniana, *Iconografia* (Tav.VIII).

822 St. Bernardino restoring a child to life (he appears in upper left corner as a man pulls a child from a sewer), by Matteo di Giovanni. Coll. Suida-Manning; Christiansen, *Siena*.

823 Miracle of St. Bernardino of Siena: Bernardino cures a paralytic (he commands the boy to sit up from his pallet, outside a building) before family members, panel by Perugino, c. 1465.

Perugia, Galleria Nazionale dell'Umbria; Enciclopedia Bernardiniana, *Iconografia* (fig.188).

824 Miracle of St. Bernardino of Siena: recovery of the daughter of Giovanni Antonio da Rieto (Bernardino and monks kneel before the girl, who sits up from the floor, to the astonishment of onlookers), panel by Perugino, c. 1465. Perugia, Galleria Nazionale; Enciclopedia Bernardiniana, *Iconografia* (fig.187).

825 Miracles of St. Bernardino of Siena: Bernardino releases a prisoner (from a cave, while the guards stand in a group a distance away); Bernardino cures a blind man (who kneels in a piazza before a building), panels by Perugino, c. 1465. Perugia, Galleria Nazionale; Enciclopedia Bernardiniana, *Iconografia* (fig.189–90).

826 Retable of the Angel and St. Bernardino of Siena (holding a sword) by Jaime Huguet, 1466. Barcelona Cathedral; Book of Art, *German & Spanish*.

827 Saint Bernardino preaching (his right hand pointing to the IHS, his left hand holding an open book), fresco by Jaime Huguet, 1468. Barcelona Cathedral; Lassaigne, *Spanish*.

828 SS. Bernardino (holding a large disc and a book) and Catherine of Siena, by Carlo Crivelli. Worcester Art Museum, MA; Zampetti, *Crivelli*.

829 St. Bernardino of Siena (pointing at a hanging IHS disc, with tiny kneeling donors in lower right), by Carlo Crivelli. Louvre, Paris; Zampetti, *Crivelli*.

830 St. Bernardino of Siena and two donors (at right, he kneels at an altar and an angel descends with a blazing disc inscribed with IHS; at left, a male and female donor kneel at their prayer benches), by an unknown Provencal painter, c. 1470. Grobet-Labadié Museum, Marseille; Laclotte, *L'Ecole d'Avignon*.

831 St. Bernardino of Siena holding up the placard of the Holy Name of Jesus (IHS) with kneeling pilgrims at his feet, woodcut, northern Italian, 1470–80. NGA, Wash. D. C.; Wroth, *Images of Penance*.

832 St. Bernardino preaching (before a large crowd in a piazza), by Lorenzo Vecchietta or Benvenuto di Giovanni. Walker Art Gallery, Liverpool; Berenson, *Ital. Painters*; Pope-Hennessy, *Sienese*.

833 Scenes from the life of St. Bernar-

dino of Siena: he persuades his mother to give their last loaf of bread to beggars; he instructs his playmates on Christian virtues; he agrees to organize the hospital during the plague, and is given the keys; he cares for the sick and buries the dead; the pope permits him to use the monogram of Jesus; frescoes by Gian Giacomo da Lodi, 1477. Lodi, S. Francesco; Kaftal, *North West Italy*.

834 St. Bernardino in glory (flanked by two saints, about to be crowned by angels, as Jesus looks on from above), fresco by Pintoricchio. Rome, Santa Maria in Ara Coeli; Lavin, *Narrative*.

835 A miracle of San Bernardino (as he prays over a woman's sickbed, a man is beaten by several others outside the house), by Fiorenzo di Lorenzo. Perugia, Pinacoteca Vannucci; Herald, *Ren. Dress*.

836 The funeral of Saint Bernardino, fresco from the cycle "The Life of St. Bernardino" by Pinturicchio. Rome, Santa Maria, Ara Coeli; Berenson, *Ital. Painters*; Lavin, *Narrative*; New Int'l Illus. *Encyclo.*

837 St. Bernardino of Siena (in a stone niche, holding a book and IHS disc), predella from the "Altar of the Coronation of the Virgin" by Carlo Crivelli, 1493. Esztergom Christian Museum; *Christian Art in Hungary*.

838 The sermon of St. Bernardino, pen and watercolor drawing by Ventura Salimbeni. Rome, Gabinetto Nazionale; Book of Art, *Ital. to 1850*.

839 St. Bernardino of Siena (one-quarter view, holding his IHS), att. to Quentin Metsys. Feltre, Museo Civico; Bosque, *Metsys*.

840 St. Bernardino of Siena (one-quarter view, holding his IHS), by Quentin Metsys. Madrid, Monastery of Descalzes Reales; Bosque, *Metsys*.

841 Virgin and Child (under a green canopy) with Anthony Abbot (leaning on a crutch with a bell), Bernardino of Siena and other saints, by Lorenzo Lotto, 1521. Bergamo, S. Bernardino; Burckhardt, *Altarpiece*.

842 Immaculate Conception (overhead) with St. Bernardino, by Dosso and Battista Dossi. Formerly Gemäldegalerie, Dresden; Gibbons, *Dossi*.

843 St. Bernardino of Siena (center), three miters at his feet representing the bishoprics he refused, with SS. Jerome,

Bertin 42

Joseph, Francis, and Nicholas of Bari, with Virgin and Child, SS. Catherine and Clara in the clouds, by Moretto da Brescia. Nat'l Gallery, London; Poynter, *Nat'l Gallery*.

844 St. Bernardino of Siena preaching (to people sitting on benches in a room), by Domenico Beccafumi. Louvre, Paris; Gowing, *Paintings*.

845 St. Bernardino (three miters at his feet, holding a staff with IHS at the end), by El Greco, c. 1603. Greco Museum, Toledo; Gudiol, *El Greco*.

846 Saint Bernardino of Siena, with St. Francis of Assisi, kneeling in prayer before the statue of the Madonna of Loreto, by Guercino, c. 1618. Cento, Pinacoteca e Galleria d'Arte Moderna; *Age of Correggio*.

847 St. Bernardino of Siena in Milan (curing his cousin Tobia Tolomei in her sickbed), etching by Bernardino Capitelli. Illus. Bartsch; *Ital. Masters of the 17th Cent.* (Vol.45).

848 St. Bernardino of Siena reviving a child (who is held by his mother; in the background, a wild bull is running loose, chasing people in the street), etching by Bernardino Capitelli. Illus. Bartsch; *Ital. Masters of the 17th Cent.* (Vol.45).

849 St. Bernardino in ecstasy (rising to heaven on a cloud with angels) by Giuseppe Maria Crespi, 1710. Bologna, Pinacoteca Nazionale; Merriman, *Crespi*.

See also 270, 360, 376, 1466, 1733, 2148, 3112, 3225, 3417, 3782, 3826

Bertin or Bertinus, missionary, abbot, d. 709 (Sept. 5)

850 St. Bertinus and his (two) companions, from "Vie de Saints Bertin, Silvin et Winnoc," ms.107, fo.6v, c. 1000. Boulogne Library; Porcher, *Medieval French Min.* (pl.VI).

851 The soul of St. Bertin borne to heaven (over a roof, two angels carry a tiny man in a white napkin), by Simon Marmion, 1454–59. Nat'l Gallery, London; Batselier, *Benedict* (p.304); Poynter, *Nat'l Gallery*.

852 St. Bertin, conversing with a bishop and tempted by a woman with a cloven hoof, from St. Bertin altarpiece by Simon Marmion, c. 1455. Picture Gallery, Berlin; Batselier, *Benedict* (p.308); Larousse, *Ren. & Baroque*; Redslob, *Berlin*.

853 The life of St. Bertinus, from wings of the St. Omer Retable by Simon Marmion, c. 1459. Picture Gallery, Berlin; *Catalogue*; Gaunt, *Pictorial Art*; *Masterworks*; Redslob, *Berlin*; Snyder, *Northern Ren.*

854 Panels of the treasure of St. Bertin by Lancelot Blondeel. Dijon, Musée des B/A; *Benedict* (p.305).

Biagio *see* **Blaise**

Bibiana or Viviana, Roman martyr; killed with dagger; mart. 363 (Dec. 2)

855 Saint Bibiana (holding palm leaves), marble sculpture by Gianlorenzo Bernini, 1624–26. Rome, S. Bibiana; Held, *17th & 18th Cent.*; McGraw, *Encyclo.* (Vol.II, pl.272).

856 St. Bibiana (leaning on a column), bronze statuette by Gianlorenzo Bernini, 1626. NGA, Washington DC.

Blaise or Biagio, bishop of Sebaste, patron of wild animals; beheaded; mart. 287 or 316 (Feb. 3)

857 St. Blaise in prison (a woman brings him a pig head and a candle made out of its fat), fresco by the Umbrian School, 14th cent. Montefalco, S. Chiara; Kaftal, *Central & So. Ital.*

858 Madonna of Humility, flanked by St. Blaise and possibly St. Helena, triptych att. to Lorenzo Veneziano, 1350–1400. Dienst Verspreide Rijkscollecties, The Hague; Dunkerton, *Giotto to Dürer*.

859 Madonna and Child enthroned, flanked by SS. Michael the Archangel and John the Evangelist at left, and SS. Blaise and Peter at right, triptych by Master of Benabbio, 1350–1400. Bob Jones Univ. Art Gallery, Greenville, SC; Pepper, *Ital. Paintings*.

860 Scenes from the life of St. Blaise: he orders a wolf to bring back a poor woman's pig, which it has stolen; the Roman Governor Agricolus orders soldiers to seize him; he is beaten with iron rods; predella panels by A. Nuzi. Bergamo, Market (Lorenzelli); Kaftal, *Tuscan.*

861 St. Blaise (enthroned, holding a crosier and a curry comb), by Rossello di Jacopo Franchi. Florence, Cathedral; Kaftal, *Tuscan.*

862 St. Blaise is brought food in prison (the grateful woman whose pig he saved brings him its head and a candle made

from its fat), by the School of Orcagna. Coll. Acton, Florence; Kaftal, *Tuscan*.

863 St. Blaise saves a poor woman's pig (she begs him to help her, and he sends the wolf back to the woman, with the pig in its mouth), predella panel by Sano di Pietro. Siena, Gallery; Kaftal, *Tuscan*.

864 St. Blaise visited by wild animals, while hiding in a cave during the persecution of Domitian, fresco by Giacomo Jaquerio and assistants. Buttigliera Alta, S. Antonio di Ranverso; Kaftal, *North West Italy*.

865 Scenes from the life of St. Blaise: he is thrown into a lake with a millstone tied around his neck; but he is miraculously saved while his persecutors drown; St. Blaise is beheaded (with a sword); frescoes by the School of the Friuli, 15th cent. Cividale, Museo Cristiano; Kaftal, *North East Italy*.

866 Scenes from the life of St. Blaise: an angel appears to him, foretelling his martyrdom; St. Blaise resuscitates a boy who choked on a fish bone; Blaise apprehended by huntsmen; Blaise brought before the prefect; St. Blaise is tortured with curry combs; women collect his blood, frescoes by the School of the Friuli, 15th cent. Cividale, Museo Cristiano; Kaftal, *North East Italy*.

867 St. Blaise (seated, in bishop's robes, holding a book and a curry comb), detached fresco by the School of the Friuli, 15th cent. Cividale, Museo Cristiano; Kaftal, *North East Italy*.

868 St. Blaise holding an iron comb, by anon. 15th cent. Roman painter. Crocker Art Gallery, Sacramento CA; Ferguson, *Signs*; Shapley, *15th–16th Cent.*

869 St. Blaise with a millstone around his neck (he kneels on the water, unharmed, while his executioners drown), by Giovanni di Antonio da Pesaro. Formerly Volterra Gallery, Florence; Kaftal, *Central & So. Ital.*

870 Torture of St. Blaise (he is hung by the hands, suspended from two posts, while torturers scrape him with curry combs), by Giovanni di Antonio da Pesaro. Palazzo Venezia, Rome; Kaftal, *Central & So. Ital.*

871 Martyrdom of St. Biagio (tied to a pillar, punctured by men holding curry combs), by Lorenzo Vecchietta, 1457-60. Pienza, Cathedral Museum; Lloyd, *1773 Milestones* (p.93).

872 Spedaletto Altarpiece; Virgin and Child enthroned with SS. Blaise, Florian, Nicholas of Bari, and John the Baptist, by Vecchietta. Pienza, Cathedral; Van Os, *Sienese Altarpieces* (Vol.II, pl.209).

873 St. Blaise in bishop's robes and crosier, from triptych by Hans Memling. Dom, Lubeck; Coulson, *Saints*.

874 Saints Florus and Laurus, Blaise, and Spiridonius, icon of 15th or early 16th cent. Hermitage, St. Petersburg; Knopf, *The Icon* (p.302).

875 Virgin and Child with St. Blaise (in bishop's robes) and St. Jerome (holding a book and a pen); the saints stand under trees, by Domenico Sursnicus (or Firgnicus) of the Lake of Lugano, 1520. Ravecchia (near Bellinzona), Church of San Biagio; Deuchler, *Swiss Paintings*.

876 St. Blaise (his hand on a child's head), by Francisco de Zurbaran, 1641-58. Bolullos de la Mitacion Parish Church; Gállego, *Zurbaran*.

877 St. Blaise with the portraits of a young woman and man, by Giambattista Tiepolo. Correr Museum, Venice; Morassi, *Catalogue* (pl.177).

878 Martyrdom of St. Blaise (he is tied to a post, while he looks up at Jesus and angels descending with a crown and a palm), chalk drawing by an unknown artist, 19th cent. Crocker Art Gallery, Sacramento CA; Bentley, *Calendar*.

See also 4089

Bonaventure or Bonaventura, minister general of Franciscan Order, doctor of the church, bishop of Albano and cardinal, d. 1274, canon. 1482 (July 14)

879 St. Bonaventure (an angel crowns him with a flower wreath), fresco by Ferrer Bassa, early 14th cent. Pedralbes Convent; Lassaigne, *Spanish*.

880 St. Bonaventure (reading, wearing cardinal's robes), fresco by Benozzo Gozzoli. Montefalco, S. Francesco; Kaftal, *Tuscan*.

881 St. Bonaventure in a fresco by Fra Angelico, in the Chapel of Nicholas V, c. 1450. Vatican; Evans, *Flowering of M.A.*

882 St. Bonaventura (in a cardinal's robe, pointing to a small crucifix), by Carlo Crivelli. Picture Gallery, Berlin; Zampetti, *Crivelli*.

883 Saints Clare (in nun's habit, holding a reliquary) and Bonaventura (in Cardinal's vestments, reading a book), panel from a polyptych formerly in S. Maria delle Grazie, Bergamo, painted by

Vincenzo Foppa, c. 1481. Brera, Milan; McGraw, *Encyclo.* (Vol.V, pl.359).

884 St. Bonaventura wearing a cope and holding an open book, panel portrait by Vittore Crivelli, c. 1481-1501. Rijksmuseum, Amsterdam; *Catalogue.*

885 St. Bonaventura (in an ecclesiastical cope, dangling a cardinal's hat) and St. John the Baptist (draped in a brocaded cloak) with donor in lower right corner, by Vittorio Crivelli, 1489. Philadelphia Museum of Art, PA.

886 St. Bonaventura holding an open book and a family tree, from polyptych by Vittore Crivelli, c. 1489. Fitzwilliam Museum, Cambridge; Catalogue, *Italian.*

887 St. Bonaventura (in a stone niche, reading a book), predella for the "Altar of the Coronation of the Virgin" by Carlo Crivelli, 1493. Esztergom Christian Museum; *Christian Art in Hungary.*

888 St. Bonaventura (standing in bishop's robes and reading), by Marco d'Oggiono. Hearst Coll., St. Simeon CA; Sedini, *Marco d'Oggiono* (p.74).

889 St. Bonaventura dressed as a cardinal, named with gold letters in his halo, in "The Disputa" fresco by Raphael, stanza della Segnatura. Vatican Palace; Ettlinger, *Raphael.*

890 Madonna in glory (holding the Child in the clouds) with SS. John the Baptist, Bonaventure (seated, center, in an ecclesiastical cope, holding a book) and Sebastian (at right, filled with arrows), by Francesco Naselli, c. 1550. Ferrara, Chiesa di S. Francesco; Frabetti, *Manieristi.*

891 SS. Bonaventura and Anthony of Padua, by Moretto da Brescia. Louvre, Paris; Gowing, *Paintings*; Larousse, *Ren. & Baroque.*

892 St. Bonaventura as a child healed by St. Francis (who holds the child in his arms as the parents kneel), by Francisco de Herrera the Elder. Louvre, Paris; *Baroque Paintings.*

893 St. Bonaventura receiving communion from an angel (as the priest says mass with his back to the miracle), by Francisco de Herrera the Elder. Louvre, Paris; *Baroque Paintings.*

894 Death of St. Bonaventura (prone on the table, holding a crucifix, in white, cardinal's hat at his feet, attended by monks and pope) by Francisco de Zurbaran, 1629. Louvre, Paris; Book of Art,

German & Spanish; Brion, *Louvre*; Coulson, *Saints*; Gállego, *Zurbaran*; Gowing, *Paintings*; Levey, *Giotto to Cézanne*; New Int'l Illus. *Encyclo.*

895 Visit of St. Thomas Aquinas to St. Bonaventura (St. Thomas shows him the crucifix in his study), by Francisco de Zurbaran, 1629 (destroyed 1945). Formerly Kaiser Frederick Museum, Berlin; Gállego, *Zurbaran*; *Masterworks* (fig.15).

896 St. Bonaventura praying at a table, as an angel looks on, by Francisco de Zurbaran, 1629-30. Picture Gallery, Dresden; *Old Masters*; Gállego, *Zurbaran.*

897 St. Bonaventure and the envoys of the Emperor Paleologus at the council of Lyons, by Francisco de Zurbaran, 1629-30. Louvre, Paris; Gállego, *Zurbaran*; Gowing, *Paintings*; McGraw, *Encyclo.* (Vol.IV, pl.478).

898 The communion of St. Bonaventura (as the priest looks on, Bonaventura is given communion by angels), by workshop of Van Dyck, c. 1628-32. Caen, Musée des B/A; Larsen, *Van Dyck* (pl.A 149).

899 St. Bonaventure received into the order of the Franciscans (he kneels before the congregation who sit on a bench, while two elders discuss the matter), by Franciscode Herrera the Elder. Prado, Madrid; Bentley, *Calendar*; Bob Jones Univ., *Baroque Painting*; New Int'l Illus. *Encyclo.*

900 St. Bonaventura (working at a table, as two monks speak in a doorway), by Francisco de Zurbaran, 1658-64. Madrid, San Francisco el Grande; Gállego, *Zurbaran.*

See also 1230

Boniface (Wynfrid), Benedictine archbishop of Mainz and Cologne; murdered by pagans, k.754 (June 5)

901 Funerary colored stone statue of St. Boniface, 1357. Mainz Cathedral; Batselier, *Benedict* (p.300).

902 St. Boniface (in bishop's robes, reading a book), linden wood sculpture, Rhenish, early 16th cent. M. H. de Young Memorial Museum, San Francisco CA; *European Works.*

903 Silver statue of St. Boniface, by 18th cent. silversmith. Fuldaer Domschatz, Augsberg; Coulson, *Saints.*

See also 4444

Boris and Gleb, sons of St. Vladimir of Kiev; killed by eldest brother's hirelings, k.1015 (July 24)

904 St. Boris and St. Gleb (both holding swords, both wearing cloaks draped over right shoulder and hanging straight down middle of front), by school of Vladimir-Suzdal, early 14th cent. State Russian Museum, St. Petersburg; Coulson, *Saints*; Knopf, *The Icon* (p.258); McGraw, *Russian*; New Int'l Illus. *Encyclo.* (see Icon).

905 Saints Boris and Gleb, with scenes from their lives, icon of the 14th cent. Kolomna, SS. Boris & Gleb; Knopf, *The Icon* (p.261).

Brandon or Brendan, Irish missionary, founded monasteries; crossed the Atlantic Ocean, d. 577 (May 16)

906 St. Brandon on an island growing on top of a fish; a mermaid coming to St. Brandon; St. Brandon coming to the earthly paradise; the devil taking one of St. Brandon's brothers; St. Brandon and his brothers riding on a fish (in their boat); St. Brandon meeting a dwarf; woodcuts by Anton Sorg from "The Wondrous Ocean Voyage of St. Brandon," Augsberg, c. 1476. The Illus. Bartsch; *German Book Illus.* (Vol.81, pp.127–29); O'Meara, *Voyage*.

907 The devil returning the brother of St. Brandon (to monks in a ship); St. Brandon entering a cloister; woodcuts by Anton Sorg from "The Legend of St. Brandon," Augsberg, 1478. The Illus. Bartsch; *German Book Illus.* (Vol.82, p.133); O'Meara, *Voyage*.

Brendan see Brandon

Brice or Britius, succeeded Martin as bishop of Tours, d. 444 (Nov. 13)

908 St. Brice (as a bishop) curing a newborn, by René Dudot, 1640–59. Rouen, Notre-Dame Cathedral; *La Peinture d'Inspiration*.

Bride see Brigid

Bridget of Sweden, founded Bridgettine order, mother of St. Catherine of Sweden, d. 1373, canon. 1391 (July 23)

909 St. Bridget of Sweden has a vision of the Nativity, by the Pisan School, 14th cent. Pisa, Museo Civico; Kaftal, *Tuscan*.

910 St. Bridget of Sweden (enthroned, writing in a book), walnut statue by an unknown artist of the Lower Rhenish School, c. 1500. Met Museum; Auchincloss, *J.P. Morgan*.

911 St. Bridget of Sweden (in a room with a small window, sitting and reading from a book on a stand), by an unknown artist. Statens Historiska Museer, Stockholm; Bentley, *Calendar*.

912 St. Bridget of Sweden (wearing a white veil, holding a book and a small cross), from a polyptych by Ludovico Brea, 1500. Monaco, Cathedral; Kaftal, *North West Italy*.

913 St. Anthony Abbot (with his pig), and St. Bridget of Sweden (holding a burning candle), altar panels by Domenico Beccafumi. York City Art Gallery; *Catalogue*.

914 St. Helen, St. Brigitte, and St. Elizabeth (all with coats of arms) woodcut by Hans Burgkmair. Strauss, *The Illus. Bartsch* (Vol.11, no.65).

915 St. Brigid in glory, ceiling fresco by Puccini, before 1700. Rome, S. Brigida; Waterhouse, *Roman Baroque*. *See also* 123, 4475

Brigid or Bride, founded monastery at Kildare, patron of poets, healers, and blacksmiths, d. 525 (Feb. 1)

916 St. Bridget (in a nun's habit; an angel carries her hands down as she holds out her stumps), from the "Boucicaut Hours" painted by the Boucicaut Master, ms.2,fo.42v. Jacquemart-André Museum, Paris; Meiss, *French Painting*.

917 Madonna and Child with St. Bridget (in nun's habit, holding two scrolls) and St. Michael (with his scales), triptych by Giovanni di Francesco, c. 1439. J. Paul Getty Museum, Malibu CA; *Catalogue*; *Western European*.

918 St. Brigid (carried over the water by two angels), by J. Duncan, 1913. NGS, Edinburgh; McGraw, *Encyclo.* (Vol.XII, pl.368).

919 St. Brigid in peasant dress and holding a staff, by Gabrielle Hayes, 1950's. Coulson, *Saints*.

Britius see Brice

Bruno, Archbishop of Cologne, founder of Carthusian order, son of St. Matilda, d. 1101, canon. 1623 (Oct. 6 & 11)

920 St. Bruno seated under a canopy,

from Flemish stained-glass window, 16th cent. Private coll.; Drake, *Saints and Emblems*.

921 The Carthusian Madonna with SS. Bruno and John the Baptist, woodcut by Albrecht Dürer, 1515. Strauss, *Woodcuts* (pl.177).

922 St. Bruno of Cologne closing a book, by Girolamo Marchesi, c. 1526. Walters Art Gallery, Baltimore; *Ital. Paintings* (Vol.II).

923 Vision of St. Bruno (he lay on the ground in the wilderness, looking up into the sky), by Pier Francesco Mola. Vatican Museums; Francia, *Vaticana*.

924 St. Bruno (looking over his left shoulder), by Anthony van Dyck, 1626-32. Private coll.; Larsen, *Van Dyck* (pl.662).

925 Saint Bruno (resting a foot on a sphere, his right index finger on his lips), from the retable of Portacoeli by Francisco Ribalta, 1627. Valencia, San Carlos Museum; Boone, *Baroque*; Lassaigne, *Spanish*; Lloyd, *1773 Milestones* (p.158).

926 St. Bruno surprised by Duke Roger of Calabria (while at the hunt, the Duke comes across Bruno praying in the forest, while his monks sleep), fresco by Daniele Crespi, 1629. Milan, Certosa di Garegnano; Fiorio, *Le Chiese di Milano*.

927 St. Bruno, holding an open book, surrounded by monks, by Stanzione, 1631. Naples, S. Martino; Murray, *Art & Artists*.

928 Saint Bruno, holding a crucifix and an open book, polychromed wooden statue by Gregorio Fernandez, 1634. Valladolid Museum; Held, *17th & 18th Cent.*

929 St. Bruno (standing in right profile, holding a crucifix in both hands), painted for Carthusian monastery at Jerez de la Frontera by Francisco de Zurbaran, 1637-39. Cadiz, Provincial Museum of Fine Arts; Gállego, *Zurbaran*; United Nations, *Dismembered Works*.

930 St. Bruno in ecstasy (kneeling on a cloud, arms outspread), from the dismembered high altar of the Carthusian Monastery at Jerez de la Frontera, by Francisco de Zurbaran. Cadiz, Provincial Museum of Fine Arts; United Nations, *Dismembered Works*.

931 St. Bruno in ecstasy (standing with a crucifix, as angels crown him with a flower wreath), by Francisco de Zurbaran, 1637-39. Cadiz, Provincial

Museum of Fine Arts; Gállego, *Zurbaran*.

932 St. Bruno (holding a skull and crucifix), by Francisco de Zurbaran, 1637-39. Cadiz, Provincial Museum of Fine Arts; Gállego, *Zurbaran*.

933 Ecstasy of St. Bruno (he is lying under a tree, visited by two cherubs), by Pier Francesco Mola. Doria Pamphili Palace, Rome; McGraw, *Encyclo.* (Vol.XII, pl.376).

934 Pope Urban II and St. Bruno, his confessor, by Francisco de Zurbaran, 1641-58. Seville, Museum of Fine Arts; Boudet, *Rome*; Gállego, *Zurbaran*.

935 St. Bruno (holding up a crucifix), by Francisco de Zurbaran, 1641-58. Convent of the Capuchin Nuns, Castellón de la Plana; Gállego, *Zurbaran*.

936 St. Bruno (standing, contemplating a skull), by Francisco de Zurbaran, 1641-58. Seville, Archbishop's Palace; Gállego, *Zurbaran*.

937 Death of St. Bruno (lying on a pallet, hands clasped) by Eustace Le Sueur, 1645-48. Louvre, Paris; Coulson, *Saints*; McGraw, *Dict.*; Mérot, *Le Sueur*; Murray, *Art & Artists*.

938 Plan of the Carthusian monastery, Paris, by Eustace Le Sueur, c. 1645-48. Louvre, Paris; Larousse, *Ren. & Baroque*.

939 St. Bruno (holding a crucifix, sitting at a rock with a book leaning against a skull), by Casper de Crayer. York City Art Gallery; *Catalogue*.

940 St. Bruno and his companions distribute their earthly goods to the poor; St. Bruno at prayer; St. Bruno says farewell to his family; scenes from the Life of St. Bruno series by Eustace Le Sueur, 1645-48. Louvre, Paris; Mérot, *Le Sueur*.

941 St. Bruno appearing to Count Roger (as the count sleeps under a canopy at the battlefield), by Eustace Le Sueur, 1645-48. Louvre, Paris; Gowing, *Paintings*; Mérot, *Le Sueur*.

942 St. Bruno attends a sermon given by Raymond Diocres, by Eustace Le Sueur, 1645-48. Louvre, Paris; Mérot, *Le Sueur*.

943 St. Bruno receives a message from the pope (as the envoy waits); St. Bruno at the feet of Pope Urban II (who leans forward from his chair); apotheosis of St. Bruno; scenes from the Life of St. Bruno series by Eustace Le Sueur, 1645-48. Louvre, Paris; Mérot, *Le Sueur*.

944 St. Bruno teaching theology (he teaches from a pulpit to many who sit and stand), by Eustace Le Sueur, 1645-48. Louvre, Paris; Mérot, *Le Sueur*.
945 St. Hugo gives the habit to St. Bruno; dream of St. Bruno (as angels descend); the arrival of St. Bruno at Grenoble; Pope Victor III approves the institution of the Carthusians; St. Bruno in his hermitage; scenes from the Life of St. Bruno series by Eustace Le Sueur, 1645-48. Louvre, Paris; Mérot, *Le Sueur*.
946 Pope Urban II offers the Archbishopric of Reggio to St. Bruno, by Eustace Le Sueur, mid-17th cent. Louvre, Paris; Brusher, *Popes thru the Ages*; Mérot, *Le Sueur*.
947 The vision of St. Bruno (Christ carrying his cross descends in the church), by Jacob Jordaens, c. 1660 (destroyed). Formerly Kaiser Friedrich Museum, Berlin; d'Hulst, *Jordaens*.
948 Vision of St. Bruno (angel carrying a shield appears to him as he prays, and points to the celestial light), by Adrien Sacquespée. Rouen, Musée des B/A; *La Peinture d'Inspiration*.
949 St. Bruno praying before a crucifix, by Roman School, 1650-1700. Christ Church, Oxford; Shaw, *Old Masters*.
950 St. Bruno interceding with Madonna for the suffering, ceiling fresco by Paolo de Matteis. Naples, San Martino; Yale Univ., *Taste* (fig.19).
951 St. Bruno praying on his knees (he leans his head against a crucifix, at a little prayer-bench; two monks look on in background), by studio of Jean Jouvenet. Lyon, Musée des B/A; Larousse, *Ren. & Baroque*; Schnapper, *Jouvenet*.
952 St. Bruno praying on his knees (he leans his head against a crucifix, at a little prayer-bench; two monks look on in background), by studio of Jean Jouvenet. Stockholm, Nat'l Museum; Schnapper, *Jouvenet*.
953 St. Bruno praying on his knees (he leans his head against a crucifix, while another monk sits next to him, reading; two others look on in background), by studio of Jean Jouvenet. Magnin Museum, Dijon; Schnapper, *Jouvenet*.
954 Saint Bruno (arms crossed, looking down), marble statue by Jean-Antoine Houdon, 1766. Rome, S. Maria degli Angeli; Held, *17th & 18th Cent*.
955 St. Bruno praying (leaning on his elbows against the floor, facing down), by D. A. de Sequeira, c. 1800. Lisbon, Museu Nacional de Arte Antiga; McGraw, *Encyclo.* (Vol.XIII, pl.149).

Burchard of Wurzburg, Bishop of Wurzburg, missionary to Germany, d. 754 (Oct. 14)
956 St. Burchard of Wurzburg, wooden statue by Tilman Riemenschneider, c. 1510. NGA, Wash. DC; Walker, *NGA*.

Caesarius, Bishop of Arles, d. 542 (Aug. 27)
957 Wooden reliquary portrait of St. Caesarius, containing his head, 12th cent. Horizon, *Middle Ages*.

Caius, Pope, uncle of St. Susan; decapitated, mart. 296 (Apr. 22)
958 St. Caius (standing in papal robes), by Lorenzo Monaco. Accademia, Florence; Kaftal, *Tuscan*.
959 Martyrdom of St. Caius (decapitated before a king and his army), by the Cionesque/Gerinesque Master, 1390's. Santa Barbara Museum of Art, CA; Eisenberg, *Monaco* (pl.232).
960 St. Caius (in ecclesiastical robes, with a crosier), by the Cionesque/Gerinesque Master, 1390's. Accademia, Florence; Eisenberg, *Monaco* (pl.229).
961 St. Caius as pope, from a panel of a triptych by Antonio Vivarini and Giovanni d'Alemagna, 1443. Venice, S. Zaccaria; Kaftal, *North East Italy*.

Cajetan or Gaetano da Thiene, founded "Theatines" order, d. 1547 (Aug. 7)
962 Saint Cajetan holding a baby, marble sculpture by Gianlorenzo Bernini. Rome, Santa Maria Maggiore; Coulson, *Saints*.
963 St. Cajetan (standing next to a pillar topped with angels holding a heart), sculpture by Ferdinand Maximilian Brokoff, 1709. Charles Bridge, Prague; Štech, *Baroque Sculpture*.
964 St. Cajetan comforting a dying man (in his bed), by Sebastiano Ricci, c. 1727. Brera, Milan; Daniels, *Ricci*.
965 Saints Gaetano (holding up a crucifix), Anthony Abbot and John the Baptist, by Giambattista Tiepolo. Poldi Pezzoli Museum, Milan; Morassi, *Catalogue* (pl.134).
966 The Holy Family with Saint Gaetano (they appear to him, surrounded

by clouds), by Giambattista Tiepolo. Accademia, Venice; Morassi, *Catalogue.*

967 Apotheosis of St. Gaetano of Thiene (his church is shown in lower left background), by Giambattista Tiepolo. Rampazzo Parish Church; Morassi, *Catalogue* (pl.184).

968 St. Cajetan (with a book and lily), by Giambattista Tiepolo. Rio de Janeiro, Museu Nacional de Belas Artes; Morassi, *Catalogue* (pl.174).

See also 188, 189

Calixtus I or Callistus, Pope; thrown into a well by a pagan mob; k. 222 (Oct. 14)
969 SS. Calixtus I and Catherine of Siena (holding a book and a lily), from a triptych by Vecchietta, 1461–62. Pienza, Cathedral; Kaftal, *Tuscan.*

970 St. Calixtus I standing in a niche, fresco by Sandro Botticelli, 1481. Vatican Museums; Brusher, *Popes*; Lightbown, *Botticelli.*

See also 3313

Callistus *see* **Calixtus I**

Calogerus or Calocerus, hermit, invoked against plague and hernia, d. 485 (July 18)
971 St. Calogerus removing an arrow from the hind's neck (it rests its front legs on his lap), from a triptych by Tommaso de Vigila, 1486. Palermo; Kaftal, *Central & So. Ital.*

Camille de Lellis, patron of hospitals and sick, founded Camilliens, d. 1614 (July 14 & 18)
972 Apotheosis of St. Camille de Lellis, by Subleyras. Amiens, Musée des B/A; *Subleyras.*

973 Christ descending from the cross to give His hand to St. Camille (He has freed His hands and is bending toward St. Camille, who leans into the arms of an angel; they are surrounded by cherubs), by Subleyras. Rieti, Church of the Crucifix; *Subleyras.*

974 St. Camille de Lellis saving a sick man (he carries the sick man on his shoulder), by Subleyras. Pushkin Museum, Moscow; *Subleyras.*

975 St. Camille de Lellis saving the sick from the flood of the Tibre in 1598 (he and his monks are carrying the sick from the hospital, where the waters are rising

nearly to their beds), by Subleyras, 1746. Rome, Museum of Rome; *Subleyras.*

Carloman, Benedictine Monk, son of King Charles Martel, 8th cent.
976 St. Carloman dons the Benedictine habit, by Francesco de Mura, 1731–41. Private coll., NY; Yale Univ., *Taste* (cat.34).

Carmelus, Bishop of Teruel
977 St. Carmelus, Bishop of Teruel (holding an open book and a pen, as the Virgin appears in upper right corner), by Francisco de Zurbaran, 1631–40. Madrid, Santa Bárbara; Gállego, *Zurbaran.*

Casilda of Burgos, bread changed to roses in her lap; d. 1126 (Apr. 9)
978 St. Casilda (in a red dress, holding roses), by Francisco de Zurbaran, 1631–40. Antonio Plandiura, Barcelona; Gállego, *Zurbaran.*

979 St. Casilda in blue and pink dress, holding a wreath of flowers, by Francisco de Zurbaran, c. 1640. Prado, Madrid; Gállego, *Zurbaran*; *Guide to Prado*; *Newsweek, Prado*; Praeger, *Great Galleries.*

Cassian (John Cassian), Bishop of Sabonia; stabbed to death with penknives by his pupils, 4th cent. (Aug. 13)
980 St. Cassian, standing, holding a small cross, mosaic, 12th–13th cent. Venice, S. Marco; Kaftal, *North East Italy.*

981 San Cassiano Altarpiece (saints pray to Madonna and Child) by Antonello da Messina, 1476. KM, Vienna; New Int'l Illus. *Encyclo.*

Castorius
982 Crucifixion with Saints Coloman, Castorius, Quirinus, and Christogon (painted in brown tints), oil on linden panel by the Master of the Tegernsee Tabula Magna, 1440–60. Alte Pinakothek, Munich; Puppi, *Torment.*

Cataldus or Cataldo, Irish monk, bishop of Taranto, d. 361 (May 10)
983 St. Cataldus (in bishop's robes, giving a blessing, with his name in background), mosaic from the 12th cent. Palermo, Cappella Palatina; Kaftal, *Central & So. Ital.*

Caterine Benincasa *see* **Catherine of Siena**

Catherine of Alexandria, one of the fourteen Holy Helpers, patron of Christian philosophers; decapitated, mart. 307 (Nov. 25)

984 Saint Catherine (with a shield, in Byzantine dress), with scenes from her martyrdom, icon, early 13th cent. Sinai, Monastery of St. Catherine; Manafis, *Sinai.*

985 Scenes from the life of St. Catherine of Alexandria (given a holy picture; mystical marriage with Christ; martyrdom and execution), from ms.A.25, fo.1. Padua, Chapter Library of the Cathedral; Salmi, *Ital. Miniatures.*

986 St. Catherine in brocade cloak, holding a palm, by Simone Martini, c. 1320. National Gallery of Canada; Hubbard, *Canadian Collections.*

987 St. Catherine (half-view, holding a palm), by Pietro Lorenzetti. Met Museum; DeWald, *Lorenzetti*; Edgell, *Sienese Painting.*

988 St. Catherine of Alexandria (half view, looking to her right), by Ambrogio Lorenzetti. Virginia Museum of Fine Arts; *European Art.*

989 Mystical marriage of Catherine of Alexandria to adult Christ by Barra da Siena, c. 1340. Boston Museum of Fine Arts, MA; Edgell, *Sienese Painting*; Kaftal, *Tuscan*; Meiss, *Painting in Florence* (pl.107).

990 St. Catherine of Alexandria wearing a crown, from a dismembered altarpiece att. to Niccolo di Segna, c. 1340. Atlanta Art Assoc. Galleries, Atlanta GA; Shapley, *Samuel H. Kress.*

991 St. Catherine of Alexandria (standing between two wheels holding a book and a palm, with a kneeling donor), by an assistant of Bernardo Daddi. Florence, S. Maria del Fiore; Offner, *Corpus* (Sect.III, Vol.V, pl.XVIII).

992 Martyrdom of St. Catherine (an angel cuts into one of the wheels, while executioners fall to the ground), by Vitale da Bologna. Bologna, S. Salvatore; Gnudi, *Vitale.*

993 Martyrdom of St. Catherine (kneeling by two wheels as executioner raises his sword and angel descends), by Giovanni da Milano, 1346–69. Prato, Museo Comunale; Book of Art, *Ital. to 1850*; Lloyd, *1773 Milestones* (p.80).

994 St. Catherine of Alexandria freed from the wheel (people are blown away as angel strikes burning wheel with a sword), by Jacopino di Francesco, c. 1360. N. Carolina Museum of Art, Raleigh; Shapley, *Samuel H. Kress.*

995 The beheading of St. Catherine of Alexandria (executioner, still holding the scabbard, is about to strike, while she bends over, her crown falling off), by Jacopino di Francesco, c. 1360. N. Carolina Museum of Art, Raleigh; Shapley, *Samuel H. Kress.*

996 Catherine of Alexandria (holding a small wheel) from a dismembered polyptych by Giusto de'Menabuoi, c. 1363. Univ. of Georgia, Athens GA; Shapley, *Samuel H. Kress.*

997 Crucifixion with Martyrdom of St. Catherine of Alexandria (she kneels between two wheels while an angel smites a wheel; next to the Crucifixion and decapitation of an unidentified saint), panel by the Bolognese School, 1350–1400. Tours, Musée; Kaftal, *North East Italy.*

998 Mystic marriage of St. Catherine of Alexandria (to an adult Jesus, as John the Baptist looks on), by the Dijon Master. Ringling Museum of Art, Sarasota FL; Meiss, *Painting in Florence* (pl.105).

999 Mystic marriage of St. Catherine of Alexandria (under draperies that have been pulled back), by a follower of the St. Cecilia Master. Hearst Coll.; Meiss, *Painting in Florence* (pl.100).

1000 St. Catherine of Alexandria (seated, with the donor Noferi di Giovanni di Bartolommeo Bischeri) with scenes from her life, by Giovanni del Biondo, 1370. Florence, Museo dell'Opera del Duomo: Offner, *Corpus* (Sect.IV, Vol.IV, part I, pl.XXIV).

1001 The martyrdom of St. Catherine (kneeling between twin broken wheels), by Altichiero. Padua, S. Giorgio; Berenson, *Ital. Painters.*

1002 Mystical marriage of St. Catherine to adult Christ, small kneeling donatrice at her feet, by Giovanni del Biondo, c. 1380. Allentown Art Museum, PA; Allentown, *Samuel H. Kress*; Shapley, *Samuel H. Kress.*

1003 St. Catherine (holding a book and a palm) and an anonymous bishop saint, by Angelo Puccinelli, c. 1380. J. Paul Getty Museum, Malibu CA; Fredericksen, *Catalogue.*

1004 Catherine of Alexandria (leaning on her wheel, holding a palm, with coats

of arms in three corners), retable by Martinus de Vilanova, 1387. Sinai, Monastery of St. Catherine; Manafis, *Sinai.*

1005 Mystical marriage of St. Catherine (as two other saints look on) by Michelino da Besozza, 1388–1450. Siena, Pinacoteca Nazionale; New Int'l Illus. *Encyclo.* (see Sienese).

1006 St. Catherine of Alexandria (standing with a book and palm), by the Cionesque/Gerinesque Master, 1390's. Accademia, Florence; Eisenberg, *Monaco* (pl.227).

1007 The beheading of St. Catherine of Alexandria (her head is already on the ground before the executioner strikes), fragment of a predella by Lorenzo Monaco or Cionesque/Gerinesque Master, c. 1390–91. Picture Gallery, Berlin; *Catalogue*; Eisenberg, *Monaco* (pl.230).

1008 Boucicaut venerating St. Catherine of Alexandria (angel holds armorial shield over his head) from "Hours of Marechal de Boucicaut" fo. 38v. Jacquemart-André Museum, Paris; Panofsky, *Early Nether.*

1009 Martyrdom of St. Catherine from the circle of the Master of the Rajhrad Altarpiece, 15th cent. Moravian Gallery, Brno; Kutal, *Gothic Art.*

1010 St. Catherine of Alexandria (with a crown), polychrome limestone statue, 1400. Jihlava, St. James; Kutal, *Gothic Art.*

1011 The marshal of France in prayer before St. Catherine (an angel holds his coat of arms above his head), from the "Boucicaut Hours" by the Boucicaut Master, ms.2,fo.38v. Jacquemart-André Museum, Paris; Meiss, *French Painting.*

1012 Two scenes from the legend of Catherine of Alexandria (at left, she looks in a hand-mirror; at right, she recognizes her betrothed in the portrait of the Christ Child), by Master of Bát I, c. 1410–20. Esztergom Christian Museum; *Christian Art in Hungary.*

1013 Scenes from the life of St. Catherine: Catherine prays and falls asleep before the image of the Virgin and Child; she is baptized by the hermit; Catherine is led to prison, while the emperor summons the philosophers; Catherine argues with and converts the philosophers; the emperor sends the philosophers to prison; frescoes att. to Bertolino dei Grossi, 1417–22. Parma, Cathedral; Kaftal, *North East Italy.*

1014 Annunciation and the Mystic Marriage of St. Catherine (as other saints watch from behind a railing), by Master of Heiligenkreuz. KM, Vienna; Larousse, *Painters.*

1015 Mystical marriage of St. Catherine of Alexandria (with adult Christ) by Giovanni dal Ponte, c. 1421. Budapest, Museum of Fine Arts; Garas, *Musée.*

1016 Mystical marriage of St. Catherine (at left, to an adult Christ, seen through a window); St. Catherine tied to a pillar and scourged with iron rods, fresco by Pietro Coleberti, 1430. Rocca Antica, Parish Church; Kaftal, *Central & So. Ital.*

1017 St. Catherine refuses to worship idols (in front of witnesses, she points up to an idol on a pedestal, while looking at a man next to her who has clasped his hands); torture of St. Catherine (as she stands between two wheels that are being turned by the executioners, an angel descends and smites one of the wheels with a sword; the emperor looks on from a balcony); martyrdom of St. Catherine (in a rocky, mountainous landscape with white stone, a group of soldiers with large shields watch as Catherine kneels before the executioner who is about to strike off her head; frescoes by Masolino da Panicale, 1425. Rome, S. Clemente.

1018 St. Catherine and the philosophers (standing up, she disputes with them; in background, she stands before the pyre as they burn), fresco by Masolino, 1420–30. Rome, S. Clemente; McGraw, *Encyclo.* (Vol.IX, pl.378).

1019 St. Catherine of Alexandria wearing a red scarf (with a bleeding gash in her neck), by the Lombard School, 15th cent. Nancy, Musée des B/A; Pétry, *Musée.*

1020 SS. Matthew, Catherine of Alexandria (standing over a broken wheel) and John the Evangelist (with a haloed brown bird at his feet), by Stephan Lochner, c. 1442. Nat'l Gallery, London; Dunkerton, *Giotto to Dürer*; Levey, *Nat'l Gallery.*

1021 St. Catherine of Alexandria in glory (enthroned with an open book, surrounded by angels), by Pietro di Giovanni d'Ambrogio, 1444. Jacquemart-André Museum, Paris; Pope-Hennessy, *Sienese.*

1022 St. Catherine holding a sword, crown at her feet, by follower of Rogier Van der Weyden. Picture Gallery, Vienna; Panofsky, *Early Netherl.*

1023 St. Catherine of Alexandria and the emperor Maximian (she is escorted from prison, as the emperor exhorts his philosophers), wall mural by an unknown artist. Embrun, Eglise des Cordeliers; *Peintures Murales*.

1024 St. Catherine of Alexandria leaning a book against a wheel, by Pietro Lorenzetti. NGA, Washington DC; Ferguson, *Signs*; Shapley, *Samuel H. Kress*.

1025 Martyrdom of St. Catherine (she kneels beside the wheel, which is demolished by an angel, and executioners are stricken to the ground), illum. by Jean Foucquet from the Hours of Etienne Chevalier, c. 1453. Condé Museum, Chantilly; Fouquet, *Hours*.

1026 Three scenes from the life of Catherine of Alexandria: the apparition of the Virgin and Child; the baptism; the mystic marriage, triptych from Swabia, mid-15th cent. Walters Art Gallery, Baltimore MD.

1027 Mystic marriage of St. Catherine, painted and gilded poplar sculpture, from the so-called Behaim Altarpiece, anon. c. 1470. Germanisches Nationalmuseum, Nuremberg; Met Museum, *Gothic Art*.

1028 SS. Catherine (with an oblong wheel) and Jerome (holding an open book, with his other hand pointing up), by Carlo Crivelli. Philbrook Art Center, Tulsa OK; Zampetti, *Crivelli*.

1029 St. Catherine of Alexandria disputing with the grammarians before Maxentius, by Giorlamo da Cremona, initial M from a choir book, north Italian, c. 1470. V & A, London; Burlington, *Illum. MS*.

1030 St. Catherine of Alexandria in a sideless surcoat, standing before Bruges and reading a book, by Master of St. Lucy Legend, 1470–90. Philadelphia Museum of Art, PA.

1031 Mystic marriage of St. Catherine (sitting, with her left hand on a book, as baby Jesus puts ring on right finger), attended by other women, by Hans Memling, c. 1475. Louvre, Paris; Brion, *Louvre*.

1032 Mystic marriage of St. Catherine (as SS. John the Evangelist, John the Baptist and Barbara look on), by Hans Memling, 1479. St. John's Hospital, Bruges; Coulson, *Saints*; *Eight Centuries*; Gaunt, *Pictorial Art*; *Int'l Dict. of Art*.

1033 St. Catherine of Alexandria (standing under a canopy, her foot atop

Maxentius), by Master of the First Prayer Book of Maximilian, from the Hours of William Lord Hastings, add. ms.54782, fo.68v. BM, London; BL, *Ren. Painting in MS*.

1034 Mystic marriage of St. Catherine (in a rose garden), by Master of St. Lucy Legend. Detroit Inst. of Art, MI; *Treasures* (p.112).

1035 Mystic marriage of St. Catherine (the Virgin holds Catherine's hand, after the Child has put a ring on it), by the studio of Paolo Veronese. Dulwich College Picture Gallery, London; Murray, *Catalogue*.

1036 Scenes from the life of St. Catherine; Catherine converts the Empress and the general Porphiry who visit her in prison; the angels destroy the wheel before Catherine is tied to it; the empress's breasts are sheared off and she is beheaded; Catherine is beheaded and carried by angels to Sinai; frescoes by Andrea da Bologna. San Francesco, Assisi; Kaftal, *North East Italy*.

1037 Martyrdom of St. Catherine of Alexandria (at right, the wheel is bursting apart; at center, the executioner is sheathing his sword and a man holds up her head), by Luca Signorelli. Sterling and Francine Clark Art Inst., Williamstown MA; Christiansen, *Siena*.

1038 Mystical marriage of St. Catherine (wearing a sideless surcoat printed with wagon wheels) among many virgin saints, by Master of the St. Lucy Legend, 1480–98. Koninklijke Museum, Brussels; Miegroet, *David*.

1039 St. Catherine (holding a sword and a wheel by the spoke), att. to Friedrich Pacher. M. H. de Young Memorial Museum, San Francisco CA; *European Works*.

1040 St. Catherine (sitting with a wheel on her lap, holding a sword), by Master of Frankfort. Prado, Madrid; *Peinture Flamande* (b/w pl.180).

1041 St. Catherine's ordeal of the wheels (she is tied, stripped to the waist, with her hands above her head; an angel smites the wheels with a sword, and they break, felling the executioners), by Juan de la Abadia, before 1491. Helen Foresman Spencer Museum of Art, Lawrence KS; *Handbook*.

1042 St. Catherine, polychromed wooden statue, Swabia, Germany, 1490–1500. Philadelphia Museum of Art, PA.

1043 The marriage of St. Catherine of Alexandria (standing baby Christ puts ring on her finger, while Catherine of Siena holds the Virgin's hand), by Bergognone, c. 1490. Nat'l Gallery, London; Dunkerton, *Giotto to Dürer*; Poynter, *Nat'l Gallery*.

1044 The marriage of St. Catherine to infant Christ in a room before a table, panel from Church of St. Catherine, Nurnberg, by Wilhelm Pleydenwurff. Germanisches Nationalmuseum, Nuremberg; McGraw, *Dict.*

1045 Virgin and Child sitting inside a garden building, with St. Catherine seated behind them, and other saints taking a walk in the garden, by Paolo da San Leocadio, c. 1490–1500. Nat'l Gallery, London; Dunkerton, *Giotto to Dürer*.

1046 St. Catherine of Alexandria disputing with the philosophers before the emperor Maximian, by Pinturicchio, in Sala dei Santi, Borgia Apartment, 1492–95. Vatican; Calvesi, *Vatican*.

1047 St. Catherine of Alexandria with a kneeling monk, by Pinturicchio. Nat'l Gallery, London; Poynter, *Nat'l Gallery*.

1048 Martyrdom of St. Catherine (as executioner draws his sword, wheel explodes and storm bursts in the sky), woodcut by Albrecht Dürer, Dresden, c. 1498–99. Met Museum; Geisberg, *Single Leaf*; Strauss, *Woodcuts* (pl.57).

1049 Miracle of St. Catherine (she prays outside the door of a sick woman's house, and demon flies out) by Girolamo di Benvenuto 1500–25. Fogg Art Museum, Cambridge MA; *Med. and Ren. Paintings.*

1050 St. Catherine of Alexandria (holding a book, trampling the figure of Maxentius), polychromed wooden statue by unknown artist, c. 1500. Joslyn Art Museum; *Paintings & Sculpture.*

1051 St. Catherine of Alexandria (in half-view, standing before a curtain with her attributes), att. to Bernardo Zenale. Bob Jones Univ. Art Gallery, Greenville, SC; Pepper, *Ital. Paintings.*

1052 St. Catherine of Alexandria (standing with a book and a sword, with a broken wheel on the floor behind her, before a brocaded backdrop), from the scenes from the life of the Virgin altarpiece by Josse Lieferinxe, c. 1500. Louvre, Paris; *L'Ecole d'Avignon.*

1053 St. Catherine of Alexandria, predella panel from altarpiece of the Virgin and Child with St. Jerome and St. Sebastian, by Carlo Crivelli after 1490. NGA, Washington DC; Book of Art, *Ital. to 1850.*

1054 The Virgin among Virgins, with Saints Catherine of Alexandria, Ursula, Cecilia, and Barbara (in a courtyard), by Master of the Virgo Inter Virgines, c. 1500. Rijksmuseum, Amsterdam; Gaunt, *Pictorial Art*; Newsweek, *Rijksmuseum.*

1055 The Virgin, St. Mary Magdalen, and St. Catherine appear to a Dominican Monk in Seriano (Catherine holds up a picture of St. Dominic, while the Virgin points to the kneeling monk), by Fray Juan Bautista. Hermitage, St. Petersburg; Eisler, *Hermitage.*

1056 The dispute of St. Catherine (with the philosophers, as a midget with his dog stands by the emperor), by Jan Provoost. Boymans-van Beuningen Museum, Rotterdam: Van Braam, *Benelux* (Vol.I).

1057 Mystical marriage of St. Catherine (Virgin and Child are enthroned, and Catherine kneels at left with her wheel; a donor in an ermine-trimmed coat kneels at right), att. to Bernardino Bergognone, c. 1501–02. Milan, S. Eufemia; Fiorio, *Le Chiese di Milano.*

1058 Mystical marriage of St. Catherine (with a kneeling donor and two angels playing music), by Marco d'Oggiono, c. 1502. Milan, S. Eufemia; Sedini, *Marco d'Oggiono* (p.37).

1059 St. Catherine (sitting with her attributes, reading a book) woodcut by Hans Baldung Grien, Stuttgart, c. 1505. Geisberg, *Single-leaf.*

1060 St. Catherine (standing with a sword and reading a book), lindenwood statue by Tilmann Riemenschneider, c. 1505–10. North Carolina Museum of Art, Raleigh; *Intro. to the Coll.*

1061 St. Catherine of Alexandria (half-portrait, hands crossed, holding a palm), by Lorenzo Lotto. Poldi Pezzoli Museum, Milan; Berenson, *Lotto.*

1062 St. Catherine wearing a crown, holding a palm leaf, by Lorenzo Lotto, c. 1505. NGA, Washington DC; Berenson, *Lotto*; Shapley, *15th–16th Cent.*; Walker, *NGA.*

1063 Altarpiece of St. Catherine (executioner draws sword; she is surrounded by people in a thunderstorm), by Lucas Cranach the Elder 1506. Picture Gallery, Dresden; *Old Masters*; Friedländer, *Cranach*; Praeger, *Great Galleries.*

1064 St. Catherine (in a landscape, leaning against her wheel, right hand on her chest), by Raphael, c. 1507. Nat'l Gallery, London; Hall, *Color and Meaning*.

1065 St. Catherine (with wheels in her crown), Barbara, and other saints in Virgo Inter Virgines (Madonna is feeding baby Christ a bunch of grapes) by Gerard David, c. 1506. Rouen, Musée des B/A; Miegroet, *David*.

1066 Three Magi Altarpiece with St. Catherine (with her sword) and St. Agnes (with her lamb on a leash) as outside wings of the triptych by Hans Baldung Grien, 1507. Picture Gallery, Berlin, *Masterworks*.

1067 Betrothal of St. Catherine (to baby Christ) in a walled garden of a city, with SS. Barbara and Mary Magdalene, by Gerard David, 1509. Nat'l Gallery, London; Dunkerton, *Giotto to Dürer*; Miegroet, *David*; Panofsky, *Early Netherl.*

1068 St. Catherine of Alexandria (standing, barefoot, in a green dress and red robe, holding a wheel), by Marco d'Oggiono. Arcivescovile Gallery, Milan; Sedini, *Marco d'Oggiono* (p.119).

1069 Madonna and Child between SS. Catherine and Jerome (with his lion) by Giampietrino. Naples, Museum; Ricci, *Cinquecento*.

1070 Mystic marriage of St. Catherine (baby Christ sits on a pillow, about to put a ring on her finger), by Franciabigio. Borghese Gallery, Rome; McKillop, *Franciabigio* (fig.80).

1071 Mystic marriage of St. Catherine of Alexandria (in a landscape), by Master of Frankfort. San Diego Fine Arts Gallery, CA; *Master Works*.

1072 The execution of St. Catherine (executioner is drawing his sword, holding her head steady, when the heavens burst into storm), by Lucas Cranach the Elder, c. 1510. Budapest, Reformed Church; Friedländer, *Cranach*; Schade, *Cranach*.

1073 Virgin and Child with St. Catherine (in a landscape; she rests her hand on a broken wheel), by Bolognese School, early 16th cent. Fitzwilliam Museum, Cambridge; Catalogue, *Italian*.

1074 St. Catherine of Alexandria refusing to pray to idols, drawing by Albrecht Altdorfer, c. 1512. Copenhagen Fine Arts Museum; Guillaud, *Altdorfer*.

1075 Wedding of St. Catherine (to baby Christ, sitting with the Virgin under a green canopy; St. Margaret looks on, sitting on the steps) by Andrea del Sarto, c. 1512. Picture Gallery, Dresden; Padovani, *Andrea del Sarto*.

1076 Mystic marriage of St. Catherine, with SS. Francis and Dominic looking on, miniature by Correggio, c. 1514-34. NGA, Wash. D.C.; *Age of Correggio*.

1077 Catherine of Alexandria and the broken wheel (the wheel bursts apart and a great snowstorm breaks out, while all the people cringe on the ground), illum. by Jean Bourdichon from the Great Hours of Henry VIII, 1514-18. Coll. Duke of Cumberland; *Great Hours*.

1078 Mystic marriage of St. Catherine of Alexandria (in an orange dress) to a baby Christ, by Correggio, c. 1514. Detroit Inst. of Art, MI; *Treasures*.

1079 St. Catherine converted by a picture of the Virgin and Child shown her by a hermit, from the Altarpiece of St. Catherine by Hans Suess von Kulmbach, 1514-15. Cracow, St. Mary; Benesch, *German*.

1080 Beheading of St. Catherine (executioner holds her hair as she kneels with hands tied), by Lucas Cranach the Elder, 1515. Kromeriz, Czechoslovakia, Archiepiscopal Palace; Friedländer, *Cranach*.

1081 Mystical marriage of St. Catherine to infant Jesus, with Virgin Mary holding grapes and other maidens looking on, by Lucas Cranach the Elder, c. 1516. Budapest, Museum of Fine Arts; Garas, *Musée*.

1082 Martyrdom of St. Catherine (rocks seem to fall from the sky as she kneels by the wheel), by Giovan Pietro Birago from the Hours of Bona Sforza, add. ms. 34294, fo.208v, c. 1517-21. BM, London; BL, *Ren. Painting in MS*.

1083 Mystical marriage of St. Catherine (Virgin in blue dress holds baby Christ, while Catherine kneels in a sideless surcoat), by Quentin Metsys, 1518-22. Nat'l Gallery, London; Bosque, *Metsys*.

1084 St. Catherine, standing, reading a book, woodcut by Lucas Cranach the Elder, Gotha, 1519. Geisberg, *Single Leaf*; Schade, *Cranach*.

1085 Execution of St. Catherine (she kneels, in a black dress and draped in a red cloak as executioner raises his sword to strike; double wheel bursts in upper

right background), by Bernard Van Orley, 1520's. Kiev, Museum of Western and Oriental Art; Nikulin, *Soviet Museums.*

1086 Martyrdom of St. Catherine (executioner looks up as storm bursts forth), woodcut by Hans Schaufelein. Strauss, *The Illus. Bartsch* (Vol.11, no.38).

1087 Mystic marriage of St. Catherine (in yellow dress) as St. Sebastian with arrows looks on, by Correggio, c. 1520. Louvre, Paris; Maison, *Art Themes*; Praeger, *Great Galleries.*

1088 St. Catherine (standing before a colonnaded building, resting a sword on its tip), drawing for a stained-glass window by Hans Holbein the Younger. Offentliche Kunstsammlung, Basel; Deuchler, *Swiss Paintings.*

1089 St. Catherine carried to her tomb by angels, by Bernardino Luini, 1520-23. Brera, Milan; Newsweek, *Brera.*

1090 St. Catherine of Alexandria (half-view amid the rubble of the wheel, thanking God for her deliverance), by Giampietrino. Walters Art Gallery, Baltimore; *Italian Paintings* (Vol.II).

1091 The martyred St. Catherine with angels (they gather around her prone body), by the Florentine School. Walters Art Gallery, Baltimore; *Italian Paintings* (Vol.II).

1092 St. Catherine (flanked by two windows, holding a palm) att. to Francesco Zaganelli. Rijksmuseum, Amsterdam; *Paintings.*

1093 Saint Jerome (in the wilderness, sitting with an open book), looking down at Catherine of Alexandria, by Michelangelo Anselmi, 1520's. Brera, Milan; *Age of Correggio.*

1094 St. Catherine of Alexandria (half-view, holding a palm and sword), by Bernardino Luini. Univ. of Notre Dame Art Gallery, IN; Lauck, *Art Gallery.*

1095 Mystical marriage of St. Catherine (with a string tied around her head), by Lorenzo Lotto. Alte Pinakothek, Munich; Berenson, *Lotto.*

1096 The mystical marriage of St. Catherine (infant Christ, held by Mary dressed in red, leans forward to put ring on her hand), with Niccolo Bonghi as donor, by Lorenzo Lotto, 1523. Carrara Academy, Bergamo, Italy; Berenson, *Ital. Painters*; Berenson, *Lotto*; McGraw, *Dict.*

1097 Beheading of St. Catherine (as a bonfire burns in the background), by Lorenzo Lotto, 1524. Oratorio Suardi, Trescore; Berenson, *Lotto.*

1098 St. Catherine (reading) by Dosso Dossi. Borghese Gallery, Rome; Gibbons, *Dossi.*

1099 St. Catherine, resting the tip of a sword on a broken wheel rim, by Fernando Yañez de la Almedina. Prado, Madrid; Lassaigne, *Spanish*; McGraw, *Dict.*; New Int'l Illus. *Encyclo.*; Newsweek, *Prado.*

1100 Mystic marriage of St. Catherine (to infant Jesus, sitting before a mirror; she rests her arm on the wheel) by Parmigianino, 1527-31. Nat'l Gallery, London; Wilson, *Nat'l Gallery.*

1101 St. Catherine of Alexandria (half-view in a red cloak, reading a red book, flanked by two cherubs), by Bernardino Luini, 1527-31. Hermitage, St. Petersburg; Eisler, *Hermitage.*

1102 St. Catherine of Alexandria (standing, with her hands clasped), by Giovanni Cariani, 1528-30. Carrara Academy, Bergamo; Pallucchini, *Cariani.*

1103 Martyrdom of St. Catherine (after wheel has broken, with a dead executioner on the ground, the emperor orders another man to decapitate her; man is drawing sword), woodcut by Hans Sebald Beham, Erlangen, c. 1530. Geisberg, *Single-Leaf.*

1104 Martyrdom of St. Catherine (wheel bursts as executioners look worriedly at the sky), woodcut by Hans Sebald Beham, c. 1530. Geisberg, *Single-Leaf.*

1105 Martyrdom of St. Catherine (wheels shatter as executioners turn a crank), by Giovanni Francesco Caroto. Christ Church, Oxford; Shaw, *Old Masters.*

1106 Saint Catherine (in red, reading a book) by Master of the Female Half-lengths, c. 1530. Brera, Milan; New Int'l Illus. *Encyclo.*

1107 St. Catherine (half-view, looking over her left shoulder), by Parmigianino. Sumu Museum, Bucharest; Oprescu, *Great Masters.*

1108 St. Catherine (half-view, looking over her left shoulder), by Parmigianino. Rumania, Art Museum of the R.P.R.; Oprescu, *Great Masters.*

1109 St. Catherine of Alexandria

(standing with a broken wheel, before a scene depicting her martyrdom in the background), att. to Garofalo. Christ Church, Oxford; Shaw, *Old Masters.*

1110 St. Catherine of Alexandria, marble statue by Antonello Gagini and Antonio Gagini, 1535-40. St. Louis Art Museum, MO.

1111 Catherine of Alexandria, before a window with a landscape, containing her wheel, copy of painting by Benvenuto da Garofalo. Christ Church, Oxford; Shaw, *Old Masters.*

1112 Martyrdom of St. Catherine (in a landscape; at left, twin wheels catch on fire), att. to Matthys Cock, c. 1540. NGA, Washington DC; Walker, *NGA.*

1113 Mystic marriage of St. Catherine (in the presence of SS. Anne and Joseph), by Paolo Veronese, 1549. Yale Univ. Art Gallery; Rearick, *Veronese.*

1114 Mystic marriage of St. Catherine (Virgin holds baby Jesus) by Bernardino di Mariotto, mid-16th cent. Fogg Art Museum, Cambridge MA; *Med. and Ren. Paintings.*

1115 St. Catherine of Alexandria (in a brocade dress trimmed with pearls wearing a crown), copy after Titian, 16th cent. Uffizi, Florence; Wethey, *Titian* (pl.168).

1116 Holy Family (raised on a marble platform) with SS. Catherine and Anthony Abbot (with a pig), by Paolo Veronese, 1551. Venice, S. Francesco della Vigna; Rearick, *Veronese.*

1117 Cameria, daughter of Suleiman the Magnificent, as St. Catherine of Alexandria, att. to Titian, c. 1555. Courtauld Inst. of Art, London; *Catalogue.*

1118 Martyrdom of St. Catherine (she lay on a mounted wheel, while angels descend with swords; executioners fall through the wooden floor), by Lelio Orsi, 1555-63. Estense Gallery, Modena; *Age of Correggio*; Boschloo, *Carracci*; Briganti, *Ital. Mannerism*; McGraw, *Encyclo.* (Vol.IX, pl.301); Puppi, *Torment.*

1119 Mystic marriage of St. Catherine (in a blue brocade dress) as an angel plays the cello, by Paolo Veronese, 1555-60. Detroit Inst. of Art, MI; *Treasures.*

1120 Mystic marriage of St. Catherine (with the Holy Family; they stand under a scalloped curtain), by Paolo Veronese. Brussels, Musées Royaux des B/A; Rearick, *Veronese.*

1121 St. Catherine of Alexandria at prayer (in a large hall before a cross), by

Titian, 1567-68. Boston Museum of Fine Arts; *Illus. Handbook*; Wethey, *Titian* (pl.188).

1122 Mystic marriage of St. Catherine (hands clasped, looking up at the Virgin and Child, as Joseph and St. Francis look on), by Orazio Samacchini, late 1560's. Coll. Ferrari-Boschetto, Bologna; *Age of Correggio.*

1123 The marriage of St. Catherine (in a striped dress), with an unidentified Franciscan Saint, by Paolo Veronese, c. 1570. Christ Church, Oxford; Shaw, *Old Masters.*

1124 Mystical marriage of St. Catherine (with baby Jesus, who sits on Virgin's lap at the top of a staircase, between two pillars), by Paolo Veronese, 1570's. Accademia, Venice; Freedberg, *Circa 1600*; Hartt, *Ital. Ren.*

1125 Portrait of a lady as St. Catherine (with an arm on the wheel, wearing a veil), by a follower of Agnolo Bronzino, c. 1575. Cleveland Museum of Art, OH; *European 16-18th Cent.*

1126 St. Catherine and the angel (she sits, a hand over her heart, comforted by a child angel who holds out a palm), by Veronese, c. 1580-85. Prague Castle; Neumann, *Picture Gallery.*

1127 St. Catherine of Alexandria (holding out a palm, with her right hand on a broken wheel), by an unknown Venetian mannerist, c. 1580-85. Correr Museum, Venice; Frabetti, *Manieristi.*

1128 St. Catherine (bestriding her prone executioner), by Bartholomaus Spranger. Archer Huntington Gallery, Austin TX; Kaufmann, *School of Prague.*

1129 St. Catherine (with a sword and a palm, wearing a crown), by Bartholomaus Spranger, after 1580. Prague Castle; Neumann, *Picture Gallery.*

1130 St. Catherine adoring the Trinity (she is kneeling in the wilderness, arms upraised to the Trinity, enthroned on clouds above her), by Dielai, c. 1581. Ferrara, Cathedral; Frabetti, *Manieristi.*

1131 Martyrdom of Catherine of Alexandria (executioner raises two-handed sword to strike, while bearded man atop white horse and others watch), by Corel van Mander, 1582. Courtrai, St. Martin; Bosque, *Mythologie.*

1132 Martyrdom of St. Catherine (as she kneels next to the wheel, an angel appears, knocking down the executioners),

by Francesco Bassano, 1580–90. Pitti Palace, Florence; McGraw, *Encyclo.* (Vol.II, pl.243).

1133 Visit of the Empress Faustina to Saint Catherine in prison (a servant points the way through a window, where Catherine is seen in ecstasy), by Antonio Campi, 1583. Milan, Sant'Angelo; Fiorio, *Chiese di Milano*; Moir, *Caravaggio.*

1134 Martyrdom of St. Catherine (executioners are about to crank two spiked wheels together, while she kneels between them, stripped to the waist; the emperor seems mildly curious as angel descends brandishing a sword), by Gaudenzio Ferrari. Brera, Milan; Fiorio, *Le Chiese di Milano.*

1135 Martyrdom of St. Catherine (kneeling before the wheel, as her executioners recoil at the opening heavens; other prisoners are beaten in foreground), by Tiburzio Passerotti. Bologna, S. Giacomo Maggiore; Boschloo, *Carracci.*

1136 Mystic marriage of St. Catherine (she accepts the ring from baby Christ, looking away from him, as an angel puts an arm around her shoulder), by Annibale Carracci. Capodimonte, Naples; Boschloo, *Carracci.*

1137 Mystic marriage of St. Catherine (to a baby Christ, under a canopy in the wilderness), by Otto van Veen, 1589. Brussels, Musées Royaux des B/A; Larsen, *17th Cent. Flem.*

1138 Martyrdom of St. Catherine of Alexandria (angels descend brandishing swords, as she is raised from the ground between two wheels), drawing by Bernardino Poccetti. Met Museum; Bean, *15th & 16th cent.*

1139 Mystical marriage of St. Catherine to baby Christ, by Pietro Candido, c. 1590. Boston Museum of Fine Arts, MA.

1140 The dream of St. Catherine of Alexandria (Madonna and Child appear to her), by Ludovico Carracci. NGA, Washington DC; *Age of Correggio*; Freedberg, *Circa 1600*; New Int'l Illus. *Encyclo.*

1141 Madonna and Child with SS. Jerome (sitting at their feet, eyes closed), and Catherine of Alexandria (the Madonna touches her hand) by Pietro Faccini, c. 1595. Capitoline Gallery, Rome; *Age of Correggio.*

1142 St. Catherine crowned, holding a sword and palm, by Bartholomaus

Spranger, late 16th cent. Picture Gallery, Berlin; *Catalogue.*

1143 St. Catherine of Alexandria in a brown dress leaning against a broken wheel, holding a small-sword, by Caravaggio, c. 1597. Thyssen-Bornemisza Coll., Lugano; Met Museum, *Caravaggio*; Spear, *Caravaggio.*

1144 Madonna enthroned with Saints Catherine of Alexandria and Mary Magdalene, by Francesco Albani, 1599. Bologna, Pinacoteca Nazionale; *Age of Correggio.*

1145 The martyrdom of St. Catherine (she stands amidst the rubble of several large wheels, broken chains hanging from her arms, as an angel descends), by Tintoretto. Venice, S. Caterina; McGraw, *Encyclo.* (Vol.XIV, pl.88).

1146 Betrothal of St. Catherine to baby Christ (as St. Francis and a bishop saint look on), by Ippolito Scarsella. Budapest, Museum of Fine Arts: Haraszti-Takács, *Masters of Mannerism.*

1147 Madonna and Child enthroned, with SS. John the Evangelist and Catherine of Alexandria, by Annibale Carracci. Bologna, Pinacoteca Nazionale; Freedberg, *Circa 1600.*

1148 St. Catherine in prison (comforted by angels, as a guard looks on) by Ludovico Carracci. Bologna, S. Leonardo; Freedberg, *Circa 1600.*

1149 The Virgin, St. Mary Magdalen, and St. Catherine appear to a Dominican Monk in Seriano (Catherine holds up a picture of St. Dominic, while the Virgin points to the kneeling monk), by Fray Juan Bautista. Hermitage, St. Petersburg; Eisler, *Hermitage.*

1150 Martyrdom of St. Catherine (she kneels, hands tied over her breasts, amid the rubble of the broken wheel, which has crushed her executioners), by Il Cerano, c. 1606–09. Milan, Santa Maria dei Miracoli; Fiorio, *Le Chiese di Milano.*

1151 Mystic marriage of St. Catherine (she kneels on a cushion, as the Virgin and Child appear in a vision, overlooked by God above), by Vincenzo Pellegrini, 1608–10. Bob Jones Univ. Art Gallery, Greenville, SC; Pepper, *Ital. Paintings.*

1152 Mystic marriage of St. Catherine (child Jesus puts ring on her finger, and touches her cheek with his other hand) by Giulio Procaccini, 1625. Brera, Milan; Gowing, *Biog. Dict.*; Newsweek, *Brera.*

1153 St. Catherine of Alexandria

(wrapped in an orange cloak, holding a palm and looking heavenward), by Guido Reni, 1601-14. Prado, Madrid; *Guido Reni.*

1154 St. Catherine of Alexandria holding a palm and broken wheel, her mouth open, after Pier Francesco Morazzone. Rijksmuseum; *Paintings.*

1155 St. Catherine of Alexandria with a wheel, sword, and laurel leaf, by El Greco, 1600-05. Boston Museum of Fine Arts, MA.

1156 The mystic marriage of St. Catherine, with Emperor Matthias portrayed as Apostle Matthew, and Empress Anna portrayed as St. Helena, by Matthäus Gundelach, 1614. KM, Vienna; Kaufmann, *School of Prague.*

1157 The martyrdom of St. Catherine (wheel shatters, elaborate building behind her starts to crumble), by Monsù Desiderio, 1617. Southampton City Art Gallery; RA, *Painting in Naples*; Wright, *Reality.*

1158 The martyrdom of St. Catherine (executioner, sword in hand, tries to pull her away from her women, who are pinning her hair back), by P.P. Rubens, c. 1618. Lille, Musée des B/A; d'Hulst, *Jordaens.*

1159 Mystic marriage of St. Catherine (baby standing on ledge puts ring on her finger; she wears a spiked circlet) by Bernardino Luini, c. 1520-25. Baltimore Museum of Art, MD.

1160 Mystic marriage of St. Catherine of Alexandria (as angels play instruments in background), round drawing by Avanzino Nucci. Met Museum; Bean, *15th & 16th cent.*

1161 Mystical marriage of St. Catherine (draped in a brocade cloak, she stands in left profile while baby Jesus puts a ring on her finger), by Anthony van Dyck, c. 1620. Prado, Madrid; *Peinture Flamande.*

1162 Mystical marriage of St. Catherine of Alexandria (she is floating up to the Virgin and Child in a cloud, while below, cherubs unveil a portrait of the Virgin and Child), by Andrea Ansaldo, c. 1620. Rome, Museo Diocesano; *Tresori d'Arte.*

1163 St. Catherine of Alexandria (crowned) holding a palm, by Gentileschi, early 1620's. El Paso Museum of Art, TX; *Kress.*

1164 St. Catherine of Alexandria, as

seen from below, in a plumed hat, holding a sword point-down against a piece of a wheel, etching att. to P.P. Rubens, 1620-21. Met Museum; Baudouin, *Rubens*; Rowlands, *Rubens, Drawings.*

1165 Martyrdom of St. Catherine (executioner pulls back her hair, as she kneels on a cushion, with a crown on the step below her), by Gaspar de Crayer, 1622. Grenoble, Musée de Peinture et de Sculpture; Lemoine, *Musée.*

1166 Mystical marriage of St. Catherine (close-up view of her and the Holy Family; baby Jesus touches her wedding ring), by Giulio Cesare Procaccini. Hermitage, St. Petersburg; Eisler, *Hermitage.*

1167 Virgin and Child with Catherine of Alexandria, by Anthony van Dyck, c. 1628. Met Museum.

1168 Mystic marriage of St. Catherine (to baby Christ, as angel holds a sword behind her), by Nicolas Poussin, c. 1629. NGS, Edinburgh; Oberhuber, *Poussin.*

1169 Burial of St. Catherine on Mount Sinai (angels put her into a tomb), by Francisco de Zurbaran, 1613-40. Private coll., Château de Courcon; Gállego, *Zurbaran.*

1170 St. Catherine of Alexandria (sitting, with a hand on the wheel and holding a palm and sword with the other), by Bernardo Strozzi. Wadsworth Atheneum, Hartford CT; *Handbook.*

1171 Mystic marriage of St. Catherine (to baby Christ as she holds a palm; Virgin holds a flower wreath), by Anthony van Dyck, c. 1633. Royal coll., Buckingham Palace; Larsen, *Van Dyck* (pl.473).

1172 The coronation of St. Catherine (by infant Jesus), by P.P. Rubens, 1633. Toledo Museum of Art, OH; Baudouin, *Rubens.*

1173 The Roman empress Faustina visiting St. Catherine of Alexandria in prison (as guards listen), by Mattia Preti. Dayton Art Inst., OH; *50 Treasures*; Yale Univ., *Taste* (fig.38).

1174 Entombment of St. Catherine (by three angels), by Francisco de Zurbaran, 1636-37. Nelson-Atkins Museum of Art, Kansas City MO; *Collections*; *Handbook.*

1175 The martyred St. Catherine (wrapped in a pink robe, holding a palm and wearing a crown), by Guido Reni, c.

1638–39. Manchester City Art Gallery; *Guido Reni.*

1176 Coronation of the Virgin (above) with SS. Catherine of Alexandria, John the Evangelist, John the Baptist, and Benedict, by Guido Reni. Bologna, Pinacoteca Nazionale; *Guido Reni.*

1177 Mystical marriage of St. Catherine of Alexandria (she stands in left profile, with dark brown hair, as the Child puts the ring on her finger; two men look on from behind her), by Jacob Jordaens. Prado, Madrid; Bentley, *Calendar.*

1178 St. Catherine of Alexandria visited in prison by the Empress, by Mattia Preti, c. 1640–43. Dayton Art Inst., OH; Spear, *Caravaggio.*

1179 Coronation of St. Catherine (by the Virgin and Jesus), by Francisco de Zurbaran, 1641–58. Coll. Duke of Dalmacia, Saint-Amans-Soult; Gállego, *Zurbaran.*

1180 St. Catherine (holding a sword and a palm), by Francisco de Zurbaran, 1641–58. Bilbao, Provincial Museum of Fine Arts; Gállego, *Zurbaran.*

1181 St. Catherine (standing next to her wheel, wearing a crown), by Francisco de Zurbaran, 1641–58. Bolullos de la Mitacion Parish Church; Gállego, *Zurbaran.*

1182 Marriage of St. Catherine, flanked by John the Baptist and St. Charles Borromeo, by Giovanni Francesco Romanelli, c. 1642. Bob Jones Univ. Art Gallery, Greenville, SC; Pepper, *Ital. Paintings.*

1183 St. Catherine of Alexandria (one-third portrait) holding a palm, by Cavallino, 1640's. Barber Inst. of Fine Arts, Birmingham; RA, *Painting in Naples.*

1184 St. Catherine of Alexandria (sitting, foot on a step and elbow on a manuscript, in a blue dress and orange mantle, right hand on a wheel) by Francesco Fracanzano. Instituto Nazionale di Previdenza Sociale, Rome; RA, *Painting in Naples.*

1185 Holy Family with SS. Anne and Catherine of Alexandria (putting Jesus's hand against her cheek), by Jusepe de Ribera, 1648. Met Museum; Hibbard, *Met Museum.*

1186 St. Catherine (kneeling beside her broken wheel, while a cherub descends with a palm and a flower wreath), by the circle of Eustace Le Sueur. Paris, Saint-Etienne-du-Mont; Mérot, *Le Sueur.*

1187 The martyrdom of Catherine of Alexandria (executioner is about to strike, as she looks at an angel descending with a laurel wreath) by Mattia Preti, c. 1659. Met Museum.

1188 St. Catherine of Alexandria disputing with the doctors, by Mattia Preti. Naples, San Pietro a Maiella; Yale Univ., *Taste* (fig.12).

1189 Mystical marriage of St. Catherine (to baby Christ; a group of cherubs wait expectantly at the Virgin's side), by Corneille De Vos. Staatliche Kunsthalle Karlsruhe; Hairs, *Sillage de Rubens.*

1190 Martyrdom of St. Catherine (just after the executioner severs her head, the head is grabbed by one angel and another supports her body) by Pierre Thys the Elder, 1667. Alost, St. Martin; Hairs, *Sillage de Rubens.*

1191 The mystical marriage of Catherine (to baby Christ, on top of a cloud), by Pierre Mignard. Hermitage, St. Petersburg; Eisler, *Hermitage*; *Peinture Francaise*; Schnapper, *Jouvenet.*

1192 St. Catherine of Alexandria, holding a palm in her left hand, by Claudio Coello, 1683. Apsley House, Wellington Museum, London; Book of Art, *German & Spanish*; Murray, *Art & Artists.*

1193 St. Catherine (enthroned, wearing an ermine-lined cloak with bird designs, holding a palm and a crucifix, her hand on the wheel), by painter and monk Jeremiah Palladas, 17th cent. Sinai, Monastery of St. Catherine; Manafis, *Sinai.*

1194 Miracle of St. Catherine of Alexandria (she spreads her arms for an angel with a flaming sword, as the executioners recoil), by Paolo de Matteis, 1708. Private coll., NY; Yale Univ., *Taste* (cat.29).

1195 St. Catherine (with her hands crossed over her chest, she looks down at a cherub, while another cherub carries her palm), by Geronimo Cenatiempo, early 18th cent. Bob Jones Univ. Art Gallery, Greenville, SC; Pepper, *Ital. Paintings.*

1196 Madonna del Carmelo with St. Catherine and the Archangel Michael, by Giambattista Tiepolo. Piove di Sacco, S. Martino; Morassi, *Catalogue.*

1197 Mystical marriage of St. Catherine, St. John and the Infant Christ, by Giambattista Tiepolo. Coll. Hausammann, Zurich; Morassi, *Catalogue* (pl.108).

1198 St. Catherine (sitting on a cloud, holding a palm) and angels, by Giambattista Tiepolo. Private coll., Venice; Morassi, *Catalogue* (pl.203).

1199 Mystical marriage of St. Catherine (to a baby Christ), with SS. Jerome (with a knee on his lion) and Lucy, by Pompeo Batoni, 1779. Rome, Palazzo del Quirinale; Clark, *Batoni*.

See also 54, 63, 72, 114, 131, 198, 314, 373, 444, 483, 526, 573, 584, 590, 591, 596, 599, 601, 604, 761, 843, 1270, 1342, 1416, 1452, 1744, 1810, 2061, 2468, 2532, 2671, 3108, 3458, 3465, 3523, 3526, 3531, 3679, 3760, 4100, 4125, 4276, 4433, 4523, 4657, 4777, 4814, 4864

Catherine of Ricci, Dominican nun from Prato, d. 1590, canon. 1746 (Feb. 13)

1200 Mystical marriage of St. Catherine of Ricci (she is presented to an adult Christ, who holds a banner), by Subleyras, 1746. Northampton, Smith College Museum of Art; *Subleyras.*

Catherine of Siena or Caterine Benincasa, Dominican nun of the Order of Penance, d. 1380, canon. 1380 (Apr. 30)

1201 St. Catherine of Siena, polychromed wooden statue, 14th cent. Private coll., Rome; New Int'l Illus. *Encyclo.*

1202 The mystic marriage of St. Catherine (baby Jesus, in cote hardie, puts ring on Catherine's finger) by Lorenzo Veneziano, c. 1356–72. Accademia, Venice; Denvir, *Art Treasures.*

1203 Catherine of Siena offering Christ her heart (as she kneels outside a building and He appears over the roof), by Giovanni di Paolo. Coll. Stoclet, Brussels; Christiansen, *Siena*; Meiss, *Painting in Florence* (pl.112).

1204 Mystic marriage of St. Catherine of Siena (as a roomful of saints look on), by Giovanni di Paolo. Coll. Stoclet, Brussels; Christiansen, *Siena*; Meiss, *Painting in Florence* (pl.104).

1205 Mystic marriage of St. Catherine of Siena (to an adult Jesus, who leans over a garden wall to give her the ring), by a Pisan Master. Pisa, Museo Civico; Meiss, *Painting in Florence* (pl.111).

1206 Stigmatization of St. Catherine of Siena (as she kneels before an altar, the crucifix leans toward her), by Giovanni di Paolo. Met Museum, NY; Christiansen, *Siena*; Meiss, *Painting in Florence* (pl.117).

1207 St. Catherine of Siena, touching a supplicant's lips, fresco by Andrea Vanni, c. 1385. Siena, S. Domenico; Coulson, *Saints*; Edgell, *Sienese Painting*; McGraw, *Encyclo.* (Vol.XII, pl.375).

1208 Death of Catherine of Siena (on her deathbed, as Jesus, Mary, and SS. Jerome and Augustine watch from above, an angel saves her soul from the devil), by Bartolomeo degli Eri or Domenico Morone. Ferrara, Pinacoteca Nazionale; Kaftal, *North East Italy.*

1209 Miraculous communion of St. Catherine of Siena (receiving communion from Christ), by Giovanni di Paolo. Met Museum; Christiansen, *Siena.*

1210 Mystic marriage of St. Catherine of Siena (Christ and saints appear to her in a room), by Giovanni di Paolo. Private coll., New York; Christiansen, *Siena.*

1211 St. Catherine of Siena beseeching Christ to resuscitate her mother (who sits up in her death bed), by Giovanni di Paolo. Met Museum; Christiansen, *Siena*; Van Os, *Sienese Altarpieces* (Vol.II, pl.123).

1212 St. Catherine of Siena dictating her dialogues to Raymond of Capua (as Christ speaks to her), by Giovanni di Paolo. Detroit Inst. of Art, MI; Christiansen, *Siena*; *Treasures.*

1213 St. Catherine of Siena invested with the Dominican habit (St. Dominic, St. Francis, and St. Augustine all appear to her, offering habits of their own sects), by Giovanni di Paolo. Cleveland Museum of Art, OH; Christiansen, *Siena.*

1214 St. Catherine of Siena receives communion from Christ (while two angels suspend a crown over her head), fresco by the Umbrian School, 15th cent. Spoleto, S. Domenico; Kaftal, *Central & So. Ital.*

1215 St. Catherine of Siena holding a lily and a red book, by Giovanni di Paolo di Grazia, 1420–82. Fogg Art Museum, Cambridge MA; Mortimer, *Harvard Univ.*

1216 Canonization of St. Catherine of Siena by Pope Pius II (he sits enthroned above her body, giving a blessing, surrounded by cardinals), fresco by Pinturicchio, 1461. Siena, Cathedral; Hibbert, *Rome, The Biography*; Kaftal, *Central & So. Ital.*

1217 Death of St. Catherine of Siena (on a bed, surrounded by monks and crying nuns), by Giovanni di Paolo, c. 1463. Minneapolis Inst. of Art, MN; Kaftal, *Tuscan.*

1218 Scenes from the life of St. Catherine of Siena: Christ inspires her dictation of the "Dialogues" (he appears in a corner of the room as she dictates, kneeling); she preaches before Urban VI and his cardinals; panels by Giovanni di Paolo, c. 1463. Coll. Stoclet, Brussels; Kaftal, *Tuscan*.

1219 Scenes from the life of St. Catherine of Siena: mystical marriage (to an adult Christ who leans from a cloud, surrounded by saints); Catherine gives her cloak to a beggar, and later Christ returns it to her in the form of an invisible cloak which protects her from the cold; as she prays, Christ raises her in the air, making her heart one with His; panels by Giovanni di Paolo, c. 1463. Coll. Stoclet, Brussels; Kaftal, *Tuscan*.

1220 St. Catherine and the beggar, from the Pizzicaiolo Altarpiece by Giovanni di Paolo, c. 1463. Cleveland Museum of Art, OH; Christiansen, *Siena*; *European before 1500*; *Selected Works*.

1221 St. Catherine of Siena before Pope Gregory XI (with cardinals and scribes), by Giovanni di Paolo. Thyssen-Bornemisza Coll., Lugano; Christiansen, *Siena*; Cleveland Museum of Art, *European before 1500*.

1222 St. Catherine of Siena cures the rector of the Misericordia of the plague (she tells him "It is no time to lie in bed" while he lies in bed, dying), fresco by Vincenzo Tamagni. Siena, Contrada dell'Oca; Kaftal, *Tuscan*.

1223 St. Catherine of Siena leads Pope Gregory XI out of Avignon (she leads him on his horse), fresco by Benvenuto di Giovanni. Società di Esecutori di Pie Disposizioni, Siena; Kaftal, *Tuscan*.

1224 St. Catherine of Siena prays for the soul of a dying woman who has wronged her (and is answered, while the devil leaves the room with a scroll), by Girolamo di Benvenuto. Fogg Art Museum, Cambridge; Edgell, *Sienese Paintings*; Kaftal, *Tuscan*.

1225 St. Catherine of Siena receives communion from Christ (as a priest gives mass, holding the other half of the Eucharist), panel by Giovanni di Paolo, c. 1463. Met Museum; Kaftal, *Tuscan*.

1226 Catherine of Siena, painted wooden statue by Neroccio de Landi, 1470. Siena, Church of Santa Caterina; New Int'l Illus. *Encyclo.*

1227 St. Jerome writing and St. Catherine of Siena holding a lily by Sano di Pietro, 1470–80. Boston Museum of Fine Arts.

1228 St. Catherine of Siena (giving a book and a scroll to kneeling nuns), by Cosimo Rosselli. NGS, Edinburgh; *Illustrations*.

1229 St. Catherine of Siena (standing in a niche, with a book and a palm), by Lorenzo Vecchietta. Siena, Palazzo Pubblico; Christiansen, *Siena*; Edgell, *Sienese Paintings*; Pope-Hennessey, *Sienese*.

1230 Saints Dominic, Francis, and Bonaventura offer St. Catherine of Siena the robe of the Dominican Order, fragment of a predella by Neroccio de'Landi. Coll. Bernard Berenson, Villa I Tatti, Florence; Cooper, *Private Collections*; Kaftal, *Tuscan*.

1231 St. Catherine with the Virgin and Child, and Mary Magdalen, by Giovanni Bellini, c. 1490–1500. Accademia, Venice; Book of Art, *Ital. to 1850*.

1232 SS. Catherine of Siena, Mary Magdalene, and kneeling Jerome, left panel of the detached Bichi polyptych by Luca Signorelli, 1498. Picture Gallery, Berlin; United Nations, *Dismembered Works*.

1233 St. Catherine of Siena exorcising a possessed woman (a demon flies from the woman's mouth), by Girolamo di Benvenuto, 1500–10. Denver Art Museum, CO; *Major Works*; Shapley, *Samuel H. Kress*.

1234 St. Catherine of Siena, from Flemish stained-glass window, 16th cent. Private coll.; Drake, *Saints and Emblems*.

1235 God the Father (holding a book open to the letters A & W) above Saints Mary Magdalen and Catherine of Siena, by Fra Bartolommeo 1509. Lucca, Pinacoteca; Fischer, *Fra Bartolommeo*; McGraw, *Dict.*; Murray, *Art & Artists*.

1236 St. Catherine of Siena (collapsed after her stigmatization, supported by two nuns), by Sodoma. Siena, S. Domenico; Bentley, *Calendar*.

1237 Vision of St. Catherine of Siena (she kneels with two other nuns, looking up at a vision of the Trinity, Mary, and angels), by Sodoma. Siena, San Domenico; Ricci, *Cinquecento*.

1238 Coronation of St. Catherine of Siena (she is crowned by Jesus, in the presence of other saints and Tobias and

the angel, before a landscape), by Francesco Bissolo. Accademia, Venice; Fischer, *Fra Bartolommeo* (fig.84).

1239 Sacra Conversazione with the mystic marriage of St. Catherine of Siena (who is kneeling in a white nun's habit), by Fra Bartolommeo, c. 1510-13. Louvre, Paris; Book of Art, *Ital. to 1850*; Fischer, *Fra Bartolommeo* (fig.105); Gowing, *Paintings*; *Int'l Dict. of Art*; Newsweek, *Louvre*.

1240 The Mystical marriage of Catherine of Siena with St. George and other saints, known as the "Pala Pitti" altarpiece by Fra Bartolommeo, 1512. Accademia, Florence; Fischer, *Fra Bartolommeo* (fig.163).

1241 The mystical marriage of St. Catherine (under a canopy), by Fra Bartolommeo, 1512. Pitti Palace, Florence; Book of Art, *Ital. to 1850*.

1242 Catherine of Siena (standing with a book, a crucifix, and a lily), by Giovanni di Pietro, c. 1516. Chicago Art Inst.; Maxon, *Art Institute*.

1243 St. Catherine of Siena (in a nun's habit, holding a book and a lily), by Domenico Beccafumi. Esztergom Christian Museum; *Christian Art in Hungary* (pl.III/54).

1244 St. Catherine receiving the stigmata (between two archways, she kneels before a crucifix) flanked by two saints, by Domenico Beccafumi. Accademia, Siena; Briganti, *Ital. Mannerism*; Gaunt, *Pictorial Art* (Vol.II, pl.273); Hartt, *Ital. Ren.*

1245 St. Catherine of Siena intercedes at the execution of a criminal (the executioner holds up the severed head, while three angels descend, catching the soul as it rises), by Sodoma. Siena, S. Domenico; Boase, *Vasari* (pl.146).

1246 St. Catherine of Siena (in a nun's habit, holding a book), stucco sculpture by C. Mariani, c. 1600. Rome, S. Bernardo alle Terme; McGraw, *Encyclo.* (Vol.XII, pl.86).

1247 Madonna of the Rosary with St. Dominic and Catherine of Siena (Jesus puts a crown of thorns on her head), by G.B. Crespi, c. 1615. Brera, Milan; Bob Jones Univ. Art Gallery, Greenville SC; *Baroque Paintings*.

1248 The Virgin and Child with Chaplets, appearing to St. Dominic and St. Catherine of Siena, drawing att. to Pietro Mera. Met Museum; Bean, *15th & 16th cent.*

1249 Catherine of Siena receives communion from Jesus (the priest goes on with the mass, but a monk sees the miracle), by Philippe Quantin, after 1620. Dijon, Musée des B/A; Georgel, *Musée des B/A*; Nicolson, *Caravaggesque Movement*.

1250 Christ on the cross with St. Dominic and St. Catherine of Siena (wearing a crown of thorns, she embraces Christ's feet), by Anthony van Dyck, c. 1626. Koninklijke Museum, Antwerp; Larsen, *Van Dyck* (pl.201).

1251 Mystical marriage of St. Catherine of Siena (in nun's habit, she marries an adult Christ), by Francisco de Zurbaran, 1641-58. Meadows Museum, Dallas TX; Gállego, *Zurbaran*.

1252 St. Catherine of Siena receiving the crown of thorns and a rosary from the Christ Child (who stands on a cushion), by Sassoferrato, c. 1643. Cleveland Museum of Art, OH; *European 16-18th Cent.*

1253 Madonna of the Rosary with St. Dominic (she holds a rosary over his bent back) and St. Catherine of Siena (Jesus holds flowers over her head), by Carlo Francesco Nuvolone. Bob Jones Univ. Art Gallery, Greenville SC; *Baroque Paintings*; Pepper, *Ital. Paintings*.

1254 St. Catherine in ecstasy (on a cloud with angels), polychromed marble altar by M. Caffà. Rome, S. Caterina da Siena; McGraw, *Encyclo.* (Vol.II, pl.165).

1255 St. Catherine of Siena (head portrait, wearing a crown of thorns), by Carlo Dolci. Dulwich Picture Gallery, London; Murray, *Catalogue*.

1256 St. Catherine of Siena (wearing a crown of thorns, praying before a crucifix and a skull), by Il Volterrano. Grenoble, Musée de Peinture et de Sculpture; Chiarini, *Tableaux Italiens*.

1257 Virgin and Child enthroned, with St. Dominic and St. Catherine of Siena, also called Madonna of the Rosary, by Francesco Solimena, 1680-82. Picture Gallery, Berlin; *Gemäldegalerie*.

1258 Ecstasy of St. Catherine of Siena (she kneels before a crucifix, hands crossed over her chest), by Joseph Van de Kerckhove, c. 1716. Bruges, State Museum; Pauwels, *Musée Groeninge*.

1259 St. Catherine of Siena (wearing a crown of thorns, showing her stigmata), by Giambattista Tiepolo. KM, Vienna; Morassi, *Catalogue* (pl.202).

1260 Ecstasy of St. Catherine of Siena (she is receiving the stigmata, falling back into the arms of angels), by Pompeo Batoni, 1743. Lucca, Museo Nazionale di Villa Guinigi; Clark, *Batoni.*
See also 270, 793, 828, 969, 1043, 1622, 3260, 3657, 3800, 3826, 4252, 4605, 4616

Catherine of Vadstena, daughter of St. Bridget of Sweden, Bridgettine nun, d. 1381 (Mar. 24)
1261 St. Catherine of Vadstena (sitting in a room with a tiny window, reading, with a stag at her side), painting by unknown artist. Statens Historiska Museer, Stockholm; Bentley, *Calendar.*

Cecilia, Roman martyr, patroness of musicians; died of wounds inflicted by executioner in his attempt to behead her, mart. 229 (Nov. 22)
1262 St. Cecilia, arms outspread, wall-painting, 2nd–5th cent. A.D. Rome, S. Callisto; Boucher, *20,000 Years* (283).
1263 Altarpiece of St. Cecilia with scenes from her life, by Master of St. Cecilia, 1300–05. Uffizi, Florence; Andres, *Art of Florence* (Vol.I, pl.73); Murray, *Art & Artists.*
1264 St. Cecilia (with a palm, wearing a circlet of roses), panel of a polyptych by the workshop of Bernardo Daddi. Coll. Jakob Hirsch, NY; Offner, *Corpus* (Sect.III, Vol.VIII, pl.VIII).
1265 St. Cecilia, St. Valerian, an unidentified saint, and three companions (before a wall), predella panel by Bernardo Daddi. Czartoryski Museum, Cracow; Offner, *Corpus* (Sect.III, Vol.VIII, pl.II).
1266 St. Cecilia, holding a dove, pipes at her feet, by Master of the Braunschweig Diptych, c. 1490. Rijksmuseum, Amsterdam; Bentley, *Calendar; Paintings.*
1267 St. Cecilia (standing before a building, holding a palm and a book, with an angel playing the lute at her feet), by Riccardo Quartararo. Palermo, Cathedral; Kaftal, *Central & So. Ital.*
1268 St. Cecilia, holding a set of pipes with St. Paul, John the Evangelist, St. Augustine, and St. Mary Magdalene in "Sacra Conversazione" by Raphael, c. 1516. Bologna, Pinacoteca Nazionale; Book of Art, *Ital. to 1850*; Burckhardt, *Altarpiece*; Coulson, *Saints*; Ettlinger, *Raphael*; Hall, *Color and Meaning*;

McGraw, *Encyclo.* (Vol.XII, pl.367); Raphael, *Complete Works* (1.186).
1269 St. Cecilia playing the keyboard (as angels sing), by Michel Coxcie. Prado, Madrid; *Peinture Flamande* (b/w pl.86).
1270 Virgin and Child enthroned with SS. Michael, Catherine of Alexandria, Cecilia, and Jerome, by Bernardino Zaganelli, late 15th-early 16th cent. Houston Museum of Fine Arts, TX; *Guide to the Coll.*
1271 Martyrdom of St. Cecilia (she kneels, looking at an angel who points to heaven, as the executioner recoils at the sight), by Carlo Saraceni, c. 1599. Coll. Manning, New York; *Around 1610.*
1272 Martyrdom of St. Cecilia (she kneels, looking at an angel who points to heaven, as the executioner approaches, sword in hand), by Carlo Saraceni, c. 1599. Matthiesen Fine Art Ltd., London; *Around 1610.*
1273 St. Cecilia (playing the lute, while an angel holding an instrument touches her shoulder), att. to Carlo Saraceni. Corsini Gallery, Rome; *Around 1610.*
1274 Saint Cecilia, marble sculpture fashioned after the pose her body was supposedly found in, when it was discovered in 1599, by Stefano Maderno, c. 1600. Rome, S. Cecilia; Held, *17th & 18th Cent.*; New Int'l Illus. *Encyclo.*
1275 The death of St. Cecilia (mourned by two female followers), by the Southern Netherlands school, c. 1600. Rijksmuseum, Amsterdam; *Paintings.*
1276 St. Cecilia (in a turban, holding a violin) by Guido Reni, 1606. Norton Simon Museum of Art, Pasadena CA; Gowing, *Biog. Dict.*
1277 St. Cecilia (playing the keyboard) and an angel (holding her music) by Gentileschi, c. 1610. NGA, Washington DC; Walker, *NGA.*
1278 SS. Cecilia and Valerian crowned by an angel; St. Cecilia in glory (ascending to heaven, as angels carry her attributes); the condemnation of St. Cecilia (man points to her as another drags in a ram); frescoes by Domenichino, 1612–15. Rome, S. Luigi dei Francesi; Spear, *Domenichino.*
1279 St. Cecilia distributing alms to the poor (she hands down clothes from a balcony), by Domenichino, 1612–15. Rome, S. Luigi dei Francesi; Gowing, *Hist. of Art* (p.697); Spear, *Domenichino.*

1280 The martyrdom of St. Cecilia (people gather around her as an angel descends with a palm), by Domenichino, 1612-15. Rome, S. Luigi dei Francesi; Piper, *Illus. Dict.* (p.212); Random House, *Paintings* (185); Spear, *Domenichino.*

1281 St. Cecilia (playing the violin) and angels (singing), by Domenichino. Orléans, Musée des B/A; Boone, *Baroque.*

1282 St. Cecilia (singing, flanked by two angels playing instruments), by Antiveduto Gramatica. Lisbon, Museu Nacional de Arte Antiga; Spear, *Caravaggio.*

1283 St. Cecilia, playing the organ, accompanied by a violinist and a lutist, by Carlo Sellitto, 1613. Capodimonte, Naples; RA, *Painting in Naples.*

1284 St. Cecilia (sitting with a palm and lute, in a blue slashed skirt), by Bernardo Strozzi, 1615-20. Nelson-Atkins Museum of Art, Kansas City MO; *Collections*; *Handbook.*

1285 St. Cecilia (playing a viola) with an angel holding music, by Domenichino, 1620. Louvre, Paris; *Age of Correggio*; Gowing, *Paintings.*

1286 St. Cecilia (playing the organ as an angel crowns her with a flower wreath), oil sketch by P.P. Rubens. Akademie der Bildenden Künste, Vienna; Held, *Oil Sketches* (pl.34).

1287 St. Cecilia (sitting at an organ, as two angels peek over the keyboard), by Giovanni Lanfranco, 1620-21. Bob Jones Univ. Art Gallery, Greenville, SC; Pepper, *Ital. Paintings.*

1288 St. Cecilia playing the organ, anon. Picture Gallery, Dresden; *Old Masters.*

1289 St. Valerian, St. Tiburzio, and St. Cecilia looking up at an angel, by Gentileschi, 1620. Brera, Milan; Book of Art, *Ital. to 1850*; McGraw, *Dict.*; New Int'l Illus. *Encyclo.*; Newsweek, *Brera.*

1290 St. Cecilia (taking a song book from a cherub, as another cherub holds a violin and a third holds a lute), by Domenichino and Antonio Barbalonga, c. 1623-30. Pallavicini-Rospigliosi Palace, Rome; Spear, *Domenichino.*

1291 St. Cecilia (holding a violin and music score) and St. Dorothy (holding a bowl of fruit), by the School of Emilia, 1620's. Walters Art Gallery, Baltimore; *Italian Paintings* (Vol.II).

1292 St. Cecilia (playing the keyboard as cherubs hold the score for her), by Nicolas Poussin, c. 1629. Prado, Madrid; Oberhuber, *Poussin*; Wright, *Poussin.*

1293 St. Cecilia (playing the organ, surrounded by cherubs), by P.P. Rubens, 1639-40. Picture Gallery, Berlin; Alpers, *Art of Describing*; DeBles, *Saints in Art*; *Masterworks.*

1294 St. Cecilia (half-view with her face half-shadowed; a cherub hands her a flower from behind), by Jacopo Vignali. Crocker Art Gallery, Sacramento CA; *Catalogue.*

1295 St. Cecilia (about to be crowned with a circlet of flowers by an angel) by Bernardo Cavallino, 1645. Vecchio Palace, Florence; Murray, *Art & Artists*; RA, *Painting in Naples.*

1296 St. Cecilia playing the violin, by Bernardo Cavallino, c. 1645. Boston Museum of Fine Arts.

1297 St. Cecilia, crowned by an angel with a floral crown, by Bernardo Cavallino, 1645. Capodimonte, Naples; New Int'l Illus. *Encyclo.*

1298 St. Cecilia and angel musicians (she plays the organ accompanied by angels, while she is crowned with a flower wreath), by Giovanni Battista Beinaschi, 1650-88. Bob Jones Univ. Art Gallery, Greenville, SC; Pepper, *Ital. Paintings.*

1299 St. Cecilia (in contemporary dress, sitting and playing the organ) copy after Carlo Dolci, c. 1670. Hermitage, St. Petersburg; Eisler, *Hermitage.*

1300 St. Cecilia and angels (playing instruments), by Gherardi, before 1692. Rome, S. Carlo ai Catinari; Waterhouse, *Roman Baroque.*

1301 St. Cecilia (playing the organ), by Corrado Giaquinto. Coll. D. Stephen Pepper, NY; Yale Univ., *Taste* (cat.47).

1302 St. Cecilia distributing her goods to the poor (they hang from the balcony to reach her), by Domenico Zampieri, 1753. Grenoble, Musée de Peinture et de Sculpture; Chiarini, *Tableaux Italiens.*

1303 St. Cecilia (about to turn the page of a book, looking upwards), by unknown artist of the French School, c. 1825-50. Hermitage, St. Petersburg; Berezina, *French Painting.*

1304 St. Cecilia (sleeping in a chair, as angels play violins), by John William Waterhouse. Maas Gallery; Wood, *Dict. of Victorian Painters.*

1305 St. Cecilia (playing a tiny pipe

organ), stained-glass window designed by Sir Edward Burne-Jones, c. 1880–85. Princeton Univ. Art Museum.
1306 St. Cecilia and angel musicians (she is sitting on a balustrade, leaning on a harp, while angels play instruments above her head), by Gustave Moreau, 1895. Private coll., Japan; Moreau, *Gustave Moreau.*
See also 70, 75, 143, 1054, 3558, 4798, 4799, 4802, 4803

Celestine I, Pope, r. 422–32 (July 27 & Apr. 6)
1307 St. Celestine I, mosaic. Rome, St. Paul-Outside-the-Walls; Brusher, *Popes.*

Celestine V *see* **Peter Celestine**

Celsus or Cellach, archdeacon of Armagh, d. 1129 (Apr. 7)
1308 Christ in Glory (above, with angels) with SS. Celsus, Julian, Marcionilla, and Basilissa, by Pompeo Batoni, c. 1736–38. Rome, SS. Celso e Giuliano; Clark, *Batoni.*
See also 3180, 3518

Charalambios, bishop in Magnesia; flayed to death; mart. 202 (Feb. 10)
1309 Saints Charalambios, Onophrius (as a hermit) and Marina, icon from Melnik, 18th cent. Bulgaria, National Archaeological Museum; Paskaleva, *Bulgarian Icons.*

Chariton, of Palestine, hermit, d. 340 (Sept. 28)
1310 Saint Chariton, fresco, 1176–80. Patmos; Kominis, *Patmos* (p.91).

Charles Borromeo, Cardinal Archbishop of Milan, co-patron of Bologna, d. 1580, canon. 1610 (Nov. 4)
1311 Pilgrimage of St. Charles Borromeo to the Sacred Mount of Varalio (he is blessing bread), by Cesare Nebbia. Pavia, Collegia Borromeo; Bentley, *Calendar* (detail).
1312 Dinner of St. Charles Borromeo (he sits at a table, eating a piece of bread and reading from a book; two men peek in at the door), by Daniele Crespi. Milan, Santa Maria della Passione; Fiorio, *Le Chiese di Milano.*
1313 St. Charles Borromeo administering the Eucharist (baptizing a baby), by Ludovico Carracci. Nonantola, Abbey Church; Freedberg, *Circa 1600.*

1314 St. Charles erecting the crosses at the gates of Milan, by Giovanni Battista Crespi, 1602–03. Milan Cathedral; New Int'l Illus. *Encyclo.*
1315 St. Carlo Borromeo (in ecstasy, looking up at a celestial light), by Orazio Borgianni, c. 1610–16. Hermitage, St. Petersburg; Eisler, *Hermitage.*
1316 St. Charles Borromeo adoring the crucified Christ (while cherubs catch His blood in chalices), by Morazzone. Rome, Museo Diocesano; *Tresori d'Arte.*
1317 St. Charles Borromeo in glory (enthroned, surrounded by cherubs, he gestures toward heaven, as the Holy Spirit hovers above his head), by Giulio Cesare Procaccini, 1610. Milan, San Tomaso in Terra Amara; Fiorio, *Le Chiese di Milano.*
1318 Ecstasy of St. Charles Borromeo (ascending to heaven on clouds, supported by cherubs; he holds out his arms in ecstasy), by Il Morazzone, c. 1611. Milan, Sant'Angelo; Fiorio, *Le Chiese di Milano.*
1319 St. Charles Borromeo and the Rospigliosi family (they greet him in the street, and a daughter kneels for a blessing), by Jacopo da Empoli, c. 1613. Vassar College Art Gallery, NY; *Paintings, 1300–1900.*
1320 St. Charles Borromeo in glory (standing on a cloud, holding a crosier while a cherub holds his staff), by Giovan Battista Crespi, c. 1615. Rome, Museo Diocesano; *Tresori d'Arte.*
1321 Madonna and Child with Saints Charles Borromeo and Bartholomew, by Giovanni Lanfranco, c. 1616. Capodimonte, Naples; *Age of Correggio.*
1322 St. Charles Borromeo praying, as angels offer a garland of roses, by Giovanni Lanfranco, c. 1617–18. Picture Gallery, Berlin; *Catalogue.*
1323 SS. Charles Borromeo and Philip Neri kneeling before the Virgin and Child, by Bartolomeo Cesi. Propaganda Fide, Rome; Waterhouse, *Roman Baroque.*
1324 St. Charles Borromeo giving communion to the plague-stricken of Milan, by Gaspar de Crayer. Nancy, Musée des B/A; *Musée*; Pétry, *Musée.*
1325 St. Charles Borromeo (kneeling at prayer, lit by a beam from heaven), by Philippe de Champagne, c. 1656. Orléans, Musée des B/A; O'Neill, *L'Ecole Francaise.*

1326 Candlelight procession of St. Carlo Borromeo, by Pietro da Cortona, 1667. Rome, S. Carlo ai Catinari; Held, *17th & 18th Cent.*

1327 St. Charles Borromeo distributing the last sacrament to plague victims of Milan, by Jean-Erasmus Quellin, 1694. Malines, St.-Catherine-et-St.-Alexis Church; Hairs, *Sillage de Rubens.*

1328 Portrait bust of St. Charles Borromeo in left profile, by Giuseppe Maria Crespi. Ambrosiana, Milan; Coulson, *Saints.*

1329 Madonna and Child surrounded by angels, and St. Charles Borromeo, by Pittoni. Brescia, S. Maria della Pace; Boccazzi, *Pittoni* (pl.392).

1330 St. Charles Borromeo displaying the holy nail to Saints Francis of Sales and Philip Neri (he stands at the altar and points to the nail embedded in a crucifix), by Francesco Trevisani, c. 1725. Camerino (Macerata) Museo Diocesano; DiFederico, *Trevisani.*

1331 Assumption of the Virgin in the presence of SS. Charles Borromeo and Léonce, by Subleyras, c. 1728. Bourg-en-Bresse, Musée de Brou; *Subleyras.*

1332 Assumption of the Virgin in the presence of SS. Charles Borromeo and Léonce, by Subleyras, c. 1728. Grasse, Cathedral; *Subleyras.*

1333 St. Charles Borromeo praying for the end of the plague in Milan, relief by Pierre Puget, 1730. Marseille, Musée des B/A; *Amours.*

1334 St. Charles Borromeo giving alms (to a woman holding a baby; he is dressed in archbishop's robes), by Pierre-Louis Dumesnil Le Jeune, 1741. Ponce, Museo de Arte; Held, *Catalogue.*

1335 St. Charles Borromeo (looking down at a crucifix in ecstasy, hand crossed on his chest), by Giovanni Battista Tiepolo, 1767–69. Cincinnati Art Museum, OH; *Handbook; Masterpieces;* Morassi, *Catalogue* (pl.190).

1336 St. Charles Borromeo meditating on the crucifix (which is leaning against a table), by Giovanni Battista Tiepolo, 1767–69. Courtauld Inst. of Art, London; *Catalogue;* Morassi, *Tiepolo.*

1337 St. Charles of Borromeo administering the sacrament to the plague-stricken, by Casper Franz Sambach. Esztergom Christian Museum; *Christian Art in Hungary* (pl.XV/360).

1338 St. Charles Borromeo giving communion to the plague-stricken, by Januarius Zick, 1787. Picture Gallery, Berlin; Murray, *Art & Artists.*

See also 1182, 1835, 2692, 3108, 3224, 4035, 4734

Christina of Bolsena, patron of Bolsena, thrown by her father into the lake of Bolsena; killed with arrows; mart. 3rd cent. (July 24)

1339 Martyrdoms of St. Christina of Bolsena: she is tied to a wheel and is roasted, unharmed; she is tied to an iron bed and roasted over fire, unharmed; she is thrown into a lake with a millstone around her neck and is saved by angels; she is thrown into an oven; snakes are thrown into her cell, but do not harm her; partially destroyed frescoes by the School of the Alto Adige, 14th cent. Bressanone, S. Giovanni; Kaftal, *North East Italy.*

1340 St. Christina of Bolsena (holding a book and a millstone), fresco by Nardo di Cione. Florence, S. Maria Novella; Kaftal, *Tuscan.*

1341 St. Christina of Bolsena (holding a book and an arrow), from a polyptych by Sano di Pietro. Bolsena, S. Cristina; Kaftal, *Tuscan.*

1342 Saints Catherine, Margaret (with the dragon), Martha, Christine (with a book) and Barbara (with her tower), from the "Boucicaut Hours" painted by the Boucicaut Master, ms.2,fo.40v. Jacquemart-André Museum, Paris; Meiss, *French Painting.*

1343 Virgin and Child (crowned by angels) with SS. Sebastian (filled with arrows), Jerome (reading, holding a scroll), Nicholas of Bari (reading, three balls at his feet) and Christina (holding an arrow), by Luca Signorelli. Nat'l Gallery, London; Levey, *Nat'l Gallery.*

1344 St. Christina (arms crossed) and St. Ottilie (holding a book), side panel from St. Catherine Altarpiece by Lucas Cranach the Elder, 1506. Nat'l Gallery, London; Friedländer, *Cranach;* Schade, *Cranach.*

1345 St. Christina of Bolsena holding two arrows, by Master of the Boissiere Bartholomew. Alte Pinakothek, Munich; Coulson, *Saints.*

1346 St. Christina (kneeling at the lake shore in prayer, as angels hold a millstone tied by a rope to her neck), by Vincenzo Catena. Venice, Santa Maria Mater Domini; Berenson, *Ital. Painters;* New Int'l Illus. *Encyclo.*

1347 St. Christine refuses her father's command to sacrifice to an idol, by David Teniers the Elder, 1617. Termonde, Notre-Dame Church; Hairs, *Sillage de Rubens.*

1348 St. Christina, by Francisco de Zurbaran, 1641–58. Strasbourg Fine Arts Museum; Gállego, *Zurbaran.*

See also 4582

Christogon *see* 982

Christopher, 3rd cent., patron of travelers (July 25)

1349 St. Christopher, wearing a hat and holding an oar, from "Apocalypse and Latin Commentary of Berengaudus," English, second half of 13th cent. Canterbury Diocese; Burlington, *Illum. MS.*

1350 St. Christopher carrying the Christ Child, a small wing of a portable altarpiece by Bernardo Daddi. Coll. Bernard Berenson, Villa I Tatti, Florence; Cooper, *Private Collections.*

1351 Saints Anthony (in black, holding a book and staff) and Christopher (standing in water with the Christ Child), wings of the Coronation of the Virgin altarpiece by Niccolo di Tommaso. Walters Art Gallery, Baltimore; *Italian Paintings* (Vol.I).

1352 SS. Luke and Christopher (carrying the Child, with fish at his feet), panel by Lorenzo di Bicci. Bob Jones Univ. Art Gallery, Greenville, SC; Pepper, *Ital. Paintings.*

1353 St. Christopher (holding a heavy staff, carrying the Child), lindenwood statue, West German or French, c. 1390. M. H. de Young Memorial Museum, San Francisco CA; *European Works.*

1354 St. Christopher carrying the Child, from "Book of Hours 19263" ms Canonici Liturg. 118. Bodleian Library, Oxford; Panofsky, *Early Nether.*

1355 St. Christopher (crossing the river, with a starry sky in background), from the "Boucicaut Hours" painted by the Boucicaut Master, ms.2, fo.28v. Jacquemart-André Museum, Paris; Meiss, *French Painting.*

1356 St. Christopher and St. Anthony, from "Hours of Daniel Rym," ms.166, fo.160v. Walters Art Gallery, Baltimore; Panofsky, *Early Nether.*

1357 St. Christopher beckoning to the Child, by Master of the Guelders, 1400–10. Mayer van den Bergh Museum,

Antwerp; Châtelet, *Early Dutch* (pl.9); New Int'l Illus. *Encyclo.* (see Gothic); Panofsky, *Early Nether.*

1358 St. Christopher, carrying the Child, leans on his staff, from "Book of Hours" ms. 57, fo.65v. Carpentras, Biblio. de la Ville; Panofsky, *Early Nether.*

1359 St. Christopher crossing with the Child, lit by a man in a cave, from "Beaufort Hours" ms Royal 2 A xviii, fo.11v. BM, London; Panofsky, *Early Nether.*

1360 St. Christopher carrying the Child, looking back at house (jutting out from picture) from "Hours of John the Fearless" ms lat. nouv. acq. 3055, fo.178. BN, Paris; Panofsky, *Early Nether.*

1361 St. Christopher (pulling his cloak above the water as he carries the Child), from the Hours of St. Maur. painted by a follower of the Boucicaut Master, ms. nouv. acq. lat.3107, fo.217v. BN, Paris; Châteauroux; Meiss, *French Painting.*

1362 St. Christopher (crossing the stream, while the Child points to heaven), min. by the Rohan Master from a Book of Hours, ms. Latin 9471, f.220, c. 1415–16. BN, Paris; *Rohan Master* (pl.99).

1363 Martyrdom of St. Christopher (he is decapitated; they collect his blood to pour it into the eye of King Dagnus; King Dagnus is baptized), frescoes att. to Bertolino dei Grossi, 1417–22. Parma, Cathedral; Kaftal, *North East Italy.*

1364 Martyrdoms of St. Christopher: he converts the two courtesans that are sent to convert him; they destroy the idols and are beheaded; Christopher is seated on an iron stool above a fire; and a red hot helmet is placed on his head; he is tied to a stake and shot with arrows, but the arrows stop in mid-air; one arrow plunges into the king's eye, frescoes att. to Bertolino dei Grossi, 1417–22. Parma, Cathedral; Kaftal, *North East Italy.*

1365 St. Christopher leaning on a staff, carrying the Child dressed in black, by anon. Viennese workshop, c. 1420–40. Picture Gallery, Berlin; *Catalogue.*

1366 St. Christopher (holding onto a tree as he crosses the river), called The Buxheim St. Christopher, earliest known dated woodcut, 1423. John Ryland's Library, Manchester; *German Book Illus.* (Vol.80, pl.2); Gowing, *Hist. of Art* (pl.639); *Illus. Bartsch*; McGraw, *Encyclo.* (Vol.IV, pl.423); Murray, *Art & Artists*; New Int'l Illus. *Encyclo.* (see Woodcut).

1367 St. Christopher (the Child stands on his shoulder as he crosses, encircled by ripples), by Konrad Witz, c. 1435. Basel, Kunstmuseum; *150 Paintings.*
1368 St. Christopher, woodcut from "Annunciation" by Jacques Daret, c. 1435. Brussels, Musées Royaux des B/A; Janson, *History* (pl.482).
1369 St. Christopher carrying the Child with billowing cloak, as an old man on the shore holds out a lantern, by follower of Jan van Eyck, 1440–50. Philadelphia Museum of Art, PA.
1370 St. Christopher, silver point drawing by Jan van Eyck. Louvre, Paris; Coulson, *Saints.*
1371 St. Christopher with blowing mantle traversing high waves, carrying the Child on his head, by circle of Konrad Witz, 1444–50. Picture Gallery, Berlin; *Catalogue.*
1372 Martyrdom of St. Christopher (the king is seen in an upper window with an arrow in his eye), fresco by Andrea Mantegna. Padua, Church of the Eremitani; McGraw, *Encyclo.* (Vol.IX, pl.324).
1373 St. Christopher (crossing between several tiny cities), from "Book of Hours of the Virgin" of the use of Rome, Spanish, 1450–1500. Coll. C. W. Dyson Perrins; Burlington, *Illum. MS.*
1374 St. Christopher carrying the Christ Child, marble sculpture by unknown 15th cent. French sculptor. Portland Art Museum, OR; Phaidon, *Art Treasures.*
1375 St. Christopher converts the soldiers who are sent to arrest him; after he is martyred, St. Christopher's body is dragged away, because it is too large to carry; frescoes by Andrea Mantegna. Padua, Church of the Eremitani; Kaftal, *North East Italy.*
1376 St. Christopher, crossing in a canyon, dragging his cloak in the water, from "The Pearl of Brabant" triptych by a follower of Dirck Bouts, second half of 15th cent. Alte Pinakothek, Munich; Bentley, *Calendar*; Panofsky, *Early Nether.*; Praeger, *Great Galleries.*
1377 St. Christopher (standing at the edge of the water before a straw hut), fresco by Bono da Ferrara, c. 1451. Padua, Church of the Eremitani; McGraw, *Encyclo.* (Vol.XII, pl.33).
1378 St. Christopher before the king (with a dwarf outside the door); St.

Christopher refusing to follow the devil (who is on horseback), frescoes by Asuino da Forlì, c. 1454. Padua, Church of the Eremitani; Lavin, *Narrative.*
1379 Saint Christopher crossing, in a blue tunic and red cloak, holding staff with both hands, from "Altarpiece of St. Vincent Ferrer" by Giovanni Bellini, c. 1465. Venice, SS. Giovanni e Paolo; New Int'l Illus. *Encyclo.* (see Venetian Art).
1380 Saint Christopher (carrying the Child) and Saint Peter (with a book and a key), panel from the high altar of Bern Minster by Heinrich Büchler, 1468. Kunstmuseum, Bern; Deuchler, *Swiss Painting.*
1381 St. Christopher preaching (to kneeling soldiers), fresco by Ansuino da Forlì (destroyed in 1944). Formerly Church of the Eremitani, Padua; Ruhmer, *Tura.*
1382 St. Christopher with the infant Christ (holding an orb); Christopher crosses with a hand on his left hip, by Ghirlandaio, c. 1475. Met Museum; Hibbard, *Met Museum.*
1383 St. Christopher (city in background), by Hans Memling, c. 1479–80. Cincinnati Art Museum, OH; *Handbook*; *Masterpieces.*
1384 St. Christopher (crossing, holding a flowering staff) flanked by SS. Maurus (reading, holding a staff topped by a cross) and St. Giles (holding a book, petting the hind), with donor William Moreel and family presented by SS. George and Barbara on the wings, from Moreel triptych by Hans Memling, 1484. Bruges, State Museum; Pauwels, *Musée Groeninge.*
1385 St. Christopher carrying the Christ Child (who stands on his shoulders), by Cosimo Tura, c. 1484. Formerly Kaiser Friedrich Museum, Berlin; Ruhmer, *Tura.*
1386 St. Christopher (sitting, looking across the river), ms. illum. by the Master of Charles V, ms.1859, fol.231r. ON, Vienna; Dogaer, *Flemish Min.*
1387 St. Christopher (one foot out of the water, looking at the Child on his shoulder), by Master of Frankfurt. Mauritshuis, The Hague; *Catalogue*; Hoetink, *Mauritshuis.*
1388 St. Christopher, crossing in a gorge, in a red cloak, wearing a white headband, by Quentin Metsys or studio of Metsys, c. 1490. Allentown Art

Museum, PA; Eisler, *European Schools*; Phaidon, *Art Treasures*; Samuel H. Kress.

1389 The Crucifixion before a river landscape, with St. Jerome (kneeling, smiting his breast with a rock) and St. Christopher (standing in the water, carrying baby Jesus), by Bernardino Pinturicchio. Borghese Gallery, Rome; Arcona, *Garden* (fig.111); Bentley, *Calendar*; Denvir, *Art Treasures*; Praeger, *Great Galleries*.

1390 St. Christopher (looking up at the Child as he crosses), woodcut by Albrecht Dürer. Strauss, *Woodcuts* (pl.29).

1391 St. Christopher (wearing a short tunic, crossing while the Child holds up a hand in blessing), att. to the Master of St. Ildefonso, late 15th cent. Fogg Art Museum, Cambridge MA; Mortimer, *Harvard Univ.*

1392 St. Christopher (crossing with the Child) and the birds in flight, woodcut by Albrecht Dürer, Bremem, c. 1500. Geisberg, *Single Leaf*; Strauss, *Woodcuts* (pl.86).

1393 St. Christopher ferrying the Christ Child (in a landscape), by Joachim Patiner. El Escorial, Spain; McGraw, *Encyclo.* (Vol.XII, pl.378).

1394 St. Christopher in ankle-deep water, no landscape, pen and wash drawing by Niklas Manuel. Bern, Kunstmuseum; Book of Art, *German & Spanish*.

1395 St. Christopher stepping out of the water (Child Jesus holds a little banner) by Master with the Embroidered Leaves, c. 1500. Picture Gallery, Dresden; *Old Masters*.

1396 St. Christopher (pulling himself onto the bank), woodcut by Lucas Cranach the Elder, Munich, 1506. Geisberg, *Single Leaf*.

1397 SS. Elizabeth (reading, with a donor), Anne, Christopher (with a tree branch and a large pouch, carrying the Child) and George (holding the tail of the dragon), altarpiece shutters by Lucas Cranach the Elder, 1508-10. Thyssen-Bornemisza Coll., Lugano; Friedländer, *Cranach*.

1398 St. Christopher (with a beard) and the Christ Child (with a mermaid in the water; the Child points forward with two fingers, by Lucas Cranach the Elder. Cummer Gallery of Art, Jacksonville FL; *Handbook*.

1399 St. Christopher (falling onto the water), drawing by Albrecht Altdorfer, c. 1509. Albertina, Vienna; Guillaud, *Altdorfer*.

1400 Landscape with the legend of St. Christopher (he is climbing out of the water balancing the Christ Child on an orb; several grotesques carrying everyday attributes crowd boats in the water), by Jan Mandyn, early 16th cent. Hermitage, St. Petersburg; Eisler, *Hermitage*; Nikulin, *Soviet Museums*.

1401 Saint Christopher and the Virgin, by follower of Master of Alkmaar, 1510. Philadelphia Museum of Art, PA.

1402 St. Christopher (crossing the river, looking up at the Christ Child who speaks to him, holding out an orb), by Cesare da Sesto. Sforza Castle, Milan; Sedini, *Marco d'Oggiono* (p.209).

1403 St. Christopher (with a forked beard) and the infant Jesus, by the school of Lucas Cranach the Elder. Esztergom Christian Museum; *Christian Art in Hungary* (pl.XIV/337).

1404 St. Christopher (with a headband and pouch), att. to Albrecht Dürer (missing since 1945). Formerly Staatliche Galerie, Dessau; Strieder, *Dürer*.

1405 St. Christopher with a forked walking stick (Child stands on his shoulders, arm wrapped around stick), drawing on blue paper by Albrecht Altdorfer, 1510. Hamburg, Kunsthalle; Guillaud, *Altdorfer*.

1406 St. Christopher (knee deep in water, as the Child leans on his head), woodcut by Albrecht Dürer, 1511. Strauss, *Woodcuts* (pl.166).

1407 St. Christopher (standing in the water, looking up at the Child on his shoulders), woodcut by Hans Baldung Grien, Aschaffenburg, c. 1511. Geisberg, *Single-leaf*.

1408 The Virgin of Christopher Columbus (Columbus kneels before the Virgin, presented by St. Christopher), anon., early 16th cent. Lázaro Galdiano Museum, Madrid; Smith, *Spain*.

1409 St. Christopher (on one knee before a tree, leaning on his walking stick), woodcut by Albrecht Altdorfer, Nuremberg, c. 1513. Geisberg, *Single-Leaf* (Vol.I).

1410 St. Christopher leaving his master (his master rides away on a rearing white horse at a crossroads, while Christopher waves farewell, walking barefoot), illum. by Jean Bourdichon from the

Great Book of Hours of Henry VIII, 1514-18. Coll. Duke of Cumberland; *Great Hours.*

1411 St. Christopher (crossing the river, looking up at the Christ Child), by a follower of Pordenone, c. 1515. Indiana University, Bloomington IN; Shapley, *15th-16th Cent.*

1412 St. Christopher at the shore (sitting, with the Christ Child), woodcut by Albrecht Altdorfer, Nuremberg, c. 1515-17. Geisberg, *Single-Leaf* (Vol.I).

1413 St. Christopher (in a red cloak with a white cloth tied around his head, holding a forked staff and carrying the Child) by Quentin Metsys. Antwerp, Musée Royal des B/A; Bosque, *Metsys.*

1414 St. Christopher (crossing, with a mermaid in the foreground), by Lucas Cranach the Elder, 1518-20. Detroit Inst. of Art, MI; Friedländer, *Cranach.*

1415 St. Christopher (crossing, with a shark and a mermaid in the foreground), by Lucas Cranach the Elder, 1518-20. Coll. Frau Meyer-Glitza, Hamburg; Friedländer, *Cranach.*

1416 Landscape in the Thebaid with scenes from the lives of the saints, with St. Francis receiving the stigmata, St. Jerome with the crucifix, St. Catherine kneeling by the wheel, St. Christopher crossing the water, St. George killing the dragon, by Dosso Dossi. Pushkin Museum, Moscow; Malitskaya, *Great Paintings.*

1417 St. Christopher (as they climb out of the water, Child points up; coats of arms hang from tree branches), woodcut by Lucas Cranach the Elder. Strauss, *The Illus. Bartsch* (Vol.11, no.58).

1418 St. Christopher (leaning on his staff in ankle-deep water, filled with fishes), formerly att. to Matteo Balducci. Christ Church, Oxford; Shaw, *Old Masters.*

1419 St. Christopher wading between two boulders, by Quentin Metsys. Kress Coll., NY; Ferguson, *Signs.*

1420 St. Christopher (crossing in ankle-deep water, city landscape in lower left corner), by Titian, c. 1523. Venice Ducal Palace; Wethey, *Titian* (pl.151).

1421 St. Christopher (crossing; Child puts a hand on his head), woodcut by Hans Sebald Beham, Hamburg, c. 1528. Geisberg, *Single-leaf.*

1422 St. Christopher bearing the Christ Child (the Child hangs onto his hair), drawing by Giovanni Antonio da Pordenone. Met Museum; Bean, *15th & 16th Cent.*

1423 SS. Christopher, Sebastian, and Roch, by Lorenzo Lotto, 1531. Loreto, Apostolico Palace; Berenson, *Lotto*; Burckhardt, *Altarpiece.*

1424 St. Christopher and St. Sebastian, by Lorenzo Lotto, 1531. Formerly Kaiser Friedrich Museum, Berlin; Berenson, *Lotto.*

1425 St. Christopher (emerging from the water, while the Child straddles his neck, holding an orb), by Bastarolo, c. 1538. Ferrara, Pinacoteca Nazionale; Frabetti, *Manieristi.*

1426 Martyrdom of St. Christopher (he kneels, stripped to the waist, beside his armor, while a swordsman draws back to strike), by Tintoretto, c. 1560. Venice, Madonna dell'Orto; Tietze, *Tintoretto.*

1427 St. Christopher coming out of the water in discussion with Christ Child who is pointing up, by Orazio Gentileschi, 1600-10. Picture Gallery, Berlin; *Catalogue.*

1428 St. Christopher (carrying the Christ Child in the dark, lit by the moon), oil on copper by Adam Elsheimer. Hermitage, St. Petersburg; Eisler, *Hermitage.*

1429 St. Christopher (stepping from the water with a tiny Child on his shoulders, leaning on a tree-branch staff) by Orazio Borgianni, 1610-15. NGS, Edinburgh; Met Museum, *Caravaggio*; NGS, *Illustrations.*

1430 A burly St. Christopher, leaning on a thick staff, left wing of "Descent from the Cross" triptych by P.P. Rubens, 1614. Antwerp, Our Lady Cathedral; Baudouin, *Rubens.*

1431 St. Christopher and the hermit (the hermit shines a light on the Child as Christopher exits from the water), by P.P. Rubens, c. 1614. Alte Pinakothek, Munich; Jaffé, *Rubens and Italy*; White, *Rubens.*

1432 St. Christopher carrying the Christ Child (lit by the beggar's candle), by Jacob Jordaens, c. 1630. Ulster Museum Art Gallery, Belfast; d'Hulst, *Jordaens.*

1433 St. Christopher carrying the infant Christ, one-third view by Giovanni Battista Piazzetta, c. 1730. Met Museum; Hibbard, *Met Museum.*

1434 Saints George and Christopher Kynokephalos (who has the head of a

dog, and carries the Christ Child on his shoulder), icon fresco, 1745. Church of St. George of Arpera, near Tersephanou; Stylianou, *Painted Churches* (p.445). *See also* 3426, 3628, 4299, 4760

Chrysanthus, Roman knight; stoned and burned alive after tortures; mart. 283 (Oct. 25)
1435 The torture of St. Chrysanthus (wrapped in a bull hide), copy of a lost oil sketch by P.P. Rubens. Private coll., NY; Held, *Oil Sketches.*

Chrysogonus, Roman knight; beheaded and thrown into the sea; mart. 304 (Nov. 24)
1436 St. Chrysogonus in armor on horseback, att. to Jacopo Bellini. Venice, SS. Gervasio e Protasio; Coulson, *Saints.*
1437 St. Chrysogonus (mounted on a white horse, in black armor and holding a lance), from an altarpiece by Michele Giambono. Venice, S. Trovaso; Kaftal, *North East Italy.*
1438 St. Chrysogonus glorified (with angels), by Guercino. Rome, Galleria Nazionale; Bentley, *Calendar.*
See also 3888

Ciriacus
1439 Saint Ciriacus holding a sword and a palm, panel from an altarpiece by Master of Messkirch, c. 1530–43. Philadelphia Museum of Art, PA.

Clara of Montefalco, Franciscan nun, patron of Montefalco, d. 1308 (Aug. 18)
1440 St. Clara of Montefalco holding a plate with a heart and a small crucifix, by Francesco Melanzio. Montefalco, S. Francesco; Coulson, *Saints*; Kaftal, *Central & So. Ital.*
1441 St. Clara of Montefalco holding three nails, from Flemish stained-glass window, 16th cent. Private coll.; Drake, *Saints and Emblems.*
See also 202

Clare, Foundress of the 2nd Order of St. Francis, d. 1253, canon. 1255 (Aug. 12)
1442 Owner of book kneeling before St. Clare, from Flemish Psalter, 1250–1300. Pierpont Morgan Library, NY; Burlington, *Illum. Ms.*
1443 Christ mounting the cross and the death of Saint Clare (she is lowered into her coffin), by an unknown Duecento artist, late 13th cent. Wellesley College, MA; Edgerton, *Punishment.*
1444 St. Clare, fresco by Cimabue, before 1302. San Francesco, Assisi; Coulson, *Saints.*
1445 Crucifixion with SS. Clare and Francis (who kneel between the Virgin and St. John), by Pietro Lorenzetti, c. 1320. Fogg Art Museum, Cambridge MA; Mortimer, *Harvard Univ.*
1446 St. Clare praying for the safety of Assisi (with two standing nuns before the city), stained-glass window, c. 1325–30. Königsfelden (Aargau), Abbey Church; Deuchler, *Swiss Painting.*
1447 St. Clare with a halo, fresco by Simone Martini, 1325–26. San Francesco, Assisi; Colombo, *World Painting*; New Int'l Illus. *Encyclo.* (see Techniques).
1448 Death of St. Clare (the Virgin brings her a pall of great beauty, as the nuns surround her bed), panel of a triptych att. to Paolo Veneziano. Trieste, Museo Civico di Storia e d'Arte; Kaftal, *North East Italy.*
1449 St. Francis of Assisi (holding a crucifix and parting his robe to show his stigmata) and St. Clare (in a nun's habit), fresco by Ferrer Bassa, early 14th cent. Pedralbes Convent; Lassaigne, *Spanish.*
1450 St. Clare in nun's habit, holding a torch, att. to Pietro Lorenzetti, c. 1335. Univ. of Georgia, Alabama GA; Shapley, *Samuel H. Kress.*
1451 St. Clare kneeling with St. Francis of Assisi (he holds a scroll up to heaven), fresco by the Lombard School, 1347. Bergamo, S. Maria Maggiore; Kaftal, *North West Italy.*
1452 Scenes from the lives of St. Francis (receiving the stigmata), St. Bartholomew (martyred), St. Clare (workmen fall from a house onto spectators below), and Catherine (tortured on the wheel), altar panels by the workshop of Guido da Siena. Siena, Pinacoteca Nazionale; Hills, *The Light.*
1453 Death and coronation of St. Clare (she is embraced on her deathbed by a female saint, as others look on; above she is crowned in heaven), from an altarpiece of the life of St. Clare, c. 1360. Germanisches Nationalmuseum, Nuremberg; Met Museum, *Gothic Art.*
1454 The bishop of Assisi giving a palm to St. Clare (as they stand at an altar), from an altarpiece of the life of St.

Clare, c. 1360. Met Museum; Met Museum, *Gothic Art.*

1455 Clare blesses the bread of Innocent IV (imprinting a deep cross on the loaves), predella panel by Giovanni di Paolo. Coll. Jarves, New Haven CT; Kaftal, *Tuscan.*

1456 St. Clare saves a ship in distress (posthumously), predella panel by Giovanni di Paolo. Philadelphia Museum of Art, PA; Kaftal, *Tuscan.*

1457 Saint Clare on her deathbed, Gothic tapestry, c. 1400. Bernheimer Gallery, Munich; New Int'l Illus. *Encyclo.* (see Gothic).

1458 St. Clare in nun's habit, standing before a vase, by Andrea Vanni, c. 1400. Pomona College, Claremont CA; Shapley, *Samuel H. Kress.*

1459 The death of St. Clare (female saints surround her bed, and one supports her chin), by Master of Heiligenkreuz, 1410. NGA., Washington DC; Newsweek, *Nat'l Gall.*; Phaidon, *Art Treasures.*

1460 Altarpiece of St. Clare, by Luis Borrassa, 1415. Episcopal Museum, Vich, Spain; McGraw, *Encyclo.* (Vol.VI, pl.335).

1461 St. James the Great (holding a pilgrim's staff) and St. Clare, by Master of Flémalle. Prado, Madrid; Panofsky, *Early Nether.*

1462 A miracle of St. Clare (kneeling before Pope Innocent IV, she blesses a loaf of bread and it breaks into four parts), by Giovanni di Paolo. Yale Univ. Art Gallery, CT; Christiansen, *Siena.*

1463 St. Clare rescuing the shipwrecked, by Giovanni di Paolo, mid-15th cent. Picture Gallery, Berlin; *Catalogue*; Christiansen, *Siena.*

1464 Investiture of St. Clare (by St. Francis), by Giovanni di Paolo, c. 1455-60. Picture Gallery, Berlin; *Catalogue*; Christiansen, *Siena.*

1465 St. Clare saving a child mauled by a wolf (wolf has child's arm in its mouth), by Giovanni di Paolo, mid-1450's. Houston Museum of Fine Arts, TX; Christiansen, *Siena*; *Guide to the Collection*; *Permanent Legacy.*

1466 St. Bernardino of Siena (holding a disc) and St. Clare (holding a lily), by Carlo Crivelli, 1485-90. Worcester Art Museum; *Handbook.*

1467 St. Clare (in nun's habit, holding a crucifix and a book), by Alvise Vivarini. Accademia, Venice; McGraw, *Encyclo.* (Vol.XII, pl.375).

1468 St. Clare (in a nun's habit, holding a host), by Marco d'Oggiono. Arcivescovile Gallery, Milan; Sedini, *Marco d'Oggiono* (p.118).

1469 St. Clare of Assisi (wearing a nun's habit and holding a lily and a crucifix), by Benedetto Coda, c. 1515-20. Walters Art Gallery, Baltimore; *Italian Paintings* (Vol.II).

1470 St. Clare taking her vow (arms spread against the steps before the altar); miracles of St. Clare, by Lorenzo Lotto, 1524. Oratorio Suardi, Trescore; Berenson, *Lotto*; McGraw, *Encyclo.* (Vol.IX, pl.209).

1471 St. Francis and St. Clare (she is tending the stigmata wound on his hand, lit by a candle), by Trophime Bigot. Coll. Guglielmo Maccaferri, Bologna; Nicolson, *Caravaggesque Movement.*

1472 St. Clare of Assisi preparatory oil sketch, for the ceiling of the Jesuit Church in Antwerp by P.P. Rubens. Ashmolean Museum, Oxford; Rowlands, *Rubens, Drawings.*

1473 St. Clare (with a reliquary) and St. Francis receiving the stigmata (he bends backward in the light), side panels from the dismembered "St. Francis Receiving the Infant Jesus from the Hands of the Virgin" altarpiece by P.P. Rubens, 1618. Lier, Church of St. Grommaire; United Nations, *Dismembered Works.*

1474 St. Clara of Assisi (sitting in a chair, holding a reliquary, attended by two nuns), oil sketch by P.P. Rubens. Private coll., Paris; Held, *Oil Sketches* (pl.35).

1475 St. Clare between the fathers of the Church (framed by pillars), by P.P. Rubens. Prado, Madrid; *Peinture Flamande* (b/w pl.280).

1476 St. Francis cutting the hair of St. Claire (before the altar in a church), by Fra Semplice da Verona. Grenoble, Musée de Peinture et de Sculpture; Chiarini, *Tableaux Italiens.*

1477 Madonna of the purification of the soul with Saints Francis and Clare, by Giovanni Battista Caracciolo, c. 1625. Nola, S. Chiara; RA, *Painting in Naples.*

1478 Death of St. Clare (other saints appear to the nuns at her death bed), by Bartolomé Esteban Murillo, c. 1647. Picture Gallery, Dresden; Boone, *Baroque.*

1479 St. Clare driving the Saracens out of the temple (by holding up the host), by Paolo de Matteis. Naples, Gesù delle Monache; Yale Univ., *Taste* (fig.94).

See also 114, 815, 843, 883, 1815, 1818, 1861, 3428, 3859, 4616

Claude or Claudius, Bishop of Besancon, abbot of monastery of St. Oyland, d. 7th cent. (June 6)
1480 St. Claude (in bishop's regalia, giving a blessing), panel by Sebastiani, 1475. Cambery, Musée des B/A; Kaftal, *North West Italy.*
1481 St. Claudius (in bishop's regalia) raises a man from the dead (the man sits up from a grave in the floor), illum. by Jean Bourdichon from the Great Book of Hours of Henry VIII, 1514-18. Coll. Duke of Cumberland; *Great Hours.*
1482 Legend of St. Claude (made a bishop at left; resuscitating a dead man at right), min. by the Master of Claude from a Prayer Book of Queen Claude of France, fo.36r, c. 1515-16. Coll. H.P. Kraus, NY; Sterling, *Master of Claude.*

Claudius and Castor
1483 SS. Claudius and Castor (tied to a pillar and whipped), woodcut by Günther Xanier from "Leben der Heiligen, Winterteil," Augsburg, 1471. The Illus. Bartsch; *German Book Illus.* (Vol.80, p.71).

Clement I, Pope, disciple of St. Peter; drowned with anchor tied around his neck; mart. 100 (Nov. 23)
1484 Miracle of St. Clement and the submerged temple (a woman comes to the temple during the passion of Clement I, when the sea withdrew for seven days, and finds her baby, which had slept for a year; posthumous miracle), fresco by the Roman school, 11th cent. Rome, S. Clemente; Kaftal, *Central & So. Ital.*
1485 Miracle of San Clemente (restores a boy to life), wall-painting, late 11th cent. Rome, S. Clemente; Boucher, *20,000 Years* (291).
1486 Drowning of St. Clement, altar frontal of Sant Climent de Taüll, 13th cent. Barcelona, Museo d'Art de Catalunya; Lasarte, *Catalan*; Lassaigne, *Spanish.*
1487 St. Clement at mass, spied upon by the pagan Sisinnius, who followed his wife Theodora to the church; Sisinnius is struck blind, and has to be led away by his children, mosaic, 13th cent. Venice, S. Marco; Kaftal, *North East Italy.*
1488 St. Clement thrown into the sea

with a millstone around his neck (the two executioners glare at each other in the boat as Clement floats below them), illum. from Ms. Cod. Lat. III, iii, Venetian School, 1300-50. Marciana Library, Venice; Kaftal, *North East Italy.*
1489 Martyrdom of Clement I (he is seized by soldiers and thrown from a cliff with an anchor tied around his neck; angels lift him from the water), predella panel by a follower of Ghirlandaio. Lucca, Cathedral; Kaftal, *Tuscan.*
1490 St. Clement I (holding a cross and a millstone), panel by an unknown Sienese provincial master, early 15th cent. Poggibonsi, S. Michele al Padule; Kaftal, *Tuscan.*
1491 St. Clement sends St. Denis and two acolytes to preach the gospel in France (Clement says goodbye, then the three go up a winding path at right), fresco from the cycle of SS. Dionysius, Rustico e Eleuterio, 15th cent. Borgo Velino, Dionisio Cappelli; Kaftal, *Central & So. Ital.*
1492 Pope Clement reading a book, mural by Ghirlandaio. Sistine Chapel, Vatican; Brusher, *Popes*; Coulson, *Saints.*
1493 Conversion of St. Clement (while listening to the preaching of St. Barnabas); reunion of St. Clement with his family (who he thought was dead), by Bernardino Fungai. Strasbourg Fine Arts Museum; Christiansen, *Siena.*
1494 St. Clement striking the rock (which expelled drinking water for his followers); martyrdom of St. Clement (thrown by a ship with an anchor tied around his neck), by Bernardino Fungai. York City Art Gallery; *Catalogue*; Christiansen, *Siena.*
1495 Martyrdom of St. Clement I, Pope (executioners tie an anchor around his neck, while he kneels on a cliff above the sea), preparatory sketch for a fresco by Agostino Ciampelli, c. 1596. Met Museum; Bean, *15th & 16th Cent.*
1496 The martyrdom of St. Clement (about to be drowned with an anchor) by Giovanni Battista Tiepolo, c. 1734-39. Courtauld Inst. of Art, London; *Catalogue.*
1497 The Trinity appearing to St. Clement (as he prays), by Giovanni Battista Tiepolo, c. 1735. Nat'l Gallery, London; Book of Art, *Ital. to 1850*; Levey, *Nat'l Gallery*; Morassi, *Catalogue* (pl.127).

1498 Pope St. Clement adoring the Trinity, by Giovanni Battista Tiepolo. Alte Pinakothek, Munich; Morassi, *Catalogue* (pl.127).
See also 3734, 3888

Clement of Ohrid, one of the Seven Apostles of Bulgaria, 9th–10th cent. (July 17)
1499 St. Clement of Ohrid, bilateral icon by a Greek painter working at Ohrid, early 15th cent. Ohrid, Macedonia, St. Clement; Knopf, *The Icon* (p.195).

Clement of Volterra, Co-patron of Volterra with Justus, 5th cent. (June 5)
1500 Saints Justus and Clemente multiplying the grain of Volterra, by Master of Castello Nativity, 1450–1500. Philadelphia Museum of Art, PA; Kaftal, *Tuscan* (fig.698).
1501 A legend of St. Justus and St. Clement of Volterra (at a castle) by Domenico Ghirlandaio, c. 1484. NGA, Washington DC; Book of Art, *Ital. to 1850.*
1502 SS. Clement and Justus pray in a cave, while the city is besieged by Vandals, predella panel by the Master of the Castello Nativity, 1450–1500. Philadelphia Museum of Art, PA; Kaftal, *Tuscan.*
1503 St. Clement of Volterra (standing with a book), from an altarpiece by the Master of the Castello Nativity. Faltugnano, SS. Clemente e Giusto; Kaftal, *Tuscan.*

Cleridonia, abbess and patron of Subiaco
1504 St. Cleridonia (sitting in a cave mouth, giving a blessing; a bird brings her a sack of food), fresco att. to Conxolus. Subiaco, Sacro Speco; Kaftal, *Central & So. Ital.*

Cletus, Bishop of Ruvo in Calabria and third Pope, mart. 91 (April 26)
1505 St. Cletus, fresco by Ghirlandaio in the Sistine Chapel. Vatican Museums; Brusher, *Popes.*

Clotilde, wife of Clovis king of the Franks, d. 545 (June 3)
1506 How king Clotaire and king Childebert killed their nephews in front of Queen Cotilda, from "Grandes Chroniques de France." BN, Paris; Castries, *K. & Q. of France.*

1507 Statue of St. Clotilde. Corbeil, Church of Notre-Dame; Castries, *K. & Q. of France.*
1508 An angel gives the shield with fleurs de lis to a hermit, the hermit gives it to St. Clotilde, who then gives it to King Clovis, from a Chronology, ms. 523, early 16th cent. Sainte-Geneviève, Biblio.; Garnier, *Langage de l'Image* (pl.157).
1509 St. Clotilde constructing the abbey of Andelys (workman points the details to her as pilgrims drink from a miraculous fountain), by Adrien Sacquespée. Rouen, St.-Léger-du-Bourg-Denis; *La Peinture d'Inspiration.*

Coloman or Kolman, pilgrim, patron of Austria; hanged as a spy in Vienna; mart. 1012 (Oct. 13)
1510 Johann Stabius as Saint Coloman (dressed as a pilgrim), woodcut by Albrecht Dürer, 1513. Strauss, *Woodcuts* (pl.169).
1511 The patron saints of Austria: SS. Quirinus, Maximilian, Florian, Severinus, Coloman, and Leopold, woodcut by Albrecht Dürer, 1515. Berlin, Kupferstichkabinett der Staatlichen Museen; Strauss, *Woodcuts* (pl.174).
See also 982, 3947

Colomba, Virgin martyr under Emperor Aurelian; beheaded, 3rd cent. (Dec. 31)
1512 St. Colomba before Emperor Aurelian (in a courtyard), from the scenes from the life of St. Colomba triptych by the Master of St. Colomba, c. 1340. Brera, Milan; Kaftal, *North East Italy*; Newsweek, *Brera.*
1513 St. Colomba saved by a bear (it mauls a man who was sent to her prison to seduce her); beheading of St. Colomba (she lies flat on the ground), from a triptych by the Master of St. Colomba, c. 1340. Brera, Milan; Kaftal, *North East Italy*; Newsweek, *Brera.*
See also 4085

Colomba the Dominican, Dominican Nun, d. c. 1500 (May 20)
1514 St. Colomba (standing in white habit and black veil, with a wreath of roses on her head, holding a crucifix, rosary, a dove in a halo, and a lily, while a hand appears from heaven, offering the Eucharist), from the school of G. Spagna, c. 1501. Perugia; Kaftal, *Central & So. Ital.*

Columba, Irish missionary, founded monasteries at Derry, Durrow, and Kells, d. 597 (June 9)
1515 The mission of St. Columba to the Picts (he holds up a cross as the crowd listens patiently), fresco by W. Hole. Edinburgh, Scottish NPG; Bentley, *Calendar.*

Concordius, Hermit, beheaded after torture; mart. 178 (Jan. 1)
1516 St. Concordius (standing in prayer), statue by Luca della Robbia. Lucca, S. Concordio; Bentley, *Calendar.*

Conrad, Bishop of Constance, d. 975 (Nov. 26)
1517 St. Conrad as patron saint of a Cistercian monk, with holy virgin Agnes, by Bernhard Strigel, c. 1520. Picture Gallery, Berlin; *Catalogue.*
See also 3888

Conrad of Piacenza, Hermit, Franciscan preacher, d. 1351 (Feb. 19)
1518 St. Conrad the Hermit (standing with his staff, in bare feet, holding a book), by Vincenzo de Palma, 16th cent. Palermo, Museo Nazionale; Bentley, *Calendar.*

Constantine the Great, Emperor, son of St. Helena, d. 337 (May 21)
1519 St. Sylvester shows Emperor Constantine the portraits of SS. Peter and Paul (who had appeared to the emperor in a vision); Sylvester baptizes Constantine; Constantine gives Sylvester the papal insignia; Constantine leads Sylvester's horse; frescoes by the Roman School, 1246. Rome, SS. Quattro Coronati; Kaftal, *Central & So. Ital.*
1520 St. Sylvester baptizes emperor Constantine (the emperor kneels inside of a cauldron, hands clasped), fresco by Ugolino di Prete Ilario. Orvieto, Cathedral; Kaftal, *Central & So. Ital.*
1521 Scenes between SS. Constantine and Sylvester: SS. Peter and Paul appear in a dream to Constantine, and tell him to send for Sylvester, who will cure his leprosy; Sylvester shows Constantine the portraits of Paul and Peter, whom the Emperor recognizes; baptism of Constantine by St. Sylvester; frescoes by Maso di Banco. Santa Croce, Florence; Kaftal, *Tuscan.*
1522 St. Nicholas of Bari appears in a

dream to St. Constantine (and orders him to free the tribunes Ursus, Nepotian and Apilion from prison), fresco by a follower of Giotto. S. Francesco, Assisi; Kaftal, *Tuscan.*
1523 The dream of St. Constantine (before the battle with Maxentius, he dreams, in a pavilion, that an angel appears to him with a shining cross, saying "In hoc signo vinces"), fresco by Piero della Francesca, 1452–66. Arezzo, S. Francesco; Kaftal, *Tuscan.*
1524 St. Helena (holding the cross) and the Emperor Constantine, by Cornelis Engelbrechtsz. Alte Pinakothek, Munich; Bousquet, *Mannerism* (p.110).
1525 Saints Constantine and Helena (both holding the Cross), icon from Nessebur, 17th cent. Nessebur Museum; Paskaleva, *Bulgarian Icons.*
1526 The Emperor Constantine presented to the Holy Trinity by his mother St. Helena, by Corrado Giaquinto, 1744. St. Louis Art Museum, MO.
See also 2607, 2634, 3624, 3743, 4569, 4574, 4577, 4578

Constantius
1527 Polyptych of the San Francesco, with St. Francis in the center panel, trampling pride, lust and avarice, flanked by SS. Hercolanus and Anthony of Padua at left, and SS. Louis of Toulouse and Constantius at right, by Taddeo di Bartolo, 1403. Perugia, Galleria Nazionale dell'Umbria; Van Os, *Sienese Altarpieces* (Vol.II, pl.72).

Cornelius, Bishop of Rome and Pope; beheaded; mart. 253 (Sept. 14 or 16)
1528 St. Cornelius and St. Cyprian from "Hours of Catherine of Cleves," c.1434–39. Pierpont Morgan Library, NY; Châtelet, *Early Dutch* (pl.44).
1529 Saints Anthony Abbot (with a crutch), Pope Cornelius (with a cross and a horn), Mary Magdalene, with a kneeling donor, side panel from the dismembered "Last Judgment" altarpiece by Stephan Lochner, c. 1441–48. BS, Munich; United Nations, *Dismembered Works.*
1530 St. Cornelius standing in a niche, fresco by Sandro Botticelli, 1481. Sistine Chapel, Vatican; Brusher, *Popes*; Lightbown, *Botticelli.*
1531 St. Anthony Abbot, Pope Cornelius, Mary Magdalene, and a kneeling donor, by Pietro Longhi. Alte Pinako-

thek, Munich; McGraw, *Encyclo.* (Vol.IX, pl.182).
See also 1588

Cosmas and Damian, brothers, Christian doctors, patrons of physicians; tortured and beheaded; mart. 297 (Sept. 27)
1532 SS. Cosmas (holding a medicine box) and Damian (holding a palm), panels of a polyptych by the Riminese School, 1350-60. Rimini, Pinacoteca Civica; Kaftal, *North East Italy.*
1533 St. Cosmas and St. Damian (both have mustaches; both hold a black book), by Master of the Rinuccini Chapel, c. 1350-1400. North Carolina Museum of Art, Raleigh; *Intro. to the Coll.* ; Shapley, *Samuel H. Kress.*
1534 A miracle of Saints Cosmas and Damian (they are putting a black leg on a man sleeping in bed, as a woman cries at his bedside), by Fra Angelico, c. 1420. Coll. George Spencer-Churchill, Gloucestershire; Cooper, *Private Collections.*
1535 The attempted martyrdom of Saints Cosmas and Damian with their brothers (tied together, back to back in the center of a fire; one executioner lies dead beside the fire, the other runs away), by Fra Angelico. NGI, Dublin; Daniel, *Encyclo. of Themes*; Pope-Hennessey, *Fra Angelico* (pl.61).
1536 Annunciation polyptych, with Annunciation flanked by SS. Cosmas and Damian, by Taddeo di Bartolo. Siena, Pinacoteca Nazionale; Van Os, *Sienese Altarpieces* (Vol.II, pl.97).
1537 The healing of Palladia by St. Cosmas and St. Damian, by Fra Angelico, 1438-43. NGA, Washington DC; Ferguson, *Signs*; Phaidon, *Art Treasures*; Pope-Hennessy, *Fra Angelico*; Shapley, *Samuel H. Kress.*
1538 The martyrdom of St. Cosmas and St. Damian (with three others; severed heads lie on the ground), by Fra Angelico 1438-45. Louvre, Paris; Book of Art, *Ital. to 1850*; Gowing, *Paintings*; Hartt, *Ital. Ren.*; McGraw, *Encyclo.* (Vol.I, pl.273); Pope-Hennessy, *Fra Angelico.*
1539 St. Francis receiving the stigmata; St. Cosmas and St. Damian caring for a patient, by Pesellino, 1442-45. Louvre, Paris; Gowing, *Paintings*; Lloyd, *1773 Milestones.*
1540 Seven Saints (sitting on a long bench) with John the Baptist at center, flanked by Cosmas and Damian, with Francis and Lawrence at left, and Anthony and Peter Martyr at right, painted by Fra Filippo for the Medici family, c. 1448-50. Nat'l Gallery, London; Dunkerton, *Giotto to Dürer.*
1541 Attempted martyrdom of SS. Cosmas and Damian by fire; the crucifixion of SS. Cosmas and Damian; the decapitation of SS. Cosmas and Damian, by Fra Angelico. San Marco Museum, Florence; Kaftal, *Tuscan*; Pope-Hennessy, *Fra Angelico* (fig.37c-e).
1542 Burial of Saints Cosmas and Damian (a camel tells the men to bury the brothers side-by-side), by Fra Angelico. San Marco Museum, Florence; Andres, *Art of Florence* (Vol.I, pl.332); Kaftal, *Tuscan*; Pope-Hennessy, *Fra Angelico* (pl.63).
1543 Cosmas and Damian (both holding pestles), companion frescoes by the School of the Abruzzi, 15th cent. Aquila, Museo Nazionale; Kaftal, *Central & So. Ital.*
1544 Cosmas and Damian thrown into the sea, while their persecutor Lycias is possessed by devils, by Fra Angelico. Alte Pinakothek, Munich; Pope-Hennessy, *Fra Angelico* (pl.56b).
1545 Saints Cosmas and Damian before Lycias (who orders them to be sacrificed to the pagan gods), by Fra Angelico. Alte Pinakothek, Munich; Pope-Hennessy, *Fra Angelico* (pl.60).
1546 St. Damian receiving a gift from Palladia; the attempted martyrdom of Saints Cosmas and Damian by drowning (they are rescued by an angel), by Fra Angelico. San Marco Museum, Florence; Kaftal, *Tuscan*; Pope-Hennessy, *Fra Angelico* (fig.37a-b).
1547 The Annalena Altarpiece, with the Virgin and Child enthroned, with Saints Peter Martyr, Cosmas, Damian, John the Evangelist, Lawrence, and Francis, by Fra Angelico. San Marco Museum, Florence; Pope-Hennessy, *Fra Angelico* (pl.96).
1548 The Crucifixion of Saints Cosmas and Damian (the archers shoot arrows at the crucified martyrs, but the arrows turn back onto them), by Fra Angelico. Alte Pinakothek, Munich; Bentley, *Calendar*; Pope-Hennessy, *Fra Angelico.*
1549 The San Marco Altarpiece, with the Virgin and Child enthroned, flanked by SS. Cosmas and Damian, Lawrence,

John Evangelist, Mark, Dominic, Francis, and Peter Martyr, by Fra Angelico. San Marco Museum, Florence; Pope-Hennessy, *Fra Angelico.*

1550 Virgin and Child with saints, including John the Baptist, Cosmas and Damian, Lawrence, Julian, Anthony, and kneeling Francis and Peter Martyr, altarpiece painted by Alesso Baldovinetti for the Medici family, c. 1454. Uffizi, Florence; Dunkerton, *Giotto to Dürer.*

1551 SS. Cosmas and Damian Altarpiece; Virgin and Child enthroned with angels, flanked by SS. Cosmas and Damian, by Sano di Pietro. Siena, Pinacoteca Nazionale; Van Os, *Sienese Altarpieces* (Vol.II, pl.191).

1552 St. Cosmas and St. Damianus, martyrs, and the Virgin Mary, by Master of Liesborn, c. 1465. Nat'l Gallery, London; Dunkerton, *Giotto to Dürer*; Poynter, *Nat'l Gallery.*

1553 Saint Damian and St. Cosmas, companion paintings att. to Bartolomeo Vivarini. Rijksmuseum, Amsterdam; *Paintings.*

1554 St. Cosmas healing a man with a bloated stomach; St. Damian cures a lame man (cutting into his head), limestone sculptures, Northern French, 1490–1500. Walters Art Gallery, Baltimore.

1555 The miracle of Saints Cosmas and Damian (putting a dead Moor's leg on a white man and the bad white leg on the Moor) by Fernando del Rincón de Figueroa, late 15th cent. Prado, Madrid; Lassaigne, *Spanish*; Prado, *Guide to Prado.*

1556 Saints Cosmas and Damian (standing with palms), by the Sienese School, c. 1500. Mint Museum of Art, Charlotte, NC; Shapley, *15th–16th Cent.*

1557 Madonna (enthroned) with SS. Cosmas and Damian, by Gianfrancesco del Bembo. Cremona, San Pietro; Ricci, *Cinquecento.*

1558 Saints Cosmas and Damian (in discussion, as one holds up a glass) by Dosso Dossi. Borghese Gallery, Rome; Gibbons, *Dossi.*

1559 SS. Cosmas and Damian, holding medicine boxes and surgical instruments, bone on wood icon with frame, c. 1569. State Russian Museum, St. Petersburg.

1560 Cosmas and Damian, painting by Emmanual, 17th cent. Nat'l Gallery, London; Coulson, *Saints.*

1561 SS. Cosmas and Damian with scenes from their lives, icon by Radul of Serbia, 1673–74. Patriarchate of Peć; Knopf, *The Icon* (p.369).

1562 Saint John the Baptist flanked by saints Cosmas and Damian (sitting on a marble bench), by Edward Burne-Jones after an original by Fra Filippo Lippi in the National Gallery, London. Ponce, Museo de Arte; Held, *Catalogue*; *Museo de Arte.*

See also 2806, 3250, 3867, 3967, 4628, 4890

Cosme *see* **Cosmas**

Crescenzio or Crescentius, Roman knight, patron of Siena; beheaded; mart. 303 (Sept. 14)
1563 St. Crescentius (holding a platter with his own severed head), painted casket by Bartolo di Maestro Fredi, 1373. Siena, Palazzo Pubblico; Kaftal, *Tuscan.*
See also 207

Crispin and Crispinian, Roman martyrs, brothers, patrons of cobblers; beheaded; mart. 285 (Oct. 25)
1564 Crucifixion, with two scenes from the legend of SS. Crispin and Crispinian: above the saints are arrested in their shop; below, the saints are bent over a table, and the executioners start to cut into their backs, by an unknown Franco-Flemish artist. Sandelin Museum, Saint-Omer; Bentley, *Calendar* (title page).

1565 Crispin and Crispinian, both richly dressed, holding a book and a crucifix, with an angel holding a crown above their heads, companion panels att. to P. Ruzzolone or Quartararo. Palermo, Confraternita dei SS. Crispino e Crispiano; Kaftal, *Central & So. Ital.*

1566 SS. Crispin and Crispinian (holding leather cutting tools), panels from a polyptych by Defendente de'Ferrari. Turin, Cathedral; Kaftal, *North West Italy.*

1567 Scenes from the life of SS. Crispin and Crispinian: birth of the twins; they are blessed by their mother; in the cobbler's shop; baptizing a woman; brought before the prefect, where they refuse to apostatize; making idol crumble; in prison visited by angels; tied to a tree and beaten; tied to a column and beaten; panels by Defendente de'Ferrari. Turin, Cathedral; Kaftal, *North West Italy.*

1568 Scenes from the life of SS. Crispin and Crispinian: they are put in an oven, but are unharmed; they are boiled in a cauldron, with hot lead poured on their heads; thrown into the river with millstones around their neck; one is held up by an angel; tied to a tree and nails driven under their nails; beheaded; cripples are cured at their tombs; panels by Defendente de'Ferrari. Turin, Cathedral; Kaftal, *North West Italy*.

1569 Virgin and Child flanked by SS. Crispin and Crispinian, altarpiece by Andrea di Niccolò. Siena, S. Mustiola; Edgell, *Sienese Paintings*; Kaftal, *Tuscan*.

1570 St. Crispin (sitting with a strap of leather across his knee), polychromed wooden statue, French, late 15th cent. Rochester Memorial Art Gallery, NY; *Handbook*.

1571 Crispin and Crispinian, standing in brocade robes, under the Holy Spirit, by the Campanian School, 15th–16th cent. Naples, SS. Crispino e Crespiniano; Kaftal, *Central & So. Ital.*

1572 St. Crispin (holding a sword and an axe, standing before a window showing a building), by Master of the Embroidered Foliage. Pushkin Museum, Moscow; Nikulin, *Soviet Museums*.

1573 Martyrdom of SS. Crispin and Crispinian (they are boiled in a cauldron; they are decapitated), side panels by an unknown Southern Netherlandish painter, from a dismembered Martyrdom of SS. Crispin and Crispinian altarpiece, early 16th cent. Private coll., Paris; United Nations, *Dismembered Works*.

1574 Martyrdom of SS. Crispin and Crispinian (they are tied to a tree and flogged while emperor and attendants look on; city of Soissons in background), panel by an unknown Southern Netherlandish painter, from a dismembered Martyrdom of SS. Crispin and Crispinian altarpiece, early 16th cent. Narodowe Museum, Warsaw; United Nations, *Dismembered Works*.

1575 Saints Crispin and Crispinian (working at their benches), by an unknown painter of Gouda, c. 1565. Gouda, Musées Communaux; Huvenne, *Pourbus*.

1576 Martyrdom of St. Crispin and St. Crispinian (they are tied to racks, and executioners begin to flay them), by Hieronymus Francken, 1560's. Antwerp,

Musée Royal des B/A; Larsen, *17th Cent. Flem.*

1577 Martyrdom of SS. Crispin and Crispinian (one saint is already decapitated, while the other saint kneels, hands clasped, while the executioner raises his sword; angels descend with palms and flower wreaths), by Ghislain Vroylinck, 1613. Bruges, State Museum; Pauwels, *Musée Groeninge*.

See also 3947

Crispinian *see* **Crispin**

Cucufas, throat cut with knife
1578 Martyrdom of Cucufas (tied to a post, kneeling, while executioner slits his throat with a knife) by Anye Bru, c. 1507. Barcelona, Museo d'Art de Cataluyna; McGraw, *Dict.*; McGraw, *Encyclo.* (Vol.XIII, pl.129).

Cunegund, wife of Henry King of the Romans, d. 1033 (Mar. 3)
1579 SS. Dorothy (accepting a flower from a child), Agnes (holding a lamb), and St. Cunegund, right wing of the Martyrdom of St. Catherine triptych by Lucas Cranach the Elder, c. 1502. Budapest, Reformed Church; Friedländer, *Cranach*.

1580 SS. Henry the Emperor and Cunigonde, with a model of Bamberg Cathedral, woodcut by Albrecht Dürer from the "Salus Animae" of 1503. Strauss, *Woodcuts* (pl.72).

1581 St. Cunegund holding a scepter, limewood statue, waxed white and gilded, by Ignaz Günther. Rottam Inn, Bavaria; Bentley, *Calendar*; Coulson, *Saints*; McGraw, *Encyclo.* (Vol.XII, pl.170); Schörberger, *Age of Rococo* (pl.298).

Cuthbert, monk and Bishop of Hexham then Lindisfarne, d. 687 (Mar. 20)
1582 St. Cuthbert's body on a ship brought to Lindisfarne; a monk announces his death with two torches, from Bede's "Life of St. Cuthbert," ms.165, c. 1100-50. Oxford, University College; Burlington, *Illum. MS.*

1583 St. Cuthbert in his study (writing), min. from "The Life and Miracles of St. Cuthbert" by Bede, 12th cent. BM, London; Bentley, *Calendar*.

1584 St. Cuthbert (monk is kissing his foot) from Bede's "Life of St. Cuthbert" ms., late 12th cent. BM, London; Coulson, *Saints*.

1585 St. Cuthbert implored by three brethren to accept the see of Hexham, from Bede's "Life and Miracles of St. Cuthbert," late 12th cent. Coll. H. Yates Thompson; Burlington, *Illum. MS.*

Cyprian, Bishop of Carthage; beheaded, mart. 258 (Sept. 14 or 16)
1586 St. Cyprian of Carthage (in bishop's regalia, holding a book and a crosier), panel of a triptych by Pietro Alamanno. Castel Folignano, S. Maria e S. Cipriano; Kaftal, *North East Italy.*
1587 St. Cyprian of Carthage with crosier, pointing to his open book, by Bartholomeus Zeitblom. Alte Pinakothek, Munich; Coulson, *Saints.*
1588 St. Anthony as an abbot (enthroned), with Pope St. Cornelius and St. Cyprian, by Paolo Veronese. Brera, Milan; De Bles, *Saints in Art.*
See also 1528, 3513

Cyriacus, Roman healer, protector of Altidona; invoked against maladies of the eyes; mart. 303 (Mar. 16)
1589 St. Cyriacus (curing Artemia, the mad daughter of Diocletian through exorcism), by Matthias Grünewald, 1508-10. Städelsches Kunstinstitut, Frankfort; Snyder, *Northern Ren.*
See also 4901

Cyril and Methodius, Thessalonican brothers, Methodius became archbishop of Sirmium, apostles of the southern Slavs, d. 869 and 884 (July 7)
1590 Pope Adrian II receiving SS. Cyril and Methodius in audience, by L. Nobili, 1886. Rome, S. Clemente; John, *Popes.*
See also 3735

Cyril Belozerskii, founded Russian Monastery
1591 St. Cyril Belozerskii with scenes from his life, icon by Dionysii, early 16th cent. State Russian Museum, St. Petersburg.
1592 St. Cyril Belozerskii, in monk's robe, giving a blessing and holding a rolled-up scroll, embroidered funeral shroud, Moscow, 1555. State Russian Museum, St. Petersburg.

Cyril of Alexandria, Bishop and patron of Alexandria, d. 444 (Jan. 28 or Feb.9)
1593 Saint Cyril of Alexandria looking up, fresco, early 16th cent. Monastery of St. Neophytus, near Paphos; Stylianou, *Painted Churches* (p.378).
1594 St. Cyril (pointing up), fresco by Domenichino, 1608-10. Grottaferrata Abbey; Spear, *Domenichino.*
1595 Vision of St. Cyril of Alexandria (kneeling before the Virgin, he reads from a book held by an angel), by Angelo and Francesco Solimena, 1675-77. Solofra, San Domenico; Yale Univ., *Taste* (fig. 63).

Cyril of Constantinople, prior general of the Carmelites in Palestine, d. 1235 (Mar. 6)
1596 St. Cyril of Constantinople holding an open book, looking up in meditation, by Francisco de Zurbaran, 1630-32. Boston Museum of Fine Arts; Gállego, *Zurbaran.*

Dagobert II, king of Austrasia, r. 675-79 (Dec. 23)
1597 St. Denis aids Dagobert (as he lies sleeping in St. Denis's tomb, St. Denis and companions appear to him in a dream; with saint's help Dagobert is forgiven by his father Clotharius) from "Missal of St. Denis" ms 1346-1891, fo.261, c. 1350-51. V & A, London; Avril, *MS Painting.*

Damasus I, Pope, commissioned St. Jerome to translate the Bible, d. 384 (Dec. 11)
1598 Virgin and Child appearing to St. Peter, St. Damasus, St. Paul, and St. Lawrence; martyrdom of St. Lawrence in background, drawing by Federico Zuccaro. Met Museum; Bean, *15th & 16th Cent.*
See also 2818

Damian *see* **Cosmas and Damian**

Daniel, Franciscan minister provincial of Calabria; martyred for preaching to the Mohammedans; mart. 1227 (Oct. 10)
1599 Martyrdom of Saint Daniel (dragged by a horse), bronze relief by Tiziano Aspetti, 1592. Padua Cathedral; New Int'l Illus. *Encyclo.* (see Relief).
1600 Martyrdom of St. Daniel (he is tied, hands and feet, and looks up while angels descend with flower wreaths), by Antonio Zanchi, 1677. Padua, S. Giustina; DiFederico, *Trevisani.*
1601 St. Prosdocimus baptizing St.

Daniel, by Giovanni Battista Pittoni. York City Art Gallery; Boccazzi, *Pittoni* (pl.102); *Catalogue*; Levey, *Giotto to Cézanne*.

Daniel of Padua, Deacon; placed on a board with nails, which pierced his body until dead, 4th cent. (Jan.?)
 1602 St. Daniel of Padua (holding a banner and a model of the city of Padua), from a fresco by Giusto de'Menabuoi. Padua, Baptistery; Kaftal, *North East Italy*.
 1603 St. Louis of Toulouse (holding a tiny model of a city with people) and St. Daniel of Padua (in bishop's robes and crosier), by Bernardo Zenale. Detroit Inst. of Art, MI.

David or Dewi, son of St. Non, patron of Wales, founded monasteries, d. 500 (Mar. 1)
 1604 St. David (standing three-quarters to the left, in a red cloak, holding a scroll), fresco by Giotto di Bondone. Assisi, Maddalena Chapel; Bentley, *Calendar*.
 1605 St. David of Wales (standing in a nave, with book and scepter), by the Master of the First Prayer Book of Maximilian, from the Hours of William Lord Hastings, add. ms.54782, fo.40, late 1470's. BM, London; BL, *Ren. Painting in MS*.
 1606 Saint David, chestnutwood statue by studio of Prinknash Abbey, 1948. Church of God of the Holy Ghost, Newtown, Montgomeryshire; Coulson, *Saints*.

Defendens or Defendente, Roman knight, invoked against fire, wolves, and rabid dogs; probably beheaded; mart. under Maximilian (Jan. 2)
 1607 SS. Bernard (holding a staff with a chained demon), Defendens (dressed as a knight, holding a sword and a mace), Helena (holding the true cross), Liberata (dressed as a nun, holding a book), Lucy (holding a plate with eyes and an awl), and Stephen, fresco by Christoforo and Niccolò da Seregno. Montecarasso, S. Bernardo; Kaftal, *North West Italy*.

Defendente *see* **Defendens**

Demetrius, "The great Martyr," proconsul of Achia and companion of St. Nestor, deacon; stabbed with lance, mart. 303 or 306 (Oct. 8)
 1608 St. Demetrius (standing between two torches, holding a crown), mosaic, c. 570. Ravenna, S. Apollinare Nuovo; Kaftal, *North East Italy*.
 1609 St. Demetrius with the archbishop and governor of Thessalonica, 7th cent. mosaic. St. Demetrius; Oxford, *Medieval Europe*.
 1610 St. Demetrius of Thessalonica, small Byzantine reliquary, 10th cent. Coll. Klaus G. Beyer, Weimar DDR; Oxford, *Medieval Europe*.
 1611 St. Demetrius (in scale armor with a large shield), ivory, late 10th cent. Met Museum; Knopf, *The Icon* (p.32).
 1612 Icon of the Apostle Philip and Saints Theodore (with a spear and sword) and Demetrius (with a raised sword), second half of 12th cent. Hermitage, St. Petersburg; Bank, *Byzantine* (pl.237).
 1613 Icon of St. Demetrius, on horseback with a drawn sword, steatite, late 13th–early 14th cent. Kremlin Museums, Moscow; Bank, *Byzantine* (pl.262).
 1614 Saint Demetrius of Thessalonica in armor, with sword and spear, by a Greek painter, early 15th cent. Belgrade, Museum of Applied Arts; Knopf, *The Icon* (p.199).
 1615 St. Demetrius of Thessalonica, holding a cross and a sword and shield, tempera on wood icon from Pskov, 1425–50. State Russian Museum, St. Petersburg.
 1616 St. Martin and St. Demetrius, both holding swords, by School of Master of the Martyr Apostles, c. 1490. Esztergom Christian Museum; *Christian Art in Hungary* (pl.XI/223).
 1617 St. Sebastian (tied to a tree by his arms), St. Roch (as a pilgrim) and St. Demetrius (in armor, hand over his mouth), by Giovanni Battista Benvenuti. Nat'l Gallery, London; Poynter, *Nat'l Gallery*.
 1618 St. Demetrius (in armor, with stars in background), icon by Dobromir of Tîrgoviste, 1526. Bucharest, Museum of Rumanian Art; Knopf, *The Icon* (p.387).
 1619 Massacre of Saint Demetrius (he is enthroned before a building, as soldiers pierce him with spears), icon, late 16th cent. Sinai, Monastery of St. Catherine; Manafis, *Sinai*.
 1620 Saint Demetrius (on a horse, spearing a Saracen in the neck), icon from Veliko Turnovo, 1617. Bulgaria, National Art Gallery; Paskaleva, *Bulgarian Icons*.

1621 Saint Demetrius with scenes from his life (stomping on a scorpion) late 17th-early 18th cent. Tempera, St. Demetrius; Paskaleva, *Bulgarian Icons.*
1622 The mystic marriage of St. Catherine of Siena (observed by Saints Dominic, Augustine, and Demetrius of Spoleto), by Lorenzo da San Severino, 1450-1500. Nat'l Gallery, London; Poynter, *Nat'l Gallery.*
See also 3743

Denis or Dionysius the Areopagite, first bishop of Paris, patron of France; invoked against headaches and rabies; beheaded; mart. 250 (Oct. 9)
1623 St. Dionysius and his companions; martyrdom of St. Dionysius, from "Gospels and Collects," ms.342, bis, f.63v, c. 1000. Saint-Omer Library; Porcher, *Medieval French Min.*
1624 Communion of St. Dionysius, from the "Missal of St. Denis," ms. lat. 9436, fo.106v, mid-11th cent. BN, Paris; Porcher, *Medieval French Min.* (fig.10).
1625 Saint Dionysius the Areopagite, holding a book, fresco, c. 1200. Patmos; Kominis, *Patmos* (p.98).
1626 St. Denis and his companions before the Christians put to death (soldiers hold them, in the midst of decapitated bodies), ms. illum. from the "Life of St. Denis" by the studio of an illuminator traveling to Paris about 1315-20, ms. fr. 2090, fol. 37v. BN, Paris; Sterling, *Peinture Médiévale.*
1627 St. Denis preaching to the people of Paris, illum. from "Life of St. Denis" ms. fr. 2091, fo.99, c. 1317. BN, Paris; Batselier, *Benedict* (p.295); Porcher, *Med. French Min.*; Snyder, *Medieval.*
1628 St. Denis (standing in a niche, holding his own head), from the "Boucicaut Hours" painted by the Boucicaut Master, ms.2,fo.31v. Jacquemart-André Museum, Paris; Meiss, *French Painting.*
1629 St. Denis (holding his own severed head), fresco by Jaquerio, 1402-10. Buttigliera Alta, S. Antonio di Ranverso; Kaftal, *North West Italy.*
1630 Martyrdom of St. Denis and his companions (executioner is about to strike his head off), by the Circle of Boucicaut, ms. Douce 144,fo.135, c. 1407. Bodleian Library, Oxford; Meiss, *French Painting.*
1631 Martyrdom of St. Denis and his companions at Montmartre (they kneel

together as three executioners raise their axes), from a breviary by the Boucicaut Master, ms.2,fo.364v, before 1415. Châteauroux, Biblio. Municipale; Meiss, *French Painting*; Porcher, *Med. French Min.* (fig.74); Sterling, *Peinture Médiévale.*
1632 Preaching of St. Denis near Paris, from a breviary by the Boucicaut Master, ms.2,fo.367v, before 1415. Châteauroux, Biblio. Municipale; Meiss, *French Painting*; Sterling, *Peinture Médiévale.*
1633 Preaching of St. Denis with a view of Paris, French, ms.fr.2091, fo.99. BN, Paris; Meiss, *French Painting.*
1634 Veneration of the supposed St. Denis (a bishop blesses him as he lies on the floor), from "Grandes Chroniques" illus. by the Boucicaut Master, ms.Cotton Nero E.II,I,fo.188. BM, London; Meiss, *French Painting.*
1635 The holy communion and martyrdom (decapitation) of St. Denis with crucified Christ in center, by Henri Bellechose or Malouel, 1416. Louvre, Paris; Châtelet, *Early Dutch*; Châtelet, *French Painting*; Gowing, *Biog. Dict.*; Gowing, *Paintings*; McGraw, *Encyclo.* (Vol.V, pl.382); New Int'l Illus. *Encyclo.*; Panofsky, *Early Nether.*; Puppi, *Torment*; Snyder, *Northern Ren.*
1636 The martyrdom of St. Denis (flanked by two angels, he holds his severed head), by Rodrigo de Osona, 1484. Valencia Cathedral; Book of Art, *German & Spanish.*
1637 St. Denis the Areopagite (half-view, hands clasped in prayer, before a bookcase), by an unknown Provencal painter, c. 1505-10. Rijksmuseum, Amsterdam; *L'Ecole d'Avignon*; *Paintings.*
1638 St. Dionysius (Denis) in prayer (half-view, in a room before a bookshelf), by the French School, c. 1505-10. Mauritshuis, The Hague; *Catalogue.*
1639 St. Denis (holding his decapitated head) and martyrdom of St. Denis (after decapitation), min. by the Master of Claude from a Prayer Book of Queen Claude of France, fo.32r, c. 1515-16. Coll. H.P. Kraus, NY; Sterling, *Master of Claude.*
1640 St. Dionysius holding an open book, fresco by Fra Diamante in the Sistine Chapel Vatican Museums; Brusher, *Popes.*
See also 428, 1491, 1597, 3313, 4037

Desiderio or Desiderius, follower of St. Gennaro, mart. c. 305 (Sept. 19)
1641 St. Desiderius receives the blessing of St. Benedict, from a ms. about the life of St. Benedict, ms. Vat. Lat. 1202, f.2r, 11th cent. Rome, Biblio. Vaticana; Batselier, *St. Benedict* (p.57); Bazin, *Loom of Art* (pl.186). *See also* 1962

Dewi *see* **David**

Didacus *see* **Diego**

Diego or Didacus de Alcalá, Franciscan missionary, d. 1463 (Nov. 13)
1642 St. Diego healing a blind boy with holy oil, by Annibale Carracci and Francesco Albani, c. 1604-06. Barcelona, Museo d'Art de Cataluyna; Spear, *Domenichino* (pl.78).
1643 St. Diego de Alcalá (holding flowers in his friar's robe), by Francisco de Zurbaran, 1631-40. Madrid, Santos Justo y Pastor; Gállego, *Zurbaran.*
1644 St. Diego de Alcalá (holding roses in his friar's robe) by Francisco de Zurbaran, 1631-40. Lázaro Galdiano Museum, Madrid; Gállego, *Zurbaran.*
1645 San Diego de Alcalá, polychromed wooden statue by Alonso Cano. Palace of Charles V, Granada; Wethey, *Alonso Cano* (pl.128).
1646 St. Diego de Alcalá, polychromed wooden statue by Alonso Cano, 1653-57. Granada, Museo Provincial; *Int'l Dict. of Art*; McGraw, *Encyclo.* (Vol.XII, pl.377).
1647 St. Diego de Alcalá (holding roses in his robe, accompanied by other friars), by Francisco de Zurbaran, 1658-64. Prado, Madrid; Gállego, *Zurbaran.*
1648 St. Diego de Alcalá kneeling before the Virgin and Child (presenting the cross), polychromed terracotta sculpture by Luisa Roldan, 1675-1700. V & A, London; Burton, *V & A.*

Dimitrii of Salonika
1649 St. Dimitrii of Salonika in armor, holding spear and shield, mosaic by master of the St. Michael mosaics, c. 1109-13. Tretyakov Gallery, Moscow; McGraw, *Russia.*
1650 St. Dimitrii of Salonika, drawing his sword, from school of Vladimir-Suzdal, late 12th–early 13th cent. Tretyakov Gallery, Moscow; McGraw, *Russia.*

1651 St. Dimitrii of Salonika and St. George, fresco by Feodosii, 1508. Cathedral of the Annunciation, Kremlin, Moscow; McGraw, *Russia.*

Dionysius the Areopagite *see* **Denis**

Dominic Guzman, founder of Dominican order, co-patron of Bologna, d. 1221 (Aug. 4)
1652 St. Dominic, holding a book with his right hand held up in blessing, by Guido da Siena, mid-13th cent. Fogg Art Museum, Cambridge MA; Edgell, *Sienese Painting*; Mortimer, *Harvard Univ.*; Van Os, *Sienese Altarpieces* (Vol.I, pl.17).
1653 Pope Innocent III dreams that Dominic is supporting the walls of the Lateran church, which induces him to confirm the Order of the Preachers; St. Dominic sells his books and gives the money to the poor, during a famine, panels of an altarpiece by the Campanian School, second half of 13th cent. Capodimonte, Naples; Kaftal, *Central & So. Ital.*
1654 St. Dominic raises Napoleone Orsini, Florentine School, 14th cent. Vatican Museums; Boudet, *Rome.*
1655 St. Dominic (kneeling in prayer) clothed by angels, by a follower of Ambrogio Lorenzetti, early 14th cent. Picture Gallery, Berlin; De Bles, *Saints in Art.*
1656 St. Dominic in black cloak holding a book and lily, by Lippo Vanni. Nelson-Atkins Museum of Art, Kansas City MO; Ferguson, *Signs.*
1657 St. Dominic saving the shipwrecked in the Garonne (he stands with two monks on the shore, while people he has just saved climb out of the water, kiss the earth, and kneel before him, raising their arms in gratitude), by Francesco Traini, 1345. Pisa, Museo Nazionale di San Matteo; Laclotte, *L'Ecole d'Avignon.*
1658 St. Dominic, holding a lily and an open book, by Francesco Traini, c. 1345. Pisa, Museo Nazionale di San Matteo; McGraw, *Encyclo.* (Vol.VIII, pl.183); Meiss, *Traini.*
1659 St. Dominic (standing full-length, holding a lily), by Carlo Crivelli. Met Museum; Zampetti, *Crivelli.*
1660 St. Dominic saving the shipwrecked mariners, fragment of the Altarpiece of Sta. Clara by Luis Borrassa, 1415.

Episcopal Museum, Vich, Spain; Erlande-Brandenburg, *Gothic Art*; Larousse, *Ren. & Baroque.*

1661 Madonna and Child with St. Dominic and St. Thomas Aquinas, fresco from San Domenico monastery in Fiesole by Fra Angelico, 1424–30. Hermitage, St. Petersburg; Piotrovsky, *Hermitage.*

1662 Dream of Honorius III, where St. Dominic shores up the tottering church, fragment of a predella by Fra Angelico. Louvre, Paris; Venturi, *Italian Painting.*

1663 St. Dominic revives Napoleon Orsini (Napoleon sits up from his bloody deathbed, as in background a horse steps on his head), from the Coronation of the Virgin altarpiece by Fra Angelico. Louvre, Paris; Gowing, *Paintings*; Pope-Hennessy, *Fra Angelico.*

1664 St. Peter and St. Paul appear to St. Dominic (in a colonnaded room, they hand him a staff and a red book), from the Coronation of the Virgin altarpiece by Fra Angelico. Louvre, Paris; Gowing, *Paintings*; Pope-Hennessy, *Fra Angelico.*

1665 The dispute of St. Dominic and the miracle of the book (a man takes the book from Dominic, but it hovers over a fire in the next room and will not burn) from the Coronation of the Virgin altarpiece by Fra Angelico. Louvre, Paris; Gowing, *Paintings*; Pope-Hennessy, *Fra Angelico.*

1666 Death of St. Dominic, from the Coronation of the Virgin altarpiece by Fra Angelico, mid-15th cent. Louvre, Paris; Boucher, *20,000 Years*; Gowing, *Paintings*; Pope-Hennessy, *Fra Angelico.*

1667 The miracle of the loaves, which St. Dominic performed at the monastery of S. Sisto Vecchio (The Golden Legend), predella of the Coronation of the Virgin altarpiece, by Fra Angelico. Louvre, Paris; Boudet, *Rome*; Gowing, *Paintings*; Pope-Hennessy, *Fra Angelico.*

1668 St. Dominic with the crucifix (blood spurts from the wounds of Jesus; Dominic hits himself with a flail), by the workshop of Fra Angelico. San Marco Museum, Florence; Pope-Hennessy, *Fra Angelico*; Verdon, *Christianity.*

1669 The meeting of St. Francis and St. Dominic (as monks look on), att. to Fra Angelico, c. 1445. M. H. De Young Memorial Museum, San Francisco CA; *European Works*; Shapley, *Samuel H. Kress.*

1670 Meeting of SS. Francis and Dominic, att. to Fra Angelico. Picture Gallery, Berlin; Pope-Hennessy, *Fra Angelico* (fig.49).

1671 Raising of Napoleone Orsini and the disputation of St. Dominic and the miracle of the book, fresco by Fra Angelico. Cortona, Museo Diocesano; Pope-Hennessy, *Fra Angelico* (fig.23b).

1672 St. Dominic burning books, by Fra Angelico. Jean Dieuzaide, Toulouse; Hallam, *Four Gothic.*

1673 The Dream of Pope Innocent III and the meeting of Saints Dominic and Francis; Saints Peter and Paul appear to St. Dominic, fresco by Fra Angelico. Cortona, Museo Diocesano; Pope-Hennessy, *Fra Angelico* (fig.23a).

1674 The birth of St. Dominic; St. Dominic receives the habit of the Dominican order (from the Virgin), by Fra Angelico. Cortona, Museo Diocesano; Pope-Hennessy, *Fra Angelico* (fig.9).

1675 The Virgin (as well as other female saints) appears to St. Dominic, by Sano di Pietro. Vatican Museums; Francia, *Vaticana.*

1676 St. Dominic resuscitates Napoleone Orsini who has fallen from a horse, by Benozzo Gozzoli, c. 1461. Brera, Milan; Newsweek, Brera; RA, *Italian.*

1677 St. Dominic (hands clasped, holding a lily and book and looking to his left), by Carlo Crivelli. Rijksmuseum, Amsterdam; Zampetti, *Crivelli.*

1678 St. Dominic (holding a book and a lily), by the School of Sano di Pietro, 1480. Univ. of Arizona Museum of Art, Tucson AZ; *Paintings & Sculpture.*

1679 St. Dominic in prayer, by Cosimo Tura, 1484. Uffizi, Florence; Bentley, *Calendar*; McGraw, *Dict.*; New Int'l Illus. *Encyclo.*; Ruhmer, *Tura.*

1680 Virgin and Child (in a landscape) with SS. Jerome (in penitence), and Dominic (reading a book), predella panel by Filippino Lippi, c. 1485. Nat'l Gallery, London; Book of Art, *Ital. to 1850*; Dunkerton, *Giotto to Dürer.*

1681 St. Dominic (in a stone niche, holding a book and pointing upward), predella from the "Altar of the Coronation of the Virgin" by Carlo Crivelli, 1493. Esztergom Christian Museum; *Christian Art in Hungary.*

1682 St. Dominic preaching (in the wilderness, with angels playing trumpets in upper left), by Sandro Botticelli,

c. 1495-98. Hermitage, St. Petersburg; Lightbown, *Botticelli*.

1683 St. Dominic and the Albigenses burning books, by Pedro Berruguete. Prado, Madrid; Book of Art, *German & Spanish*; Gaunt, *Pictorial Art*; Lassaigne, *Spanish*; Newsweek, *El Escorial*.

1684 St. Dominic at the tribunal of the inquisition, in "Auto de Fe," by Pedro Berruguete, c. 1500. Prado, Madrid; European Painting, *15th Cent.* ; Hay, *Renaissance*; *Int'l Dict. of Art*; McKendrick, *Frederick*; New Int'l Illus. *Encyclo.*; Puppi, *Torment*; Smith, *Spain*.

1685 St. Dominic (gesturing to the heavens, where he sees a vision), by Sandro Botticelli. Hermitage, St. Petersburg; Eisler, *Hermitage*.

1686 St. Dominic (with a finger to his lips for silence, holding a lily), fresco by Fra Bartolommeo. Florence, San Marco; Fischer, *Fra Bartolommeo* (fig.155).

1687 Friar Theodore of Urbino represented as St. Dominic holding a book and a lily, by Giovanni Bellini, 1515. Nat'l Gallery, London; Arcona, *Garden* (fig.84); Book of Art, *Ital. to 1800*; *Saints*; Hendy, *Nat'l Gallery*.

1688 St. Dominic (half-view, pointing to a light in upper left corner), by Titian, c. 1565. Borghese Gallery, Rome; Wethey, *Titian* (pl.187).

1689 St. Dominic and the Albigensians (their books perish in the fire, while his Gospel book remains unscathed), by Bartolomeo Passerotti, c. 1580. Bologna, Pinacoteca Nazionale; *Age of Correggio*.

1690 St. Dominic in prayer (kneels next to a boulder) by El Greco, 1587-97. Coll. Urquijo, Madrid; Gudiol, *El Greco*.

1691 St. Dominic in prayer in his cell (he is partially bald), by El Greco, 1587-97. Coll. J. Nicholas Brown, Newport; Gudiol, *El Greco*.

1692 St. Dominic receiving the rosary, oils on paper, by Federigo Barocci, 1588. Ashmolean Museum, Oxford; Held, *Oil Sketches* (Vol.I); Piper, *Treasures*.

1693 The vision of St. Dominic (looks up at Virgin and Child) by Federico Barocci, 1592-93. Sinigaglia Bishop's Palace; Held, *17th & 18th Cent.*

1694 St. Dominic in prayer, by El Greco, 1600-05. Boston Museum of Fine Arts.

1695 The Virgin and Child, St. Dominic, and angels distributing chaplets to the faithful (ecclesiastics and nobles),

drawing by Giovanni Mauro della Rovere. Met Museum; Bean, *15th & 16th Cent.*

1696 St. Dominic in prayer (kneeling by boulders), by El Greco, 1603-07. Toledo Cathedral; Gudiol, *El Greco*.

1697 Immaculate conception with Saints Dominic and Francis of Paola, by Giovanni Battista Caracciolo, 1607. Naples, S. Maria della Stella; RA, *Painting in Naples*.

1698 Madonna and Child with St. Francis and St. Dominic and angels, showing the institution of the rosary, by Giulio Cesare Procaccini, c. 1612. Met Museum; Hibbard, *Met Museum*.

1699 Madonna and Child giving the rosary to St. Dominic (at bottom, a bush with scenes from the New Testament), by Guido Reni. Bologna, Madonna di San Luca; *Guido Reni*.

1700 St. Dominic received into heaven (in S. Domenico church above his tomb), by Guido Reni, c. 1613-15. Bologna, S. Domenico; Roberts, *Master*.

1701 St. Dominic (in prayer to a tiny Madonna and Child in upper right corner), by Francisco de Zurbaran, 1625-30. Aurteuropa, Barcelona; Gállego, *Zurbaran*.

1702 St. Dominic holding a book in an archway, by P.P. Rubens. NGI, Dublin; *Catalogue*.

1703 Madonna offering the rosary to St. Dominic (as St. Peter and other saints look on), by Gaspar de Crayer, c. 1639. Brussels, Musées Royaux des B/A; Larsen, *17th Cent. Flem.*

1704 The miracle of St. Dominic, by Jacob Jordaens, 1640-45. Oldenburg, Landesmuseum für Kunst und Kulturgeschichte; d'Hulst, *Jordaens*.

1705 Apparition of the Virgin (and Child) to St. Dominic, by Francisco de Zurbaran, 1641-58. Coll. Duke of Dalmacia, Saint-Amans-Soult; Gállego, *Zurbaran*.

1706 Death of St. Dominic (as a way opens to heaven), by Francisco de Zurbaran, 1641-58. Coll. Duke of Dalmacia, Saint-Amans-Soult; Gállego, *Zurbaran*.

1707 St. Dominic (holding up a crucifix), by Francisco de Zurbaran, 1641-58. Convent of the Capuchin Nuns, Castellón de la Plana; Gállego, *Zurbaran*.

1708 St. Dominic (studying a crucifix), by Francisco de Zurbaran 1641-58. Seville, Archbishop's Palace; Gállego, *Zurbaran*.

1709 St. Dominic's miraculous portrait at Soriano (the Virgin and saints show Dominic's portrait to a monk), by Alonso Cano, c. 1648-52. Manuel Gomez-Morano, Madrid; Wethey, *Alonso Cano* (pl.79).

1710 St. Dominic (holding a lily), by Francisco de Zurbaran, 1658-64. Seville, Museum of Fine Arts; Gállego, *Zurbaran*.

1711 St. Dominic (standing in meditation, as a dog with a bone lies at his feet), by Francisco de Zurbaran, 1658-64. Coll. Duke of Alba, Madrid; Gállego, *Zurbaran*.

1712 The Virgin and Child give the rosary to St. Dominic (she points to a pallet written with the 15 mysteries of Christ's life), by Pierre Le Tellier. Rouen, Musée des B/A; *La Peinture d'Inspiration*.

1713 The apparition of St. Dominic in Soriano, drawing by Alonso Cano. Prado, Madrid; Canton, *Spanish Drawings*.

1714 St. Dominic (looking heavenward while beset by devils), by Luca Giordano, 1705. Nantes, Musée des B/A; Cousseau, *Musée*.

1715 St. Dominic in glory (angels carry him to heaven), by Giambattista Tiepolo. Venice, Chiesa dei Gesuati; Morassi, *Catalogue*.

1716 St. Dominic in glory (carried to heaven along with a cross), by Giambattista Tiepolo. Accademia, Venice; Morassi, *Catalogue* (pl.114).

1717 St. Dominic instituting the rosary (he hands it down to people who wait below him on steps), fresco by Giambattista Tiepolo, 1737-39. Venice, Chiesa dei Gesuati; Morassi, *Tiepolo*.

1718 The Virgin hearing the prayers of St. Dominic, fresco by Giambattista Tiepolo. Venice, Chiesa dei Gesuati; Morassi, *Catalogue*.

1719 The Virgin receiving the prayers of St. Dominic, oil sketch by Giovanni Battista Tiepolo, 1737. Boston Museum of Fine Arts; Morassi, *Catalogue*.

1720 The glory of St. Dominic (carried to heaven by angels), by Giovanni Battista Tiepolo, 1738-39. Philadelphia Museum of Art, PA.

See also 201, 489, 563, 1076, 1213, 1230, 1247, 1248, 1250, 1253, 1257, 1549, 1622, 2702, 2843, 3423, 3965, 4035, 4250, 4925

Dominic of Silos, Spanish Benedictine prior, abbot of Silos, d. 1073 (Dec. 20)
1721 Santo Domingo de Silos (in gold ecclesiastical cope, sitting on golden throne, holding an open book but looking straight ahead) by Bartolomé Bermejo, 1474-77. Prado, Madrid; Bentley, *Calendar*; *Guide to Prado*; Lloyd, *1773 Milestones* (p.158); McGraw, *Encyclo.* (Vol.XIII, pl.135); New Int'l Illus. *Encyclo.*; Newsweek, *Prado*.

Domitilla, Roman, converted by SS. Nereus and Achilleus; beheaded; mart. 1st cent. (May 12)
1722 Saints Agnes (holding a lamb) and Domitilla (holding a disc inscribed with "YHS"), by Andrea Bonaiuti da Firenze, c. 1365. Accademia, Florence; Andres, *Art of Florence* (Vol.I, pl.142).

1723 Saint Domitilla, with Saints Nereus and Achilleus (all three being crowned with wreaths of flowers), by Il Pomarancio, c. 1598. Rome, Santi Nereo ed Achilleo; Jaffé, *Rubens and Italy*; Met Museum, *Caravaggio*; White, *Rubens*.

1724 SS. Gregory, Domitilla, Maurice, and Papianus, black chalk and ink on paper by P.P. Rubens, c. 1606. Fabre Museum, Montpellier; Jaffé, *Rubens and Italy*; White, *Rubens*.

1725 SS. Gregory, Domitilla, Maurice, and Papianus, oil sketch by P.P. Rubens, c. 1606-07. Coll. Count Antoine Seilern, London; Jaffé, *Rubens and Italy*.

1726 Study for St. Domitilla (half-view, sitting in left profile), oil on paper by P.P. Rubens, c. 1606. Carrara Academy, Bergamo; Jaffé, *Rubens and Italy*.

See also 3685, 3732, 3910

Donation *see* **Donatus**

Donatus or Donation, Bishop and patron of Arezzo; stabbed with a knife; mart. 362 (Aug. 7)
1727 St. Donatus (in bishop's robes with miter), by Pietro Lorenzetti. Arezzo, Sta. Maria della Pieve; DeWald, *Lorenzetti*.

1728 St. Donatus in a cope, giving a blessing, by Taddeo di Bartolo, c. 1400. Witte Memorial Museum, San Antonio, TX; Meiss, *Traini*; Shapley, *Samuel H. Kress*.

1729 Mass of St. Donatus, from an altarpiece by Giovanni d'Agnolo di

Balduccio. Arezzo, S. Domenico; Kaftal, *Tuscan*.

1730 St. Donatus in an ecclesiastical cope holding a wheel-shaped candelabra, from "Madonna with Canon Van der Paele" by Jan van Eyck, 1436. Bruges, State Museum; *Eight Centuries*; Gaunt, *Pictorial Art*; Gowing, *Biog. Dict.*; Oxford, *Medieval Europe*; Pauwels, *Musée Groeninge*.

1731 St. Donatus and St. Augustine (each behind a sill bearing his name) two panels from a predella att. to Filippino Lippi, c. 1490. N. Carolina Museum of Art, Raleigh; Shapley, *Samuel H. Kress*.

1732 A miracle of St. Donation of Arezzo (he prays at the grave of a penitent's wife, who has stolen tax money, to discover where she hid it), by Lorenzo di Credi. Worcester Art Museum; *Handbook*.

1733 St. Donatus holding a candelabra; St. Bernardino of Siena and St. Martin flank the kneeling donor, in Canon Bernardinus de Salviatis and Three Saints, shutter of an altarpiece by Gerard David, c. 1501. Nat'l Gallery, London; Coulson, *Saints*; Dunkerton, *Giotto to Dürer*.

See also 3504

Donatus of Fiesole, Irish Bishop of Fiesole, d. 876 (Oct. 22)
See also 197

Donnino, Warrior martyr, invoked against rabies; beheaded; mart. 304 (Mar. 9)
1734 St. Donnino (as a youth, holding a mace and a sword), fresco by the Piedmontese School, 14th cent. Isola di S. Giulio (Orta); Kaftal, *North West Italy*.

1735 Posthumous scenes of St. Donnino: he is beheaded near the river Sisterion, but he lifts his own severed head and carries it across the river, so he can be buried by Christians; translation of St. Donnino; predella panels to a triptych by Giovanni del Biondo. Brozzi, S. Donnino; Kaftal, *Tuscan*.

1736 Scenes from the life of St. Donnino: he persuades Roman soldiers to leave their pagan emperor; he distributes his possessions to the poor; he cures a man bitten by a rabid dog; he is seized by imperial soldiers; predella panels to a triptych by Giovanni del Biondo. Brozzi, S. Donnino; Kaftal, *Tuscan*.

1737 St. Donnino (standing in a fur-trimmed cloak, holding a sword and a cross, with a dog at his feet), from a triptych by Giovanni del Biondo. Brozzi, S. Donnino; Kaftal, *Tuscan*.

1738 St. Donnino enthroned, with disciples and a worshipper attacked by a dog, by Taddeo di Bartolo. Pisa, Museo Nazionale di San Matteo; Kaftal, *Tuscan*; New Int'l Illus. *Encyclo*.

1739 St. Donnino (headless, holding his own head), panel of a polyptych by the Romagnole-Marchigian School, c. 1449. Viadana, S. Maria; Kaftal, *North East Italy*.

1740 St. Donnino (standing with a sword, with a dog at his feet, and holding a chalice), by Antonio da Fabriano. Coll. Ex Andrássy, Budapest; Kaftal, *Central and So. Ital*.

Dorothy, virgin martyr; beheaded, mart. c. 300 (Feb. 6)
1741 St. Dorothy (with a striped ribbon in her hair, holding a bunch of flowers in her hand and other flowers in her skirt), from the Santa Petronilla altarpiece by Ambrogio Lorenzetti, c. 1335. Siena, Pinacoteca Nazionale; Edgell, *Sienese Painting*; Kaftal, *Tuscan*; McGraw, *Encyclo*. (Vol.IX, pl.193).

1742 St. Dorothy with Infant Christ (holding a basket), woodcut, c. 1420. Staatliche Graphische Sammlung, Munich; Janson, *History* (pl.481).

1743 Virgin and Child with St. Dorothy (Dorothy holds a basket of flowers, and the Child reaches for it), att. to the workshop of Gentile da Fabriano. Urbino, Galleria Nazionale delle Marche; Kaftal, *Central and So. Ital*.

1744 Saint Dorothy (accepting a basket from the Christ Child), and St. Catherine of Alexandria (with a sword and wheel), by the Master of the Passion of Darmstadt, first half of 15th cent. Dijon, Musée des B/A; Georgel, *Musée des B/A*.

1745 St. Dorothy (handing a rose to the Christ Child), colored woodcut by anon. German Upper Rhenish artist, 1440-60. NGA, Washington DC.

1746 St. Dorothy and the Infant Christ, by Francesco Di Giorgio Martini before 1466. Nat'l Gallery, London; Book of Art, *Ital. to 1850*; Coulson, *Saints*; Gaunt, *Pictorial Art*.

1747 Saint Peter (holding keys and

glasses) and St. Dorothy (holding a basket of flowers), by Master of St. Bartholomew, c. 1490–1510. Nat'l Gallery, London; Dunkerton, *Giotto to Dürer*; Herald, *Ren. Dress.*
1748 Holy family with St. Dorothy (she hands the Child a bowl of flowers), att. to Veronese, c. 1553–57. Bordeaux, Musée des B/A; *Peinture Ital.*
1749 Martyrdom of St. Dorothy (executioner is about to plunge a dagger into her from behind), by Bernardo Strozzi. Chrysler Museum, Norfolk VA; *Treasures.*
1750 St. Dorothy (in a hooped dress and striped shawl, holding a plate of fruit), by Francisco de Zurbaran, c. 1650. Seville, Museum of Fine Arts; Book of Art, *German & Spanish*; Gállego, *Zurbaran.*
1751 St. Dorothy (looking up, with her hand in a bowl of flowers held by an angel), by Simone Pignone, c. 1650. Bob Jones Univ. Art Gallery, Greenville, SC; Pepper, *Ital. Paintings.*
1752 St. Dorothy (accepting a basket of fruit from an angel, as a man holding a sword looks on), by Alessandro Tiarini. Doria Pamphili Palace, Rome; McGraw, *Encyclo.* (Vol.VIII, pl.219).
1753 St. Dorothy (holding a rapier; an angel gives her a basket of flowers), by Ignaz Stern, c. 1723. Walters Art Gallery, Baltimore; *Italian Paintings* (Vol.II).
See also 1291, 1579

Dunstan, Archbishop of Canterbury, d. 988 (May 19)
1754 St. Dunstan kneeling at the foot of Christ, ms. illum. Bodleian Library, Oxford; Woodruff, *Alfred.*
1755 St. Dunstan, archbishop of Canterbury, ms. illum. BM, London; Strutt, *Regal.*
1756 St. Dunstan seizing the devil with pincers, 15th cent. stained-glass window. Bodleian Library, Oxford; Drake, *Saints and Emblems.*
1757 The insolence of Dunstan to King Edwy, by William Bromley, 1793. RA.
1758 St. Dunstan separating Edwy and Elgiva, by William Dyce, 1839. RA.

Dympna, 7th cent. martyr, patroness of insane and epileptics, killed by her father because she wouldn't marry him (May 15)
1759 Martyrdom of St. Dympna

(Dymphine) and her confessor St. Gerebernus (Gebern), decapitated by her father, by Anvers master, c. 1500. Liechtenstein coll.; Baumstark, *Masterpieces*; Flammarion, *Toison d'Or.*

Edmund of Abingdon, archbishop of Canterbury, d. 1240 (Nov. 16)
1760 The consecration of St. Edmund of Abingdon, drawing by Matthew Paris from "Historia Anglorum," 1240. BM, London; Coulson, *Saints.*

Edmund the Martyr, King of the East Angles; killed in battle against the Danes, d. 870 (Nov. 20)
1761 Coronation of St. Edmund (by two bishops), from ms.736, fo.8v, c. 1125. Pierpont Morgan Library, NY; Pierpont, *Medieval and Ren.*
1762 Hanging of the thieves who tried to rob Edmund's tomb, from ms.736, fo.19v, c. 1125. Pierpont Morgan Library, NY; McGraw, *Encyclo.* (Vol.VI, pl.429).
1763 St. Edmund crowned by angels, ms.736, f.22v, c. 1125. Pierpont Morgan Library, NY.
1764 St. Edmund feeding the hungry, from "Life of St. Edmund," 1125–50. Pierpont Morgan Library, NY; Rickert, *Painting in Britain.*
1765 Wolf who guarded St. Edmund's head follows the man carrying it away; Saint's head is fitted to the body in the wolf's presence, from "Miracles of St. Edmund King and Martyr," by Abbo, Abbot of Fleury, dedicated to Archbishop Dunstan, c. 1125–50. Coll. Major G. L. Holford; Burlington, *Illum. MS.*
1766 St. Edmund condemned to death by Hinguar the Dane; death of St. Edmund; both from MS Royal 2 B vii. BM, London; Strutt, *Regal.*
1767 St. Edmund enthroned, by Matthew Paris, MS Cotton Claud. D vi, fo.7v. BM, London; Lewis, *Paris.*
1768 Coronation of Edmund as king of East Anglia by Bishop Humbert; hanging of eight thieves who had broken into the church where the saint lay, and were struck motionless until captured in the morning, ms. illums. from "Miracles of St. Edmund, king and martyr." Coll. Sir George Holford; RA, *Primitive.*
1769 St. Edmund supervises the building of an abbey, from "Metrical Life of St. Edmund," ms. Harley 2278, 15th cent. BM, London; *Benedict* (p.389).

1770 St. Edmund the Martyr (in regal robes, holding an arrow), stained-glass window, 15th cent. Stoke D'Abernon, St. Mary's Church; Bentley, *Calendar.*

1771 St. Edmund, king of East Anglia, on the morning of his last battle with the Danes, by whom he was captured and martyred near Bury, November 20, 890, by John Rogers Herbert, 1867. RA.
See also 1781

Edward the Confessor, King of England, d. 1066, canonized 1161 (Oct. 13)
1772 Queen Emma, King Harthacnut and Prince Edward, with the author of "Encomium Emmae," frontispiece to MS 33241, fo. Iv, mid-11th cent. BM, London; Smalley, *Historians.*

1773 Edward the Confessor, from "Effigies Regum Angliae a S. Edwardo rege et Confessore ad Edwardum I," MS Vitellius A xiii. BM, London; Strutt, *Regal.*

1774 Pictures of the life of Edward the Confessor, from an insert into an abbreviated Domesday Book: Edward and Earl Leofric at mass in Westminster Abbey, seeing Jesus in the flesh; Edward accused Earl Godwine of the murder of his brother Alfred, MS E 36/24, 13th cent. London Public Record Office; Ashley, *William*; Barlow, *Edward the Confessor.*

1775 Pictures of the life of Edward the Confessor, from an insert into an abbreviated Domesday Book: Edward recovers from a pilgrim the ring which he had given to a beggar who was St. John the Evangelist in disguise; Edward's vision of the drowning of King Svegn of Denmark; Edward's vision of the seven sleepers of Ephesus, from MS E 36/24, c. 13th cent. London Public Record Office; Ashley, *William*; Barlow, *Edward the Confessor.*

1776 Edward the Confessor enthroned, from Matthew Paris, MS Cotton Claud. D vi. fo.8v. BM, London; Lewis, *Paris.*

1777 Edward the Confessor's marriage to Ealdgyth from Matthew Paris, "La Estoire de Seint Aedward li Rei," c. 1245. Cambridge Univ. Library; Davenport, *Book of Costume* (pl.491).

1778 Edward the Confessor discussing the construction of Westminster Abbey with his architect and workmen, from MS Ee 3.59, mid-13th cent. Cambridge Univ. Library; Hibbert, *London.*

1779 Edward the Confessor receiving petitions and letters, colored illus. from "The Life of St. Edward the King." Cambridge Univ. Library; Ashley, *William.*

1780 Edward the Confessor; Edward at a banquet; from 14th cent. ms. BM, London; Ashley, *William.*

1781 Richard II, with Saints Edmund and Edward the Confessor, adoring the Virgin and Child, left-hand panel from the Wilton Diptych, Anglo-French, 1395–1405. Nat'l Gallery, London; Dunkerton, *Giotto to Dürer*; Erlande-Brandenburg, *Gothic Art*; European Painting, *15th Cent.*; Fowler, *Age of Plant.*; Hendy, *Nat'l Gallery*; Larousse, *Ren. & Baroque.*

1782 Christ in glory with SS. Mary Magdalene, Hermenegild, and Edward the Confessor, with the patron Cardinal Odoardo Farnese, by Annibale Carracci, c. 1595. Pitti Palace, Florence; *Age of Correggio.*

1783 Edward the Confessor leaving the crown to Harold, by John Cross, 1851. RA.

1784 The dedication of St. Edward the Confessor, by Miss Mary Winefride Freeman, 1904. RA.
See also 3313

Edward the Martyr, king of England; murdered; k.979 (Mar. 18)
1785 Edward the Martyr hunting; Edward the Martyr given a cup before being stabbed by servant, from MS Royal 2 B. vii. BM, London; Strutt, *Regal.*

1786 Scenes from the life of St. Edward the Martyr, king of England (he is stabbed while sitting on his horse at the entrance to his castle), from the Breviary of the Duke of Bedford, called the Breviary of Salisbury, ms. lat. 17294, fol. 432v, c. 1424. BN, Paris; Sterling, *Peinture Médiévale.*

1787 The assassination of Edward the Martyr, by J. Hadwen Wheelright, 1848. RA.

Efriam, the Syrian
1788 Death of St. Efriam the Syrian (surrounded by cripples), icon by Andreas Pavias, 1450–1500. Jerusalem, St. Constantine & Helena; Knopf, *The Icon* (p.320).

Egidius *see* **Giles of Rome**

Eleutherius 88

Eleutherius or Eleuterio, pope, co-patron
of Parenzo; beheaded, mart. 189 (April
18 or May 6)
1789 St. Eleutherius (pointing at a
closed book), fresco by Fra Diamante in
the Sistine Chapel. Vatican Museums;
Brusher, *Popes.*

Eleutherius of Tournai, Bishop of
Tournai, d. 532 (Feb. 20)
1790 St. Eleutherius raises Blande from
the dead (he helps her out of a coffin),
tapestry. Tournai, Belgium; Bentley,
Calendar.

Elias, patriarch of Antioch, 5th cent.
(July 20)
1791 St. Elias (barefoot, holding a
palm), by Francisco de Zurbaran, 1641–58.
Castellón de la Plana, Convent of the
Capuchin Nuns; Gállego, *Zurbaran.*
1792 St. Elias (holding a flaming
sword), by Francisco de Zurbaran,
1641–58. Córdoba, Provincial Museum of
Fine Arts; Gállego, *Zurbaran.*

Eligius or Eloi or Loy or Alò, bishop of
Noyon, master of the Frankish mint
under Clotaire II, patron of metal
workers, d. 660 (Dec. 1)
1793 Birth of St. Eligius, by a follower
of Altichiero. Ashmolean Museum, Ox-
ford; Kaftal, *North East Italy.*
1794 Scenes from the life of St.
Eligius: his pregnant mother dreams of an
eagle that promises great things for her
baby, by a follower of Altichiero.
Philadelphia Museum of Art, PA; Kaftal,
North East Italy.
1795 St. Eligius performing his offices,
from a manuscript given by Charles IV to
the King of France to thank him for the
gift of Eligius's miter, 1378. Biblio.
Historique de la Ville de Paris; Stejskal,
Charles IV.
1796 St. Eloi making a horseshoe at his
forge; St. Eloi raised to the Episcopat; St.
Eloi protector of the cripples and the
horses; stained-glass panels from Church
of St.-Ouen de Rouen. St.-Ouen de
Rouen; Corpus Vitrearum Medii Avei,
*Les Vitraux de l'eglise Saint-Ouen de
Rouen,* Caisse Nationale des Monuments
Historiques, Paris, 1970.
1797 Saint Eligius, marble statue att.
to Nanni di Banco, c. 1411–14. Florence,
Or San Michele Church; Andres, *Art of
Florence* (Vol.I, pl.187); New Int'l Illus.
Encyclo. (see Nanni).

1798 St. Eligius (standing in a fur-lined
cloak, holding a hammer), by the work-
shop of Gentile da Fabriano. Kress Coll.,
NY; Kaftal, *Central and So. Ital.*
1799 St. Eligius as a goldsmith (weigh-
ing gold for wedding rings), by Petrus
Christus, 1449. Lehman Coll., New York;
Cooper, *Private Coll.*; Coulson, *Saints*;
Gyratzsch, *Dutch*; Hibbard, *Met Mu-
seum*; Munro, *Golden Encyclo.* (p.128);
New Int'l Illus. *Encyclo.*; Piper, *Illus.
Dict.* (p.86); Snyder, *Northern Ren.*
1800 Clothaire II orders St. Eligius to
make him a gold saddle; St. Eligius
weighs the gold at a shop; Eligius works
on the saddle in the goldsmith's shop;
panels in the Orcagna-Daddi tradition.
Coll. Cambo, Barcelona; Kaftal, *Tuscan.*
1801 Coronation of the Virgin with
SS. John the Evangelist, Jerome,
Augustine, and Eligius, by Sandro Bot-
ticelli, c. 1490–93. Uffizi, Florence;
Lightbown, *Botticelli.*
1802 Miracle of St. Eligius (he puts a
horseshoe on the detached horse's foot),
predella panel of the San Marco Altar-
piece by Sandro Botticelli, c. 1490–93.
Uffizi, Florence; Lightbown, *Botticelli.*
1803 SS. Anthony Abbot (standing
with a staff, reading a book), and Eligius
(holding a horse's severed leg and a but-
teris), with tiny hooded kneeling members
of a confraternity of penitents, from a
banner by the Studio of Lucca Signorelli.
Borgo San Sepolcro, Pinacoteca; Kaftal,
Tuscan.
1804 St. Eligius in his workshop; St.
Eligius presenting two gold saddles to
King Clothaire II; St. Eligius giving alms
to the poor; consecration of St. Eligius as
Bishop of Noyon; pilgrims visit the tomb
of St. Eligius; predellas for an altarpiece
by the Sardinian School, 15th-16th cent.
Cagliari, Museo Civico; Kaftal, *Central
and So. Ital.*
1805 St. Eligius shoeing the detached
foot of a diabolical horse (the devil is
standing by in the form of a woman while
a man holds up the horse's stump), panel
by Gerinesque. Bagnères de Bigorre,
Musée; Kaftal, *Tuscan.*
1806 St. Eligius at the anvil, holding
the horse's foot, painted stone statue,
French, early 16th cent. John Higgins Ar-
mory Museum, Worcester MA.
1807 The consecration of St. Eligius,
by Lorenzo Lotto, c. 1536. Univ. of Ari-
zona Museum of Art, Tucson AZ; Eisler,

European Schools; *Paintings & Sculpture*.
1808 St. Eligius (kneeling in an ecclesiastic cope) adoring the crucified Christ (he holds out a golden saddle; he kneels in the wilderness with a town in the background), by Bastarolo. Trecenta, Parochial Church; Frabetti, *Manieristi*.
1809 St. Eligius presenting Clothaire with the golden saddle, by Francisco Ribalta after Juan de Juanes, 1607. Valencia, San Martín; Eisler, *European Schools*.
1810 St. Catherine and St. Eligius, study for the "Raising of the Cross" altarpiece, oil sketch by P.P. Rubens, 1609. Dulwich College Picture Gallery, London; Rowlands, *Rubens, Drawings*.
1811 Virgin and Child (above) with Saints Eligius and Petronius, by G. Cavedone. Bologna, Pinacoteca Nazionale; McGraw, *Encyclo*. (Vol.VIII, pl.219).
1812 Virgin and Child (in the clouds) appearing to St. Eligius (who kneels before them; at left, cherubs hold his crosier), by Pompeo Batoni, c. 1748-50. Rome, S. Eligio dei Ferrari; Clark, *Batoni*.
1813 Virgin and Child (in the clouds) appearing to St. Eligius (who kneels before them; at left, cherubs hold his crosier), by Pompeo Batoni, c. 1748-50. Private coll., London; Clark, *Batoni*.
See also 131, 238, 3320, 4080

Elizabeth of Hungary, Queen of Hungary, Franciscan Tertiary, d. 1231, canon. 1235 (Nov. 19)
1814 St. Elizabeth of Hungary with flowers in her apron, triangular oil by Ambrogio Lorenzetti, c. 1319-47. Isabella Stewart Gardner Museum, Boston MA.
1815 SS. Francis, Louis of Toulouse, Elizabeth of Hungary, and Clare, fresco by Simone Martini, c. 1320-39. San Francesco, Assisi; Edgell, *Sienese Painting*.
1816 St. Elizabeth of Hungary holding an apronful of roses, by Lippo Vanni. Nelson-Atkins Museum of Art, Kansas City MO; Ferguson, *Signs*.
1817 Doge Francesco Dandolo and his wife presented to the Madonna and Child by SS. Francis and Elizabeth (the Child faces the Doge, the Virgin faces the wife), by Paolo Veneziano. Venice, Santa Maria Gloriosa dei Frari; Hills, *The Light*.

1818 St. Clare and St. Elizabeth of Hungary, fresco by Simone Martini. San Francesco, Assisi; Boase, *Vasari* (pl.98).
1819 St. Elizabeth giving bread to a beggar, wing of the Deichsler Altarpiece, c. 1415-20. Picture Gallery, Berlin; *Catalogue*.
1820 Elizabeth of Hungary holding a crown, from "Virgin and Child with saints" by Jan van Eyck. Frick Coll., NY; Coulson, *Saints*.
1821 St. Elizabeth of Hungary clothing the poor, by the Master of the First Prayer Book of Maximilian, from the Hours of William Lord Hastings, add. ms. 54782, fo.50v, late 1470's. BM, London; BL, *Ren. Painting in MS*.
1822 St. Elizabeth of Hungary, holding a loaf of bread, lindenwood statue, Upper Rhenish or Swabian, c. 1490. Isabella Stewart Gardner Museum, Boston MA; Hadley, *Museums Discovered*.
1823 St. Elizabeth of Hungary (holding a pitcher and a loaf of bread), wooden statue, Franconian, c. 1500. Rochester Memorial Art Gallery, NY; *Handbook*.
1824 The engagement of St. Elizabeth and Louis of Thuringia; the wedding feast on the Wartburg; St. Elizabeth tending the sick in Marburg; the death of St. Elizabeth; the St. Elizabeth's Day flood before the city of Dordrecht; panels by the Master of the St. Elizabeth Panels, late 15th–early 16th cent. Rijksmuseum, Amsterdam; *Paintings*.
1825 St. Francis in glory, with St. Louis IX of France and St. Elizabeth of Hungary, by Filippino Lippi and assistants, c. 1503. Brooks Memorial Art Gallery, Memphis TN; Shapley, *Samuel H. Kress*.
1826 St. Elizabeth of Hungary, hair blowing, holding a palm leaf, by Matthias Grünewald, c. 1512. Furstenbergische Gallery, Donaueschingen; Book of Art, *German & Spanish*; Cooper, *Family Collections*; McGraw, *Encyclo*. (Vol.VII, pl.93).
1827 The coronation of the Virgin with Saints Louis IX and Elizabeth of Hungary, by Giovanni da Asolo. Nancy, Musée des B/A; *Musée*; Pétry, *Musée*.
1828 St. Elizabeth of Hungary with the three beggars, from the Altarpiece of St. Sebastian by Hans Holbein the Elder, 1516. Alte Pinakothek, Munich; Benesch, *German*.

1829 Madonna with a Carthusian monk between St. Barbara and St. Elizabeth (before a window showing a city in background), by Jan van Eyck and a follower. Frick Coll., NY; Picture Gallery, Berlin, *Gemäldegalerie.*
1830 Madonna and Child with SS. Elizabeth (seated at a table), the infant St. John the Baptist, and St. Justina (in a yellow dress, touching the leg of the Child), by Paolo Veronese, 1555–60. Timken Art Gallery, San Diego CA; *European Paintings.*
1831 Visitation of the Virgin to St. Elizabeth (as several people look on), drawing by Giovanni Balducci. Met Museum; Bean, *15th & 16th Cent.*
1832 St. Elizabeth distributing her wealth to the poor (she is handing out her jewels, while a man waits with a basketful of silver plate), by Martin Pepyn, 1623. Koninklijke Museum, Antwerp; Hairs, *Sillage de Rubens.*
1833 St. Elizabeth of Hungary in brocade dress with black hair, by Francisco de Zurbaran, 1640's. Coll. Mrs. William Van Horne, Montreal; Hubbard, *Canadian Collections.*
1834 St. Elizabeth of Hungary cures a leper (she baptizes him), by Murillo. Madrid, Academy of Fine Arts; De Bles, *Saints in Art.*
1835 Madonna and Child with SS. Anthony Abbot (holding a bell), Charles Borromeo, Elizabeth, and John the Evangelist, by Francesco Fontebasso. Ponce, Museo de Arte; Held, *Catalogue.*
1836 St. Elizabeth of Hungary (she stands next to her throne, wearing a crown, looking down at a kneeling knight), watercolor by Gustave Moreau, 1882. Private coll., Paris; Moreau, *Gustave Moreau.*
See also 914, 1397, 3888

Elizabeth of Portugal, Queen of Portugal, Franciscan, d. 1336 (July 8)
1837 St. Elizabeth of Portugal holding an apronful of roses, mural painting by Ferrer Bassa in Chapel of St. Miguel. Pedralbes Monastery, Barcelona; McGraw, *Dict.*
1838 St. Elizabeth of Portugal (holding flowers in her skirt), by Francisco de Zurbaran, 1641–58. Coll. Sir William van Horne, Montreal; Gállego, *Zurbaran.*
1839 Elizabeth of Portugal washing a beggar's hair, by Murillo. Hospital de la Caridad, Seville; Coulson, *Saints.*

Elizabeth of Thuringia, countess of Thuringia
1840 Statue of St. Elizabeth of Thuringia (holding a basket of bread), statue by the Master of the Altar of St. Elizabeth in Gdańsk, c. 1400. Wawel Castle, Poland; Szablowski, *Collections.*
1841 Triptych with the Virgin and Child, with side panels of St. Agnes (with her lamb) and Elizabeth of Thuringia (giving a cloak to a cripple), by the Master of the Older Holy Kinship, first third of the 15th cent. Picture Gallery, Berlin; *Gemäldegalerie.*
1842 St. Elizabeth of Thuringia (holding a book and palm), by Francisco de Zurbaran, 1641–58. Bilbao, Provincial Museum of Fine Arts; Gállego, *Zurbaran.*

Elmo *see* **Erasmus**

Eloi *see* **Eligius**

Elzéar, Prince, Count of Arian, Franciscan Tertiary, d. 1323, canon. 1369 (Sept. 27)
1843 St. Elzéar healing lepers, marble sculpture/relief from Provence, c. 1373. Walters Art Gallery, Baltimore.
1844 St. Elzéar (in monk's robes, holding a scroll and a scepter), fresco by the Lombard School, c. 1430. Lodi, S. Francesco; Kaftal, *North West Italy.*

Emerentia
1845 St. Emerentia with Virgin and Child and St. Anne (Emerentia stands behind the others, with a walking stick and an open book), wall statuette, polychrome and gilt, by an unknown Urban Master of Hildesheim, c. 1515–30. Met Museum; Auchincloss, *J.P. Morgan.*

Emidius or Emygdius, first Bishop and patron of Ascoli; beheaded (Aug. 5)
1846 The Annunciation with St. Emidius (Emidius, carrying a model of the town of Ascoli, joins Gabriel on the way to the Virgin Mary), by Carlo Crivelli, 1486. Nat'l Gallery, London; Dunkerton, *Giotto to Dürer*; Kaftal, *North East Italy*; Wilson, *Nat'l Gallery.*
1847 Virgin and Child giving the key to St. Peter, with SS. Francis, Emidius, John Capestrano, Louis of Toulouse, and the Blessed Giacomo della Marca, by Carlo Crivelli, 1488. Picture Gallery, Berlin; *Gemäldegalerie*; *Masterworks.*

Emmerich or Henry, Prince of Hungary, d. 1031, canon. 1087 (Nov. 4)
1848 St. Emmerich (standing in an ermine-trimmed tunic, holding a lily, with his left hand on his dagger), from an altarpiece by a Remote Orcagnesque, 1391. Florence, S. Martino a Mensola; Kaftal, *Tuscan.*
1849 St. Emmerich and his wife vow to live a life of continence, while his father St. Stephen looks on (from behind the door), predella to an altarpiece by a Remote Orcagnesque, 1391. Florence, S. Martino a Mensola; Kaftal, *Tuscan.*
See also 3221, 4561

Emygdius *see* **Emidius**

Enagrius and Benignus
1850 Martyrdom of Theodosia (she is decapitated), burial of Mary of Egypt, and Enagrius and Benignus, illumination from the so-called Dietrichstein Martyrologium, c. 1410. Gerona, Diocesan Museum, Spain; Bachmann, *Gothic Art.*

Endoxus
1851 Saint Endoxus, giving a blessing, fresco, end of 12th cent. Church of Christ Antiphonitis, near Kalogrea; Stylianou, *Painted Churches* (p.477).

Engracia, Portuguese princess, killed for denouncing Roman persecution
1852 Santa Engracia apprehended upon entering Zaragoza, Spain, by Bartolomé Bermejo, c. 1475–80. San Diego Fine Arts Gallery; L.A. Times, *Calif. Museums*; *Master Works*; Timken Gallery, *European Paintings.*
1853 St. Engracia (in a green cloak, holding a palm), by Bartolomé Bermejo, c. 1477. Isabella Stewart Gardner Museum, Boston MA; Hadley, *Museums Discovered*; Lassaigne, *Fifteenth Cent.*
1854 St. Engracia (praying, an arrow in her forehead), by Zurbaran, 1641–58. Seville Cathedral; Gállego, *Zurbaran.*
1855 St. Engracia, by Francisco de Zurbaran, 1641–58. Seville, Museum of Fine Arts; Gállego, *Zurbaran.*

Ephesus or Ephysius, Roman knight, patron of Sardinia and Pisa; beheaded, mart. 286 (Jan. 15)
1856 Martyrdom of St. Ephesus: he is taken before the judge Flavian; he is put into an oven, but the flames turn on his persecutors; he is beheaded; his soul is taken to heaven by angels, fresco by Spinello Aretino, 1391. Campo Santo, Pisa; Kaftal, *Tuscan.*
See also 4081

Epiphanius, Bishop, Patron of Pavia, 5th–6th cent. (June 18)
1857 St. Epiphanius (dressed as a bishop) standing with SS. Liberata (holding a lily), Luminosa (holding a lily and a bag with a book in it), and Speciosa, from an altarpiece by Ambrogio Bergognone, c. 1485. Pinacoteca Ambrosiana, Milan; Kaftal, *North West Italy.*

Erasmus or Elmo, bishop of Formaie, patron saint of sailors; invoked against cramp and diseases of the intestines; entrails pulled out with windlass; mart. 303 (June 2)
1858 St. Erasmus (with his entrails being pulled out, as the pagan magistrate looks on), ms. illum. by the school of Van Eyck, ms. Ludwig IX 7, fol.18v. J. Paul Getty Museum, Malibu CA; Dogaer, *Flemish Min.*
1859 The martyrdom of St. Erasmus (executioners use a windlass to pull his entrails out of his body), flanked by SS. Jerome (in cardinal robes, reading a book) and Bernard of Clairvaux (standing in a black robe, holding a book and crosier, demon at his feet), by Dirck Bouts, c. 1428. Louvain, St. Pierre; Daniel, *Encyclo. of Themes*; Puppi, *Torment.*
1860 Martyrdom of St. Erasmus (executioners wind his bloody entrails on a windlass), wall mural by unknown artist. Névache, Plampinet, Eglise Saint-Sébastien; *Peintures Murales.*
1861 Virgin and Child enthroned, flanked by SS. John the Baptist and Erasmus, and Clare and Francis of Assisi, panel transferred to canvas by Leonardo da Pavia, 1466. Bianco Palace, Genoa; Kaftal, *North West Italy.*
1862 Martyrdom of St. Erasmus (pulling his entrails out with a windlass), ms. illum. by the Master of Mary of Burgundy, ms.15503, fol.36v. Lázaro Galdiano Museum, Madrid; Dogaer, *Flemish Min.*
1863 Martyrdoms of St. Erasmus: tied to a column and flogged; hung by his hands and flogged; boiled in a cauldron, unhurt; his bowels are tied to a windlass,

while the emperor looks on, from an altarpiece att. to Ludovico Brea. Briga Marittima, S. Martino; Kaftal, *North West Italy.*

1864 Martyrdom of St. Erasmus (executioner, knife in mouth, reaches into Erasmus's stomach to secure the intestines), woodcut by Lucas Cranach the Elder, Aschaffenburg, 1506. Geisberg, *Single Leaf*; Puppi, *Torment*; Schade, *Cranach.*

1865 St. Erasmus (standing in bishop's robes, holding a crosier and a candle), altarpiece by the Sicilian school, early 16th cent. Messina, Museum; Kaftal, *Central and So. Ital.*

1866 Martyrdom of St. Erasmus (executioner reaches into saint's stomach, pulling his intestines), after Lucas Cranach the Elder, 1516. Aschaffenburg, Staatsgalerie; Friedländer, *Cranach.*

1867 Meeting of Saints Erasmus and Maurice, by Grünewald, 1517–23. Alte Pinakothek, Munich; Coulson, *Saints*; Benesch, *German*; Bentley, *Calendar*; Gowing, *Bio. Dict.*; Praeger, *Great Galleries.*

1868 St. John's Altarpiece, with side panels of St. Erasmus (leaning on a windlass, looking toward the central panel) and Martin of Tours (with a beggar), by Hans Burgkmair, 1518. Alte Pinakothek, Munich; Int'l Dict., *Art.*

1869 St. Erasmus as Bishop (holding a small windlass), woodcut by Hans Sebald Beham. Geisberg, *Single Leaf.*

1870 St. Erasmus (holding a book and a windlass), painted wooden sculpture, 1550–1600. Huy, Saint-Rémy; *Tresors.*

1871 The martyrdom of St. Erasmus (he lies on his back, hands tied over his head, as executioners pull out his entrails and wind them on a windlass), by Nicolas Poussin, c. 1628. Vatican Museums; Châtelet, *French Paintings*; McGraw, *Encyclo.* (Vol.XII, pl.369); Oberhuber, *Poussin*; Puppi, *Torment.*

1872 St. Erasmus in glory (carried to heaven by angels), ceiling fresco, by Giacinto Brandi, 1663–66. Gaeta, Duomo; Waterhouse, *Roman Baroque.*

1873 Martyrdom of St. Erasmus (in darkened scene, all the executioners lean toward his face, as they pull his entrails out with their hands), by Giovan Battista Beinaschi, c. 1665. Salerno, Museo del Duomo; Puppi, *Torment.*

See also 1949, 4444, 4738

Erhard, bishop of Ratisbon; killed with an axe; mart. 686 (Jan. 8)

1874 Saint Erhard with a deacon, Ottonian ms. illum. from Uta Codes, ms.cod.lat. 13601, f.4r, c. 1002–25. Bayerische Staatsbibliothek, Munich; Gowing, *Hist. of Art* (p.553); New Int'l Illus. *Encyclo.* (see Illum.); Read, *Origins.*

See also 4905

Erigius *see* **Arigius**

Erme *see* **Hermes**

Etheldreda or Audrey, founded monastery at Ely, d. 679 (June 23)

1875 Life of St. Etheldreda, four painted panels, Ely, c. 1425. Society of Antiquaries, London; Bentley, *Calendar*; Rickert, *Painting in Britain.*

Eudoxia, Roman virgin; killed with sword; mart. 2nd cent. (Mar. 1)

1876 Saint Eudoxia, icon of marble and colored stones, 13th–14th cent. Istanbul Museum; Boucher, *20,000 Years.*

Eugene, Bishop saint, martyred

1877 Martyrdom of St. Eugene (he kneels, miter and crosier on the ground, as executioners draw their swords), by Carlo Saraceni. Toledo, Cathedral; Nicolson, *Caravaggesque Movement.*

Eugenios, Bishop saint; pushed into the sea; mart. 275 (Mar. 4)

See also 564

Eulalia, of Merida, 12 year old Spanish virgin; smothered by smoke then beheaded; mart. 304 (Dec. 10 & Feb. 12)

1878 Altarpiece of St. Eulalia (presented by armed guards to the king), by Maestro de los Privilegios, after 1349. Palma de Mallorca Cathedral; McGraw, *Encyclo.* (Vol.VI, pl.374).

1879 The martyrdom of St. Eulalia (bared to the waist, they are about to whip her), from the polyptych "Saints John the Baptist and Eulalia" by Bernardo Martorell, c. 1427–52. Barcelona, Museo d'Art de Catalyuna; New Int'l Illus. *Encyclo.* (see Spanish).

1880 Martyrdom of St. Eulalia (she is placed in a flaming oven, but is unharmed; she is beheaded, and her soul rises to heaven in the form of a dove), panels by Bicci di Lorenzo. Campo Santo, Pisa; Kaftal, *Tuscan.*

1881 St. Eulalia (standing on a check-erboard floor next to a wooden cross, holding a crucifix and a palm), att. to Pedro Serra. Syracuse, Museo Bellomo; Kaftal, *Central and So. Ital.*
1882 St. Eulalia (standing with a lily and a book), panel by Bicci di Lorenzo. Campo Santo, Pisa; Kaftal, *Tuscan.*
1883 St. Eulalia before the Roman prefect, marble relief by Bartolomé Ordonez, 1517–20. Barcelona Cathedral; Book of Art, *German & Spanish.*
1884 Saint Eulalia holding a book and a palm, panel from an altarpiece by Master of Messkirch, c. 1530–43. Philadelphia Museum of Art, PA.
1885 St. Eulalia (holding a book, with a cloak fastened to her left shoulder), by Francisco de Zurbaran, 1641–58. Seville, Museum of Fine Arts; Gállego, *Zurbaran.*

Euphemia of Chalcedon; exposed to wild beasts, burned alive then stabbed with sword; mart. 303 (Sept. 16)
1886 St. Euphemia (her arm in a lion's mouth), by Andrea Mantegna, 1454. Capodimonte, Naples; Kaftal, *North East Italy*; Lightbown, *Mantegna.*
1887 Torture of St. Euphemia (her hands and foot are already cut off, and the executioner is about to sever her head), tavoletta by the School of Bastarolo, late 16th cent. Ravenna, Pinacoteca Communale; Edgerton, *Punishment*; Frabetti, *Manieristi.*
1888 St. Euphemia (holding a saw), by Francisco de Zurbaran, 1641–58. Bianco Palace, Genoa; Gállego, *Zurbaran.*
1889 St. Euphemia (holding a saw), by Francisco de Zurbaran, 1641–58. Prado, Madrid; Gállego, *Zurbaran.*
See also 4433, 4890

Euphrosinos of Alexandria, monk, d. 470 (Jan. 1)
1890 St. Euphrosinos (holding an orange tree branch), fresco by Theophanes Bathas from Crete, 1527. Meteora, Monastery of St. Nicholas Anapavsas; Knopf, *The Icon* (p.334).
See also 4642

Eusanius or Eusanio of Fuscone, deacon, Roman; mart. 305 (July 9)
1891 St. Eusanius standing in priest's robes holding an open book and his viscera, by Saturnino de'Gatti, 1516.

Aquila, Museo Nazionale; Kaftal, *Central and So. Ital.*
1892 St. Eusanius with scenes from his life: curing the blind and raising the dead; refusing to worship idols; making the idol fall; and being taken to prison, frescoes by Saturnino de'Gatti, 1516. Aquila, Museo Nazionale; Kaftal, *Central and So. Ital.*

Eusebia *see* **2344**

Eusebius of Sicily, Pope, died while banished by Maxentius, c. 309 or 310 (Sept. 26)
1893 St. Eusebius, bronze statue att. to G. Finelli. Naples, Cathedral; Brusher, *Popes.*
1894 St. Eusebius intercedes for the plague-stricken (he holds up a crucifix, praying to the Virgin and Child above), marble sculpture by Alessandro Arrighi, 1650. Cremona, Cathedral; Voltini, *Cremona.*
1895 Christ on the Cross between SS. Eusebius, Philip Neri, and the Magdalene, by Subleyras, c. 1744. Brera, Milan; *Subleyras.*
See also 2818

Eustace, patron of huntsmen, one of the Fourteen Holy Helpers; roasted alive in a brazen bull, mart. 118 (Sept. 20)
1896 Conversion of St. Eustace, round French stained-glass window, beginning of 13th cent. Chartres Cathedral; Keller, *20 Centuries.*
1897 The conversion of St. Eustace (flanked by his horse and the stag with crucifix between its horns), ms. illum. from Psalter with canticles (hymns), 13th cent. Marciana, Venice; New Int'l Illus. *Encyclo.* (see Illum.).
1898 Baptism of St. Eustace (with his wife and two children), by Vitale da Bologna. Pomposa, Abbey; Gnudi, *Vitale.*
1899 Conversion of St. Eustace (he stops in the hunt, hawk on his wrist, and looks at the stag with Christ between its horns), by Vitale da Bologna. Pomposa, Abbey; Gnudi, *Vitale.*
1900 Martyrdom of St. Eustace (with his wife and two children in a brazen bull), by Vitale da Bologna. Pomposa, Abbey; Gnudi, *Vitale.*
1901 Scenes from the life of St. Eustace: Eustace and his family are bap-

tized; Eustace and family sail for Egypt, but the captain keeps his wife for payment; Eustace and his family are imprisoned then roasted in the belly of a brazen bull, and angels carry their souls to heaven; frescoes by Vitale da Bologna, 1351. Pomposa, Abbey; Kaftal, *North East Italy.*

1902 The vision of St. Eustace (at the hunt, he kneels before a stag with a crucifix between its horns), by Pisanello, c. 1438. Nat'l Gallery, London; Book of Art, *Ital. to 1850*; Dunkerton, *Giotto to Dürer*; Hartt, *Ital. Ren.*; Herald, *Ren. Dress*; Levey, *Nat'l Gallery*; McGraw, *Encyclo.* (Vol.VII, pl.373); New Int'l Illus. *Encyclo.*; Wilson, *Nat'l Gallery.*

1903 St. Eustace crosses the river with one of his children, while another child is carried away by a wolf; Eustace is reunited with his wife and children; Eustace and his family are roasted alive, inside a brazen bull; scenes from the life of St. Eustace, frescoes by the Marchigian School, 14th–15th cent. Ascoli Piceno, S. Vittore; Kaftal, *Central and So. Ital.*

1904 Torture of St. Eustace (he and his family are impaled on a spiked tree), predella panel by the Bolognese School, 15th cent. Bologna; Kaftal, *North East Italy.*

1905 St. Eustace (standing with a sword, holding a tiny stag in his hand), fresco by the Basilica School of Lazio, 15th cent. Sant'Elia, Castle; Kaftal, *Central and So. Ital.*

1906 St. Eustace (astride a white horse, holding a banner), from a polyptych by G. Boccati, 1468. Belforte Sul Chienti, S. Eustachio; Kaftal, *Central and So. Ital.*

1907 Vision of St. Eustace (kneeling before the stag with a crucifix between its antlers), engraving by Albrecht Dürer, 1500–01. Houston Museum of Fine Arts, TX; *Guide to the Coll.*; Snyder, *Northern Ren.*

1908 Panel of St. Eustace (in armor breastplate and red hose and red slashed doublet, holding a banner pole), from Paumgartner altarpiece by Albrecht Dürer, c. 1504. Alte Pinakothek, Munich; Benesch, *German*; New Int'l Illus. *Encyclo.*

1909 The vision of St. Eustace (kneeling before the stag in a landscape with a castle in background), by an unknown follower of Joachim Patiner, c. 1510. Nelson-Atkins Museum of Art, Kansas City MO; *Handbook.*

1910 Martyrdom of St. Eustace (burned alive with three others and a bull), French stained glass window from Church of St. Patrice, Rouen, 1543. Detroit Inst. of Art, MI.

1911 The baptism of St. Eustace (he baptizes a grown man and woman), by Pierre Pourbus, before 1572. Gouda, Musées Communaux; Huvenne, *Pourbus.*

1912 The vision of St. Eustace (he reacts in amazement, almost kneeling while one dog sleeps at his feet), drawing by Federico Zuccaro. Met Museum; Bean, *15th & 16th Cent.*

1913 Landscape with the vision of St. Eustace (dismounted, he reacts in amazement at a stag with a crucifix between its antlers), by Annibale Carracci. Capodimonte, Naples; Boschloo, *Carracci.*

1914 St. Eustace, dismounted, kneels before a stag, by Jan Bruegel. Prado, Madrid; Coulson, *Saints.*

1915 Apotheosis of St. Eustace and his family, by Simon Vouet. Nantes, Musée des B/A; Cousseau, *Musée.*

1916 St. Eustace (he kneels before the stag; above, the Trinity and the Virgin look on), by Francesco Trevisani, 1720. Ascoli Piceno, Chiesa degli Agostininani Calzati; DiFederico, *Trevisani.*

1917 St. Eustace refuses to worship the idols, by Giovanni Battista Pittoni, c. 1722. Bordeaux, Musée des B/A; Boccazzi, *Pittoni* (pl.40); *Peinture Ital.*

1918 St. Eustachio refuses to worship the idols, by Giovanni Battista Pittoni, c. 1722. Alte Pinakothek, Munich; Boccazzi, *Pittoni* (pl.41).

See also 4834

Eustachio *see* **Eustace**

Eustathios
1919 SS. Procopius, Nikita, and Eustathios (holding orthodox crosses), two-sided feast day icon (tabletki), Novgorod, late 15th cent. State Russian Museum, St. Petersburg.

1920 Saints Nestor (holding an arrow with both hands, hanging the short bow from his arm), and Eustathios (with a spear and shield), fresco, 1520's. Palaeochorio, Church of the Transfiguration of the Savior; Stylianou, *Painted Churches* (p.275).

See also 564

Eustochium, Roman matron, later nun, follower of St. Jerome, d. 419 (Sept. 28).

1921 Trinity with SS. Jerome, Paula, and Eustochium (all looking up), fresco by Andrea del Castagno, mid-1450's. Florence, SS. Annunziata; Andres, *Art of Florence* (Vol.I, pl.387); Boase, *Vasari* (pl.140).
1922 St. Jerome sitting with SS. Paula and Eustochium, by Francisco de Zurbaran, 1640–58. NGA, Washington DC; Bentley, *Calendar*; Ferguson, *Signs*; Gállego, *Zurbaran*; Phaidon, *Art Treasures*; Walker, *NGA*.
1923 St. Eustochium (dressed as a nun, holding a palm), painted for the Monastery of Saint Jerome of Buenavista by Juan de Valdés Leal, c. 1657. Bowes Museum, Barnard Castle, Durham; United Nations, *Dismembered Works.*
See also 2818, 3946

Eustratios
1924 Iconostasis beam with Miracles of Saint Eustratios (he heals an insane man; he heals a woman who was mute and motionless; and other miracles), 1150–1200. Sinai, Monastery of St. Catherine; Manafis, *Sinai.*

Euthymius or Eutimio, ascetic and
 founder of monasteries, d. 473 (Jan. 20)
1925 Virgin Hodegetria between Peter and Paul and Saints Anthony and Euthymius, by a French artist working in the Holy Land, 1250–1300. Sinai, St. Catherine's Monastery; Knopf, *The Icon* (p.221).

Eutimio *see* **Euthymius**

Eutychian, Pope, r. 275–283 (Dec. 8)
1926 St. Eutychian, fresco by Ghirlandaio in the Sistine Chapel. Vatican Museums; Brusher, *Popes.*

Evaristus, Pope, r. 100–105 (Oct. 26)
1927 St. Evaristus, fresco by Sandro Botticelli in the Sistine Chapel, 1481. Vatican; Brusher, *Popes*; Lightbown, *Botticelli.*

Exuperantius, Companion of St.
 Sabrinus, deacon; beheaded (Dec. 30)
1928 The beheading of SS. Felix, Regula and Exuperantius (two out of three are decapitated, and hold their severed heads in their hands, while executioner is about to strike the third), by the Master of the Martyrdom of Apostles, c. 1490. Esztergom Christian Museum; *Christian Art in Hungary.*
1929 St. Ambrose (as a bishop), St.

Exuperius Martyr (in armor with sword), and St. Jerome (with rearing lion), by the Master of Liesborn, c. 1465. Nat'l Gallery, London; Poynter, *Nat'l Gallery.*
See also 1950

Fabian, Pope; beheaded; mart. 250
 (Jan. 20)
1930 St. Fabian (giving a blessing) and St. Sebastian (filled with arrows), with two tiny confraternity figures, by Giovanni di Paolo, c. 1465. Nat'l Gallery, London; Dunkerton, *Giotto to Dürer.*
1931 Saint Fabian, fresco att. to Fra Diamante. Sistine Chapel, Vatican; Brusher, *Popes*; Coulson, *Saints.*
1932 St. Fabian (in papal robes, giving a blessing), flanked by SS. Sebastian (filled with arrows) and Roch (exposing his plague sore), fresco by the School of Antonio da Viterbo, late 15th cent. Viterbo, Museo Civico; Kaftal, *Central and So. Ital.*
1933 St. Sebastian (holding bow and arrow, with red hose and spurs) and St. Fabian (in an ecclesiastical cope), by Catalan painter of the late 15th cent. Hermitage, St. Petersburg; *Old Masters*; *Western European.*
1934 St. Fabian enthroned, flanked by SS. Sebastian and Roch, fresco by Giovanni Pietro da Cemmo, 1504. Berzo Inferiore, S. Lorenzo; Kaftal, *North West Italy.*
1935 Saint Fabian (sitting with a book), St. Roch (with a cherub curing the sore on his leg) and St. Sebastian (tied to a pillar), by Giacomo Bassano. Hermitage, St. Petersburg; Eisler, *Hermitage.*
1936 Saint Fabian, Pope, att. to Antoniazzo Romano, late 16th cent. Fogg Art Museum, Cambridge MA; *Med. and Ren. Paintings.*
See also 4475

Fabiola, friend of Jerome, founded first
 public hospital in the West, d. 399
1937 St. Fabiola (half-view in left profile, wearing a veil edged with a black stripe), by Jean Jacques Henner. Ponce, Museo de Arte; Held, *Catalogue.*

Faith of Agen, young virgin; burned on a
 gridiron, beheaded; mart. 287 (Oct. 6)
1938 Reliquary statue of Saint Foy (enthroned), silver, gilt, and jewels, 10th cent. Conques Abbey, Aveyron, France;

Munro, *Golden Encyclo.* (p.108); Oxford, *Medieval Europe.*
1939 St. Faith, in a red dress, holding a gridiron, French stained-glass window. Coll. Grosvenor Thomas; Drake, *Saints and Emblems.*
1940 Beheading of St. Faith (executioner stands behind her with a sword), stained-glass window by R. Buron, c. 1535. Conques, Ste-Foy; McGraw, *Encyclo.* (Vol.XIII, pl.177).
See also 3504

Faust, priest, and Giovita, deacon, brothers from Brescia; beheaded after tortures; mart. 120 (Feb. 15)
1941 SS. Faust (holding a palm) and Giovita (holding a sword), from a reliquary by the Veronese School, 1300–50. Arbizzano, Parish Church; Kaftal, *North East Italy.*
1942 Mass of SS. Faust and Giovita (Faust elevates the host, while Giovita holds up his chasuble, and holds a candle), fresco by the Lombard School, 14th cent. Brescia, S. Salvatore; Kaftal, *North West Italy.*
1943 Virgin and Child enthroned, flanked by SS. Faust and Giovita, altarpiece by Vincenzo Foppa. Brescia, Pinacoteca Tosio-Martinengo; Kaftal, *North West Italy.*
1944 Martyrdom of SS. Faust and Giovita (executioner holds up the decapitated head of one, while assistant bends back the other saint's head by the hair), by Giovanni Battista Pittoni. Brescia, SS. Faustino e Giovita; Boccazzi, *Pittoni* (p.62).

Felice, Bishop
1945 St. Felice enthroned (in bishop's dress), by Lorenzo Lotto, 1542. Bari, St. Domenico; Berenson, *Lotto.*

Felicianus *see* **Primus and Felicianus**

Felicity or Felicitas, Roman, mother of SS.MM. Januarius, Felix, Alexander, Philip, Silvanus, Vitalis, and Martial; beheaded; mart. 162 (July 10)
1946 St. Felicity (in a nun's habit, holding a book, surrounded by her seven children), panel by Rossello di Jacopo Franchi. Accademia, Florence; Kaftal, *Tuscan.*
1947 St. Felicity (enthroned, with a book on her lap, surrounded by her seven

sons all holding palms), altarpiece by Neri di Bicci, 1463. Florence, S. Felicita; Kaftal, *Tuscan.*
1948 St. Felicity and her sons before the judge; Felicity witnesses the martyrdoms of her sons (one at a time), panels from an altarpiece by Neri di Bicci, 1463. Florence, S. Felicita; Kaftal, *Tuscan.*
1949 Saint Erasmus (holding a winch and a folded banner) and St. Felicity (holding a sword with her seven sons' severed heads), stained-glass window by the workshop of Veit Hirschvogel the Elder, 1517. Germanisches Nationalmuseum, Nuremberg; Met Museum, *Gothic Art.*
See also 3952, 4582

Felix, bishop, invoked against children's diseases; beheaded, mart. 299 (May 18)
1950 SS. Felix, Regula and Exuperantius before the judge, by Master of the Martyr Apostles, c. 1490. Esztergom Christian Museum; *Christian Art in Hungary* (pl.XI/201).
See also 1928, 4905

Felix I, Pope; drowned with anchor; mart. 274 (May 30)
1951 Pope Felix I, 6th cent. mosaic. Rome, SS. Cosmas e Damian; Coulson, *Saints.*
1952 St. Felix I, fresco by Ghirlandaio in the Sistine Chapel. Vatican Museums; Brusher, *Popes.*
See also 3504

Felix III, Pope, r. 526–530
1953 St. Felix III, mosaic. Rome, St. Paul-Outside-the-Walls; Brusher, *Popes.*

Felix of Cantalice, Capuchin monk, d. 1587 (May 18 & 21)
1954 Apparition of the Virgin to St. Felix of Cantalice (she and the Christ Child appear to him and another monk), by the studio of Alonso Cano, 1648–52. Cadiz, Provincial Museum of Fine Arts; Wethey, *Alonso Cano* (pl.94).

Felix of Valois, supposed to have founded the Order of the Holy Trinity, d. 1212
1955 SS. John of Mathy (holding a chain and manacles), Felix of Valois, and Ivan, sculpture by Ferdinand Maximilian Brokoff, 1714. Charles Bridge, Prague; Štech, *Baroque Sculpture.*

Ferdinand III, King of Castile, d. 1252 (May 30)

1956 St. Ferdinand (in half-armor and a plumed hat, holding a sword point up), by Francisco de Zurbaran, 1631–40. Seville, Museum of Fine Arts; Gállego, *Zurbaran.*

1957 St. Ferdinand (in half-armor, holding a sword pointed up), by Francisco de Zurbaran, 1641–58. Seville, San Esteban; Gállego, *Zurbaran.*

1958 The surrender of Seville to St. Ferdinand (a man kneels before him with a platter carrying the keys), by Charles-Joseph Flipart, c. 1757. Prado, Madrid; *L'Art Européen.*

1959 St. Ferdinand (standing with sword and orb), cartoon for a tapestry by Jean-Auguste Dominique Ingres, 1842. Louvre, Paris; Rosenblum, *Ingres.*

See also 4006

Fermus and Rusticus, Roman companions, beheaded near Verona; mart. 304 (Aug. 9)

1960 SS. Firmus and Rusticus (both holding a palm and a sword, dressed as Renaissance knights), panels by Maestro del Cespo dei Garofani. Verona; Kaftal, *North East Italy.*

1961 Saints Fermus and Rustico in prison (visited by an angel), by Giuseppe Maria Crespi, 1729. Bergamo, S. Paolo d'Argon Parish Church; Merriman, *Crespi.*

See also 2745, 4102, 4103, 4104, 4105

Festo or Festus, follower of St. Gennaro, Roman martyr, mart. 305 (Sept. 19)

1962 San Gennaro in prison visited by Saints Festo and Desiderio, by an assistant after a design by Domenichino, 1635–37. Naples Cathedral; Spear, *Domenichino.*

Festus *see* **Festo**

Fiacre, bishop of Meaux, patron of gardeners, 6th cent. (Sept. 1)

1963 Portrait of a notary in the character of St. Fiacre (holding a cross and rose), by Quentin Metsys, c. 1500. Coll. George Spencer-Churchill, Gloucestershire; Cooper, *Private Collections.*

1964 St. Fiacre (leaning on a shovel), wood sculpture, 1650–1700. Huy, Augustinian Convent; *Tresors.*

Fidelis of Sigmaringen, Capuchin monk; beaten with spiked club; mart. 1622 (April 24)

1965 St. Fidelis of Sigmaringen crushing heresy (in the guise of a pagan man), oil sketch by Giambattista Tiepolo. Turin, Pinacoteca; Morassi, *Catalogue* (pl.117).

1966 St. Fidelis of Sigmaringen crushing heresy (in the guise of a pagan man), by Giambattista Tiepolo. Parma, Pinacoteca; Morassi, *Catalogue* (pl.120).

Fidentius or Fidenzio, third bishop of Padua, mart. 168 (Nov. 16)

1967 St. Fidentius (in bishop's robes, giving a blessing), panel of a polyptych by the Emilian School, 15th cent. Teplice, Museum; Kaftal, *North East Italy.*

Fidenzio *see* **Fidentius**

Filippo Benizi *see* **Philip Benizi**

Fina or Seraphina, child saint, patron of S. Gimignano, d. 1253 (Mar. 12)

1968 St. Gregory the Great appears to the ailing St. Fina and announces her impending death, fresco by the Master of the Virgin in the Duomo at Siena. S. Gimignano, Collegiata; Kaftal, *Tuscan*; McGraw, *Encyclo.* (Vol.VI, pl.179).

1969 Posthumous scenes from the St. Fina cycle: as her body is carried on a litter, her hand reaches down and grabs a cripple's arm, curing the cripple; she saves a man falling from a roof; she saves a ship in distress; exorcisms at her tomb; a pole carried with her shirt stops a fire, from an altarpiece by Lorenzo di Niccolò, 1402. S. Gimignano, Museo Civico; Kaftal, *Tuscan.*

1970 Scenes from the life of St. Fina: her mother feeds her on her sickbed, while rats chew on her rotting flesh; the devil in the form of a serpent knocks Fina's mother down the stairs; death of St. Fina, as angels ring bells and flowers sprout from the plank she lies on, from an altarpiece by Lorenzo di Niccolò, 1402. S. Gimignano, Museo Civico; Kaftal, *Tuscan.*

1971 Scenes from the life of St. Fina (funeral of St. Fina; St.Gregory announces the death of St. Fina, as she lay on a pallet), fresco by Ghirlandaio. Collegiata, Italy, San Gimignano; McGraw, *Encyclo.* (Vol. VI, pl.179).

Fiorenzo *see* **Florentius**

Firmus *see* **Fermus**

Fivamon
1972 St. Fivamon crowned by an angel, fresco, 6th cent. Bawit, Egypt, Monastery; McGraw, *Encyclo.* (Vol.III, pl.454).

Flavia, sister of Placidus; stabbed, mart. 540 (Oct. 5)
1973 The martyrdom of SS. Placidus (kneeling, arms crossed, as the executioner is about to strike) and Flavia (stabbed through the side), by Correggio. Parma, Galerie Nazionale; *Age of Correggio*; McGraw, *Encyclo.* (Vol.III, pl.469); Puppi, *Torment*.
See also 4071

Florentius or Fiorenzo, Roman martyr; stoned to death; mart. 304 (May 11)
1974 St. Florentius (as a young man, with a cloak thrown over his left shoulder, holding a palm and a book), from a polyptych by Pietro da Montepulciano, 1418. Osimo, Cathedral; Kaftal, *Central and So. Ital.*
1975 Scenes from the life of St. Florentius: before the emperor; tied to a column and beaten with clubs; beheaded; he saves the city from being devoured by dragons, frescoes by the Piedmontese School, 15th cent. Bastia Mondovi, S. Fiorenzo; Kaftal, *North West Italy*.

Florian of Lorch, Patron of Poland, Linz, and U. Austria, co-patron of Bologna, protector against fire; drowned with millstone around neck, mart. 304 (May 4)
1976 St. Florian (standing in a surcoat and cloak, holding a shield), wooden statue, c. 1340. St. Florian's Monastery, Linz, Austria; Bachmann, *Gothic Art*.
1977 St. Florian pouring a bucket of water on a burning castle, polychromed wooden statue, 1450–1500. John Higgins Armory Museum, Worcester MA.
1978 St. Florian, with right foot on a ledge, holding a sword and a flower, from the dismembered Griffoni polyptych by Francesco del Cossa, c. 1471. NGA, Washington DC; Dunkerton, *Giotto to Dürer*; McGraw, *Encyclo.* (Vol.IV, pl.7); Shapley, *Samuel H. Kress*; United Nations, *Dismembered Works*; Walker, *NGA*.

1979 Scenes from the life of St. Petronius: he buys the remains of St. Florian and sends them on a ship; arrival of the body of St. Florian; frescoes by Giovanni da Modena. Bologna, S. Petronino; Kaftal, *North East Italy*.
1980 St. Florian saving a burning city (as a battle rages, he pours water from a pail onto a burning city), fresco by the School of the Cadore, 15th–16th cent. San Vito di Cadore, S. Maria della Difesa; Kaftal, *North East Italy*.
1981 St. Florian in blue traveler's cloak and hat, shaking a man's hand, from St. Florian Altar by Albrecht Altdorfer, 1516–18. St. Florian's Monastery, Linz, Austria; New Int'l Illus. *Encyclo.*
1982 Arrest of St. Florian (standing on a wooden walkway); St. Florian before the judge; by Albrecht Altdorfer. Germanisches Nationalmuseum, Nuremberg; Guillaud, *Altdorfer*.
1983 Coronation of the Virgin triptych with St. Benedict (in ecclesiastic robes) and St. Florian (in armor, with a banner), by Jakob Schick, first third of 16th cent. Georgetown Univ. Art Coll.; *Catalogue*.
1984 Departure of St. Florian (he shakes a man's hand), by Albrecht Altdorfer. Uffizi, Florence; Bentley, *Calendar*; Newsweek, *Uffizi*.
1985 Martyrdom of St. Florian (kneeling on a bridge with a millstone around his neck), by Albrecht Altdorfer. Uffizi, Florence; McGraw, *Encyclo.* (Vol.I, pl.62); Newsweek, *Uffizi*.
1986 Recovery of the body of St. Florian (putting him into a cart), by Albrecht Altdorfer. Germanisches Nationalmuseum, Nuremberg; Guillaud, *Altdorfer*; Murray, *Art & Artists*.
1987 St. George and St. Florian, polychromed and gilded lindenwood statues by Christian Jorhan the Elder, 18th cent. Nelson-Atkins Museum of Art, Kansas City MO; *Handbook*.
See also 872, 1511, 4035

Florus and Laurus, patrons of tillers and grooms (Aug. 18)
1988 St. Florus and St. Laurus, charged by Archangel Michael with keeping herds of horses, icon by Novgorodian school, early 16th cent. Tretyakov Gallery, Moscow; McGraw, *Encyclo.* (Vol.XIII, pl.69); Tretyakov, *Russian Painting*.
See also 874

Fortunade or Fortunatus of Spoleto, deacon of Aquileia, patron of Montefalco, d. 395 (June 1)
1989 St. Hermagoras (standing in bishop's regalia, with a hand on the head of a kneeling donor) and Fortunatus (standing in deacon's robes with a palm), wings of the Cernazai-Manin triptych by Matteo Giovannetti, c. 1345. Correr Museum, Venice; Laclotte, *L'Ecole d'Avignon.*
1990 Reliquary head of St. Fortunade, bronze, French, c. 1450–60. Corrèze, St. Fortunade; Snyder, *Northern Ren.*
1991 St. Fortunade (wearing a chasuble, holding a blossoming staff), from a fresco imitating a polyptych by Benozzo Gozzoli, 1452. Montefalco, S. Francesco; Kaftal, *Tuscan.*
1992 St. Fortunatus of Spoleto (in priest's robes, holding a model of a city, and a tall, thin, blossoming tree), altarpiece by Melanzio, 1498. Montefalco, S. Francesco; Kaftal, *Central and So. Ital.*
1993 Saints Hermagoras (with bishop's robes, holding a palm) and Fortunatus (in deacon's robe, holding a palm), by Giambattista Tiepolo. Udine Cathedral; Morassi, *Catalogue* (pl.147).
See also 2648

Fortunatus *see* **Fortunade**

Four Crowned Martyrs, brothers Claudius, Nicostratus, Sempronianus, and Castor, patrons of stone carvers and carpenters; beaten to death; mart. 400 (Nov. 8)
1994 Legend of the Four Crowned Martyrs (Emperor Diocletian instructs his men, who are about to cast a lead box containing one of the Four Martyrs into the river), att. to Niccolo di Pietro Gerini, c. 1390. Birmingham Museum of Art, AL; Shapley, *Samuel H. Kress.*
1995 The Four Crowned Martyrs before Emperor Diocletian, refusing to build his pagan temple, att. to Niccolo di Pietro Gerini, c. 1390. Denver Art Museum, CO; Bentley, *Calendar*; Shapley, *Samuel H. Kress.*
1996 The Four Crowned Martyrs are scourged with scorpions (while devils strangle the tribune Lampadius), by the School of Gerini. Philadelphia Museum of Art; Kaftal, *Tuscan.*
1997 The Four Crowned Martyrs before the Tribune Lampadius, by the

school of Gerini. NGA, Washington, D.C.; Kaftal, *Tuscan.*
1998 Martyrdom of Four Crowned Saints (they are tied to a pillar and beaten; at right, executioner places his left foot on one of the martyrs' necks), by Francesco Trevisani, 1688. Siena, Cathedral; DiFederico, *Trevisani.*

Foy *see* **Faith of Agen**

Francesca Romana, founded the Olivetan Oblates, d. 1440, canon. 1608 (Mar. 9)
1999 Scenes from the life of Francesca Romana: feeding grain and wine to the poor, which is miraculously reproduced; resuscitates a smothered child; cures a man's injured arm; her son, accompanied by an angel, visits her after he is dead; Raphael shows her souls in hell; frescoes by the School of Antoniazzo Romano, c. 1469. Rome, Monastero di Tor de'Specchi; Kaftal, *Central and So. Ital.*
2000 Scenes from the life of Francesca Romana: she cures a mute; the multiplication of loaves in the refectory in 1437; she makes black grapes grow in January, for her thirsty nuns; she raises a drowned man to life; frescoes by the School of Antoniazzo Romano, c. 1469. Rome, Monastero di Tor de'Specchi; Kaftal, *Central and So. Ital.*
2001 Scenes from the life of Francesca Romana: the devil throws her onto a corpse, to torture her with its stink; an angel chases away demons who appear in the form of dragons and serpents; she is tortured and beaten by demons; frescoes by the Roman School, 1485. Rome, Monastero di Tor de'Specchi; Kaftal, *Central and So. Ital.*
2002 St. Francesca Romana (holding an open book, while angels stand by), from an altarpiece att. to Liberale da Verona. Rome, S. Maria Nuova; Kaftal, *North East Italy.*
2003 Madonna and Child with SS. Francesco Romana (kneeling with an open book), Nicholas of Bari, and Lawrence (holding a palm), by Francesco Gessi, 1630's. Brera, Milan; *Age of Correggio.*
2004 St. Francesca Romana with the guardian angel, by Alessandro Tiarini. Bologna, S. Michele in Bosco.
2005 The vision of St. Francesca Romana (she kneels in a nun's habit, holding baby Christ as an angel plays the

violin), by Giovanni Francesco Barbieri Guercino. Hermitage, St. Petersburg; Eisler, *Hermitage.*

2006 St. Francesca Romana giving alms (she hands a pouch to a beggar who is supporting two children), by Giovanni Battista Gaulli, called Baciccio, c. 1675. J. Paul Getty Museum, Malibu CA; Fredericksen, *Catalogue.*

2007 St. Francesca Romana handing the Infant Jesus to her confessor, by Giuseppe Maria Crespi, 1735–37. Location unknown; Merriman, *Crespi.*

Francis Bonaventure *see* **Francis of Sales**

Francis Borgia, Duke of Grandia, "The Holy Duke," d. 1572, canon. 1671 (Oct. 10)

2008 St. Francis Borgia holding a book with a skull, anon. English College, Valladolid, Spain; Coulson, *Saints.*

2009 St. Francis Borgia (standing in a black robe, holding a crown), by Alonso Cano, 1624. Seville, Museum of Fine Arts; Wethey, *Alonso Cano* (pl.36).

2010 St. Francis Borgia visiting an inn (he and another monk sit at a table with a torn tablecloth, talking to the innkeeper), by Jan Jiří Heinsch, after 1680. Prague, Nat'l Gallery; National Gallery, *Baroque.*

2011 Saints Stanilaos Kotska, Luigi Gonzaga, and Francesco Borgia by Antonio Balestra, 1704. Venice, Chiesa dei Gesuati; New Int'l Illus. *Encyclo.*

2012 St. Francis Borgia (with angels holding pictures), sculpture by Ferdinand Maximilian Brokoff, 1710. Charles Bridge, Prague; Štech, *Baroque Sculpture.*

2013 St. Francis Borgia (still in his noble clothing) saying good-bye to his family (all crying, outside on the steps), by Goya, c. 1788. Marquise of Santa Cruz, Madrid; *L'Art Européen.*

2014 St. Francis Borgia and the impenitent dying man (kneeling with a crucifix, he chases demons away), by Goya, c. 1788. Marquise of Santa Cruz, Madrid; Clay, *Romanticism*; *L'Art Européen.*

2015 St. Francis Borgia exorcising a dying impenitent, by Francisco de Goya y Lucientes, 1788. Valencia Cathedral; Rosenblum, *19th Cent.*

Francis of Assisi, founder of Franciscan order, co-patron of Bologna, d. 1226, canon. 1228 (Oct. 4)

2016 St. Francis, panel by the Master of the St. Francis Cycle, from Church of Santa Maria degli Angeli, 13th cent. San Francesco, Assisi; New Int'l Illus. *Encyclo.*

2017 St. Francis talking to animals, illum. initial from a Psalter "Quid Gloriaris," ms.39, fo.54 (D 39), early 13th cent. Beaune, Biblio. Municipale; Garnier, *Langage de l'Image* (pl.2).

2018 St. Francis of Assisi (showing his stigmata), by the school of Latium, first half of 13th cent. Louvre, Paris; Gowing, *Paintings.*

2019 St. Francis, from "Scenes in the Life of St. Gregory," Ital.-Byzantine School, 1228. Subiaco, S. Benedetto; Davenport, *Book of Costume* (plate 496).

2020 St. Francis talking to the birds, from an altarpiece by Bonaventura Berlinghieri, c. 1235. Pescia, Italy, St. Francis; Boase, *Vasari*; Hallam, *Four Gothic*; Lopez, *Birth*; Smart, *Assisi Problem.*

2021 Scenes from the life of St. Francis: the bishop gives him a tunic, which is laid out like a crucifix; St. Francis tending lepers; Pope Innocent III approves the rule of St. Francis in 1209; Francis does public penance for breaking his fast (hands tied to a pole); Francis preaching to the birds; death of St. Francis; from an altarpiece by the Florentine School, c. 1240. Santa Croce, Florence; Kaftal, *Tuscan.*

2022 St. Francis (giving a blessing) with scenes from his life, altarpiece by the Bardi St. Francis Master, c. 1240. Santa Croce, Florence; Hills, *The Light.*

2023 St. Francis preaching to the Muslims, altarpiece in the Bardi Chapel by the Bardi St. Francis Master, c. 1240. Santa Croce, Florence; Kaftal, *Tuscan* (fig.460); Oxford, *Europe.*

2024 St. Francis preaching to the birds, from Psalter of Gerard de Damville, Bishop of Cambrai, 1250–1300. Pierpont Morgan Library, NY; Burlington, *Illum. MS.*

2025 St. Francis with scenes from his life, att. to Guido da Siena, 13th cent. Siena, Pinacoteca Nazionale; Van Os, *Sienese Altarpieces* (Vol.I, pl.16).

2026 St. Francis preaching to the birds, from the Chronicle of Matthew Paris, c. 1255. CCC, Cambridge; Lloyd, *1773 Milestones* (p.8).

2027 St. Francis (showing his stigmata), by Margaritone di Arezzo. Vatican Museums; Francia, *Vaticana*.

2028 Madonna and Child with St. Francis, by Cimabue, c. 1295. San Francesco, Assisi: Book of Art, *Ital. to 1850*.

2029 St. Francis and the miracle of the spring (as he prays in the wilderness, a spring miraculously appears, to slake the thirst of his brethren), fresco by Giotto. San Francesco, Assisi; Boase, *Vasari*.

2030 St. Francis giving his cloak to a beggar, fresco by Master of the St. Francis Cycle, early 14th cent. San Francesco, Assisi; Erlande-Brandenburg, *Gothic Art*; Hartt, *Ital. Ren. Art*; McGraw, *Encyclo.* (Vol.VI, pl.196); New Int'l Illus. *Encyclo.*; Smart, *Assisi Problem*.

2031 St. Francis receiving the stigmata with three scenes from his legend: the vision of Pope Innocent III, the pope receives the statues from the order of St. Francis, and St. Francis preaching to the birds, by Giotto di Bondone, 1295–1300. Louvre, Paris; Brion, *Louvre*; Gowing, *Paintings*; Smart, *Assisi Problem*.

2032 Stigmatization of St. Francis (Christ on cross descending, enveloped by winged seraph), by Giotto di Bondone, c. 1295. Fogg Art Museum, Cambridge MA; Mortimer, *Harvard Univ.*

2033 Dream of Innocent III about Francis of Assisi, supporting the Lateran basilica, fresco att. to Giotto di Bondone, end 13th cent. San Francesco, Assisi; Boudet, *Rome*; Evans, *Flowering of M.A.*; Milestones, *Dawn*; Smart, *Assisi Problem*.

2034 Honorius III listens to a sermon by St. Francis of Assisi, fresco by Giotto di Bondone, c. 1300. San Francesco, Assisi; John, *Popes*; Smart, *Assisi Problem*.

2035 Marriage of St. Francis to lady poverty, fresco by Giotto di Bondone, from vault in the Lower Church. San Francesco, Assisi; Keen, *Medieval Europe*.

2036 Pope Gregory IX dreams that St. Francis shows him his stigmata, fresco by Giotto di Bondone in the Upper Church of S. Francesco. San Francesco, Assisi; John, *Popes*.

2037 St. Francis banishing demons from the city of Arezzo, fresco by Giotto di Bondone. San Francesco, Assisi; Erlande-Brandenburg, *Gothic Art*; Horizon, *Middle Ages*; Lavin, *Narrative*; Smart, *Assisi Problem*.

2038 St. Francis celebrates Christmas at Greccio (as others look on, he puts baby Christ into the Nativity cradle), att. to Giotto di Bondone. San Francesco, Assisi; Verdon, *Christianity*.

2039 St. Francis curing an unbeliever, from Master of the St. Cecily Altarpiece, or Giotto di Bondone, 1290's. San Francesco, Assisi; Davenport, *Book of Costume* (plate 497).

2040 St. Francis praying before the cross of San Damiano (he kneels inside of a cut-away building), att. to Giotto di Bondone. San Francesco, Assisi; Verdon, *Christianity*.

2041 St. Francis preaching to the birds, by Giotto di Bondone. San Francesco, Assisi; Horizon, *Middle Ages*; Milestones, *Dawn*; Smart, *Assisi Problem*.

2042 St. Francis receives the stigmata (kneeling on a cliff before a small square house), fresco by Giotto di Bondone. San Francesco, Assisi; McGraw, *Encyclo.* (Vol.VI, pl.198); Smart, *Assisi Problem*.

2043 St. Francis renouncing his inheritance, fresco by school of Giotto, c. 1300. San Francesco, Assisi; Horizon, *Middle Ages*; Kidson, *World*; McGraw, *Encyclo.* (Vol.VI, pl.207).

2044 The Pope approves the rule of St. Francis, fresco by Giotto di Bondone. San Francesco, Assisi; Andres, *Art in Florence* (Vol.I, pl.83); McGraw, *Encyclo.* (Vol.IX, pl.89); Smart, *Assisi Problem*.

2045 The death of the knight of Celano (as St. Francis stands at the dinner table, looking on), fresco by Giotto di Bondone. San Francesco, Assisi; McGraw, *Encyclo.* (Vol.VI, pl.198); Smart, *Assisi Problem*.

2046 St. Francis and the trial by fire (he stands next to the fire as the sultan points to it and his priests walk away), fresco by the Master of the St. Francis Cycle. San Francesco, Assisi; Hills, *The Light*.

2047 St. Francis receiving the stigmata, ms. illum. from a book of hours, MS 77. Carpentras, Biblio. Inguimbertine; Eydoux, *St. Louis*.

2048 St. Francis triumphs over a dragon, miniature from a ms. of the Life of St. Francis, ms. 13, c. 1300. Prague, Biblio. Nostic; Stejskal, *Charles IV*.

2049 St. Francis appears to the brethren in the church at Arles (posthumously), fresco by Giotto di Bondone, 1320's.

Santa Croce, Florence; Andres, *Art of Florence* (Vol.I, pl.82); Hills, *The Light.*

2050 St. Francis renounces his father, by Giotto di Bondone, 1295–1300. Santa Croce, Florence; Andres, *Art in Florence* (Vol.I, pl.84); Duby, *Medieval Art*; Davenport, *Book of Costume* (pl.498); Smart, *Assisi Problem.*

2051 St. Francis undergoing the test by fire before the Sultan Saladin, fresco by Giotto di Bondone, c. 1317–23. Santa Croce, Florence; Andres, *Art in Florence* (Vol.I, pl.86); Evans, *Flowering of M.A.*; Hartt, *Ital. Ren. Art*; Milestones, *Dawn*; Smart, *Assisi Problem.*

2052 Stigmatization of St. Francis (before a white mountain), fresco by Giotto di Bondone, 1320's. Santa Croce, Florence; Andres, *Art of Florence* (Vol.I, pl.81).

2053 The death of St. Francis, by Giotto di Bondone, Bardi Chapel, 1325. Santa Croce, Florence; Andres, *Art in Florence* (Vol.I, pl.87); Hartt, *Ital. Ren. Art*; Larousse, *Ren. & Baroque*; McGraw, *Encyclo.* (Vol.VI, pl.206); Piper, *Illus. Dict.* (p.27); Smart, *Assisi Problem.*

2054 Stigmatization of St. Francis (in the rocks before the monastery, as his companion reads), by Pietro Lorenzetti. San Francesco, Assisi; Boase, *Vasari* (pl.97); DeWald, *Lorenzetti.*

2055 SS. Francis (hands clasped, with a seraph near his chest) and Mary Magdalene (holding an urn), diptych by Ambrogio Lorenzetti. Siena, Opera del Duomo; Edgell, *Sienese Painting.*

2056 St. Francis, hands crossed showing his stigmata, from the Peruzzi Altarpiece by Giotto di Bondone, 1330's. North Carolina Museum of Art, Raleigh; *Intro. to the Collection*; Shapley, *Samuel H. Kress.*

2057 A miracle from the legend of St. Francis: Francis comes down from the sky to resurrect a boy who fell from a window, by Taddeo Gaddi, mid-14th cent. Picture Gallery, Berlin; *Catalogue.*

2058 Scenes from the St. Bonaventura's "Legenda Major S. Francisci": St. Francis and the three Franciscan virtues (fo.27v); St. Francis worshipped by beasts (fo.32v); St. Francis and the death of the knight of Celano (fo.45v); death of St. Francis (fo.60v), from ms. Vittorio Emanuele 411. Rome, National Library; Salmi, *Ital. Miniatures.*

2059 St. Francis (standing, reading a scroll), by the Master of the Fogg Pieta, 14th cent. Worcester Art Museum; *Handbook.*

2060 St. Francis holds the knotted rope as his monks climb the wall to the celestial city, from Guillaume de Deguileville, "Pèlerinage de la vie humaine," ms. 10178, 14th cent. Biblio. Royale, Brussels; Batselier, *St. Benedict* (p.33).

2061 Madonna and Child with SS. Francis and the Baptist on her right, and SS. Catherine and blessed Peter on her left; fresco by Lippo Vanni, c. 1360. Siena, S. Francesco: Van Os, *Sienese Altarpieces* (Vol.II, pl.5).

2062 St. Francis of Assisi (showing his stigmata), by Giovanni da Milano, c. 1360. Louvre, Paris; Gowing, *Paintings.*

2063 Stigmatization of St. Francis (with coats of arms in background), from the "Boucicaut Hours" painted by the Boucicaut Master, ms.2, fo.37v. Jacquemart-André Museum, Paris; Meiss, *French Painting.*

2064 Funeral of St. Francis (surrounded by monks before an inner courtyard wall), by workshop of Lorenzo Monaco. Rome, Galleria Pallaviknci; Eisenberg, *Monaco* (pl.191).

2065 Stigmatization of St. Francis (kneeling amid jagged rocks before a monastery), by Lorenzo Monaco. Rijksmuseum, Amsterdam; Eisenberg, *Monaco* (pl.190).

2066 Stigmatization of St. Francis (by a seraph who flies above a rooftop), by The Master of 1419. NGS, Edinburgh; *Illustrations.*

2067 Funeral of St. Francis of Assisi (in a walled inner courtyard with several monks), by Lorenzo Monaco, c. 1420. Pallavicini-Rospigliosi Palace, Rome; Cooper, *Family Collections.*

2068 St. Francis at the deathbed of the miser of Celano, by Bicci di Lorenzo, c. 1423. Vatican Museums; Cleveland Museum of Art, *European before 1500.*

2069 Stigmatization of St. Francis (he receives the stigmata from a life-sized Christ, in a rocky landscape before a monastery), by Bicci di Lorenzo, c. 1423. Cleveland Museum of Art, OH; *European before 1500.*

2070 St. Francis d'Assisi looking at stigmata, by Jan van Eyck, c. 1425. Sabauda Gallery, Turin.

2071 The funeral and canonization of

St. Francis of Assisi (a crowd, some holding candles, gathers around his bier; at right, Pope Gregory IX signs decree for his canonization), by Bartolomeo di Tommaso, 1425-55. Walters Art Gallery, Baltimore; *Italian Paintings* (Vol.I).

2072 Stigmatization of St. Francis by Jan van Eyck. Turin, Pinacoteca; Larousse, *Ren. & Baroque*; Panofsky, *Early Nether.*

2073 Dream of Innocent III (he dreams of St. Francis supporting the walls of the church), from The Coronation of the Virgin altarpiece by Fra Angelico. Louvre, Paris; Gowing, *Paintings*.

2074 Madonna della Neve Altarpiece, with SS. John the Baptist, Peter, Paul, and Francis of Assisi, by Sassetta, 1430. Pitti Palace, Florence; Van Os, *Sienese Altarpieces* (Vol.II pl.169).

2075 St. Jerome and St. Francis (each holding a book with both hands), by Giovanni dal Ponte. Fitzwilliam Museum, Cambridge; Catalogue, *Italian*.

2076 St. Matthew and St. Francis of Assisi (showing the wound on his side), by Giovanni di Paolo, c. 1436. Met Museum; Christiansen, *Siena*.

2077 Funeral of St. Francis (before an altar; a knight checks for the stigmata), by Sassetta, c. 1437. Nat'l Gallery, London; Book of Art, *Ital. to 1850*; Dunkerton, *Giotto to Dürer*; Pope-Hennessy, *Sienese*; Van Os, *Sienese Altarpieces* (Vol.II, pl.89).

2078 Pact with the wolf of Gubbio (St. Francis holds the paw of a wolf, after persuading the animal not to eat the inhabitants of Gubbio), from the Sansepolcro altarpiece by Sassetta, 1437-44. Nat'l Gallery, London; Hartt, *Ital. Ren.*

2079 St. Francis prepares to walk through the fire before the Sultan, Francis and his companions before Pope Innocent III, panels from a dismembered altarpiece by Sassetta, 1437-44. Nat'l Gallery, London; Van Os, *Sienese Altarpieces* (Vol.II, pl.88 & 90).

2080 St. Francis renounces his earthly father, from the dismembered Sansepolcro altarpiece by Sassetta, c. 1437. Nat'l Gallery, London; Gowing, *Biog. Dict.*; Hendy, *Nat'l Gallery*; Oxford, *Europe*; Van Os, *Sienese Altarpieces* (Vol.II, pl.87); Wilson, *Nat'l Gallery*.

2081 The dream of St. Francis (at left, he gives his cloak to a poor knight; at right, he dreams of a castle floating on a

cloud, representing the Franciscan Order, which he was destined to found), from the dismembered Sansepolcro altarpiece by Sassetta, 1437-44. Nat'l Gallery, London; Dunkerton, *Giotto to Dürer*; Hall, *Color and Meaning*; Herald, *Ren. Dress*; Levey, *Nat'l Gallery*; Pope-Hennessy, *Sienese*; Wolheim, *Painting as an Art* (72).

2082 St. Francis before the Sultan (shielding his eyes, he is about to step into the fire), by Sassetta. Coll. Mackay, Roslyn, Long Island; Edgell, *Sienese Painting*.

2083 St. Francis in ecstasy, on the back of the Sansepolcro Altarpiece by Sassetta, 1437-44. Coll. Bernard Berenson, Villa I Tatti, Florence; Clark, *Piers*; Cooper, *Private Coll.* ; Hartt, *Ital. Ren. Art.*

2084 St. Francis kneeling before the crucifix, by Sassetta, 1437. Cleveland Museum of Art, OH; *European before 1500*; Van Os, *Sienese Altarpieces* (Vol.II, pl.85).

2085 St. Francis's betrothal with my lady poverty (in the form of three women who fly away at upper right), by Sassetta, 1437-44. Condé Museum, Chantilly; Berenson, *Ital. Painters*; Hartt, *Ital. Ren. Art*; Herald, *Ren. Dress*; Pope-Hennessy, *Sienese*; Van Os, *Sienese Altarpieces* (Vol.II).

2086 St. Francis receiving the stigmata by Jan van Eyck, 1438-40. Philadelphia Museum of Art, PA; Panofsky, *Early Nether.*; Snyder, *Northern Ren.*; *Treasures.*

2087 John the Baptist and St. Francis (both standing in a niche; John looks heavenward with his left hand against his chest, and Francis looks down, hands clasped), fresco by Domenico Veneziano. Santa Croce, Florence; McGraw, *Encyclo. of Art* (Vol.IV).

2088 Madonna and Child with St. Francis, by followers of Paolo Ucello, Florentine school, c. 1440-50. Allentown Art Museum, PA.

2089 St. Francis receiving the Stigmata, by Domenico Veneziano. NGA, Washington DC; Phaidon, *Art Treasures*; RA, *Italian*; Shapley, *Samuel H. Kress*; Walker, *NGA.*

2090 Apparition of St. Francis at Arles (with inscription "Pax Vobis"); death of St. Francis, att. to Fra Angelico. Picture Gallery, Berlin; *Catalogue*; Pope-Hennessy, *Fra Angelico.*

2091 Crucifixion with SS. Francis of

Assisi (holding a book, showing his stigmata), Anthony Abbot (with a pig), John Evangelist, and Nicholas of Bari (holding three balls), wall mural by unknown artist. Embrun, Eglise des Cordeliers; *Peintures Murales.*

2092 St. Francis of Assisi showing his stigmata, from an altarpiece by Carlo Crivelli, 15th cent. Brussels, Musées Royaux des B/A; RA, *Italian*; Zampetti, *Crivelli.*

2093 St. Francis receiving the stigmata from a small cross, by Vittore Crivelli. Kress Coll., NY; Ferguson, *Signs.*

2094 St. Francis, by Fra Angelico or Fra Giovanni da Fiesole, mid-15th cent. Philadelphia Museum of Art, PA; Pope-Hennessy, *Fra Angelico.*

2095 The Crucifixion, with St. Jerome and St. Francis, by Francesco Pesellino. NGA, Washington DC; Ferguson, *Signs.*

2096 Scenes from the life of St. Francis: Innocent dreams that Francis supports the Lateran church; Innocent confirms the rule of St. Francis; he exorcises the demons from the town of Arezzo, who have been fomenting civil war; he predicts the death of his host at Celano; Francis preaches to the birds; frescoes by Benozzo Gozzoli, 1452. Montefalco, S. Francesco; Kaftal, *Tuscan.*

2097 St. Francis before Arezzo, fresco by Benozzo Gozzoli, c. 1452. San Francesco Museum, Montefalco.

2098 St. Francis of Assisi, by Bartolomeo Vivarini, c. 1460-70. Philadelphia Museum of Art, PA.

2099 St. Francis receiving the stigmata (he kneels among large boulders with another monk), by Marco Zoppo, 1460's. Walters Art Gallery, Baltimore; *Italian Paintings* (Vol.I).

2100 Madonna and Child with SS. Francis of Assisi and Sebastian (with a kneeling donor in nun's habit), by Carlo Crivelli. Nat'l Gallery, London; Zampetti, *Crivelli.*

2101 St. Jerome (in foreground, praying before a crucifix) and St. Francis (in background, receiving the stigmata), by Jacopo del Sellaio. El Paso Museum of Art, TX; *Kress.*

2102 The Madonna and Child with SS. Francis, Jerome, John the Baptist, and other saints, with a kneeling, armored Federico di Montefeltro known as the Montefeltro altarpiece, by Piero della Francesca, c. 1472. Brera, Milan; Hall, *Color and Meaning.*

2103 St. Francis receiving the stigmata (before a red monastery with a bell tower), by Vincenzo Foppa, 1478-81. Brera, Milan; McGraw, *Encyclo.* (Vol.XII, pl.41); Praeger, *Great Galleries.*

2104 St. Jerome (in foreground, praying before a crucifix) and St. Francis (in background, receiving the stigmata), by Jacopo del Sellaio, 1480. El Paso Museum of Art, TX; *Kress*; Shapley, *Samuel H. Kress.*

2105 The Altarpiece of Pérussis, with St. Francis of Assisi (at left, Louis de Pérussis is presented by John the Baptist; at center is an empty cross; at right, another donor is presented by Francis of Assisi), by an unknown Provencal painter, c. 1480. Met Museum; *L'Ecole d'Avignon.*

2106 St. Francis receiving the stigmata (as a monk looks on, amazed, from inside a building), by Sano di Pietro, 1481. Nantes, Musée des B/A; Cousseau, *Musée.*

2107 Pope Honorius confirms the rule of St. Francis (before an open plaza), fresco by Domenico Ghirlandaio, c. 1482. Florence, Santa Trinita; Andres, *Art of Florence* (Vol.II, pl.472).

2108 The pope confirms St. Francis in his rule, pen and ink drawing by Domenico Ghirlandaio, c. 1482. Berlin, Kupferstichkabinett; Andres, *Art of Florence* (Vol.II, fig.106).

2109 St. Francis resuscitating a child of the Spini family (from a cloud), fresco by Domenico Ghirlandaio. Florence, Santa Trinita; Andres, *Art of Florence* (Vol.II, pl.473); Berenson, *Ital. Painters.*

2110 St. Francis in ecstasy, by Giovanni Bellini, 1485. Frick Coll., NY; Book of Art, *Italian Art*; Goffen, *Bellini*; Hall, *Color and Meaning*; Horizon, *Ren.*; Huse, *Venice*; Janson, *History* (col-orpl.57); Janson, *Picture History*; Munro, *Golden Encyclo.* (p.162).

2111 St. Francis receiving the stigmata (in a rocky landscape), drawing by Jacopo Bellini. Louvre, Paris; Huse, *Venice.*

2112 Stigmatization of St. Francis (as his companion reads beside a rocky cave), predella of the Pesaro altarpiece by Giovanni Bellini. Pesaro, Museo Civico; Goffen, *Bellini.*

2113 St. Francis receiving the stigmata (as a monk, at left, reads a book), by Giovanni Battista Cima. York City Art Gallery; *Catalogue.*

2114 St. Francis showing his stigmata, by Antonio Lionelli da Crevalcore, c. 1490. Princeton Univ. Art Museum.

2115 St. Francis in glory (standing with a small crucifix, flanked by tiny angels), by Filippino Lippi, 1492. Nat'l Gallery, London; Poynter, *Nat'l Gallery*.

2116 Head of St. Francis, drawing by Lorenzo di Credi, c. 1500. Royal Collection; Roberts, *Master*.

2117 St. Francis receiving the Stigmata, side panel of Triptych by Gerard David. Met Museum.

2118 St. Francis receiving the stigmata (before a garden wall) by Vittore Crivelli, c. 1500. El Paso Museum of Art, TX; *Kress*.

2119 St. Francis receiving the stigmata by Francesco Morone, early 16th cent. Verona, Municipal Museum.

2120 St. Francis receiving the stigmata by Lorenzo di Credi. Fesch Museum, Ajaccio; Roberts, *Master*.

2121 Stigmatization of St. Francis, by Hans Fries from "The Universal Judgment" Panels, 1501. Neue Pinakothek, Munich; Benesch, *German*; New Int'l Illus. *Encyclo*.

2122 St. Francis receiving the stigmata (from a crucified Christ carried by a seraph), by Lucas Cranach the Elder, 1502. KM, Vienna; Friedländer, *Cranach*; Snyder, *Northern Ren*.

2123 Stigmatization of St. Francis, by Lucas Cranach the Elder, c. 1502. Akademie der Bildenden Künste, Vienna; Schade, *Cranach*.

2124 St. Francis receiving the stigmata (from a seraph), woodcut by Albrecht Dürer, Munich, c. 1504. Geisberg, *Single Leaf*.

2125 St. Francis and St. Michael, by Juan de Flandes, c. 1505–09. Met Museum.

2126 St. Francis receiving the stigmata in the wilderness, by Albrecht Altdorfer, 1507. Picture Gallery, Berlin; *Catalogue*; Guillaud, *Altdorfer*; Snyder, *Northern Ren*.

2127 St. Francis and the donor, Bona Trivulzio Bevilacqua, by Marco d'Oggiono. Brera, Milan; Sedini, *Marco d'Oggiono* (p.116).

2128 Stigmatization of St. Francis as another monk looks on, shielding his eyes, by Bartholommeo della Gatta. Castiglion Fiorentino, Communal Picture Gallery, Italy; McGraw, *Dict*. (see Barto.).

2129 St. Francis Altarpiece (he kneels before enthroned Jesus and Mary, flanked by angels and monks), by Niccolo Pisano, 1499–1520. Bob Jones Univ. Art Gallery, Greenville, SC; Pepper, *Ital. Paintings*.

2130 St. Francis of Assisi (standing on a marble floor, with a coat of arms near his feet), by the Umbrian School, c. 1510–15. Walters Art Gallery, Baltimore; *Italian Paintings* (Vol.I).

2131 St. Francis of Assisi (standing with a book and a crucifix), from the Colonna altarpiece by Raphael. Dulwich Picture Gallery, London; Murray, *Catalogue*.

2132 Madonna of St. Francis (Francis looks up at Madonna and Child as St. John the Baptist points at them), by Correggio, 1514–15. Picture Gallery, Dresden; Burckhardt, *Altarpiece*.

2133 St. Francis receiving the stigmata (which looks like thin lines extending from the seraph to his wounds), att. to Joachim Patiner. M. H. de Young Memorial Museum, San Francisco CA; *European Works*.

2134 Stigmatization of St. Francis (a seraph sends solid beams to his body), illum. by Jean Bourdichon from the Great Book of Hours of Henry VIII, 1514–18. Coll. Duke of Cumberland; *Great Hours*.

2135 Madonna of the Harpies with St. Francis, and John the Evangelist, by Andrea del Sarto, 1517. Uffizi, Florence; Andres, *Art of Florence* (Vol.II, pl.584); Hall, *Color and Meaning*; Piper, *Illus. Dict.* (p.149).

2136 Temptation of St. Francis of Assisi (angels hold a skull and a crucifix to him, while a demon pulls him from behind), by the Florentine school. Walters Art Gallery, Baltimore; *Italian Paintings* (Vol.II).

2137 Madonna with members of the Pesaro family (presented by St. Francis), by Titian, 1526. Venice, Sta. Maria del Gloriosa del Frari; Janson, *History of Art* (pl.677).

2138 St. Francis holding a book, in a niche, by Francesco Granacci. Christ Church, Oxford; Shaw, *Old Masters*.

2139 St. Francis receiving the stigmata (his companion looks on), by Domenico Beccafumi. Louvre, Paris; Gowing, *Paintings*.

2140 St. Francis looks down in horror at the corruption in the church, from "Der Unterschied Zwischen dem Evangelischen

und Katholischen Gottesdienst," right half of a colored woodcut by Lucas Cranach the Elder, c. 1545. Berlin, Kupferstichkabinett der Staatlichen Museen; Hay, *Renaissance*.

2141 St. Francis receiving the stigmata (from Christ in the clouds, as a monk reading a book and a donor look on), by Titian, c. 1561. Ascoli Piceno, Pinacoteca Comunale; Wethey, *Titian* (pl.164).

2142 St. Francis receiving the stigmata (he kneels, arms outspread, in expectation), by Titian, c. 1545-50. Pepoli Museum, Trapani; Wethey, *Titian* (pl.163).

2143 St. Francis receiving the stigmata (as he kneels under a tree), by El Greco, before 1570. Coll. Antonio Zuloaga, Geneva; Gudiol, *El Greco*.

2144 Stigmatization of St. Francis by Federico Barocci, c. 1574-76. Urbino, Galleria Nazionale delle Marche; Met Museum, *Caravaggio*.

2145 St. Francis receiving the stigmata (he kneels in a patched tunic, with a hand open, staring at the celestial light), by Girolamo Muziano. Vatican Museums; Francia, *Vaticana*.

2146 St. Francis and the lay brother (Francis meditates on a skull as the lay brother prays), by El Greco, 1579-86. Monforte de Lemos Piarist Fathers; Gudiol, *El Greco*.

2147 St. Francis receiving the stigmata (from a crucifix carried by seraphs in upper left corner), by El Greco, 1579-86. Coll. Marqués de Pidal, Madrid; Gudiol, *El Greco*.

2148 SS. Bartholomew, Francis (center, receiving the stigmata) and Bernardino of Siena (kneeling, with a book and contrafraternity symbol), by Giovanni Paolo Lomazzo, c. 1580. Milan, San Barnaba; Fiorio, *Le Chiese di Milano*.

2149 St. Francis in a swoon, supported by angels, by Annibale Carracci. Christ Church, Oxford; Shaw, *Old Masters*.

2150 St. Francis in a swoon, supported by angels, by Annibale Carracci. Graves Art Gallery, Sheffield; Shaw, *Old Masters*.

2151 St. Francis in prayer (standing in the wilderness before a skull and a crucifix), by El Greco, 1580-85. Joslyn Art Museum; *Paintings & Sculpture*.

2152 St. Francis adoring the crucifix (he looks down at it, hands on chest), by Annibale Carracci. Capitoline Gallery, Rome; Boschloo, *Carracci*.

2153 St. Francis adoring the crucifix (he looks up at it, arms crossed), by Bartolomeo Passerotti. Bologna, Pinacoteca Nazionale; Boschloo, *Carracci*.

2154 St. Francis adoring the crucifix (he shows it to the viewer), by Annibale Carracci. Accademia, Venice; Boschloo, *Carracci*.

2155 St. Francis in meditation (on a crucifix) by El Greco, 1587-97. Coll. Montesinos, Valencia; Gudiol, *El Greco*.

2156 St. Francis in meditation (on a crucifix; paper with writing is under his hand in lower left corner), by El Greco, 1587-97. Coll. Torelló, Barcelona; Gudiol, *El Greco*.

2157 St. Francis kneeling in meditation (arms crossed), by El Greco, 1587-97. Bilbao, Provincial Museum of Fine Arts; Gudiol, *El Greco*.

2158 St. Francis of Assisi (pointing to the crucifix), by workshop of Annibale Carracci, late 1580's. Walters Art Gallery, Baltimore; *Italian Paintings* (Vol.II).

2159 Last communion of St. Francis of Assisi (he is lying on a step below the altar, supported by a monk, while a priest stands above him with the eucharist), by Agostino Carracci, c. 1590. Dulwich Picture Gallery, London; Murray, *Catalogue*.

2160 SS. Peter (at left, holding a key) and Francis of Assisi (standing at right, holding a crucifix against his arm), att. to Ludovico Carracci. Dulwich Picture Gallery, London; Murray, *Catalogue*.

2161 St. Francis kneeling in prayer before a crucifix and skull, by El Greco, 1590-1604. Chicago Art Inst.; *Paintings*.

2162 St. Francis venerating the crucifix, by El Greco, c. 1590. M. H. de Young Memorial Museum, San Francisco CA; Eisler, *European Schools*; *European Works*.

2163 Portrait head of St. Francis by El Greco, 1592-99. Hispanic Society of America, New York.

2164 Death of St. Francis, by Bartolomé Carducho, 1593. Lisbon, Museu Nacional de Arte Antiga; Brown, *Velazquez*.

2165 St. Francis and Brother Leo in prayer, by El Greco. Brera, Milan; Newsweek, *Brera*.

2166 St. Francis receiving the stigmata (from a Christ in the clouds), by El Greco. Walters Art Gallery, Baltimore; Zafran, *50 Old Master Paintings*.

2167 St. Francis receiving the stigmata (while his companion falls to the ground), by El Greco. Women's Hospital, Cadiz; Gudiol, *El Greco*; Larousse, *Ren. & Baroque.*

2168 St. Francis receiving the stigmata, by El Greco, 1587-97. El Escorial, Spain; Gudiol, *El Greco*; Newsweek, *El Escorial.*

2169 St. Francis in ecstasy (looking up to heaven, near a crucifix placed on a rock), by El Greco, 1597-1603. Pau, Musée des B/A; Gudiol, *El Greco.*

2170 St. Francis in ecstasy (the crucifix lay across the skull), by El Greco, 1597-1603. Coll. Aaroz, Madrid; Gudiol, *El Greco.*

2171 Saints Andrew and Francis, by El Greco. Prado, Madrid; Gudiol, *El Greco*; Praeger, *Great Galleries.*

2172 St. Francis of Assisi, by Ludovico Cardi, called "il Cigoli," late 16th cent. Allentown Art Museum, PA.

2173 Birth of St. Francis of Assisi (as they are giving the newborn a bath, a mysterious pilgrim visitor announces his saintly vocation), drawing by Camillo Procaccini. Met Museum; Bean, *15th & 16th Cent.*

2174 Holy Family with St. Francis and donors (Joseph sits at right in a bright red cloak), by Ludovico Carracci. Cento, Museo Civico; Freedberg, *Circa 1600.*

2175 Madonna of St. Matthew, with St. Francis kissing the Child's foot, by Annibale Carracci. Picture Gallery, Dresden; Freedberg, *Circa 1600.*

2176 Pietà, with St. Francis and other saints (angels carry the cross to heaven, while the Virgin swoons, and Francis gestures to the sitting Christ), by Annibale Carracci. Parma, Gallerie Nazionale; Freedberg, *Circa 1600.*

2177 St. Francis of Assisi resuscitating a dead youth (he holds the youth by the wrist, blessing him while ecclesiastics look on in amazement), drawing by Camillo Procaccini. Met Museum; Bean, *15th & 16th Cent.*

2178 The vision of St. Francis of Assisi (he looks into the heavens), by Luis Tristan. Louvre, Paris; Gowing, *Paintings.*

2179 Madonna and Child with SS. Francis (holding a crucifix) and Sebastian (standing behind Mary with an arrow in his throat), by Orazio Gentileschi, after 1600. Matthiesen Fine Art Ltd., London; *Around 1610.*

2180 The ecstasy of St. Francis (he lay back, eyes closed, into an angel's arms, while another angel points to a celestial light), by Giovanni Baglione, 1601. Private coll., Chicago; Spear, *Caravaggio.*

2181 St. Francis and the lay brother (Francis shows him a skull), by El Greco, 1603-07. Prado, Madrid; Gudiol, *El Greco.*

2182 St. Francis and the lay brother (they both meditate on the crucifix), by El Greco, 1603-07. Coll. Buhler, Zurich; Gudiol, *El Greco.*

2183 St. Francis comforted by a musician angel (as he sits in the wilderness before a cave, sleeping), by Guido Reni, 1605-10. Coll. Denis Mahon, London; *Guido Reni.*

2184 St. Francis in meditation (holding a skull) with a monk, by El Greco, c. 1605. National Gallery of Canada, Ottowa; Gudiol, *El Greco*; Hubbard, *Canadian Collections.*

2185 St. Francis in prayer (facing three-quarters away to our left), ink and charcoal drawing after Titian by P.P. Rubens, c. 1605. Louvre, Paris; Jaffé, *Rubens and Italy.*

2186 St. Francis in prayer (before a crucifix under a thatched shrine) by Domenichino, c. 1606-08. Doria Pamphili Palace, Rome; Spear, *Domenichino.*

2187 The stigmatization of St. Francis (touching the wound in his chest, Francis lies in the arms of an angel), by Caravaggio, c. 1606. Wadsworth Atheneum, Hartford CT; *Handbook*; Met Museum, *Caravaggio*; Moir, *Caravaggio*; Spear, *Caravaggio.*

2188 St. Francis of Assisi receiving the Christ Child from the Virgin, by Denis Calvaert, 1607. Bob Jones Univ. Art Gallery, Greenville SC; *Baroque Paintings*; Pepper, *Ital. Paintings.*

2189 St. Francis supported by an angel, by Orazio Gentileschi. Prado, Madrid; Met Museum, *Caravaggio.*

2190 A vision of St. Francis (he holds baby Christ, as Virgin looks on), by Ludovico Carracci. Rijksmuseum, Amsterdam; Met Museum, *Caravaggio.*

2191 Madonna and Child with St. Francis (he leans his head against the Child's shoulder, and touches the Child's knee), by Giovanni Battista Crespi. Ponce, Museo de Arte; Held, *Catalogue.*

2192 St. Francis (half view; he holds his torn robe open at his chest), by Moraz-

zone, c. 1610. Brera, Milan; Newsweek, *Brera.*

2193 St. Francis consoled by an angel playing the violin, by Giuseppe Cesari called the Cavaliere d'Arpino. Douai, Musée de la Chartreuse; Met Museum, *Caravaggio.*

2194 St. Francis in meditation (holding a skull), by Caravaggio. Rome, Santa Maria della Concezione; Freedberg, *Circa 1600*; Met Museum, *Caravaggio.*

2195 St. Francis in meditation (holding a skull), by Caravaggio. Carpineto Romano, San Pietro; Met Museum, *Caravaggio.*

2196 St. Francis in prayer (he kneels, looking down at the floor where a crucifix is laid across an open book), by Caravaggio. Cremona, Museo Civico; Met Museum, *Caravaggio.*

2197 St. Francis kneeling at a rock holding a rosary, skull in lower right corner, by Bernardo Strozzi, 1600–50. Princeton Univ. Art Museum.

2198 St. Francis in ecstasy (hands crossed over his chest, he kneels before his crucifix, looking up), by Bernardo Strozzi, 1615–18. Dayton Art Inst., OH; *Fifty Treasures.*

2199 St. Francis receiving the stigmata (he leans back, lit by a celestial light, just after having received the stigmata), by Orazio Gentileschi, c. 1615. Matthiesen Fine Art Ltd., London; *Around 1610.*

2200 St. Francis receiving the stigmata, by P.P. Rubens, c. 1617. Wallraf-Richartz Musée, Cologne; Baudouin, *Rubens*; Rooses, *L'Oeuvre.*

2201 St. Francis (in a cave, holding a crucifix and looking up), by Velazquez, 1618–19. Private coll., Madrid; Gudiol, *Velazquez.*

2202 The Virgin presenting the infant Jesus to St. Francis, from a dismembered altarpiece by P.P. Rubens, 1618. Dijon, Musée des B/A; Georgel, *Musée des B/A*; United Nations, *Dismembered Works.*

2203 The last communion of St. Francis of Assisi, by P.P.Rubens, c. 1619. Koninklijk Museum, Antwerp; Baudouin, *Rubens*; McGraw, *Encyclo.* (Vol.XII, pl.330); Rooses, *L'Oeuvre*; White, *Rubens.*

2204 Ecstasy of St. Francis (kneeling at the mouth of a cave, before a skull and a crucifix), by Guido Reni, c. 1620. Naples, Chiesa dei Gerolamini; *Guido Reni.*

2205 St. Francis in prayer, in a cave, by school of Zurbaran, early 17th cent. Indianapolis Museum of Art, IN; *100 Masterpieces.*

2206 St. Francis embracing the crucified Christ (Francis stands on a crowned leopard, embracing Christ around the waist, as Christ puts a crown of thorns on Francis's head; an angel approaches Christ with a flower wreath, and another angel plays the viola), by Francisco Ribalta, c. 1620's. Prado, Madrid; Int'l Dict., *Art.*

2207 St. Francis in ecstasy (as an angel stands behind him, a hand on his shoulder), by Domenichino, c. 1622–23. Elsa Garone Inghirami Fiaschi, Volterra; Spear, *Domenichino.*

2208 The ecstasy of St. Francis of Assisi (he lay against a rock, looking at an angel who is playing the violin), by anon. Italian artist, 1620–40. Rouen, Musée des B/A; *La Peinture d'Inspiration.*

2209 St. Francis (in meditation with a crucifix and a skull, as an angel watches from above), by Anthony van Dyck. Prado, Madrid; *Peinture Flamande* (b/w pl.95).

2210 St. Francis at the foot of the cross, after Anthony Van Dyck. Rijksmuseum, *Paintings.*

2211 St. Francis in ecstasy (looking at a vision of a crucifix), by Anthony van Dyck, c. 1626–32. Brussels, Musées Royaux des B/A; Larsen, *Van Dyck* (pl.665).

2212 Vision of St. Francis of Assisi (he sees an angel playing the lute) by Francisco Ribalta. Prado, Madrid; Larousse, *Ren. & Baroque*; McGraw, *Encyclo.* (Vol.II, pl.188).

2213 St. Francis giving the cordon of the Third Order to (kneeling) Louis XIII, att. to Laurent de La Hyre, 1627–30. Orléans, Musée des B/A; O'Neill, *L'Ecole Francaise.*

2214 The stigmatization of St. Francis (he collapses into an angel's arms), by Domenichino, 1628–30. Rome, Santa Maria della Concezione; Spear, *Domenichino.*

2215 Vision of St. Francis of Assisi (he sees an angel holding a crystal ball), by Jusepe de Ribera. Prado, Madrid; Bentley, *Calendar.*

2216 St. Francis before the crucifix (hands crossed across his chest), by Guido Reni, c. 1630. Nelson Atkins Museum of Art, Kansas City MO; *Guido Reni.*

2217 St. Francis' vision of musical angels, by Antonio Barbalonga after Domenichino, 1629-30. Rome, Santa Maria della Vittoria; Spear, *Domenichino*.
2218 The stigmatization of St. Francis (he collapses into two angels' arms), by Antonio Barbalonga after Domenichino, 1629-30. Rome, Santa Maria della Vittoria; Spear, *Domenichino*.
2219 Lamentation of Christ with the Virgin Mary, St. Francis (kneeling at left) and an angel, att. to Giovanni Andrea de Ferrari, c. 1630. Prague Castle; Neumann, *Picture Gallery*.
2220 Pope Nicholas V opening the tomb of St. Francis of Assisi, by La Hyre, 1630. Louvre, Paris; Brusher, *Popes thru the Ages*; Larousse, *Ren. & Baroque*.
2221 St. Francis in a doorway with a lamb, by P.P. Rubens. NGI, Dublin; *Catalogue*.
2222 St. Francis in ecstasy (eyes closed, holding a crucufix and a skull as an angel plays the violin), by Anthony van Dyck, c. 1626-32. Prado, Madrid; Larsen, *Van Dyck* (pl.668).
2223 St. Francis in ecstasy (eyes closed, holding a crucifix and a skull as an angel plays the violin), by Anthony van Dyck, c. 1626-32. KM, Vienna; Larsen, *Van Dyck* (pl.667).
2224 St. Francis (kneeling in prayer), by Francisco de Zurbaran, 1631-40. Santos Justo y Pastor, Madrid; Gállego, *Zurbaran*.
2225 St. Francis (kneeling) receiving the stigmata (as his companion sleeps), by Francisco de Zurbaran, 1631-40. Coll. Alvaro Gil, Madrid; Gállego, *Zurbaran*.
2226 St. Francis (looking up), by Francisco de Zurbaran, 1631-40. Barcelona, Museo d'Art de Catalunya; Gállego, *Zurbaran*.
2227 St. Francis in meditation (he looks at a skull he is holding), by Francisco de Zurbaran, 1631-40. Santa Barbara Museum of Art, CA; Gállego, *Zurbaran*.
2228 St. Francis in the Portiuncula (he kneels, arms raised, amid flowers strewn on steps, looking up at Christ and the Virgin), by Francisco de Zurbaran, 1631-40. Cadiz, Provincial Museum of Fine Arts; Gállego, *Zurbaran*.
2229 St. Francis kneeling (holding a skull), by Francisco de Zurbaran, 1631-40. Düsseldorf, Municipal Museum of Art; Gállego, *Zurbaran*.

2230 St. Francis kneeling (praying), by Francisco de Zurbaran, 1631-40. Sürmondt Museum, Aachen; Gállego, *Zurbaran*.
2231 Temptation of St. Francis (he lies, half-nude, on the floor, recoiling from a woman who pulls her skirt back from one leg, as another woman looks in through the door), by Simon Vouet. Rome, S. Lorenzo in Lucina; McGraw, *Encyclo*. (Vol.II, pl.208).
2232 St. Francis in meditation (in friar's robe with pointed hood, bent over a closed book) by Francisco de Zurbaran, 1632. Coll. Dr. A.E. Shaw, Buenos Aires; Gállego, *Zurbaran*; Gowing, *Biog. Dict*.
2233 St. Francis standing with a skull (he is looking down at it), by Francisco de Zurbaran, after 1634. St. Louis Art Museum, MO; Gállego, *Zurbaran*.
2234 Holy family with Saint Francis, by P.P. Rubens, 1630's. Met Museum.
2235 St. Francis in prayer, by Francisco de Zurbaran, c. 1638-39. Norton Simon Museum of Art, Pasadena CA; Gállego, *Zurbaran*.
2236 Saint Francis kneeling (with a skull) by Francisco de Zurbaran, 1639. Nat'l Gallery, London; Gállego, *Zurbaran*; New Int'l Illus. *Encyclo*.
2237 St. Francis holding a skull, by Francisco de Zurbaran. Alte Pinakothek, Munich; Gállego, *Zurbaran*; Newsweek, *Pinakothek*.
2238 St. Francis in meditation (holding a skull, his face shadowed by his hood), by Francisco de Zurbaran, 1639. Nat'l Gallery, London; Boone, *Baroque*; Gállego, *Zurbaran*; Gaunt, *Pictorial Art*; New Int'l Illus. *Encyclo.*; Wilson, *Nat'l Gallery*.
2239 St. Francis in ecstasy, by Georges de la Tour. Le Mans Museum; Larousse, *Ren. & Baroque*.
2240 St. Francis of Assisi (standing, looking up, his hands buried in his sleeves), by Francisco de Zurbaran, 1640-45. Lyons Musée des B/A; Gállego, *Zurbaran*; Larousse, *Ren. & Baroque*; *Musée*.
2241 St. Francis standing on his tomb, his eyes raised to heaven, by Francisco de Zurbaran, c. 1640. Boston Museum of Fine Arts; Friedrich, *Age of Baroque*; *Int'l Dict. of Art*.
2242 St. Francis (meditating over a skull), by Francisco de Zurbaran, 1641-58. Seville, Archbishop's Palace; Gállego, *Zurbaran*.

2243 St. Francis in prayer (with a halo), by Francisco de Zurbaran, 1641-58. Puig Palau, Barcelona; Gállego, *Zurbaran.*

2244 St. Francis of Assisi (in meditation over a skull), by Francisco de Zurbaran, 1641-58. Convent of the Capuchin Nuns, Castellón de la Plana; Gállego, *Zurbaran.*

2245 St. Francis receiving the stigmata (crucifix carried by seraphs in upper right corner), by Francisco de Zurbaran, 1641-58. Bobotá, Monastery of San Francisco; Gállego, *Zurbaran.*

2246 St. Francis meditating in a landscape, altarpiece in the Church of S. Giovanni, by Guercino, 1645. Bologna, Monte; Roberts, *Master.*

2247 St. Francis meditating in a landscape, pen and brown ink drawing preparatory to Guercino's Altarpiece. Roberts, *Master.*

2248 Death of St. Francis (propped up in bed, as two monks look at each other; at top, Francis is pulled to heaven by two horses drawing a chariot), by Alonso Cano, 1652-57. San Fernando Academy, Madrid; Wethey, *Alonso Cano* (pl.112).

2249 St. Francis in meditation (looks at a crucifix affixed to a tree branch), by Francisco de Zurbaran, 1658-64. Coll. Aguilera, Barcelona; Gállego, *Zurbaran.*

2250 St. Francis kneeling (in the wilderness, holding a skull), by Francisco de Zurbaran, 1659. Coll. Felix Valdés, Bilbao; Gállego, *Zurbaran.*

2251 St. Francis with the bread changed to roses (his superiors exclaim when they see his apronful of roses, which he is giving to the poor), etching by Giovanni Andrea Podesta. Illus. Bartsch; *Ital. Masters of the 17th Cent.* (Vol.45).

2252 The portinucula (St. Francis kneels amid roses, looking at a vision of the Virgin and Child), by Francisco de Zurbaran, 1661. Private Coll., New York; Gállego, *Zurbaran.*

2253 St. Francis preaching Christianity to the Indians, by Pietro Liberi, c. 1662-63. Grenoble, Musée de Peinture et de Sculpture; Chiarini, *Tableaux Italiens.*

2254 St. Francis of Assisi (hands hidden in his sleeves), painted wood statue by Pedro de Mena, 1663. Toledo Cathedral; Book of Art, *German & Spanish.*

2255 St. Francis consoled with the music of the angels, by an unknown Rouen artist. Rouen, Musée des B/A; *La Peinture d'Inspiration.*

2256 Thanks to the intervention of the Virgin, and with the help of the angels, Christ gives the rules of their order to St. Francis and his companions, by an unknown Rouen artist. Rouen, Saint-Ouen Church; *La Peinture d'Inspiration.*

2257 Madonna and Child adored by St. Francis (he holds the Child, while cherubs read a book at his feet), by Domenico Piola. J. Paul Getty Museum, Malibu CA; *Catalogue; Western European.*

2258 Apparition of the Virgin to St. Francis of Assisi (he intercedes for a penitent woman with her three babies), by Luca Giordano, 1680's. Cleveland Museum of Art, OH; *European 16th-18th Cent.*

2259 Death of St. Francis (some monks sit at his bedside with books; one leans over him with a crucifix, another blesses him, others pray, and an angel descends with a crown topped with stars), by Jean Jouvenet. Rouen, Musée des B/A; Schnapper, *Jouvenet.*

2260 St. Francis preaching (to a crowd as angels look on), by Garzi, 1695-96. Rome, S. Silvestro in Capite; Waterhouse, *Roman Baroque.*

2261 St. Francis of Assisi (he prays, kneeling next to a table with a rosary and a skull), by Jan Kryštof Liška, 1699. Mělník, Castle Gallery; National Gallery, *Baroque.*

2262 The ecstasy of St. Francis (angel plays violin to him), by Sebastiano Ricci, c. 1700. Prague, Nat'l Gallery; Daniels, *Ricci.*

2263 St. Francis receiving the stigmata (the clouds are opened up by cherubs, and he looks up into a celestial light; his companion reads, unobserving), by Francesco Trevisani, 1715-19. Rome, Stimmate di S. Francesco; DiFederico, *Trevisani.*

2264 St. Francis in ecstasy (supported by an angel, while another plays the violin), by Francesco Trevisani, c. 1727. Rome, S. Maria in Aracoeli; DiFederico, *Trevisani.*

2265 St. Francis with a violin-playing angel (he listens, seated with a skull, eyes closed), by Francesco Trevisani, c. 1729. Picture Gallery, Dresden; DiFederico, *Trevisani.*

2266 Ecstasy of St. Francis (eyes closed, supported by an angel), by Giambattista Piazetta, c. 1732. Vicenza, Museo Civico; Held, *17th & 18th Cent.*

2267 St. Francis in ecstasy (he turns as

an angel puts his hands on Francis's shoulders), by Flaminio Torri. Private Coll., Urbino; Merriman, *Crespi*.

2268 Stigmatization of St. Francis (leaning against an angel, before a tall crucifix made from sticks) by Giovanni Battista Tiepolo, 1767. Courtauld Inst. of Art, London; *Catalogue*; Morassi, *Tiepolo*.

2269 St. Francis receiving the stigmata (angel puts a hand to his chest) by Giambattista Tiepolo, 1770. Prado, Madrid; Boone, *Baroque*; Morassi, *Catalogue* (pl.195); New Int'l Illus. *Encyclo*.

2270 St. Francis receiving the stigmata (he is supported by angels), by Pompeo Batoni and assistants, 1786. Lisbon, Basilica of the Estrela; Clark, *Batoni*.

2271 St. Francis of Assisi (holding out a cross), pine wood retable with water-based paints, gesso, att. to José Benito Ortega, c. 1875-90. Taylor Museum for Southwest Studies, CO; Wroth, *Images of Penance*.

See also 114, 201, 270, 406, 489, 645, 730, 731, 817, 843, 846, 892, 1076, 1213, 1230, 1416, 1445, 1449, 1451, 1452, 1464, 1471, 1473, 1476, 1477, 1527, 1539, 1540, 1547, 1549, 1550, 1669, 1670, 1673, 1698, 1815, 1817, 1825, 1847, 1861, 2296, 2332, 2498, 2645, 2811, 2947, 2979, 3225, 3323, 3344, 3390, 3414, 3423, 3425, 3486, 3656, 3671, 3782, 3800, 3809, 3826, 3967, 4035, 4100, 4309, 4324, 4575, 4678, 4924, 4925

Francis of Paola, founder of Franciscan Minim Friars, d. 1507, canon. 1519 (Apr. 2)

2272 The miracles of St. Francis of Paola (he is floating in the air, above the sick and insane), oil sketch by P.P. Rubens, c. 1627-28. Picture Gallery, Dresden; Held, *Oil Sketches*.

2273 The miracles of St. Francis of Paola (he is floating in the air, above the sick and insane), oil sketch by P.P. Rubens, c. 1627-28. Alte Pinakothek, Munich; Held, *Oil Sketches*.

2274 St. Francis of Paola at the feet of Sixtus IV, by Charles Mellin, c. 1628-30. Plessis- lèz Tours Castle, Indre-et-Loire; Châtelet, *French Paintings*.

2275 The miracles of St. Francis of Paola (he is floating in the air, above the sick and insane), oil sketch by P.P. Rubens, 1628. Sudeley Castle, Winchcombe; Held, *Oil Sketches*.

2276 Saints Anthony of Padua (hold-

ing a lily) and Francis of Paola (reading), by Simone Cantarini, c. 1637-45. Bologna, Pinacoteca Nazionale; *Age of Correggio*.

2277 St. Francis of Paola receiving benediction from Sixtus IV (he leans his head against the top step to the pope's throne), by Charles Mellin. Rouen, Musée des B/A; Bergot, *Musée*.

2278 St. Francis of Paola (barefoot, with a walking stick), by Francisco de Zurbaran, 1641-58. Lima, Monastery of St. Camillus de Lellis; Gállego, *Zurbaran*.

2279 St. Francis of Paola kneeling before the Madonna and Child, by Sassoferrato, 1641. Rome, S. Francesco de Paola; Waterhouse, *Roman Baroque*.

2280 St. Francis of Paola (right hand on his chest, left hand holding rosary that hangs from his belt), statue by Gilles Guerin. Jardin des Carmes, Paris; Larousse, *Ren. & Baroque* (pl.915).

2281 St. Francis of Paola (kneeling in prayer), pen and wash drawing by Francisco Camilo, 1673. Prado, Madrid; Book of Art, *German & Spanish*.

2282 St. Francis of Paola resuscitating a child (as he looks up to heaven), by Nicolas Perelle, 1683. Orléans, Musée des B/A; O'Neill, *L'Ecole Francaise*.

2283 St. Francis of Paola blessing a child (as his mother holds him), by Giuseppe Maria Crespi, c. 1690-95. Private Coll., Bologna; Merriman, *Crespi*.

2284 Ecstasy of St. Francis of Paola (lifted up to heaven by angels), by the Lombardy School, c. 1700. Walters Art Gallery, Baltimore; *Italian Paintings* (Vol.II).

2285 The Virgin and Child with a boy presented by his guardian angel and St. Francis of Paola, by Francesco Solimena, c. 1705-08. Fitzwilliam Museum, Cambridge; *Catalogue, Italian*.

2286 St. Francis of Paola in ecstasy (half view, holding a staff topped with CHA RI TAS), by Giuseppe Maria Crespi, 1730. Bologna, Pinacoteca Nazionale; Merriman, *Crespi*.

2287 St. Francis of Paola resuscitating a dead child, by Sebastiano Ricci, c. 1732-33. Venice, S. Rocco; Daniels, *Ricci*.

2288 St. Francis of Paola (holding a staff and rosary, looking up at angels), by Giambattista Tiepolo. Venice, S. Benedetto; Morassi, *Catalogue* (pl.183).

2289 St. Francis of Paola (with a book and rosary, and the inscription CHA RI TAS in upper right corner), by Giambattista Tiepolo. Formerly Coll. Böhler, Munich; Morassi, *Catalogue* (pl.172).

2290 St. Francis of Paola (with a cherub who holds a staff topped with a disc inscribed with CHA RI TAS), by Giambattista Tiepolo. Coll. O. Miani, Milan; Morassi, *Catalogue* (pl.181).

2291 St. Francis of Paola (with a cherub who holds a staff topped with a disc inscribed with CHA RI TAS), by Giambattista Tiepolo. Padua, S. Nicolo, Piove di Sacco; Morassi, *Catalogue* (pl.182).

2292 St. Francis of Paola with a brother (he leans against his staff, looking up at angels in the clouds), by Francesco Fontebasso, 18th cent. Bordeaux, Musée des B/A; *Peinture Ital.*

2293 St. Francis of Paola intercedes for a bricklayer (while lit by angels bearing a blazing disc inscribed with CHS, the man tumbles down from the cloud), by Francesco Daggiù, called Cappella, c. 1756. Rome, Museo Diocesano; *Tresori d'Arte.*

2294 Construction of a monastery with the apparition of St. Francis of Paola (he appears in a cloud, pointing down), att. to Noël Quillerier. Augustinian Museum, Toulouse; Mérot, *Le Sueur.*

See also 1697, 3493

Francis of Sales or Francis Bonaventure, Bishop of Geneva, d. 1622 (Jan. 24 & 29)
2295 Mass of St. Francis of Sales (as he prays, an angel descends and a dove appears above his head, before witnesses), oval painting by I. Hugford. Florence, St. Francis de Sales; Bentley, *Calendar.*

2296 Saints Francis of Sales, Francis of Assisi, and Anthony of Padua, sitting on clouds with angels, by Francesco Solimena. Naples, San Nicola alla Carità; Yale Univ., *Taste* (fig.15).

2297 St. Francis of Sales (kneeling in prayer, his forefinger against a book), by Giuseppe Maria Crespi, 1730–35. Mantua, Ducal Palace; Merriman, *Crespi.*

2298 St. Francis of Sales (bestriding evil, holding a serpent), by Giambattista Tiepolo. Udine, Museo Civico; Morassi, *Catalogue* (pl.186).

2299 Triumph of St. Francis of Sales (he hands a flaming heart to SS. Mary and

Anne, who reach down from the clouds), by Giovan Battista Pittoni. Milan, Santa Maria della Visitazione; Fiorio, *Le Chiese di Milano.*

2300 Half-portrait of St. Francis of Sales wearing a crucifix, anon. Turin, Monastero della Visitazione; Coulson, *Saints.*

See also 1330

Francis Regis, Patron of Languedoc
2301 St. Francis Regis distributing his clothing (from a balcony to peasants), by Michel-Ange Mouasse, 1722–23. Prado, Madrid; *L'Art Européen.*

2302 St. Francis Regis preaching in the wilderness, by Michel-Ange Mouasse, 1722–23. Prado, Madrid; *L'Art Européen.*

2303 St. Francis Regis (in the wilderness with a crucifix, pointing up), by Giuseppe Maria Crespi, 1737–38. Mantua, Ducal Palace; Merriman, *Crespi.*

Francis Seraphicus
2304 St. Francis Seraphicus (in a friar's robe), statue from the Charles Bridge in Prague, by Franz Preiss, 1708. Prague, St. Joseph's Church; Štech, *Baroque Sculpture.*

Francis Solano of Lima, Spanish Franciscan missionary, d. 1610 (July 13)
2305 Woodcut of St. Francis Solano baptizing natives, issued in Barcelona in the 18th cent. McGraw, *Encyclo.* (Vol.XII, pl.380).

Francis Xavier, missionary of Soc. of Jesus, d. 1552, canon. 1622 (Dec. 3)
2306 Saint Francis Xavier holding a heart, from which extends a crucifix, by 16th cent. Japanese artist. Kobe Municipal Museum; Horizon, *Elizabethan.*

2307 The miracles of St. Francis Xavier, by P.P. Rubens, 1616–17. KM, Vienna; Baudouin, *Rubens*; Held, *Oil Sketches*; Held, *17th & 18th Cent.*

2308 Francis Xavier (hands crossed on his chest), by P.P. Rubens. Brukenthal Museum, Rumania; Oprescu, *Great Masters.*

2309 St. Francis Xavier (praying in a ray of light, as cherubs descend with a flower wreath), by Anthony van Dyck, c. 1622–23. Vatican Museums; Francia, *Vaticana*; Larsen, *Van Dyck* (pl.162b).

2310 St. Francis Xavier (praying, with a ray of light behind him), att. to An-

thony Van Dyck, c. 1622–23. Schloss Weissenstein der Grafen von Schönborn, Pommersfelden; Larsen, *Van Dyck* (pl.430).
2311 The miracle of St. Francis Xavier (interceding with God to save a sick woman's life), by Nicolas Poussin, 1641. Louvre, Paris; Gowing, *Paintings*; Wright, *Poussin*.
2312 St. Francis Xavier (standing with a staff, looking up at a celestial light), by Bartolomé Esteban Murillo, c. 1642. Wadsworth Atheneum, Hartford CT; *Handbook*.
2313 St. Francis Xavier unconscious, as they bring fagots to burn him, by Carlo Maratta. Rome, Church del Gesu; Coulson, *Saints.*
2314 St. Francis Xavier baptizing (a grown woman), by Baciccio, c. 1705–09. Rome, S. Andrea al Quirinale; Waterhouse, *Roman Baroque.*
2315 St. Francis Xavier raising a dead man (he holds up a lily, and holds the hand of the dead man, who is just sitting up), by Giuseppe Maria Crespi. Ferrara, Chiesa del Gesù; Merriman, *Crespi.*

Frediano or Frigidian, bishop and patron of Lucca, son of King Ultach of Ulster, d. 588 (Mar. 18)
2316 Virgin and Child with Saints Frediano and Augustine, known as the Barbadori Altarpiece by Filippo Lippi, 1437. Louvre, Paris; Gowing, *Paintings.*
2317 St. Frediano diverts the river Serchio (by charting a new course with a rake), by Filippo Lippi. Uffizi, Florence; Bentley, *Calendar.*

Frideswide, Mercian princess, founded nunnery at Binsey, d. 753 (Oct. 19)
2318 Legend of St. Frideswide (above, she overlooks a battle; below, she prays in a stable), stained-glass window by Edward Burne-Jones, 1859. Christ Church, Oxford; Bentley, *Calendar.*

Fridolin, 6th cent. Irish monk, abbot and founder of Sackingen (Mar. 6)
2319 Saint Fridolin and Death (shaking hands), by Master of the Eyelets, Swiss, end of 15th cent. Dijon, Musée des B/A; Bentley, *Calendar*; Flammarion, *Toison D'Or.*

Frigidian *see* Frediano

Gaetano *see* Cajetan

Galganus Guidotti, hermit knight, d. 1181, canon. 1185 (Dec. 3)
2320 Scenes from the life of St. Galganus: Michael the Archangel stops his horse and enrolls Galganus as his knight; Michael leads Galganus's horse to the site where he is to build his hermitage; panels by Bartolo di Maestro Fredi. Pisa, Museo Civico; Kaftal, *Tuscan.*
2321 Galganus cuts down trees with his sword; envious monks who try to steal his sword from the stone are struck dead; panels by Bartolo di Maestro Fredi. Pisa, Museo Civico; Kaftal, *Tuscan.*
2322 Madonna and Child flanked by SS. Ansanus (holding a palm and a banner) and Galganus (drawing a sword from a stone), by an unknown follower of Lorenzetti known as Ugolino Lorenzetti, c. 1320–40. Siena, Pinacoteca Nazionale; Edgell, *Sienese Painting.*
2323 St. Galganus and Archangel Michael (Galganus kneels before Michael, who places a hand on a sword in a stone), from a tavoletta by Guido Cinatti, 1320. Siena, Archivio di Stato; Kaftal, *Tuscan.*
2324 St. Galganus (with a sword in the stone) and Blessed Peter, from an altarpiece by Giovanni di Paolo. Aartsbisschoppelijk Museum, Utrecht; Van Os, *Sienese Altarpieces* (Vol.II, pl.124).

Gall, founded Abbey of St. Gall, Switzerland, d. 646 (Oct. 16)
2325 St. Gall (holding a book, wearing a mitre and holding a crozier), panel of a polyptych by Battista da Vicenza. Vicenza; Kaftal, *North East Italy.*
2326 Saint Gall preaching to a pagan king and his subjects, by W. Durr. Carlsruhe, Galerie Grand Ducale; Coulson, *Saints.*
See also 3947

Gamaliel, Confessor, 1st cent. (Aug. 3)
2327 St. Stephen (lying on a pile of stones), mourned by Saints Gamaliel and Nicodemus, by the "Pensionante del Saraceni," c. 1615. Boston Museum of Fine Arts.

Gangolfus or Gangulphus, Burgundian, patron of unhappy marriages, mur. 760
2328 St. Gangolfus (in a pink poncho, holding a palm and a sword) and St.

Gregory (in ecclesiastic robes), by Master of Messkirch, c. 1535-40. Yale Univ. Art Gallery; *Selected Paintings.*

Gaudiosor, Bishop of Brescia, d. 445 (Mar. 7)
2329 St. Filippo Benizio, St. Alessandro (in armor), St. Gaudiosor and St. Jerome, four panels flanking the Nativity by Romanino. Nat'l Gallery, London; Poynter, *Nat'l Gallery.*

Geminianus, Bishop and patron of Modena, patron of S. Gimignano, friend of St. Ambrose of Milan, 5th cent. (Jan. 31)
2330 St. Geminianus, St. Michael, and St. Augustine, each with an angel above, three panels from a polyptych by Simone Martini, c. 1325-30. Fitzwilliam Museum, Cambridge; Catalogue, *Italian.*
2331 St. Geminianus in Bishop's mitre and staff, by Taddeo di Bartolo, c. 1410. Univ. of Notre Dame, IN; Shapley, *Samuel H. Kress.*
2332 Saints Geminianus and Francis of Assisi (holding a model of a church), by Giovanni dal Ponte. Philadelphia Museum of Art, PA.
2333 St. Geminianus (in bishop's robes, holding a crosier and a model of St. Gimignano), fresco by Lippo Vanni. S. Gimignano, Palazzo Comunale; Kaftal, *Tuscan.*

Genevieve, Patroness of Paris, rallied Parisians against the invading Huns, d. 500 (Jan. 3)
2334 St. Genevieve (holding a candle) and St. Apollonia (holding pincers), side panel from St. Catherine Altarpiece by Lucas Cranach the Elder, 1506. Nat'l Gallery, London; Friedländer, *Cranach*; Schade, *Cranach.*
2335 St. Genevieve and the miracle of the candle (a demon tries unsuccessfully to blow out the candle with a bellows), min. by Jean Bourdichon, c. 1515. Paris, Ecole des B/A; Sterling, *Master of Claude.*
2336 St. Genevieve and the miracle of the candle (a demon tries unsuccessfully to blow out the candle with a bellows), min. by the Master of Claude from a Book of Prayers of Queen Claude, fo.46r, c. 1515-16. Coll. H.P. Kraus, NY; Sterling, *Master of Claude.*
2337 St. Germaine and St. Genevieve

(the two shepherdesses are met on the road by two traveling cardinals, who speak to them as an angel descends), by Nicolas Coypel. Dijon, Musée des B/A; Schnapper, *Jouvenet.*
2338 Saint Genevieve praying, as shepherd and wife look on, by Puvis de Chavannes. Pantheon, Paris; Coulson, *Saints.*

Genevieve of Brabant, Duchess of Brabant, confessor, unknown date
2339 St. Genevieve of Brabant discovered by her husband (he strides toward her at the hunt, as she sits surrounded by cherubs), by Valerio Castello. Chrysler Museum, Norfolk VA; *Treasures.*
2340 St. Genevieve of Brabant in the forest (sitting with a child, and feeding a deer), by George Frederick Bensell, 1860-70. Smithsonian Institute, Washington DC; Zellman, *300 Years.*

Gennaro or Januarius, Bishop of Benevenuto; thrown to wild animals then beheaded; mart. 305 (Sept. 19)
2341 San Gennaro (in bishop's robes, pointing to a severed head), by Louis Finson, c. 1612. Coll. Morton B. Harris, NY; Spear, *Caravaggio.*
2342 The scourging of San Gennaro (his arms bound to a rope run through a pulley); San Gennaro led to martyrdom; San Gennaro protects the city of Naples from the eruption of Mt. Vesuvius (holding up a crucifix); translation of the relics of San Gennaro; a beggar receives the saint's blindfold; frescoes by Domenichino and assistants, 1635-37. Naples Cathedral; Spear, *Domenichino.*
2343 Decollation of St. Gennaro (his decapitated head lay sideways on the block), by Mattia Preti, 1630's. Private coll., NY; Yale Univ., *Taste* (cat.7).
2344 Eusebia collecting the blood of San Gennaro; San Gennaro protects the city of Naples from the Saracens (he flies at them during the battle); San Gennaro refusing to worship pagan idols; San Gennaro appearing to his mother in a vision; apparition of the Virgin and Child to San Gennaro at the miraculous oil lamp; frescoes by Domenichino and assistants, 1635-37. Naples Cathedral; Spear, *Domenichino.*
2345 The attempted martyrdom of San Gennaro and his companions at Pozzuoli (thrown in with disinterested lions); the

curing of the sick at the tomb of San Gennaro (he flies in the air above them); San Gennaro resuscitating Massima's son (the boy gets up, gasping for breath, as Gennaro looks on from above); frescoes by Domenichino and assistants, 1635–37. Naples Cathedral; Spear, *Domenichino*.

2346 St. Gennaro interceding for Naples (he sits on a cloud way above the city), by Onofrio Palumbo and Didier Barra, c. 1652. Naples, Arciconfraternità della Santissima Trinità dei Pellegrini; RA, *Painting in Naples*.

2347 Saint Januarius (in ecclesiastical garments) sculpture by Cosimo Fanzaga. Naples Cathedral; Coulson, *Saints*.

2348 St. Gennaro frees Naples from the plague (kneeling on a cloud, he prays to Jesus; plague victims lie in a heap beneath him), by Luca Giordano, c. 1660–61. Naples, S. Maria del Pianto; RA, *Painting in Naples*; Yale Univ., *Taste* (fig.46).

2349 Martyrdom of St. Januarius (he kneels on a stone slab, while an angel descends with a palm), by Giordano. Nat'l Gallery, London; Bentley, *Calendar*.

2350 St. Januarius visited in prison by St. Proculus and St. Sosius (in the presence of angels), by Francesco Solimena, 1728. Coll. The Counts Harrach; Cooper, *Family Collections*.

See also 1962, 4477

George of Cappadocia, patron Saint of England, patron of knights, archers, armorers; beheaded after tortures; mart. 303 (Apr. 23)

2351 St. George (standing on his squire's back, who kills the dragon) from "Moralia in Job" ms., early 12th cent. Dijon, Biblio. Municipale; Gardner, *Art Thru Ages*.

2352 St. George (holding a spear in right hand and sword in left hand) by school of Novgorod, 12th cent. Kremlin, Cathedral of the Dormition, Moscow; McGraw, *Russia*.

2353 Martyrdom of St. George (tied inside of a wheel), from Psalter of the diocese of Constance, Switzerland, after 1224. Coll. C. W. Dyson Perrins; Burlington, *Illum. MS*.

2354 Scenes from the life of St. George: he declares his conversion to Dacian and his 72 counselors; George is tortured on the rack; nails are driven into his feet; he is beaten with clubs; he is stabbed 140 times with lances, swords, and daggers; he is imprisoned; illum. from ms. 1853, Veronese School, end of 13th cent. Verona, Biblio. Civica; Kaftal, *North East Italy*.

2355 St. George and the Magician Athanasius; Emperor Dacian searches for a magician to dispel the Christian magic; Athanasius divides a bull in two parts; Athanasius hooks the two parts of the bull to a plow; Athanasius gives George the poisoned cup; George converts Athanasius; George is imprisoned, illum. from ms. 1853, Veronese School, late 13th cent. Verona, Biblio. Civica; Kaftal, *North East Italy*.

2356 St. George and the Queen: George converts the Queen; the Queen confesses to Dacian that she is a Christian; George and the Queen are beheaded together; illum. from ms. 1853, Veronese School, end of 13th cent. Verona, Biblio. Civica; Kaftal, *North East Italy*.

2357 Tortures of St. George: George is roasted in the belly of a brazen bull; he is smoked over a cauldron; Jesus comforts George in prison; he is sawed in half; his body is placed in a boiling cauldron then buried in it; he is raised to life again and brought before the judge; he is put on the wheel; Emperor Dacian has George's dismembered body thrown in a well; Christ reassembles the parts of George's body and resurrects him; Dacian executes those who are converted by George's resurrection; George is roasted on a gridiron, and lead is poured on his head; from ms. 1853, Veronese School, late 13th cent. Verona, Biblio. Civica; Kaftal, *North East Italy*.

2358 Saint George (killing a green dragon), by Paolo Veneziano, active 1323–62. Bologna, Santa Maria Maggiore; New Int'l Illus. *Encyclo.* (see Venetian Art).

2359 The earl of Lancaster and St. George, from Sarum Hours, ms. Douce 231, fo.1r, c. 1325–30. Bodleian Library, Oxford.

2360 St. George and the dragon (as a crowd watches from castle walls and the princess stands before the dragon, raising her arms in prayer, St. George tramples the fire-breathing dragon and stabs it with a spear), drawing by Simone Martini, 1336–43. Avignon, Cathedral Notre-Dame-des-Doms; *L'Ecole d'Avignon*.

2361 St. George killing the dragon (as the princess holds up her hands in prayer), by Francesco Traini. Parma, Baptistery; Meiss, *Traini.*

2362 St. George freeing the princess (he fights a dragon coming out of a swamp), by Master of the Codex of St. George from J.De Stephanescius, "The Miracles and Martyrdom of St. George," ms.C. 129, fo.85. Vatican, St. Peter's; Salmi, *Ital. Miniatures.*

2363 St. George killing the dragon (he is nearly out of his saddle, as the horse strains its head up to its right), by Vitale da Bologna. Bologna, Pinacoteca Nazionale; Gnudi, *Vitale*; McGraw, *Encyclo.* (Vol.XIV, pl.375).

2364 Decapitation of St. George (he kneels, as executioner and soldiers holding pikes look on), fresco by Altichiero and Avanzo, c. 1380. Padua, S. Giorgio; Erlande-Brandenburg, *Gothic Art*; McGraw, *Encyclo.* (Vol.I, pl.69).

2365 St. George (on a leaping horse) and the dragon, by school of Novgorod, late 14th cent. State Russian Museum, St. Petersburg; Bazin, *Loom of Art*; McGraw, *Russian.*

2366 St. George (in a blue tunic and red cloak, pinned on one shoulder) Byzantine icon, c. 1400. Coll. S. Amberg, Koelliken, Switzerland; Munro, *Golden Encyclo.* (p.68).

2367 St. George and the dragon (biting the spear that pierces its belly), marble statuette by English school, c. 1400. NGA, Washington DC; Walker, *NGA.*

2368 St. George killing the dragon (before a white castle), from the "Boucicaut Hours" painted by the Boucicaut Master, ms.2, fo.23v. Jacquemart-André Museum, Paris; Meiss, *French Painting.*

2369 St. George killing the dragon with a sword, from Book of Hours, ms.3. John Carter Brown Library, Providence; Panofsky, *Early Nether.*

2370 St. George slaying the dragon, from "Durante Hours" fo.35v. Lisbon, Nat'l Archives, Armario dos Tratados; Panofsky, *Early Nether.*

2371 Retable of St. George killing the dragon (on the reverse, the citizens of Silene feed a baby to the dragon for a sacrifice), att. to Marzal de Sas, c. 1410–20. V & A, London; Burton, *V & A.*

2372 St. George (in a billowing red cloak) and the dragon (snake-like, curled on the ground the length of the horse), by Novgorodian school, early 15th cent. Tretyakov Gallery, Moscow; McGraw, *Dict.* (see Novgorod); Tretyakov, *Russian Paintings.*

2373 St. George (with a shield), marble statue by Donatello, c. 1415–17. Bargello, Florence; Ettlinger, *Raphael*; Gardner, *Art thru Ages*; Gowing, *Hist. of Art* (p.643); Hartt, *Ital. Ren.*; Int'l Dict. of Art; Janson, *History* (pl.490); New Int'l Illus. *Encyclo.*

2374 St. George and the dragon (he is about to smite the green dragon a second time with his sword; the lance is broken in the beast's neck; the princess watches from a cliff), illum. by the Rohan Master from a Book of Hours. Latin 9471, fo.223, c. 1415–16. BN, Paris; *Rohan Master* (pl.105).

2375 The Duke of Bedford kneeling in prayer before St. George, from the Hours of the Duke and Duchess of Bedford, ms. add. 18850, fol. 256v., c. 1424. BL, London; Sterling, *Peinture Médiévale.*

2376 The legend of St. George (he kills a dragon before a city, as people run away), from "Bedford Breviary," ms. lat. 17294, fo.447v, c. 1424–35. BN, Paris; Porcher, *Medieval French Min.*

2377 Flagellation of St. George (he is tied, kneeling, to a post as the emperor looks on), from the St. George's altarpiece by Bernardo Martorell, c. 1430. Louvre, Paris; Gowing, *Paintings.*

2378 St. George (in blue, wearing an open-visored pig-nosed bassinet) slaying the dragon (he is standing on it, brandishing a two-handed sword), illum. by a follower of the Master of Guillebert de Mets for a Book of Hours, ms. W.170, fo.157v, Belgium, c. 1430–40. Walters Art Gallery, Baltimore.

2379 St. George being pulled to the block (feet tied to a horse); decapitation of St. George, from St. George's Altarpiece by Bernardo Martorell, c. 1430. Louvre, Paris; Book of Art, *German & Spanish*; Gowing, *Paintings*; Puppi, *Torment.*

2380 The trial of St. George (before an enthroned man with a pointed hat, resting his elbow on a two-handed sword), from St. George's Altarpiece by Bernardo Martorell, c. 1430. Louvre, Paris; Book of Art, *German & Spanish.*

2381 St. George killing the dragon with a long spear in its neck, small oil by Rogier van der Weyden, 1432–35. NGA, Washington DC; Walker, *NGA.*

2382 St. George (standing next to his horse) and the princess, fresco by Pisanello, c. 1433. Verona, Museo Civico; Berenson, *Ital. Painters*; Erlande-Brandenburg, *Gothic Art*; Hartt, *Ital. Ren.*

2383 St. George (in black armor) and the dragon, before a white city and princess wearing ermine-trimmed cloak, by Bernardo Martorell, c. 1435–40. Art Inst. of Chicago, *Paintings*; Art Inst., *100 Master.*; Maxon, *Art Institute*; McGraw, *Dict.*

2384 St. George (on white horse with cross on shield) killing winged dragon, right panel from "Madonna and Child with Saints" triptych by Giovanni dal Ponte, 1430's. Columbia Museum of Art, SC; Shapley, *Samuel H. Kress.*

2385 St. George tipping his helmet, as he introduces George Van der Paele, canon of St. Donation's church, to the Virgin and Child, by Jan van Eyck, 1436. Bruges, State Museum; Gowing, *Biog. Dict.*; Hall, *Color and Meaning*; Oxford, *Medieval Europe.*

2386 St. George (dismounted) and the princess (standing on the other side of his horse), by fresco by Pisanello. Verona, S. Anastasia; McGraw, *Encyclo.* (Vol.XI, pl.177); Puppi, *Torment.*

2387 Madonna and Child (inside the sun) with St. George (in a wide-brimmed white hat) and St. Anthony Abbott, by Pisanello. Nat'l Gallery, London; Berenson, *Ital. Painters*; Book of Art, *Ital. to 1850*; Coulson, *Saints*; Dunkerton, *Giotto to Dürer*; Levey, *Nat'l Gallery*; McGraw, *Encyclo.* (Vol.XI, pl.176).

2388 St. George slaying the dragon (dragon wraps its tail around the horse's leg), by Sano di Pietro and Master of the Osservanza. Siena, S. Cristoforo; Christiansen, *Siena.*

2389 Madonna and Child (inside the sun) with St. George (in a wide-brimmed white hat) and St. Anthony Abbott, by Pisanello, 1445. Nat'l Gallery, London; Berenson, *Ital. Painters*; Book of Art, *Ital. to 1850*; Coulson, *Saints*; Gowing, *Biog. Dict.*; Levey, *Nat'l Gallery*; McGraw, *Encyclo.* (Vol.XI, pl.176).

2390 St. George (in gothic armor, holding a halberd) and the princess (handing him his helmet topped with a pennon), fresco by Jaime Huguet, before 1448. Barcelona, Museo d'Art de Cataluyna; Book of Art, *German & Spanish*;

Erlande-Brandenburg, *Gothic Art*; Lassaigne, *Spanish.*

2391 St. George defeating the dragon, wooden sculpture by Bernt Notke, 1448. Storkyrkan, Stockholm; Bazin, *Loom of Art* (pl.239); Snyder, *Northern Ren.*

2392 St. George (in partial armor with bare legs) slaying the dragon, outer sides of an organ door by Cosimo Tura. Museu dell'Opera, Duomo; McGraw, *Encyclo.* (Vol.XIV, pl.202).

2393 St. George and the dragon (the dragon has its tail wrapped around the lance, and is pulling the broken end from its mouth, while George rears his horse, wielding his sword; the princess flees at right), fresco by Bernardino Lanino. Milan, S. Ambrogio; Fiorio, *Le Chiese di Milano.*

2394 St. George slaying the dragon (before a walled city on the coast) by Pedro Nisart after Jan van Eyck. Palma, Museo Arqueologico; Panofsky, *Early Nether.*

2395 St. George thrusting spear through dragon's mouth while his horse tramples on it, from stained-glass window, 15th cent. Doddiscombsleigh, Devon; Drake, *Saints and Emblems.*

2396 St. George and the dragon (two-footed creature) before a cave-like rock and a landscape cultivated with farms, while the princess looks on, by Paolo Ucello, 1456–60. Jacquemart-André Museum, Paris; Gowing, *Biog. Dict.*; Hogarth, *Dragons* (p.141).

2397 St. George (on a white horse) and the (green) dragon (held on a leash by the princess) by Paolo Ucello, c. 1460. Nat'l Gallery, London; Book of Art, *Ital. to 1850*; Dunkerton, *Giotto to Dürer*; Hogarth, *Dragons*; McGraw, *Encyclo.*; (Vol.XI, pl.40); New Int'l Illus. *Encyclo.*; Praeger, *Great Galleries*; Rowling, *Art Source Book.*

2398 St. George (on his horse) and the dragon, by Cosimo Tura, c. 1460. Coll. Hon. Mrs. K. Asquith, Mells, Frome, Somerset; Ruhmer, *Tura.*

2399 St. George and the dragon (princess puts a hand on dragon's head) copperplate engraving by Hugo van der Goes. NGA, Washington DC; Flammarion, *Toison D'Or.*

2400 St. George baptizes the king of Silena, by Sano di Pietro. Vatican Museums; Christiansen, *Siena*; Francia, *Vaticana*; Kaftal, *Tuscan.*

2401 St. George preaching to the king of Silena (with the leashed dragon standing by), by Sano di Pietro. Vatican Museums; Christiansen, *Siena*; Francia, *Vaticana*; Kaftal, *Tuscan.*

2402 Virgin and Child enthroned, with an angel playing the lute, and St. George presenting a kneeling donor (before a walled garden), by the workshop of Hans Memling, c. 1465–80. Nat'l Gallery, London; Dunkerton, *Giotto to Dürer.*

2403 St. George (on a white horse with thin red trappings) and the dragon (under an oak tree with a gourd) by Cosimo Tura, 1469. Ferrara Cathedral; Arcona, *Garden* (fig.56); Berenson, *Ital. Painters*; Lassaigne, *Fifteenth Cent.*; New Int'l Illus. *Encyclo.* (see Ferrarese).

2404 St. George (in Roman-style armor, bestriding the conquered dragon, one arm raised with a spear, the other lowered with a sword), by Cosimo Tura, c. 1470. Coll. Cini, Venice; Cooper, *Private Collections*; Ruhmer, *Tura.*

2405 St. George (on a rearing horse) and the dragon (with a broken lance through its mouth and throat), by Carlo Crivelli, 1470. Isabella Stewart Gardner Museum, Boston MA; Berenson, *Ital. Painters*; Gowing, *Biog. Dict.*; Hadley, *Museums Discovered*; Zampelli, *Crivelli.*

2406 St. George (standing in decorated armor, holding a broken striped lance), by Carlo Crivelli. Met Museum; Zampetti, *Crivelli.*

2407 St. George's Altar (with scenes from the life of the Virgin), by Master of the St. George Altarpiece, c. 1470. Prague, Nat'l Gallery; Bachmann, *Gothic Art.*

2408 St. George (standing in armor in a doorway before a landscape, holding a broken lance; dragon lies dead at his feet), by Andrea Mantegna, 1470's. Accademia, Venice; Denvir, *Art Treasures*; Gowing, *Hist. of Art* (p.652); Praeger, *Great Galleries.*

2409 Head of St. George (wearing a black cap), detached panel from the Roverella polyptych by Cosimo Tura, c. 1474. San Diego Fine Arts Gallery, CA; United Nations, *Dismembered Works.*

2410 Scenes from the life of St. George: he leads the dragon into the city on a leash (standing above it with raised sword, as king and citizens look on); he converts and baptizes the king and court, by Vittore Carpaccio. Venice, S. Giorgio degli Schiavoni; Kaftal, *North East Italy.*

2411 St. George (standing next to a decapitated dragon), engraving by Benedetto Montagna. Illus. Bartsch; *Early Ital. Masters* (Vol.25).

2412 St. George slaying the dragon (with a broken lance in the dragon's chest, before a square tower in upper right corner), predella of the Pesaro altarpiece by Giovanni Bellini. Correr Museum, Venice; Goffen, *Bellini.*

2413 St. George killing the dragon (he leans from his horse, hand on head) from a predella of the Coronation of the Virgin by Giovanni Bellini. Pesaro, Museo Civico; McGraw, *Encyclo.* (Vol.II, pl.254).

2414 St. George and the dragon (his face is hidden by the horse's head), by Carlo Crivelli, after 1490. Nat'l Gallery, London; McGraw, *Encyclo.* (Vol.XII, pl.42).

2415 St. George, crossing a river on his horse, holding a tiny man in the crook of his arm, fresco, 1494. Church of the Holy Cross of Agiasmati, near Platanistasa; Stylianou, *Painted Churches* (p.209).

2416 St. George (in armor, dead dragon at his feet) and St. Sebastian (holding a sword in a red sheath and an arrow), between two archways, by Andrea da Solario. Detroit Inst. of Art, MI.

2417 St. George and the dragon (he kills it before a castle atop a rock), stained-glass window, Swiss, c. 1500. V & A, London; Burton, *V & A.*

2418 St. George baptizing the pagan king and his daughters, wooden sculpture, Netherlandish, late 15th–early 16th cent. Helen Foresman Spencer Museum of Art, Lawrence KS; *Handbook.*

2419 St. George in red-slashed doublet with military skirt in armor, holding a banner, and the dragon at his side, from the Paumgartner Altarpiece by Albrecht Dürer, 1503. Alte Pinakothek, Munich; Benesch, *German*; Hogarth, *Dragons* (p.195).

2420 Saint George killing the dragon (with a spear in its mouth), woodcut by Albrecht Dürer, c. 1504–05. Strauss, *Woodcuts* (pl.90).

2421 St. George (about to strike with his sword) and the dragon (broken lance in its chest), by Raphael, 1504. Louvre, Paris; Bentley, *Calendar*; Ettlinger, *Raphael*; Gowing, *Paintings*; McGraw, *Encyclo.* (Vol.XI, pl.421); Raphael, *Complete Works* (1.29).

2422 St. George and the dragon (he kills it with a spear), by Raphael, 1504. NGA, Washington DC; Hartt, *Ital. Ren.*; Newsweek, *Nat'l Gall.*; Praeger, *Great Galleries*; Raphael, *Complete Works*; Walker, *NGA.*

2423 St. George killing the dragon (with a lance held in one hand), woodcut by Albrecht Dürer, Erlangen c. 1504. Geisberg, *Single Leaf.*

2424 St. George (in black armor) killing the dragon (with bodies in several stages of decomposition lying around), by Vittore Carpaccio. Venice, Scuola di S. Giorgio degli Schiavoni; Hogarth, *Dragons* (p.137); McGraw, *Encyclo.* (Vol.III, pl.70); Pischel, *World History.*

2425 St. George and the dragon (three nude bodies lay on the ground), att. to Luca Signorelli. Rijksmuseum, Amsterdam; *Paintings.*

2426 St. George (standing, while two angels arm him), woodcut by Lucas Cranach the Elder, Munich, 1506. Geisberg, *Single Leaf*; Schade, *Cranach.*

2427 St. George and the dragon (dragon bites lance piercing its shoulder) marble relief by Michel Colombe, 1508. Louvre, Paris; New Int'l Illus. *Encyclo.*

2428 St. George and the dragon (he sits astride his horse, facing three quarters away to the right, while the dragon lies dead on the ground), copper engraving by Albrecht Dürer, 1508. Crocker Art Gallery, Sacramento CA; *Catalogue.*

2429 St. George on horseback (in full plate and barding, holding a broken lance), woodcut by Hans Burgkmair the Elder, 1508. Geisberg, *Single Leaf.*

2430 Cartoon of St. George and the dragon, for the painting in the NGA, Wash. D. C. by Raphael. Uffizi, Florence; Book of Art, *Ital. to 1850*; Raphael, *Complete Works* (3.39).

2431 St. George in black armor, on a white horse in a forest, by Albrecht Altdorfer, 1510. Alte Pinakothek, Munich; Benesch, *German*; Guillaud, *Altdorfer*; Jacobs, *Color Encyclo.*

2432 St. George (in Gothic plate, brandishing a small sword) and the dragon, by Francesco Francia. Barberini Palace, Rome; New Int'l Illus. *Encyclo.*

2433 St. George (in a plumed helmet, killing the dragon before a castle on a rocky hilltop), woodcut by Albrecht Altdorfer, Dresden, 1511. Geisberg, *Single-Leaf*; McGraw, *Encyclo.* (Vol.IV, pl.427).

2434 St. George and the dragon (he spears the prone dragon in the mouth, before a landscape with a house atop a tall hill), woodcut by Albrecht Altdorfer, 1511. McGraw, *Encyclo.* (Vol.IV, pl.427).

2435 St. George killing the dragon (with bones strewn all over the ground), woodcut by Lucas Cranach the Elder, Munich, c. 1513. Geisberg, *Single-Leaf*; Schade, *Cranach.*

2436 Madonna between Saint John the Baptist and George, by Cesare da Sesto, c. 1514. M. H. de Young Memorial Museum, San Francisco CA; *European Works.*

2437 St. George (in black armor and military skirt, on a horse with a red caparison) and the (lizard-like) dragon, by Leonard Beck, c. 1515. KM, Vienna; Benesch, *German.*

2438 St. George (bestriding the conquered dragon), by Titian, c. 1517-20. Coll. Cini, Venice; Cooper, *Private Collections*; Wethey, *Titian* (pl.150).

2439 St. George (in red cloak, with thin broken lance) and the dragon (in the forest, with body parts lying about), by Giovanni Antonio Bazzi, called Sodoma. Nat'l Gallery, London; Ferguson, *Signs*; Gowing, *Biog. Dict.*

2440 St. George (on a brown horse) and the dragon (with body parts lying about), by Sodoma, c. 1518. NGA, Washington DC; Berenson, *Ital. Painters*; Phaidon, *Art Treasures*; Shapley, *15th-16th Cent.*; Walker, *NGA.*

2441 St. George (in armor and military skirt on white rearing horse) and the dragon, after Georg Breu the Elder, c. 1520. North Carolina Museum of Art, Raleigh; Eisler, *European Schools.*

2442 St. George (mounted in full armor, bestriding the dead dragon, the princess kneels before him), etching by Hans Burgkmair. Strauss, *The Illus. Bartsch* (Vol.11, no.23).

2443 St. George (on a white horse, raising his sword) and the dragon, by Lucas Cranach the Elder, 1520-25. Formerly Forsthaus Uhlenstein, Harz, West Germany (stolen); Friedländer, *Cranach.*

2444 St. George on horseback (in Gothic plate and military skirt, killing dragon with a sword) by Lucas Cranach the Elder, 1520-25 (lost 1945). Formerly Staatliche Galerie, Dessau; Hogarth, *Dragons* (p.139); Schade, *Cranach.*

2445 St. George blesses the poison cup in the presence of the Emperor and the magician Athanasius; the magician, turned Christian, is beheaded before the Emperor and St. George, wings of the St. George's Altar from the Cathedral of Cologne by Gossen Van Der Weyden's Studio. Esztergom Christian Museum; *Christian Art in Hungary* (pl.XVI/41 4/5).

2446 St. George, standing over the dragon, holding a banner, by Hans Holbein the Younger, 1522. Carlsruhe, Galerie Grand Ducale; Classiques, *Holbein.*

2447 Madonna (overhead) with Saints George (in armor, holding a banner) and Michael, by Dosso Dossi. Estense Gallery, Modena; Gibbons, *Dossi.*

2448 Madonna with Saints Sebastian (standing, hands tied above his head) and George (in armor, holding a striped staff), anon. Estense Gallery, Modena; Gibbons, *Dossi.*

2449 St. George (in black armor and plumed helmet, holding broken lance, piece of lance on ground) by Battista Dossi. Picture Gallery, Dresden; *Age of Correggio*; Gibbons, *Dossi*; Ricci, *Cinquecento.*

2450 The Madonna of St. George (he and other saints surround her), by Correggio. Picture Gallery, Dresden; Freedberg, *Circa 1600*; McGraw, *Encyclo.* (Vol.III, pl.467).

2451 St. George (on a brown rearing horse wearing a plumed helmet) and the (kneeling) princess, by Lucas Cranach the Elder. Uffizi, Florence; New Int'l Illus. *Encyclo.* (see German).

2452 The legend of St. George (in center panel, he kills the dragon while the princess kneels with a lamb; the scene is flanked by four panels depicting the martyrdoms of St. George, separated by an elaborate architectural frame), by the School of Lancelot Blondel, c. 1535–40. Bruges, State Museum; Pauwels, *Musée Groeninge.*

2453 St. George (standing in plate armor, holding a banner, his right foot on the dragon's head), by Bastarolo, c. 1538. Ferrara, Chiesa di S. Gerolamo; Frabetti, *Manieristi.*

2454 St. George and the dragon (as God's hand descends from the upper left corner, George kills the dragon with a spear through its head, while the princess stands at the city gate, holding its leash; people look on from the walls), tempera on wood icon by Vologada, 16th cent. State Russian Museum, St. Petersburg.

2455 St. George and the dragon (he leans from his rearing horse), pen and ink drawing by Paolo Veronese, 1550. Florence, Gabinetto Disegni e Stampe; Rearick, *Veronese.*

2456 St. George killing the (winged, snake-like) dragon, 16th cent. icon. Guslitski Monastery Restoration Workshop, Moscow; Munro, *Golden Encyclo.* (p.68).

2457 St. Michael the Archangel holds a scale for "The Weighing of a Soul" while on his right St. George conquers a dragon and St. John the Baptist holds the lamb of God, by South German school, 16th cent. Fogg Art Museum, Cambridge MA; *Collection.*

2458 St. George and the dragon (before a walled city; a dead man lies in the lower left corner), by Jacopo Tintoretto. Hermitage, St. Petersburg; Eisler, *Hermitage.*

2459 St. George and the dragon (it already has a broken lance in its neck, while he attacks it with a sword), by Paris Bordone. Vatican Museums; Francia, *Vaticana.*

2460 St. George and the dragon (killing dragon over body of a dead man, as princess—wearing blue dress and billowing red cloak—flees the scene) by Jacopo Tintoretto, c. 1558. Nat'l Gallery, London; Gowing, *Biog. Dict.*; Hogarth, *Dragons* (p.174); Tietze, *Tintoretto*; *Tietze, Tintoretto*; Valcanover, *Tintoretto*; Wilson, *Nat'l Gallery.*

2461 St. George (about to strike the dragon, as his horse rears over the body of a man who has been stripped to the bones), by Giorgio Vasari. Arezzo, Badia of SS. Fiore e Lucilla; Boase, *Vasari* (pl.110).

2462 Martyrdom of St. George (he looks up at the saints in heaven as executioners tie his hands), by Paolo Veronese. Verona, S. Giorgio in Velabro; Huse, *Venice.*

2463 Martyrdom of St. George (they try to get him to pray to an idol while he kneels, submitting to their abuse, looking to the saints in heaven), by Paolo Veronese, 1566. Verona, S. Giorgio in Braida; Burckhardt, *Altarpiece.*

2464 Martyrdom of St. George (he kneels, while an executioner raises his

sword, as many look on), central panel of a triptych by Francois Pourbus the younger, 1577 (destroyed by fire, 1940). Dunkirk, Musées des B/A; Huvenne, *Pourbus*.

2465 St. George and the (snake-like) dragon, by the Greco-Venetian school, late 16th cent. Christ Church, Oxford; Shaw, *Old Masters*.

2466 Martyrdom of St. George (tied to a wheel, about to be clamped between boards studded with iron teeth), by Michel Coxcie, 1587. Malines, St. Rombaud; Bosque, *Mythologie*.

2467 St. George (sitting astride his horse, thanking God for his victory over the dragon), by Cesare Rossetti. Walters Art Gallery, Baltimore; *Italian Paintings* (Vol.II).

2468 St. George and St. Catherine led to martyrdom (she sits on the ground as he is led past the wheel, looking back at her), by Ludovico Carracci. Reggio Emilia, Church of the Ghiara; Freedberg, *Circa 1600*.

2469 St. George killing the dragon (dragon tries to extricate a broken lance from its mouth, while George brandishes a dagger), by P.P. Rubens, 1606. Prado, Madrid; *Guide to Prado*; Jaffé, *Rubens and Italy*; *La Peinture Flamande*.

2470 St. George and the dragon (his horse rears above a griffin-like dragon), bronze statuette by C. Benati, early 17th cent. Rochester Memorial Art Gallery, NY; *Handbook*.

2471 Landscape with St. George killing the dragon (princess runs away), att. to Domenichino. Nat'l Gallery, London; Spear, *Domenichino*.

2472 St. George (half view, holding a pennon wrapped around its staff), by Anthony van Dyck, c. 1615-16. Private Coll., England; Larsen, *Van Dyck* (pl.42).

2473 St. Sebastian (nude, holding a quiver of arrows) and St. George (in armor, talking to him, standing on a dragon), in "Virgin and Child Adored by Saints" altarpiece by P.P. Rubens, 1628. Antwerp, St. Augustine; Baudouin, *Rubens*.

2474 St. Sebastian (nude, holding a quiver of arrows) and St. George (in armor), oil sketch, study for "Virgin and Child adored by Saints" altarpiece in Antwerp, by P.P. Rubens, 1628. Caen, Musée des B/A; Baudouin, *Rubens*; Held, *Oil Sketches*; White, *Rubens*.

2475 St. George and the dragon (he hands the princess the leash, as several peasants look on, and two servants on horses wait; the horses stare in fright at decomposing bodies), by P.P. Rubens, 1629-30. Royal Coll., England; White, *Rubens*.

2476 St. George liberating the princess (she stands next to him in a brocaded dress, and he sits on his horse in armor, looking down at her), att. to Filippo Angeli. Vassar College Art Gallery, NY; *Paintings, 1300-1900*.

2477 Martyrdom of St. George (angels light him from above, startling the executioners) by Corneille Schut, 1643. Koninklijk Museum, Antwerp; Hairs, *Sillage de Rubens*; Larsen, *17th Cent. Flem.*

2478 St. George and the dragon (in a landscape), by Claude Lorrain, 1646. Wadsworth Atheneum, Hartford CT; *Handbook*.

2479 St. George (half-portrait, right hand on his chest), att. to Francesco Guarino, late 1640's. Banco di Napoli, Capodimonte; RA, *Painting in Naples*.

2480 St. George slaying the dragon (while the king inside a building holds the dragon's leash), Northern-style icon, 17th cent. Hermitage, St. Petersburg; Piotrovsky, *Hermitage*.

2481 St. George killing the dragon (before a pink castle full of witnesses), icon from end of 17th cent. Bucharest, Museum of Rumanian Art; Knopf, *The Icon* (p.408).

2482 Saint George on horseback with scenes from his life (horse's tail is tied in a knot; a tiny figure sits on horse's haunches), from the Church of the Holy Virgin, Veliko Turnovo, by Yoan of Chevindol, 1684. Bulgaria, National Art Gallery; Paskaleva, *Bulgarian Icons*.

2483 Icon of St. George killing the dragon, anon., late 17th-early 18th cent. Bulgaria, Arbanási Church; New Int'l Illus. *Encyclo.* (see Icon).

2484 St. George and the dragon (George is about to plunge a lance into the dragon's mouth), by Jacob Van Oost the Younger. Bruges, State Museum; Pauwels, *Musée Groeninge*.

2485 St. George, killing the dragon with a flamberge sword, silver statue by Egid Quirin Asam, 1735-36. Weltenburg Cloister Church; Bazin, *Loom of Art* (pl.327); Gowing, *Hist. of Art* (p.717); Held, *17th & 18th Cent.*

2486 St. George (with a leopard skin tied to his horse) killing the dragon, by Carle van Loo, c. 1741. Dijon, Musée des B/A; Georgel, *Musée des B/A*.

2487 St. George destroying the dragon (holding his shield between himself and the dragon, he prepares to throw his spear; the dragon has encircled the princess with its tail), by Benjamin West, 1786. Reading Public Museum and Art Gallery, PA; von Erffa, *West*.

2488 St. George with scenes from his life (killing the dragon, saving the king's daughter), by Dimiter Kunchov, 1838. Veliko Turnovo, District History Museum; Paskaleva, *Bulgarian Icons*.

2489 St. George (killing the dragon, as the princess watches, chained to the rock), by Eugène Delacroix. Grenoble, Musée de Peinture et de Sculpture; Lemoine, *Musée*.

2490 St. George and the princess (they embrace), water-color by Dante Gabriel Rossetti, 1857. Tate Gallery, London; Levey, *Giotto to Cézanne*; Maas, *Victorian*; Murray, *Art & Artists*.

2491 The wedding of St. George (he and the princess sit in the middle, flanked by her parents and two trumpeters), watercolor by Dante Gabriel Rossetti, 1864. Coll. Jerrold N. Moore; Maas, *Victorian*.

2492 St. George (in a plumed helmet, killing the dragon), by Hans von Marées, 1885–87. Neue Pinakothek, Munich; Lenz, *Neue Pinakothek*.

See also 100, 338, 1240, 1384, 1397, 1416, 1434, 1651, 1987, 2531, 3393, 3427, 3680, 3701, 4629, 4633, 4636, 4908

Gerard of Brogne, monastic reformer, d. 959 (Oct. 3)
2493 St. Gerard of Brogne (in armor, holding a model of a church), stone statue, early 16th cent. Walcourt, St. Materne; *Benedict* (p.331).

Gerebernus, seventh century martyr; decapitated (May 15)
See also 1759

Gereon, martyred with his 318 companions by Maximian (Oct. 10)
2494 St. Gereon and his companions, wing of the Altarpiece of the Patrons of the city of Ratskopene, by Stephen Lochner, 1440–50. Cologne Cathedral; Keller, *20 Centuries*.

See also 3726

Germain *see* **Germanus**

Germain Cousin of Pibrac, shepherdess, d. 1601 (June 15)
2495 St. Germain Cousin of Pibrac (as a shepherdess), by Jean-Auguste-Dominique Ingres, 1856. Sapiac Church, Fabourg de Montauban; Wildenstein, *Ingres*.
See also 2337

Germanus or Germain, abbot of St. Symphorian, bishop of Paris, d. 576 (May 28)
2496 St. Germain (or Germanus), in ecclesiastic robes, marble sculpture, 14th cent. Huy, Saint-Germain; *Tresors*.
2497 St. Germanus, round French enamel, c. 1400. BM, London; Coulson, *Saints*.
See also 3504

Germinianus
2498 Saints Germinianus and Francis of Assisi (holding a model of a church), by Giovanni da Ponte. Philadelphia Museum of Art, PA.
2499 Saints Germinianus and Severus (both as bishops, reading from a book held by a boy standing between them), by Paolo Veronese, 1560. Estense Gallery, Modena; Rearick, *Veronese*.

Gertrude, of Nivelles, patroness of travelers and the harvest, d. 659 (Mar. 17)
2500 St. Gertrude of Nivelles reading a book with a mouse at her feet, from "The Virgin and Child with Saints" polyptych by Master of the Legend of St. Lucy. Tallinn Art Museum; Nikulin, *Soviet Museums*.
2501 St. Gertrude (standing with a staff, reading), oak statue, end of 15th cent. Etterbeek, St. Gertrude; *Benedict* (p.330).
2502 St. Gertrude de Nivelles (in nun's habit, holding a staff up which rats are climbing), drawing by Abraham Van Diepenbeeck. Courtauld Inst. of Art, London; Hairs, *Sillage de Rubens*.
2503 St. Gertrude professing her faith before a judge, by Ubaldini, c. 1665. Rome, S. Nicola da Tolentino; Waterhouse, *Roman Baroque*.
2504 St. Gertrude (holding a staff statue by Jacinto Vieira, 1723–25.)

Arouca, Monastery; Larousse, *Ren. & Baroque* (pl.1085).
See also 3697

Gervasius and Protasius, Roman knights, twin brothers, patrons of Milan; beheaded; mid-first cent. (June 10)
2505 Mosaic medallions of SS. Gervasius and Protasius, 12th cent. Palermo, Cappella Palatina; Kaftal, *Central and So. Ital.*
2506 SS. Gervasius and Protasius (holding palms), from a triptych by Angelo Puccinelli, 1350. Lucca, Pinacoteca; Kaftal, *Tuscan.*
2507 St. Gervasius exorcizing a demon from a schackled woman; St. Protasius curing a man with a humpback, limestone sculptures, Northern French, 1490–1500. Walters Art Gallery, Baltimore.
2508 SS. Gervasius and Protasius brought before Astasius (they are escorted by a crowd of soldiers), by Eustace Le Sueur, 1645–50. Louvre, Paris; Mérot, *Le Sueur.*
2509 The flagellation of St. Gervasius (he is laid across a low table, while torturers whip him), by Eustace Le Sueur, 1645–50. Lyon, Musée des B/A; Mérot, *Le Sueur.*
2510 Invention of the relics of SS. Gervasius and Protasius (as a large crowd and bishops look on, they raise the two bodies with a large windlass; one of the saints' heads is lying on his belly), by Philippe de Champagne, 1657. Lyon, Musée des B/A; Durey, *Musée.*
See also 3514, 4080

Giles, Benedictine abbot, patron of Montalcino, patron of cripples, beggars, and blacksmiths, invoked against epilepsy, insanity, sterility, and demonic possession; d. 725 (Sept. 1)
2511 Miracle of St. Giles (gives a beggar his garment), fresco from Church of Saint-Aignan-sur-Cher, late 12th cent. Paris, Musée des Monuments Francais; Boucher, *20,000 Years* (304).
2512 St. Giles (in monk's robes, holding a book), from a triptych by Segna di Buonaventura. Montalcino, Conservatorio; Kaftal, *Tuscan.*
2513 St. Giles and the miracle of the hind (St. Giles deflects a hunter's arrow into his own chest, to save a hind which has been feeding him milk), by Thomas de Coloswar, 1427. Esztergom Christian

Museum; *Christian Art in Hungary.*
2514 Scenes from the life of St. Giles: he exorcises a possessed man; he receives his habit from St. Verecundius; a doe takes refuge from the hunt in his cave; one of the king's men shoots Giles with an arrow instead of the doe; Charles Martell writes his sins on a scroll, which is carried off by an angel during mass; from an altarpiece by the School of Lorenzo da Viterbo. Orte, Cathedral; Kaftal, *Central and So. Ital.*
2515 Scenes from the life of St. Giles: he saves a ship in distress; he cures cripples who visit him; he saves the doe from the hunters, who shoot him instead; from a polyptych by Master of Staffolo. Staffolo, S. Francesco; Kaftal, *Central and So. Ital.*
2516 Scenes from the life of St. Giles: his mother finds his cradle empty; he is carried through the woods by two devils; he is suckled by a doe; he gives his cloak to a beggar; he distributes his wordly goods to the poor; from an altarpiece by the School of Lorenzo da Viterbo. Orte, Cathedral; Kaftal, *Central and So. Ital.*
2517 St. Giles (in monk's robes, holding a book and an arrow), from an altarpiece by the school of Lorenzo da Viterbo. Orte, Cathedral; Kaftal, *Central and So. Ital.*
2518 St. Giles protecting the hind from the hunters of Charlemagne, by Master of St. Giles, c. 1480–90. Nat'l Gallery, London; Châtelet, *French Painting*; Levey, *Nat'l Gallery*; Snyder, *Northern Ren.*
2519 The mass of St. Giles (an angel holding a scroll hovers in upper left corner), by the Master of St. Giles, c. 1480–90. Nat'l Gallery, London; Coulson, *Saints*; Dunkerton, *Giotto to Dürer*; Gaunt, *Pictorial Art*; McGraw, *Encyclo.* (Vol.V, pl.386); Murray, *Art & Artists*; Snyder, *Northern Ren.*
See also 1384, 4813, 4901

Giles of Rome or Egidius, Archbishop of Bourges, General of the Augustinian Order, d. 1316 (Dec. 22)
2520 St. Egidius enthroned (with angels), illum. from a Missal, Inv. 557, fo.35v by Bartolomeo di Frusiono. San Marco Museum, Florence; Eisenberg, *Monaco* (pl.248); Salmi, *Ital. Miniatures.*
2521 St. Giles (in bishop's robes, holding a crosier and a book), from a polyptych by the Master of Staffolo.

Staffolo, S. Francesco; Kaftal, *Central and So. Ital.*
2522 St. Giles of Rome (in bishop's regalia, holding a crosier and an open book), detached fresco by the Lombard School, 15th cent. Vercelli, Museo Borgogna; Kaftal, *North West Italy.*

Gimignano
2523 St. Gimignano enthroned with angels, by Niccoló Tegliacci from a Gradual, ms.Cor. LXVIII, I, fo.22. San Gimignano, Museo Civico; Salmi, *Ital. Miniatures.*

Giovanni Gualberto *see* **John Gualbertus**

Giovita *see* **Faust and Giovita**

Giuliana or Juliana, Virgin martyr; struggled with the devil in prison; mart. 4th cent. (Feb. 16)
2524 St. Giuliana as protector of Benedictine nuns (the nuns are kneeling under her mantle, as she towers over them), by an unknown Umbrian painter, c. 1376. Perugia, Galleria Nazionale dell'Umbria; Van Os, *Sienese Altarpieces* (Vol.II, pl.38).
2525 St. Giuliana Polyptych, with Madonna and Child enthroned, with SS. Benedict and John the Baptist at the left, and SS. Giuliana and Bernard at the right, by Domenico di Bartolo, 1438. Perugia, Galleria Nazionale dell'Umbria; Van Os, *Sienese Altarpieces* (Vol.II, pl.37).
2526 Martyrdom of St. Giuliana (she is hung by her hair, hands tied, while executioners beat her and pour hot lead on her), by an unknown Umbrian painter, 15th cent. Perugia, Galleria Nazionale dell'Umbria; Van Os, *Sienese Altarpieces* (Vol.II, pl.38).

Giustina *see* **Justina**

Gleb *see* **Boris and Gleb**

Glisente, Knight of Charlemagne, later hermit, d. 796 (Aug. 6)
2527 St. Glisente (standing, in noble dress, a ewe at his feet), fresco by the Lombard School, 15th cent. Berzo Inferiore, S. Lorenzo; Kaftal, *North West Italy.*
2528 St. Glisente, hermit, milking a doe, while a bear brings him berries; Glisente

prays before a chapel, while a dove approaches carrying a leaf; fresco by the Lombard School, 15th cent. Berzo Inferiore, S. Lorenzo; Kaftal, *North West Italy.*

Godelieve or Godelva of Ghistelles, strangled to death by her husband's servants, k.1070 (July 6)
2529 St. Godelieve (with a scarf tied around her neck) with a kneeling female donor, with scenes from the legend of St. Godelieve de Ghistelles in the background, by Jan Provost, c. 1521. Bruges, State Museum; Pauwels, *Musée Groeninge.*
2530 Martyrdom of St. Godelva (two men strangle her with a scarf; at left, a nun kneels at a table with a coat of arms hanging on its side), anon., 1537. Louvain, St. Pierre; Bentley, *Calendar.*

Gothard
2531 St. Gothard (writing at his desk); SS. Seconda and Calocerus (being decapitated); St. George (about to be decapitated); St. Vitalis (being thrown into a hole); St. Walpurgis (holding a twig); St. Sigismund (decapitated in a well); St. Alexander I (tied to a pillar and whipped); woodcuts by Günther Zainer from "Leben der Heiligen, Sommerteil," Augsburg, 1472. The Illus. Bartsch; *German Book Illus.* (Vol.80, pp.82–83).

Grata of Bergamo, Virgin, companion of St. Adelaide, c. 300 (Sept. 4)
2532 Madonna and Child enthroned, flanked by SS. Apollonia, Augustine, and Catherine at left, and SS. Joseph, Grata, Philip Benizi, and Barbara at right, by Giovanni Cariani, 1517–19. Brera, Milan; Pallucchini, *Cariani.*
2533 The saints of the Gratta Family: St. Grata converts her father, Doge of Bergamo, by showing him the head of St. Alexander (dripping blood which turns into flowers), by Giovanni Battista Tiepolo. Städelsches Kunstinstitut, Frankfort; Praeger, *Great Galleries.*

Gratus, Bishop and patron of Aosta, protector against lightning, hail, and mice, d. 5th cent. (Sept. 7)
2534 St. Gratus holding the head of John the Baptist, panel of a polyptych att. to Giacomo Durandi. Masséna Museum, Nice; Kaftal, *North West Italy.*
2535 Scenes from the life of St.

Gratus: SS. Gratus and Jucundus travel to the Holy Land; Gratus pulls John's head from the well; they travel back to Rome, and the pope gives Gratus the jaw of the Baptist; the two saints present the relic to the canons at Aosta; frescoes by the Piedmontese school, 1460. Masséna Museum, Nice; Kaftal, *North West Italy.* *See also* 3179

Gregory I, Pope "The Great," one of the four Latin Fathers of the Church, d. 604 (Mar. 12)
2536 Gregory the Great, from Sacramentary of Charles the Bald, by the court School of Charles the Bald, St. Denis, MS Lat. 1141, fo.3, c. 860. BN, Paris; Hollander, *Early Medieval Art*; Snyder, *Medieval.*
2537 Gregory the Great dictating to a monk, from "Registrum Gregorii," Trier, MS 1171/626, c. 983. Trier, Stadtbibliothek; De Hamel, *Illum. Ms.*; Hollander, *Early Medieval Art.*
2538 Inspiration of Pope Gregory the Great, ivory book cover, end of 10th cent. KM, Vienna; De Hamel, *Illum. Ms.*; Hollander, *Early Medieval Art.*
2539 St. Gregory the Great, ms. illum. from "Letters of St. Gregory" from St. Martin's Abbey, Tournai, MS Latin 2288, fo.1, c. 1150. BN, Paris; Pernoud, *Peuple*; Zarnecki, George, *Romanesque Art*, Universe Books, New York, 1971.
2540 St. Gregory enthroned, holding an open book, author page of the "Letters of St. Gregory" from Saint-Amand-en-Pevèle, ms. lat. 2287, fo.1v, second half of 12th cent. BN, Paris; McGraw, *Encyclo.* (Vol.XII, pl.218).
2541 St. Gregory (with the Holy Ghost on his shoulder); St. Benedict's youth, from "Vita Sancti Benedicti," ms.55, ff.iv-2, 14th cent. Pierpont Morgan Library, NY; Harrsen, *Central European.*
2542 St. Gregory the Great, min. on a sheet of music, "L'Antiphonaire" for the consecration of the church of Vauclair, ms.240. Laon, Biblio. Municipale; Eydoux, *St. Louis.*
2543 Madonna and Child, flanked by SS. Gregory I (with a dove speaking in his ear) and Job, triptych by a follower of Nardo di Cione. Santa Croce, Florence; Offner, *Corpus* (Sect.IV, Vol.II, pl.XXVII).
2544 Gregory the Great and the miraculous apparition of the angel on the

mausoleum of Hadrian (hence called the Castel Sant'Angelo), painting by Giovanni di Paolo, Sienese School, 15th cent. Louvre, Paris; Boudet, *Rome.*
2545 Mass of St. Gregory, copy after Master of Flémalle. Coll. E. Schwarz, New York; Panofsky, *Early Nether.*
2546 St. Gregory I refuses the papacy (as he sits outside of city walls), panel by a follower of Fra Angelico. Philadelphia Museum of Art; Kaftal, *Tuscan.*
2547 St. Gregory I stops the plague at Castel Sant'Angelo (as a crowd kneels before the city, St. Michael appears on the summit), predella panel by Agnolo Gaddi. Vatican; Kaftal, *Tuscan.*
2548 St. Gregory (sitting at table) dictating to a monk, from "Grandes Heures" ms. lat. 919, fo.100, c. 1409. BN, Paris; Meiss, *French Painting*; Panofsky, *Early Nether.*
2549 St. Gregory listening to monks, while putting together his Life of St. Benedict, from "Miracles de Saint Benoît par St. Grégoire, Adrevaldus et Aimoin," ms. 1401, c. 1437. Condé Museum, Chantilly; Batselier, *St. Benedict* (p.15).
2550 The mass of St. Gregory (Christ comes out of his tomb, hands tied) by school of Fernando Callego, c. 1480. Fitzwilliam Museum, Cambridge; Catalogue, *Dutch.*
2551 SS. Mark (writing) and Gregory I (sitting at a table, with an attendant washing his feet), vault fresco by Bonifacio Bembo, 1450. Cremona, S. Agostino; Kaftal, *North West Italy.*
2552 St. Gregory the Great, by Justus Van Ghent. Barberini Palace, Rome; Brusher, *Popes thru the Ages.*
2553 Jean le Meingre witnesses the vision of St. Gregory, from the "Boucicaut Hours," ms.2,fo.241, third quarter of 15th cent. Jacquemart-André Museum, Paris; Meiss, *French Painting.*
2554 St. Gregory the Great reading a green book, from polyptych by Antonello da Messina. Palermo, Galleria Nazionale; Coulson, *Saints.*
2555 The miracle of Castel Sant'Angelo (procession carrying gilded effigy enters castle, as angel appears on battlements), by anon. Argonese Spanish artist, 1450-1500. Philadelphia Museum of Art, PA.
2556 St. Gregory I, in papal tiara, holding a book, panel from the Famous Men series commissioned by Federigo da

Montefeltro and painted by Justus van Ghent, 1473-74. Urbino, Galleria Nazionale delle Marche; United Nations, *Dismembered Works.*

2557 St. Gregory (with a half-nude king standing in a fire-pit), from "The Four Latin Fathers" altarpiece by Michael Pacher, c. 1483. Alte Pinakothek, Munich; Bentley, *Calendar*; Janson, *Picture History*; Janson, *History of Art* (pl.568); McGraw, *Dict.*; Piper, *Illus. Dict.* (p.87).

2558 Mass of St. Gregory (Christ rises from the altar, with his crucifix, flail, spear, and other attributes), ms. illum. by the Master of Mary of Burgundy, ms. II 3634-6. Biblio. Royale, Brussels; Dogaer, *Flemish Min.*

2559 Pope Gregory the Great in procession against the plague in Rome in 590, min. from "Tres Riches Heures du Duc de Berry" by Jean Colombe, MS 65, fo. 71v, c. 1488-90. Condé Museum, Chantilly; Evans, *Flowering of M.A.*

2560 Julius II depicted beardless as Gregory the Great, in Raphael's "Disputa dei Sacramento" fresco in the Stanza della Segnatura. Vatican; De Campos, *Vatican.*

2561 The St. Gregory Mass (Christ appears on the altar), by Master of the Holy Sippe, end of 15th cent. Aartsbisschoppelijk Museum, Utrecht; Van Braam, *Benelux.*

2562 Dinner in the house of St. Gregory the Great (with Pope Clement VII), by Giorgio Vasari, early 16th cent. Bologna, Pinacoteca Nazionale; Cox-Rearick, *Dynasty*; New Int'l Illus. *Encyclo.*

2563 Mass of St. Gregory (the angels pull away the drape covering the tabernacle, to reveal Christ standing before the Cross), left-hand outside shutter of the Aachen Altarpiece by the Master of the Aachen Altarpiece, c. 1500. Nat'l Gallery, London; Dunkerton, *Giotto to Dürer.*

2564 St. Gregory holding a book and crosier, from a roodscreen. Exeter, St. Mary Steps Church; Drake, *Saints and Emblems.*

2565 Mass of St. Gregory (Christ sits on his sarcophagus, feet bleeding onto the altarcloth), by Hans Baldung Grien, c. 1511. Cleveland Museum of Art, OH; *European 16th-18th Cent.; Selected Works.*

2566 Mass of St. Gregory (Christ, sitting on the altar, leans toward Gregory),

woodcut from the series "Hortulus animae" by Hans Baldung Grien. BS, Munich; Cleveland Museum of Art, *European 16th-18th Cent.*

2567 Mass of St. Gregory (Jesus rises from the altar), woodcut by Albrecht Dürer, Brunswick, 1511. Geisberg, *Single Leaf*; Strauss, *Woodcuts* (pl.160).

2568 Mass of St. Gregory (while he raises the host, two angels help the crucified Christ up from a sarcophagus on the altar), illum. by Jean Bourdichon from the Great Book of Hours of Henry VIII, 1514-18. Coll. Duke of Cumberland; *Great Hours.*

2569 Mass of St. Gregory (attended by several other saints), by unknown 16th cent. artist. Wildenstein & Co., London; Bosque, *Metsys.*

2570 Mass of St. Gregory (little Jesus stands on the altar), by an unknown 16th cent. Holland artist. Utrecht Museum; Bosque, *Metsys.*

2571 The mass of St. Gregory (Christ steps onto the altar as he prays) by Adriaen Isenbrandt. Prado, Madrid; *Peinture Flamande* (b/w pl.156).

2572 Mass of St. Gregory (at mass as Christ rises from a coffin), by Adriaen Isenbrandt. J. Paul Getty Museum, Malibu CA; *Catalogue; Western European.*

2573 Mass of St. Gregory (Christ sits on his sarcophagus, spurting blood into the chalice from his palms), by an unknown northern European artist, 16th cent. Joslyn Art Museum; *Paintings & Sculpture.*

2574 St. Gregory (standing on a cloud, looking over his left shoulder), by Martin Freminet. Orléans, Musée des B/A; O'Neill, *L'Ecole Francaise.*

2575 St. Gregory the Great and other saints worshipping the Madonna, by P.P. Rubens, c. 1607-08. Grenoble, Musée de Peinture et de Sculpture; Baudouin, *Rubens*; Jaffé, *Rubens and Italy*; Larsen, *17th Cent. Flemish*; Lemoine, *Musée*; Mauritshuis, *Royal Pict. Gall.*; White, *Rubens.*

2576 St. Gregory the Great (enthroned, viewed from below), oil sketch by P.P. Rubens. Coll. Count Antoine Seilern, London; Held, *Oil Sketches* (pl.36).

2577 St. Gregory and the miracle of the corporal, by Sacchi, 1625-27. Vatican, Canonica di S. Pietro; Waterhouse, *Roman Baroque.*

2578 St. Gregory (in papal robes,

standing and reading), by Francisco de Zurbaran, 1626-27. Seville, Museum of Fine Arts; Gállego, *Zurbaran.*

2579 St. Gregory the Great (sitting, reading) by Jacopo Vignali. Walters Art Gallery, Baltimore.

2580 St. Gregory the Great (sitting at his desk, looking up at a dove), by Lubin Baugin. Orléans, Musée des B/A; O'Neill, *L'Ecole Francaise.*

2581 St. Gregory I, polychromed wooden statue by Janjŕé Bendl, 1655. Prague, Municipal Museum; National Gallery, *Baroque.*

2582 St. Gregory I (in papal regalia, holding an open book, looking upward over his left shoulder), marble sculpture by Johann Mauritz Gröninger. Münster, St. Martini; *800 Jahre.*

2583 St. Gregory (sitting at a table with his arm on a large open book, holding out a pen; the Holy Spirit approaches his ear), by an unknown Italian artist, late 17th-early 18th cent. Bob Jones Univ. Art Gallery, Greenville, SC; Pepper, *Ital. Paintings.*

2584 St. Gregory the Great invoking the Virgin to liberate Rome from the plague, by Sebastiano Ricci, 1700. Padua, Santa Giustina; Daniels, *Ricci.*

2585 Death of St. Gregory the Great, by Michele Rocca. Walters Art Gallery, Baltimore; *Italian Paintings* (Vol.II).

2586 St. Gregory the Great releasing a soul from purgatory (celestial light glows from his host, as a soul is lifted up in background), by Michele Rocca. Walters Art Gallery, Baltimore; *Italian Paintings* (Vol.II).

2587 The intercession of St. Gregory for the souls in purgatory, by Sebastiano Ricci, 1730-31. Picture Gallery, Berlin; *Catalogue.*

2588 St. Gregory (sitting in ecclesiastic robes, writing in a book), by Goya, 1781-85. Romantico Museum, Madrid; Cleveland Museum of Art, *European 16th-18th Cent.*

See also 137, 138, 139, 144, 167, 458, 657, 1724, 1725, 1968, 2328, 2658, 3116, 3123, 3503, 3685, 3742, 3909, 3910, 4089, 4862

Gregory II Pope, r. 715-731 (Feb. 13)
2589 St. Gregory II, holding a book and cross, by Master of the Liesborn School of Westphalia. Nat'l Gallery, London; Brusher, *Popes.*

Gregory VII, of Salerno, Pope (Hildebrand), r. 1073-85 (May 25)
2590 Gregory VII driven from Rome, from "Chronik der Otto von Freising," MS Bos. 9.6, fol.79r. Jena, Universitätsbibliothek; Horizon, *Middle Ages*; Smalley, *Historians.*

2591 Meeting between Duchess Mathilde and Pope Gregory VII, fresco by Giovanni Francesco Romanelli in the Sala Della Contessa Matilde. Rome; De Campos, *Vatican.*

2592 St. Gregory VII pardons the excommunicated Emperor Henry IV at Canossa in the presence of St. Hugo, abbot of Cluny, and the Countess Matilda, fresco by the Zuccari brothers in the Sala Regia, 16th cent. Vatican Museums; Boudet, *Rome*; Brusher, *Popes*; John, *Popes.*

Gregory Nazianzen, "the Theologian," briefly Bishop of Constantinople, d. 390 (May 9)
2593 Gregory Nazianzen, mosaic, 1148. Duomo, Cefalù, Sicily; Coulson, *Saints.*

2594 St. Basil the Great, St. Paraskeva, St. Gregory Nazianzen and St. John Chrysostom, in "Four Saints" painting by school of Pskov, 14th cent. Tretyakov Gallery, Moscow; McGraw, *Russia.*

2595 St. Gregory Nazianzen, holding a scroll, from a reliquary by Antonio Vivarini and Giovanni d'Alemagna, 1443. Venice, S. Zaccaria; Kaftal, *North East Italy.*

2596 St. Gregory Nazianzen, pointing up, fresco by Domenichino, 1608-10. Grottaferrata Abbey; Spear, *Domenichino.*

2597 St. Gregory of Nazianzus, driving his crosier through a demon's eye, oil sketch by P.P. Rubens, 1620-21. Albright-Knox Art Gallery, Buffalo; Baudouin, *Rubens*; Held, *Oil Sketches* (pl.37); White, *Rubens.*

Gregory of Armenia, "The Illuminator," Bishop, first Patriarch of Armemia, d. 331 (Sept. 30)
2598 A miracle of St. Gregory of Armenia (King Tiridates, turned into a bull, comes to St. Gregory for help), by Francesco Francanzano, 1635. Naples, S. Gregorio Armeno; RA, *Painting in Naples.*

2599 St. Gregory of Armenia thrown

into the well (full of wild beasts) by order of King Tiridates, by Francesco Francanzano, 1635. Naples, S. Gregorio Armeno; RA, *Painting in Naples.*

Gregory of Nyssa, bishop of Nyssa, d. 395 (Mar. 9)
2600 St. Gregory of Nyssa, holding a book and a crosier, by Domenichino, 1608-10. Grottaferrata Abbey; Spear, *Domenichino.*

Gregory Palamas, Archbishop of Thessalonica, canon. 1363
2601 Icon of St. Gregory Palamas (holding a book), late 14th-early 15th cent. Pushkin Museum, Moscow; Bank, *Byzantine* (pl.319).

Gregory Thaumaturgos
2602 Icon of St. Gregory the Thaumaturgist (bearded, holding a book), second half of 12th cent. Hermitage, St. Petersburg; Bank, *Byzantine* (pl.236); McGraw, *Encyclo.* (Vol.II, pl.461).

Guido *see* **Guy**

Guiliana of Collalto, founder of Monastery of Giudecca, Venice
2603 Stories in the life of St. Guiliana of Collalto, four panels from a polyptych by an unknown master of the Venetian School, 14th cent. Hermitage, St. Petersburg; Piotrovsky, *Hermitage.*

Guthlac, English hermit monk, d. 714 (Apr. 11)
2604 Guthlac receives the tonsure, from "Life of St. Guthlac," c. 1200. BM, London; Rickert, *Painting in Britain.*

Guy or Guido, Benedictine monk, abbot of Pomposa, d. 1046 (Mar. 31)
2605 St. Guy (standing in monk's robes, holding an open book and a crozier), fresco by the Riminese School, 1300-50. Pomposa, Abbey; Kaftal, *North East Italy.*
2606 St. Guy turns water into wine (while dining with Gherardus, archbishop of Ravenna), fresco by the Riminese School, 1300-50. Pomposa, Abbey; Kaftal, *North East Italy.*

Hadrian *see* **Adrian**

Hadrianus *see* **Adrian**

Helena, empress, mother of Constantine, discovered the true cross; d. 330 (Aug. 18)
2607 The emperor Constantine and his mother, Saint Helena, Byzantine ms. illum., 11th cent. Palatine Library, Parma; New Int'l Illus. *Encyclo.*
2608 St. Helena (seated) and Judas Cyriacus, from the Berthold Missal, ms. 710, fo.89, c. 1200-35. Pierpont Morgan Library, NY; Swarzensski, *Berthold Missal* (pl.XX).
2609 St. Helena (standing with the cross, wearing a crown), fresco by an unknown 13th cent. artist. Milan, San Lorenzo; Fiorio, *Le Chiese di Milano.*
2610 Helena restoring the cross to Jerusalem, fresco by Agnolo Gaddi. Santa Croce, Florence; Verdon, *Christianity.*
2611 The discovery and proof of the cross (as St. Helena looks on), fresco by Agnolo Gaddi. Santa Croce, Florence; Kaftal, *Tuscan*; Lavin, *Narrative*; Verdon, *Christianity.*
2612 Scenes from the legend of the true cross (St. Helena points out the place where the crosses can be found; at right, the cross restores a dead woman to life), tapestry, c. 1430-40. Germanisches Nationalmuseum, Nuremberg; Met Museum, *Gothic Art.*
2613 St. Helena finds the true cross (Judas the Jew points out the place where the men must dig; they pull three crosses from the ground), fresco by Marco Palmezzano. Rome, S. Croce in Gerusalemme; Kaftal, *North East Italy.*
2614 St. Sylvester and his priests dispute with St. Helena and her Jewish rabbis; from an altarpiece by the School of the Abrizzi, 15th cent. Mutignano, S. Silvestro; Kaftal, *Central & So. Ital.* (fig. 1207).
2615 Scene from the life of St. Helena: the Jew Judas, having agreed to find the cross, is raised from the cistern (he is pulled up with a hoist), fresco by Piero della Francesca, 1452-66. Arezzo, S. Francesco; Janson, *History of Art* (pl. 609); Kaftal, *Tuscan.*
2616 Discovery of the true cross (St. Helena kneels, accompanied by several women); invention of the true cross (St. Helena directs the workmen, who unearth the crosses); frescoes by Piero della Francesca, 1453-54. San Francesco, Arezzo; Hartt, *Ital. Ren.*; Janson,

History of Art (pl.609); Lassaigne, *Fifteenth Cent.*
2617 Recognition of the true cross, fresco by Piero della Francesca, 1453–54. San Francesco, Arezzo; Hartt, *Ital. Ren.*; Janson, *History* (colorpl.53).
2618 St. Helena watches as a Jew lays each of the three crosses atop a crippled woman to see which was Christ's cross, by the Ferrarese School, 15th cent. Ehrich Galleries; De Bles, *Saints in Art.*
2619 Scenes from the life of St. Helena: she commands the Jew Judas to find the Cross; when he refuses, she threatens him with the stake; Helena orders Judas to be imprisoned in a dry cistern; the invention of the cross; the true cross raises a corpse while on his death bed; Judas brings the cross to Helena; panels from a relic cupboard by the School of the Lorenzetti. Siena, Opera del Duomo; Kaftal, *Tuscan.*
2620 St. Helena, in a hilly landscape before a city, holding the true cross, by Cima da Conegliano, c. 1495. NGA, Wash. DC; Phaidon, *Art Treasures*; Shapley, *15th–16th Cent*; Walker, *NGA.*
2621 St. Helena, holding the true cross, interior panel of Crucifixion altarpiece by studio of Quentin Metsys. Coll. Count Harraach, Rohrau; Bosque, *Metsys.*
2622 St. Helena (half-view, standing with a crucifix), by Lucas Cranach the Elder, 1525. Cincinnati Art Museum, OH; Friedländer, *Cranach*; *Handbook.*
2623 St. Helena with relic of the true cross, by Bruyn, 1534. Xanten, S. Victor; Murray, *Art & Artists.*
2624 Discovery of the true cross (as St. Helena looks on, the cross is unearthed), by Tintoretto, 1560–70. Hyde Coll., Glens Falls NY; Kettlewell, *Catalogue.*
2625 The vision of St. Helena (sitting at a window, she dreams of a crucifix), copy by Paolo Veronese of his original in the National Gallery, London. Rijksmuseum, Amsterdam; *Paintings.*
2626 St. Helena (holding a cross, in a green robe with a pink collar), by Il Poppi, c. 1570. Walters Art Gallery, Baltimore.
2627 The dream of St. Helena (she dreams, sitting up, of an angel showing her the true cross), by Paolo Veronese, 1580–81. Vatican Museums; Francia, *Vaticana*; Rearick, *Veronese.*
2628 The legend of finding the true cross (St. Helena kneels while they

unearth the cross, which still has the scroll "INRI" attached to it), by Francesco Cavazzoni, early 1580's. Bob Jones Univ. Art Gallery, Greenville, SC; Pepper, *Ital. Paintings.*
2629 St. Helena, standing next to the true cross, looking up to heaven, by P.P. Rubens, painted for church of Santa Croce in Gerusalemme, 1601. Grasse, Old Cathedral of Notre-Dame; Baudouin, *Rubens*; Jaffé, *Rubens and Italy*; White, *Rubens.*
2630 St. Helena, standing beside the true cross, as a cherub crowns her with a laurel wreath, by P.P. Rubens, c. 1602. Grasse City Hospital; Larsen, *17th Cent. Flem.*
2631 St. Helena and the true cross, tapestry from the "History of Constantine the Great" series after design by P.P. Rubens, 1625. Philadelphia Museum of Art, PA.
2632 St. Helena (holding the true cross), marble statue by Andrea Bolgi, 1629–39. Rome, St. Peter's; Murray, *Art & Artists*; New Int'l Illus. *Encyclo.*
2633 The rediscovery of the holy cross (St. Helena, crowned, astride a horse, holds out her hand as workmen pull the cross from the ground), by Gérard Douffet. Schleissheim Castle; Larsen, *17th Cent. Flem.*
2634 SS. Constantine and Helena, icon from 17th cent. Wallachia, Monastery of Hurezi; Knopf, *The Icon* (p.407).
2635 St. Helena finding the true cross (it towers over her head), by Sebastiano Ricci, c. 1732–33. Venice, S. Rocco; Daniels, *Ricci.*
2636 The vision of St. Helena (angels take the true cross to heaven), by Gaspare Diziani. Picture Gallery, Lvov; *Old Master.*
2637 The finding of the true cross by St. Helena and Macarius, patriarch of Jerusalem, by Johann Baumgartner, c. 1758. Akademie der Bildenden Künste, Vienna; Schönberger, *Age of Rococo* (pl.290).
2638 St. Helena (standing in a Byzantine-style niche, holding a crucifix and a lily), watercolor by Gustave Moreau, 1882. Private coll., Paris; Moreau, *Gustave Moreau.*
See also 914, 1156, 1524, 1525, 1526, 1607, 4574

Henry, prince of Hungary *see* **Emmerich**

Henry the Emperor, II of Germany, d. 1025, canon. 1146 (July 13 & 15)
2639 St. Henry II, Holy Roman Emperor (blessed by God above, flanked by two other saints), min. from Sacramentario of Henry II, 12th cent. Staatsbiblio., Munich; Bentley, *Calendar.*
2640 St. Henry the emperor, sculpture of Adams Porte, 1240. Dom, Bamberg; Coulson, *Saints.*
2641 Henry and Cunegunda (enthroned), ms. illum. by Master of Margaret of York, ms. 219-21, fol.108r. Biblio. Royale, Brussels; Dogaer, *Flemish Min.*
See also 1580

Heracleidius
2642 Saint Heracleidius, giving a blessing, fresco from 1513. Galata, St. Sozomenus Church; Stylianou, *Painted Churches* (p.89).

Herculanus, Bishop and patron of Perugia; beheaded; mart. 547 (Mar. 1 & Nov. 7)
2643 Siege of Perugia (by King Totila), and exhumation of Saint Herculanus's body at right, fresco by Benedetto Bonfigli, mid-15th cent. Perugia, Galleria Nazionale dell'Umbria; New Int'l Illus. *Encyclo.*
2644 St. Herculanus (reading), by Perugino. Perugia, St. Peter; Bentley, *Calendar.*
2645 Saints Francis of Assisi, Herculanus (holding a banner), Luke, and the Apostle James the Elder (standing side-by-side before a pink wall), by Bartolommeo Caporali. Hermitage, St. Petersburg; Eisler, *Hermitage.*
2646 St. Herculanus (in bishop's robes with a crosier, hands clasped) and James the Minor, by Perugino, 1502. Lyon, Musée des B/A; Durey, *Musée.*
See also 1527, 4585

Heribert, Imperial chancellor to Otto III, Archbishop of Cologne, d. 1021 (Mar. 16)
2647 St. Heribert enthroned, flanked by two female saints, silver-gilt reliquary. Cologne, Deutz Church; Bentley, *Calendar.*

Hermagoras, First bishop of Aquileia; beheaded in prison; mart. 67 (July 12)
2648 Scenes from the life of St. Her-magoras: the inhabitants of Aquileia present Hermagoras to St. Mark as his successor; St. Peter consecrates Hermagoras as bishop of Aquileia; beheading of SS. Hermagoras and Fortunatus; burial of the saints, frescoes, 12th-13th cent. Aquileia, Basilica; Kaftal, *North East Italy.*
See also 1989, 1993

Hermenegild, son of Leovigild king of Spain, k.585 (Apr. 13)
2649 The apotheosis of St. Hermenegild (going up to heaven carrying a crucifix) by Herrera the Elder. Prado, Madrid; Larousse, *Ren. & Baroque.*
2650 St. Hermenegildus (wearing a crown, holding an axe), by Francisco de Zurbaran, 1641-58. Seville, San Esteban; Gállego, *Zurbaran.*
See also 1782

Hermes or Erme, Roman martyr, 3rd cent. (Aug. 28)
2651 St. Hermes (in an ermine cloak, holding a long scroll), by Konrad Laib. Salzburger Barockmuseum, Salzburg; Larousse, *Painters.*

Heydrop, Bishop and Confessor, date unknown
2652 St. Heydrop carrying three cruets on a book, with shield in corner of stained-glass medallion, 16th cent. Private coll.; Drake, *Saints and Emblems.*

Hieronymus *see* **Jerome**

Hilarion, of Gaza, hermit, abbot, father of the Palestinian monks, d. 371 (Oct. 21)
2653 Virgin and Child flanked by SS. Hilarion and Matthew, dossale by the Lucchese School, 13th cent. Fogg Art Museum, Cambridge MA; Kaftal, *Tuscan.*
2654 St. Hilarion killing a dragon by making the sign of the cross (he is riding an ass), fresco by Traini and assistants. Campo Santo, Pisa; Kaftal, *Tuscan.*
2655 St. Hilarion (holding an open book), fresco medallion by the School of Orcagna. Santa Croce, Florence; Kaftal, *Tuscan.*
2656 St. Hilarion praying, tempted by half-nude women, by N.F.O. Tassaert, 1857. Coulson, *Saints.*
See also 4649

Hilary Martyr, Bishop

2657 St. Hilary at a council convened by Pope Leo (he sits on the floor, but the ground rises up beneath him, raising him to the level of the other bishops; below, he chases the reptiles from the island of Gallinaria), min. by Jean Foucquet from the Hours of Etienne Chevalier, c. 1453. Condé Museum, Chantilly; Fouquet, *Hours.*

2658 St. Gregory (as pope), St. Hilary Martyr (in armor with sword and shield), and St. Augustine (holding a heart pierced by an arrow), by Master of Liesborn, c. 1465. Nat'l Gallery, London; Poynter, *Nat'l Gallery.*

2659 St. Hilary (in bishop's robes, holding a model of a church), marble sculpture, c. 1530. Huy, Saint-Hilaire; *Tresors.*

Hilary of Poitiers, Bishop of Poitiers, d. 368 (Jan. 13)

2660 Scenes from the life of St. Martin: as he sleeps, Christ appears to him, wearing the cloak he gave to the beggar; he is ordained exorcist by Hilary of Poitiers; he kneels before three bishops who oppose his ordination as Bishop; he is consecrated bishop; funeral of St. Martin; frescoes by the Emilian School, early 15th cent. Piacenza, Cathedral; Kaftal, *North East Italy.*

Hildebrand or Aldebrandus, bishop of Fossombrone, d. 1270 (May 1)

2661 Scenes from the life of St. Hildebrand: he restores life to a cooked partridge (which is offered to him in bed); he asks for cherries which miraculously appear; he exorcises a demon and cures cripples at his bedside; death of St. Hildebrand; frescoes by the Umbrian school, 15th cent. Fossombrone, S. Aldebrando; Kaftal, *Central and So. Ital.*

Hilduard

2662 St. Hilduard orders a young man to break an idol, by David Teniers the Elder, 1617. Termonde, Notre-Dame Church; Hairs, *Sillage de Rubens.*

Hippolytus, Patron of horses & their riders; disciple of St. Lawrence; torn apart by wild horses; mart. 258 (Aug. 13)

2663 John of France presented by St. Hippolytus, 17th cent. copy of original illustration painted around 1372, ms. Est.

Oa. 11, fo.90. BN, Paris; Sterling, *Peinture Médiévale.*

2664 St. Hippolytus (holding a palm), from a triptych by Bartolommeo di Andrea da Pistoia, 1430. Serravalle Pistoiese, S. Michele; Kaftal, *Tuscan.*

2665 St. Hippolytus (in Roman armor, holding a palm and a sword), from a triptych by Bicci di Lorenzo, 1435. Bibbiena, Sant'Ippolito; Kaftal, *Tuscan.*

2666 St. Hippolytus is tied to the tails of wild horses and dragged on the ground, as the emperor looks on, predella to a triptych by Bicci di Lorenzo, 1435. Bibbiena, Sant'Ippolito; Kaftal, *Tuscan.*

2667 Scenes from the life of St. Lawrence (Lawrence converts Hippolytus from his prison cell; Lawrence and Hippolytus before the Judge), from an altarpiece by the Master of St. Martino. Bellomo Museum, Syracuse; Kaftal, *Central and So. Ital.* (fig. 780 & 781).

2668 Scenes from the life of St. Lawrence: Lawrence cures the sick and blind in prison; Hippolytus is converted by these miracles and is baptized; fresco att. to Jacobello del Fiore. Vittorio Veneto, S. Lorenzo; Kaftal, *North East Italy.*

2669 The martyrdom of St. Hippolytus (drawn and quartered; his clothes lay on the ground), by Dirck Bouts, c. 1475. Bruges, St. Savior's Church; *Eight Centuries*; Miegroet, *David*; Puppi, *Torment.*

2670 The martyrdom of St. Hippolytus (drawn and quartered), by anon. Flemish artist, c. 1485. Boston Museum of Fine Arts; *Illus. Handbook.*

2671 Madonna and Child (in the clouds) with St. Hippolytus (in partial armor, holding a palm) and St. Catherine of Alexandria, by Moretto. Nat'l Gallery, London; Bentley, *Calendar.*

2672 Martyrdom of St. Hippolytus (as the emperor watches, they tie his legs to a rearing horse; an angel descends with a flower wreath), by Simon Julien. Lyon, Cathédrale Saint-Jean; *Subleyras.*

2673 Martyrdom of St. Hippolytus (he lies on his back, hands bound, feet tied to a horse that is beaten by a mounted man with a whip; broken bodies lay about the ground), by Subleyras. Fountainebleau; *Subleyras.*

2674 Martyrdom of St. Hippolytus (he lies on his back, hands bound, feet tied to a horse that is beaten by a mounted man with a whip; broken bodies lay about the

ground), by studio of Subleyras. Rome, Treasury Minister; *Subleyras.*
See also 4585, 4901

Honoratus of Amiens, succeeded St. Benedict, patron of bakers and confectioners, 6th cent. (Jan. 16 & May 16)
2675 St. Honoratus (half view, holding a book), vault fresco att. to Conxolus. Subiaco, Sacro Speco; Kaftal, *Central and So. Ital.*
2676 St. Honoratus (standing in a vestibule before a tapestry), from the "Boucicaut Hours" painted by the Boucicaut Master, ms.2,fo.36v. Jacquemart-André Museum, Paris; Meiss, *French Painting.*
2677 St. Honoratus (in Benedictine monk's robe, holding a crosier and a model of a castle), panel of a triptych by Cristoforo Sacco, 1499. Fondi, Cathedral; Kaftal, *North East Italy.*

Hormisdas, Pope, r. 514–523 (Aug. 6)
2678 St. Hormisdas, mosaic. Rome, St. Paul-Outside-the-Walls; Brusher, *Popes.*

Hubert, Bishop of Maestricht, patron & founder of Liège, d. 727 (Nov. 3)
2679 The exhumation of St. Hubert (taken from a hole in the floor before an altar in a church), by a follower of Rogier Van der Weyden, c. 1437. Nat'l Gallery, London; Dunkerton, *Giotto to Dürer*; Panofsky, *Early Nether.*; Wilson, *Nat'l Gallery.*
2680 St. Hubert on a horse, looking at a deer, drawing by Jacopo Bellini, c. 1440–50. Louvre, Paris; Book of Art, *Ital. to 1850.*
2681 Translation of the relics of St. Hubert (two priests carry a reliquary in a litter, as monks follow them), ms. illum. by Loyset Liédet, ms. 76 f 10, fol.59v. Koninklijke Bibliotheek, The Hague; Dogaer, *Flemish Min.*
2682 St. Hubert (in bishop's robes with a crosier, holding a horn and standing next to a stag), by Dirck Bouts. Antwerp, Musée Royal des B/A; McGraw, *Encyclo.* (Vol.XII, pl.374).
2683 The mass of St. Hubert (an angel from heaven descends with a stole) by Meister von Werden, 1485–90. Nat'l Gallery, London; Dunkerton, *Giotto to Dürer*; Poynter, *Nat'l Gallery.*
2684 The conversion of St. Hubert (he kneels before a stag bearing a crucifix be-

tween its antlers) by studio of the Master of the Life of the Virgin, late 1480's. Nat'l Gallery, London; Bentley, *Calendar*; Coulson, *Saints*; Dunkerton, *Giotto to Dürer*; Levey, *Giotto to Cézanne*; Wilson, *Nat'l Gallery.*
2685 St. Hubert kneeling below a rock upon which the stag with the cross is standing, by Lucas Cranach the Elder, 1515–20. Liechtenstein Coll., Vaduz; Friedländer, *Cranach.*
2686 The conversion of St. Hubert (praying before the deer as his hunters discuss the matter), att. to Jan de Beer, c. 1520. Portland Art Museum, OR; Eisler, *European Schools.*
2687 The vision of St. Hubert (dismounted, looking at a stag with his dogs), by Bruegel and P.P. Rubens. Prado, Madrid; *Guide to Prado.*
2688 The conversion of St. Hubert (he kneels against a bounder, looking up at the stag above him with a glowing crucifix between its antlers), by Jean Boeckhorst, 1666. Grand, St. Michel; Hairs, *Sillage de Rubens.*
See also 3483, 4125

Hugh of Grenoble, Bishop of Grenoble and Confessor, d. 1132, canon. 1134 (Apr. 1)
2689 SS. Hugh of Grenoble (in bishop's regalia, holding an open book), and Hugh of Lincoln (in bishop's regalia, holding a closed book), panels of a triptych by the Master of the Susa triptych, late 15th cent. Susa, S. Giusto; Kaftal, *North West Italy.*
2690 St. Hugh of Grenoble, holding a crosier, from Flemish stained-glass window, 16th cent. Private coll.; Drake, *Saints and Emblems.*
2691 St. Hugh of Grenoble (standing in right profile, hands clasped), painted for the Carthusian Monastery at Jerez de la Frontera by Francisco de Zurbaran, 1637–39. Cadiz, Provincial Museum of Fine Arts; Gállego, *Zurbaran*; United Nations, *Dismembered Works.*
2692 The Virgin with St. Charles Borromeo (hands crossed over his chest) and Hugh of Grenoble (bowing against the Virgin's cloak), by Cerano. Pavia, Carthusian Monastery; Bentley, *Calendar.*

Hugh of Lincoln, Carthusian Bishop of Lincoln and Confessor, d. 1200, canon. 1220 (Nov. 17)

2693 St. Hugh of Lincoln (holding a chalice with baby Jesus, standing next to a large swan), by Master of Amiens, c. 1480. Chicago Art Inst.; Maxon, *Art Institute.*

2694 St. Hugh of Lincoln holding a chalice out of which rises baby Jesus, from a Flemish stained-glass window, 16th cent. Private coll.; Drake, *Saints and Emblems.*

2695 St. Hugh of Lincoln (holding a chalice from which rises a young Christ), painted for the Carthusian monastery at Jerez de la Frontera by Francisco de Zurbaran, 1637–39. Cadiz, Provincial Museum of Fine Arts; Gállego, *Zurbaran*; United Nations, *Dismembered Works.*
See also 2689

Hugo, abbot of Cluny
2696 St. Matthew and St. Hugo, by a follower of Barend van Orley, early 16th cent. Houston Museum of Fine Arts, TX; *Guide to the Coll.*

2697 The miracle of St. Hugo (as the monks eat dinner), by Francisco de Zurbaran, c. 1633. Seville, Museum of Fine Arts; Book of Art, *German & Spanish*; Gállego, *Zurbaran*; Lloyd, *1773 Milestones* (p.190); Smith, *Spain.*

2698 St. Hugo gives the habit to St. Bruno, by Eustace Le Sueur, 1645–48. Louvre, Paris; Mérot, *Le Sueur.*
See also 2592

Humility or Umiltà, abbess of first Vallombrosan nunnery, d. 1310 (May 22)
2699 The ice miracle of St. Humility; St. Humility healing a sick nun, sections of a polyptych named "Two Scenes from the Legend of St. Humility" by Pietro Lorenzetti, c. 1341. Picture Gallery, Berlin; *Catalogue.*

Humphrey *see* Onophrius

Hyacinth, Apostle of Poland, Dominican, d. 1257 (Aug. 17)
2700 The Virgin and Child appearing to St. Hyacinth (as he prays before an engraved tablet), by Ludovico Carracci, 1594. Louvre, Paris; Freedberg, *Circa 1600*; Gowing, *Paintings.*

2701 Apparition of the Virgin to St. Hyacinth (as he kneels at prayer) by El Greco, 1605–10. Memorial Art Gallery, Rochester NY; *Intro. to the Coll.*; Gudiol, *El Greco*; *Handbook.*

2702 The Virgin with Saints Dominic and Hyacinth, by Giambattista Tiepolo, 1740's. Chicago Art Inst.; Maxon, *Art Institute*; Morassi, *Catalogue.*

2703 A miracle of St. Hyacinth (he walks across the water to save drowning monks from a broken bridge), by Francesco Guardi, 1763. KM, Vienna; McGraw, *Encyclo.* (Vol.VII, pl.98); Newsweek, *Art History Museum.*
See also 3409, 3513

Hyginus, Pope, r. 138–140 (Jan. 11)
2704 St. Hyginus, fresco by Ghirlandaio in the Sistine Chapel. Vatican Museums; Brusher, *Popes.*

Ignatius of Antioch, bishop of Antioch, called Theophoros; thrown to wild beasts, mart. 107 (Feb. 1)
2705 St. Ignatius of Antioch (as a young beardless man, with a bleeding wound in his stomach), fresco by the Umbrian School, c. 1400. Montefalco, S. Francesco; Kaftal, *Central and So. Ital.*

2706 St. Ignatius of Antioch in prison (praying behind bars), fresco by the Veronese School, early 15th cent. Modena, Cathedral; Kaftal, *North East Italy.*

2707 St. Ignatius of Antioch, with bishop's crosier, by Florentine School, 1486. Rijksmuseum, Amsterdam; *Paintings.*

2708 St. Ignatius in Glory, by Giovanni Battista Gaulli, called Il Baciccia, after 1679. Gesu, Rome; Book of Art, *Ital. to 1850.*
See also 4475

Ignatius of Loyola, founder of Jesuits, d. 1556 (July 31)
2709 St. Ignatius before Pope Paul III (he kneels before the enthroned pope, offering a book), anon. Rome, Church of Jesus; Bentley, *Calendar.*

2710 Extraction of the heart of St. Ignatius, predella panel of the St. Barnaba Altarpiece by Sandro Botticelli, c. 1487. Uffizi, Florence; Lightbown, *Botticelli.*

2711 St. Ignatius of Loyola (holding a host with IHS), by Juan de Roelas. Seville, Museum of Fine Arts; Smith, *Spain.*

2712 St. Ignatius pleading before Pope Julius III for the establishment of a Jesuit college in Rome, drawing by P.P. Rubens, 1609. NGS, Edinburgh; Rowlands, *Rubens, Drawings.*

2713 The miracles of St. Ignatius of Loyola (as he stands by the altar, men carry dead woman to him), by P.P. Rubens, 1618. KM, Vienna; Baudouin, *Rubens*; Coulson, *Saints*; Held, *Oil Sketches*; Larsen, *17th Cent. Flemish*; White, *Rubens*.

2714 St. Ignatius of Loyola as worker of miracles (the sick are carried to him), oil sketch by P.P. Rubens, c. 1619. Dulwich College Picture Gallery, London; Held, *Oil Sketches*; Murray, *Catalogue*.

2715 St. Ignatius of Loyola (in ecclesiastical robes, looking up at the celestial light), by P.P. Rubens. Brukenthal Museum, Rumania; Oprescu, *Great Masters*.

2716 Chalk study for St. Ignatius (kneeling), by Domenichino. Windsor Castle, London; *Around 1610*.

2717 St. Ignatius of Loyola (holding an open book, with a suit of armor in the lower right corner, Christ bearing the cross in the lower left corner, and cherubs holding a scroll above his head), by Anthony van Dyck, c. 1622-23. Vatican Museums; Larsen, *Van Dyck* (pl.162a).

2718 St. Ignatius of Loyola's vision of Christ and God the Father (who look at him from the clouds as he kneels in the wilderness), at La Storta, by Domenichino, early 1620's. Matthiesen Fine Art Ltd., London; *Age of Correggio*; *Around 1610*.

2719 Triumph of St. Ignatius (the Trinity and Mary accept him into heaven, while other saints look on), by Claude Vignon, 1628. Orléans, Musée des B/A; O'Neill, *L'Ecole Francaise*.

2720 St. Ignatius in glory and the works of the Jesuit fathers, by Giovanni Battista Caracciolo, c. 1629. Sorrento, Museo Correale di Terranova; RA, *Painting in Naples*.

2721 St. Ignatius (holding a book, with IHS in left upper corner), by Francisco de Zurbaran 1641-58. Convent of the Capuchin Nuns, Castellón de la Plana; Gállego, *Zurbaran*.

2722 St. Ignatius Loyola (holding a book and his IHS), by Francisco de Zurbaran 1641-58. Lima, Monastery of St. Camillus de Lellis; Gállego, *Zurbaran*.

2723 St. Ignatius of Loyola receiving permission to found the Society of Jesus from Pope Paul III, by Juan de Valdés Leal, 17th cent. Seville, Museum of Fine Arts; Smith, *Spain*.

2724 Triumph of St. Ignatius of Loyola, ceiling of nave of St. Ignazio, Rome, by Andrea Pozzo, 1691-94. Rome; McGraw, *Dict.*; Munro, *Golden Encyclo.*

2725 Vision of St. Ignatius of Loyola (Christ holding the cross appears to him as he prays), by Pierre Subleyras, c. 1767. Picture Gallery, Berlin; *Catalogue*; *L'Art Européen*; *Subleyras*.

2726 St. Ignatius of Loyola (in a yellow tunic, wearing a beard), wood statue with water-based paints by José Benito Ortega, c. 1875-90. Taylor Museum for Southwest Studies, CO; Wroth, *Images of Penance*.

2727 St. Ignatius of Loyola (holding a blazing disc), pine wood retable with enamel paints, Retablo Style II, late 19th cent. Taylor Museum for Southwest Studies, CO; Wroth, *Images of Penance*.

See also 4484

Ignatius the Martyr *see* **4074**

Ilarion
2728 Saint Ilarion, fresco, 1176-80. Patmos; Kominis, *Patmos* (p.91).

Ildefonso, archbishop of Toledo, Doctor of the Church, d. 667 (Jan. 23)
2729 St. Ildefonso writing (as a monk holds the ink well), min. from "De Virginiate Sanctae Mariae" by St. Ildefonso, ms. 1650, c. 1100. Palatine Library, Parma; Batselier, *Benedict* (p.206).

2730 St. Ildefonso and (a kneeling) Cardinal Alfonso Borgia, panel from the altarpiece in the Borgia chapel by Jaime Baco, 1444-57. Valencia, Collegiata of Jativa, Spain; Book of Art, *German and Spanish*; New Int'l Illus. *Encyclo.*

2731 St. Ildefonso receiving the chasuble (as other saints and angels look on) by Master of St. Ildefonso, end of 15th cent. Louvre, Paris; Gowing, *Paintings*.

2732 Vision of St. Ildefonso (at mass, he sees the Virgin descend with a red robe), by Adriaen Isenbrant. Carnegie Inst., Pittsburgh PA; *Catalogue of Painting*.

2733 St. Ildefonso (in bishop's regalia, reading), by El Greco, 1603-07. El Escorial, Monastery; Gudiol, *El Greco*.

2734 St. Ildefonso (writing at a red-draped table), by El Greco, 1603-05. Hospital de la Caridad, Illescas; Gudiol, *El Greco*.

2735 St. Ildefonso sitting at a red-draped table, by El Greco, 1605-14. NGA, Washington DC; Walker, *NGA*.

2736 St. Ildefonso receiving the chasuble (the Virgin is about to put it over his head), by Velazquez, 1622-23. Seville, Museum of Fine Arts; Gudiol, *Velazquez*.

2737 St. Ildefonso receives the chasuble from the Virgin, oil sketch by P.P. Rubens, c. 1630-2. Hermitage, St. Petersburg; Held, *Oil Sketches*.

2738 The Ildefonso altar (he receives a chasuble from the Virgin), triptych with Archduke Albert and Archduchess Isabella by P.P. Rubens, c. 1630-32. KM, Vienna; Bentley, *Calendar*; Gowing, *Biog. Dict.*; Held, *17th & 18th Cent.*; Larsen, *17th Cent. Flemish*; McGraw, *Encyclo.* (Vol.XII, pl.326).

2739 St. Ildefonso receiving the chasuble, by Francisco de Zurbaran 1631-40. Hieronymite Monastery, Guadeloupe; Gállego, *Zurbaran*.

2740 St. Ildefonso receiving the chasuble (from the Virgin), by Francisco de Zurbaran, 1643-44. Zafra, Santa Maria; Gállego, *Zurbaran*.

2741 Saint Ildefonso receives the chasuble from the Virgin, by Bartolomé Esteban Murillo, 1675-82. Prado, Madrid; New Int'l Illus. *Encyclo.*

2742 The Virgin presenting the chasuble to Ildefonso, by an unknown Roman artist, c. 1740. Bob Jones Univ. Art Gallery, Greenville, SC; Pepper, *Ital. Paintings*.

Illuminata of Todi or Luminata, Roman martyr, 4th cent. (Nov. 29)
2743 St. Illuminata of Todi (standing, wrapped in a robe, holding a book and a flaming vase), fresco by Palmetto, 1423. Città della Pieve, S. Maria degli Angeli; Kaftal, *Central and So. Ital.*

Inés
2744 The Virgin with St. Inés (with a lion, holding a palm) and St. Thecla (with a lamb), by El Greco. NGA, Wash. D. C.; Bentley, *Calendar*.

Innocent I, Pope, d. 417 (July 28)
2745 Crucifixion with SS. Jerome (kneeling, draped in a red robe, holding a rock), Fermus (in armor, pointing at Christ) and Innocent I (a cherub holds his tiara), by L. Cattapane, late 15th cent. Cremona, Cathedral; Voltini, *Cremona*.

See also 112

Innocent V, Pope, Cardinal Bishop of Ostia, Archbishop of Lyons, Provincial of France, Dominican, d. 1276 (June 22)
2746 St. Innocent V (in papal tiara, holding a key), fresco medallion by Fra Angelico. Florence, San Marco; Kaftal, *Tuscan* (fig. 581).

Irene, Roman martyr, 3rd cent. (Jan. 20)
2747 Saint Irene nurses (a standing) Saint Sebastian (she and a man pull arrows from his bleeding body), from the Altarpiece of St. Sebastian att. to Josse Lieferinxe, 1497-98. Philadelphia Museum of Art, PA; Laclotte, *L'Ecole d'Avignon*; McGraw, *Encyclo.* (Vol.V, pl.386); Snyder, *Northern Ren.*

2748 Healing of St. Sebastian (Irene pulls his head out of the sewer water), by Albrecht Altdorfer, c. 1518. Städelsches Kunstinstitut, Frankfurt; Keller, *20 Cent.*

2749 St. Sebastian (lying on the ground, tended by St. Irene), by the Italian School, first half of 16th cent. Mauritshuis, The Hague; *Catalogue*.

2750 St. Sebastian nursed by Irene and her helpers, by Jacques Blanchard. Rijksmuseum; *Paintings*.

2751 St. Sebastian (sitting) attended by St. Irene (pulling an arrow from his chest), by Tanzio da Varallo, 1620-30. NGA, Washington DC.

2752 St. Sebastian cured of his wounds (St. Irene pulls an arrow from his arm, while another woman pours ointment into his wound with a spoon), etching by Bernardino Capitelli. Illus. Bartsch; *Ital. Masters of the 17th Cent.* (Vol.45).

2753 St. Sebastian tended by Irene and her maid (he has an arrow in the center of his chest; supporting his sitting body, she loosens his tied wrist), by Hendrick Terbrugghen, 1625. Allen Memorial Art Museum, Oberlin OH; Guratzsch, *Dutch*; *Int'l Dict. of Art*; Spear, *Caravaggio*.

2754 St. Sebastian tended by St. Irene (as he lies unconscious, Irene rubs salve into his wounds), by Nicolas Regnier, 1625-30. Rouen, Musée des B/A; Bergot, *Musée*.

2755 St. Sebastian helped down from the tree by St. Irene, by Bernardo Strozzi, early 1630's. Boston Museum of Fine Arts; *Illus. Handbook*.

2756 St. Sebastian tended by St. Irene (she pulls an arrow from his leg, lit by a

lantern), by Georges de la Tour, c. 1632-33. Nelson-Atkins Museum, Kansas City MO; *Handbook*; Spear, *Caravaggio*.

2757 St. Sebastian tended by St. Irene (she looks at his prone body as a servant kneels with a torch), by Georges de la Tour. Louvre, Paris; Gowing, *Paintings*.

2758 St. Sebastian untied from his tree by St. Irene and another, by Bernardo Strozzi, c. 1635. Venice, S. Benedetto; Book of Art, *Ital. to 1850*; Held, *17th & 18th Cent.*

2759 The finding of St. Sebastian (by St. Irene, holding a torch), by Georges de la Tour, c. 1638-49. Picture Gallery, Berlin; Châtelet, *French Paintings*; Larousse, *Ren. & Baroque*; McGraw, *Encyclo.* (Vol.IX, pl.92); Picture Gallery, *Catalogue*; Praeger, *Great Galleries*; Redslob, *Berlin*.

2760 St. Sebastian tended by St. Irene (lit by a lantern, she pulls an arrow from his leg), after Georges de la Tour, c. 1639. Rouen, Musée des B/A; *La Peinture d'Inspiration*.

2761 St. Irene nursing St. Sebastian (pulling an arrow from his chest), by Nicolas Regnier. Mauritshuis, The Hague; Hoetink, *Mauritshuis*.

2762 St. Sebastian helped by St. Irene and angels (he leans to the side as an angel pulls an arrow from his belly) by Corneille Schut, 1643. Tamise, Notre-Dame Church; Hairs, *Sillage de Rubens*.

2763 St. Sebastian tended by St. Irene (the angels support Sebastian while she pulls arrows out), by Eustace Le Sueur, 1650-55. Tours, Musée des B/A; Mérot, *Le Sueur*.

2764 St. Sebastian (still tied to the tree) cured by St. Irene (who pulls an arrow from his leg), by Luca Giordano, after 1655. Philadelphia Museum of Art, PA; Yale Univ., *Taste* (fig.14).

2765 St. Sebastian attended by the pious women (he is lying, doubled up, on a table while Irene and others look at his wounds), by B. Schedoni. Capodimonte, Naples; McGraw, *Encyclo.* (Vol.II, pl.197).

2766 St. Sebastian succored by holy women in a forest landscape, by J.B.C. Corot, 1851-73. Walters Art Gallery, Baltimore.

Isicius *see* **458**

Isidore "the Farm Laborer," patron of Madrid, d. 1130 (May 15)
2767 Miracle of the well, (a mother pulls her baby from the well), from episodes from the life of St. Isidore, by Alonso Cano, 1638-52. Prado, Madrid; Bentley, *Calendar*; McGraw, *Encyclo.* (Vol.XIII, pl.147).

Ivan *see* **1955**

Ives or Yves or Ivo of Kermartin, priest, patron of lawyers, judges & notaries, d. 1303, canon. 1366 (May 19)
2768 St. Ives (enthroned, accepting a scroll from a woman, while a man offers him a sack of money), panel by Domenico di Michelino. Florence, Museo dell'Opera del Duomo; Kaftal, *Tuscan*.

2769 St. Ives (standing in doctor's robes, holding a book and a pair of white gloves), min. by the Rohan Master from a Book of Hours, ms. Latin 9471, f.222, c. 1415-16. BN, Paris; *Rohan Master* (pl.103).

2770 St. Ivo (reading a letter before a window) by Rogier Van der Weyden. Nat'l Gallery, London; Wilson, *Nat'l Gallery*.

2771 St. Yves, patron of lawyers (he talks to one man as a woman sits beside them, nursing a baby), altarpiece by Hendrick de Clerk. Antwerp, Musée Royal des B/A; Larsen, *17th Cent. Flem.*

2772 St. Ives, patron of layers, defender of widows and orphans (he takes a petition from a widow), by P.P. Rubens. Detroit Inst. of Art, MI; *Treasures*.

2773 St. Ives, patron of lawyers (in the middle of the room, as several poor supplicants push through the door), by Jacob Jordaens, 1645. Brussels, Musées Royaux des B/A; d'Hulst, *Jordaens*.

2774 St. Ivo, copy of the sculpture by Matthias Bernard Braun. Charles Bridge, Prague; Štech, *Baroque Sculpture*.

Ivo *see* **Ives**

James of the March, Franciscan Observant, d. 1476 (Nov. 28)
2775 St. James of the March (in Franciscan robes, pointing to a disc with the monogram of Christ, with two kneeling donors at his feet), by Carlo Crivelli, 1477. Rome, Vatican; Kaftal, *North East Italy*.

2776 St. James of the March, standing

in right profile, holding a book and a sun with a phial of blood and the monogram of Christ, by Cola dell'Amatrice. Urbino, Galleria Nazionale delle Marche; Kaftal, *Central and So. Ital.*

Januarius *see* **Gennaro**

Jerome or Hieronymus, one of the four Latin Fathers of the Church; founded Hieronymite Order, transl. Bible into Vulgate Latin, d. 420 (Sept. 30)
2777 Story of St. Jerome's translation of the Bible, illum. in the first Bible of Charles the Bald, the "Vivian Bible," ms. Lat.1152 fo.3v, c. 845. BN, Paris; deHamel, *Illum.*; Snyder, *Medieval.*
2778 St. Jerome giving a letter to two bishops, Chromace and Heliodorus, illuminated initial from the Bible of Souvigny, ms. 1, fo.226 (D 38), second half of 12th cent. Moulins, Biblio. Municipale; Garnier, *Langage de l'Image* (pl.1).
2779 St. Jerome, marble statue, c. 1220-30. Chartres Cathedral; Gardner, *Art thru Ages* (pl.1029).
2780 St. Jerome (in his cell, a book on his lap and pointing to another) by Tommaso da Modena. Treviso, S. Nicolo; McGraw, *Encyclo.* (Vol.XIV, pl.105).
2781 St. Jerome (enthroned, in cardinal's robes, holding a plume and an open book), fresco att. to Giovanni del Biondo. Florence, S. Maria Novella, Strozzi Chapel; Kaftal, *Tuscan.*
2782 St. Jerome (in right profile, opening a book), by Master Theodoric, c. 1367. Prague, Nat'l Gallery; Praeger, *Great Galleries*; Stejskal, *Charles IV.*
2783 St. Jerome in his study (looking at a crucifix on the paneled wall), by Cecco di Pietro, c. 1370. N. Carolina Museum of Art, Raleigh; Shapley, *Samuel H. Kress.*
2784 St. Jerome (tending to the paw of his lion), by the Veneto-Byzantine school, late 14th cent. Samuel H. Kress Found., N.Y.; Shapley, *Samuel H. Kress.*
2785 St. Jerome (holding a book and quill, with a cardinal's hat hovering over his head), from an antiphonary illus. by Lorenzo Monaco, ms. Cod. Cor. 5, fo.138, c. 1394. Florence, Biblio. Laurenziana; Eisenberg, *Monaco* (pl.I).
2786 St. Jerome in his cell (his lion paws at the table leg), from the "Boucicaut Hours" painted by the Boucicaut

Master, ms.2,fo.171v. Jacquemart-André Museum, Paris; Meiss, *French Painting*; Panofsky, *Early Nether.*
2787 St. Jerome standing in kneelength tunic, holding a scroll and rock, by Giovanni Di Francesco Toscani, c. 1375-1430. Princeton Univ. Art Museum.
2788 St. Jerome in his study (standing, in a dark green robe, looking down at the lion), by Lorenzo Monaco, c. 1420. Rijksmuseum, Amsterdam; Eisenberg, *Monaco* (pl.129); Newsweek, *Rijksmuseum.*
2789 St. Jerome (reading while standing up), by Giovanni di Paolo. Siena, Museo dell'Opera del Duomo; Pope-Hennessy, *Sienese.*
2790 St. Jerome (holding an open book and a church, lion at his feet) and St. John the Baptist (barefoot, holding a cross), from the Sta. Maria Maggiore triptych by Masaccio & Masolino, c. 1423. Nat'l Gallery, London; Dunkerton, *Giotto to Dürer*; Hartt, *Ital. Ren.*; Wilson, *Nat'l Gallery.*
2791 St. Jerome (in a cardinal's hat) holding a church, by Jacopo Bellini, c. 1430-35. Picture Gallery, Berlin; *Catalogue.*
2792 St. Jerome in his study (he turns from his book to look at the lion, which stands on its hind legs against his chair), by Stefan Lochner, c. 1440. North Carolina Museum of Art, Raleigh; *Intro. to the Coll.*
2793 St. Jerome in his cell, next to a cupboard full of books, by Master H, c. 1442. Detroit Inst. of Art, MI; Châtelet, *Early Dutch* (pl.36).
2794 St. Jerome in his study, musing over a book, by Jan van Eyck and Petrus Christus, c. 1442. Detroit Inst. of Art, MI; Panofsky, *Early Nether.*; Random House, *Themes* (p.72); Snyder, *Northern Ren.*; *Treasures.*
2795 Scenes from the life of St. Jerome: baptism of St. Jerome; sent to ecclesiastics for his religious education; St. Jerome is made a cardinal (sic); St. Jerome prays at the Pope's deathbed; Jerome living in a hut; the Pope orders Jerome to translate the Holy Scriptures; frescoes by Giovanni Badile, 1443-44. Verona, S. Maria della Scala; Kaftal, *North East Italy.*
2796 Madonna and Child (holding a scroll inscribed with EGO), with saints Jerome and St. Bernardino of Siena, by Sano di Pietro. Esztergom Christian

Museum; *Christian Art in Hungary* (pl.III/50).

2797 St. Jerome and the lion (at left, he cures the lion's paw; at right, a caravan steals the donkey the lion was appointed to guard, but the lion recovers the donkey and proves his innocence), panel from an altarpiece by Sano di Pietro, 1444. Louvre, Paris; Gowing, *Paintings*; Kaftal, *Tuscan* (fig. 608); Van Os, *Sienese Altarpieces* (Vol.II, pl.34).

2798 St. Jerome before a crucifix (with scorpions on the ground), by Sano di Pietro. Siena, Pinacoteca Nazionale; Pope-Hennessy, *Sienese*.

2799 St. Jerome dreams he is whipped by angels on Christ's orders; St. Jerome appears to Sulpicius Severus and to St. Augustine; death of St. Jerome; panels from the "Gesuati" altarpiece by Sano di Pietro, 1444. Louvre, Paris; Gowing, *Paintings*; Van Os, *Sienese Altarpieces* (Vol.II, pl.33).

2800 St. Jerome in the wilderness (before a crucifix; his cardinal's robe is strewn on the ground), by Antonello da Messina. Reggio Calabria, Museo Nazionale; McGraw, *Encyclo.* (Vol.I pl.314).

2801 Landscape (full of tall, straight trees) with St. Jerome penitent, by Piero della Francesca, 1450. Picture Gallery, Berlin; *Catalogue*; Clark, *Piero*; *Masterworks*.

2802 Pietà, with St. Jerome presenting a donor, and possibly St. Dominic, by the workshop of Rogier van der Weyden, 1450-60. Nat'l Gallery, London; Dunkerton, *Giotto to Dürer*.

2803 St. Jerome (book in his lap) with a (kneeling) donor, by Piero della Francesca. Accademia, Venice; Praeger, *Great Galleries*.

2804 St. Jerome in his study, as seen through an archway, by Antonello de Messina, c. 1450-64. Nat'l Gallery, London; Book of Art, *Ital. to 1850*; Coulson, *Saints*; Hartt, *Ital. Ren.*; *Int'l Dict. of Art*; Lassaigne, *Fifteenth Cent.*; McGraw, *Encyclo.* (Vol.I, pl.311); Praeger, *Great Galleries*; Rowling, *Art Source Book*.

2805 St. Jerome leaves Rome (as he leaves, he looks down on the ground, where stones and a cardinal's hat lie at his feet), fresco by Benozzo Gozzoli, 1450. Montefalco, S. Francesco; Kaftal, *Tuscan*.

2806 St. Jerome Altarpiece, with Ma-

donna and Child enthroned, with St. Jerome, SS. Cosmas and Damian, Lawrence, John the Baptist, and Stephen, by the Master of the Buckingham Palace Madonna. Petit Palais, Avignon; Van Os, *Sienese Altarpieces* (Vol.II, pl.36).

2807 Madonna and Child flanked by SS. Peter and John the Baptist at left, and SS. Jerome and Paul at right, by Benozzo Gozzoli, 1456. Perugia, Galleria Nazionale dell'Umbria; Hall, *Color and Meaning*.

2808 St. Jerome (sitting at a study desk before a small window, translating the Bible), panel of a triptych by an unknown Neapolitan painter, c. 1460-70. Naples, Church of Sant'Anna dei Lombardi; Laclotte, *L'Ecole d'Avignon*.

2809 St. Jerome (sitting in his study before a set of long, cluttered bookshelves, removing a thorn from the lion's paw), from the Retable of San Lorenzo Maggiore by Colantonio. Capodimonte, Naples; Laclotte, *L'Ecole d'Avignon*.

2810 Christ in the sepulcher between saints John the Baptist and Jerome (embracing Christ's head) by Marco Zeppo. Nat'l Gallery, London; New Int'l Illus. *Encyclo.*

2811 St. Jerome (in a belted tunic, scorpion and snake at his feet), and St. Francis (holding a crucifix, birds at his side), two sides of a polyptych att. to Domenico di Michelino, c. 1460. Dallas Museum of Fine Arts, TX; Shapley, *Samuel H. Kress*.

2812 Virgin and Child with SS. Paul and Jerome (both saints stand behind the Virgin), by Bartolomeo Vivarini, 1460-65. Nat'l Gallery, London; Dunkerton, *Giotto to Dürer*.

2813 St. Jerome in the desert (kneeling before a crucifix while a man runs away from his lion), marble relief by Desiderioda Settignano, c. 1461. NGA, Washington DC.

2814 St. Jerome is flogged before Christ, for favoring the classical writings over the sacred ones, predella panel by Matteo di Giovanni, 1462. Chicago Art Institute, IL; Christiansen, *Siena*; Kaftal, *Tuscan*.

2815 St. Jerome in cardinal's robe, flanked by angels, by Niccolo Corso, 1465-1503. Philadelphia Museum of Art, PA.

2816 St. Jerome in penitence (kneeling amidst city ruins), by Marco Zoppo,

1460's. Walters Art Gallery, Baltimore; *Italian Paintings* (Vol.I).

2817 St. Jerome in penitence (kneeling in right profile before a large crucifix), hand-colored engraving by the Master of the Vienna Passion, Florentine, 1465–70. Boston Museum of Fine Arts; *Illus. Handbook.*

2818 St. Jerome in the desert kneeling before a crucifix, in a distinct compartment, flanked by Saints Damasus and Eusebius, and Saints Paula and her daughter Saint Eustochia, with two kneeling donors, by Tuscan School, 15th cent. Nat'l Gallery, London; Poynter, *Nat'l Gallery.*

2819 St. Jerome in the wilderness (holding a rock high over his head; an owl perches in upper right corner), by Cosimo Tura. Nat'l Gallery, London; Dunkerton, *Giotto to Dürer*; Levey, *Nat'l Gallery*; Poynter, *Nat'l Gallery*; Ruhmer, *Tura.*

2820 Dead Christ (sitting in a sepulcher) with Saints John the Baptist and Jerome (embracing Christ's head), by Marco Zoppo, c. 1470. Nat'l Gallery, London; Dunkerton, *Giotto to Dürer.*

2821 Head of St. Jerome with a halo, att. to Piero del Pollaiuolo. Pitti Palace, Florence; Denvir, *Art Treasures*; Praeger, *Great Galleries.*

2822 St. Jerome (reading a book, with a lion at his feet), by Matteo di Giovanni. Esztergom Christian Museum; *Christian Art in Hungary* (pl.III/44).

2823 St. Jerome in the desert (sitting on a rock, holding a rosary, the lion at his feet), by Da Ferrara, 15th cent. Nat'l Gallery, London; Poynter, *Nat'l Gallery.*

2824 St. Jerome in the desert (with other scenarios in the background) by Jacopo del Sellajo. Louvre, Paris; Gowing, *Paintings.*

2825 St. Jerome with a donor (before a window showing a landscape, and another window colored with a coat of arms below a cardinal's hat) by Simon Marmion. Philadelphia Museum of Art, PA; Gowing, *Biog. Dict.*

2826 Virgin and Child enthroned with Saints Jerome (holding books and a church) and Sebastian (fully clothed, holding an arrow, left hand on the hilt of a curved sword), from "Madonna della Rondine" altarpiece by Carlo Crivelli. Nat'l Gallery, London; Praeger, *Great Galleries*; Zampetti, *Crivelli.*

2827 St. Jerome (standing in cardinal's robes, looking down at a church he is holding), from a dismembered altarpiece by Carlo Crivelli, c. 1476. Nat'l Gallery, London; Dunkerton, *Giotto to Dürer*; Zampetti, *Crivelli.*

2828 Madonna with St. Jerome (holding a book, glove on left hand, head draped with a large red hood) and St. Sebastian (filled with arrows, leaning slightly forward), by Bartolommeo Montagna. Accademia, Venice; Denvir, *Art Treasures.*

2829 St. Jerome and a donor (Jerome stands next to the kneeling donor, with his right hand raised above the man's head, and holding a model of a church in his left hand), by Paolo Veronese, 1480–90. Dulwich Picture Gallery, London; Murray, *Catalogue.*

2830 St. Jerome in his study (before a green curtain, sitting at a table draped in a woven fringed cloth), by Domenico Ghirlandaio, 1480. Ognissanti, Florence; Lightbown, *Botticelli.*

2831 St. Jerome in the wilderness (about to beat his chest with a rock, under an orange tree) with city in background, by Andrea Mantegna, c. 1480–90. NGA, Wash. DC; Walker, *NGA.*

2832 St. Jerome in the wilderness (balding, with black hair and a black beard, kneeling before a crucifix with his lion), woodcut by Martin Flach from a "Life of St. Jerome," Basel, c. 1480. The Illus. Bartsch; *German Book Illus.* (Vol.82, p.235).

2833 St. Jerome in the wilderness (kneeling at the edge of a cliff, worshipping a crucifix tied to a tree branch), by Pinturicchio, 1480's. Walters Art Gallery, Baltimore; *Italian Paintings* (Vol.I).

2834 St. Jerome reading (before a well at his cave; rabbits touch noses on a grassy ledge at his side), by Giovanni Bellini, c. 1480–90. NGA, Wash. DC; Phaidon, *Art Treasures*; Shapley, *15th– 16th Cent.*; Walker, *NGA.*

2835 St. Jerome, before a crucifix in the wilderness, eyes closed, by Filippino Lippi. Uffizi, Florence; Praeger, *Great Galleries.*

2836 St. Jerome, sitting in cardinal's robe, with his lion, from "Four Fathers of the Church" altarpiece from Neustift Monastery by Michael Pacher, c. 1480. Alte Pinakothek, Munich; Bentley, *Calendar*; Janson, *Picture History*; McGraw, *Dict.*; Piper, *Illus. Dict.* (p.87).

2837 St. Jerome in the wilderness (kneeling, holding a rock; Christ Child and John the Baptist stand behind him), by Pietro Perugino, c. 1481-82. NGA, Wash. DC; Shapely, *15th-16th Cent.*; Walker, *NGA*.
2838 St. Jerome penitent, sitting on a rock, by Leonardo Da Vinci, 1483. Vatican Museums; Book of Art, *Ital. to 1850*; Calvesi, *Vatican*; Denvir, *Art Treasures*; McGraw, *Encyclo.* (Vol.IX, pl.115); Rowling, *Art Source Book.*
2839 The Crucifixion with the Virgin and St. John in center panel, flanked by St. Jerome at left, and Mary Magdalene at right, by Pietro Perugino, after 1483. NGA, Wash. D.C.; Hall, *Color and Meaning.*
2840 Saint Jerome in the desert (in a white sleeveless tunic buttoned at the shoulder, reading a book before a cave), by Giovanni Bellini, c. 1485. Coll. Contini-Bonacossi, Florence; New Int'l Illus. *Encyclo.* (see Venetian Art).
2841 St. Jerome in the wilderness (kneeling before a tiny crucifix at the mouth of his cave), predella of the Pesaro altarpiece by Giovanni Bellini. Correr Museum, Venice; Goffen, *Bellini.*
2842 St. Jerome in the wilderness before a fantasy mountain landscape by Jacopo da Valenza, 1484-1509. Boston Museum of Fine Arts.
2843 Virgin and Child (in a landscape) with SS. Jerome (in penitence), and Dominic (reading a book), predella panel by Filippino Lippi, c. 1485. Nat'l Gallery, London; Dunkerton, *Giotto to Dürer.*
2844 St. Jerome in penitence (he prays before a large crucifix), by Simon Marmion from the Huth Hours, add. ms.38126,fo.133v, late 1480's. BM, London; BL, *Ren. Painting in MS.*
2845 St. Jerome in penitence (in the wilderness), predella panel of the San Marco Altarpiece by Sandro Botticelli, c. 1490-93. Uffizi, Florence; Lightbown, *Botticelli.*
2846 St. Jerome in the wilderness (under a rocky overhang, holding a rosary), by Andrea Mantegna. São Paulo, Museo de Arte, Brazil; Berenson, *Ital. Painters*; Lightbown, *Mantegna.*
2847 St. Jerome supporting two men on the gallows (he prevents them from dropping), by Perugino. Louvre, Paris; Gowing, *Paintings*; Puppi, *Torment.*
2848 The Pieta of Canon Lluis Desplà

(Mary supports Jesus on her lap, as Lluis Desplà i Oms kneels at her left, and Jerome kneels at her right, wearing glasses, paging through his Bible), by Bartolomé Bermejo, 1490. Catalan Museum, Barcelona: Int'l Dict., *Art.*
2849 St. Jerome in his study (facing the viewer, sitting at a table), by Antonio da Fabriano, 1491. Walters Art Gallery, Baltimore; *Italian Paintings* (Vol.I).
2850 St. Jerome in his study (tending to his lion), woodcut by Albrecht Dürer, 1492. Snyder, *Northern Ren.*
2851 St. Jerome in the wilderness (kneeling next to a cliff, wrapped in a pink cloak), by Sandro Botticelli, early 1490's. Hermitage, St. Petersburg; Eisler, *Hermitage*; Lightbown, *Botticelli.*
2852 St. Jerome in a landscape before a crucifix, on one knee, leaning forward, a rock held out in his right hand, by Cima da Conegliano, after 1492. Nat'l Gallery, London; Dunkerton, *Giotto to Dürer*; Praeger, *Great Galleries.*
2853 St. Jerome in his study (reading at a long desk, before open cupboards) by school of Bellini. Nat'l Gallery, London; Poynter, *Nat'l Gallery.*
2854 St. Jerome in the wilderness, kneeling before a cross (castle in background), by Giovanni Battista Cima da Conegliano. NGA, Washington DC; Berenson, *Ital. Painters*; Ferguson, *Signs*; Shapely, *15th-16th Cent.*; Walker, *NGA.*
2855 The last communion of St. Jerome (he kneels, supported by a monk), by Sandro Botticelli, 1494-95. Met Museum; Hibbard, *Met Museum*; Kaftal, *Tuscan*; Lassaigne, *Fifteenth Cent.*; Lightbown, *Botticelli*; Praeger, *Great Galleries.*
2856 St. Jerome in his cell (writing, as his lion claws at his robe), by Matteo di Giovanni, late 15th cent. Fogg Art Museum, Cambridge MA; Edgell, *Sienese Paintings*; *Med. and Ren. Paintings.*
2857 Last communion of St. Jerome (he is supported by two monks); the death of St. Jerome (a monk examining him holds his own head), by Bartolomeo di Giovanni. Walters Art Gallery, Baltimore; *Italian Paintings* (Vol.I).
2858 San Jerónimo as a monkish scribe, by Segovia School, c. 1500. Lázaro Galdiano Museum, Madrid; Smith, *Spain.*
2859 St. Jerome (in a pink robe) in the

wilderness, from triptych of Three Hermit Saints by Hieronymus Bosch, c. 1500. Venice, Ducal Palace; McGraw, *Encyclo.* (Vol.XII, pl.372); New Int'l Illus. *Encyclo.*

2860 St. Jerome (meditating, with a closed book, before his cave), by Bartolomeo Montagna, c. 1500. Brera, Milan; Newsweek, *Brera.*

2861 St. Jerome kneels before a cross, predella panel from altarpiece of The Virgin and Child with St. Jerome and St. Sebastian, by Carlo Crivelli after 1490. NGA, Washington DC; Book of Art, *Ital. to 1850.*

2862 St. Jerome penitent, wearing his mantle open across his chest, in a landscape, by Master of St. Giles, c. 1500. Picture Gallery, Berlin; *Catalogue.*

2863 St. Jerome reading (sitting in a rocky landscape, a book on his knee), by Marco Basaiti, late 15th–early 16th cent. Nat'l Gallery, London; Poynter, *Nat'l Gallery.*

2864 St. Jerome, sitting before a cave, left foot elevated on a rock, contemplating a skull, by anon. Italian artist, late 15th–early 16th cent. Walters Art Gallery, Baltimore; *Ital. Paintings* (Vol.II).

2865 St. Jerome revives three dead men; the miracle of St. Jerome (he prays for a decapitated woman), in predella of the Crucifixion by Raphael, c. 1501. Lisbon, Museu Nacional de Arte Antiga; Raphael, *Complete Works* (1.22).

2866 Madonna enthroned (flanked by angels) with SS. Jerome and Bartholomew, by Raffaellino del Garbo, 1502. M. H. de Young Memorial Museum, San Francisco CA; *European Works.*

2867 St. Jerome in penitence (holding a rock and pulling his beard), by Lucas Cranach the Elder, 1502. KM, Vienna; Friedländer, *Cranach*; McGraw, *Encyclo.* (Vol.IV, pl.42); Schade, *Cranach*; Snyder, *Northern Ren.*

2868 The funeral of St. Jerome (he is lying on the ground, surrounded by kneeling monks), by Vittore Carpaccio, 1502. Venice, Scuola di S. Giorgio degli Schiavoni; Huse, *Venice*; McGraw, *Encyclo.* (Vol.XII, pl.45).

2869 St. Jerome punishing the heretic Sabinian (Jerome comes out of a cloud and grabs Sabinian's arm, as he is about to decapitate a man; another man lay on the ground with his head severed), by Raphael, 1503. North Carolina Museum of Art, Raleigh; *Intro. to the Coll.*

2870 St. Jerome in his study (at a table on a small platform) before a cubicle containing an altar, by Vittore Carpaccio. Venice, Scuola di San Giorgio degli Schiavoni; Berenson, *Ital. Painters*; New Int'l Illus. *Encyclo.*

2871 St. Jerome, with a church in the background, by Hans Schaufelein, c. 1505. Picture Gallery, Berlin; *Catalogue.*

2872 The Holy Virgin with St. John the Baptist, St. Jerome, and a kneeling donor, by Jan Provoost, c. 1505. Mauritshuis, The Hague; *Catalogue.*

2873 St. Jerome (balding, kneeling before a crucifix on a hillside), by the school of Gerard David, c. 1506. Städelsches Kunstinstitut, Frankfurt; Miegroet, *David.*

2874 St. Jerome in a landscape (balding, kneeling before a cross with a rock in his right hand, dressed in a grey robe, with his red robe on the ground behind him), by the workshop of Gerard David. Nat'l Gallery, London; Dunkerton, *Giotto to Dürer*; Miegroet, *David.*

2875 St. Jerome in the wilderness (sitting on a flat rock, leaning against a boulder), by Lorenzo Lotto, 1506. Louvre, Paris; Berenson, *Lotto*; Gowing, *Paintings*; Lloyd, *1773 Milestones* (p.127).

2876 Penitence of St. Jerome (holding a book and rock, in the forest), by Albrecht Altdorfer, c. 1507. Picture Gallery, Berlin; Guillaud, *Altdorfer*; Picture Gallery, *Catalogue.*

2877 St. Jerome (reading, hands clasped), stained glass window by the workshop of Veit Hirschvogel the Elder, c. 1507. Germanisches Nationalmuseum, Nuremberg; Met Museum, *Gothic Art.*

2878 St. Jerome (with a black beard, standing in his cardinal's robes and reading before a garden wall), from the dismembered "God Between Two Angels" altarpiece by Gerard David, c. 1507. Bianco Palace, Genoa; Miegroet, *David*; United Nations, *Dismembered Works.*

2879 St. Jerome and the lion (as he enters the monastery with the lion, the monks run away from him), by Vittore Carpaccio, c. 1507. Venice, Scuola Dalmata; Munro, *Golden Encyclo.*

2880 St. Jerome penitent, holding two rocks before nearly life-sized crucifix, grisaille by Jan Grossaert, 1509–12. NGA, Washington DC; Phaidon, *Art Treasures*; Walker, *NGA.*

2881 St. Jerome, in scarlet robe, stands

behind a kneeling votary, from altarpiece by Gerard David, c. 1509. Jules S. Bache Collection; *Catalogue.*

2882 St. Jerome, penitent (kneels before a crucifix nailed to a tree, next to a stream), woodcut by Lucas Cranach the Elder, Munich, 1509. Geisberg, *Single Leaf*; Schade, *Cranach.*

2883 St. Jerome (kneeling before a crucifix, rock in hand), by Lucas Van Leyden. Picture Gallery, Berlin; McGraw, *Encyclo.* (Vol.IX, pl.215).

2884 St. Jerome and the lion (he is tending its foot), alabaster statuette by Tilmann Riemenschneider, c. 1510. Cleveland Museum of Art, OH; *Selected Works.*

2885 St. Jerome in his study (with a lion and a dog on the floor before his table), engraving by Albrecht Dürer. Nelson-Atkins Museum of Art, Kansas City MO; *Handbook.*

2886 St. Jerome kneeling before a cross, his cardinal's robe hanging on a tree, by Adriaen Isenbrandt, 1510–15. Philadelphia Museum of Art, PA.

2887 The penance of St. Jerome (in a landscape, dressed in blue), by Albrecht Dürer. Fitzwilliam Museum, Cambridge; Strieder, *Dürer.*

2888 St. Jerome (penitent before a stream), woodcut by Hans Baldung Grien, Wolfenbüttel, 1511. Geisberg, *Single-Leaf.*

2889 St. Jerome in his chamber (writing), woodcut by Albrecht Dürer, Brunswick, 1511. Geisberg, *Single-Leaf*; Strauss, *Woodcuts* (pl.159).

2890 St. Jerome in a rocky landscape (writing at a slate table) by Lucas Cranach the Elder, c. 1512–15. Picture Gallery, Berlin; *Catalogue*; Friedländer, *Cranach.*

2891 St. Jerome in the wilderness (translating the Bible, looking up), woodcut by Albrecht Dürer, 1512. Strauss, *Woodcuts* (pl.167).

2892 St. Jerome in the cave (praying), woodcut by Albrecht Altdorfer, Munich, c. 1513–15. Geisberg, *Single-Leaf.*

2893 St. Jerome in his cell (lion sleeping at his feet), woodcut by Albrecht Dürer, c. 1514. BM, London; *Book of Art, German & Spanish.*

2894 St. Jerome in his study (writing at his table next to a large window), engraving by Albrecht Dürer, 1514. Gowing, *Hist. of Art* (p.655); Snyder, *Northern Ren.*

2895 St. Jerome in the wilderness (dressed in a net-like shirt, kneeling among the thistles before a crucifix leaning against the cave opening), illum. by Jean Bourdichon from the Great Book of Hours of Henry VIII, 1514–18. Coll. Duke of Cumberland; *Great Hours.*

2896 Landscape with St. Jerome (kneeling at lower left), by Joachim Patiner. Nelson-Atkins Museum of Art, Kansas City MO; *Handbook.*

2897 St. Jerome (reading in his cave), woodcut by Hans Baldung Grien, Erlangen, 1515. Geisberg, *Single-Leaf.*

2898 St. Jerome in the wilderness (leaning across his book, holding a crucifix), by Lorenzo Lotto. Bruckenthal Gallery, Sibiu; Berenson, *Lotto*; Oprescu, *Great Masters.*

2899 St. Jerome in the wilderness (sitting before a fence made of tree branches), by Lorenzo Lotto. Castel Sant'Angelo, Rome; Berenson, *Lotto.*

2900 St. Jerome penitent, kneeling in the wilderness holding a rock behind him in his right hand, by Lorenzo Lotto, c. 1515. Birmingham Museum of Art, AL; *Samuel H. Kress Coll.*

2901 St. Jerome in the wilderness (writing at a table), by Lucas Cranach the Elder, 1515–20. Picture Gallery, Berlin; Friedländer, *Cranach.*

2902 St. Jerome (leaning toward a picture-book, hand on his skull, while sitting in his study), by Quentin Metsys, 1518–22. KM, Vienna; Bosque, *Metsys.*

2903 St. Jerome in the desert (he kneels before a crucifix, as his lion walks away), by Giovanni di Pietro. Louvre, Paris; Gowing, *Paintings.*

2904 Rocky landscape with St. Jerome (he kneels under a hide-covered shelter, his cardinal's robe flung over a broken tree branch), by Joachim Patinir, c. 1520. Louvre, Paris; Gowing, *Paintings*; Snyder, *Northern Ren.*

2905 St. Jerome (head in hand, in his studio, studying a book) by studio of Quentin Metsys. Private coll., Spain; Bosque, *Metsys.*

2906 St. Jerome (sitting, hand against his cheek, next to a candle in his study, with an open book), by Jan Metsys. KM, Vienna; Bosque, *Metsys.*

2907 St. Jerome (very gaunt, sitting in his studio next to an illuminated book), by Marinus van Reymerswaele. KM, Vienna; Bosque, *Metsys.*

2908 St. Jerome (with a forked, curly beard, pointing at a skull), by Albrecht Dürer. Lisbon, Museu Nacional de Arte Antiga; Bosque, *Metsys.*
2909 St. Jerome in cardinal's robe, by Quentin Metsys. Philadelphia Museum of Art, PA.
2910 St. Jerome in a (rocky) landscape, sitting under a shelter made of animal-hide (at lower right corner) by Joachim Patinir, c. 1520. Nat'l Gallery, London; Gowing, *Biog. Dict.*; McGraw, *Encyclo.* (Vol.V, pl.296); Wilson, *Nat'l Gallery.*
2911 St. Jerome in a landscape under a rude shelter, holding his lion's paw, by Joachim Patinir, c. 1520. Prado, Madrid; Gardner, *Art thru Ages*; New Int'l Illus. *Encyclo.* (see Flemish).
2912 St. Jerome in solitude (praying before a crucifix), engraving by Giovanni Battista Franco. Strauss, *The Illus. Bartsch* (Vol.32, no.38).
2913 St. Jerome in the wilderness (contemplating the Holy Scriptures), att. to Vincenzo Catena. Walters Art Gallery, Baltimore; *Italian Paintings* (Vol.II).
2914 St. Jerome in the wilderness (he wears a garment tied together with string, and sits on the ground, holding up a crucifix, with his right hand on a skull), by Giovanni Cariani, 1520–21. Formerly coll. Suardi, Bergamo; Pallucchini, *Cariani.*
2915 St. Jerome in the wilderness (kneeling before a cross, rock in hand), by Lorenzo Lotto, 1520. Allentown Art Museum, PA; Berenson, *Lotto*; *Samuel H. Kress*; Shapley, *15th–16th Cent.*
2916 St. Jerome in the wilderness (sitting, holding a crucifix), by Moretto da Brescia, 1520. Allentown Art Museum, PA; *Samuel H. Kress.*
2917 St. Jerome reading at a table before a cave (a tiny cardinal's hat and crucifix hang from a thin stick attached to table), by Bernardino or Giovanni da Asola. Rijksmuseum, Amsterdam; Gibbons, *Dossi.*
2918 The penitence of St. Jerome before a landscape, center panel of a triptych by Joachim Patinir, c. 1520. Met Museum; Hibbard, *Met Museum.*
2919 St. Jerome (at his desk, head in hand, finger on a skull, sitting beside a window showing himself in the wilderness with his lion), by Pieter Coeck. Coll. J. O. Leegenhoek, Paris; Marlier, *Coeck.*
2920 St. Jerome (at his desk, head in

hand, finger on a skull, sitting beneath an ornate clock), by Pieter Coeck, 1521. Coll. L. R. Piovano, Turin; Marlier, *Coeck.*
2921 St. Jerome (at his desk, head in hand, reading a manuscript and putting a forefinger on a skull), by Pieter Coeck, 1521. Coll. Dr. Clark-Kennedy, London; Marlier, *Coeck.*
2922 St. Jerome (at his desk, turning a page, finger on a skull, sitting beside an open window), by Pieter Coeck, 1521. Geneva, Art and History Museum; Marlier, *Coeck.*
2923 St. Jerome (in the wilderness, elbow on a boulder, contemplating the crucifix), by Pieter Coeck. Wiesbaden, Gemäldegalerie; Marlier, *Coeck.*
2924 St. Jerome (sitting before an open illuminated book, hands crossed at the wrists), by Marinus van Reymerswaele, 1521. Prado, Madrid; *La Peinture Flamande* (b/w pl.239); Snyder, *Northern Ren.*
2925 St. Jerome in his study (head in hand, his index finger against a skull), after the painting in Lisbon after Albrecht Dürer, att. to Joos van Cleve the Elder, c. 1521. Busch-Reisinger Museum, Cambridge; Mortimer, *Harvard Univ.*
2926 St. Jerome in penitence (he kneels in the wilderness holding up a crucifix; silhouette of Venice in background), by Paolo Veronese. Crocker Art Gallery, Sacramento CA; *Catalogue.*
2927 St. Jerome in the wilderness (praying before a crucifix with a rosary), by Domenico Beccafumi. Doria Pamphili Palace, Rome; Cooper, *Family Collections.*
2928 Cardinal Albrecht of Brandenburg as St. Jerome, indoors (sitting under a chandelier made of antlers), by Lucas Cranach the Elder, c. 1525. Ringling Museum of Art, Sarasota FL; Friedländer, *Cranach.*
2929 St. Jerome (in the forest, contemplating a crucifix as caravan crosses bridge in background) by Jacopo Bertucci. Louvre, Paris; Gibbons, *Dossi.*
2930 St. Jerome doing penance in a luxuriant landscape, by Lucas Cranach the Elder, c. 1525. Tiroler Landesmuseum Ferdinandeum, Innsbruck; Friedländer, *Cranach.*
2931 St. Jerome in the wilderness (chin in hand, leaning against a stump atop which lays a crucifix), by Dosso Dossi, 1525. Coll. Silj, Rome; Gibbons, *Dossi.*

2932 St. Jerome sitting in the forest, holding out a crucifix, an open book before him on a log (letter "D" with bone through its center in lower right corner), by Dosso Dossi. KM, Vienna; Gibbons, *Dossi.*

2933 Cardinal Albert of Brandenburg as St. Jerome in his study (lion walks across the floor toward a family of birds), by Lucas Cranach the Elder. Darmstadt, Landesmuseum; Friedländer, *Cranach*; McGraw, *Encyclo.* (Vol.IV, pl.34).

2934 Cardinal Albrecht of Brandenburg as St. Jerome, by Lucas Cranach the Elder, 1527. Picture Gallery, Berlin; *Catalogue*; Friedländer, *Cranach*; Redslob, *Berlin*; Schade, *Cranach*; Snyder, *Northern Ren.*

2935 Madonna and Child look down on St. John the Baptist and St. Jerome by Francesco Parmigianino, c. 1527. NGA, Washington DC; Book of Art, *Ital. to 1850.*

2936 The vision of St. Jerome (as saint sleeps, he dreams of St. John the Baptist, who points upward at Virgin and Child) by Parmigianino 1527. Nat'l Gallery, London; Gowing, *Biog. Dict.*; Hartt, *Ital. Ren.*; Levey, *Nat'l Gallery*; McGraw, *Encyclo.* (Vol.XI, pl.45).

2937 St. Jerome (in red) in his study, forefinger on a skull, with sign on wall reading "Homo Bulla" by Joos Van Cleve, 1528. Princeton Univ. Art Museum.

2938 St. Jerome in his study (with a forefinger on a skull), att. to Joos Van Cleve. Ponce, Museo de Arte; Held, *Catalogue.*

2939 St. Jerome (kneeling before a crucifix tied to a tree, with his forgiveness of two merchants who stole an ass from his lion's keeping), by the circle of Adriaen Isenbrandt, c. 1530. Ackland Art Museum, Chapel Hill; *A Handbook.*

2940 St. Jerome in his study (sitting on the floor beside a series of receding doorways), by Lorenzo Lotto. Hamburg, Kunsthalle; Berenson, *Lotto.*

2941 St. Jerome with a halo (wearing a cardinal's hat, reading a book), woodcut by Hans Sebald Beham. Geisberg, *Single-Leaf.*

2942 St. Jerome in penitence (in the wilderness), by Titian, c. 1531. Louvre, Paris; Gowing, *Paintings*; Wethey, *Titian* (pl.155).

2943 St. Jerome (sitting on a pedestal in the wilderness, wrapped in a red cloak, holding a crucifix at arm's length, with his right hand on a skull), by Bastarolo. Ferrara, Curia Archivescovile; Frabetti, *Manieristi.*

2944 St. Jerome in his study (at a table before a crucifix and an illustrated book, pointing at a skull), by Marinus van Reymerswaele. Ponce, Museo de Arte; Held, *Catalogue.*

2945 St. Jerome in the wilderness (in a rocky landscape with a walled city in background), by Giovanni Bellini and assistants. Nat'l Gallery, London; Goffen, *Bellini.*

2946 St. Jerome in the wilderness (sitting by a cave and pointing up, while his lion holds out a paw with a thorn), by Giovanni Bellini. Barber Inst. of Fine Arts, Birmingham; Goffen, *Bellini.*

2947 Virgin and Child, flanked by SS. Jerome and Francis, by Pontormo. Uffizi, Florence; Briganti, *Ital. Mannerism.*

2948 Temptation of St. Jerome, by Vasari, 1541. Pitti Palace, Florence; Murray, *Art & Artists.*

2949 St. Jerome in the wilderness (kneeling before a cross which is propped against a boulder), by Lorenzo Lotto. Doria Pamphili Palace, Rome; Berenson, *Lotto.*

2950 St. Jerome (at his desk, chest exposed, rock in his hand), by Pieter Coeck, 1543. Brussels, Musées Royaux des B/A; Marlier, *Coeck.*

2951 St. Jerome in his study (sleeping) by candlelight, att. to Aertgen van Leyden. Rijksmuseum, Amsterdam: *Paintings.*

2952 The penitent St. Jerome (nude, on one knee and kneeling forward on his left hand as he bends over the book and a crucifix, while holding a rock), by Jan Sanders Van Hemessen. Hermitage, St. Petersburg; Nikulin, *Soviet Museums.*

2953 St. Jerome (kneeling, adoring the crucifix which lies on the ground between his knees), by Lorenzo Lotto, 1546. Prado, Madrid; Berenson, *Lotto*; Newsweek, *Prado.*

2954 St. Jerome (praying, with his lion), from "Matricula of the University of Erfurt," painted by Hans Brosamer, ms. 1-1/X, B XIII-46, vol.2, fol.186r., 1549. Erfurt, Stadtarchiv; Rothe, *Med. Book Illum.* (pl.156).

2955 Madonna and Child with St. Jerome (reading), by Polidoro da Lanciano,

mid-16th cent. Fogg Art Museum, Cambridge MA; *Collection.*

2956 Mystical vision of St. Jerome (as he kneels in prayer, a woman walks away from him, taking putti with her), by Giorgio Vasari, c. 1550. Chicago Art Inst.; Maxon, *Art Institute.*

2957 St. Jerome (writing at a desk), engraving by Jacopo de Barbari. Strauss, *The Illus. Bartsch* (Vol.13, no.7).

2958 The meditation of St. Jerome (in his cell, he points at a skull) after a work by Albrecht Dürer. Rumania, Art Museum of the R.P.R.; Oprescu, *Great Masters.*

2959 Landscape (with a walled city) with the penitence of St. Jerome, pen and brown ink drawing by Pieter Bruegel the Elder, 1553. NGA, Washington DC; Walker, *NGA.*

2960 St. Andrew (holding a cross) and St. Jerome (seated facing Andrew with his books), by Tintoretto, 1553. Accademia, Venice; Valcanover, *Tintoretto.*

2961 St. Jerome (sitting, in a cave, leaning against one hand, a rock in the other hand), by Jacopo Bassano. Accademia, Venice; Denvir, *Art Treasures*; Praeger, *Great Galleries.*

2962 St. Jerome (with a brown beard) in his study, before a book with an illustrated page, by studio of Marinus van Roemerswaele. Rijksmuseum, Amsterdam: *Paintings.*

2963 St. Jerome in penitence (kneeling on boulders), by Titian and workshop, c. 1555. San Luca Academy, Rome; Wethey, *Titian* (pl.169).

2964 Holy Family with St. Jerome (semi-nude, kneeling before the Child, holding a skull; above, angels play an organ on a cloud), from an altarpiece by Paris Bordon. Milan, Santa Maria dei Miracoli; Fiorio, *Le Chiese di Milano.*

2965 St. Jerome (leaning against a boulder, looking up at a crucifix, rock in hand), by Titian, c. 1560. Brera, Milan; Ancona, *Garden* (fig.27); Newsweek, *Brera*; Wethey, *Titian* (pl.171).

2966 St. Jerome doing penance (he kneels in the wilderness, looking down at an open book), by Jacopo Bassano. Ponce, Museo de Arte; Held, *Catalogue*; *Museo de Arte.*

2967 St. Jerome with his lion, marble sculpture by Alexander Vittoria, c. 1565. Venice, S. Maria Gloriosa dei Frari; McGraw, *Encyclo.* (Vol.XII, pl.86); New Int'l Illus. *Encyclo.*

2968 Madonna (holding an apple) and Child with SS. Mary Magdalene and Jerome (with his lion), att. to Orazio Samacchini. Wight Art Gallery, Univ. of CA, Los Angeles; *Age of Correggio.*

2969 St. Jerome in penitence (hand on a book, looking at a crucifix), by Titian, c. 1570. Thyssen-Bornemisza Coll., Lugano; Wethey, *Titian* (pl.172).

2970 St. Jerome in the desert (turning to look at a serpent coming from the river) by Paris Bordon. Philadelphia Museum of Art, PA.

2971 St. Jerome in penitence (holding a book, looking at a crucifix, lion in lower left corner), by Titian, 1575. Nuevos Museos, Escorial; Wethey, *Titian* (pl. 195).

2972 St. Jerome in the wilderness (sitting on the ground before a cave, books at his feet, a sleeping donkey behind him) by studio of Jacopo Bassano. Fitzwilliam Museum, Cambridge; Catalogue, *Italian.*

2973 St. Jerome in the wilderness, laying a crucifix against an open book, by Paolo Veronese, c. 1580. NGA, Washington DC; Walker, *NGA.*

2974 St. Jerome kneeling next to a stream, miniature from Breviary of Philip II, fo.118v. El Escorial, Spain; Newsweek, *El Escorial.*

2975 St. Jerome (standing on a cloud, looking over his right shoulder), by Martin Freminet. Orléans, Musée des B/A; O'Neill, *L'Ecole Francaise.*

2976 St. Jerome (walking in the wilderness with his crucifix), woodcut by Giuseppe Scolari, c. 1590. Bayly Art Museum, Charlotte; *Selections.*

2977 St. Jerome in cardinal's robes, his hands on the Vulgate Bible, by El Greco, 1590–1600. Frick Coll., NY; Gudiol, *El Greco.*

2978 Last communion of St. Jerome (as cherubs descend) by Agostino Carracci, c. 1592. Bologna, Pinacoteca Nazionale; Book of Art, *Ital. to 1850*; Held, *17th & 18th Cent.*; Murray, *Art & Artists.*

2979 Madonna and Child with St. Jerome (holding an open book) and St. Francis (bending toward the Child's hand), known as the Scalzi Altar by Ludovico Carracci. Bologna, Pinacoteca Nazionale; Freedberg, *Circa 1600.*

2980 Madonna of St. Jerome (he stands at left, with a scroll and his lion, before the Madonna and Child with another female saint), called "Il Giorno"

by Correggio. Parma, Pinacoteca Nazionale; Book of Art, *Ital. to 1850*; Freedberg, *Circa 1600*; Larousse, *Ren. & Baroque*; Murray, *Art & Artists*; New Int'l Illus. *Encyclo.*

2981 St. Jerome (front view, wearing glasses and reading the Bible, with a skull on the table), by Hendrick Bloemaert. BS, Munich; Nicolson, *Caravaggesque Movement.*

2982 St. Jerome (in the wilderness, wearing glasses and translating the Bible), by Hendrick Bloemaert. Nasjonalgalleriet, Oslo; Nicolson, *Caravaggesque Movement.*

2983 St. Jerome in penitence (with all his attributes), by El Greco. NGS, Edinburgh; *Illustrations.*

2984 St. Jerome and the angel (he points to a page in his book), by Domenico Zampieri, called Domenichino, 1602. Nat'l Gallery, London; Poynter, *Nat'l Gallery*; Spear, *Domenichino.*

2985 The baptism of St. Jerome (as a young man); the vision of St. Jerome; frescoes by Domenichino, 1604–05. Rome, Sant'Onofrio; Spear, *Domenichino.*

2986 The temptation of St. Jerome (in the wilderness), fresco by Domenichino, 1604–05. Rome, Sant'Onofrio; Spear, *Domenichino.*

2987 The penitent St. Jerome (in the wilderness), ink drawing after Titian by P.P. Rubens, c. 1605. Stichting Teyler, Haarlem; Jaffé, *Rubens and Italy.*

2988 St. Jerome (kneeling in the wilderness, looking up as an angel steps out from a cloud), by Domenichino, c. 1606–08. Coll. Denis Mahon, London; Spear, *Domenichino.*

2989 St. Jerome in meditation (over a skull), by Caravaggio. Montserrat Museum, Barcelona; Met Museum, *Caravaggio.*

2990 The penitent St. Jerome (leaning on a skull, holding a rock, a painting of the nativity scene behind him) by Alessandro Allori 1606. Princeton Univ. Art Museum.

2991 St. Jerome (kneeling, semi-nude, on a rock, holding an open book with his left hand), by El Greco, c. 1610–14. NGA, Washington DC; Gudiol, *El Greco*; Walker, *NGA.*

2992 St. Jerome in a landscape, looking up as he writes, by Domenichino, c. 1610. Glasgow Art Gallery and Museum; Spear, *Domenichino.*

2993 The inspiration of St. Jerome, by Johann Liss. Venice, S. Niccolo dei Tolentini; Murray, *Art & Artists*; New Int'l Illus. *Encyclo.*

2994 St. Jerome (in penitence, holding a crucifix with a rock on his right hand, beneath a pillar atop which rests the lion), by Domenico Fetti, c. 1613–14. Prague Castle; Neumann, *Picture Gallery.*

2995 Last communion of St. Jerome, by Domenichino, 1614. Vatican Museums; *Age of Correggio*; Book of Art, *Ital. to 1850*; Gardner, *Art Thru Ages*; *Int'l Dict. of Art*; Larousse, *Ren. & Baroque*; Murray, *Art & Artists*; Spear, *Domenichino.*

2996 Study for the last communion of St. Jerome, drawing by Domenichino c. 1614. Windsor Castle; Spear, *Domenichino.*

2997 St. Jerome, holding up his hand in surprise as he looks at the celestial light, by unknown artist, c. 1615. Worcester Art Museum, MA; Spear, *Caravaggio.*

2998 St. Jerome in the wilderness (in the opening of a cave), by Anthony van Dyck, c. 1616. Coll. Lord Spencer, Althorp; Larsen, *Van Dyck* (pl.53).

2999 St. Jerome in the wilderness (sitting with a scroll across his lap, as a cherub stands at his back, plume in hand), by Anthony van Dyck, c. 1616–17. Stockholm, Nat'l Museum; Larsen, *Van Dyck* (pl.57).

3000 St. Jerome in the wilderness (writing on a parchment, with an open book at his feet), by Anthony van Dyck, c. 1616–17. Liechtenstein Coll., Vaduz; Baumstark, *Masterpieces*; Larsen, *Van Dyck* (pl.56).

3001 St. Jerome (holding a rock), after Anthony van Dyck, c. 1617. Prado, Madrid; Larsen, *Van Dyck* (pl.223).

3002 St. Jerome in the wilderness (kneeling before a crucifix beneath a cloth canopy, holding a rock), by Anthony van Dyck, c. 1617. Picture Gallery, Dresden; Larsen, *Van Dyck* (pl.54).

3003 St. Jerome in the wilderness (sitting with a scroll across his lap, as a cherub stands at his back, plume in hand), by Anthony van Dyck, c. 1617. Boymans-van Beuningen Museum, Rotterdam; Larsen, *Van Dyck* (pl.58).

3004 Saint Jerome (kneeling before a wicker table) by Domenico Robusti. Rome, Galleria Nazionale d'Arte Antica; New Int'l Illus. *Encyclo.* (see Tintoretto).

3005 St. Jerome (head and shoulders only, reading a book with a rough crucifix in his right hand), by Bernardo Strozzi. Accademia, Venice; Denvir, *Art Treasures*.

3006 St. Jerome (reading a book, as an angel instructs him), by Guercino. Georgetown Univ. Art Coll.; *Catalogue*.

3007 St. Jerome in ecstasy (one foot on his lion's head, left hand on an open book supported by a cherub), oil sketch by P.P. Rubens 1620. Akademie der Bildenden Künste, Vienna; Held, *Oil Sketches* (pl.38).

3008 St. Jerome in the wilderness (kneeling before a crucifix in left profile, as lion sleeps in lower right corner), by P.P. Rubens. Picture Gallery, Dresden; Larsen, *Van Dyck* (pl.55); *Old Masters*.

3009 St. Jerome, hands clasped, looking down at a skull, by Jacques de Rousseau, early 17th cent. Princeton Univ. Art Museum.

3010 St. Jerome in his study (sitting, at left, in a wood-paneled room, as seen through a large archway), by Hendrik van Steenwyck the Younger, 1624. Courtauld Inst. of Art, London; *Catalogue*.

3011 St. Jerome (looking at a manuscript through a magnifying glass, while he translates with his right arm stretched full length), by Valentin de Boulogne, c. 1625. Formerly Drouot Hotel, Paris; Mojana, *Valentin de Boulogne*.

3012 St. Jerome (writing) and the angel (behind him, holding a horn), by Simon Vouet, c. 1625. NGA, Washington DC; Phaidon, *Art Treasures*; Walker, *NGA*.

3013 St. Jerome (in cardinal's robes, holding open a large book), by Francisco de Zurbaran, 1626-27. Seville, Museum of Fine Arts; Gállego, *Zurbaran*.

3014 St. Jerome and the angel of the judgment (blowing on a trumpet), by Jusepe de Ribera, 1626. Capodimonte, Naples; Mojana, *Valentin de Boulogne* (p.33); RA, *Painting in Naples*; Yale, *Taste for Angels*.

3015 St. Jerome hears the trumpet (blown by an angel as he translates the Bible), by Jusepe de Ribera, 1626. Hermitage, St. Petersburg; Eisler, *Hermitage*.

3016 St. Jerome (sitting in penitence before a crucifix, wrapped in a cardinal's robe), by Valentin de Boulogne, 1628-30. Jewett Arts Center, Wellesley; Mojana, *Valentin de Boulogne*.

3017 St. Jerome (sitting with his book, half nude, looking at a light source), by Valentin de Boulogne, 1629. Camerino, Santa Maria in Via; Mojana, *Valentin de Boulogne*.

3018 St. Jerome (in meditation, holding up his right hand as a trumpet extends from a cloud above his head), by Anthony van Dyck, c. 1630. Coll. Bertil Rapp, Stockholm; Larsen, *Van Dyck* (pl.671a).

3019 St. Jerome (translating by the light of a candle), by Theophile Bigot, c. 1630. Nat'l Gallery of Canada, Ottawa; Spear, *Caravaggio*.

3020 St. Jerome reading (a piece of paper), holding spectacles, by Georges de la Tour. Hampton Court, Royal Coll.; Wright, *Reality*.

3021 St. Jerome translating the Bible (holding a Hebrew scroll), by workshop of Jusepe de Ribera. Detroit Inst. of Art, MI; *Treasures*.

3022 St. Jerome (in the wilderness, sitting before a crucifix, his hands crossed over a skull), by an unknown Ferrarese artist, c. 1632. Ferrara, Chiesa di S. Gerolamo; Frabetti, *Manieristi*.

3023 St. Jerome, half-length view holding a rock against his chest, looking at a crucifix, by Guido Reni, 1633-34. Nat'l Gallery, London; *Guido Reni*; Poynter, *Nat'l Gallery*.

3024 Penitence of St. Jerome (holding a crucifix and a flail) by Georges de la Tour, 1630's. Stockholm, Nat'l Museum; McGraw, *Encyclo.* (Vol.IX, pl.94); Praeger, *Great Galleries*; Random House, *Paintings* (p.192).

3025 St. Jerome (semi-nude, draped in a red mantle, approached by an angel while writing in a book), by Guido Reni, c. 1635. KM, Vienna; Lloyd, *1773 Milestones* (p.164).

3026 St. Jerome reading (at a table, draped in a cloak), by the studio of Claude Vignon, c. 1635. Orléans, Musée des B/A; O'Neill, *L'Ecole Francaise*.

3027 The penitence of St. Jerome (holding a crucifix and a flail), by Georges de la Tour. Grenoble, Musée de Peinture et de Sculpture; Châtelet, *French Paintings*; Levey, *Giotto to Cézanne*.

3028 Landscape with St. Jerome (kneeling, semi-nude) by Nicolas Poussin, 1636-37. Prado, Madrid; *Guide to Prado*; Wright, *Poussin*.

3029 Apotheosis of St. Jerome (cherubs

escort him to heaven), by Francisco de Zurbaran, 1638-40. Hieronymite Monastery, Guadeloupe; Gállego, *Zurbaran*.

3030 Scourging of St. Jerome (angels scourge him before Christ), by Francisco de Zurbaran, 1638-40. Hieronymite Monastery, Guadeloupe; Gállego, *Zurbaran*.

3031 Temptation of St. Jerome (women play musical instruments for him) by Francisco de Zurbaran, 1638-39. Hieronymite Monastery, Guadeloupe; Gállego, *Zurbaran*; Held, *17th & 18th Cent.*

3032 St. Jerome (reclining, leaning on an elbow, reading), att. to Pier Francesco Mola. NGS, Edinburgh; *Illustrations*.

3033 St. Jerome (sitting with a rock, contemplating a crucifix), by Anthony van Dyck. Prado, Madrid; *Peinture Flamande* (b/w pl.94).

3034 St. Jerome and the Angel (as he sits in the cave with his book, the angel speaks to him from upper left corner), by Guido Reni, c. 1640. Piacenza, Cathedral; *Guido Reni*.

3035 St. Jerome sitting with SS. Paula and Eustochium, by Zurbaran, 1640-58. NGA, Washington DC; Ferguson, *Signs*; Gállego, *Zurbaran*; Phaidon, *Art Treasures*; Walker, *NGA*.

3036 St. Jerome, wrapped in a red cloak, holding rock in right hand and skull in left, by Jusepe de Ribera, 1640. Fogg Art Museum, Cambridge MA; Cleveland Museum, *European 16th-18th Cent.*; Mortimer, *Harvard Univ.*; Spear, *Caravaggio*.

3037 The angel appearing to St. Jerome (as he writes), by Guido Reni, c. 1640. Detroit Inst. of Art, MI; *Guido Reni*.

3038 St. Jerome (holding a book, pointing up to upper left corner, where we see only a horn), by Francisco de Zurbaran, 1641-58. San Diego Fine Arts Gallery; Gállego, *Zurbaran*; *Master Works*.

3039 St. Jerome (pointing to a horn in upper right corner), by Francisco de Zurbaran 1641-58. Lima, Monastery of St. Camillus de Lellis; Gállego, *Zurbaran*.

3040 St. Jerome (sitting, wrapped in a cloak, holding a skull), by the workshop of Jusepe de Ribera, after 1640. Joslyn Art Museum; *Paintings & Sculpture*.

3041 St. Jerome in penitence (smiting his chest with a rock), by Francisco de Zurbaran 1641-58. Córdoba, Provincial Museum of Fine Arts; Gállego, *Zurbaran*.

3042 St. Jerome (bare-chested, resting his head against his right hand and looking up, resting a wooden cross against a book with his left hand) by Antonio de Pereda, 1643. Prado, Madrid; Larousse, *Ren. & Baroque*.

3043 St. Jerome (half-view, sitting at a table with his hands crossed, looking to the viewer's left), by Jusepe de Ribera, 1644. Prado, Madrid; Cleveland Museum of Art, *European 16th-18th Cent.*

3044 St. Jerome sitting, a red cloak on his lap, by Jusepe de Ribera, 1646. Prague, Nat'l Gallery; Praeger, *Great Galleries*.

3045 St. Jerome (circle bust portrait, with brown hair and beard, holding a sword's hilt), by Jusepe de Ribera. Ponce, Museo de Arte; Held, *Catalogue*.

3046 St. Jerome (sitting at a table with a brocade tablecloth, leaning his cheek on his hand in meditation), att. to Pietro Martire Neri, mid-17th cent. Bob Jones Univ. Art Gallery, Greenville, SC; Pepper, *Ital. Paintings*.

3047 St. Jerome (sitting on the floor with his books, sharpening his pen), by Elisabetta Sirani, 1650. Bologna, Pinacoteca Nazionale; *Age of Correggio*.

3048 St. Jerome (wrapped in a red cloak, looking holding a skull and looking at a small crucifix), by Jusepe de Ribera, 1651-52. Cleveland Museum of Art, OH; *European 16th-18th Cent.*; Spear, *Caravaggio*.

3049 St. Jerome in the wilderness (in a red wrap, writing on a slab table), by Hendrick van Someren, 1651. Trafalgar Galleries, London; Briels, *Peintures Flamands*.

3050 St. Jerome (sitting at a rough-hewn table before a crucifix, hand on a book, lit by a small window), by Matthias Stomer, after 1650. Nantes, Musée des B/A; Cousseau, *Musée*.

3051 St. Jerome in the desert (he holds his crucifix, while angels watch him from a cloud), oil on copper by Pietro da Cortona. Detroit Inst. of Art, MI; *Treasures*.

3052 Vision of St. Jerome (he recoils as the angel of judgment blasts him with a trumpet), by Giovanni Battista Langetti. Cleveland Museum of Art, OH; *European 16th-18th Cent.*

3053 Baptism of St. Jerome (dressed as

a rich young man, he is greeted by the pope and cardinals); flagellation of St. Jerome (beaten by angels as Christ looks on); panels painted for the Monastery of Saint Jerome of Buenavista by Juan de Valdés Leal, c. 1657. Seville, Museum of Fine Arts; United Nations, *Dismembered Works*.

3054 The temptation of St. Jerome (he resists beautiful women playing musical instruments for him), by Juan de Valdés Leal, 1657. Seville, Museum of Fine Arts; Book of Art, *German & Spanish*; United Nations, *Dismembered Works*.

3055 St. Jerome with the pagan doctors (he disputes with them as they sit around a table); painted for the Monastery of Saint Jerome of Buenavista by Juan de Valdés Leal, c. 1657. Coll. Cremer, Dortmund; United Nations, *Dismembered Works*.

3056 St. Jerome (half-nude, hands clasped with a skull resting on his wrists, looking up over his left shoulder, lion at his feet), marble sculpture by Johann Mauritz Gröninger. Münster, St. Martini; *800 Jahre*.

3057 St. Jerome (resting a crucifix against his cheek), marble sculpture by Gianlorenzo Bernini, 1661-63. Siena, Cathedral; Held, *17th & 18th Cent.*

3058 Terracotta head of St. Jerome, by Giovanni Lorenzo Bernini, c. 1661. Fogg Art Museum, Cambridge MA; Mortimer, *Harvard Univ.*

3059 St. Jerome and the recording angel (it blows a horn as he listens), by Michael Willmann Leopold, c. 1665. Prague, Nat'l Gallery; National Gallery, *Baroque*.

3060 St. Jerome kneeling before the crucifix (arms outspread), drawing by Gianlorenzo Bernini, 1665. Louvre, Paris; Boone, *Baroque*.

3061 St. Jerome, kneeling, looking up from his manuscript, by G. de Haen. Rijksmuseum, Amsterdam: *Paintings*.

3062 St. Jerome (crouching in prayer, his head level with a table), by Matthijs Naiveu, 1676. Rijksmuseum, Amsterdam: *Paintings*.

3063 St. Jerome standing, holding manuscript and quill, as angels hover over his head with a cardinal's hat, by Juan de Valdés Leal. Prado, Madrid; Gowing, *Biog. Dict.*; United Nations, *Dismembered Works*.

3064 St. Jerome and the angel (he looks up in surprise as the angel blows a horn), by Michel II Corneille Le Jeune, c. 1691. Orléans, Musée des B/A; O'Neill, *L'Ecole Francaise*.

3065 Last communion of St. Jerome (before the altar, Jerome is held up by his companions as the priest bends over with a host), by Subleyras. Carcassonne, Church of St. Vincent; *Subleyras*.

3066 St. Jerome reading (sitting in the wilderness), by Giuseppe Maria Crespi, c. 1700. Nat'l Gallery, London; Merriman, *Crespi*.

3067 St. Jerome (his back to the viewer, contemplating his manuscript), by Pieter van der Werff, 1710. Rijksmuseum, Amsterdam; *Paintings*.

3068 St. Jerome (contemplating his crucifix, as cherubs look on from a cloud), by Giovanni Battista Pittoni. Rimini, Pinacoteca Civica; Boccazzi, *Pittoni* (pl.38).

3069 The death of St. Jerome (leaning against a rock, as angels look on), oil sketch by Giambattista Tiepolo, 1732-33. Poldi-Pezzoli Museum, Milan; Morassi, *Tiepolo*.

3070 The last communion of St. Jerome (given by angels), oil sketch by Giambattista Tiepolo, 1732-33. Stuttgart, Staatsgalerie; Morassi, *Tiepolo*.

3071 Vision of St. Jerome (he kneels in the wilderness, hand on his papers, and looks up into the heavens at four angels who blow the trumpets of Judgment), by Subleyras, 1739. Brera, Milan; *Subleyras*.

3072 St. Jerome in the desert (reclining in a cave, writing in a book while holding an ink pot; the lion looks in near his feet), by Pompeo Batoni, 18th cent. Private coll., Rome; Clark, *Batoni*.

3073 St. Jerome (helped by an angel) and St. Peter of Alcantara (kissing a large cross) by Giambattista Pittoni. NGS, Edinburgh; Boccazzi, *Pittoni* (pl.131); Gowing, *Biog. Dict.*

3074 St. Jerome in the desert listening to angels, drawing by Giovanni Battista Tiepolo. NGA, Washington DC; Walker, *NGA*.

3075 St. Jerome on a rock, holding a crucifix, painted wooden sculpture by Francisco Salzillo, 1755. Salzillo Museum, Murcia; Book of Art, *German & Spanish*.

3076 St. Jerome (sitting at a table with an open book, looking at a crucifix), by Januarius Zick. Helen Foresman Spencer Museum of Art, Lawrence KS; *Handbook*.

3077 St. Jerome (leaning against a boulder, studying the crucifix), by Goya, 1781-85. Norton Simon Museum of Art, Pasadena CA; Cleveland Museum of Art, *European 16th-18th Cent.*

3078 St. Jerome (kneeling with his lion, listening to the trumpet), cotton cloth retable with oil-based paints and wood frame, Retablo Style IV, late 19th cent. Taylor Museum for Southwest Studies, CO; Wroth, *Images of Penance.*

See also 137, 138, 139, 141, 144, 146, 167, 209, 389, 450, 489, 490, 494, 497, 499, 502, 505, 512, 517, 520, 766, 818, 843, 875, 1028, 1069, 1093, 1141, 1199, 1208, 1227, 1232, 1270, 1343, 1389, 1416, 1680, 1801, 1859, 1921, 1922, 1929, 2075, 2095, 2101, 2102, 2104, 2329, 2745, 3323, 3338, 3393, 3418, 3424, 3426, 3507, 3551, 3976, 4014, 4065, 4183, 4299, 4308, 4925, 4932

Jerome Emiliani, Patron of orphans and abandoned children, priest in Venice; died of the plague in 1537 (Feb. 8)
3079 St. Jerome Emiliani (hands clasped in prayer), portrait by L. de Bassano. Correr Museum, Venice; Bentley, *Calendar.*

Joan of Arc, virgin martyr, rallied the French in the Hundred Years' War; burned at the stake; mart. 1432 (May 30)
3080 Joan of Arc brought before the Dauphin at Chinon, from Monstrelet's "Chroniques de France," ms. Royal D VIII, fo. 7, c. 1428. BM, London; Minney, *Tower.*

3081 Joan of Arc attacks Paris (fo. 66v); Joan with Charles VII (fo.64v); from "Les Vigiles de Charles VII," ms. fr. 5054, c. 1429. BN, Paris; Horizon, *Middle Ages.*

3082 Joan of Arc chasing away the camp followers of the army, from "Vigiles de Charles VII," ms. fr. 5054, fo.60v, c. 1429. BN, Paris; Maurois, *Histoire.*

3083 Joan of Arc tied to a stake, from "Les Vigiles de Charles VII," ms. fr. 5054, fo.72, c. 1429. BN, Paris; Horizon, *Middle Ages*; Milestones, *Expanding.*

3084 Joan of Arc, while attempting to raise the siege of Compiegne, is captured by John of Luxembourg and sold to the English, from "Vigiles de Charles VII," ms. fr. 5054, c. 1429. BN, Paris; Larousse, *Medieval History.*

3085 Joan of Arc arrives at Chinon before Charles VII, contemp. tapestry. Orléans, Musée des B/A; Weygand, *L'Armee.*

3086 Joan of Arc in armor, carrying Christ's banner, miniature. Private Coll., Belgium; Horizon, *Middle Ages.*

3087 Jeanne d'Arc taken to prison at Rouen, woodcut from Martial d'Auvergne, "Les Vigiles de la Mort du Roi Charles V," Paris, c. 1493. Hind, *Woodcut.*

3088 Joan of Arc at the siege of Orleans, from ms. 2679, fo.66. BN, Paris; Fowler, *Age of Plant.*

3089 Joan of Arc on horseback in armor carrying a banner, drawing from Antoine du Four's "Lives of Famous Women." Nantes, Biblio.; Castries, *K & Q of France*; Milestones, *Expanding.*

3090 Joan of Arc (kneeling in left profile, wearing a full suit of armor), by P.P. Rubens, c. 1615-20. North Carolina Museum of Art, Raleigh; *Intro. to the Coll.*

3091 Joan of Arc and the furies (Joan holds up an arm and they shrink away from her), by William Hamilton, 1791-1800. Vassar College Art Gallery, NY; Cummings, *Romantic*; *Paintings, 1300-1900.*

3092 Joan of Arc imprisoned at Rouen (she sits chained to a straw bed in prison, rejecting the men who come in to laugh at her), by Pierre Révoil, 1819. Rouen, Musée des B/A; Bergot, *Musée.*

3093 Joan of Arc in prison, by Paul Delaroche, 1824. Private coll.; Ziff, *Delaroche.*

3094 Joan of Arc, sick in prison, is interrogated by the cardinal of Winchester, by Paul Delaroche, 1824. Rouen, Musée des B/A; Bergot, *Musée.*

3095 The entry of Joan of Arc into Orleans, 1429, by H. Scheffer. Versailles, Galerie des Batailles; Gaehtgens, *Versailles.*

3096 Joan of Arc at the coronation of Charles VII (standing by the altar in full Gothic plate and a skirt), by Jean-Auguste-Dominique Ingres, 1854. Louvre, Paris; McGraw, *Encyclo.* (Vol.XII, pl.373); Wildenstein, *Ingres.*

3097 Marble statue of Joan of Arc. Versailles; Minney, *Tower.*

3098 Joan of Arc (in a peasant's dress, standing under a tree; transparent angels float behind her), by Jules Bastien-Lepage, 1879. Met Museum; Hibbard, *Met Museum.*

3099 Gilded bronze equestrian statue of Joan of Arc, by Emmanuel Fremiet, 1880. Place des Pyramides, Paris; New Int'l Illus. *Encyclo.*

3100 Joan of Arc storming the "Bulwark" at Orleans, by J.E. Lenepveu. Parrott, *British.*

3101 Joan of Arc at the coronation of Charles VII (king is crowned as she stands behind him with a banner), by Jules-Eugène Lenepveu, 1889. Pantheon, Paris; Rosenblum, *Ingres.*

3102 Joan of Arc (on horseback, holding up a standard), bronze statuette by Emmanuel Fremiet. Snite Museum of Art, IN; *Guide to the Snite Museum.*

3103 Joan of Arc, statue by Rude. Louvre, Paris; Coulson, *Saints.*

Joan of Montefalco, Augustinian nun, founded Monastery of Santa Croce, d. 1291 (Nov. 22)

3104 St. Joan of Montefalco (in nun's habit, holding a lily), fresco by the Umbrian School, 15th cent. Montefalco, S. Chiara; Kaftal, *Central and So. Ital.*

Joan of Valois, Queen of France, d. 1505, canon. 1950 (Feb. 4)

3105 Joan of France, repudiated by Louis XII, obtains permission from the Pope to found the Order of the Annunciation, ms. illumination. BN, Paris; Castries, *K & Q of France.*

John I, Pope, r. 523–526 (May 27)

3106 Pope John I before Theodoric, king of the Ostrogoths, fresco from the Church of Santa Maria in Portofuori, 14th cent. Ravenna, Italy; Boudet, *Rome*; John, *Popes.*

3107 John I, from mosaic in the Basilica of St. Paul-Outside-the-Walls, Rome. Brusher, *Popes thru the Ages.*

John Bishop

3108 Madonna with Saints Catherine of Alexandria, Charles Borromeo and John Bishop, by Giambattista Tiepolo. Private Coll., Milan; Morassi, *Catalogue.*

John Calibrita *see* **John Kalyvitis**

John Calybites *see* **John Kalyvitis**

John Capistrano or Giovanni Capestrano, Franciscan Monk, d. 1456, canon. 1689 (Mar. 28 or Oct. 23)

3109 Scenes from the life of St. John

Capistrano: mass of St. John, where a divine arrow descends with a scroll bearing "Giovanes noli timere"; St. John blesses the army against the Turks at the battle of Belgrade; St. John exorcises a man while preaching in Aquila; funeral of St. John, from an altarpiece by the Master of St. John Capestrano. Aquila, Museo Nazionale; Kaftal, *Central and So. Ital.*

3110 St. John Capistrano (standing in monk's robes, holding a book and a banner), from an altarpiece by the Master of St. John Capestrano. Aquila, Museo Nazionale; Kaftal, *Central and So. Ital.*

3111 St. John of Capistrano (with a banner showing a saint), by Bartolomeo Vivarini. Louvre, Paris; Gowing, *Paintings*; Kaftal, *North East Italy.*

3112 St. John Capistrano (holding a banner) and St. Bernardino of Siena (holding a book with IHS on cover), by Alonso Cano, 1653–57. Granada, Museo Provincial; Book of Art, *German & Spanish*; Wethey, *Alonso Cano* (pl.103).
See also 1847, 3425

John Cassian *see* **Cassian**

John Chrysostom, archbishop of Constantinople, Doctor of the Eastern Church, d. 407 (Jan. 27 & Sept. 14)

3113 Transportation of the relics of St. John Chrysostom (carried in a coffin by two men, while others hold candles), anon. fresco. Constantinople, Church of the Apostles; Pischel, *World History* (p.249).

3114 John Chrysostom holding an open book, miniature on reliquary, 11th cent. Cristiano Museum, Vatican; Coulson, *Saints.*

3115 Emperor Nicephorus II Botaniates (1078–81) flanked by St. John Chrysostom and Archangel Michael, ms. illum. from a copy of Homilies of St. John Chrysostom, ms. Coislin 79, fo.2v, c. 1070. BN, Paris; Oxford, *Medieval Europe.*

3116 Saints Gregory, Basil the Great, and John Chrysostom, mosaic c. 1143. Palatina, Palermo; McGraw, *Encyclo.* (Vol.II, pl.457).

3117 St. John Chrysostom, mosaic, mid-12th cent. Palatina, Palermo; Snyder, *Medieval.*

3118 St. John Chrysostom, miniature mosaic, Constantinople, early 14th. cent.

Dumbarton Oaks Collection, Washington, D.C.; Beckwith, *Pelican History*; Knopf, *The Icon* (pl.81).
3119 St. John Chrysostom, icon of the 16th cent. Archangel, Museum of Fine Arts; Knopf, *The Icon* (p.292).
3120 St. John Chrysostom altarpiece (John sits at center in right profile, writing, surrounded by other saints), by Sebastiano del Piombo, c. 1510. Venice, San Crisostomo; Fischer, *Fra Bartolommeo* (fig.232).
3121 St. John Chrysostom holding a scroll, fresco by Domenichino, 1608–10. Grottaferrata Abbey; Spear, *Domenichino*.
3122 St. John Chrysostom and Fray Luis de Granada, by Francisco de Zurbaran, 1651. Private coll., Lima; Gállego, *Zurbaran*.
3123 Immaculate Conception, with SS. John the Evangelist, Gregory I, John Chrysostom, and Augustine, by Carlo Maratti. Rome, S. Maria del Popolo; DiFederico, *Trevisani*.
See also 627, 2594, 4475

John Climacos, abbot at Mt. Sinai, spiritual writer of "The Ladder to Paradise," "7th cent. (Mar. 30)
3124 The vision of St. Climacos (he exhorts the brethren to climb the heavenly ladder; two monks fall off toward hell), tempera on wood icon, Novgorod, mid-16th cent. State Russian Museum, St. Petersburg.
3125 St. John Climacos and the communion of St. Mary of Egypt, icon by Longin, 1596. Serbia, Monastery of Decani; Knopf, *The Icon* (p.349).

John Damascene, Basilian monk, Doctor of the Eastern church, author of "Of the Orthodox Faith," d. 570 (Mar. 27)
3126 Scenes from the life of St. John Damascene: taken prisoner by the Saracens; sold by pirates to a rich Saracen; the Saracen makes him a tutor; the emperor Theodosius hears of John, and demands that the Saracen give him up; he debates with John; he appoints him counselor; John is betrayed by his old master's son, who gives the emperor a forged letter; frescoes by the Lombard School, late 14th cent. Lodi, S. Francesco; Kaftal, *North West Italy*.
3127 Scenes from the life of St. John Damascene: the emperor shows John a

forged letter, but John denies having written it; the emperor orders John's thumb to be cut off; the executioner cuts off both John's hands; John prays to Our Lady, who takes his hands which are hung above the church's door; the Virgin replaces John's hands in his sleep; frescoes by the Lombard School, late 14th cent. Lodi, S. Francesco; Kaftal, *North West Italy*.
3128 Scenes from the life of St. John Damascene: John gives mass after his hands are restored; the emperor begs his forgiveness, and condemns the man who has falsely accused John; John intercedes for the man, and changes the punishment to exile; death of St. John Damascene; frescoes by the Lombard School, late 14th cent. Lodi, S. Francesco; Kaftal, *North West Italy*.
3129 St. John Damascene pointing at an open book, fresco by Domenichino, 1608–10. Grottaferrata Abbey; Spear, *Domenichino*.

John Fisher, Bishop of Rochester; beheaded same day as St. Thomas More, mart. 1535, canon. 1935 (June 22)
3130 Executions of Thomas More and John Fisher, engraving from R. Verstegan's "Theatrum Crudelitatium Haerecticorum Nostri Temporis," Antwerp, 1592. Hay, *Renaissance*.

John Francis Regis *see* **Francis Regis**

John Gualbertus, founded the Vallombrosan Benedictines, d. 1073, canon. 1210 (July 12)
3131 Scenes from the life of St. John Gualbertus: he is about to kill a murderer, then decides against it; Christ speaks to him from the crucifix, acknowledging his act of mercy; he takes the Benedictine habit; predella to an altarpiece by Master of S. Andrea a Cecina, c. 1380. Florence, S. Miniato; Kaftal, *Tuscan*.
3132 Conversion of St. John Gualbertus (he is about to kill the murderer of a relative, then decides against it), by the Florentine School, 15th cent. Vatican Museums; Francia, *Vaticana*; Kaftal, *Tuscan* (fig.660).
3133 Scenes from the life of St. John Gualbertus: he puts on the habit of the Benedictines, while his father talks to the abbot; he assists at the ordeal of fire for blessed Peter Igneus, for maintaining the

indictment of simony against archbishop of Florence, death of John Gualbertus, predella panels att. to the Venetian School, late 15th cent. Campana Museum, Avignon; Kaftal, *North East Italy*.
3134 St. John Gualbertus (enthroned, holding a crucifix and an open book, surrounded by other saints of his order), fresco by Neri di Bicci. Florence, S. Pancrazio; Kaftal, *Tuscan*.
3135 St. John Gualbertus and his monks witness a flood devastating the luxurious monastery of Morcheto, which he had predicted, panel by Bicci di Lorenzo. Private Coll., Milan; Kaftal, *Tuscan*.
3136 The glory of St. John Gualbertus (he ascends above the other monks), illuminated page by Fra Benedetto Toschi. Coll. Cini, Venice; Salmi, *Ital. Miniatures*.
3137 St. John Gualbertus and the crucifix (he has spared his brother's murderer, and Christ bends forward, showing his approval), by Benvenuto di Giovanni, c. 1485-90. N. Carolina Museum of Art, Raleigh; Shapley, *Samuel H. Kress*.
3138 St. Bernard, St. Michael, St. John Gualbertus, and St. John the Baptist, in "Four Saints" by Andrea del Sarto, 1528. Uffizi, Florence; Padovani, *Andrea del Sarto*; Praeger, *Great Galleries*.
See also 3957, 3958

John Houghton
3139 St. John Houghton (in left profile, holding a heart), painted for the Carthusian monastery at Jerez de la Frontera by Francisco de Zurbaran, 1637-39. Cadiz, Provincial Museum of Fine Arts; Gállego, *Zurbaran*; United Nations, *Dismembered Works*.

John Kalyvitis or Calybites or Calibrita of Constantinople, d. 450 (Jan. 15)
3140 St. John Kalyvitis, holding a book and an orthodox cross, fresco, 1494. Church of the Holy Cross of Agiasmati, near Platanistasa; Stylianou, *Painted Churches* (p.210).
3141 The glory of St. John Calibrita (accepted into heaven above the sick and dying), by Corrado Giaquinto. Prado, Madrid; Yale Univ., *Taste* (fig.124).

John Lampadistis
3142 Saint John Lampadistis "Maratheftis," fresco c. 1350-1400. Kakopet-

ria, St. Nicholas of the Roof Church; Stylianou, *Painted Churches* (p.74).
3143 Saint John Lampadistis (holding a candle and an incense burner), icon fresco, 1520's. Palaeochorio, Church of the Transfiguration of the Savior; Stylianou, *Painted Churches* (p.279).

John Nepomucen or Nepomuk of Prague, patron of Czechs, mart. 1393 (May 16)
3144 St. John Nepomucen (holding a crucifix), bronze statue by Matthias Rauchmiller, 1683. Charles Bridge, Prague; Štech, *Baroque Sculpture*.
3145 St. John of Nepomucen hearing confession, ivory sculpture on wood backing by the Austrian school, early 18th cent. Ponce, Museo de Arte; Held, *Catalogue*.
3146 St. John Nepomucen (holding out a cross), statue by Ferdinand Maximilian Brokoff, 1725. Nořin, near Mřelník; Štech, *Baroque Sculpture*.
3147 St. John Nepomucen (ascending to heaven on a cloud with angels), by Luigi Crespi. Bologna, S. Giuseppe; Merriman, *Crespi*.
3148 St. John Nepomucen (half view, holding a crucifix, with a circle of five stars above his head), by Giuseppe Maria Crespi, c. 1730. Bologna, Santa Maria della Misericordia; Merriman, *Crespi*.
3149 Madonna appearing to St. John Nepomucen (as he kneels with a crucifix), by Giambattista Tiepolo. Venice, S. Polo; Morassi, *Catalogue* (pl.104).
3150 The Holy Trinity with the martyrdom of St. John Nepomucen (he kneels on the shore beside a boat), by Giambattista Tiepolo. Formerly coll. Nicholson, London; Morassi, *Catalogue* (pl.128).
3151 St. John Nepomucen confessing the queen of Bohemia, by Giuseppe Maria Crespi, 1743. Turin, Pinacoteca; Held, *17th & 18th Cent.*; Merriman, *Crespi*; Murray, *Art & Artists*.
3152 Virgin and Child with St. John of Nepomuk (he kneels before them, as the Child stands on a ledge; at right, an angel holds out a palm), by Pompeo Batoni, c. 1743-46. Brescia, S. Maria della Pace; Clark, *Batoni*.
3153 Virgin and Child with St. John of Nepomuk (he kneels before them, as the Child stands on a ledge; at right, an angel holds out a palm), by Pompeo Batoni, c.

1743-46. Vatican Museums; Clark, *Batoni.*
3154 The assumption of St. John Nepomucen, by Paul Troger, 1750. Osterreichische Galerie, Vienna; Book of Art, *German & Spanish.*

John of Avila, "Apostle of the Andalousie," confessor of St. Teresa, d. 1569
3155 Portrait of St. John of Avila (half portrait in black, holding a hat, with his right hand on his chest), by El Greco. Toledo Museum of Art; *Subleyras.*
3156 St. John of Avila (standing behind a balustrade, holding a crucifix, about to preach), by Subleyras. Louvre, Paris; *Subleyras.*
3157 St. John of Avila (standing behind a balustrade, holding a crucifix, about to preach), by Subleyras. Birmingham City Museum and Art Gallery; *Foreign Paintings*; *Subleyras.*

John of Bergamo, Bishop of Bergamo; stabbed in the neck; mart. 690 (July 11)
3158 The martyrdom of St. John Bishop of Bergamo (he is stabbed in the neck as an angel descends with a palm), oil sketch by Giambattista Tiepolo. Accademia, Bergamo; Morassi, *Catalogue* (pl.129).
3159 The martyrdom of St. John Bishop of Bergamo (he is stabbed in the neck as an angel descends with a palm), by Giambattista Tiepolo. Bergamo Cathedral; Morassi, *Catalogue* (pl.130).

John of God, founder of Brothers Hospitallers, d. 1550 (Mar. 8)
3160 St. John of God (about to kiss a crucifix), by Francisco de Zurbaran 1641-58. Lima, Monastery of St. Camillus de Lellis; Gállego, *Zurbaran.*
3161 St. John of God (holding a crucifix and a heart), by Francisco de Zurbaran 1641-58. Seville, Museum of Fine Arts; Gállego, *Zurbaran.*
3162 John of God curing a cripple, by Murillo. Munich Gallery; De Bles, *Saints in Art.*

John of Mathay, founded Trinitarians, d. 1213 (Feb. 8)
See also 1955

John of Rila, patron saint of Bulgaria
3163 Saint John of Rila in a brown

cloak, holding a scroll and a red cross, icon from the Rila Monastery, mid-14th cent. Rila Monastery; Paskaleva, *Bulgarian Icons.*
3164 Saint John of Rila (standing in a brown cloak and orange robe), icon from the Rila Monastery, 17th cent. Bulgaria, National Art Gallery; Paskaleva, *Bulgarian Icons.*
3165 Saint John of Rila (wearing a himation, holding a crutch and a scroll), icon from the Rila Monastery, 18th cent. Rila Monastery; Paskaleva, *Bulgarian Icons.*
3166 St. John of Rila the miracle worker with scenes from his life, by Yoan of Samokov, 1839-40. Museum of the Plovdiv Metropolitanate; Paskaleva, *Bulgarian Icons.*

John of the Cross, Carmelite monk, d. 1591, canon. 1726 (Nov. 24 & Dec. 14)
3167 Apparition of Christ (holding the cross) and the Virgin to St. John of the Cross (as he kneels) by Pierre Thys the Elder. Koninklijke Museum, Antwerp; Hairs, *Sillage de Rubens.*
3168 St. John of the Cross and the miracle of Ségovie (Christ appears to him bearing a cross), by the French School, 17th cent. Carmelites of Auch; Rocher, *Carmels de France.*
3169 St. John of the Cross in ecstasy before the cross (held by cherubs) by the French School, 17th cent. Montpellier, St. Matthew; Rocher, *Carmels de France.*
3170 St. John of the Cross, half view holding a cross, oval, by the French School, 17th cent. Carmelites of Beaune; Rocher, *Carmels de France.*
3171 St. Teresa of Avila and St. John of the Cross in ecstasy during confession (God and Jesus appear to them), by the French School, 17th cent. Carmelite Collection; Rocher, *Carmels de France.*
3172 Death of St. John of the Cross (in his cell, as other monks pray) by Regnault, 1681. Carmelites of Créteil; Rocher, *Carmels de France.*
3173 St. John of the Cross puts out a fire (from a cloud), by Regnault, 1681. Carmelites of Créteil; Rocher, *Carmels de France.*
3174 Ecstasy of John of the Cross (he kneels with a large cross, which is also supported by an angel), by Giambettino Cignaroli, 18th cent. Bob Jones Univ. Art Gallery, Greenville, SC; Pepper, *Ital. Paintings.*

John the Almsgiver, Patriarch of Alexandria; gave all his money to the poor; seventh cent. (Jan. 23)
3175 St. John the Almsgiver (giving alms to cripples), woodcut by Günther Xanier from "Leben der Heiligen, Winterteil," Augsburg, 1471. The Illus. Bartsch; *German Book Illus.* (Vol.80, p.71).

John the Hospitaller
3176 St. John the Hospitaller (giving alms to a beggar), by Titian, c. 1550. Venice, S. Giovanni Elemosinario; Wethey, *Titian* (pl.166).

John the Martyr *see* **756**

Joseph Benedict Labre, pilgrim, d. 1783 (Apr. 16)
3177 Joseph Benedict Labre (his eyes closed, his arms crossed) by Antonio Cavalucci. Rome, Galleria Nazionale d'Arte Antica; Coulson, *Saints.*

Joseph of Copertino, Franciscan priest, known for miraculous levitation; patron of pilots and airline passengers, d. 1663 (Sept. 18)
3178 Levitation of St. Joseph of Copertino (he is lifted from the ground as he serves mass), drawing by Giuseppe Cades. Ashmolean Museum, Oxford; Bentley, *Calendar.*

Juan Gualbertus *see* **John Gualbertus**

Jucundus, Deacon of St. Gratus
3179 Scenes from the life of St. Gratus: it is revealed to a monk in Samaria that Gratus, bishop of Aosta would find the head of John the Baptist in a well; the monk goes to Rome and tells the pope, who sends for Gratus; Gratus travels to Rome with his deacon, St. Jucundus; the pope greets the two saints and gives them his instructions; frescoes by the Piedmontese school, 1460. Masséna Museum, Nice; Kaftal, *North West Italy.*
See also **2535**

Julian and Basilissa, Roman husband and wife, martyred for their faith; mart. 304 (Jan. 9)
3180 Christ in Glory (above, with angels) with SS. Celsus, Julian, Marcionilla, and Basilissa, by Pompeo

Batoni, c. 1736-38. Rome, SS. Celso e Giuliano; Clark, *Batoni.*
See also **1308**

Julian the Hospitaller: patron of innkeepers, ferrymen & traveling minstrels, patron of Castiglion Fiorentino, 4th cent. (Feb. 12)
3181 Scenes from the life of St. Julian the Hospitaller: a stranger foretells that he will kill his parents; he joins the king's army and marries the widow of one of the king's courtiers; while Julian is on the hunt, his parents show up at his house; the devil insinuates that his wife is unfaithful; finding his parents in his bed, he slays them; frescoes by Monte da Bologna, 14th cent. Trent, Cathedral; Kaftal, *North East Italy.*
3182 St. Julian carries a pilgrim across the river as penance for his crime, while his wife kneels at the shore, panel by the Florentine School, c. 1400. Coll. Acton, Florence; Kaftal, *Tuscan.*
3183 St. Julian enthroned between Saints Anthony Abbot and Martin, altarpiece att. to the Master of 1419. San Gimignano, Museo Civico; Cleveland Museum of Art, *European before 1500.*
3184 St. Julian murdering his parents, part of a predella of an altarpiece by Masaccio, 1426. Picture Gallery, Berlin; *Catalogue.*
3185 St. Julian the Hospitaller (standing with a sword and a palm, with snakes at his feet), panel of a polyptych by Vittore Crivelli. Campana Museum, Avignon; Kaftal, *North East Italy.*
3186 St. Julian the Hospitaller (standing with a sword, holding the severed heads of his parents), fresco by the North Italian School, 1436-38. Castel Tesino, S. Ippolito; Kaftal, *North East Italy.*
3187 St. Julian the Hospitaller (standing, nude, covered with serpents, with a kneeling donor at his feet), fresco by Master of Bussolengo. Bussolengo, S. Valentino; Kaftal, *North East Italy.*
3188 The penitence of St. Julian (he cries in his garden outside the inn), by an imitator of Fra Angelico. Cherbourg Museum; Pope-Hennessy, *Fra Angelico* (fig.68).
3189 St. Julian, his hands crossed over his chest, stands before the house of the murder, as Christ (holding orb and cross) hovers above him, fresco by Andrea del Castagno, c. 1454-55. Florence, SS.

Annunziata; Andres, *Art of Florence* (Vol.I, pl.388); Hartt, *Ital. Ren.*; Mc-Graw, *Dict.*

3190 Scenes from the life of St. Julian: hearing the prophecy that Julian would kill them, his father tries to murder the infant, but is stopped by a servant; the parents of Julian find his new home, and are met by his wife; the devil leads Julian home; Julian kills his parents in his bed; predella panels by Bartolommeo della Gatta, 1486. Castiglion Fiorentino, Collegiata; Kaftal, *Tuscan.*

3191 Virgin and Child with St. Julian (hands clasped in prayer) and St. Nicholas of Myra (reading), by Lorenzo di Credi. Louvre, Paris; Gowing, *Paintings.*

3192 St. Julian the Hospitaler, standing with his dog, right hand on chest, resting his sword point down against the ground, by Piero del Donzello. Fitzwilliam Museum, Cambridge; Catalogue, *Italian.*

3193 Julián Romero de las Azañas (kneeling in prayer) and St. Julian (in armor), by El Greco, 1587-97. Prado, Madrid; Gudiol, *El Greco.*

3194 The hospitality of St. Julian (helping a boy out of a boat before his inn), by Cristofano Allori. Pitti Palace, Florence; Denvir, *Art Treasures.*

3195 Miracle of St. Julian, by Antonio Zanchi, 1674. Venice, S. Giuliano; DiFederico, *Trevisani.*

See also 1550, 3518, 3708, 4475

Juliana *see* **Giuliana**

Julienne of Cornillon
3196 St. Julienne de Cornillon (in a nun's habit, kneeling before a vision of cherubs holding the Holy Sacrament), by Theodore Boyermans. Antwerp, St. André; Hairs, *Sillage de Rubens.*

Julitta *see* **Quirico**

Just or Justus; decapitated; date unknown
3197 St. Just (holding his own decapitated head), oil sketch by P.P. Rubens, c. 1630. Budapest, Museum of Fine Arts; Held, *Oil Sketches.*

Justa and Rufina, refused to sell heathen pottery, mart. 287 (July 19)
3198 St. Justa (holding a bowl on a platter and a palm), by Francisco de Zur-baran, 1625-30. Private Coll., London; Gállego, *Zurbaran.*

3199 St. Justa (holding pottery bowls and plates) by Francisco de Zurbaran, 1641-58. Coll. Kugel, Paris; Gállego, *Zurbaran.*

3200 St. Justa (holding two pottery pitchers) by Francisco de Zurbaran, 1641-58. NGI, Dublin; Gállego, *Zurbaran.*

Justin Martyr, the first great Christian philosopher; beheaded; mart. 165 (June 1)
3201 St. Justin Martyr (standing with a dog at his feet, holding a palm), fresco by unknown artist. Rome, St. Vitus; Bentley, *Calendar.*

Justina or Giustina of Padua, patron of Padua and Venice; stabbed with sword through the breast, mart. 304 (Oct. 7)
3202 St. Justina of Padua (standing in an ermine-lined cloak, wearing a crown and holding a palm), panel of a polyptych by Guariento, 1344. Norton Simon Museum, Los Angeles CA; Kaftal, *North East Italy.*

3203 St. Justina with a sword through both breasts, roodscreen. Heavitree Church, Devon; Drake, *Saints and Emblems.*

3204 St. Justina (standing with a palm leaf and a book, with a dagger in her chest), by Giovanni Bellini. Bagatti Valsecehi Found., Milan; Berenson, *Lotto*; Goffen, *Bellini.*

3205 St. Justina (holding a palm leaf) and a donor, by follower of Francesco del Cossa, c. 1475. Univ. of Wisconsin, Madison WI; Shapley, *Samuel H. Kress.*

3206 Murder of St. Justina (as she pleads on her knees before the king, executioner stands above, ready to plunge dagger into her heart), from "Evangeliarium of the Church of St. Justina at Padua," c. 1520. Coll. Major G. L. Holford; Burlington, *Illum. Ms.*

3207 St. Justina with a kneeling donor and a unicorn, by Moretto da Brescia, 1530-35. KM, Vienna; Levey, *Giotto to Cézanne*; Praeger, *Great Galleries.*

3208 Baptism of St. Justina (before enthroned Madonna and Child), by Domenico Campagnola. Padua, Museo Civico; Bentley, *Calendar*; New Int'l Illus. *Encyclo.*

3209 Martyrdom of St. Justine (about

to be decapitated on a scaffolding) engraving by Giovanni Battista D'Angeli after Bernardino Campi. Strauss, *The Illus.* Bartsch (Vol.32, no.15).
3210 Martyrdom of St. Justina (black executioner standing behind her plunges a dagger into her heart), by Paolo Veronese, 1572–73. Uffizi, Florence; Newsweek, *Uffizi*; Rearick, *Veronese.*
3211 The martyrdom of St. Justina (leaning against a man with a dagger in her heart, below enthroned king), by Paolo Veronese, c. 1575. Padua, Museo Civico; Book of Art, *Ital. to 1850.*
3212 St. Justina with three treasurers, by Tintoretto, 1580. Accademia, Venice; Tietze, *Tintoretto.*
3213 Martyrdom of St. Justina (man is about to plunge a dagger into her heart) by Giulio Cesare Procaccini, early 17th cent. Princeton Univ. Art Museum.
3214 Madonna with Saint Giustina and the Little Saint John, by Giambattista Tiepolo. Coll. Lilienfeld, New York; Morassi, *Catalogue* (pl.101).
See also 1830

Justus, Bishop and co-patron of Volterra, 5th cent. (June 5)
3215 St. Justus (standing in bishop's robes, holding a crosier), from an altarpiece by the Master of the Castello Nativity. Faltugnano, SS. Clemente e Giusto; Kaftal, *Tuscan.*
See also 1500, 1501, 1502

Kilian, Bishop and patron of Würzburg, Apostle of Franconia; killed with sword and spear; mart. 688 (July 8)
3216 Miniature from the "Life of St. Kilian" ms. 189, Fulda Abbey, end of 10th cent. Niedersachsiche Landesbiblio., Hanover; Batselier, *Benedict* (p.167).
See also 4080

Kolman *see* **Coloman**

Kyriaki
3217 Saint Kyriaki (with medallions down her front, personifying the days of the Holy Week), fresco, 1474. Pedoulas, Church of the Archangel Michael; Stylianou, *Painted Churches* (p.340).

Laborio
3218 Virgin with Saints Anna, Joseph, Laborio, and Pascal Baylon, by Luigi Crespi. Bologna, S. Sigismondo; Merriman, *Crespi.*

Ladislaus I, King of Hungary, d. 1095, canon. 1192 (June 27)
3219 St. Ladislaus I of Hungary (dressed as a king, holding a banner), panel of a polyptych by the School of Lippo Memmi. Altomonte, S. Maria della Consolazione; Kaftal, *Tuscan.*
3220 St. Ladislaus with Vladislav Jagiello and his two children, by Bernard Strigel, 1510–12. Budapest, Museum of Fine Arts; Korejsi, *Ren. Art in Bohemia.*
3221 St. Ladislaus I, King of Hungary is triumphant general, watching St. Stephen, King of Hungary and his son St. Emmerich, who stand with St. Martin, Bishop of Tours, in "The Apotheosis of the Hungarian Saints" by Franz Anton Maulbertsch, 1773. Picture Gallery, Berlin; *Catalogue.*
See also 4561

Lambert, Bishop of Maastricht and patron of Liege, d. 705 (Sept. 17)
3222 Reliquary of St. Lambert (with two armored men, one of them kneeling), enamel on gold by Gerard Loyset, 1477. Liège, St. Paul Cathedral; Flammarion, *Toison d'or.*

Lanfranc
3223 St. Lanfranc, enthroned between St. John the Baptist and possibly St. Licerius, by Cima da Conegliano. Fitzwilliam Museum, Cambridge; Catalogue, *Italian.*

Latinus, of Brescia, Bishop, 2nd cent. (Mar. 24)
3224 The Virgin and Child with Saints Latinus and Charles Borromeo (the Child puts an arm around Charles's head), by G. C. Procaccini. Brescia, S. Afra; McGraw, *Encyclo.* (Vol.II, pl.198).

Laurence Justinian, first patriarch of Venice, bishop of Castello, d. 1455 (Jan. 8 or Sept. 5)
3225 St. Laurence Justinian in Glory, surrounded by SS. Augustine, Francis of Assisi, Bernardino of Siena, John the Baptist, and two minor canons, by Pordenone. Accademia, Venice; Bentley, *Calendar*; De Bles, *Saints in Art*; Larousse, *Painters.*
3226 Alms of St. Laurence Justinian, by Gregorio Lazzarini c. 1690. Castello, San Pietro; New Int'l Illus. *Encyclo.*

Laurus, stone-mason and martyr of unknown date (Aug. 18)
3227 St. Laurus, fresco by Andrei Rublëv, early 15th cent. Cathedral of the Dormition, Zvenigorod; McGraw, *Encyclo.* (Vol.XII, pl.338).

Lawrence, Archdeacon of Sixtus II, patron of bakers; roasted on a gridiron and beheaded; mart. 258 (Aug. 10)
3228 Saint Lawrence the Martyr (a crucifix on his right shoulder, an open book in his left hand), mosaic from Mausoleum of Galla Placidia, 440–450. Ravenna, Italy; New Int'l Illus. *Encyclo.* (see Early Christian).
3229 Scenes from the life of St. Lawrence, from Troper, mid-11th cent. BM, London; Rickert, *Painting in Britain.*
3230 Scenes from the life of St. Lawrence altar frontal of Sant Llorenc de Dosmunts, 12th cent. Vic, Museu Episcopal; Lasarte, *Catalan.*
3231 Martyrdom of St. Lawrence (lying nude on a gridiron), from the Berthold Missal, ms. 710, fo.104v, c. 1200–35. Pierpont Morgan Library, NY; Swarzensski, *Berthold Missal* (pl.XXVII).
3232 Martyrdom of St. Lawrence (prone on a gridiron, prodded by his executioners as an angel descends with a shirt), from a martyrology, ms. El.fol.3, South German, early 13th cent. Jena, Universitätsbibliothek; Rothe, *Med. Book Illum.* (pl.37).
3233 Scenes from the life of St. Lawrence (Lawrence washes the feet of the poor; Lawrence and Sixtus II destroy the temple of Mars; Lawrence baptizes Romanus; Lawrence refuses to worship idols), frescoes by the Roman School, 13th cent. Rome, S. Lorenzo; Kaftal, *Central and So. Ital.*
3234 St. Lawrence (holding a book and a gridiron), panel of a polyptych by the workshop of Bernardo Daddi. Bagno A Ripoli, S. Maria Quarto; Offner, *Corpus* (Sect.III, Vol.VIII, pl.VIII).
3235 Martyrdom of St. Lawrence (lying on a gridiron as they stoke the fire) att. to Bernardo Daddi. Santa Croce, Florence; Andres, *Art of Florence* (Vol.I, pl.102); Coulson, *Saints*; McGraw, *Dict.*; McGraw, *Encyclo.* (Vol.IV, pl.106).
3236 St. Lawrence saving the soul of Emperor Henry II (he battles with a demon who tries to weigh down the scales), from the Strozzi Altarpiece by

Andrea Orcagna, 1354–57. Florence, S. Maria Novella; Lloyd, *1773 Milestones* (p.77).
3237 Martyrdom of Saints John (pulled by the hair as they decapitate him) and Lawrence (held over burning coals), predella panel by Cenni di Francesco di Sercenni, 1369–1415. Philadelphia Museum of Art, PA.
3238 Madonna and Child flanked by SS. Augustine and Anthony Abbot at left, and SS. Bartholomew and Lawrence at right, polyptych by Giovanni del Biondo, 1372. Santa Croce, Florence; Offner, *Corpus* (Sect.IV, Vol.IV, part I, pl.XXVI).
3239 Scenes from the life of St. Lawrence: he distributes the wealth of the church to the poor; Valerianus demands that he deliver the church treasure; Lawrence roasted on a gridiron (an executioner stokes the fire with a bellows); he is entombed with St. Stephen; he descends into purgatory every Friday to redeem a soul; predella panels by Lorenzo di Niccolò. Brooklyn Art Museum, NY; Kaftal, *Tuscan.*
3240 St. Lawrence holding a gridiron, 15th cent. stained-glass window. Trull Church, Somerset; Drake, *Saints and Emblems.*
3241 The roasting of St. Lawrence (as God looks on, flanked by angels carrying coats of arms), from the "Boucicaut Hours," painted by the Boucicaut Master, ms.2,fo.20v. Jacquemart-André Museum, Paris; Meiss, *French Painting.*
3242 SS. Lawrence (holding a book and a palm) and Stephen (holding a book and a pennon, with rocks on his head), wing of a polyptych by Mariotto di Nardo, 1408. J. Paul Getty Museum, Malibu CA; Fredericksen, *Catalogue.*
3243 The martyrdom of St. Lawrence (on his stomach, on a gridiron), with two Dominican nuns, att. to Jacobello del Fiore. Rijksmuseum: *Paintings.*
3244 Martyrdom of St. Lawrence (as his judges look on from a balcony), from a Breviary by the Boucicaut master, ms.2, fo.270v, before 1415. Châteauroux, Biblio. Municipale; Meiss, *French Painting.*
3245 Martyrdom of St. Lawrence (executioner hides his face as he stokes the fire), from a Book of Hours illus. by an unknown Netherlandish painter. Coll. Corsini, Florence; Meiss, *French Painting.*

3246 Martyrdom of St. Lawrence (roasted on a gridiron, as executioners turn their faces from the heat), min. by the Rohan Master from a Book of Hours, ms. Latin 9471, f.219, c. 1415-16. BN, Paris; *Rohan Master* (pl.97).

3247 Martyrdom of St. Lawrence (on the gridiron, while one executioner pokes him and another adds coal to the fire), by an imitator of Lorenzo Monaco. Vatican Museums; Eisenberg, *Monaco* (pl.245).

3248 St. Lawrence enthroned, with Saints Ansanus and Margaret, by an imitator of Lorenzo Monaco. Petit Palais, Avignon; Eisenberg, *Monaco* (pl.244).

3249 St. Lawrence (holding a palm and a gridiron), by the School of Tuscany, 1430-40. Walters Art Gallery, Baltimore; *Italian Paintings* (Vol.I).

3250 St. Lawrence enthroned with SS. Cosmas and Damian and donors, from the Alessandri Altarpiece by Filippo Lippi, c. 1435-40. Met Museum; Herald, *Ren. Dress* (pl.8).

3251 Scenes from the life of St. Lawrence (he kisses the hand of Sixtus II on the pope's death bed; Lawrence converts Hippolytus from his prison cell; Lawrence and Hippolytus before the judge; the persecutors burn Lawrence's sides with hot irons), from an altarpiece by the Master of St. Martino. Bellomo Museum, Syracuse; Kaftal, *Central and So. Ital.*

3252 St. Lawrence (enthroned atop a gridiron, imprisoning one of his persecutors underneath; he holds an open book and a palm), from an altarpiece by Master of St. Martino. Bellomo Museum, Syracuse; Kaftal, *Central and So. Ital.*

3253 St. Lawrence distributing the treasures of the church (to the poor), fresco by Fra Angelico, c. 1447-50. Vatican, Chapel of Nicholas V; Calvesi, *Vatican*; Hartt, *Ital. Ren.*; Lassaigne, *Fifteenth Cent.*; McGraw, *Dict.*; Pope-Hennessy, *Fra Angelico.*

3254 Sixtus II giving the treasures of the church to St. Lawrence, fresco by Fra Angelico, c. 1448. Vatican Museums; Book of Art, *Ital. to 1850*; Brusher, *Popes*; Colombo, *World Painting*; McGraw, *Encyclo.* (Vol.I, pl.270); Pope-Hennessy, *Fra Angelico.*

3255 Scenes from the life of St. Lawrence: Decius orders him to deliver the treasures of the church; Lawrence cures the sick and blind in prison; conversion of St. Hippolytus; Lawrence presents crip-

ples to the emperor, saying this is the treasure of the church; frescoes att. to Jacobello del Fiore. Vittorio Veneto, S. Lorenzo; Kaftal, *North East Italy.*

3256 Scenes from the life of St. Lawrence: Lawrence is beaten with plummets or thongs, as an angel descends and says "Adhud multa certamina tibi debentur," and only Lawrence and Romanus see the angel; Lawrence has his teeth knocked out with stones; his clothes are torn off his body; Lawrence is roasted on a gridiron; frescoes att. to Jacobello del Fiore Vittorio. Veneto, S. Lorenzo; Kaftal, *North East Italy.*

3257 St. Lawrence before Valerian; martyrdom of St. Lawrence, fresco by Fra Angelico in the Chapel of Nicholas V. Vatican; Pope-Hennessy, *Fra Angelico* (pl.113).

3258 St. Nicholas of Bari (holding three balls), St. Lawrence, and John the Baptist, att. to the Master of the Buckingham Palace Madonnas, mid-15th cent. Hyde Coll., Glens Falls NY; Kettlewell, *Catalogue.*

3259 Madonna and Child with SS. Benedict and Stephen on the left, and SS. John the Baptist and Lawrence on the right, known as the "S. Bonda Polyptych" by Sano di Pietro, c. 1454. Siena, Pinacoteca Nazionale; Van Os, *Sienese Altarpieces* (Vol.II, pl.35).

3260 Madonna della Neve Altarpiece; Virgin and Child enthroned with angels, flanked by standing SS. Peter and Paul, and kneeling SS. Lawrence and Catherine of Siena, by Matteo di Giovanni, 1472. Siena, Sta. Maria della Neve; Van Os, *Sienese Altarpieces* (Vol.II, pl.192).

3261 Martyrdom of St. Lawrence (lying on a gridiron, while five men look from the side), lindenwood sculpture, south German, c. 1480. M. H. de Young Memorial Museum, San Francisco CA; *European Works.*

3262 St. Lawrence (holding a palm and a book), by Cosimo Rosselli. Walker Art Gallery, Liverpool; Gaunt, *Pictorial Art.*

3263 The martyrdom of St. Lawrence (roasting him on a gridiron), woodcut by Hans Baldung Grien, c. 1505. Geisberg, *Single-Leaf.*

3264 St. Lawrence (reading, holding his gridiron) stained glass window by the workshop of Veit Hirschvogel the Elder, c. 1507. Germanisches Nationalmuseum, Nuremberg; Met Museum, *Gothic Art.*

3265 St. Lawrence (seated, with book and gridiron), from a Gradual, ms. 905, fo.88, c. 1507-10. Pierpont Morgan Library, NY; Pierpont, *Medieval and Ren.*

3266 St. Lawrence, holding a book and a gridiron, dressed in a fringed tunic, from Heller Altarpiece by Matthias Grünewald, c. 1508-09. Städelsches Kunstinstitut, Frankfort; Praeger, *Great Galleries.*

3267 St. Lawrence, painted linden-wood statue by Tilmann Riemenschneider, c. 1510. Cleveland Museum of Art, OH; *Selected Works.*

3268 Madonna and Child flanked by SS. Lawrence and Anthony of Padua (holding a book and a lily; the Child grabs the flower), by Lorenzo Lotto. Private Coll., Milan; Pallucchini, *Cariani.*

3269 Martyrdom of St. Lawrence (lying on a gridiron; they are stoking the fire as another executioner prods him with a forked tool, before a colonnaded building), by Titian, 1548-57. Gesuiti, Venice; Hall, *Color and Meaning*; Wethey, *Titian* (pl.178).

3270 Martyrdom of St. Lawrence (on a gridiron in the middle of a plaza, before nobles and king), by Antoine Caron, c. 1560. Georgetown Univ. Art Coll.; *Catalogue.*

3271 Martyrdom of St. Lawrence (lying on a gridiron; they are stoking the fire as another executioner sticks him with a forked tool), by Titian and workshop, 1564-67. Iglesia Vieja, Escorial; Wethey, *Titian* (pl.181).

3272 Martyrdom of St. Lawrence (lying on a gridiron in a colonnaded plaza, surrounded by people), fresco by Bronzino, 1565-69. Coll. A. Lorenzo, Florence; Gowing, *History of Art* (p.677).

3273 St. Lawrence's vision of the Virgin (Virgin and Child in upper right corner) by El Greco, 1576-79. Monforte de Lemos Priarist Fathers; Gudiol, *El Greco.*

3274 The martyrdom of St. Lawrence (on his side on a gridiron, as judges watch), by Tintoretto, late 1570's. Christ Church, Oxford; Shaw, *Old Masters*; Tietze, *Tintoretto.*

3275 Martyrdom of St. Lawrence (a man pushes his head down as he lies on the gridiron, looking at a child who holds a torch), by Antonio Campi, 1581. Milan, San Paolo Converso; Fiorio, *Le Chiese di Milano.*

3276 St. Lawrence, holding a palm leaf and a gridiron, min. from a breviary of Philip II of Spain, fo.82v. El Escorial, Spain; Newsweek, *El Escorial.*

3277 Martyrdom of St. Lawrence (in front of the emperor, he is on the gridiron, as an executioner prods him in the belly with a pole), by Pietro Faccini, 1590. Bologna, S. Giovanni in Monte; *Age of Correggio.*

3278 The martyrdom of St. Lawrence (he is being undressed) by Adam Elsheimer, c. 1600. Nat'l Gallery, London; New Int'l Illus. *Encyclo.*

3279 Martyrdom of St. Lawrence (they are backing him onto the gridiron, while a man approaches with more fuel; the emperor looks on from above), by Valentin de Boulogne, 1622-24. Prado, Madrid; Mojana, *Valentin de Boulogne.*

3280 Madonna and Child with St. Lawrence (they appear to him on a cloud as he kneels beside a gridiron before a landscape), by Guercino, 1624. Finale, Seminario Archivescovile Church, Italy; Cleveland Museum of Art, *European 16th-18th Cent.*

3281 The martyrdom of St. Lawrence (they lay him down on a gridiron as others stoke the fire), by Nicolas Poussin. Prado, Madrid; Wright, *Poussin.*

3282 St. Lawrence (half view, holding a gridiron), by Francisco de Zurbaran, 1625-30. Private coll., Madrid; Gállego, *Zurbaran.*

3283 St. Lawrence (hands crossed, looking upward in prayer), by Cecco del Caravaggio. Filippini, Rome; Spear, *Caravaggio.*

3284 St. Lawrence distributing the goods of the church (he has his hand on a candlestick as beggars look on), by Bernardo Strozzi, c. 1625. North Carolina Museum of Art, Raleigh; *Intro. to the Coll.*

3285 St. Lawrence giving the treasures of the church to the poor (old woman accepts shawl and incense burner from him), by Bernardo Strozzi, 1631. Portland Art Museum, OR; New Int'l Illus. *Encyclo.*

3286 Martyrdom of St. Lawrence (an executioner is tugging on his right arm, as they prepare to put him on the gridiron), by Giuseppe Ribera. Vatican Museums; Francia, *Vaticana.*

3287 Martyrdom of St. Lawrence (as a youth, put onto the gridiron as the pagan

priest holds up an idol), by Francesco Pacecco de Rosa, 1635-40. Bob Jones Univ. Art Gallery, Greenville, SC; Pepper, *Ital. Paintings*; RA, *Painting in Naples*.

3288 St. Lawrence (giving an incense burner to a beggar), by Bernardo Strozzi, 1635. Venice, S. Niccolo dei Tolentini; New Int'l Illus. *Encyclo.*

3289 St. Lawrence, holding a gridiron, looking up in ecstasy, by Francisco de Zurbaran, c. 1636. Hermitage, St. Petersburg; Eisler, *Hermitage*; Gállego, *Zurbaran*; Hermitage, *Western European*; United Nations, *Dismembered Works*.

3290 St. Lawrence (sitting in prayer in left profile, resting the gridiron on his lap), from the dismembered high altar of the Carthusian monastery at Jerez de la Frontera, by Francisco de Zurbaran, c. 1637-39. Cadiz, Provincial Museum of Fine Arts; Gállego, *Zurbaran*; United Nations, *Dismembered Works*.

3291 Martyrdom of St. Lawrence (he is seated on the gridiron, and the executioners are starting to lay him down by pulling him backward, hands on his chest and his neck), by Johann Heinrich Schönfeld, 1639-48. Marianella (Naples), House of Sant'Alfonso de'Liguori; Puppi, *Torment*.

3292 Martyrdom of St. Lawrence (executioners are struggling to get him onto the gridiron), by Pietro da Cortona, 1646. Rome, S. Lorenzo in Miranda; McGraw, *Encyclo.* (Vol.XII, pl.368).

3293 Martyrdom of St. Lawrence (executioners are loading coals, while a man pulls a sheet out from under him; emperor watches, pointing, from above, while cherubs descend with palm and flower wreath); by Eustace Le Sueur, 1650-55. Coll. Duke of Buccleuch, Kettering, England; Mérot, *Le Sueur*.

3294 Martyrdom of St. Lawrence (at center, he is placed on a gridiron, which is mounted on a large brick oven; scene takes place in a landscape with classical ruins), by Micco Spadaro, known as Domenico Gargiulo, early 1650's. Benevento, Banca Sannitica; Puppi, *Torment*.

3295 St. Lawrence in glory (he kneels on a cloud, while cherub next to him holds a palm), by Anton Angelo Bonifazi. Bob Jones Univ. Art Gallery, Greenville, SC; Pepper, *Ital. Paintings*.

3296 Martyrdom of St. Lawrence (as executioners try to stretch him onto the gridiron, an angel descends with a palm and flower wreath), by Filippo Lauri. Burghley House, Northamptonshire, England; Di Federico, *Trevisani*.

3297 Martyrdom of St. Lawrence (he leans back on the gridiron, looking to heaven, as a man in white gestures angrily toward him, pointing up), by Luca Giordano, c. 1696. Hood Museum of Art: Dartmouth College, *Treasures*.

3298 The Martyrdom of St. Lawrence (as he is being manhandled, an angel with palm and laurel wreath descends), by Placido Costanzi, mid-18th cent. Princeton Univ. Art Museum.

See also 198, 1540, 1547, 1549, 1550, 1598, 2003, 2806, 3314, 3868, 3974, 4220, 4221, 4473, 4474, 4575, 4657

Lebuin *see* **Livinus**

Leger *see* **Leodegarius**

Leo I, Pope, "The Great," d. 461 (Apr. 11 & Nov. 10)
3299 Two miracles of St. Leo, by Francesco Pesellino. Doria Pamphili Palace, Rome; Berenson, *Ital. Painters*.

3300 Leo X represented as Pope Leo I, from "The Repulse of Attila by Pope Leo I," fresco by Raphael in the stanze of Raphael, 1514. Vatican Museums; Bentley, *Calendar*; Brion, *The Medici*; Cuzin, *Raphael*.

3301 Leo I enthroned with angels, by Giulio Romano. Raphael Rooms, Vatican; Brusher, *Popes thru the Ages*.

3302 Meeting of Pope Leo I and Attila, marble relief by Alessandro Algardi, c. 1646-53. Rome, St. Peter's; Book of Art, *Italian to 1850*; Held, *17th & 18th Cent. Art*; Piper, *Illus. Dict.* (p.214).
See also 4582

Leo II, Pope, r. 682-683 (June 28)
3303 St. Leo II (in papal robes, giving a blessing), from a reliquary by Antonio Vivarini and Giovanni d'Alemagna, 1443. Venice, S. Zaccaria; Kaftal, *North East Italy*.

3304 St. Leo II, mosaic. Rome, St. Paul-Outside-the-Walls; Brusher, *Popes*.

Leo III, Pope, d. 816 (June 12)
3305 Leo III (enthroned) between St. Peter and Charles the Great, contemp. watercolor. Apostolica Library, Vatican; Bentley, *Calendar*.

3306 Coronation of Charlemagne by Pope Leo III in St. Peter's, Rome, from "Les Grandes Chroniques de France," MS Douce 217, f.77 c. 1460. Bodleian Library, Oxford; Bradfore, *Sword*; Castries, *K & Q of France*.

Leo IV, Pope, d. 855 (July 17)
3307 Leo X represented as Pope Leo IV in "Victory of St. Leo over the Saracens," fresco by Giulio Romano in the stanze of Raphael, 16th cent. Vatican Museums; Boudet, *Rome*.
3308 Leo IV from "The Battle near Ostia" fresco by Raphael. Vatican Museums; Brusher, *Popes thru the Ages*.
3309 The fire in the Borgo (with Leo IV) by Raphael, c. 1514-17. Vatican Collection; New Int'l Illus. *Encyclo.*

Leo IX, Pope, r. 1049-1054 (April 19)
3310 Leo IX by Francesco de Mura. Naples, SS. Severino e Sosio; Brusher, *Popes thru the Ages*.

Leocadia, Patroness of Toledo; killed with sword, mart. 303 (Dec. 9)
3311 St. Leocadia in prison (an angel behind her points to a candle on the wall), by Carlo Saraceni. Toledo, Cathedral; Nicolson, *Caravaggesque Movement*.
3312 St. Leocadia in the judgment hall (she is lit by celestial light while her judge passes sentence), by Mariano Salvador Maella, 1775-76. Toledo Cathedral; *L'Art Européen*.

Leocritia *see* **Lucretia**

Leodegarius or Leger, bishop of Autun; blinded and murdered; mur. 679 (Oct. 2)
3313 St. Remigius of Rheims (exorcising a possessed man); St. Margaret (accepting bread, while in a hermitage); St. Leodegarius (about to be decapitated with a sword); St. Dionysius (holding his own severed head); coronation of St. Edward the Confessor; St. Callistus (thrown into a lake with a millstone around his neck); woodcuts by Günther Xainer from "Leben der Heiligen," 1471. The Illus. Bartsch; *German Book Illus.* (Vol.80, p.62).
See also 3313

Leonard of Limoges, Hermit, Benedictine deacon, patron of prisoners and pregnant women, founded abbey of Noblac, d. 560 (Nov. 6)
3314 Saints Paul, James the Greater,

Stephen, Lawrence, Martin of Tours, and Leonard of Limoges, icon, 1150-1200. Sinai, St. Catherine's Monastery; Knopf, *The Icon* (p.209).
3315 St. Leonard releasing prisoners, from "Book of Hours," cat. 49, f.4, Champagne, 13th cent. Walters Art Gallery, Baltimore; Randall, *Manuscripts*.
3316 St. Leonard talking to enchained prisoners, from "Heures de Savoie." Portsmouth Catholic Episc. Library; Panofsky, *Early Nether.*
3317 St. Leonard with two prisoners (he holds a chain connecting the two kneeling prisoners), from the "Boucicaut Hours," painted by the Boucicaut Master, ms.2,fo.9v. Jacquemart-André Museum, Paris; Bentley, *Calendar*; Meiss, *French Painting*.
3318 St. Leonard (standing with a prisoner, holding fetters), fresco by the School of Stefano da Zevio, 1413. Verona, S. Pietro Martiere; Kaftal, *North East Italy*.
3319 St. Leonard (standing with a long rope), Flemish manuscript, nouv. acq. lat. 3055, fo.164v. BN, Paris; Meiss, *French Painting*.
3320 Saints Anthony Abbot, Benedict, Leonard of Limoges, and Eligius (all sitting with books), from a triptych of Norfolk by the Master of Liège or the Meuse area, c. 1415. Boymans-van Beuningen Museum, Rotterdam; Batselier, *St. Benedict* (p.63).
3321 St. Leonard and female saint, from painted screen, c. 1451. V & A, London; Rickert, *Painting in Britain*.
3322 St. Leonard (holding a heavy chain), by Circle of Hans Pleydenwurff, c. 1460. North Carolina Museum of Art, Raleigh; Eisler, *European Schools*.
3323 Madonna and Child with SS. Leonard, Jerome (reading, in Cardinal's robes, with a tiny kneeling donor), John the Baptist, and Francis of Assisi, by Nicola d'Ancona, 1472. Carnegie Inst., Pittsburgh PA; *Catalogue of Painting*.
3324 Three saints: Andrew, Nicholas of Bari (holding a book with three balls and a crosier) and Leonard (holding a book and manacles), by the circle of Michael and Friedrich Pacher, 1475-1500. Joslyn Art Museum; *Paintings & Sculpture*.
3325 SS. Leonard (holding a book and fetters), and Sebastian (holding an arrow and a palm), panel by Angelo Puccinelli.

Mayer van den Bergh Museum, Antwerp; Kaftal, *Tuscan.*

3326 St. Leonard prays for the queen (as she is carried out of the forest, suffering from the pangs of childbirth), panel by Neri di Bicci. Coll. Serristori, Florence; Kaftal, *Tuscan.*

3327 St. Martin (with a sword) and St. Leonard (with a chain and a book) both standing on pedestals; altar panels by the German School. York City Art Gallery; *Catalogue.*

3328 The resurrection with SS. Leonard and Lucy, by Marco d'Oggiono, 1491. Picture Gallery, Berlin; Sedini, *Marco d'Oggiono.*

3329 St. Leonard (standing with a chain and lock draped over his shoulder, holding a book), from a fresco by Pietro Fuluto, 1500. Forni di Sopra, S. Floriano; Kaftal, *North East Italy.*

3330 Archangel Raphael flanked by Tobias (holding a fish) and St. Leonard (with a kneeling donor), by Andrea del Sarto, 1512. KM, Vienna; Padovani, *Andrea del Sarto.*

3331 Scenes from the legend of St. Leonard (he taps a man on the shoulder, who is reading a scroll), by the Master of Szászfalva, c. 1515. Esztergom Christian Museum; *Christian Art in Hungary* (pl.IX/238).

3332 SS. Peter, Martha (Margaret), Mary Magdalene, and Leonard (standing in a forest), by Correggio, c. 1517-19. Met Museum; *Age of Correggio;* Hibbard, *Met Museum.*

See also 3726

Léonce, bishop of Fréjus
3333 Study for St. Léonce (bust portrait in right profile, looking up), by Subleyras, c. 1741. Pinacoteca, Munich; *Subleyras.*

See also 1331, 1332

Leopardus or Leopoldo, bishop of Osimo, 7th cent. (Nov. 7)
3334 St. Leopardus (in bishop's robes, giving a blessing), from a polyptych by Pietro da Montepulciano, 1418. Osimo, Cathedral; Kaftal, *Central and So. Ital.*

Leopold III, prince of Austria, founded abbeys, d. 1136, canon. 1485 (Nov. 15)
3335 St. Leopold holding a model of an abbey, polychromed wooden statue, Austrian, 1480-90. John Higgins Armory Museum, Worcester MA.

3336 St. Leopold riding out to the hunt (on a white horse, wearing a red, ermine-trimmed cloak), by Rueland Frueauf the Younger, 1505. Stiftsmuseum, Klosterneuburg, near Vienna; Benesch, *German.*

3337 St. Leopold finding the veil, from an altarpiece of St. Leopold by Erhard Altdorfer, c. 1510-11. Stiftsmuseum, Klosterneuburg, near Vienna; Benesch, *German.*

3338 SS. Jerome (holding his lion's paw) and Leopold of Austria (standing, with a lance and shield), by Lucas Cranach the Elder, 1515. KM, Vienna; Friedländer, *Cranach.*

3339 Virgin and Child appearing to Saints Anthony of Padua (in friar's robe) and Leopold (in Roman armor), ink and watercolor, anon. 1855. Fogg Art Museum, Cambridge MA.

See also 1511

Leopoldo *see* **Leopardus**

Leu or Lupus of Sens, protector of mentally disturbed children, d. 623
3340 St. Lupus (or Leu, holding mass, before a king); St. Regina (crucified and burned with torches); St. Adrian (his limbs are cut off); St. Nicholas (chased by a demon with a club); woodcut by Günther Zainer from "Leben der Heiligen, Sommerteil," Augsburg, 1472. The Illus. Bartsch; *German Book Illus.* (Vol.80, pp.91-92).

3341 St. Leu healing the sick children, by Master of St. Giles, late 15th cent. NGA, Washington DC; Eisler, *European Schools.*

Liberalis, Roman knight, patron of Treviso, d. 400 (Apr. 27)
3342 St. Liberalis (holding a model of a city and a staff), fresco by the School of Veneto, c. 1450. Vittorio Veneto, S. Lorenzo; Kaftal, *North East Italy.*

3343 St. Liberalis (in a brocade surcoat, holding a sword and palm), fresco att. to the School of Baschenis, 1498. Pagliaro, Parish Church; Kaftal, *North West Italy.*

3344 Enthroned Madonna with St. Liberalis (in full armor) and St. Francis of Assisi, by Giorgione, c. 1500-05. San Liberale Cathedral, Castelfranco Venice; Hartt, *Ital. Ren.;* McGraw, *Encyclo.* (Vol.VI, pl.185); New Int'l Illus. *Encyclo.* (see Venetian).

See also 3224

Liberata
3345 St. Liberata (crucified), wood sculpture with water-based paints by José Benito Ortega, 1879–90. Taylor Museum for Southwest Studies, CO; Wroth, *Images of Penance*.
See also 1607, 1857

Licerius or Icerius or Niciero, Roman knight; killed by having nails driven into his head, mart. 4th cent. (Oct. 2)
3346 St. Licerius (standing in a short pleated tunic and wide belt, holding a palm and a hammer), panel of a triptych by Antonio Vivarini and Giovanni d'Alemagna, 1443. Venice, S. Zaccaria; Kaftal, *North East Italy*.
See also 3223

Liudger *see* **Ludger**

Livinus or Lebuin, Irish bishop martyr, d. 773 (Nov. 12)
3347 The martyrdom of St. Livinus (executioner pulls out his tongue and feeds it to a dog), oil sketch by P.P. Rubens, c. 1633–35. Boymans-Van Beuningen Museum, Rotterdam; Held, *Oil Sketches*.
3348 The martyrdom of St. Livinus (executioner pulls out his tongue and feeds it to a dog), oil sketch by P.P. Rubens, c. 1633–35. Brussels, Musées Royaux des B/A; *Eight Centuries*; Held, *Oil Sketches*; McGraw, *Encyclo.* (Vol. XII, pl.333); *Peinture Ancienne*.
See also 4085

Longinus, pierced Christ's side with a lance; decapitated; 1st cent. (Mar. 15)
3349 The risen Christ between Saint Andrew and St. Longinus, engraving by Andrea Mantegna, c. 1472. Kimbell Art Museum, Fort Worth TX; *Handbook*.
3350 Martyrdom of St. Longinus (he is about to be decapitated with a sword), woodcut by Jacobus de Voragine from "Leben der Heiligen, Winterteil," 1478. The Illus. Bartsch; *German Book Illus.* (Vol.82, p.125).
3351 Saint Longinus, outstretched arm holding a lance, marble sculpture by Gianlorenzo Bernini, 1629–38. Rome, St. Peter's; Held, *17th & 18th Cent.*
3352 St. Longinus, statuette with outstretched arm, by Giovanni Bernini,

1630–31. Fogg Art Museum, Cambridge MA; Mortimer, *Harvard Univ.*
See also 4089

Lorentinus and Pergentinus, brothers, patrons of Arezzo; beheaded for their faith; mart. 251 (June 3)
3353 The Virgin protecting the people of Arezzo, with St. Lorentinus and St. Pergentinus (she extends her robe over the people), by Parri Spinelli, 1435. Arezzo, Pinacoteca; Boase, *Vasari* (pl.117).

Louis IX, King of France, Franciscan tertiary, d. 1270, canon. 1297 (Aug. 25)
3354 Successive steps of the coronation of Louis IX at Rheims, from MS Lat. 1246, c. 1225–50. BN, Paris; Eydoux, *St. Louis.*
3355 Louis IX healed by the true cross, from Matthew Paris, "Chronica Majora," MS 16, fo.182. CCC, Cambridge; Lewis, *Paris.*
3356 Louis IX with the true cross and crown of thorns, from Matthew Paris, "Chronica Majora," MS 16, fo.141v. CCC, Cambridge; Bradfore, *Sword*; Lewis, *Paris.*
3357 Death of Louis IX with his son Philippe at his side, ms. illum. BN, Paris; Jullian, *Histoire.*
3358 Louis IX healed by the true cross, from Matthew Paris, "Historia Anglorum," MS Royal 14 C vii, fo.137v. BM, London; Lewis, *Paris.*
3359 Psalter of St. Louis, M. 240, fol. 8. Pierpont Morgan Library, NY; Horizon, *Middle Ages.*
3360 Attack on Damietta during St. Louis's expedition to Egypt, 1260, from "Le Livre des Saintes paroles et des bons gaits de Notre Roi St. Louis," MS Fr. 13568, fo. 83, c. 1260. BN, Paris; Barber, *Chivalry.*
3361 Louis IX departing for the seventh crusade in 1248, given farewell by monks, from "Chronique de St. Denis," MS Roy. 16 G vi, c. 1275. BM, London; Edoux, *St. Louis*; Evans, *Flowering of M.A.*; Larousse, *Medieval History.*
3362 Miracle of the breviary brought to St. Louis in prison (he holds it up) fol. 154v-155v.; St. Louis recovering the remains of the Christians massacred at Sidon (he puts their bones in a bag as others hold their noses) fol. 159-160v.; St. Louis submitting himself to discipline (a monk whips him) fol. 102v-103v.; from

"Heures de Jeanne d'Evreux" by Jean Pucelle, ms. Acc 54 (1.2.), c. 1325–28. Cloisters Museum NY; Avril, *MS Painting*; Sterling, *Peinture Médiévale*.
3363 Anointing of St. Louis (as he kneels at an altar), fo.99; coronation of St. Louis (fo.100v); St. Louis and his brother Robert, Comte d'Artois, carrying the crown of thorns to the Saints Chapelle (fo.102); from the Book of Hours of Joan II, Queen of Navarre, c. 1330. Roxburghe Club; Thompson, *Book of Hours*.
3364 Education of St. Louis (the tutor holds a switch, while his mother looks on) fo.85v; St. Louis at prayer (as others kneel behind him) fo.91v; the coronation journey to Rheims (St. Louis is pulled in a wagon), fo.97; St. Louis (in bed) taking the cross from the Archbishop of Paris for his first Crusade, A.D. 1245 (fo.104); from the Book of Hours of Joan II, Queen of Navarre, c. 1330. Roxburghe Club; Thompson, *Book of Hours*.
3365 Louis IX on a ship for Cypress, from "Vie et Miracles de St. Louis," MS Fr. 5716. BN, Paris; Jullian, *Histoire*.
3366 Louis IX, king of France, with St. John the Baptist, from a predella by Simone Martini. Naples, Museo Nazionale; Coulson, *Saints*.
3367 St. Louis arriving at Damietta; and St. Louis dispersing justice, from G. de Saint Pathus: "Vie et Miracles de St. Louis," MS Fr. 5716, f. 246, c. 1330–50. BN, Paris; Hallam, *Four Gothic*.
3368 St. Louis remains in Palestine to bury the dead, while churchmen hold their noses; St. Louis sends home his mother and brothers, then buys back Christian prisoners; from "Vie et Miracles de St. Louis," MS Fr. 5716. BN, Paris; Castries, *K & Q of France*.
3369 Birth of Louis IX; young Louis IX studying; coronation of Louis IX at twelve years old; from "Grandes Chroniques de France," MS Fr. 2813, fo.265r. BN, Paris; Edoux, *St. Louis*; Jullian, *Histoire*; McGraw, *Encyclo.* (Vol.VI, pl.316).
3370 Henry III of England pays homage to Louis IX, from "Grandes Chroniques de France," 14th cent. BN, Paris; Jullian, *Histoire*.
3371 Louis IX on Crusade, from MS Royal 16 G VII f. 404v. BM, London.
3372 Siege of Louis IX before Avignon, from "Grandes Chroniques," MS Fr. 2813. BN, Paris; Edoux, *St. Louis*.

3373 The king Louis with a scepter and the hand of justice, min. from "Ordonnances de L'Hotel du Roi." France, National Archives; Guth, *Douce*.
3374 Louis IX, the French king with the crown of thorns relic (fo. 14r.); the French king and Roman Emperor Charlemagne with spearheads (fo. 10 r.); from "The Travels of Sir John Mandeville," MS Add. 24189, c. 1356. BM, London; Krasa, *Travels*.
3375 Blanche of Navarre and her daughter Joan of France presented by St. Louis of France, 17th cent. copy of original illustration painted c. 1372, ms. Est. Oa. 11, fol. 90. BN, Paris; Sterling, *Peinture Médiévale*.
3376 Louis IX presented to his mother at birth; Louis serving dinner to a monk; Louis washing a beggar's feet; Louis being scourged; Louis collecting bones of martyrs; from "Grandes Chroniques de France," MS Fr. 2813, fol. 265, c. 1375. BN, Paris; Hallam, *Four Gothic*; Horizon, *Middle Ages*; McGraw, *Encyclo.* (Vol.VI, pl.316).
3377 Marriage of Louis IX with Marguerite de Provence; St. Louis reading his hours while on horseback; St. Louis takes sick and is led away from battle; death of St. Louis; from "Vie et Miracles de St. Louis" by Guillaume de St. Pathus, MS Fr.5716, end of 14th cent. BN, Paris; Edoux, *St. Louis*.
3378 Death of St. Louis, stained-glass window. Champigny-sur-Veude, Sainte-Chapelle; Mayflower, *Great Dynasties*.
3379 St. Louis set sail on Aug. 25, 1248, from "Viede St. Louis," manuscript of the 15th cent. Grousset, *Epic*.
3380 St. Louis with scepter and model of Sainte-Chapelle, ms. illum. Sainte-Geneviève, Biblio.; Eydoux, *St. Louis*.
3381 Wooden sculpture of Louis IX. Hallam, *Four Gothic*.
3382 St. Louis IX (standing in robes of a king, holding a knotted cord and a scepter), fresco by Giotto di Bondone. Santa Croce, Florence; Kaftal, *Tuscan*.
3383 St. Louis embarks on a ship for the crusades, from "Voyages d'Outremer" by Sebastien Mamerot, MS Fr. 9087. BN, Paris; Weygand, *L'Armee*.
3384 St. Louis receives the crown of thorns, from "Chroniques de St. Denis," MS Roy. 16 G vi. BM, London; Edoux, *St. Louis*.
3385 Death of St. Louis, from "Grandes

Chroniques," MS Fr. 6465, fo.284v, c. 1458. BN, Paris; Perls, *Fouquet.*
3386 Coffin of St. Louis carried onto the ship in Tunis, from "Les Grandes Chroniques de France," c. 1460. Bradfore, *Sword.*
3387 St. Louis of France wearing a cope, and holding a book and a staff, panel portrait by Vittore Crivelli, c. 1481-1500. Rijksmuseum, Amsterdam; *Catalogue.*
3388 St. Louis of France (in an ecclesiastical cope, holding a crosier) and St. Francis of Assisi (holding a cross from which he is receiving his stigmata), by Vittorio Crivelli, 1489. Philadelphia Museum of Art, PA.
3389 St. Louis, king of France, giving alms to the poor, by Andrea Mantegna. Doria Pamphili Palace, Rome.
3390 St. Louis and his brothers Alphonse and Charles taken prisoner by the Saracens in 1250, woodcut from "Archiv fur Kunst und Geschichte." Larousse, *Medieval History.*
3391 St. Louis, King of France (approaching beggars who hold out their bowls), min. by the Master of Claude from a Prayer Book of Queen Claude of France, fo.37r, c. 1515-16. Coll. H.P. Kraus, NY; Sterling, *Master of Claude.*
3392 St. Louis (wearing a hat and a tabard with fleuries), side panel of "La Vierge Trônante de Bale" triptych by Pieter Coeck. Nat'l Gallery, London; Marlier, *Coeck.*
3393 St. Louis IX and St. George with the princess; St. Andrew and St. Jerome (in discussion), companion pictures by Tintoretto, 1552. Accademia, Venice; Tietze, *Tintoretto*; Valcanover, *Tintoretto.*
3394 St. Louis, king of France in armor, by El Greco, c. 1586-94. Louvre, Paris; Gowing, *Paintings*; Gudiol, *El Greco*; Newsweek, *Louvre.*
3395 Julian Romero kneeling before his patron Saint, Louis of France, by El Greco, c. 1594-1604. Prado, Madrid; Smith, *Spain.*
3396 St. Louis King of France distributing alms, by Luis Tristan. Louvre, Paris; Gowing, *Paintings.*
3397 The death of St. Louis (sitting on the floor, taking his last benediction, as attendants pray for him), by Jacques de Lestin. Paris, St. Paul and St. Louis; Châtelet, *French Paintings.*

3398 St. Louis tending the sick (he washes the feet of a sick man, while his attendants stand behind him with his regalia), by Eustace Le Sueur, 1650-55. Tours, Musée des B/A; Mérot, *Le Sueur.*
3399 Blanche of Castile introducing young St. Louis to religion, faith, and piety (the boy king leans against his mother, as she shows him a vision of the virtues), by the studio of Jean Jouvenet. Dole, Municipal Museum; Schnapper, *Jouvenet.*
3400 Last communion of St. Louis (at his pavilion, a monk holds up a torch as a priest approaches with the host; the army watches and prays), drawing by Jean Jouvenet. Alencon, Musée des B/A; Schnapper, *Jouvenet.*
3401 St. Louis visiting the wounded after the battle of Mansourah (as the wounded are tended and given their last rites, Louis prays to heaven, as an angel descends with a palm and laurel wreaths), by Jean Jouvenet. Versailles; Schnapper, *Jouvenet.*
3402 Immaculate Conception with St. Louis of France and the Blessed Amadeus of Savoy, by Francesco Trevisani, 1724. University of Turin; DiFederico, *Trevisani.*
3403 St. Louis of France exhibiting the crown of thorns, by Sebastiano Ricci, c. 1730. Turin, Superga Basilica; Daniels, *Ricci.*
3404 Apotheosis of St. Louis IX, by the French School, 18th cent. Nancy, Musée des B/A; *Musée*; Pétry, *Musée.*
3405 SS. Augustine (holding a flaming heart), Louis IX of France, John the Evangelist, and a bishop saint (under an archway), by the studio of Giovanni Battista Tiepolo. York City Art Gallery; *Catalogue.*
3406 Louis IX at the battle of Taillebourg 1242, by Eugene Delacroix. Versailles, Galerie des Batailles; Geahtgens, *Versailles.*
3407 Louis IX at the battle of Taillebourg 1242, by Eugene Delacroix, 1837. Louvre, Paris; Gaehtgens, *Versailles.*
See also 1825, 1827, 4901

Louis Beltran or Louis Bertrand of Valencia, Dominican missionary, d. 1581 (Oct. 9)
3408 St. Louis Beltran (holding a cup from which rises a tiny dragon), by Francisco de Zurbaran, 1631-40. Seville,

Museum of Fine Arts; Book of Art, *German & Spanish*; Gállego, *Zurbaran*.

3409 Saints Vincent Ferrer, Hyacinth, and Louis Beltran (looking up at an angel) by Giovanni Battista Piazella, before 1740. Venice, Chiesa dei Gesuati; Levey, *Giotto to Cézanne*; Murray, *Art & Artists*.

Louis Bertrand *see* **Louis Beltran**

Louis of Anjou *see* **Louis of Toulouse**

Louis of Toulouse or Louis of Anjou, great-nephew of Louis IX, Franciscan Bishop, d. 1297, canon. 1317 (Aug. 19)

3410 St. Louis of Toulouse crowning Robert of Anjou, king of Naples, by Simone Martini, 1317. Capodimonte, Naples; Berenson, *Ital. Painters*; Hall, *Color and Meaning*; Hartt, *Ital. Ren. Art*; Hills, *The Light*; Kaftal, *Tuscan*; McGraw, *Encyclo.* (Vol.IX, pl.336); New Int'l Illus. *Encyclo.*

3411 St. Louis of Toulouse (standing before a fleuried cloth held by two angels, giving a blessing), by the Master of St. Martino Alla Palma. Coll. Walter Burns, Hertfordshire; Offner, *Corpus* (Sect.III, Vol.V, pl.VI).

3412 Vestition of St. Louis of Toulouse (he dons the robe given him by Pope Boniface), fresco by the Veronese School, mid-14th cent. Verona, S. Fermo; Kaftal, *North East Italy.*

3413 St. Louis of Toulouse (standing wearing a miter, holding a crosier and a book, in a fleuried robe), panel by the Riminese School, 14th cent. Liechtenstein coll., Vaduz; Kaftal, *North East Italy.*

3414 Madonna and Child with two angels, St. Francis of Assisi and St. Louis of Toulouse, by Paolo di Giovanni Fei, c. 1400. Atlanta Art Assoc. Galleries, Atlanta GA; Shapley, *Samuel H. Kress.*

3415 St. Louis of Toulouse, gilded bronze statue by Donatello, 1430. Santa Croce, Florence; Andres, *Art of Florence* (Vol.I, pl.195); Book of Art, *Ital. to 1850.*

3416 St. Louis of Toulouse and his companions before Pope Boniface VIII (Louis kneels, putting his hands into the Pope's hands), fresco by Ambrogio Lorenzetti. Siena, San Francesco; Davenport, *Book of Costume* (pl.612); McGraw, *Encyclo.* (Vol.IX, pl.197); Van Os, *Sienese Altarpieces* (Vol.II, pl.91).

3417 SS. Louis of Toulouse (in a fleuried robe, holding a book and a crosier), and Bernardino of Siena (standing behind Louis), from a triptych by the Master of the Eboli Coronation, 15th cent. Salerno, Museum; Kaftal, *Central and So. Ital.*

3418 SS. Louis of Toulouse, Jerome, and Peter Apostle (standing in three trompe l'oeil arches, flanked by fruit), by Carlo Crivelli. Jacquemart-André Museum, Paris; Zampetti, *Crivelli.*

3419 St. Louis of Toulouse reading, half of a polyptych by Alvise Vivarini, c. 1480–83. Picture Gallery, Berlin; *Catalogue.*

3420 St. Louis of Toulouse wearing a cope, panel from a polyptych by Vittore Crivelli, c. 1481–1501. Fitzwilliam Museum, Cambridge; *Catalogue* (Vol.II).

3421 St. Louis of Toulouse (in bishop's robes and miter), by Cosimo Tura, c. 1484. Met Museum; Ruhmer, *Tura.*

3422 Madonna and Child with St. Louis of Toulouse (in a blue fleuried robe), St. John and donors, by Ghirlandaio, 1486. St. Louis Art Museum, MO.

3423 The St. Giobbe Altarpiece, with Madonna and Child enthroned, surrounded by SS. Francis of Assisi, John the Baptist, Job, Dominic, Sebastian, and Louis of Toulouse, by Giovanni Bellini, c. 1489. Accademia, Venice: Int'l Dict., *Art.*

3424 Virgin and Child with SS. Jerome and Louis of Toulouse in a landscape with an orange tree, by Cima da Conegliano, c. 1496–98. Accademia, Venice: Int'l Dict., *Art.*

3425 St. Louis of Toulouse, St. Francis of Assisi, and the Blessed John Capistrano, triptych by Cristoforo Caselli. Walters Art Gallery, Baltimore; *Ital. Paintings* (Vol.I).

3426 St. Jerome (center, reading) with St. Christopher and St. Louis of Toulouse (in Bishop's robes), by Giovanni Bellini, c. 1513. Venice, S. Giovanni Crisostomo; Burckhardt, *Altarpiece*; Goffen, *Bellini*; Wollheim, *Painting as an Art.*

3427 St. Louis of Toulouse and St. George with the princess (she is sitting on the dragon, holding its leash), by Tintoretto, 1552–53. Accademia, Venice; Valcanover, *Tintoretto.*

3428 Saint Clara and St. Louis of Toulouse (half view), by the studio of Alonso Cano. Granada, Museo Provincial; Wethey, *Alonso Cano* (pl.107).

3429 Vision of St. Louis of Toulouse (he sees the Virgin and Child adored by the Blessed Solomea above his altar), by Carlo Dolci, c. 1675–81. New Orleans Museum of Art, LA; *Handbook.* *See also* 114, 233, 815, 1527, 1603, 1815, 1847, 3782, 3826, 3888, 3967, 4793

Loy *see* **Eligius**

Lucilla, Baptized by Stephen I, who restored her sight; beheaded with her father St. Nemesius; mart. 257 (Oct. 31)
3430 St. Benedict and St. Lucilla (holding her own severed head), by Spinello Aretino, 1385. Fogg Art Museum, Cambridge MA; *Med. and Ren. Paintings.*

Lucius, Pope, r. 253–254 (Mar. 4)
3431 St. Lucius standing in a niche, fresco by Sandro Botticelli in the Sistine Chapel, 1481. Vatican; Brusher, *Popes*; Lightbown, *Botticelli.*

Lucretia or Leocritia of Cordova, Moslem convert, mart. 859 (Mar. 15)
3432 St. Lucretia sitting on a wall, book in her lap, by Dosso Dossi. NGA, Washington DC; Gibbons, *Dossi*; Shapley, *15th–16th Cent.*

Lucy of Syracuse, Roman virgin; stabbed in the neck, mart. 303 (Dec. 13)
3433 Scenes from the life of St. Lucy: she takes her sick mother to the tomb of St. Agatha, who appears and cures her; she sells her possessions; frescoes by the South Italian school, 1192. Melfi, Grotta di S. Lucia; Kaftal, *Central and So. Ital.*
3434 Scenes from the life of St. Lucy (one eye put out before the king, her breasts grabbed by pincers while she is tied to a post, she is tied with ropes and is decapitated), altarpiece from Santa Llúcia de Mur, 13th cent. Barcelona, Museo d'Art de Catalunya; Lasarte, *Catalan.*
3435 St. Lucy (holding a burning urn), icon portrait by Jacopo Torriti, c. 1287–92. Grenoble, Musée de Peinture et de Sculpture; Chiarini, *Tableaux Italiens*; Lemoine, *Musée.*
3436 St. Lucy (with a dagger in her neck, holding a flaming urn and a palm), by Pietro Lorenzetti. Florence, Sta. Lucia tra le Rovinate; DeWald, *Lorenzetti*; Edgell, *Sienese Painting.*

3437 St. Lucy (holding a small vase with a flame), by Jacopo del Casentino and assistant, c. 1330. El Paso Museum of Art, TX; Shapley, *Samuel H. Kress.*
3438 St. Lucy (holding a flaming urn and a dagger by the blade), by Niccolo di Segna. Walters Art Gallery, Baltimore; *Italian Paintings* (Vol.I).
3439 St. Lucy (holding a sword and a burning lamp), panel by Simone Martini. Coll. Berenson, Settignano; Kaftal, *Tuscan.*
3440 St. Lucy (holding a dagger and a burning urn), by the Master of the Sacristy of Siena Cathedral, c. 1375. Minneapolis Inst. of Art, MN; *European Paintings.*
3441 Funeral of St. Lucy, fresco by Altichiero and Avanzo, c. 1380. Padua, S. Giorgio; McGraw, *Encyclo.* (Vol.I, pl.72).
3442 Martyrdom of St. Lucy (in three parts: standing before the pyre, leaving the room, nude, as they boil a cauldron, at right, they stab her in the neck), by Avanzo, c. 1380. Padua, S. Giorgio; McGraw, *Encyclo.* (Vol.I, pl.72).
3443 Miracle of St. Lucy (they are unable to pull her forward as oxen strain at their yokes), fresco by Altichiero and Avanzo, c. 1380. Padua, S. Giorgio; McGraw, *Encyclo.* (Vol.I, pl.70).
3444 Martyrdoms of St. Lucy (executioners pour burning oil and pitch on her head; they try to burn her, but flames do not harm her; Lucy is stabbed in the neck), panels of a polyptych by Paolo Veneziano and workshop. Veglia, Bishop's Palace; Kaftal, *North East Italy.*
3445 St. Lucy (standing in a flowered robe, wearing a crown, holding a palm and a flaming lamp), panel of a polyptych by Paolo Veneziano and workshop. Veglia, Bishop's Palace; Kaftal, *North East Italy.*
3446 St. Lucy in a red cloak with a sword through her neck, roodscreen. Heavitree Church, Devon; Drake, *Saints and Emblems.*
3447 The immolation of St. Lucy (she is burned at the stake, while her persecutor points at her) by Jacobello del Fiore, 1408–10. Fermo, Pinacoteca Civica; New Int'l Illus. *Encyclo.*
3448 Martyrdom of St. Lucy (executioner stabs her in the neck as the king watches from a balcony), predella panel from St. Lucy altarpiece by Domenico

Veneziano, c. 1444. Picture Gallery, Berlin; Book of Art, *Ital. to 1850*; Kaftal, *Tuscan*; Lassaigne, *15th Cent.*; McGraw, *Encyclo.* (Vol.IV, pl.234); Picture Gall., *Catalogue*; United Nations, *Dismembered Works.*

3449 Funeral of Saint Lucy, fresco by Jacopo Avanzo. Padua, S. Giorgio; New Int'l Illus. *Encyclo.*

3450 St. Lucy and the consul Pascasius (she points to her eye sockets, while holding a vase with her eyes in it), wall mural by an unknown artist. La Balme, Puy-Saint-Vincent; *Peintures Murales.*

3451 SS. Anthony Abbot (with staff and bell) and Lucy (holding a plate with eyes and a palm), by Carlo Crivelli. Narodowe Museum, Cracovia; Zampetti, *Crivelli.*

3452 St. Lucy in green, holding a palm frond and flower with eyes, from the dismembered Griffoni polyptych by Francesco del Cossa, c. 1470–75. NGA, Washington DC; Book of Art, *Ital. to 1850*; McGraw, *Encyclo.* (Vol.IV, pl.7); Phaidon, *Art Treasures*; Shapley, *Samuel H. Kress*; United Nations, *Dismembered Works*; Walker, *NGA.*

3453 St. Lucy (wrapped in a green mantle, holding a plate with eyes), from a dismembered altar by Carlo Crivelli, c. 1476. Nat'l Gallery, London; Dunkerton, *Giotto to Dürer*; Zampetti, *Crivelli.*

3454 Martyrdom of St. Lucy (she is tied to four oxen, who are straining to pull her), by Bernardino Fungai, c. 1490. Isaac Delgado Museum of Art, New Orleans LA; Shapley, *15th–16th Cent.*

3455 St. Lucy (holding a bowl with eyes and a palm), by Girolamo di Benvenuto, 1490's. Walters Art Gallery, Baltimore; *Italian Paintings* (Vol.I).

3456 Martyrdom of St. Lucy (she kneels in a burning pyre, while an executioner runs a sword through her neck), by the Master of The Figdor Deposition, late 15th–early 16th cent. Rijksmuseum, Amsterdam; Bentley, *Calendar*; Châtelet, *Early Dutch* (pl.119); *Paintings.*

3457 SS. Lucy (pointing to a plate with eyes), Apollonia, and Agatha, by Gaspare Traversi. Parma, Galleria Nazionale; Pierleoni, *Denti e Santi* (fig.143).

3458 Madonna and Child with SS. Peter, Catherine, Lucy, Paul, and the infant John the Baptist, known as the Colonna altarpiece, by Raphael, 1505. Met Museum; Hibbard, *Met Museum.*

3459 Sacra Conversazione: Virgin and Child sit on a wall, flanked by St. Lucy holding a candle at left, and SS. Joseph and Mary Magdalene in conversation at right, by Giovanni Cariani, c. 1512–14. Accademia, Venice; Pallucchini, *Cariani.*

3460 St. Lucy (in a wimple and a pleated dress), by Grünewald, c. 1512. Furstenbergische Gallery, Donaueschingen; Book of Art, *German & Spanish*; Cooper, *Family Collections.*

3461 St. Lucy (holding a book with two eyes on its cover, and a palm), fresco by Bernardino Luini. Milan, San Maurizio al Monastero Maggiore; Fiorio, *Le Chiese di Milano.*

3462 The St. Lucy Altarpiece (she disputes with the tribunal, as they attempt to pull her away with oxen; St. Lucy at the tomb of St. Agatha), by Lorenzo Lotto, 1532. Jesi, Pinacoteca Comunale; Berenson, *Lotto*; McGraw, *Encyclo.* (Vol.IX, pl.211).

3463 St. Lucy holding a plate with eyes, in "Madonna Enthroned with Saints" by Benvenuto da Garofalo, 1533. Estense Gallery, Modena; New Int'l Illus. *Encyclo.*

3464 St. Lucy, holding a glass cup with eyes, by Sebastiano del Piombo. Ponce, Museo de Arte; Held, *Catalogue.*

3465 St. Lucy (standing on a pedestal, holding a burning urn), flanked by SS. Mary Magdalene and Catherine of Alexandria, before a mountainous landscape, att. to the studio of Cima da Conegliano. Picture Gallery, Berlin; Pallucchini, *Cariani.*

3466 St. Lucy (holding a stick with an eye and a palm) and a donor, by Paolo Veronese, c. 1580. NGA, Washington DC; Walker, *NGA.*

3467 Martyrdom and last communion of St. Lucy (taking communion as she is being stabbed at the same time in the heart), by Paolo Veronese, c. 1582. NGA, Washington DC; Rearick, *Veronese.*

3468 Burial of St. Lucy (she is placed in a hole in the floor), by Caravaggio, 1608. Syracuse, S. Lucia; Freedberg, *Circa 1600*; Held, *17th & 18th Cent.*; Moir, *Caravaggio.*

3469 The martyrdom of St. Lucy (in a crowd; a dagger is in her heart), etching with engraving by Jacques Bellange, 1615–16. Nelson-Atkins Museum of Art, Kansas City MO; *Collections.*

3470 Martyrdom of St. Lucy; her last

communion before being dragged by oxen, drawing att. to Alessandro Maganza. Met Museum; Bean, *15th & 16th Cent.*

3471 The martyrdom of St. Lucy (tied to a tree, as executioner drives a dagger into her throat), with the apparition of St. Agatha, oil sketch by P.P. Rubens, 1620. Quimper, Musée des B/A; Held, *Oil Sketches* (pl.39).

3472 St. Lucy (holding a plate with eyes and a palm), by Francisco de Zurbaran, 1631-40. Chartres Museum; Gállego, *Zurbaran*; United Nations, *Dismembered Works.*

3473 St. Lucy holding a plate with eyes, by Francisco de Zurbaran, 1625-30. NGA, Washington DC; Gállego, *Zurbaran*; Walker, *NGA.*

3474 St. Lucy (holding up a platter), by Francisco de Zurbaran, 1641-58. Hispanic Society of America, New York; Gállego, *Zurbaran.*

3475 St. Lucy (looking down at a plate with eyes), by Francisco de Zurbaran, 1641-58. Bolullos de la Mitacion Parish Church; Gállego, *Zurbaran.*

3476 St. Lucy (holding a writing plume) by Bernardo Cavallino, c. 1645. Coll. De Vito, Naples; RA, *Painting in Naples.*

3477 St. Lucy distributing alms, by Aniello Falcone, c. 1646. Capodimonte, Naples; RA, *Painting in Naples.*

3478 Martyrdom of St. Lucy (she is held by many men, while one is about to run her through; an angel descends with palm and wreath), by Francesco Trevisani, c. 1688. Corsini Palace, Rome; Di Federico, *Trevisani.*

3479 The last communion and martyrdom of St. Lucy (throat bleeding, she is about to receive communion), by Sebastiano Ricci, 1730. Florence, Sta. Lucia tra le Rovinate; Daniels, *Ricci.*

3480 The communion of St. Lucy (as she kneels before a priest), by Giambattista Tiepolo. Venice, SS. Apostoli; Morassi, *Catalogue* (pl.118).

3481 The communion of St. Lucy (as she kneels with a dagger in her throat), oil sketch by Giambattista Tiepolo. Milan, Museo Civico; Morassi, *Catalogue* (pl.115).

3482 Martyrdom of St. Lucy (she kneels on a burning bier, holding a plate with eyes, while executioners stoke the fire and a man runs a long sword through her neck; angels descend with a palm and a

crown), by Pompeo Batoni, 1759. Real Academia de Bellas Artes de San Fernando, Madrid; Clark, *Batoni.*
See also 67, 75, 1199, 1607, 3328, 3697, 4783, 4924

Ludger or Liudger, bishop of Münster, d. 809 (Mar. 26)
3483 St. Augustine, St. Ludger, St. Hubert (all three as bishops), and St. Maurice, by the Meister von Werden. Nat'l Gallery, London; Poynter, *Nat'l Gallery.*

Ludmilla, grandmother of St. Wenceslas, patron of Prague; strangled; mart. 921 (Sept. 16)
3484 Bust reliquary of St. Ludmilla, wrought and gilded copper, after 1350. Prague, St. Vitus Cathedral; Kutal, *Gothic Art.*

3485 St. Ludmilla with St. Wenceslas, sculpture by Matthias Bernard Braun, 1710. Charles Bridge, Prague; Štech, *Baroque Sculpture.*
See also 3704, 4888

Luigi Gonzaga or Aloysius, Jesuit of noble birth, d. 1590, canon. 1726 (June 21)
3486 Madonna and Child with Saints Francis of Assisi and Aloysius Gonzaga (pointing to the Madonna) and Alvise Gozzi as donor, by Titian, 1520. Ancona, Museo Civico; Wethey, *Titian* (pl.24).

3487 Portrait of St. Aloysius Gonzaga in white doublet by anon. artist. KM, Vienna; Bentley, *Calendar*; Coulson, *Saints.*

3488 The vocation of San Luigi Gonzaga (an angel shows him a crucifix) by Guercino, c. 1650. Met Museum.

3489 Vows of St. Luigi Gonzaga (he embraces a cross before his superiors, seated on a cloud, while pagan temptations are warded off by St. Michael), by Theodore Boyermans, 1671. Nantes, Musée des B/A; Cousseau, *Musée*; Hairs, *Sillage de Rubens.*

3490 St. Aloysius Gonzaga in glory (thought to commemorate the saint's canonization), by Giovanni Battista Tiepolo, 1726. Courtauld Inst. of Art, London; *Catalogue*; Morassi, *Catalogue* (pl.113).

3491 St. Luigi Gonzaga adoring a crucifix (with hands clasped), by Giuseppe

Maria Crespi, c. 1730. Finarte, Milan; Merriman, *Crespi*.

3492 St. Luigi Gonzaga (looking down at a crucifix which he cradles in his arm, before a table holding a lily and a skull), by Pompeo Batoni, c. 1744. Private coll., New York; Clark, *Batoni*.

3493 The Holy Family with Saints Francis of Paola (holding a staff topped with CHS) and Aloysius Gonzaga, by Francesco Capella, 1760–65. Boston Museum of Fine Arts.

3494 St. Luigi Gonzaga in glory, terracotta relief by Pierre Legros II. Detroit Inst. of Art, MI.

See also 2011, 4484, 4486

Luminata *see* **Illuminata**

Luminosa *see* **1857**

Lupus *see* **Leu**

Lutgard or Lutgardis of Flanders, Cistercian nun, blind, d. 1246 (June 16)
3495 William of Afflighem praying to St. Lutgard (who crowns him from above), from his "Life of St. Lutgard" from the Abbey of St. Trond, ms. Ny kgl. Saml. 168, 43, c. 1300. Copenhagen Royal Library; *Benedict* (p.447).

3496 St. Lutgard at the foot of the cross, sculpture by Matthias Bernard Braun, 1710. Charles Bridge, Prague; Štech, *Baroque Sculpture*.

Luxine *see* **3890**

Macaire of Ghent or Macarius, invoked against epidemics, d. 1012 (Apr. 10)
3497 St. Macaire of Ghent tending the plague-stricken (he is giving communion), by Jacob van Oost the Younger, 1673. Louvre, Paris; Gowing, *Paintings*.

Macarius of Egypt, hermit in the desert of Scete, d. 391 (Jan. 15)
3498 St. Macarius of Egypt (balding, with a long white beard, holding a crutch and a rolled scroll), predella of an altarpiece by Lorenzo Veneziano, 1357. Venice; Kaftal, *North East Italy*.

3499 St. Macarius of Egypt (holding a crutch, giving a blessing, with devils in the background), by the Marchigian school, 15th cent. Ostra, S. Lucia; Kaftal, *Central and So. Ital.*

3500 St. Macarius of Egypt (standing with a crutch resting against a skull),

fresco att. to Spagna. Gavelli (Spoleto), S. Michele; Kaftal, *Central and So. Ital.*

Macarius of Jerusalem *see* **Makarios**

Machutus *see* **Malo**

Maclou *see* **Malo**

Madeleine Sophie Barat, founded New Congregation, d. 1865 (May 25)
3501 Madeleine Sophie Barat (in nun's habit), portrait by Savinien Petit. Amiens, Sacre Coeur; Coulson, *Saints*.

Mafalda *see* **Matilda**

Maglorio, Monk, bishop of Dol, d. 605 (Oct. 24)
3502 St. Maglorio (wearing a miter, holding a crosier), detached fresco by the Romagnone School, 15th cent. Faenza, Museo Internazionale delle Ceramiche; Kaftal, *North East Italy*.

3503 Madonna with Saints Gregory I and Maglorio, by Jacopo Bertucci. Faenza, Pinacoteca; Gibbons, *Dossi*.

Magnus, Earl of Orkney, killed by his cousin Haakon, mur. 1116 (Apr. 16)
3504 St. Magnus (stabbed with knives); St. Germanus (with a mule); St. Felix I (about to be beheaded); SS. Faith, Hope, Charity, and Wisdom (decapitated); St. Stephen the Pope (stabbed with a sword at the altar); St. Oswald the King; St. Donatus (resuscitating a boy); woodcuts by Günther Zainer from "Leben der Heiligen, Sommerteil," Augsburg, 1472. The Illus. Bartsch; *German Book Illus.* (Vol.80, pp.88–89).
See also 3513

Makarios or Macarius, Patriarch of Jerusalem, d. 335 (Mar. 10)
3505 Saint Makarios, patriarch of Jerusalem, fresco, c. 1176–80. Patmos; Kominis, *Patmos* (p.91).
See also 4905

Malo or Machutus or Maclou of Brittany, Bishop, d. 627 (Nov. 15)
3506 Saint Malo holding a model of a church, limestone statue from St. Hillaire du Harcouet, Normandy, c. 1250–1300. Boston Museum of Fine Arts.

Mamas, shepherd; pierced with a trident; mart. 275 at Caesarea (Aug. 17)
3507 The Trinity (with crucified Christ)

with SS. Mamas (with lions) and John the Evangelist at left, and SS. Zenobius and Jerome at right, altarpiece by Pesellino, 1455–60. Nat'l Gallery, London; Dunkerton, *Giotto to Dürer.*

3508 St. Mamas, mounted on a lion, holding a lamb, fresco, 1494. Church of the Holy Cross of Agiasmati, near Platanistasa; Stylianou, *Painted Churches* (p.208).

3509 Scenes from the life of St. Mamas: St. Mamas is thrown to the beasts, but they lie down at his feet; his belly is pierced with a trident; he flees to a hut and dies while in prayer; an angel carries his soul to heaven; predella panels by Francesco dei Franceschi. Correr Museum, Venice; Kaftal, *North East Italy.*

3510 Soldiers flee as they try to arrest St. Mamas (when wild animals approach), predella panel by Francesco dei Franceschi. Yale Univ. Art Gallery, New Haven CT; Kaftal, *North East Italy.*

3511 St. Mamas (sitting with an open book on his knee, holding a palm, with a lion at his side), central panel of a polyptych by Francesco dei Franceschi. Verona; Kaftal, *North East Italy.*

3512 St. Mamas (riding a lion, holding a lamb) icon fresco, early 16th cent. Pelendri, Church of Panagia Katholiki; Stylianou, *Painted Churches* (p.234).

Mamertinus

3513 St. Mamertinus (on his deathbed, surrounded by monks); St. Magnus (with a wild beast before a fruit tree); SS. Protus and Hyacinth (pursued by men bearing clubs); St. Cyprian (decapitated); woodcuts by Günther Zainer from "Leben der Heiligen, Sommerteil," Augsburg, 1472. The Illus. Bartsch; *German Book Illus.* (Vol.80, pp.91–92).

Marcellina, Sister of St. Ambrose, d. 398 (July 17)

3514 St. Ambrose enthroned, flanked by SS. Satyrus and Gervase, and SS. Marcellina and Protase, from an altarpiece by Ambrogio Bergognone, 1490. Pavia, Certosa; Kaftal, *North West Italy.*

Marcellinus I, Pope, mart. 304 (Apr. 26)

3515 St. Marcellinus, fresco in the Sistine Chapel by Sandro Botticelli, 1481. Vatican; Brusher, *Popes*; Lightbown, *Botticelli.*

Marcellus I, Pope, r. 308–309 (Jan. 16)

3516 St. Marcellus I standing in a niche, fresco in the Sistine Chapel by Sandro Botticelli, 1481. Vatican; Brusher, *Popes*; Lightbown, *Botticelli.*

3517 St. Marcellus I (in papal regalia), by Domenico Ghirlandaio. Sistine Chapel, Rome; Bentley, *Calendar.*

See also 4905

Marcionilla

3518 Christ in Glory (above, with angels) with SS. Celsus, Julian, Marcionilla, and Basilissa, by Pompeo Batoni, c. 1736–38. J. Paul Getty Museum, Malibu CA; Clark, *Batoni.*

See also 1308, 3180

Marcisius

3519 St. Marcisius holding a book, by Ferrer Bassa, c. 1346. Convent of the Nuns of The Order of St. Clare, Pedralbes; Book of Art, *German & Spanish.*

Mardarios *see* **564**

Margaret or Marina, patron of women in childbirth, one of the Fourteen Holy Helpers; decapitated; mart. 306 (July 17 or 20)

3520 Frontal of St. Margaret, second half of 12th cent. Episcopal Museum, Vich, Spain; McGraw, *Encyclo.* (Vol. XIII, pl.127).

3521 Martyrdoms of St. Margaret: she is burned with brands as she is hung by her hands; she is placed in a cauldron of water; a dove descends with a crown and 5000 witnesses are converted; the five thousand men are beheaded; Margaret is beheaded, and her executioner falls to the ground; illum. from ms. 1853, late 13th cent. Verona, Biblio. Civica; Kaftal, *North East Italy.*

3522 Scenes from the life of St. Margaret: King Olybrius sends for Margaret, who has smitten him with her beauty; after admitting she is Christian, she is imprisoned; she is beaten with rods; she is tortured with iron combs; she is tended in prison; a dragon appears to her in prison and eats her; she bursts open the dragon; illum. from ms. 1853, late 13th cent. Verona, Biblio. Civica; Kaftal, *North East Italy.*

3523 Saints Catherine of Alexandria and Marina (Margaret), icon of mid-13th cent. Sinai, St. Catherine's Monastery; Knopf, *The Icon* (p.235).

3524 Virgin and Child with scenes from the life of St. Margaret (confronting a king, devoured by a dragon, hung by her wrists, decapitated with a sword), altar frontal of St. Margaret, 13th cent. Vic, Museu Episcopal; Lasarte, *Catalan.*

3525 SS. Margaret (holding a cross) and Agnes (holding a lamb) in half-length, predella panel by the workshop of Bernardo Daddi. Strasbourg, Musée de la Ville; Offner, *Corpus* (Sect.III, Vol.VIII, pl.IX).

3526 St. Benedict (with a book and crutch), St. Catherine of Alexandria (holding a wheel) and St. Margaret, by Pietro Lorenzetti. Coll. Horne, Florence; DeWald, *Lorenzetti.*

3527 St. Margaret taming a demon (with a hammer), from Mystical Marriage of St. Catherine of Alexandria by Barra da Siena c. 1340. Boston Museum of Fine Arts.

3528 Martyrdom of St. Margaret (hung by her wrists, stripped to the waist, her body covered with wounds), fresco by the Veronese School, 14th cent. Cazzano di Tramigna, S. Pietro in Briano; Kaftal, *North East Italy.*

3529 St. Margaret (spearing a dragon with a staff topped by a crucifix), panel from a cathedral screen, by the East Anglian School, 14th cent. Norwich Cathedral; Gaunt, *Pictorial Art* (Vol.I, pl.88).

3530 St. Margaret and the story of her life, by the Florentine School, 14th cent. Vatican Museums; Francia, *Vaticana.*

3531 Madonna enthroned between St. Catherine of Alexandria and St. Margaret, c. 1360. Aleš Gallery, Hluboká (Frauenberg); Bachmann, *Gothic Art.*

3532 St. Margaret and the dragon (she kneels over the dragon, which holds the skirt of her robe in its mouth), illum. by the Rohan Master from a Book of Hours, ms. Latin 9471, fo.232v, c. 1415-16. BN, Paris; *Rohan Master* (pl.118).

3533 St. Margaret and the prefect (she interrupts him at his hunt), by an imitator of Lorenzo Monaco. Vatican Museums; Eisenberg, *Monaco* (pl.246).

3534 St. Margaret (emerging from the dragon), from a polyptych by Giacomo Durandi, c. 1450. Frejus, Cathedral; Kaftal, *North West Italy.*

3535 St. Margaret subduing the dragon Tarasque on the banks of the Rhone by sprinkling it with holy water, woodcut by Hartmann Schedel. Archiv-

für Kunst und Geschichte, Berlin; Hogarth, *Dragons* (p.101).

3536 Meeting of St. Margaret and the Prefect Olybrius (she stands with other maidens in the midst of her herd, holding a spindle, unaware of the prefect who leaves the road), illum. by Jean Foucquet from the Hours of Etienne Chevalier, c. 1453. Condé Museum, Chantilly; Fouquet, *Hours.*

3537 St. Margaret (tending sheep, as armored men ride up), from the "Hours of Etienne Chevalier," 1452-61. Louvre, Paris; Gowing, *Paintings.*

3538 St. Margaret with the dragon, polychromed wooden sculpture att. to Heinrich Yselin, c. 1470. Allentown Art Museum, PA; *Samuel H. Kress.*

3539 St. Margaret and St. Mary Magdalene with Mary Portinari and her daughter, from Portinari Altarpiece by Hugo van der Goes, 1474-76. Uffizi, Florence; New Int'l Illus. *Encyclo.*; Praeger, *Great Galleries.*

3540 St. Margaret with a donor (kneeling inside a room before a window), by Vrancke van der Stockt. Rochester Memorial Art Gallery, NY; *Handbook.*

3541 St. Margaret and the dragon (breathing fire at her), by the Master of the First Prayer Book of Maximilian, from the Hours of William Lord Hastings, add.ms.54782, fo.50v, late 1470's. BM, London; BL, *Ren. Painting in MS.*

3542 Scenes from the life of St. Margaret: while tending sheep, she is seen by Olybrius, who is seduced by her beauty; she is brought before Olybrius, who discovers she is Christian and throws her into prison; tied to a column and scourged; overcomes a dragon in prison; tied to a column and scorched with burning brands; beheaded; predella panels by Ludovico Brea. Masséna Museum, Nice; Kaftal, *North West Italy.*

3543 St. Margaret rejects the prefect; Margaret killing the dragon with a crucifix on a staff; woodcut by Michael Wolgemut. Archiv für Kunst und Geschichte, Berlin; Hogarth, *Dragons* (p.150).

3544 SS. Barbara, Ursula (holding an arrow) and Margaret, left wing of the Martyrdom of St. Catherine triptych by Lucas Cranach the Elder, c. 1502. Budapest, Reformed Church; Friedländer, *Cranach.*

3545 St. Margaret and St. Barbara (sitting in discussion), drawing by Albrecht Altdorfer, c. 1509. Städelsches Kunstinstitut, Frankfort; Guillaud, *Altdorfer*.

3546 St. Margaret and St. Barbara (seated in discussion), from polyptych of St. Florian by Albrecht Altdorfer, 1518. Monastery of St. Florian, near Linz, Austria; Guillaud, *Altdorfer*.

3547 St. Margaret (bestriding a dead dragon), by Giulio Romano. Louvre, Paris; Raphael, *Complete Works*.

3548 St. Margaret (holding a crucifix, a dead dragon curled around her legs), by Giulio Romano. KM, Vienna; Hogarth, *Dragons* (p.151); Raphael, *Complete Works* (2.100).

3549 St. Margaret (holding a leash), by Lucas Cranach the Elder, 1513-14. Minneapolis Inst. of Art, MN; Friedländer, *Cranach*; Schade, *Cranach*.

3550 St. Margaret herding sheep (as the prefect and courtiers ride past her), below, St. Margaret in prison with the dragon; St. Margaret drawing the dragon from the cave (she leads the dragon out of the cave with a leash, while a man strikes with a spear; the dragon has two legs sticking out of its mouth), illums. by Jean Bourdichon from the Great Hours of Henry VIII, 1514-18. Coll. Duke of Cumberland; *Great Hours*.

3551 Madonna and Child with Saints Margaret, Jerome, and other saints, by Parmigianino, 1528-29. Bologna, Pinacoteca Nazionale; Freedberg, *Circa 1600*; New Int'l Illus. *Encyclo.*; Ricci, *Cinquecento*.

3552 Margaret or Marina, standing on a dragon, French limestone statue, 16th cent. V & A, London; Coulson, *Saints*.

3553 St. Margaret (subduing a dragon with a crucifix), by workshop of Titian, c. 1552. El Escorial, Spain; Wethey, *Titian* (pl.175).

3554 St. Margaret (subduing a dragon with a crucifix), copy after Titian. Calahorra Cathedral (Logroño); Wethey, *Titian* (pl.176).

3555 St. Margaret (subduing a dragon with a crucifix), by Titian, c. 1565-70. Heinz Kisters, Kreuzlingen; Wethey, *Titian* (pl.174).

3556 St. Margaret and the dragon (subduing a dragon with a crucifix), by Titian, c. 1565. Prado, Madrid; Newsweek, *Prado*; Wethey, *Titian* (pl.173).

3557 St. Margaret (with a dragon), by Bartholomaus Spranger. Archer Huntington Gallery, Austin TX; Kaufmann, *School of Prague*.

3558 Madonna and Child with SS. John the Baptist, Benedict, Margaret, and Cecilia, by Agostino Carracci, 1586. Parma, Galleria Nazionale; *Age of Correggio*.

3559 St. Margaret (leaning against a stone wall and pointing to heaven), by Annibale Carracci, c. 1597-99. Rome, Santa Caterina dei Funari; *Age of Correggio*.

3560 St. Margaret (in prison, holding a blue rope, which is tied to a conquered demon in the form of a winged man), by Domenico Feti. Pitti Palace, Florence; Bentley, *Calendar*.

3561 Saint Marina (in half-length wearing a red cloak, holding a cross), icon, early 17th cent. Bulgaria, National Art Gallery; Paskaleva, *Bulgarian Icons*.

3562 The martyrdom of St. Margaret (she kneels, as executioner holds up sword, watched by Madonna and two saints) by Giuseppe Cesari, c. 1615. NGA, Washington DC.

3563 Martyrdom of St. Margaret (she leans away from the executioner, who is about to strike with a sword), by Ludovico Carracci, 1616. Mantua, S. Maurizio; Freedberg, *Circa 1600*; McGraw, *Encyclo.* (Vol.XI, pl.452).

3564 St. Margaret in a hat, with a striped bag hanging from her arm, by Francisco de Zurbaran, c. 1635. Nat'l Gallery, London; Book of Art, *German & Spanish*; Gállego, *Zurbaran*.

3565 St. Margaret (attacked by the devil in the form of a dragon), by Nicolas Poussin, c. 1637. Sabauda Gallery, Turin; Wright, *Poussin*.

3566 St. Margaret (holding a palm, her hand on the snout of a dragon), by Mario Balassi, mid-17th cent. Bob Jones Univ. Art Gallery, Greenville, SC; Pepper, *Ital. Paintings*.

3567 St. Marina (or Margaret, in a red dress and a hat, holding a book, a hooked staff, and a striped bag), by Francisco de Zurbaran 1641-58. Seville, Museum of Fine Arts; Gállego, *Zurbaran*.

3568 Virgin and Child with St. Margaret (she kneels, holding Jesus), by Antonio Crespi. Formerly Ghedini, Bologna; Merriman, *Crespi*.

3569 St. Margaret (bestriding a fallen demon in a mountainous landscape) by

Alexandre Desgoffe, c. 1845. Dijon, Musée des B/A; Georgel, *Musée des B/A*. *See also* 25, 437, 483, 761, 1075, 1309, 1342, 3248, 3313, 3332, 3913, 4357

Margaret of Cortona, Franciscan Penitent, d. 1297 (Feb. 22)
3570 St. Margaret of Cortona (standing in a checkered tunic, holding a rosary), altarpiece by a Sienizing master of the second quarter of the 14th cent. Cortona, Museo Diocesano; Kaftal, *Tuscan*.
3571 St. Margaret of Cortona (in a Franciscan tunic and a wimple, holding beads and a rock), fresco by the School of the Abruzzi, 15th cent. Atri, Cathedral; Kaftal, *Central and So. Ital.*
3572 Death of St. Margaret of Cortona (she is given her last confession as she lies on the bed), by Marco Benefial. Rome, S. Maria in Aracoeli; Bentley, *Calendar*.
3573 The ecstasy of St. Margaret of Cortona (in a nun's habit, she is supported by angels as Jesus appears to her from above), by Giovanni Lanfranco, 1622. Pitti Palace, Florence; *Age of Correggio*; *Int'l Dict. of Art*; McGraw, *Encyclo.* (Vol.II, pl.197); Merriman, *Crespi*; Stagni, *Canuti*.
3574 St. Margaret of Cortona (kneeling in a nun's habit in prayer), by Giuseppe Maria Crespi. Vatican Museums; Francia, *Vaticana*.
3575 Margaret of Cortona, standing before a large crucifix, by Martinetti, 1901. Coulson, *Saints*.

Margaret of Hungary, Daughter of Belak of Hungary, Dominican nun, d. 1270 (Jan. 26)
3576 St. Margaret of Hungary receiving the stigmata (from a crucified Christ, at mass), detached fresco by a Brescian master, early 15th cent. Pinacoteca Tosio-Martinengo, Brescia; Kaftal, *North West Italy*.
3577 St. Margaret of Hungary receiving the stigmata (from a crucified Christ), fresco by the Umbrian School, 15th cent. Città di Castello, S. Domenico; Kaftal, *Central and So. Ital.*
3578 St. Margaret of Hungary (standing with a scroll, showing her stigmata, with two angels holding a crown above her head and a kneeling donor at her feet), fresco by Tomaso da Modena.

Treviso, S. Niccolò; Kaftal, *North East Italy*.

Margaret of Scotland, Queen of Scotland, d. 1093, canon. 1251 (June 10 & Nov.16)
3579 St. Margaret, from MS Add. 39761, f.93b, 15th cent. BM, London; Maclean, *Scotland*.
3580 St. Margaret, from a stained-glass window in St. Margaret's chapel. Edinburgh Castle; *Official Guide to Edinburgh Castle*.
3581 St. Margaret of Scotland (standing in a beam of celestial light, holding her crown and a book), by Benjamin West, 1799. Coll. The Lord Bishop of London; von Erffa, *West*.
3582 The landing of St. Margaret at Queensferry (greeted by King Malcolm III), mural, 19th cent. Scottish NPG; Bentley, *Calendar*.
3583 Marriage of Malcolm III and St. Margaret on Easter day, 1070, by Runciman. Pennycuick House, Scotland

Mariano or Marianus, Roman martyr; beheaded; mart. 259 (April 30)
3584 Martyrdom of St. Mariano (hung by his hands with a weight on his feet), by Guido Palmerucci, 1315-49. Nancy, Musée des B/A; Kaftal, *Tuscan*; *Musée*; Pétry, *Musée*.
3585 St. John and St. Mariano conducted to prison (as soldiers look on), by Guido Palmerucci, 1315-49. Nancy, Musée des B/A; Kaftal, *Tuscan*; *Musée*; Pétry, *Musée*.

Marinus, Established hermitage at San Marino, 4th cent. (Sept. 4)
3586 Allegory of St. Marinus receiving the Republic of San Marino after the siege of Cardinal Alberoni (he stands on a cloud, taking a woman's hand, and points to the city towers in the background), by Pompeo Batoni, 1740-41. San Marino, Museo di Stato; Clark, *Batoni*.

Marius, Martha, Audifax and Ambachum, martyred for burying Christians burned in the amphitheater (Jan. 19)
3587 Martyrdom of SS. Marius, Martha, Audifax and Ambachum (executioner is about to decapitate one of the saints with an ax), fresco by G. Gimignani, 1641. Rome, S. Carlo ai Catinari; Waterhouse, *Roman Baroque*.

Martha *see* **Margaret**

Martial *see* **Marziale**

Martin, Bishop of Tours, co-patron of Bellumo, patron of wine merchants, c. 397 (Nov. 11)
3588 St. Martin dividing his cloak, from the altar frontal of Hix, c. 1100. Barcelona, Museo d'Art de Catalunya; Lasarte, *Catalan*; Lassaigne, *Spanish*.
3589 Miracles of St. Martin (he raises the dead; he exorcises demons from men), from a Collectanea on St. Martin, ms.73, f.5v, first half of 12th cent. Epinal Library; Porcher, *Medieval French Min.* (fig.19).
3590 St. Martin (with a red banner) sharing his cloak, the altar frontal of Sant Marti de Puigbò, 12th cent. Vic, Museu Episcopal; Lasarte, *Catalan*; Lassaigne, *Spanish*.
3591 Christ between the Virgin and St. Martin and members of the brotherhood of Saint-Martin-du-Canigou attending mass, min. from 1195. Paris, Biblio. de l'Ecole des B/A; Lasarte, *Catalan*.
3592 St. Martin dividing his cloak; St. Martin raising three dead persons (from coffins), from the Berthold Missal, ms. 710, fo.125v, c. 1200-35. Pierpont Morgan Library, NY; Swarzensski, *Berthold Missal* (pl.XXXVII).
3593 St. Martin, marble statue, c. 1220-30. Chartres Cathedral; Gardner, *Art thru Ages* (pl.1029).
3594 St. Martin and the beggar, facade sculpture by Guido da Como, c. 1240. Lucca, S. Martino; McGraw, *Dict.*
3595 Mass of St. Martin (hand of God reaches down as he lifts the host), altar frontal of Santa Maria de Gia by Joan the Painter, 13th cent. Barcelona, Museo d'Art de Catalunya; Lasarte, *Catalan*.
3596 St. Martin and the beggar, painted glass from Yugoslavia. Paris, Musée de l'Homme; McGraw, *Encyclo.* (Vol.V, pl.353).
3597 St. Martin being knighted by Emperor Julian (a man buckles on his spurs, while another buckles on his belt), fresco by Simone Martini. San Francesco, Assisi; Berenson, *Ital. Painters*; Edgell, *Sienese Painting*; Hills, *The Light*; Kaftal, *Tuscan*.
3598 Funeral of St. Martin (in Gothic chapel; youth kisses St. Ambrose's ring, who conducts the funeral), fresco by Simone Martini, c. 1328. San Francesco, Assisi; Hartt, *Ital. Ren.*
3599 Scenes from the life of St. Martin: he decides to leave the army (accused of cowardice, he offers to go before the enemy with a cross instead of a sword); Emperor Valentinian, unwilling to rise when Martin enters his chamber, is forced to do so when his throne catches fire; frescoes by Simone Martini, 1328. San Francesco, Assisi; Edgell, *Sienese Painting*; Kaftal, *Tuscan*.
3600 Vision of St. Martin (Christ and angels appear at his bedside), fresco by Simone Martini, c. 1328. San Francesco, Assisi; Edgell, *Sienese Painting*; Hartt, *Ital. Ren.*; Kaftal, *Tuscan*; Levey, *Giotto to Cézanne.*
3601 St. Martin and the beggar (he sits astride a horse outside of a building, cutting his cloak), att. to Simone Martini, c. 1340-45. Yale Univ. Art Gallery; *Selected Paintings.*
3602 St. Martin dividing his cloak (he towers over the beggar, splitting an ermine cloak), panel of a polyptych by Guariento, 1344. Norton Simon Museum, Los Angeles CA; Kaftal, *North East Italy.*
3603 St. Martin dividing his cloak (half-view, with St. Martin looking down as he cuts his cloak; the beggar watches at left), wing of an altarpiece by Master of the Rebellious Angels. Louvre, Paris; Laclotte, *L'Ecole d'Avignon.*
3604 Scenes from the life of St. Martin: he renounces his profession of arms; he is beaten by robbers; he turns water into wine in the presence of St. Ambrose; because the cloak he divided was too short, an angel appeared at mass and covered his arms with bracelets; from a polyptych att. to Paolo Veneziano. Chioggia, S. Martino; Kaftal, *North East Italy.*
3605 Scene from the life of St. Martin of Tours (dividing his cloak), marble relief. Rathaus, Fritzlar, Germany; New Int'l Illus. *Encyclo.* (see Gothic).
3606 St. Martin and the beggar (beggar is missing his left foot, and stands with a crutch), from the "Boucicaut Hours" painted by the Boucicaut Master, ms.2,fo.34. Jacquemart-André Museum, Paris; Meiss, *French Painting.*
3607 St. Martin turns water into wine in the presence of St. Ambrose, from a polyptych att. to Paolo Veneziano.

Chioggia, S. Martino; Kaftal, *North East Italy* (fig.888).

3608 St. Martin and the beggar (he cuts an ermine cloak), from a breviary by the Boucicaut Master, ms.2,fo.404v, before 1415. Châteauroux, Biblio. Municipale; Meiss, *French Painting*.

3609 St. Martin and the beggar (God hands down a cloak from heaven), from "Belles Heures de Jean Duc de Berry" illus. by the Limbourg Brothers, fo.169. Cloisters Museum NY; Meiss, *French Painting*.

3610 St. Martin and the beggar (the beggar is hidden behind the horse, as Martin comes out of a city), illum. by the Rohan Master from a Book of Hours, ms. Latin 9471, fo.225, c. 1415-16. BN, Paris; *Rohan Master* (pl.109).

3611 St. John the Evangelist and St. Martin of Tours, from the Sta. Maria Maggiore triptych by Masolino, c. 1423. Philadelphia Museum of Art, PA; Hartt, *Ital. Ren.*

3612 St. Martin sharing his cloak with the beggar, by Sassetta. Chigi-Saracini Palace, Siena; Christiansen, *Siena*; Lloyd, *1773 Milestones* (p.94); New Int'l Illus. *Encyclo.* (see Sienese).

3613 St. Martin (in a brocade tunic) dividing his cloak, from the Altar of Berenguer by the Master of Los Marti de Torres, before 1443. San Carlos Museum, Valencia; Lassaigne, *Spanish*.

3614 Miraculous mass of St. Martin, by Franconian School, mid-15th cent. Allentown Art Museum, PA; Allentown, *Samuel H. Kress*; Eisler, *European Schools*.

3615 St. Martin and the beggar (he is drawing his sword) at a triangular corner on the bridge over the river; below, angels flank a hinged scene with the name Estienne Chevalier written about its frame, min. by Jean Fouquet from Estienne Chevalier's Book of Hours, c. 1455. Louvre, Paris; Brion, *Louvre*; Fouquet, *Hours*; Gowing, *Paintings*.

3616 Scenes from the life of St. Martin: baptism of St. Martin; mass of St. Martin; entombment and ascension of St. Martin, by Martin de Soria, c. 1471. Virginia Museum of Fine Arts; *European Art*.

3617 St. Martin (on horseback) and the beggar (with crutches), att. to Jan Bockhorst. Münster, St. Martini; *800 Jahre*.

3618 St. Martin and the beggar (Martin is enthroned, and the beggar approaches with a bowl), woodcut by Johann Neumeister from "Agenda Moguntinensis," Mainz, 1480. The Illus. Bartsch; *German Book Illus.* (Vol.82, p.240).

3619 St. Martin (in a blue tunic) and the beggar (with a bird perched above the artist's inscription), by Bartolomeo Vivarini, 1491. Carrara Academy, Bergamo; Lloyd, *1773 Milestones* (p.83).

3620 St. Martin (as a youth) and the Beggar (with a white greyhound), by Lattanzio da Rimini. Bergamo, S. Martin de'Calvi; Bentley, *Calendar*.

3621 St. Martin and the beggar, oak sculpture, Flemish, c. 1500. Philadelphia Museum of Art, PA.

3622 St. Martin cutting his cloak for a beggar, woodcut by Hans Baldung Grien, Bremen, c. 1505. Geisberg, *Single-Leaf*.

3623 St. Martin (in a military skirt) and the beggar, by Marco d'Oggiono, c. 1509. Coll. Giovanna Gallarati Scotti, Castellazzo di Rho; Sedini, *Marco d'Oggiono* (p.82).

3624 St. Martin knighted by the emperor Constantine (as seen through an archway, with a street scene at left), by Bernard van Orley, c. 1515-20. Nelson-Atkins Museum of Art, Kansas City MO; *Handbook*.

3625 St. Martin (in bishop's robes, giving a cloak to a beggar) and St. Stephen (holding an apronful of stones), after Lucas Cranach the Elder. Aschaffenburg, Staatsgalerie; Friedländer, *Cranach*.

3626 St. Martin and the beggar (he cuts a billowing cloak), polychromed lindenwood sculpture, Bavarian, c. 1520. Isabella Stewart Gardner Museum, Boston MA; Hadley, *Museums Discovered*.

3627 St. Martin and the (nude) beggar, min. by Liberale da Verona from ms. fo. 76 of Graduale no.12, 1520's. Piccolomini Library, Siena; Gowing, *Biog. Dict.*

3628 St. Martin and St. Christopher (in a crowd, in a colonnaded loggia) by Giovanni Antonio de'Sacchis, called Pordenone, 1528. Venice, S. Rocco; Valcanover, *Tintoretto*.

3629 St. Martin and the beggar, by El Greco, 1597-99. NGA, Washington DC; Colombo, *World Painting*; Gudiol, *El Greco*.

3630 St. Martin (in hip boots and feathered cap) and the beggar, round

painting by Carlo Saraceni, 1600–10. Picture Gallery, Berlin; *Catalogue.*

3631 St. Martin and the beggar (outside a walled city), by Joseph Heintz, c. 1600. Coll. Julius Böhler, Munich; Kaufmann, *School of Prague.*

3632 St. Martin dividing his cloak (for two beggars), much like the painting in Saventhem, by Anthony van Dyck, c. 1619–20. Windsor Castle, Royal Coll.; Larsen, *Van Dyck* (pl.75); McGraw, *Encyclo.* (Vol.IV, pl.307).

3633 St. Martin dividing his cloak (for two beggars), oil sketch after the painting in Saventhem by Anthony van Dyck, c. 1619–20. NGA, Washington DC; Larsen, *Van Dyck* (pl.76).

3634 St. Martin dividing his cloak (in armor, astride a white horse) by Anthony van Dyck, before 1621. Saventhem Church, Belgium; *Eight Centuries*; Larousse, *Ren. & Baroque*; Larsen, *17th Cent. Flemish*; Larsen, *Van Dyck* (pl.74).

3635 The mass of St. Martin (a fiery sphere descends over his head; everyone reacts in amazement) by Jean Boeckhorst. Münster-en-Westphalie, St. Martin; *800 Jahre*; Hairs, *Sillage de Rubens.*

3636 St. Martin healing a possessed man (held by several of his friends) by Jacob Jordaens, 1630. Brussels, Musées Royaux des B/A; d'Hulst, *Jordaens.*

3637 St. Martin (dressed as a landesknecht) dividing his cloak, by Karel Skréta, c. 1645. Prague, Nat'l Gallery; Boone, *Baroque*; National Museum, *Baroque.*

3638 The Virgin appearing to St. Martin (with angels and other saints), by Eustace Le Sueur, 1650–55. Louvre, Paris; Mérot, *Le Sueur.*

3639 Mass of St. Martin of Tours (a ball of fire appears above his head) by Eustace Le Sueur, 1655. Louvre, Paris; *800 Jahre*; Held, *17th & 18th Cent.*; Mérot, *Le Sueur.*

3640 St. Martin and the beggar (he cuts the cloak, which the beggar has a hold on already), by Jacob Van Oost the Elder. Bruges, State Museum; Pauwels, *Musée Groeninge.*

3641 St. Martin (bestriding the beggar while he cuts his cloak), statue by Konrad Max Süssner. Knights of the Cross Church, Prague; Štech, *Baroque Sculpture.*

3642 Christ appearing in a dream to St. Martin (as he sleeps, sitting up), by

Francesco Solimena, c. 1733. North Carolina Museum of Art, Raleigh; *Intro. to the Coll.*

3643 Saint Martin on horseback (cutting his cloak with a curved saber), lead sculpture by Raphael Donner, 1733–35. Bratislava, St. Martin; Held, *17th & 18th Cent.*

3644 St. Martin, in contemporary dress, cutting his cloak for a nude beggar, marble statue by Raphael Donner, 1735. Pressburg Cathedral; Murray, *Art & Artists.*

3645 St. Martin bishop with a chorister boy, by Giambattista Tiepolo. Correr Museum, Venice; Morassi, *Catalogue* (pl.176).

3646 St. Martin holding a church and crosier, with three geese at his feet, stained-glass window, 16th cent. St. Mary's, Shrewsbury; Drake, *Saints and Emblems.*

See also 135, 1616, 1733, 1868, 2660, 3183, 3221, 3314, 3327

Martina, Roman virgin, patron of Rome; face torn with hooks; mart. 255 (Jan. 1 & 30)

3647 Madonna with St. Martina (with a lion) and St. Agnes (with a lamb) by El Greco, 1597–99. NGA, Washington DC; Gudiol, *El Greco.*

3648 Madonna and Child with St. Martina (holding a hooked iron rod), by Pietro da Cortona, 1645. Kimbell Art Museum, Fort Worth TX; *Pursuit of Quality.*

3649 Virgin and Child appearing to St. Martina, gilt bronze relief by Pietro da Cortona, c. 1650. NGA, Washington DC.

3650 St. Martina calling down lightning on the idols (clouds surround her, while she looks up at cherubs; witnesses recoil in awe), copy after Pietro da Cortona. Dulwich Picture Gallery, London; Murray, *Catalogue.*

3651 St. Martina (in repose), marble statue created for the shrine containing her bones, by N. Menghino. Rome, S. Martina; Bentley, *Calendar.*

See also 77

Martinian *see* **Processus and Martinian**

Mary Aegyptiaca *see* **Mary of Egypt**

Mary Magdalen Postel, French nun and teacher, d. 1846 (July 16)

3652 St. Mary Magdalen Postel (in

nun's habit, sitting with her hands folded over a book), by Lecerf. Manche, Abbey of Saint Sauveur Le Vicomte; Bentley, *Calendar*.

Mary of Egypt or Maria Egiziaca, or Mary Aegyptiaca hermit & penitent, discovered by St. Zosimus, d. 431 (Apr. 2)
3653 Saint Mary of Egypt (half draped in a cloak, the rest of her body covered with hair), fresco, 1105-06. Church of Panagia Phorbiotissa of Asinou, near Nikitari; Stylianou, *Painted Churches* (p.120).
3654 Departure of St. Mary of Egypt for Jerusalem, 13th cent. stained-glass window. Bourges Cathedral, France; McGraw, *Encyclo.* (Vol.VI, pl.290).
3655 St. Mary of Egypt receiving the sacrament from St. Zosimus, from the Thebaid altarpiece by Francesco Traini. Campo Santo, Pisa; Kaftal, *Tuscan*; Meiss, *Traini*.
3656 Virgin and Child flanked by Bartholomew and Mary of Egypt on the left, and John the Baptist and Francis of Assisi on the right, polyptych by Niccolo di Pietro Gerini, c. 1385-90. Bob Jones Univ. Art Gallery, Greenville, SC; Pepper, *Ital. Paintings*.
3657 St. Mary of Egypt (in furry dress) between St. Peter Martyr (with three descending crowns) and St. Catherine of Siena, by Gherardo del Fora, end of 15th cent. Walker Art Museum, Bowdoin College, Brunswick ME; Shapley, *Samuel H. Kress*.
3658 Mary Magdalene (kneeling, naked, covered only with hair) and Mary of Egypt (in the same posture) by Quentin Metsys. Philadelphia Museum of Art, PA; Bosque, *Metsys*.
3659 St. Mary Aegyptiaca receiving communion in the wilderness, from the triptych with the stoning of St. Stephen, by the Utrecht school, 1554. Rijksmuseum, Amsterdam; *Paintings*.
3660 Saint Mary of Egypt (under a palm tree) by Jacopo Tintoretto, 1583-87. Venice, Scuola di San Rocco; McGraw, *Encyclo.* (Vol.XII, pl.372); Int'l Illus. *Encyclo.* (see Venetian); Valcanover, *Tintoretto*.
3661 St. Mary of Egypt (three-quarter view, hands crossed in prayer, looking up, tears in her eyes), by Jusepe de Ribera, 1651. Naples, Museo Civico

Gaetano Filangieri; RA, *Painting in Naples*.
3662 Communion of St. Mary of Egypt (in the wilderness), by Francisco de Zurbaran, 1658-64. Coll. Serrano, Madrid; Gállego, *Zurbaran*.
3663 Mary Aegyptiaca in the desert, sleeping in a sitting position, by David Teniers the younger after Jacopo Palma, 1660-73. Philadelphia Museum of Art, PA.
See also 1850, 3125, 4939

Mary Salome
3664 St. Mary Salome and her family (one child reads to a crow), by Bernard Strigel, 1520-28. NGA, Wash. DC; Eisler, *European Schools*; Walker, *NGA*.

Marziale or Martial, first bishop of Limoges, apostle of Aquitaine, patron of Colle di Val d'Elsa, d. 74 (June 30)
3665 St. Marziale of Limoges (arms spread in blessing), icon fresco. Aquileia Cathedral; Bentley, *Calendar*.
3666 Two scenes from the life of St. Martial (receiving a chasuble), from the Berthold Missal, Stuttgart MS H.B.XIV.6, c. 1200-36. Stuttgart, Landesbibliothek; Swarzensski, *Berthold Missal* (figs. 12 & 13).
3667 Scenes from the life of St. Martial (consecration, miracles, founding churches); frescoes by Matteo Giovannetti, 1344-46. Avignon, Palais des Papes; Laclotte, *L'Ecole d'Avignon*.
3668 St. Marziale in glory (sitting on clouds with angels), by Sebastiano Ricci, c. 1703. Venice, S. Marziale; Daniels, *Ricci*.

Mathurin or Maturinus, reputed exorcist, d. 380 (Nov. 1 & 9)
3669 St. Mathurin exorcising Theodora, daughter of the Roman Emperor, by Adrien Sacquespée. Rouen, Saint-Ouen Church; *La Peinture d'Inspiration*.

Matilda or Mafalda, daughter of king Sancho I of Portugal, d. 1252 (May 2)
3670 St. Matilda, in three-quarter left profile, by Francisco de Zurbaran, 1641-58. Seville, Museum of Fine Arts; Gállego, *Zurbaran*.

Maturinus *see* **Mathurin**

Maurelius or Maurilius, bishop of Angers, d. 453 (Sept. 13)
3671 The Annunciation with St. Fran-

cis of Assisi and St. Maurelius, by Cosimo Tura, c. 1475. NGA, Washington DC; Ruhmer, *Tura*; Shapley, *Samuel H. Kress.*

3672 The condemnation (armed men drag him away from the judge) and execution (decapitation) of St. Maurelius, from the St. Maurelius Altarpiece by Cosimo Tura. Ferrara, Pinacoteca Nazionale; Kaftal, *North East Italy*; McGraw, *Encyclo.* (Vol.XIV, pl.204); Ruhmer, *Tura.*

3673 Niccolò Roverella (as a kneeling donor) with St. Maurelius (with a crosier) and St. Paul, from the dismembered Roverella polyptych by Cosimo Tura. Colonna Palace, Rome; Cooper, *Family Collections*; Dunkerton, *Giotto to Dürer*; Kaftal, *North East Italy*; McGraw, *Encyclo.* (Vol.XIV, pl.205); United Nations, *Dismembered Works.*

3674 St. Maurelius (standing in a robe with a large, jeweled clasp, wearing a miter and holding a crosier and a book), by Bastarolo, c. 1538. Ferrara, Chiesa di S. Gerolamo; Frabetti, *Manieristi.*

3675 St. Maurelius (in bishop's robes, with a miter at his feet, in right profile), by Carlo Bononi. Ponce, Museo de Arte; Held, *Catalogue*; *Museo de Arte.*

Maurice, Roman officer, commander of Thebian legion, refused to sacrifice to pagan gods; beheaded; mart. 287 (Sept. 22)

3676 St. Maurice (represented as a dark-skinned warrior), fresco by Simone Martini. S. Francesco, Assisi; Kaftal, *Tuscan.*

3677 Antonius and Maurice leave the city of Piacenza (on horseback), predella panel by the Emilian School, 1420–30. Piacenza, S. Antonio; Kaftal, *North East Italy.*

3678 St. Maurice (holding a sword and a shield with a cross on it, wearing a cap), from a polyptych by Carlo Braccesco, 1470. Imperia, Santuario di Montegrazie; Kaftal, *North West Italy.*

3679 The Burning Bush triptych with the vision of Moses; in the left panel, King René of Anjou is presented by SS. Magdalene, Anthony Abbot, and Maurice; in right panel, Queen Jeanne de Laval is presented by SS. John Evangelist, Catherine of Alexandria, and Nicholas of Bari, by Nicolas Froment, c. 1475–76. Aix-en-Provence, Saint-Saveur Cathedral; Laclotte, *L'Ecole d'Avignon.*

3680 Three Magi Altarpiece with St. George (in armor and military skirt, holding a banner and trampling a dragon) and St. Maurice (in armor holding a banner) as wings of the triptych by Hans Baldung Grien, 1507. Picture Gallery, Berlin, *Masterworks.*

3681 St. Maurice and the Thebian legion, wooden relief, anon. upper Rhemish or Swiss, 1515. Isabella Stewart Gardner Museum, Boston MA.

3682 The martyrs of the Thebian Legion (they are killed in the background, while the emperor gives orders in the foreground), by Jacopo da Pontormo. Pitti Palace, Florence; Bentley, *Calendar.*

3683 Wood and gilt bust of St. Maurice, Northern Italian, 16th cent. Snite Museum of Art, IN; *Guide to the Snite Museum*; Lauck, *Art Gallery.*

3684 Martyrdom of St. Maurice (in background, he lies upside-down with severed head, while in foreground soldiers are engaged in discussion), by El Greco, 1582. El Escorial, Spain; Book of Art, *German & Spanish*; Gowing, *Hist. of Art*; Gudiol, *El Greco*; McGraw, *Encyclo.* (Vol.VI, pl.459); Puppi, *Torment.*

3685 Saints Gregory the Great, Maurice (in armor), Papianus (with decorated helmet) and Domitilla, by P.P. Rubens, 1606. Picture Gallery, Berlin; Held, *Oil Sketches*; Jaffé, *Rubens and Italy*; Met Museum, *Caravaggio*; Picture Gallery, *Catalogue*; White, *Rubens.*

3686 The martyrdom of St. Maurice and the Thebian Legion (his men are chopped with axes while he inspires them to martyrdom, pushing away a priest of Apollo), by Sebastiano Ricci, c. 1730. Turin, Superga Basilica; Daniels, *Ricci.*

See also 1867, 3483, 4890

Maurilius *see* **Maurelius**

Mauro or Maurus, first bishop of Parenzo, mart. 4th cent. (Nov. 21)

3687 St. Mauro, standing in classical robes, holding a laurel wreath, mosaic, c. 550. Parenzo, Basilica; Kaftal, *North East Italy.*

Maurus, succeeded St. Benedict as abbot at Subiaco, d. 584 (Jan. 15)

3688 Scene from the life of St. Maurus (he extends his crosier over a man's head as the man is seated at dinner), from "Life and Miracles of St. Maurus," ms.2273,

f.77. Troyes Library; Porcher, *Medieval French Min.* (fig.5).

3689 St. Maurus rescuing Placid from the water (as Placid holds a pitcher), fresco by Giovanni di Consalvo, 1435-40. Badia, Florence; Batselier, *St. Benedict* (p.93).

3690 St. Benedict orders St. Maurus to the rescue of St. Placidus, by Fra Filippo Lippi. NGA, Washington DC; Ferguson, *Signs*; Phaidon, *Art Treasures*; Shapley, *Samuel H. Kress.*

3691 St. Maurus (in Benedictine robes, holding an abbot's miter), fresco by the Umbrian School, 1442. Spoleto, S. Giuliano; Kaftal, *Central and So. Ital.*

3692 St. Maurus healing a sick child (as cripples wait their turn), by Sebastiano Ricci, c. 1726-27. Bergamo, S. Paolo d'Argon Parish Church; Daniels, *Ricci.*

3693 St. Maurus, at the bidding of St. Benedict, rescuing Brother Placid from drowning (standing on water, he pulls the man up by the wrist), by Sebastiano Ricci, c. 1726-27. Bergamo, S. Paolo d'Argon Parish Church; Daniels, *Ricci.*

See also 666, 688, 756, 1384, 1724, 1725, 3909, 3910, 4905

Maximilian see 1511

Maximus, Bishop of Aix-en-Provence, 1st cent. (June 8)
3694 Saints Maximus (with bishop's crosier) and Oswald, by Giambattista Tiepolo. Padua, S. Massimo; Morassi, *Catalogue* (pl.141).

3695 Saints Maximus (with bishop's crosier) and Oswald, oil sketch by Giambattista Tiepolo. Coll. Ruzicka, Zurich; Morassi, *Catalogue* (pl.140).

See also 3885, 3886

Medardus, Bishop of Vermandois, 6th cent. (June 8)
3696 Saints Radegund and Medardus (he blesses her), from "Life of Saint Radegund," ms.250, fo.27v, end of 11th cent. Poitiers Library; Porcher, *Medieval French Min.* (fig.31).

Meinrad, Hermit; killed by robbers; mur. 861 (Jan. 21)
3697 St. Meinrad (about to be clubbed from behind); St. Gertrude (with a book); St. Patrick (standing with his crosier before a fire); St. Theodosia (hung by her hair); St. Lucy (boiled in a cauldron, with hot lead poured on her head); St.

Tryphon (dragged by a horse); St. Arsenius (with a kneeling penitent); woodcuts by Günther Xainer from "Leben der Heiligen, Winterteil," 1471. The Illus. Bartsch; *German Book Illus.* (Vol.80, pp.70-74).

Mennas, Egyptian Roman soldier; beheaded (Nov. 11)
3698 St. Mennas, icon, painting on wood, Coptic. Louvre, Paris; Bentley, *Calendar.*

3699 Saint Mennas (in armor, draped with a red mantle, standing in a niche), by Paolo Veronese, 1560. Estense Gallery, Modena; Rearick, *Veronese.*

3700 The martyrdom of St. Mennas, by Paolo Veronese. Prado, Madrid.

3701 Saint George (riding a white horse) and St. Mennas (riding a red horse), icon from the 18th cent. Melnik, St. Nicholas the Miracle Worker; Paskaleva, *Bulgarian Icons.*

Mercurius, executed for refusing to sacrifice to the heathen Gods (Nov. 25 or Dec. 10)
3702 St. Mercurius (astride a horse, killing a demon), pen and ink drawing, ms. Vat. Copto 66, fol. 287v., 9th-10th cent. Vatican Library; McGraw, *Encyclo.* (Vol.III, pl.457).

3703 St. Mercurius (riding a white horse, holding a spear, with a pointing angel in upper right corner and God's hand in upper left corner), tempera icon, 10th cent. Sinai, Monastery of St. Catherine; Manafis, *Sinai.*

Method of Salonique or Methodius, archbishop of Sirmium, d. 884 (Feb. 14)
3704 St. Method of Salonique baptizing St. Ludmilla, fresco by Master Oswald, c. 1360-61. Karlstejn Castle; Bachmann, *Gothic Art*; Stejskal, *Charles IV.*

Methodius see Cyril and Methodius

Metronius, hermit priest, chained himself to the wall of S. Vitale at Verona 8th or 9th cent. (May 8)
3705 St. Metronius (standing with hands clasped in prayer, with chains at his feet), from an altarpiece by Liberale da Verona. Verona, S. Maria del Paradiso; Kaftal, *North East Italy.*

Miniato, Patron of Florence and St. Miniato al Tedesco; beheaded; mart. 250 (Oct. 25)
3706 San Miniato Altarpiece (with

scenes from his life), by Jacopo del Casentino, c. 1342. Florence, San Miniato al Monte; Andres, *Art of Florence* (vol.I, pl.63); Kaftal, *Tuscan.*

3707 Saint Anthony Abbot (with a boar), St. Stephen (holding a rock), St. John the Baptist and St. Miniato (holding a palm and a javelin), wings of an altarpiece by Bicci di Lorenzo, 1430's. M. H. de Young Memorial Museum, San Francisco CA; *European Works.*

3708 St. Julian and St. Miniato flank the Virgin in "Assumption of the Virgin" by Andrea del Castagno, c. 1449–50. Picture Gallery, Berlin; McGraw, *Encyclo.* (Vol.VI, pl.241); Picture Gall., *Catalogue.*

Mitre, Patron of the city of Aix; decapitated, mart. 3rd cent. (Nov. 13)

3709 Legend of St. Mitre (inside a city scene; in background, he gives money to the poor; at left, he is accused of stealing; in center foreground, he carries his own severed head, and is flanked by the kneeling donors Mitre de La Roque and family), by Nicolas Froment, c. 1470–75. Aix-en-Provence, Saint-Saveur Cathedral; Laclotte, *L'Ecole d'Avignon.*

Modestus, Nurse of St. Vitus; beheaded, mart. c. 300 (June 15)

3710 Madonna and Child with Saints Vitus and Modestus, by Morto da Feltre. Feltre, Museo Civico, Italy; New Int'l Illus. *Encyclo.*

Monica, mother of St. Augustine & St. Perpetua, d. 387 (May 4)

3711 St. Monica (dressed as a nun, holding a book and a scroll), panel of a polyptych by Jacobello del Fiore. Teramo, Cathedral; Kaftal, *North East Italy.*

3712 St. Monica (sheltering kneeling nuns and the kneeling faithful under her extended cloak), fresco by the School of Lazio, early 15th cent. Bagnoregio, SS. Annunziata; Kaftal, *Central and So. Ital.*

3713 Burial of St. Monica, and St. Augustine departing for Africa, by Master of the Osservanza. Fitzwilliam Museum, Cambridge; Christiansen, *Siena.*

3714 St. Monica (in nun's habit, looking down, holding a book), fresco by Benozzo Gozzoli. S. Gimignano, S. Agostino; Kaftal, *Tuscan.*

3715 Madonna and Child with Saints

Augustine and Nicholas of Tolentino on the left, and Saints Bartholomew and St. Monica on the right, by Tuscan School, 15th cent. Nat'l Gallery, London; Poynter, *Nat'l Gallery.*

3716 Saint Monica (on her death bed), by Bennozo Gozzoli. San Gioniguiano, S. Agostino; Coulson, *Saints.*

3717 Death of St. Monica (in bed, while St. Augustine supports her head and offers a crucifix), fresco by Ottaviano Nelli. Gubbio, S. Agostino; Kaftal, *Central & So. Ital.*

3718 Madonna and Child enthroned between Saints Andrew, Monica, Ursula, Sigismund, and angel musicians, by Bartolomeo Montagna. Brera, Milan; Newsweek, *Brera.*

3719 St. Monica (standing, dressed as an Augustinian Nun), att. to Francesco Bitticini. Accademia, Florence; De Bles, *Saints in Art.*

3720 St. Monica converts her husband on his death bed, panel by Antonio Vivarini. Detroit Inst. of Art, MI; Kaftal, *North East Italy.*

3721 St. Monica puts the black habit on St. Augustine (who kneels in a white robe, hand on his chest), by Francesco Naselli. St. Meinrad Archabbey, St. Meinrad IN; Frabetti, *Manieristi.*

3722 St. Augustine and St. Monica (at the moment of his conversion, when she reads the words on the scroll, "Where there is light, there you will find Him"), by Gioacchino Assereto. Minneapolis Inst. of Art, MN; *European Paintings.*

3723 St. Monica and St. Augustine (holding hands, looking up), by Ary Scheffer. Louvre, Paris; Bentley, *Calendar.*

See also 152, 155, 495, 515

More, Thomas *see* **Thomas More**

Mustiola, Roman martyr, patron of Chiusi; whipped to death; mart. 275 (July 3)

3724 St. Mustiola (holding a string with a ring hanging from it), from a triptych by Fiorenzo di Lorenzo. Perugia, Kaftal, *Central and So. Ital.*

Naoum of Ohrid

3725 St. Naoum of Ohrid, bilateral icon by a Greek painter working at Ohrid, early 15th cent. Ohrid, St. Clement, Macedonia; Knopf, *The Icon* (p.194).

Narcissus
3726 St. Narcissus (murdered before the altar); St. Quentin (beheaded by a guillotine-like blade hit by a mallet); St. Wolfgang (enthroned, with a crosier and an axe); St. Gereon and his companions; St. Severus (in bishop's robes); St. Leonard (holding a chain attached to a prisoner's leg); woodcuts by Günther Xainer from "Leben der Heiligen, Winterteil," 1471. The Illus. Bartsch; *German Book Illus.* (Vol.80, pp.64–65).

Nazarius and Celsus, Roman knights, martyred at Milan, 4th cent. (July 28)
3727 SS. Nazarius and Celsus (and the vision of the risen Christ), by Titian. Brescia, SS. Nazarius and Celsus; Bentley, *Calendar.*
3728 Madonna and Child flanked by SS. Nazaro and Celso (each holding a sword and a palm), fresco by an unknown Lombard artist of the 15th cent. Milan, Santa Maria dei Miracoli; Fiorio, *Le Chiese di Milano.*

Nedelya, martyred in Nicodemia, d. 289
3729 Saints Paraskeva and Nedelya, each holding a bowl with a head, icon, early 17th cent. Bulgaria, National Art Gallery; Paskaleva, *Bulgarian Icons.*

Neophytus
3730 Saint Neophytus between archangels Michael and Gabriel, fresco, 1183. Monastery of St. Neophytus, near Paphos; Stylianou, *Painted Churches* (p.363).

Nereus and Achilleus, Roman soldiers, converted to Christianity; beheaded, late 1st cent. (May 12)
3731 SS. Nereus (holding a sword) and Achilleus (wearing an ermine-lined cloak), standing on a pedestal, panel of a triptych by Antonio Vivarini and Giovanni d'Alemagna, 1443. Venice, S. Zaccaria; Kaftal, *North East Italy.*
3732 Saints Domitilla, Nereus, and Achilleus (crowned by cherubs), by P.P. Rubens, c. 1608. Rome, S. Maria in Vallicella; Bentley, *Calendar*; Jaffé, *Rubens and Italy*; White, *Rubens.*
See also 1723, 3910

Nestor, bishop of Magydus, mart. 251 (Feb. 26)
3733 Saint Nestor (in tiny scaled ar-

mor, holding a spear, in a red cloak), fresco from 1513. Galata, St. Sozomenus Church; Stylianou, *Painted Churches* (p.87).
See also 1920

Nicholas I, Pope, r.858–867 (Nov. 13)
3734 Translation of the remains of St. Clement I from the Vatican by Pope St. Nicholas I, in the presence of SS. Cyril and Methodius, fresco by the Roman School, 11th cent. Rome, S. Clemente; Kaftal, *Central & So. Ital.*; McGraw, *Encyclo.* (Vol.XII, pl.276); Read, *Great Art.*
3735 St. Nicholas I, sitting with his crosier, reading a book, by Raphael. Nat'l Gallery, London; Brusher, *Popes.*

Nicholas of Bari, Bishop of Myra, patron of Bari and protector of children, d. 350 (Dec. 6)
3736 St. Nicholas and the three tonsured clerks assassinated (he stands outside their window as a man raises an ax over their sleeping forms), from a Psalter, ms. 54, fo.10 (D 23), 13th cent. Besancon, Biblio. Municipale; Garnier, *Langage de l'Image* (pl.230).
3737 St. Nicholas in red, with a checkered crosier, mid-13th cent. Sinai, St. Catherine's Monastery; Knopf, *The Icon* (p.233).
3738 Scenes from the life of St. Nicholas of Bari: as a baby, he refuses his mother's breast, except for once on Wednesday and once on Friday; he throws the golden balls through the window of a poor nobleman for his daughters' dowry; frescoes by the Piedmontese school, 13th cent. Novalesa, Abbazia; Kaftal, *North West Italy.*
3739 St. Nicholas is greeted at the door of the church at Myra; fresco by the Piedmontese school, 13th cent. Novalesa, Abbazia; Kaftal, *North West Italy.*
3740 Icon of St. Nicholas, mosaic on wax, late 13th-early 14th cent. Kiev, Museum of Western and Oriental Art; Bank, *Byzantine* (pl.267).
3741 St. Nicholas, by school of Novgorod, late 12th-early 13th cent. Tretyakov Gallery, Moscow; McGraw, *Russia.*
3742 St. Nicholas and St. Gregory in "The Crucifixion" triptych by Duccio di Buoninsegna, c. 1310. Boston Museum of Fine Arts; Dunkerton, *Giotto to Dürer.*

3743 St. Nicholas with scenes from his life: Nicholas appears to Emperor Constantine in a dream; Nicholas appears to governor Eulavius in a dream; he saves St. Demetrius from shipwreck, and returns him home to his parents; he saves St. Basil from Saracens and returns him home; icon from Novgorod, early 14th cent. State Russian Museum, St. Petersburg.

3744 St. Nicholas with scenes from his life: birth of Nicholas; Nicholas chooses his own teacher; Nicholas brought to school; made a deacon; made a priest; exorcises a tree; exorcises a ship; appears to three men in prison; saves three men from execution; multiplies loaves at dinner; buried in the monastery of Holy Sion, icon from Novgorod, early 14th cent. State Russian Museum, St. Petersburg.

3745 St. Nicholas with donors, Serbian King Stephen III Decanski and his wife, tempera on wood by the Serbian Painter, 1321-31. Bari, St. Nicholas; Knopf, *The Icon* (p.157).

3746 St. Nicholas, fresco by Theodore the painter, c. 1200. St. Sophia, island of Cythera; Knopf, *The Icon* (p.167).

3747 Madonna and Child enthroned with St. Nicholas of Bari, Elijah, and four angels, by Pietro Lorenzetti, 1329. Siena, Pinacoteca; Hills, *The Light*.

3748 The charity of St. Nicholas of Bari (one daughter and the father wake, as he slips the balls through the window, standing on tiptoe), by Ambrogio Lorenzetti. Louvre, Paris; Gowing, *Paintings*.

3749 St. Nicholas elected bishop of Myra (he kneels, as his superior serves mass and two other bishops flank the altar, holding the regalia), by Ambrogio Lorenzetti, c. 1335. Florence, Galerie des Offices; Laclotte, *L'Ecole d'Avignon*.

3750 Two scenes from the legend of St. Nicholas of Bari (he stands on the shore waiting as a boat rows in; curing a sick child through a window), by Ambrogio Lorenzetti. Uffizi, Florence; Berenson, *Ital. Painters*.

3751 Funeral of St. Nicholas of Bari (a bishop prays over the saint, as a crowd looks on), by Vitale da Bologna. Udine, Duomo; Gnudi, *Vitale*.

3752 Miracle of St. Nicholas (he saves the boy in the tub), by Vitale da Bologna. Udine, Duomo; Gnudi, *Vitale*.

3753 St. Nicholas giving three golden balls to the dowerless daughters; con-

secration of St. Nicholas as Bishop, by Ambrogio Lorenzetti. Uffizi, Florence; Christiansen, *Siena*; Edgell, *Sienese Paintings*.

3754 St. Nicholas saves a ship in distress, by Vitale da Bologna. Udine, Duomo; Gnudi, *Vitale*.

3755 Madonna and Child with St. Nicholas (holding three balls) and St. Paul, by Luca di Tomme, c. 1370-73. Los Angeles County Museum of Art, CA; Shapley, *Samuel H. Kress*.

3756 Miracle of the drowned child and the golden chalice (St. Nicholas returns child and chalice to the child's family), by Master of the St. Nicholas Legend. Santa Croce, Florence; Eisenberg, *Monaco* (pl.319).

3757 St. Nicholas and the starving maidens (as they sit about the room, heads hanging, Nicholas stands outside the building, about to toss the golden balls through the window), predella panel by Giovanni di Francesco. Casa Buonarroti, Florence; Kaftal, *Tuscan*.

3758 St. Nicholas reviving three men (who step from a tub; angels hold a tapestry worked with coats of arms), from the "Boucicaut Hours" painted by the Boucicaut Master, ms.2,fo.33v. Jacquemart-André Museum, Paris; Meiss, *French Painting*.

3759 St. Nicholas saves three men from execution (he holds the blade of the executioner's sword), by Mariotto di Nardo. Vatican Museums; Francia, *Vaticana*.

3760 Virgin and Child enthroned, with SS. Nicholas of Bari (with a kneeling donor) and Catherine of Alexandria (holding a palm), by Gentile da Fabriano, c. 1400. Picture Gallery, Berlin, *Masterworks*.

3761 Miracle of St. Nicholas (he saves a sinking ship by grabbing the mast), from "Belles Heures de Jean de Berry," fo.168, c. 1410-13. Cloisters Museum NY; Porcher, *Medieval French Min.*

3762 St. Nicholas of Bari rescuing a storm-tossed ship (next to a church shaped like a cross on the shore), by Lorenzo Monaco. Accademia, Florence; Eisenberg, *Monaco* (pl.92).

3763 St. Nicholas and the three children (the children stand in a barrel as he towers over them), illum. by the Rohan Master from a Book of Hours, ms. Latin 9471, fo.224, c. 1415-16. BN, Paris; *Rohan Master* (pl.107).

3764 Saint Nicholas holding a book, fresco, first half of 15th cent. Patmos; Kominis, *Patmos* (p.140).

3765 St. Nicholas of Bari in bishop's robes, holding crosier and three balls, by Master of the Bambino Vispo, c. 1422. El Paso Museum of Art, TX; Shapley, *Samuel H. Kress.*

3766 St. Nicholas saving a ship at sea (flying through the air holding a torch, as passengers are throwing boxes overboard), by Gentile da Fabriano, 1420's. Vatican Museums; Bentley, *Calendar*; Denvir, *Art Treasures*; Francia, *Vaticana*; New Int'l Illus. *Encyclo.* (see Gentile); Van Os, *Sienese Altarpieces* (Vol.II, pl.28).

3767 A miracle of St. Nicholas (cripples are cured by touching his tomb) by Gentile da Fabriano. NGA, Washington DC; Shapley, *Samuel H. Kress*; Walker, *NGA.*

3768 St. Nicholas throws the golden balls to three poor young women, by Gentile da Fabriano, 1425. Vatican Museums; Francia, *Vaticana*; Herald, *Ren. Dress.*

3769 The miracle of St. Nicholas (throwing three golden balls into the bedroom of a poor man and his three daughters, for their dowries) part of a predella of an altarpiece by Masaccio, 1426. Picture Gallery, Berlin; *Catalogue.*

3770 St. Nicholas's corn miracle (sailors react in amazement when he multiplies the corn to save the starving town of Garamszentbenedek) by Thomas de Coloswar, 1427. Esztergom Christian Museum; *Christian Art in Hungary.*

3771 Nicholas of Bari and the miracle of the three children (he blesses them as they stand in three barrels), by Bicci di Lorenzo. Met Museum; De Bles, *Saints in Art.*

3772 Pilgrims at the grave of St. Nicholas of Bari (they walk away cured), by Bicci di Lorenzo, 1433. Wawel Castle, Poland; Szablowski, *Collections.*

3773 St. Michael and St. Nicholas of Bari, portable triptych by Pietro di Giovanni d'Ambrogio, mid-1430's. Met Museum; Christiansen, *Siena.*

3774 Madonna and Child adored by St. Mary Magdalene and Nicholas of Bari, by Sano di Pietro, after 1436. Cleveland Museum of Art, OH; *European before 1500.*

3775 St. Dominic (with a lily and an open book) and St. Nicholas of Bari (in

Bishop's regalia, reading), by Fra Angelico. Perugia, Galleria Nazionale dell'Umbria; McGraw, *Encyclo.* (Vol.I, pl.267).

3776 St. Nicholas meets the imperial messenger (as he disembarks from ship) by Fra Angelico, c. 1437. Vatican Museums; Francia, *Vaticana*; New Int'l Illus. *Encyclo.*

3777 Birth of St. Nicholas of Bari (newborn child stands in his bath), by Pietro di Giovanni d'Ambrogio, after 1444. Basel, Kunstsammlungen; Christiansen, *Siena.*

3778 St. Nicholas saving three men condemned to execution (he stops the executioner's sword) and the death of St. Nicholas, by Fra Angelico. Perugia, Galleria Nazionale dell'Umbria; Pope-Hennessy, *Fra Angelico* (fig.24c).

3779 The birth of St. Nicholas, the vocation of St. Nicholas, and St. Nicholas and the three maidens, by Fra Angelico. Vatican Museums; Lloyd, *1773 Milestones* (p.82); Pope-Hennessy, *Fra Angelico* (fig.24a).

3780 Consecration of St. Nicholas (surrounded by churchmen, he is consecrated, sitting on a throne), illum. by Jean Foucquet from the Hours of Etienne Chevalier, c. 1453. Condé Museum, Chantilly; Fouquet, *Hours.*

3781 St. Nicholas of Bari saving a ship in distress (he flies through the sky among broken masts), by Giovanni di Paolo, 1456. Philadelphia Museum of Art, PA; Lassaigne; *Fifteenth Cent.*; Pope-Hennessy, *Sienese*; *Treasures*; Van Os, *Sienese Altarpieces* (Vol.II, pl.27).

3782 St. Nicholas enthroned, with Bernardino of Siena and Francis of Assisi at left, and Catherine of Siena and Louis of Toulouse at right, triptych by Giovanni di Paolo. Siena, Pinacoteca Nazionale; Edgell, *Sienese Painting.*

3783 St. Nicholas of Bari (looking at a golden ball in his hand), by Cosimo Tura. Nantes, Musée des B/A; Cousseau, *Musée*; Ruhmer, *Tura.*

3784 St. Nicholas prevents the execution of the three youths (he holds the executioner's sword and points it at himself), by the Hungarian Painter, 1470–80. Esztergom Christian Museum; *Christian Art in Hungary* (pl.IX/186).

3785 St. Nicholas of Bari (in ecclesiastic robes, holding a book with three balls and a crosier), from the dismem-

bered Erickson polyptych by Carlo Crivelli, 1472. Cleveland Museum of Art, OH; *European before 1500*; Zampetti, *Crivelli.*

3786 St. Nicholas and the sailors (he intercedes as they are throwing bales from the ship), by an Austrian Master, c. 1480. Esztergom Christian Museum; *Christian Art in Hungary* (pl.XIII/296).

3787 St. Nicholas and the three daughters of an impoverished nobleman (the three sleep in one bed, as he stands next to their sleeping father, holding a golden ball), by an Austrian Master, c. 1480. Esztergom Christian Museum; *Christian Art in Hungary* (pl.XIII/294).

3788 St. Nicholas fells the tree dedicated to Diana, predella panel by Piero di Cosimo. St. Louis Art Museum, MO; Kaftal, *Tuscan.*

3789 St. Nicholas of Bari with three golden balls, in Madonna and Child enthroned with four saints by Piero di Cosimo, 1485–90. St. Louis Art Museum, MO.

3790 St. Nicholas (enthroned, in bishop's regalia, giving a blessing), by the Master of the St. Lucy Legend, c. 1490. Bruges, State Museum; Pauwels, *Musée Groeninge.*

3791 The visitation with St. Nicholas and St. Anthony Abbot (both saints flank the scene; Nicholas reads and Anthony writes), by Piero di Cosimo, c. 1495. NGA, Wash. DC; Shapley, *15th–16th Cent.*; Walker, *NGA.*

3792 Tobias and the Archangel Raphael, flanked by Nicholas of Bari and another saint in a landscape, by Cima da Conegliano. Accademia, Venice; Gaunt, *Pictorial Art.*

3793 Virgin and Child (enthroned) with SS. Nicholas of Bari (reading, three balls at his feet) and John the Baptist, by Raphael, c. 1505. Nat'l Gallery, London; Levey, *Nat'l Gallery.*

3794 Madonna and Child (extending from a trompe l'oeil picture frame) with Saints Nicholas of Bari, John the Baptist, Stephen, and others, by Bartolomeo Passerotti. Bologna, S. Giacomo Maggiore; Ricci, *Cinquecento.*

3795 Miracle of the three drowned boys (stepping out of a bathtub) from "The Legend of St. Nicholas" by Gerard David. NGS, *Illustrations*; Praeger, *Great Galleries.*

3796 St. Nicholas of Bari, three-quarter view, with three balls on a book, by Florentine School, c. 1510. Christ Church, Oxford; Shaw, *Old Masters.*

3797 St. Nicholas, icon c. 1512. Antim Monastery, Bucharest; Knopf, *The Icon* (p.389).

3798 St. Nicholas giving the dowry to three poor girls (they stand dejected around their father, while Nicholas leans through the window with a sack of gold), illum. by Jean Bourdichon from the Great Hours of Henry VIII, 1514–18. Coll. Duke of Cumberland; *Great Hours.*

3799 The birth of St. Nicholas of Bari (he stands unaided in his bath); a miracle of St. Nicholas of Bari (he saves young Adeodatus from servitude to a pagan king), by studio of Luca Signorelli. High Museum of Art, Atlanta GA; Shapley, *15th–16th Cent.*

3800 Madonna and Child with Saints Catherine of Siena, Nicholas of Bari, Peter, Sebastian, Francis of Assisi, and Anthony of Padua, by Titian, c. 1520–25. Vatican Museums; Wethey, *Titian* (pl.23).

3801 St. Nicholas of Bari (standing in bishop's regalia, holding a sheaf of wheat) and a kneeling donor, with a port city in the background, by Jan Provost, c. 1521. Bruges, State Museum; Pauwels, *Musée Groeninge.*

3802 St. Nicholas of Bari in glory (ascending to heaven on a cloud, with two other saints), by Lorenzo Lotto, 1529. Venice, Chiesa del Carmine; Berenson, *Lotto.*

3803 Investiture of St. Nicholas (bishop is putting a miter on his head), design for a stained-glass window by Pieter Coeck. Albertina, Vienna; Marlier, *Coeck.*

3804 Saint Nicholas of Bari presenting four children to the Virgin and Child, by Moretto da Brescia, 1539. Brescia, Pinacoteca Tosio-Martinengo, Italy; Burckhardt, *Altarpiece*; McGraw, *Encyclo.* (Vol.VIII, pl.216); New Int'l Illus. *Encyclo.*

3805 The consecration of (kneeling) St. Nicholas, bishop of Myra, in Syria, in the fourth century, by Paolo Veronese. Nat'l Gallery, London; Levey, *Nat'l Gallery*; Poynter, *Nat'l Gall.*; Rearick, *Veronese.*

3806 Saint Nicholas (in ecclesiastical regalia) with companion panel Nicolas à Spira (dressed in the same manner), by Jacob de Punder, c. 1563. Walters Art

Gallery, Baltimore; Zafran, *50 Old Master Paintings*.
3807 St. Nicholas of Bari (getting out of his throne, as an angel hands him his miter), by Titian and workshop, c. 1563. Venice, S. Sebastiano; Wethey, *Titian* (pl.170).
3808 St. Nicholas enthroned, with the donor George and one of the saint's miracles (healing the Serbian King Stephen III Uros of his blindness), by Longin, 1577. Velika Hoca, St. Nicholas, Serbia; Knopf, *The Icon* (p.343).
3809 St. Nicholas altar, with Nicholas of Bari reading, with SS. Francis of Assisi, Sebastian, and other saints, while the Virgin and Child look on from the clouds, by Titian. Vatican Museums; Freedberg, *Circa 1600*.
3810 St. Nicholas preventing a shipwreck (he straightens the mast), from a predella by Claude Lorrain. Accademia, Florence; McGraw, *Encyclo.* (Vol.IX, pl.202).
3811 St. Nicholas of Bari (sitting before a painting of the nativity) by Francisco de Zurbaran, 1631-40. Hieronymite Monastery, Guadeloupe; Gállego, *Zurbaran*.
3812 St. Nicholas of Bari holding three balls on a book, small copy of Tintoretto's original by David Teniers the Younger, 1650-1700. Princeton Univ. Art Museum.
3813 St. Nicholas of Bari (arms outspread, supported by angels), by Mattia Preti, 1653. Capodimonte, Naples; Yale Univ., *Taste for Angels* (fig.6).
3814 St. Nicholas of Bari (with three cherubs; one angel holds up a book with three gold balls), by Mattia Preti, c. 1655. Rouen, Musée des B/A; Bergot, *Musée*.
3815 St. Nicholas in glory (kneeling on a cloud supported by cherubs, while nuns and supplicants kneel below him), by Luca Giordano, c. 1657. Rome, Museo Diocesano; *Tresori d'Arte*.
3816 St. Nicholas of Bari (standing in bishop's regalia, while a boy approaches with a pitcher and a plate; angels hover overhead with a book and three gold balls), by Massimo Stanzione. Milan, San Nicolao; Fiorio, *Le Chiese di Milano*.
3817 St. Nicholas of Bari felling a tree inhabited by demons, by Paolo de Matteis, 1707. High Museum of Art, Atlanta GA; Yale Univ., *Taste* (cat.32).

3818 St. Nicholas (looking down at a child), statue by Johann Friedrich Kohl, 1708. Charles Bridge, Prague; Štech, *Baroque Sculpture*.
3819 Saint Nicholas (sitting on a high-backed throne, flanked by a small Virgin and Christ), 1735. Elena, National Revival Museum; Paskaleva, *Bulgarian Icons*.
3820 St. Nicholas (holding a book and balls), polychromed wooden statue by Ignác František Platzer, c. 1750. Prague, Nat'l Gallery; National Gallery, *Baroque*.
3821 A miracle of St. Nicholas of Bari (he pulls young Adeodatus by the hair, rescuing him from turbaned men at a banquet), by Francesco Pascucci, 1770's. Walters Art Gallery, Baltimore; *Italian Paintings* (Vol.II).
See also 466, 843, 872, 1343, 1522, 2003, 2091, 3191, 3258, 3324, 3340, 3679, 3823, 3867, 3974, 3982, 4098, 4652, 4738

Nicholas of Myra *see* **Nicholas of Bari**

Nicholas of Tolentino, Augustinian, preacher and missionary, protector of Montefalco, d. 1305, canon. 1446 (Sept. 10)
3822 Scenes from the life of Saint Nicholas of Tolentino, fresco by Vitale da Bologna 1348. Udine Cathedral; New Int'l Illus. *Encyclo.* (see Vitale).
3823 St. Nicholas of Bari appears to the parents of Nicholas of Tolentino to announce the birth of their son, fresco by the Riminese School, 14th cent. Tolentino, S. Nicola; Kaftal, *North East Italy*.
3824 St. Nicholas of Tolentino (in Franciscan robe, holding a book and a blazing sun with a face), fresco by the Umbrian School, 14th cent. Perugia, S. Elisabetta; Kaftal, *Central and So. Ital.*
3825 St. Nicholas of Tolentino holding a scroll and a lily, intercepting arrows thrown by Christ, with a model of Empoli at his feet, panel by Bicci di Lorenzo. Empoli, S. Stefano; Kaftal, *Tuscan*.
3826 St. Nicholas Altarpiece, with St. Nicholas of Tolentino in the center panel, flanked by SS. Bernardino of Siena and Francis of Assisi at left, and SS. Catherine of Siena and Louis of Toulouse at right, by Giovanni di Paolo. Siena, Pinacoteca Nazionale; Van Os, *Sienese Altarpieces* (Vol.II, pl.82).
3827 St. Nicholas of Tolentino in a black cowl, Virgin and Christ in upper

corners of picture, by Giovanni di Francesco, c. 1451-54. Picture Gallery, Berlin; *Catalogue.*

3828 Virgin and Child with SS. John the Baptist and Nicholas of Tolentino (holding a star with the infant's head) at the right, and SS. Augustine and possibly Monica on the left, called the Augustinian Altarpiece by Giovanni di Paolo, 1454. Met Museum; Van Os, *Sienese Altarpieces* (Vol.II, pl.23).

3829 St. Nicholas of Tolentino (holding a star with Infant Christ's head, and standing on a map), by Giovanni di Paolo, 1456. Montepulciano, Sant'Agostino; Van Os, *Sienese Altarpieces* (Vol.II, pl.26).

3830 St. Nicholas of Tolentino rescuing a hanged man (he suspends the man overnight), posthumous miracle att. to Zanobi Machiavelli. Rijksmuseum: Kaftal, *Tuscan; Paintings.*

3831 St. Nicholas of Tolentino (with a blazing sun on his chest, holding a lily), panel by the School of Crivelli. Valenciennes, Musée des B/A; Kaftal, *North East Italy.*

3832 St. Nicholas of Tolentino altarpiece, with posthumous miracles: he resuscitates the daughter of Barache of Fermo, who is about to be buried; he exorcises Fra Raffaello Germano; duchess Bianca Maria Sforza sends a chalice to Tolentino and dedicates a chapel to the saint; Nicholas frees Amelia from a siege; he saves Pisa from the plague, by the Lombard School, 15th cent. Bianco Palace, Genoa; Kaftal, *North West Italy.*

3833 St. Nicholas of Tolentino altarpiece, with scenes from his life: at center panel, he stands with a crucifix and an open book, crowned with three crowns by God, the Virgin, and St. Augustine; the Virgin and St. Augustine appear at his sickbed and prescribe bread and water as medicine; an angel presents him with a star; by the Lombard School, 15th cent. Bianco Palace, Genoa; Kaftal, *North West Italy.*

3834 St. Nicholas of Tolentino in black robe (with sun on his chest) holding an open book, by Piermatteo Lauro de'Manfredi da Amelia, 1481. Philadelphia Museum of Art, PA.

3835 St. Augustine and St. Nicholas of Tolentino, two panels from a polyptych by Boccaccio Boccaccino, c. 1496-97. Vassar College Art Gallery, NY; *Paintings, 1300-1900.*

3836 St. Nicholas of Tolentino standing on the devil, holding his book, copy after Raphael, 1500. Città di Castello, Pinacoteca Civica; Raphael, *Complete Works* (1.20).

3837 Canonization of St. Nicholas of Tolentino by Eugenius IV (with the saint on a bier), predella panel by Franciabigio. NGI, Dublin; McKillop, *Franciabigio* (fig.70).

3838 St. Nicholas of Tolentino (holding an open book, a crucifix, and a lily), by Defendente Ferreri, c. 1510-15. Pallavicini-Rospigliosi Palace, Rome; Cooper, *Family Collections.*

3839 St. Nicholas of Tolentino healing the sick (he blesses a group of seated cripples), predella panel by Franciabigio. Ashmolean Museum, Oxford; McKillop, *Franciabigio* (fig.69).

3840 St. Nicholas of Tolentino performing miracles (at left, he has a vision in bed; at right, he cures a possessed woman at mass), predella panel by Franciabigio. Arezzo, Pinacoteca Comunale; McKillop, *Franciabigio* (fig.71).

3841 St. Nicholas of Tolentino reviving the birds (as he sits up in bed, he revives two birds that fly out of a bowl held by a monk, while another monk stands with a tray of food; at left, four monks sit and stand by the bedside in discussion), predella panel by Benvenuto da Garofalo. Met Museum; Auchincloss, *J.P. Morgan.*

3842 St. Nicholas of Tolentino restoring two partridges to life (from his canopy bed), by school of Perugino, c. 1550-1600. Detroit Inst. of Art, MI.

3843 St. Nicholas of Tolentino (holding a partridge on a platter), by Francisco de Zurbaran, 1625-30. Emile Huart, Cadiz; Gállego, *Zurbaran.*

3844 Miracles of St. Nicholas of Tolentino (he stops an execution with a mannaia by snapping the executioner's mallet), by Francesco Maffei, 1656. Vicenza, S. Nicolò da Tolentino; Edgerton, *Punishment.*

See also 387, 396, 3715

Nicholas of Vyssi Brod
3845 St. Nicholas of Vyssi Brod, polychrome limewood statue, 1380-90. Prague, Nat'l Gallery; Kutal, *Gothic Art.*

Nicholas of Zarisk
3846 St. Nicholas of Zarisk with scenes

from his life, icon of the 14th cent. Tretyakov Gallery, Moscow; Knopf, *The Icon* (p.268).

Nicodemus, Jew who sympathized with Jesus (Aug. 3) *see* 2327

Nikita
3847 St. Nikita in half-armor, holding a sword in its scabbard, by Prokopii Chirin, 1593. Tretyakov Gallery, Moscow; McGraw, *Russia.*
See also 1919

Nikon, "Metanoeite," missionary, d. 998 (Nov. 26)
3848 Vision of St. Sergius of Radonezhskii at Trinity-St. Sergius monastery (SS. Sergius and Nikon greet the Virgin and SS. Peter and John the Baptist), tempera on wood icon with frame, 1500-50. State Russian Museum, St. Petersburg.

Nilus, of Calabria and Rossano, monk, abbot of St. Adrians, d. 1004 or 1005 (Sept. 26)
3849 St. Nilus curing the son of Polieuto (reaching into an urn, he puts the forefinger of his other hand into the raving boy's mouth); St. Nilus in prayer (before a crucifix from which Christ blesses him); the Virgin appearing to Saints Nilus and Bartholomew; death of St. Nilus; meeting of St. Nilus and emperor Otto III (as men play the trumpets; soldiers and peasants look on); frescoes by Domenichino, c. 1608-10. Grottaferrata Abbey; Spear, *Domenichino.*

Ninian, Cumbrian Bishop in Scotland, late 4th cent. (Sept. 16)
3850 St. Ninian (in bishop's regalia) with a kneeling donor and a kneeling angel, ms. illum., 4th cent. Edinburgh Univ. Library; Bentley, *Calendar.*

Nonnosco, Abbot
3851 St. Nonnosco Abbot (with angels holding attributes of three of his miracles: the rock, the lamp, and a vase), etching by Teresa Del Po. Illus. Bartsch; *Ital. Masters of the 17th Cent.* (Vol.45).

Nonnus *see* 3947

Norbert, Archbishop of Magdeburg, founded Norbertine Order, d. 1134 (June 6)
3852 St. Norbert overcoming Tran-

chelm, alabaster sculpture by Hans van Mildert. Groot Zundert, St. Trudo, Netherlands; Held, *Oil Sketches* (Vol.I).
3853 St. Norbert preaching against the heresy of Tanchelin, by Jan Brueghel. K. G. H. Galerie, Brussels; Coulson, *Saints.*
3854 St. Norbert overcoming Tranchelm (standing on him), oil sketch by P.P. Rubens, c. 1622-23. Coll. George Baer, Atlanta GA; Held, *Oil Sketches.*
3855 St. Norbert receiving the saint hosts and church vessels (stolen by the Heretic Tranchelm) by Cornelis de Vos, 1630. Antwerp, Musée Royal des B/A; Larsen, *17th Cent. Flem.*
3856 Consecration of Blessed Waltman by St. Norbert (angels descend with a bishop's miter), by Abraham Van Diepenbeeck. Strasbourg Fine Arts Museum; Hairs, *Sillage de Rubens*; Larsen, *17th Cent. Flem.*
3857 St. Norbert Archbishop of Magdeburg (with a large spider in lower left corner) by Giambattista Tiepolo. Private Coll., Paris; Morassi, *Catalogue* (pl.180).

Odile or Ottilie, blind nun, given her sight by St. Erhard 8th cent. (Dec. 13)
3858 Baptism of St. Odile, fresco by Master Oswald, 1378. Prague Cathedral; Stejskal, *Charles IV.*
3859 St. Mary Magdalene, St. Odilia (holding an open book with eyes), and St. Clare (holding a reliquary), by an anonymous Alsatian Master, last third of 15th cent. Picture Gallery, Lvov; *Old Master.*
3860 Saint Ottilie at prayer, while an angel vanquishes a crowned man behind her, woodcut by Albrecht Dürer from the "Salus Animae" of 1503. Strauss, *Woodcuts* (pl.72).
3861 Reliquary bust of St. Odile, carved wood plated with silver, c. 1630-60. Huy, Couvent des Croisiers; *Tresors.*
See also 1344

Olaf (or Olave), king of Norway, d. 1030 (July 29)
3862 Saint Olaf enthroned, painted wooden statue, 13th cent. Nordiska Museet, Stockholm; New Int'l Illus. *Encyclo.*
3863 St. Olaf with scenes from his life, altar frontal from Holtaalen, Norway, early 14th cent. Copenhagen Fine Arts Museum; RA, *Primitive.*

Olide
3864 Legend of St. Olide (executioner puts a hand on her head, while raising his sword to strike), anon., c. 1292. Mariënlof Convent, Kolen-Kerniel; *Eight Centuries*.

Omer or Audomarus, bishop of Thérouanne, d. 670 (Sept. 670)
3865 Scene from the life of St. Audomarus (one man pulls his beard, as another pulls his clothing), from "Vie de saint Omer," ms.698, fo.34, late 11th cent. Saint-Omer Library; Gardner, *Art thru Ages*; Porcher, *Medieval French Min.*

Omobono
3866 Death of St. Omobono (he falls on the floor at mass), from a Choral, late 14th cent. Cremona, Cathedral; Voltini, *Cremona*.
3867 St. Nicholas altarpiece, with Nicholas of Bari at center, flanked by SS. Damian and Omobono (giving alms to the poor), marble sculpture by Tomase e Mabila del Mazo, 1495. Cremona, Cathedral; Voltini, *Cremona*.

Onophrius or Onuphrius, hermit, 5th cent. (June 12)
3868 Madonna and Child flanked by SS. Lawrence and Onophrius at left, and SS. James Major and Bartholomew at right, polyptych by Puccio di Simone, 1348–55. Accademia, Florence; Offner, *Corpus* (Sect.III, Vol.VIII, pl.XLVIII).
3869 St. Onophrius (standing with a crutch and a string of beads, with a crown at his feet), fresco by the South Italian School, 15th cent. Galatina, S. Caterina; Kaftal, *Central and So. Ital.*
3870 Scenes from the life of St. Onophrius: Paphnutius runs away from him in the wilderness, mistaking him for a wild beast; Onophrius begs him to come back, because he is near death; he tells Paphnutius the story of his life, by Lorenzo Monaco. Accademia, Venice; Eisenberg, *Monaco* (pl.95); Kaftal, *Tuscan*.
3871 St. Onophrius (standing in a trompe l'oeil arch, holding a walking stick and a crucifix), by Carlo Crivelli. Rome, S. Angelo Castle; Zampetti, *Crivelli*.
3872 St. Onophrius, standing with a crutch, wearing a garland of leaves around his loins, by a follower of Fra

Angelico. Certosa, Florence; Kaftal, *Tuscan*.
3873 Madonna of St. Onophrius (he leans on a crutch, looking up at her, along with other saints), by Luca Signorelli, 1484. Perugia, Museo del Duomo; Burckhardt, *Altarpiece*.
3874 John the Baptist and St. Onophrius (holding a book), woodcut by Albrecht Dürer, Erlangen, c. 1504. Geisberg, *Single-Leaf*; Strauss, *Woodcuts* (pl.84).
3875 St. Onophrius (half view with a furry torso, sitting next to a tree), woodcut by Hans Burgkmair the Elder, Vienna, c. 1508. Geisberg, *Single-Leaf*.
3876 Virgin and Child with St. Onophrius (as a hermit) and a holy bishop, by Lorenzo Lotto, 1508. Borghese Gallery, Rome; Berenson, *Lotto*.
3877 St. Onophrius (holding a rosary, leaning on a staff) and St. John the Baptist, att. to Gian Maria Falconetto. Phillips County Museum, Helena, AR; Shapley, *15th–16th Cent.*
3878 St. Onophrius with a skull, by follower of Jusepe de Ribera, c. 1642. Boston Museum of Fine Arts.
3879 St. Onophrius (in meditation, his hands pressed against his mouth, in the wilderness), by Salvator Rosa, c. 1660. Minneapolis Inst. of Art, MN; *European Paintings*.
See also 1309, 4649

Onuphrius *see* **Onophrius**

Orestios *see* **564**

Oswald, King of Northumbria; killed in battle; k. 642 (Aug. 9)
3880 St. Oswald, from Swiss ms. 645, late 12th cent. Pierpont Morgan Library, NY; Davenport, *Book of Costume* (pl.419).
3881 St. Oswald and King Aadan (at dinner; Oswald hands food outside of the Illum. letter to a cripple), from the Berthold Missal, ms. 710, fo.101v, c. 1200–35. Pierpont Morgan Library, NY; Harrsen, *Central European*; Swarzensski, *Berthold Missal* (fig.125).
3882 St. Oswald, from the Berthold Missal, Fulda MS Aa32, c. 1200–36. Fulda Public Library; Swarzensski, *Berthold Missal* (fig. 118).
3883 St. Oswald at the battle of Maserfield; Oswald slain at Maserfield,

from ms. Royal 2 B. vii. BM, London; Strutt, *Regal.*

3884 St. Oswald, king of England, holding a ring, by German Master active c. 1465. David & Alfred Smart Gallery, Chicago IL; Eisler, *European Schools.*

3885 Saints Maximus and Oswald (with a halberd), by Giambattista Tiepolo. Pushkin Museum, Moscow; Morassi, *Catalogue* (pl.142).

3886 St. Maximus (in bishop's robes) and St. Oswald (sitting, in armor, looking up at a cherub) by Giovanni Battista Tiepolo. Nat'l Gallery, London; Wilson, *Nat'l Gallery.*

See also 3504, 3694, 3695

Oswald of Worcester, Bishop of Worcester, archbishop of York, d. 992 (Feb. 28)
3887 Oswald of Worcester, stained glass window by John the Glaser, mid-15th cent. All Souls' College Chapel, Oxford; Coulson, *Saints.*

Othmar
3888 St. Othmar (holding a crosier and a handbag); St. Elizabeth of Hungary (giving plate to a cripple); St. Clement I (in a castle surrounded by a moat); St. Chrysogonus (about to be decapitated); St. Conrad (holding a flaming chalice); St. Louis of Toulouse (sitting, holding a chalice and a hammer); woodcuts by Günther Xainer from "Leben der Heiligen, Winterteil," 1471. The Illus. Bartsch; *German Book Illus.* (Vol.80, pp.66–67).

Ottilia *see* **Odile**

Ovid
3889 Martyrdom of St. Ovid (beneath the sitting statue of Jupiter, the executioner is about to strike off his head as angels descend with a crown), by Jean-Baptiste Jouvenet, 1690. Grenoble, Musée de Peinture et de Sculpture; Lemoine, *Musée*; Schnapper, *Jouvenet.*

Oyant
3890 Chilperic receiving SS. Oyant and Luxine (in the street at an entrance to a house), by the Master of Edward IV, ms. Yates Thompson 32, fol. 3r, c. 1479. BL, London; Dogaer, *Flemish Min.*

Pachomius, The Great, hermit, founded Christian community monasticism, d. 346 (May 9 & 15)
3891 St. Pachomius the Great (in half-length, holding a scroll), icon by Krustyu Zahariev of Tryana, 1824. Bulgaria, National Art Gallery; Paskaleva, *Bulgarian Icons.*

Pancras, martyred at age 13; beheaded; mart. 304 (May 12)
3892 St. Pancras, holding a sword and palm leaf, from "Hamersleben Bible," ms. 1, fo.1r, Halberstadt, c. 1170. Dommuseum, Halberstadt; Rothe, *Med. Book Illum.* (pl.27).

3893 Martyrdom of St. Pancras (executioner is about to strike off his head, as judges watch), from the "Boucicaut Hours" painted by the Boucicaut Master, ms.2,fo.29v. Jacquemart-André Museum, Paris; Meiss, *French Painting.*

3894 St. Pancras, brass from tomb of Thomas Nelond, Prior of Lewes, 1433. Cowfield, Sussex; Coulson, *Saints.*

3895 Death of St. Pancras (executioner is sheathing his sword, as emperor looks on), wall mural by unknown artist. Villard-Saint-Pancrace, La Cure; *Peintures Murales.*

3896 Scenes from the life of St. Pancras: Pancras proclaims his faith; he and his uncle Denis kneel before the pope; they are baptized; he is arrested; he is beheaded; wall murals by an unknown artist. La Roche-de-Rame, Eglise Saint-Laurent; *Peintures Murales.*

3897 Scenes from the life of St. Pancras: he is baptized by Pope Caius (or Cornelius); decapitation of St. Pancras; panels by Mariotto di Nardo. Vatican Museums; Kaftal, *Tuscan.*

3898 St. Pancras (standing in armor before a city, holding a banner and a palm), panel by the School of the Veneto, 1450–1500. Bassano, Museo Civico; Kaftal, *North East Italy.*

Pantaleon or Panteleimon, physician; known for his dried blood which liquefies; patron of doctors; invoked against wasting diseases; decapitated; mart. 305 (Feb. 18 & July 27)
3899 St. Panteleimon wearing a red robe, icon by an unknown Byzantine Master, 11th cent. Pushkin Museum, Moscow; Bank, *Byzantine* (pl.268); Malitskaya, *Great Paintings.*

3900 Martyrdom of St. Pantaleon (he is tortured on the wheel; at right, his persecutors are killed and he is standing beside the wheel), fresco by the school of Montecassino, 11th–12th cent. S. Angelo in Formis; Kaftal, *Central and So. Ital.*

3901 St. Pantaleon holding a laurel leaf, page from a Book of Gospels from Cologne, c. 1170. Cologne, Stadtarchiv; Book of Art, *German & Spanish.*

3902 St. Pantaleon (holding a palm and giving a blessing), min. from the Gospel Book of St. Pantaleon. BL, London; Bentley, *Calendar.*

3903 Saint Panteleimon (holding a cross and a box with vials) with scenes from his life and martyrdom, icon, early 13th cent. Sinai, Monastery of St. Catherine; Manafis, *Sinai.*

3904 St. Pantaleon (with his hands nailed to his head), fresco by School of the Alto Adige, 15th cent. Morter, S. Stefano; Kaftal, *North East Italy.*

3905 Martyrdoms of St. Pantaleon (he is thrown to the wild beasts; he is crucified; he is thrown into the river with a millstone around his neck; he is decapitated, and his soul carried to heaven), by the Sardinian School, before 1503. Dolianova (Cagliari), Parish Church; Kaftal, *Central and So. Ital.*

3906 St. Pantaleon (standing on a tiled floor before a balustrade, giving a blessing and holding a medicine box; with a cripple in a wheel cart at lower right and two kneeling donors at lower left; one donor is wrapped in a serpent's coils), by the Sardinian School, before 1503. Dolianova (Cagliari), Parish Church; Kaftal, *Central and So. Ital.*

3907 St. Pantaleon healing a sick boy (who is held in his father's arms) by Paolo Veronese, 1587. Venice, S. Pantaleon; McGraw, *Encyclo.* (Vol.XIV, pl.350); Rearick, *Veronese.*

3908 Silver reliquary of St. Pantaleon (half of his figure, holding a palm and a book with a vase), by Nicola Schisano, 1759. Rome, Museo Diocesano; *Tresori d'Arte.*

Panteleimon *see* **Pantaleon**

Papianus
3909 Saints Gregory I, Maurice and Papianus (all crowned by cherubs), by P.P. Rubens, c. 1608. Rome, S. Maria in Vallicella; Jaffé, *Rubens and Italy.*

3910 St. Gregory I with St. Maurice and St. Papianus; St. Domitilla with St. Nereus and St. Achilleus (first three and second three face each other), oil sketch by P.P. Rubens, 1608. Salzburger Barockmuseum, Salzburg; Held, *Oil Sketches.*
See also 1724, 1725, 3685

Paraskeva or Paraskevia, patron of trade; martyred (Oct. 28)
3911 The great martyr St. Paraskevia with scenes from her life, icon from the Carpathian region, 15th cent. Cracow, Nat'l Museum; Great Centers, *Cracow.*

3912 St. Paraskeva (holding a crucifix and a scroll), icon, 17th cent. Wallachia, Monastery of Hurezi; Knopf, *The Icon* (p.400).

3913 Saint Paraskev and St. Marina (holding martyr's crosses, standing full-length), icon from end of 18th cent. Melnik, St. Nicholas the Miracle Worker; Paskaleva, *Bulgarian Icons.*
See also 184, 2594, 3729

Paschal Baylon, Franciscan, patron of Eucharistic Congresses, d. 1592 (May 17)
3914 Two posthumous miracles of St. Paschal Baylon: at a deathbed and at a scene of birth, by Seiter, 1679–86. Rome, S. Maria in Araceli; Waterhouse, *Roman Baroque.*

3915 St. Paschal Baylon (at prayer), by Giambattista Tiepolo. Prado, Madrid; Bentley, *Calendar*; Morassi, *Catalogue* (pl.197).

3916 St. Paschal Baylon's vision of the Eucharist (held by an angel), by Giovanni Battista Tiepolo, c. 1769. Courtauld Inst. of Art, London; *Catalogue*; Morassi, *Tiepolo.*
See also 3218

Pastor
3917 St. Pastor (standing in the robes of a friar), woodcut by Günther Xanier from "Leben der Heiligen, Winterteil," Augsburg, 1471. The Illus. Bartsch; *German Book Illus.* (Vol.80, p.75).

Paterniano
3918 Madonna of Loreto appearing to St. John the Baptist, St. Paterniano, and St. Anthony Abbot (a cherub plays with a plate of jewels on the ground), by Domenichino, 1618–19. North Carolina Museum of Art, Raleigh; *Intro. to the Coll.*

Patrick, Patron and Apostle of Ireland, Bishop and Confessor, d. 465 or 492 (Mar. 17)
3919 St. Patrick holding a crosier, with serpents at his feet, stained-glass window, 15th cent. Doddiscombsleigh, Devon; Drake, *Saints and Emblems.*
3920 Scenes from the life of St. Patrick: an angel appears to him, and sends him to convert Ireland; he preaches before the king and the Irish; he baptizes the Irish; he accidentally pierces the king's foot with his crosier, but heals it with his prayers; he resuscitates the dead; he exposes a thief by commanding the stolen sheep to bleat from the man's stomach; frescoes by Lombard School, 15th cent. Colzate (Bergamo), S. Patrizio; Kaftal, *North West Italy.*
3921 Miracle of St. Patrick of Ireland (he is preaching to the sick), by Giambattista Tiepolo, 1746. Padua, Museo Civico; Morassi, *Catalogue* (pl.152).
See also 3697

Paul Aretio
3922 St. Paul Aretio (in prayer, at a table before a crucifix), etching by Bernardino Capitelli. Illus. Bartsch; *Ital. Masters of the 17th Cent.* (Vol.45).

Paul of Thebes *see* **Paul the Hermit**

Paul the Hermit, or Paul of Thebes, first hermit, d. 341 or 345 (Jan. 15)
3923 Saints Anthony Abbot and Paul (sitting at a table), woodcut by Albrecht Dürer, Erlangen c. 1504. Geisberg, *Single-Leaf.*
3924 Landscape with the hermits St. Paul and St. Anthony Abbot, att. to Jan de Cock, early 16th cent. Picture Gallery, Berlin; *Catalogue.*
3925 The hermit saints Anthony Abbot and Paul in the wilderness (they sit, facing each other, as the raven flies off after depositing bread on the ground between them), by Jan de Cock. Liechtenstein Coll., Vaduz; Baumstark, *Masterpieces.*
3926 St. Paul of Thebes as a hermit in the countryside, by an unknown artist of the Italian School. Mauritshuis, The Hague; *Catalogue*; Hoetink, *Mauritshuis.*
3927 St. Paul the Hermit and St. Anthony Abbot, sharing a piece of bread brought by a raven, Limoges enamel by

Leonard Limousin, 1536. BM, London; Coulson, *Saints.*
3928 The holy hermits Anthony Abbot and Paul (sitting together, watching a raven carry bread to them), by Gaspar de Crayer, c. 1620–30. Brussels, Musées Royaux des B/A; *Benedict* (p.318).
3929 Woodland scene with the meeting of St. Anthony and St. Paul the Hermit (as Paul reads, Anthony approaches in center of painting), by Alexander Keirincx, 1630's. Coll. Johnny Van Haeften, London; Briels, *Peintres Flamands.*
3930 Madonna in glory with SS. Paul the Hermit and Anthony Abbot, by Guido Reni. Grenoble, Musée de Peinture et de Sculpture; Chiarini, *Tableaux Italiens.*
3931 St. Anthony Abbot and St. Paul the Hermit (St. Paul prays as a raven descends with his daily bread in its mouth), by Velazquez, 1634. Prado, Madrid; Gudiol, *Velazquez.*
3932 St. Paul the Hermit (in the wilderness, praying with a rosary), by Jusepe de Ribera. Louvre, Paris; Gowing, *Paintings.*
3933 St. Paul the Hermit (hands clasped in prayer, looking over his right shoulder), by Jusepe de Ribera. Walters Art Gallery, Baltimore.
3934 St. Paul, holding a skull, his midriff wrapped in fur, by Jusepe de Ribera, 1647. Wallraf-Richartz Museum, Cologne; Praeger, *Great Galleries.*
3935 St. Paul the Hermit (reading a book) and St. Anthony Abbot (looking on), by Claude Vignon. Epinal, Musée Départmental des Vosges; Châtelet, *French Paintings.*
3936 St. Paul the Hermit (sitting on a ledge, leaning back as a raven descends with the bread), by Mattia Preti, 1656–60. Toronto, Art Gallery of Ontario; Cleveland Museum of Art, *European 16th–18th Cent.*
3937 St. Paul the Hermit (half view, holding his bread, looking up at a celestial light) by Mattia Preti, 1662–63. Cleveland Museum of Art, OH; *European 16–18th Cent.*
3938 St. Paul the Hermit and the raven (half-view; he looks up while praying, as the raven descends behind him with a piece of bread), att. to Giacinto Brandi, c. 1665. Hood Museum of Art: Dartmouth College, *Treasures.*
3939 Death of St. Paul the Hermit (he

is supported by angels as St. Anthony Abbot kneels by his side, holding a cloth), by Sebastiano and Marco Ricci, 1700–10. Helen Foresman Spencer Museum of Art, Lawrence KS; Daniels, *Ricci*; *Handbook*.
3940 Death of St. Paul the Hermit (supported by angels and mourned by St. Anthony Abbot), by Sebastiano Ricci, c. 1700–10. Univ. of Kansas, Lawrence KS; Daniels, *Ricci*.
See also 260, 302, 320, 326, 327, 330

Paula, Mother of St. Eustochium, accompanied St. Jerome on a pilgrimage, d. 404 (Jan. 26 & Sept. 30)
3941 St. Paula (standing with a scroll), altar wing by the Florentine School, 14th cent. Pinacoteca, Vatican; Bentley, *Calendar*.
3942 St. Paula (standing, holding a scroll), by the Master of the Strauss Madonna. Vatican Museums; Kaftal, *Tuscan*.
3943 St. Paula sitting on a wall, reading a book, by Dosso Dossi. Haddington Coll., Tyninghame; Gibbons, *Dossi*.
3944 St. Paula (dressed as a nun, standing with a crosier and reading), painted for the Monastery of Saint Jerome of Buenavista by Juan de Valdés Leal, c. 1657. Bowes Museum, Barnard Castle, Durham; United Nations, *Dismembered Works*.
3945 Port of Ostia: the departure of St. Paula, by Claude Lorrain. Prado, Madrid; *Guide to Prado*; Praeger, *Great Galleries*.
3946 SS. Paula and Eustochium embarking from Ostia for the Holy Land, by Ghezzi, 1676. Rome, Galleria Nazionale; Waterhouse, *Roman Baroque*.
See also 1921, 1922, 2818

Pelagia, the Penitent, courtesan turned Christian, date unknown (Oct. 8)
3947 St. Pelagia (baptized by St. Nonnus in a large chalice); St. Thaïs (speaking to a woman); St. Coloman (hung and flayed); St. Gall (approached by a wild animal); St. Ursula (a murderer is decapitating a virgin even before she disembarks); SS. Crispin and Crispinian (tied to a column and flayed); woodcuts by Günther Xainer from "Leben der Heiligen," 1471. The Illus. Bartsch; *German Book Illus.* (Vol.80, p. 62).

Pelagius or Pelayo, prior of Convent in Coimbra, Dominican, d. 1240 or 1257 (Nov. 6)
3948 St. Pelagius (in his study, sitting at a desk), fresco by Tomaso da Modena, 1352. Treviso, Dominican Seminary; Kaftal, *North East Italy*.

Pelagius I, Pope, r. 556–561
3949 St. Pelagius I, mosaic. Rome, St. Paul-Outside-the-Walls; Brusher, *Popes*.

Pelayo or Pelagius, martyred at age 13 by Moors in Cordova, 925 (June 26)
3950 The martyrdom of St. Pelayo, by Antonio del Castillo, 1645. Cordova Cathedral; Book of Art, *German & Spanish*.

Peregrinus or Peregrino, patron of Lucca and Modena, foreign pilgrim, d. 364 or 543 (Aug. 1 or 8)
3951 St. Peregrinus (standing with a pilgrim's staff, holding a thin cross, barefooted), from a triptych by Paolo di Giovanni Fei. Naples, Cathedral; Kaftal, *Tuscan*.

Pergentinus *see* **Lorentinus and Pergentinus**

Perpetua, thrown to wild beasts; mart. 203 (Mar. 6)
3952 Perpetua and Felicity, mosaic, 6th cent. Ravenna, Archbishop's Palace; Coulson, *Saints*.

Peter Celestine, Pope Celestine V, Benedictine, founder of Celestine order, d. 1296, canon. 1313 (May 19)
3953 St. Peter Celestine (enthroned, in papal robes, holding a book and giving a blessing), fresco by the Lombard School, 1435. Bergamo, S. Niccolò dei Celestini; Kaftal, *North West Italy*.
3954 Allegory of the coronation of Celestine V, by anon. 16th cent. French artist. Louvre, Paris; Brusher, *Popes*.
3955 St. Peter Celestine in glory (sitting on a cloud with angels, looking to heaven), Mattia Preti. Naples, San Pietro a Maiella; Yale Univ., *Taste* (fig.11).

Peter Cendra, preacher, prior of the convent of St. Dominic in Barcelona, d. 1244 (July 8)
3956 St. Peter Cendra (in his study, sitting at a desk), fresco by Tomaso da

Modena, 1352. Treviso, Dominican Seminary; Kaftal, *North East Italy.*

Peter Igneus, Aldobrandini, Vallombrosan bishop of Albans, d. 1094 (Feb. 8)
3957 St. John Gualbertus watches as Peter Igneus, a Vallombrosan monk, walks through fire, by Andrea del Sarto. Accademia, Florence; De Bles, *Saints in Art.*
3958 St. John Gualbertus and the trial by fire of St. Peter Igneo, detail of the Pala Vallombrosana predella by Andrea del Sarto, 1528. Uffizi, Florence; Padovani, *Andrea del Sarto.*
See also 3133

Peter Martyr, Patron of Verona, Dominican inquisitor general; stabbed to death; mart. 1252, canon. 1253 (Apr. 29)
3959 Death of St. Peter Martyr (soldier wearing chain maille plunges dagger into his back and strikes his head with a notched sword) from Psalter of Gerard de Damville, Bishop of Cambrai, 1250–1300. Pierpont Morgan Library, NY; Burlington, *Illum. MS.*
3960 Martyrdom of St. Peter Martyr (as the murderer strikes, he prays for the man's conversion; above, angels carry his soul to heaven in a boat), illum. from Ms. Corale X, C. 43, c. 1290. Gubbio, Palazzo Pretorio. Archivio; Kaftal, *Central and So. Ital.*
3961 St. Peter Martyr (standing, with a sword, before a wall painted with coats of arms), from the "Boucicaut Hours" painted by the Boucicaut Master, ms.2,fo.30v. Jacquemart-André Museum, Paris; Meiss, *French Painting.*
3962 St. Peter Martyr (with head wound and sword), wing of the Deichsler Altarpiece, c. 1415–20. Picture Gallery, Berlin; *Catalogue.*
3963 Assassination of St. Peter Martyr (executioner sinks a cleaver into his head from behind as he kneels) from Valle Romita polyptych by Gentile da Fabriano, c. 1420. Brera, Milan; Hartt, *Ital. Ren.*; Herald, *Ren. Dress* (pl.18).
3964 St. Peter Martyr enjoining silence, fresco by Fra Angelico, late 1430's–early 1440's. San Marco Museum, Florence; Andres, *Art of Florence* (Vol.I, pl.334).
3965 St. Peter Martyr Altarpiece; Virgin and Child enthroned, flanked by

St. Dominic and John the Baptist at left, and Peter Martyr and another Dominican saint at right, by Fra Angelico. Florence, San Marco; Van Os, *Sienese Altarpieces* (Vol.II pl.185).
3966 Two scenes from the life of St. Peter Martyr: the miracle of the fire before the Sultan, and the Saint's investiture upon his entry into the Dominican order, by Antonio Vivarini, c. 1440–50. Picture Gallery, Berlin; *Catalogue.*
3967 The Bosco Ai Frati Altarpiece, with the Virgin and Child flanked by SS. Anthony of Padua, Louis of Toulouse, Francis of Assisi, Cosmas, Damian, and Peter Martyr, by Fra Angelico. San Marco Museum, Florence; Pope-Hennessy, *Fra Angelico.*
3968 Martyrdom of St. Peter Martyr (he writes "Credo" with his blood as the murderer is about to stab him a second time; his companion is set upon as he runs away), fresco by Vincenzo Foppa. Milan, S. Eustorgio; Fiorio, *Le Chiese di Milano.*
3969 Miracle of St. Peter Martyr at Narni (replacing a man's foot, which he cut off in remorse for kicking his mother), fresco by Vincenzo Foppa, c. 1468. Milan, S. Eustorgio, Portinari Chapel; Book of Art, *Ital. to 1850*; Fiorio, *Le Chiese de Milano*; Kaftal, *North West Italy.*
3970 Scenes from the life of St. Peter Martyr: he unmasks the devil who appeared as the Virgin in a heretical church; he prays for a cloud to appear, to convert a heretical bishop; he is killed by the heretic Carinus, but writes "Credo" with his blood; frescoes by Vincenzo Foppa, c. 1468. Milan, S. Eustorgio; Kaftal, *North West Italy.*
3971 Scenes from the life of St. Peter Martyr: vestition; preaching in the piazza of S. Maria Novella; stabbed by his murderer, he writes "Credo" on the ground with his blood; frescoes by Andrea Bonaiuti da Firenze. Florence, S. Maria Novella; Kaftal, *Tuscan.*
3972 St. Peter Martyr (with a knife in his head and dagger in his chest, hands crossed in prayer), from a dismembered altar by Carlo Crivelli, c. 1476. Nat'l Gallery, London; Dunkerton, *Giotto to Dürer*; Zampetti, *Crivelli.*
3973 Martyrdom of St. Peter Martyr (after the murderers strike, he kneels,

writing on the ground with his blood), by Gentile da Fabriano. Dumbarton Oaks Coll., Washington D.C.; Kaftal, *Central and So. Ital.*

3974 Saints Nicholas of Bari, Lawrence, Peter Martyr, and Anthony of Padua (standing side-by-side before a pink wall), by Bartolommeo Caporali. Hermitage, St. Petersburg; Eisler, *Hermitage.*

3975 St. Augustine with a kneeling donor; St. Peter the Martyr (with a kneeling donor), panels from a polyptych by Il Bergognone. Louvre, Paris; Gowing, *Paintings.*

3976 Triptych of Madonna and Child with angels, with St. Peter Martyr and donor, and St. Jerome with his lion on side panels, by Master of the St. Lucy Legend, before 1483. Los Angeles County Museum of Art, CA; *A Decade of Coll.*

3977 St. Peter Martyr (holding a book and palm, with a knife in his head, before a background with clouds), by Giovanni Bellini and assistants. Bari, Pinacoteca Provinciale; Goffen, *Bellini.*

3978 St. Peter Martyr and the crucifix, by Pedro Berruguete, c. 1500. Prado, Madrid; Book of Art, *German & Spanish.*

3979 The sermon of St. Peter the Martyr, by Pedro Berruguete. Prado, Madrid; Praeger, *Great Galleries.*

3980 St. Peter Martyr (standing before city walls, holding a palm and a book, with a dagger in his chest), fresco by Cavallinesque. Naples, S. Domenico Maggiore; Kaftal, *Central and So. Ital.*

3981 Madonna and Child with young St. John the Baptist and St. Peter Martyr (cleaver in his head), by Lorenzo Lotto, 1503. Capodimonte, Naples; Berenson, *Lotto*; Random House, *History* (p.147).

3982 St. Peter Martyr (on a pedestal, center, with a knife in his head), St. Nicholas of Bari, St. Benedict, and an angel musician, by Giovanni Battista Cima, 1504. Brera, Milan; Burckhardt, *Altarpiece*; Newsweek, *Brera.*

3983 The assassination of St. Peter Martyr (on a forest path, a soldier is stabbing him in the chest, while another soldier murders his companion), by Giovanni Bellini, c. 1510. Nat'l Gallery, London; Dunkerton, *Giotto to Dürer*; Goffen, *Bellini*; Poynter, *Nat'l Gallery*; Wilson, *Nat'l Gallery.*

3984 Assassination of St. Peter Martyr (cropped and compacted version of the painting in the National Gallery, London), by the workshop of Giovanni Bellini, c. 1510. Courtauld Inst. of Art, London; Dunkerton, *Giotto to Dürer.*

3985 St. Peter Martyr (half portrait before a ledge, holding a palm, a knife in his chest and another in his head), by Giovanni Bellini, c. 1510. Nat'l Gallery, London; Dunkerton, *Giotto to Dürer*; Poynter, *Nat'l Gallery.*

3986 Madonna and Child flanked by St. Joseph and St. Peter Martyr, by Andrea del Sarto. Rome, Galleria Nazionale d'Arte Antica; Padovani, *Andrea del Sarto.*

3987 Martyrdom of St. Peter Martyr (the same man kills both him and his companion), by Giovan Pietro Birago from the Hours of Bona Sforza, add. ms. 34294, fo.205v, c. 1517–21. BM, London; BL, *Ren. Painting in MS.*

3988 The assassination of St. Peter Martyr (as God looks on from above, two men strike him while his companion runs away), by Lorenzo Lotto. Alanzo Lombardo, Collegiata; Berenson, *Lotto.*

3989 The death of Peter the Martyr (man in slashed pants leans on the prone saint, dagger poised to strike, as others run away in the background), att. to Cariani or Bernardo da Asola. Nat'l Gallery, London; Pallucchini, *Cariani*; Poynter, *Nat'l Gallery.*

3990 Martyrdom of St. Peter Martyr (he is knocked down by assassin in the woods, as his companion flees), copy after Titian. Fitzwilliam Museum, Cambridge; Wethey, *Titian* (pl.153).

3991 St. Peter Martyr (with a dagger in his heart and a cleaver in his head, holding a New Testament) by Lorenzo Lotto, 1549. Fogg Art Museum, Cambridge MA; Berenson, *Lotto*; Fogg, *Med. and Ren. Paintings*; Marck, *Quest of Excellence*; Mortimer, *Harvard Univ.*

3992 The martyrdom of St. Peter Martyr (man overpowers him, brandishing a dagger, as the other monk runs away), by Domenichino, c. 1619–21. Bologna, Pinacoteca Nazionale; Spear, *Domenichino.*

3993 St. Peter Martyr (stumbling, with an axe in his head and a sword in his chest), by Francisco de Zurbaran, 1641–58. Seville, Archbishop's Palace; Gállego, *Zurbaran.*

See also 509, 1540, 1547, 1549, 1550, 3657

Peter Nolasco, founded Order of our Lady of Ransom, d. 1258 (Jan. 28)
3994 Apparition of St. Peter Apostle to St. Peter Nolasco as he prays; departure of St. Peter Nolasco; engravings by Jusepe Martinez after paintings by Zurbaran, 1627. Madrid, Nat'l Library; Gállego, *Zurbaran*.

3995 Birth of St. Peter Nolasco (men are introduced into the room as child lies in his crib), by Francisco de Zurbaran, 1628-34. Bordeaux, Musée des B/A; Gállego, *Zurbaran*.

3996 Departure of St. Peter Nolasco (as a young man, dressed in civilian clothes, he says farewell to his three friends), by Francisco de Zurbaran, 1628-34. San Carlos Academy, Mexico; Gállego, *Zurbaran*.

3997 Vision of St. Peter Nolasco (an angel shows him a city as he dreams, kneeling), by Francisco de Zurbaran, 1628-34. Prado, Madrid; Gállego, *Zurbaran*.

3998 The vision of St. Peter Nolasco (Apostle Peter appears to him, upside-down on his cross) by Francisco de Zurbaran, 1629. Prado, Madrid; Gállego, *Zurbaran*; *Guide to Prado*; Larousse, *Ren. & Baroque*; McGraw, *Dict.*; McGraw, *Encyclo.* (Vol.II, pl.188); Newsweek, *Prado*.

3999 St. Peter Nolasco recovering the image of the Virgin (for the King), by Francisco de Zurbaran, 1630. Cincinnati Art Museum, OH; *Handbook*; *Masterpieces*.

4000 Embarkment of St. Peter Nolasco (a man is about to carry him to a boat) by Francesco Rosa. Seville, Museum of Fine Arts; McGraw, *Dict.*; McGraw, *Encyclo.* (Vol.XII, pl.376).

4001 Miraculous communion of St. Peter Nolasco (angels watch, holding candles) by Francisco de Zurbaran, 1641-58. Coll. Duke of Dalmacia, Saint-Amans-Soult; Gállego, *Zurbaran*.

4002 Our Lady of Ransom bestowing the habit of the Mercedarians on St. Peter Nolasco, by Francisco de Zurbaran, 1641-58. Coll. Duke of Dalmacia, Saint-Amans-Soult; Gállego, *Zurbaran*.

4003 St. Peter Nolasco (blessing a donor), by Francisco de Zurbaran 1641-58. Convent of the Capuchin Nuns, Castellón de la Plana; Gállego, *Zurbaran*.

4004 Apparition of the Virgin to St. Peter Nolasco (in the choir of the Barcelona's Cathedral), by Francisco de Zurbaran, 1658-64. Seville Cathedral; Gállego, *Zurbaran*.

4005 Death of St. Peter Nolasco (as the monks react to his death, an angel points the way to heaven), by Francisco de Zurbaran, 1658-64. Seville Cathedral; Gállego, *Zurbaran*.

4006 St. Ferdinand (with his army) handing the image of the Virgin to St. Peter Nolasco, by Francisco de Zurbaran, 1658-64. Seville Cathedral; Gállego, *Zurbaran*.

4007 The miracle of the boat (St. Peter Nolasco rides in the boat alone, using his cloak as a sail), by Francisco de Zurbaran, 1658-64. Seville Cathedral; Gállego, *Zurbaran*.

Peter of Alcantara, founder of Alcantarine Franciscans, d. 1562, canon. 1669 (Oct. 19)
4008 St. Peter of Alcantara (in ecstasy, holding a crucifix), by Francisco de Zurbaran, 1631-40. Garcia de Blanes Claros, Seville; Gállego, *Zurbaran*.

4009 St. Peter of Alcantara (meditating over a skull), by Giuseppe de Ribera, 1635-39. Esztergom Christian Museum; *Christian Art in Hungary*.

4010 Painted wooden statue of St. Peter of Alcantara, by Pedro de Mena, 17th cent. Barcelona, Museo d'Art de Cataluyna; Coulson, *Saints*.

4011 St. Peter of Alcantara (carried to heaven by angels), by Brother Luke, 17th cent. Paris, Notre-Dame-de-Bonne-Nouvelle; Rocher, *Carmels de France*.

4012 St. Peter of Alcantara (kneeling on a cloud before a cross, supported by angels), etching by Teresa Del Po. Illus. Bartsch; *Ital. Masters of the 17th Cent.* (Vol.45).

4013 Saints Anthony Abbot (leaning on a staff with a bell) and Peter of Alcantara (holding a crucifix, looking up), by Giuseppe Maria Crespi. Bologna, Collezioni Communali d'Arte; Merriman, *Crespi*.

4014 St. Jerome (on a cloud, talking to an angel) with St. Peter of Alcantara (with his cross), by Giovanni Battista Pittoni. NGS, Edinburgh; Boccazzi, *Pittoni* (pl.131); Gowing, *Biog. Dict.*; *Illustrations*.

4015 St. Peter of Alcantara (writing in his study, looks directly into the face of the Holy Spirit), by Giambattista Tiepolo.

Madrid, Royal Palace; *L'Art Européen*; Morassi, *Catalogue* (pl.187).

4016 A miracle of St. Peter of Alcantara (standing with another monk on water, atop his cloak), att. to Pier Leone Ghezzi. Walters Art Gallery, Baltimore; *Ital. Paintings* (Vol.II).

See also 3073

Peter of Arbues, headed the Inquisition in Aragon; mart. 1485 (Sept. 17)

4017 Martyrdom of Peter of Arbues, preparatory sketch by Giuseppe Maria Crespi, 1736. Bologna, Pinacoteca Nazionale; Merriman, *Crespi*.

4018 Martyrdom of Peter of Arbues (as he kneels, three men attack him with daggers), by Giuseppe Maria Crespi, 1736. Bologna, Collegio di Spagna; Merriman, *Crespi*.

4019 St. Peter of Arbues (half view, in prayer with a rosary), by Giuseppe Maria Crespi, 1736. Mari Massori Roncaglia, Florence; Merriman, *Crespi*.

4020 St. Peter of Arbues (in ecstasy, hand on chest, holding a palm), by Giuseppe Maria Crespi, 1736. Private Coll., Piacenza; Merriman, *Crespi*.

Peter of Luxembourg, Cardinal, Bishop of Metz, d. 1387 (July 2)

4021 St. Peter of Luxembourg's vision of crucified Christ; St. Peter kneeling at prie-dieu, from "Book of Hours," cat. 85, fo.93, Paris 15th cent. Walters Art Gallery, Baltimore; Randall, *Manuscripts*.

4022 St. Peter of Luxembourg and his sister (standing inside a room), by the Circle of the Master of Burgundy, ms.Douce 365, fo.xvii. Bodleian Library, Oxford; BL, *Ren. Painting in MS.* (p.28).

Peter of Slivice

4023 St. Peter of Slivice, polychrome limestone statue, 1395. Prague, Nat'l Gallery; Kutal, *Gothic Art*.

Peter Pascual, of Spain, Bishop of Jaen; murdered at the altar with a sword through the neck; mart. 1300 (Dec. 6)

4024 St. Peter Pascual, Bishop of Jaen (standing, writing in a book as an angel crowns him with a wreath and hands him a palm), by Francisco de Zurbaran, 1631-40. Seville, Museum of Fine Arts; Gállego, *Zurbaran*.

Peter Thomas, papal diplomat; killed with arrows; mart. 1366 (Jan. 28)

4025 The martyrdom of St. Peter Thomas (tied hands and feet to a tree trunk, a poisoned arrow in his chest) by Ludovico Carracci. Bologna, Pinacoteca Nazionale; Met Museum, *Caravaggio*.

4026 St. Peter Thomas in a white robe, reading, by Francisco de Zurbaran, 1630-32. Boston Museum of Fine Arts; Gállego, *Zurbaran*.

Petronilla, Roman martyr, supposed daughter of St. Peter Apostle (May 31)

4027 Burial of St. Petronilla (buried below, received by Christ in heaven above) by Guercino, 1621-23. Capitoline Gallery, Rome; *Age of Correggio*; Held, *17th & 18th Cent.* ; McGraw, *Encyclo.* (Vol.VIII, pl.218); Mojana, *Valentin de Boulogne* (p.24).

4028 Death of St. Petronilla (a priest gives her the last communion), by Simone Pignoni. Hermitage, St. Petersburg; Eisler, *Hermitage*.

4029 St. Peter and St. Petronilla (he is handing her a book), painting by unknown artist, c. 1670. Huy, Saint-Pierre Outre-Meuse; *Tresors*.

See also 4110, 4444

Petronius, Bishop and patron of Bologna, d. 450 (Oct. 4)

4030 St. Petronius (in bishop's robes, holding a model of a city), by Francesco del Cossa, 1473. Bologna, S. Petronino; McGraw, *Encyclo.* (Vol.XII, pl.374).

4031 Scenes from the life of St. Petronius: Petronius saves a workman, who was struck by a falling column; in Palestine, he buys the remains of St. Florian and sends it on a ship; arrival of the body of St. Florian; Petronius lifts the penance of a knight, by removing a stone he has carried in his mouth for seven years, frescoes by Giovanni da Modena. Bologna, S. Petronino; Kaftal, *North East Italy*.

4032 St. Petronius (enthroned, giving a blessing, with a model of a city on his knee), polychromed wooden statue by unknown Bolognese artist, early 16th cent. Joslyn Art Museum; *Paintings & Sculpture*.

4033 Madonna in Glory with the four patron saints of Bologna (Saint Petronius invokes the Virgin's protection by gesturing toward the city), by Prospero Fontana,

c. 1580–97. Matthiesen Fine Art Ltd., London; *Age of Correggio.*

4034 Virgin and Child with Saints Petronius (in Bishop's robes, holding a city on his lap) and John the Evangelist and donor, by Francesco del Cossa. Bologna, Pinacoteca Nazionale; Boschloo, *Carracci*; McGraw, *Encyclo.* (Vol.IV, pl.7).

4035 La Pieta dei Mendicanti (Pieta above), with the patron saints of Bologna: Petronius, Dominic, Francis, Florian, and Charles Borromeo at center, by Guido Reni, c. 1613. Bologna, Pinacoteca Nazionale; *Guido Reni.*

4036 Virgin enthroned with Saints John the Evangelist and Petronius (two angels put the bishop's miter on their heads), etching and engraving by Pietro Del Po after an original by Domenichino. Illus. Bartsch; *Ital. Masters of the 17th Cent.* (Vol.45).

4037 Virgin Immaculate with SS. Petronius and Dionysius the Areopagite, by Giovanni Antonio Burrini. Monhidoro, Parochial Church; *Age of Correggio.*

See also 1811, 1979, 4745

Phanourios
4038 St. Phanourios (in a red cloak and armor, with a shield), icon by Angelos, c. 1600. Patmos, Monastery of St. John the Theologian; Knopf, *The Icon* (p.358).

4039 Mary and Jesus with Saint Phanourios (in armor, holding a candle), by the workshop of the painter Angelos, mid-15th cent. Sinai, Monastery of St. Catherine; Manafis, *Sinai.*

4040 St. Phanourios (enthroned with a spear, bestriding a dragon), by the workshop of Ioannis Kolyvas, 1688. Sinai, Monastery of St. Catherine; Manafis, *Sinai.*

Phevronia
4041 Saint Phevronia (holding a cross, giving a blessing), icon, 1250–1300. Sinai, Monastery of St. Catherine; Manafis, *Sinai.*

Philip Benizi or Filippo, General of the Order of Servites, patron of Todi, d. 1285 (Aug. 23)
4042 St. Philip Benizi (in monk's robes, holding an open book), by Michele Giambono. Accademia, Venice; Bentley, *Calendar.*

4043 The Virgin (appearing in a chariot) orders St. Philip Benizi to join the order of the Servites (as witnesses look on), fresco by Cosimo Rosselli, 1476. Florence, SS. Annunziata; Kaftal, *Tuscan.*

4044 Death of St. Philip Benizi (he lay propped up in bed, surrounded by monks, looking up at Jesus and the Virgin), panel by Niccolò Giolfino. Philadelphia Museum of Art, PA; Kaftal, *North East Italy.*

4045 Meeting of St. Philip Benizi and the leper (the leper walks toward him to be cured), fresco by Andrea del Sarto, c. 1510. Florence, SS. Annunziata; Fischer, *Fra Bartolommeo* (fig.194); Padovani, *Andrea del Sarto.*

4046 Miracle of the relics of St. Philip Benizi (a child is cured at an altar as a priest holds a bundle containing the relics), fresco by Andrea del Sarto, c. 1510. Florence, SS. Annunziata; Padovani, *Andrea del Sarto.*

4047 St. Philip Benizi cures a possessed woman (who leans back, screaming, into her friend's arms), fresco by Andrea del Sarto, c. 1510. Florence, SS. Annunziata; Padovani, *Andrea del Sarto.*

4048 The punishment of the blasphemers (lightning strikes a tree, scattering them) from story of the life of San Filippo Benizi fresco by Andrea Del Sarto, c. 1510. Florence, Church of the Santissima Annunziata; Bentley, *Calendar*; New Int'l Illus. *Encyclo.*; Padovani, *Andrea del Sarto.*

4049 The resurrection of the child on contact with the deathbed of St. Philip Benizi (as monks surround the deathbed in prayer, a child sits up from the ground), fresco by Andrea del Sarto, c. 1510. Florence, SS. Annunziata; Fischer, *Fra Bartolommeo* (fig.201); Padovani, *Andrea del Sarto.*

4050 St. Philip Benizi, holding a book and lily, by Girolamo Romanino. Nat'l Gallery, London; Coulson, *Saints.*

4051 St. Philip Benizi converting two wicked women at Todi (they are prostitutes), drawing by Bernardino Poccetti. Met Museum; Bean, *15th & 16th Cent.*

4052 St. Philip Benizi (holding a crucifix and reading), by Giuseppe Maria Crespi, c. 1720–25. Bologna, S. Pellegrino; Merriman, *Crespi.*

4053 Vision of St. Philip Benizi (he

kneels beneath the Trinity and the Virgin Mary), by Jose Campeche. Ponce, Museo de Arte; Held, *Catalogue.*
See also 2329, 2532

Philip Neri, Founder of Congregation of the Oratory, d. 1595, canon. 1622 (May 26)
4054 Death mask of St. Philip Neri. Naples, Gerolomini Church; Coulson, *Saints.*
4055 St. Philip Neri in glory (at his feet, cherubs hold up laurel wreaths), drawing by Francesco Raspantino after a drawing by Domenichino, c. 1637. Windsor Castle; Spear, *Domenichino.*
4056 Virgin and Child (and saints) with St. Philip Neri (they appear as he kneels at an altar), by Maratta, c. 1690. Pitti Palace, Florence; Piper, *Illus. Dict.* (p.215).
4057 Madonna and Child with St. Philip Neri (he kneels below them while a cherub holds up a lily at his feet), by Giovanni Battista Pittoni, c. 1712. Venice, S. Giovanni Elemosinario; Boccazzi, *Pittoni* (pl.1).
4058 Apparition of the Virgin and Child to St. Philip Neri (they appear in a cloud as he says mass), by Giambattista Tiepolo, c. 1725. Rome, Museo Diocesano; *Tresori d'Arte.*
4059 Madonna and Child appear to St. Philip Neri as he prays, by Giovanni Battista Piazetta, 1725-27. NGA, Washington DC.
4060 The Virgin appearing to Saint Philip Neri, by Giovanni Battista Piazetta, 1725-27. Venice, Santa Maria della Fava; Bentley, *Calendar*; New Int'l Illus. *Encyclo.*
4061 Virgin and Child with St. Philip Neri (he kneels on a cloud with them), by Solimena, 1725-30. Capodimonte, Naples; Piper, *Illus. Dict.* (p.278).
4062 St. Philip Neri in glory (raised to heaven by several angels), by Giovanni Domenico Ferretti, 1731. Minneapolis Inst. of Art, MN; *European Paintings.*
4063 The Vision of St. Philip Neri (he kneels before the Virgin and Child, and the Child hands him a lily), by Pompeo Batoni, c. 1733-34. Coll. Marchese Mario Incisa della Rochetta, Rome; Clark, *Batoni.*
4064 Study for St. Philip Neri (he stands, with his right arm extended and the left hand on his chest), by Subleyras. Pinacoteca, Munich; *Subleyras.*

4065 Virgin and Child with SS. Jerome, James the Major (pointing at Jerome and gesturing toward the Virgin) and Philip Neri (kneeling in ecstasy), by Pompeo Batoni, 1780. Chiari, S. Maria della Chiara; Clark, *Batoni.*
See also 190, 1323, 1330, 1895

Photius, nephew of St. Anicetus, mart. 305
4066 Saint Photius, giving a blessing, fresco, end of 12th cent. Church of Christ Antiphonitis, near Kalogrea; Stylianou, *Painted Churches* (p.474).

Pius I, Pope, patron of Pienza, mart. 154 (July 11)
4067 St. Pius I (holding an open book), fresco by Ghirlandaio in the Sistine Chapel. Vatican Museums; Brusher, *Popes.*

Pius V, Pope, r. 1566-1572 (Apr. 30 & May 5)
4068 St. Pius V, enthroned, sculpture by Leonardo da Sarzana. Rome, Santa Maria Maggoire; Brusher, *Popes.*

Placidus, Benedictine Monk; tongue torn out and beheaded; mart. 543 (Oct. 5)
4069 St. Benedict rescues St. Placidus, from the St. Bernard altarpiece by the Master of the Rinuccini Chapel. Accademia, Florence; Eisenberg, *Monaco* (pl.306).
4070 Rescue of St. Placidus and St. Benedict's visit to St. Scholastica, from St. Benedict Altarpiece by Lorenzo Monaco, c. 1414. Nat'l Gallery, London; Book of Art, *Ital. to 1850*; Coulson, *Saints*; Eisenberg, *Monaco* (pl.184).
4071 Martyrdom of SS. Placidus and Flavia (at left, Placidus refuses to apostatize before the pagan Mammucco; at center, they tear his tongue out; at right, his sister Flavia is beheaded, while Placidus comforts their companions), fresco by Umbrian School, early 15th cent. Subiaco, Sacro Speco; Kaftal, *Central and So. Ital.*
4072 St. Placidus (holding pincers with his tongue in them), detached fresco by Gian Giacomo da Lodi. Lodi, Museum; Kaftal, *North West Italy.*
4073 St. Placidus (half view, hands clasped in prayer), by Perugino. Vatican Museums; Francia, *Vaticana.*
See also 666, 686, 688, 756, 1973, 3689, 3690, 3693

Polycarp, Bishop of Smyrna, disciple of John the Evangelist; unsuccessfully burned, then killed with dagger; 2nd cent. (Feb. 23)
4074 Meeting of St. Ignatius the Martyr and St. Polycarp at Smyrna (they embrace before the Roman soldiers; Polycarp is in chains), by G. Triga. Rome, S. Clement; Bentley, *Calendar*.
4075 St. Polycarpius (shoved into an oven), woodcut by Günther Xanier from "Leben der Heiligen, Winterteil," Augsburg, 1471. The Illus. Bartsch; *German Book Illus.* (Vol.80, p.71).

Polychronius, Bishop of Babylon; stoned to death; mart. 251 (Feb. 17)
4076 Saint Polychronius, giving a blessing, fresco, end of 12th cent. Church of Christ Antiphonitis, near Kalogrea; Stylianou, *Painted Churches* (p.475).

Pontian, Pope; beaten to death with rods; r. 230-235 (Nov. 19)
4077 St. Pontian, fresco by school of Botticelli. Vatican Museums; Brusher, *Popes*.

Pontianus or Ponziano, Roman youth, patron of Spoleto; beheaded, 2nd cent. (Jan. 14)
4078 St. Pontianus (dressed as a knight, holding his sword), by Spinello Aretino. Hermitage, St. Petersburg; Kaftal, *Tuscan*.
4079 St. Pontianus (standing, nude, with a banner, with his sex mutilated, a white cloth tied around his neck, leaning against a shield bearing a hammer, pincers, nails, a chalice and host), fresco by Paolo da Visso, 1481. Spoleto, S. Ponziano; Kaftal, *Central and So. Ital.*

Ponziano see Pontianus

Potentiana
4080 St. Potentiana (giving alms to a cripple); SS. Gervasius and Protasius (beheaded); St. Loy (or Eligius), with the demonic horse led to his forge; St. Ulrich (sleeping in his throne, approached by angels with food and drink); St. Kilian (approached by murderers while reading in his study); woodcuts by Günther Zainer from "Leben der Heiligen, Sommerteil," Augsburg, 1472. The Illus. Bartsch; *German Book Illus.* (Vol.80, pp.84–86).

Potitus of Pisa, companion of St. Ephesus, martyred (Jan. 13)
4081 The miracles of St. Potitus and St. Ephesus (an angel brings a sword and standard, and pagans flee), a battlescene fresco by Spinello Aretino, 1391. Campo Santo, Pisa; Kaftal, *Tuscan*; New Int'l Illus. *Encyclo.* (see Spinello).

Prassede see Praxedes

Praxedes or Prassede or Praxedis, follower of St. Cecilia, sister of Pudenziana; decapitated, mart. 150 (July 21)
4082 Martyrdom of St. Praxedes (in foreground, she is squeezing the blood of St. Cecilia from a sponge into an urn; in background she is decapitated), by Antonio Carracci, c. 1613. Matthiesen Fine Art Ltd., London; *Around 1610*.
4083 St. Praxedis (half-view, squeezing blood from a sponge into a bowl), by Simone Pignone. Ponce, Museo de Arte; Held, *Catalogue*.
4084 SS. Prassede and Pudenziana gathering up the bones of martyrs, by Muratori, 1735. Rome, S. Prassede; Waterhouse, *Roman Baroque*.
See also 4582

Priminus
4085 St. Priminus (driving three snakes from a river); St. Severinus (holding a crosier and a book); St. Livinus (about to be decapitated); St. Anastasia (burned at the stake); St. Thomas Becket of Canterbury (kneeling, about to be struck with a sword); St. Colomba (saved by a bear, who mauls her persecutor); woodcuts by Günther Xainer from "Leben der Heiligen, Winterteil," 1471. The Illus. Bartsch; *German Book Illus.* (Vol.80, pp. 64, 65, 68).

Primus and Felicianus, Roman patricians; beheaded; mart. 297 (June 9)
4086 St. Primus (holding a scroll) and St. Felicianus (holding a scroll) mosaics, c. 650. Rome, St. Stefano Rotondo; Oakeshott, *Mosaics of Rome* (pl.89 & 90).
4087 SS. Primus and Felicianus, holding crosses, mosaics, 12th–13th cent. Venice, S. Marco; Kaftal, *North East Italy*.
4088 Saints Primus and Felicianus (outside before a tall, white building on left), copy after Paolo Veronese. Maurit-

shuis, The Hague; *Catalogue*; Hoetink, *Mauritshuis*.

Prisca, Virgin martyr; burned; date unknown (Jan. 18)
4089 St. Prisca (burned at the stake, facing an idol); St. Blaise (or Blasius; brought a pig's head while in prison); St. Amand (roasted on a gridiron and hot lead poured on him); St. Thomas Aquinas preaching; St. Gregory I (enthroned with the Holy Spirit); St. Longinus (about to be decapitated); woodcuts by Günther Xainer from "Leben der Heiligen, Winterteil," 1471. The Illus. Bartsch; *German Book Illus.* (Vol.80, pp. 70–72).

Processus and Martinian, said to be gaolers of St. Peter; martyred 1st cent. (July 2)
4090 Martyrdom of Saints Processus and Martinian (they are hung up by their hair and wrists and flogged), from a Lives of the Saints, ms. 588, fo.167v (D 70), end of 13th cent. Sainte-Geneviève, Biblio.; Garnier, *Langage de l'Image* (pl.112).
4091 Martyrdom of Saints Processus and Martinian (stretched on a rack) by Valentin de Boulogne, 1629–30. Vatican Museums; Bentley, *Calendar*; Francia, *Vaticana*; Mojana, *Valentin de Boulogne*; Murray, *Art & Artists*.

Procopius, Palestinian Martyr; beheaded; mart. 303 (July 8)
4092 Saint Procopius, round bust fresco, 1110–1118. Koutsovendis, Monastery of St. Chrysostom; Stylianou, *Painted Churches* (p.460).
4093 Saint Procopius (in a red cloak, holding a sword and a crucifix), icon, 1230's. Sinai, Monastery of St. Catherine; Manafis, *Sinai*.
4094 St. Procopius and a variant of the Virgin Kykkotissa, diptych icon, 1275–1300. Sinai, Monastery of St. Catherine; Manafis, *Sinai*.
4095 Group with St. Vincent Ferrer and St. Procopius with allegory of converted heathen, sculpture by Ferdinand Maximilian Brokoff. Charles Bridge, Prague; Štech, *Baroque Sculpture*.
4096 St. Procopius (trampling a demon), polychromed wooden statue att. to Anton Braun, c. 1740. Prague, Nat'l Gallery; Štech, *Baroque Sculpture*.
4097 St. Procopius (in a red cloak), icon from 17th cent. Wallachia, Monas-

tery of Hurezi; Knopf, *The Icon* (p.406). *See also* 1919

Proculus, Bishop of Verona, archbishop of Constantinople; beheaded; mart. 542 (June 1)
4098 SS. Nicholas and Proculus, altar panels by Ambrogio Lorenzetti, c. 1332. Fiesole, Museo Bandini; Edgell, *Sienese Painting*.
4099 Journey of St. Proculus (as he and his companions thirst on their journey to Rome, St. Proculus summons a doe, who produces milk for them to drink), by Pacino di Bonaguida, 14th cent. Fogg Art Museum, Cambridge MA; Winthrop, *Retrospective*.
4100 Annunciation with Anthony Abbot, Catherine of Alexandria, Proculus, and Francis of Assisi, by Lorenzo Monaco. Accademia, Florence; Eisenberg, *Monaco* (pl.77).
4101 Flaying of St. Proculus (he stands, hands tied to a ring in the ceiling, as executioner flays his back), predella panel from a dispersed altarpiece by Pacino di Buonaguida. Coll. Stramezzi, Crema; Kaftal, *Tuscan*.
4102 St. Proculus, Bishop of Verona (reading), and the two youthful Saints Fermus and Rusticus, by Sebastiano Ricci, 1704. Bergamo Cathedral; Daniels, *Ricci*.
4103 St. Proculus, Bishop of Verona, visiting Saints Fermus and Rusticus, by Giambattista Tiepolo. Nat'l Gallery, London; Morassi, *Catalogue* (pl.138).
4104 St. Proculus, Bishop of Verona, visiting Saints Fermus and Rusticus, by Giambattista Tiepolo. Coll. Drey, New York; Morassi, *Catalogue* (pl.139).
4105 St. Proculus, Bishop of Verona, visiting Saints Fermus and Rusticus, by Giambattista Tiepolo. Accademia, Bergamo; Morassi, *Catalogue* (pl.137).
See also 2350

Prosdocimus, Bishop of Padua, disciple of St. Peter, mart. 140 (Nov. 7)
4106 Saint Prosdocimus (holding a baptismal pitcher) and St. Peter, by Pordenone, c. 1510. North Carolina Museum of Art, Raleigh; Shapley, *15th–16th Cent.*
4107 Madonna and Child with St. Prosdocimus and James (with an angel holding a violin seated between them), by Pietro Marescalchi, 1564. J. Paul Getty

Museum, Malibu CA; *Catalogue*; *Western European.*
See also 1601

Prosper, Bishop of Reggio Emilia, d. 466 (June 25)
4108 St. Prosper in bishop's miter and staff, by follower of Jacopo del Casentino, mid-14th cent. Staten Island Inst. of Arts and Science, NY; Shapley, *Samuel H. Kress.*
4109 Madonna and Child with SS. Andrew and Prosper (behind them stand two angels holding bunches of flowers), from an altarpiece by Benozzo Gozzoli, 1466. S. Gimignano, Cathedral; Kaftal, *Tuscan.*

Protasius *see* **Gervasius and Protasius**

Pudenziana, Roman martyr, sister of Prassede, 1st or 2nd cent. (May 19)
4110 SS. Petronilla (holding a palm), Pudenziana (holding beads and a palm), and Scholastica (holding a book), fresco by the Piedmontese School, 15th cent. Pecetto Torinese, S. Sebastiano; Kaftal, *North West Italy.*
See also 4084

Quentin or Quentinus, missionary; transfixed with iron spits and beheaded; mart. 303 (Oct. 31)
4111 Life of St. Quentin (brought to trial with chain around his neck), ms. illum. Saint-Quentin Library; Boucher, *20,000 Years* (288).
4112 St. Quentin (standing with two spits), pinnacle of a polyptych by Andrea Vanni, 1400. Siena, S. Stefano; Kaftal, *Tuscan.*
4113 St. Quentin (tied by his hands to a rack, transfixed with two spits, bleeding profusely), fresco by Giacomo Jaquerio, c. 1425. Manta, Castello; Kaftal, *North West Italy.*
4114 Virgin and Child with Saints Benedict and Quentin (in armor), by Francesco Marmitta, 1496–1504. Louvre, Paris; Gowing, *Paintings.*
See also 3726

Quirico or Quiricus, youth; thrown on marble pavement after tortures, son of Julitta (flayed and dismembered); mart. 304 (July 15)
4115 Saint Quirico, arms outspread, wall-painting from 8th cent. Rome, Santa

Maria Antica; Boucher, *20,000 Years.*
4116 Scenes from the life of St. Julitta (sawed in half) and St. Quirico (boiled in a cauldron), altar frontal of Sant Quirc de Durro, 12th cent. Barcelona, Museo d'Art de Catalunya; Lasarte, *Catalan.*
4117 Martyrdom of St. Julitta and St. Quirico: she is hung from her wrists and beaten with iron rods; burning pitch is poured on her; Julitta is flayed, then beheaded; the child Quiricus, held by the provost, bites and scratches at his mother's tortures, and is thrown on the marble steps, breaking his head; frescoes by the School of the Trentino, 15th cent. Termeno, SS. Quirico e Giulitta; Kaftal, *North East Italy.*
4118 Scenes from the life of St. Quirico: he and Julitta are accused of being Christians; the judge takes Quirico on his lap to persuade him to apostatize, but Quirico slaps him in the face; Julitta is suspended by her arms and her breasts are torn off; the judge stabs Quirico and throws him on the pavement; predella panels by Masaccio and Masolino. Highnam Court, coll. Gambier-Parry, Gloucester; Kaftal, *Tuscan.*
4119 SS. Quirico (as a youth, standing with a palm and a book), and Julitta (in a fur-lined cloak, holding a book and giving a blessing), fresco by the Lombard School, 1491. Domodossola, S. Quirico; Kaftal, *North West Italy.*
4120 The Martyrdom of St. Julitta (she is tied to a table; they are flaying her alive), by German Master, c. 1500–10. Esztergom Christian Museum; *Christian Art in Hungary* (pl.XIV/306).
4121 St. Julitta, reading and holding the wrist of the boy St. Quiricus, by Gerard David, c. 1502. KM, Vienna; Miegroet, *David.*
See also 4444

Quirinus, Bishop of Siscia in Hungary; drowned with millstone around his neck; mart. 300 or 350 (June 4)
4122 Martyrdom of St. Quirinus (he is thrown into a river with a millstone around his neck, but miraculously floats for a long time, preaching to the crowd), from an altarpiece by Sano di Pietro, 1471. Badia a Isola; Kaftal, *Tuscan.*
4123 St. Quirinus (standing in bishop's regalia, holding a crosier and a book), from an altarpiece by Sano di Pietro, 1471. Badia A Isola; Kaftal, *Tuscan.*

4124 Martyrdom of St. Quirinus (they shove him into a well), by Ludovico Carracci. Coll. Constantin Esarcu, Rumania; Oprescu, *Great Masters.*
See also 982, 1511

Quirinus of Neuss, Roman tribune, limbs severed one by one until dead; mart. 130 (Mar. 29)
4125 Saints Hubert (holding a book with a tiny deer), Quirinus (dressed as a knight, holding a banner) and Catherine of Alexandria, with a kneeling donor, from the dismembered "Last Judgment" altarpiece by Stephan Lochner, c. 1441–48. BS, Munich; United Nations, *Dismembered Works.*
4126 Martyrdom of St. Quirinus of Neuss (he is lying on a table, while executioners chop off his limbs; dogs are gnawing on his legs on the ground), fresco by a Provincial Tuscan master of the 15th cent. S. Maria alla Querce (near Florence); Kaftal, *Tuscan.*
4127 St. Quirinus of Neuss (standing in armor, holding a spotted shield and a lance), fresco by a Provincial Tuscan master of the 15th cent. S. Maria alla Querce (near Florence); Kaftal, *Tuscan.*
4128 St. Quirin of Neuss (standing in armor, wearing a hat), polychromed wood sculpture, c. 1520. Huy, St. Quirin; *Tresors.*

Radegonde or Radegund, married to King Clotaire I, d. 587 (Aug. 13)
4129 Child restored to life by St. Radegonde's hair shirt, from ms. 250, fo. 38v, 11th cent. Poitiers Library; Boucher, *20,000 Years* (291).
4130 Life of St. Radegonde in two scenes, from ms. 250, fo.25v, late 11th cent. Poitiers Library; Boucher, *20,000 Years* (289); Read, *Great Art.*
4131 St. Radegonde, standing with a cross, giving a blessing, mosaic, 12th cent. Monreale; Kaftal, *Central and So. Ital.*
4132 St. Radegonde (as a nun, holding a book and three ears of corn), fresco by the Piedmontese School, 1478. Camino, S. Gottardo; Kaftal, *North West Italy.*
See also 3696

Radegund *see* **Radegonde**

Radiana
4133 St. Radiana (ravaged by two wolves), woodcut by Hans Burgkmair the

Elder, Vienna, 1521. Geisberg, *Single-Leaf.*
4134 St. Radiana (standing before a kneeling donor, as a wolf ravages her sleeve), woodcut by Hans Burgkmair the Elder, Vienna, c. 1521. Geisberg, *Single-Leaf.*

Rainaldus or Rainaldo, bishop of Nocera Umbra, d. 1225 (Feb. 9)
4135 St. Rainaldus (standing in bishop's robes, looking down), from a polyptych by Niccolò da Foligno, 1483. Nocera Umbra; Kaftal, *Central and So. Ital.*

Raniero or Raynerius, pilgrim hermit, patron of Pisa, d. 1161 (June 17)
4136 St. Raniero (wearing a fur garment), by the workshop of the Master of St. Torpè. Coll. Christian Pepper, St. Louis, MO; Meiss, *Traini.*
4137 St. Raniero (standing in a hair shirt, with kneeling Confraternity penitents at his feet), processional panel by the Pisan School, 14th cent. Pisa, Museo Civico; Kaftal, *Tuscan.*
4138 Scenes from the life of St. Raniero: he is inspired by blessed Albert, and follows him; crying for his sins, he loses his eyesight which is later restored by Christ; he embarks for the Holy Land, but cannot open his coffer; Christ tells him to distribute his possessions to the poor; he distributes alms; he removes his clothes and is given a hairshirt to wear; as he prays, the devil tries to stop him, but does not succeed; the devil tries to torment him; wild beasts will not harm him; frescoes by Andrea Bonaiuti da Firenze. Campo Santo, Pisa; Kaftal, *Tuscan.*
4139 SS. Raniero (with a pilgrim's staff) and Sylvester I (holding a book and trampling a dragon), panel by Gerini. Pisa, Cathedral; Kaftal, *Tuscan.*
See also 4723

Raymond Nonnatus, patron of midwives, Mercedarian missionary, later cardinal; lips pierced and padlocked; d. 1240 (Aug. 31)
4140 St. Raymond Nonnatus preaching, by Carlo Saraceni. Rome, S. Adriano; Bentley, *Calendar*; Coulson, *Saints.*
4141 St. Raymond Nonnatus (in white robe, holding a book), by Francisco de Zurbaran, 1631–40. Private coll., Geneva; Gállego, *Zurbaran.*

Raymond of Penafort, 3rd Master General of Dominicans, Archbishop of Tarragona, wrote "The Decretals," d. 1275 (Jan. 7 & 23)
4142 St. Raymond of Penafort (standing on water, waving a banner), by Ludovico Carracci. Bologna, S. Domenico; Bentley, *Calendar*; Book of Art, *Ital. to 1850*; Coulson, *Saints*.

Raynerius *see* Raniero

Regina of Burgundy, Roman peasant virgin; beheaded after torture; mart. 251 (Sept. 7)
4143 Gold reliquary bust of St. Regina, 15th cent. Lázaro Galdiano Museum, Madrid; New Int'l Illus. *Encyclo.* (see Gold).
See also 3340

Regula or Regulus, African, patron of Lucca, Bishop of Massa Martima; beheaded; mart. 5th cent. (Sept. 1)
4144 Martyrdom of St. Regulus of Lucca (decapitated), marble lunette relief, 13th cent. Lucca Cathedral; McGraw, *Encyclo.* (Vol.XII, pl.256).
See also 1928, 1950

Regulus *see* Regula

Remi *see* Remigius

Remigius or Remi of Rheims, Bishop of Rheims, baptized King Clovis, d. 533 (Oct. 1)
4145 St. Remigius baptizing Clovis in the presence of Queen Clothild, from diptych of the Life of St. Remigius, 9th cent. Picardy Museum; Latouche, *Caesar to Charlemagne*.
4146 St. Remigius baptizing Clovis, king of the Franks, from "Vie de Saint Denis," ms. Nouv. acq., Fr. 1098, fo.50. BN, Paris; Horizon, *Middle Ages*.
4147 Clovis is baptized by Archbishop Remi, from "Grandes Chroniques de France." BN, Paris; Castries, *K & Q of France*.
4148 St. Remigius of Rheims baptizing the kneeling Clovis, as a dove with a halo hovers between them, Flemish stained-glass medallion. Private coll.; Drake, *Saints and Emblems*.
4149 St. Remi converts an Arian before Notre Dame de Paris, by Master of St. Giles, c. 1480–90. NGA, Washington

DC; Lloyd, *1773 Milestones* (p.153); Phaidon, *Art Treasures*; Snyder, *Northern Ren.*
4150 Baptism of Clovis by St. Remigius, and the battle of Tolbiac (496 A.D.), woodcut from "Mer des Hystoires," Paris, 1899–89. Hind, *Woodcut*.
4151 Baptism of Clovis by St. Remigius, by Master of St. Giles, c. 1500. NGA, Washington DC; Walker, *NGA*.
4152 Baptism of Clovis by St. Remigius, from "Francis I's entry into Lyon," Cod. Guelf. 86.4, c. 1515. Wolfenbuttel, Ducal Library; Strong, *Splendor*.
4153 St. Remy (or Remigius) in bishop's regalia, holding a crosier and an open book, gilded wooden sculpture, 1500–50. Huy, Saint-Rémy; *Tresors*.
4154 Baptism of Clovis by St. Remigius, from "History of St. Remi" tapestry, 1531. Rheims, Church of St. Remi; Lejard, *Tapestry*.
4155 Baptism of Clovis by St. Remigius (inside a vaulted church, the king kneels before St. Remigius), fresco by Siciolante da Sermoneta, c. 1548–49. Rome, San Luigi dei Francesi; Hall, *Color and Meaning*.
4156 Baptism of Clovis by St. Remigius, by Paul Delaroche, 1840. Unlocated; Ziff, *Delaroche*.
See also 3313

René
4157 The legend of St. René (resuscitating a dead child, who is pulled from a grave in the floor), min. by the Master of Claude from a Prayer Book of Queen Claude of France, fo.39v, c. 1515–16. Coll. H.P. Kraus, NY; Sterling, *Master of Claude*.

Reparata, Roman virgin; patron of Florence; tortured with hot irons against breasts and beheaded; 3rd cent. (Oct. 8)
4158 Martyrdom of St. Reparata (put to the flames while standing in a little building), from the dismembered St. Reparata predella by Bernardo Daddi, c. 1345. Private coll., Cologne; Offner, *Corpus* (Sect.III, Vol.VIII, pl.VI).
4159 Scenes from the life of St. Reparata: hot lead is poured on her head; she is placed in an oven; red-hot irons are pressed against her breasts; she is beheaded; from an altarpiece by the Florentine School, 15th cent. Florence, Cathedral; Kaftal, *Tuscan*.

Rita of Cascia, Augustinian nun, patron of desperate causes, d. 1457, canon. 1900 (May 22)
4160 St. Rita of Cascia (carried on the clouds to join the Augustinian nuns at Cascia), by Nicolas Poussin, c. 1634. Dulwich College Picture Gallery, London; Wright, *Poussin*.
4161 St. Rita of Cascia (in a black dress, holding up a cross), milled pine retable with water-based paints, gesso, att. to José Benito Ortega, c. 1875–90. Taylor Museum for Southwest Studies, CO; Wroth, *Images of Penance*.

Robert Archbishop of Capua, preacher, Doctor of the Church; Jesuit; d. 1621, canon. 1928 (May 13)
4162 Retable of St. Robert; Robert stands in the central panel in bishop's regalia; at left stands St. Peter with a kneeling donor, and at right stands St. Anthony Abbot with a kneeling donor, by an unknown Provencal painter, c. 1470–80. Private Coll., Aix; Laclotte, *L'Ecole d'Avignon*.
4163 The mother of St. Robert has a vision of (baby) son being adopted as the Virgin's spouse, by Lippo Vanni. Rome, S. Croce in Gerusalemme; Waterhouse, *Roman Baroque*.

Roch, hermit, pilgrim, patron of plague-stricken, Franciscan, co-patron of Deruta; died in prison, d. 1378 (Aug. 16)
4164 St. Roch (standing on a tiled floor next to a pillar depicting three saints, with his staff and his hands clasped), from an altarpiece by Andrea di Niccolò. Sarteano (Val di Chiana), SS. Martino e Vittorio; Kaftal, *Tuscan*.
4165 Saint Roch (standing in a plaza on a red pavement, with his staff) by Bartolomeo della Gatta, 1478–79. Arezzo, Pinacoteca Comunale; New Int'l Illus. *Encyclo.* (see Ren.).
4166 Scenes from the life of St. Roch: he takes leave of his family; he cures the plague-stricken in the hospital of Acqua Pendente; Gothardus follows his dog to St. Roch, who sits under a tree, stricken with plague; he is miraculously cured of the plague; he dies in prison, mistaken for a spy, but is recognized by his uncle when carried out; frescoes by the Piedmontese School, 15th cent. Brossasco, Cappella di S. Rocco; Kaftal, *North West Italy*.
4167 St. Roch (standing and holding a

loaf of bread, with a sword hanging from his belt and a dog at his feet), by Orlando Merlini. Gubbio, Pinacoteca; Kaftal, *Central and So. Ital.*
4168 St. Roch (wearing hose, with the right leg unlaced to show his plague wound), by Carlo Crivelli. Wallace Coll., London; Herald, *Ren. Dress*; Zampetti, *Crivelli.*
4169 St. Sebastian (holding two arrows in his right hand, and balancing a crown on top of a feather in his left hand), and St. Roch (with a pilgrim's staff), altar panels by Biagio di Antonio. York City Art Gallery; *Catalogue.*
4170 St. Roch (his dog paws at his leg, holding a loaf of bread in its mouth), polychromed wooden statue, French, c. 1500. Rhode Island School of Design; *Handbook.*
4171 St. Roch interceding for Arezzo during the plague (he prays as angels drop arrows into the city), by Bartolomeo della Gatta. Arezzo, Pinacoteca; Boase, *Vasari* (pl.102); Kaftal, *Tuscan.*
4172 Scenes from the life of St. Roch: birth of St. Roch (he is bathed, and is seen with a cross on his left shoulder); burial of St. Roch, as angels carry his soul to heaven; frescoes by Giovanni Pietro da Cemmo, 1504. Berzo Inferiore, S. Lorenzo; Kaftal, *North West Italy.*
4173 St. Roch (standing with his staff, pointing to a sore on his leg), by Marco d'Oggiono, c. 1506. Carrara Academy, Bergamo; Sedini, *Marco d'Oggiono* (p.30).
4174 St. Roch (showing the plague wound on his thigh) and St. Peter, panels by Gianfrancesco Bembo, 1515–20. Cremona, Cathedral; Voltini, *Cremona.*
4175 St. James and St. Roch intercede with St. Anne for the victims of the plague (who wait below in a landscape), by Niklaus Manuel Deutsch, 1517. Basel, Kunstmuseum: *150 Paintings.*
4176 Christ Benedictine, flanked by John the Baptist and Peter on the left, and SS. Paul and Roch on the right, by Giovanni Cariani, 1518–19. Private Coll., Bergamo; Pallucchini, *Cariani.*
4177 St. Roch with the (pointing) angel, by Francesco Cavazzola, 1518. Nat'l Gallery, London; Poynter, *Nat'l Gallery.*
4178 Landscape with a scene from the legend of St. Roch (as he sleeps against a tree, an angel approaches him), att. to

Joachim Patiner. Kharkov Art Museum; Nikulin, *Soviet Museums*.

4179 St. Roch (sitting, as an angel looks at the sore on his leg, and the dog offers him some food), panel from an altarpiece of the Trinity by the studio of Quentin Metsys. Munich, Pinacoteca; Bosque, *Metsys*.

4180 St. Roch (walking up with his staff) and St. Sebastian (holding three arrows), woodcut by Hans Schaufelein. Strauss, *The Illus. Bartsch* (Vol.11, no.37).

4181 The life of St. Roch (in foreground, he gives his earthly goods to the poor; in middle, St. Roch kneels before the pope; in background St. Roch in solitude, brought bread by a dog; in upper right corner Roch is in prison, giving his last confession) by the school of Bernard Van Orley. Bruges, State Museum; Pauwels, *Musée Groeninge*.

4182 St. Roch (in pilgrim's dress, sitting on a ledge looking at a tiny angel, with the dog holding bread at his feet), by Cesare da Sesto, c. 1523. Sforza Castle, Milan; Fiorio, *Le Chiese di Milano*; Sedini, *Marco d'Oggiono* (p.209).

4183 Madonna and Child with SS. Roch (holding an angel's hand), Jerome (with his lion looking up), and a third saint, by Giulio Romano, c. 1524. Rome, Santa Maria dell'Anima; Hall, *Color and Meaning*.

4184 Madonna (overhead) with Saints Roch and Sebastian, by Dosso Dossi. Budrio, Pinacoteca; Gibbons, *Dossi*.

4185 St. Roch (standing) with a donor, by Parmigianino, 1527. Bologna, S. Petronino; *Age of Correggio*; Boase, *Vasari* (pl.80); McGraw, *Encyclo.* (Vol.XI, pl.46).

4186 An angel appearing to St. Roch (he lay on the ground in the forest, shading his eyes), by Lorenzo Lotto. Formerly Coll. Giovanelli, Venice; Berenson, *Lotto*.

4187 Saints Sebastian (holding arrows) and Roch, woodcut by Barthel Beham, Erlangen, c. 1535. Geisberg, *Single-Leaf*.

4188 St. Roch ministering to the plague victims (in a dark room, he looks at one man's raised leg, as several others wait their turn) by Tintoretto, 1549. Venice, S. Rocco; Valcanover, *Tintoretto*.

4189 Madonna and Child (in the clouds) with St. Roch (sitting on a

boulder, looking up) and St. Sebastian (arm tied above his head, with an arrow in his right shoulder), att. to Francesco Naselli, c. 1550. Finale Emilia, Chiesa del Seminario; Frabetti, *Manieristi*.

4190 St. Roch (standing in a niche, exposing his plague sore, with two donors), by Giovanni Paolo Cavagna. Bergamo, S. Roch; Bentley, *Calendar*.

4191 Apotheosis of St. Roch (carried to heaven by angels), drawing by Paolo Veronese. Isabella Stewart Gardner Museum, Boston MA; Rearick, *Veronese*.

4192 Christ stopping the plague, at the prayer of the Virgin, St. Roch (lower left) and St. Sebastian (tied to a tree, lower right), by Veronese. Rouen, Musée des B/A; Bergot, *Musée*.

4193 St. Roch in glory (standing before God and angels, as viewed from below), by Tintoretto, 1564. Venice, Scuola Grande di San Rocco; Valcanover, *Tintoretto*.

4194 St. Roch in prison comforted by an angel (surrounded by several other prisoners, including one who sticks her head through a grate in the floor), by Tintoretto, 1567. Venice, S. Rocco; Valcanover, *Tintoretto*.

4195 St. Roch (sitting on a rock, wearing a floppy hat, looking into the clouds where he sees a beam of light issuing from a cherub), by Giorgio Vasari, 1568. Arezzo, Pinacoteca; Boase, *Vasari* (pl.114).

4196 St. Roch blessing the plague-stricken, by Jacopo da Ponte, called Bassano, c. 1575. Brera, Milan; Book of Art, *Ital. to 1850*; Newsweek, *Brera*; Praeger, *Great Galleries*.

4197 St. Sebastian (an arrow in his forehead) and St. Roch, companion pieces by Tintoretto, 1578–84. Venice, Scuola di San Rocco; Tietze, *Tintoretto*.

4198 St. Roch giving alms (a crowd of beggars reach up as he stands atop the stairs, giving alms), by Annibale Carracci. Picture Gallery, Dresden; Boschloo, *Carracci*; Freedberg, *Circa 1600*.

4199 St. Roch and the angel (pointing up) by Annibale Carracci, late 1580's. Fitzwilliam Museum, Cambridge; Catalogue, *Italian*.

4200 St. Roch and the angel (curing him) by Saraceni. Doria Pamphili Palace, Rome; Met Museum, *Caravaggio*.

4201 St. Roch as patron of the plague stricken (looking at Christ as the sick im-

plore his help), oil sketch by P.P. Rubens, c. 1623. Private coll.; Held, *Oil Sketches.*

4202 St. Roch curing the sick (he stands inside of an asylum, extending a hand toward the sick, who react in surprise), from the St. Roch altarpiece by il Genovesino, 1645. Cremona, Cathedral; Voltini, *Cremona.*

4203 St. Roch helped by angels (they cure him of the plague, while cherubs above him hold a parchment with the inscription "Eris in Peste Patronus"), by Erasmus Quellin, 1660. St. Jacques Collegiate Church, Anvers; Hairs, *Sillage de Rubens.*

4204 St. Roch received into heaven (his dead body still lies on the ground), by Giacinto Brandi, before 1674. Rome, S. Rocco; Waterhouse, *Roman Baroque.*

4205 St. Roch (sitting, looking up to heaven), by Giovanni Battista Pittoni. Rovigo, Accademia dei Concordi; Boccazzi, *Pittoni* (pl.128).

4206 St. Roch (sitting in meditation, wearing a cloak with a pilgrim's shell), by Giovanni Battista Tiepolo, 1730–35. Courtauld Inst. of Art, London; *Catalogue*; Morassi, *Catalogue* (pl.163).

4207 St. Roch in huntsman dress, sitting with his dog, by Giovanni Battista Tiepolo, 1730. Fogg Art Museum, Cambridge MA; Morassi, *Catalogue* (pl.159).

4208 St. Roch sitting on a rock in left profile, holding a staff, by Giovanni Battista Tiepolo, 1730–35. Philadelphia Museum of Art, PA; Morassi, *Catalogue* (pl.160).

4209 St. Roch, with pilgrim's staff and hat, and his dog, by Giovanni Battista Tiepolo, c. 1730–35. Picture Gallery, Berlin; *Catalogue*; Morassi, *Catalogue* (pl.168).

4210 Saint Roch carried to heaven by two angels, oil sketch by Giambattista Tiepolo. Yale Univ. Gallery, New Haven; Morassi, *Catalogue* (pl.146).

4211 Saints Roch (with a pilgrim's shell on his cloak) and St. Sebastian (tied to a tree), by Giambattista Tiepolo. Noventa Vicentina Parish Church; Morassi, *Catalogue* (pl.145).

4212 St. Roch (leaning his head against a wall, looking over his left shoulder), by Giambattista Tiepolo. Huntington Library, San Marino CA; Morassi, *Catalogue* (pl.157).

4213 St. Roch (reclining against a rock, looking up), by Giambattista

Tiepolo. Besancon Museum; Morassi, *Catalogue* (pl.167).

4214 St. Roch (sitting with an open book on his lap), by Giambattista Tiepolo. Strasbourg Fine Arts Museum; Morassi, *Catalogue* (pl.155).

4215 St. Roch (sitting with his staff, looking down to his right), by Giambattista Tiepolo. Sydney, Nat'l Gallery of New South Wales; Morassi, *Catalogue* (pl.162).

4216 St. Roch interceding with the Virgin for the plague-stricken, by Jacques-Louis David, 1780. Marseille, Musée des B/A; *Amours*; Nanteuil, *David.*

See also 372, 377, 583, 766, 1423, 1617, 1932, 1934, 1935, 4219, 4357

Romanus, Deacon of Caesarea, disciple of St. Lawrence, co-patron of Deruta, mart. 303 (Nov. 18)

4217 Scenes from the life of St. Lawrence (Lawrence baptizes Romanus; Romanus is beheaded before the emperor), frescoes by the Roman School, 13th cent. Rome, S. Lorenzo; Kaftal, *Central and So. Ital.*

4218 Scenes from the life of St. Lawrence: Lawrence is beaten with plummets or thongs, as an angel descends and says "Adhud multa certamina tibi debentur," and only Lawrence and Romanus see the angel; fresco att. to Jacobello del Fiore. Vittorio Veneto, S. Lorenzo; Kaftal, *North East Italy.*

4219 SS. Roch and Romanus (standing above the city of Deruta, of which they are co-patrons), fresco by Fiorenzo di Lorenzo, 1478. Deruta, S. Francesco; Kaftal, *Central and So. Ital.*

4220 Baptism of St. Romanus (by St. Lawrence), by Sebastiano Filippi Bastianino, c. 1577–80. Ferrara, Pinacoteca Nazionale; *Age of Correggio.*

4221 Conversion of St. Romanus (inspired by the forbearance of St. Lawrence, who was tortured), by Sebastiano Filippi Bastianino, c. 1577–80. Ferrara, Pinacoteca Nazionale; *Age of Correggio.*

4222 St. Romanus (wearing an ecclesiastical cope, holding an open book) and a child (St. Barulas), by Francisco de Zurbaran, 1638. Chicago Art Inst.; *Paintings*; Gállego, *Zurbaran*; Maxon, *Art Inst.*

See also 566, 3233, 3256

Romanus Melodus, Greek hymn-writer, 6th cent. (Oct. 1)
4223 Saint Romanus Melodus, holding an open book with writing on a page, icon fresco, 1490's. Church of Christ Antiphonitis, near Kalogrea; Stylianou, *Painted Churches* (p.483).

Romuald, founder of Camaldolese Benedictine order, d. 1027 (Feb. 7 & June 19)
4224 St. Romuald (enthroned) pointing up, fresco by Tommaso da Modena, c. 1352. Treviso, S. Nicolo, Italy; McGraw, *Encyclo.* (Vol.XIV, pl.104); New Int'l Illus. *Encyclo.*
4225 Scenes from the life of St. Romuald: he is beaten by the hermit Marino; he is molested by demons; while looking for a hermitage in the Apennines, he sleeps and dreams that his brethren ascend a ladder to heaven; predella panels by the Orcagnesque Master of 1365. Accademia, Florence; Kaftal, *Tuscan.*
4226 The Holy Trinity flanked by St. Romuald and St. John the Evangelist, triptych by a follower of Nardo di Cione. Accademia, Florence; Offner, *Corpus* (Sect.IV, Vol.II, pl.XXVI).
4227 St. Romuald's vision of St. Apollinaris, from the Trinity Altarpiece by the workshop of Nardo di Cione. Accademia, Florence; Eisenberg, *Monaco* (pl.305).
4228 St. Romuald (holding a book and a walking stick), from an antiphonary illus. by Lorenzo Monaco, ms. Cod.Cor.8, fo.76, c. 1395. Florence, Biblio. Laurenziana; Eisenberg, *Monaco* (pl.4); McGraw, *Encyclo.* (Vol.IX, pl.201).
4229 St. Benedict giving the rule to St. Romuald (who kneels with his monks), by the Pisan School. Uffizi, Florence; Bentley, *Calendar.*
4230 St. Romuald, holding walking stick and book, by studio of Lorenzo Monaco, c. 1420. Philbrook Art Center, Tulsa OK; Eisenberg, *Monaco* (pl.258); Shapley, *Samuel H. Kress.*
4231 St. Romuald appearing to Emperor Otto III (as they stand on a mountain, he forbids the emperor to enter the church until he has done penance for taking a mistress), by an imitator of Fra Angelico. Antwerp, Musée Royal des B/A; Kaftal, *Tuscan*; Pope-Hennessy, *Fra Angelico.*
4232 St. Romuald (standing with an open book and a church), fresco by the School of Fabriano, 1473. Fabriano, S. Maria del Popolo; Kaftal, *Central and So. Ital.*
4233 Dream of St. Romuald (he sleeps, outside of a building, and dreams that his brethren ascend a ladder to heaven), panel of a polyptych by Jacopino di Francesco. Bologna; Kaftal, *North East Italy.*
4234 The Legend of St. Romuald (citizens of Mechlin give an armored St. Romuald a chest of coins, asking him to save their besieged city), by The Frankfurt Master, 1510's. Pushkin Museum, Moscow; Nikulin, *Soviet Museums.*
4235 Death of St. Romuald (attended by monks in white, he lies on his deathbed under a fleece, as a skeleton with a scythe sits by), by Antiveduto Gramatica, c. 1619. Certosa dei Camaldoli, Naples; RA, *Painting in Naples.*
4236 St. Romuald recounting his vision to Camaldolese monks, by Andrea Sacchi. Vatican Museums; Francia, *Vaticana*; Held, *17th & 18th Cent.*; McGraw, *Encyclo.* (Vol.VIII, pl.220); Murray, *Art & Artists.*
See also 756

Rosalie or Rosalia of Palermo, hermit nun, d. 1160 (Sept. 4)
4237 St. Rosalie of Palermo (holding a book, with a flower wreath on her head), from an altarpiece by Domenico Ghirlandaio. Pisa, Museo Civico; Kaftal, *Tuscan.*
4238 Saint Rosalie interceding for the plague-stricken of Palermo (cherubs raise her to heaven) by Anthony van Dyck, 1624. Met Museum; Hibbard, *Met Museum*; Larsen, *Van Dyck* (pl.193).
4239 St. Rosalie (in meditation, hand on a skull, as an angel crowns her with a flower wreath), by Anthony van Dyck. Prado, Madrid; Larsen, *Van Dyck* (pl.455); *Peinture Flamande* (b/w pl.106).
4240 St. Rosalie in glory crowned by two angels, by Anthony van Dyck, c. 1624-25. Rice Univ., Houston TX; Larsen, *Van Dyck* (pl.452).
4241 St. Rosalie in glory crowned by two angels, by Anthony van Dyck, c. 1624-25. Coll. Duke of Wellington, Apsley House, London; Larsen, *Van Dyck* (pl.453).
4242 St. Rosalie interceding for the city of Palermo (kneeling, she points to

city in background), by Anthony van Dyck, c. 1624–25. Ponce, Museo de Arte; Held, *Catalogue*; Larsen, *Van Dyck* (pl.454).

4243 St. Rosalie interceding for the plague-stricken of Palermo (she kneels on a cloud with cherubs) by Anthony van Dyck, c. 1624. Alte Pinakothek, Munich; Larsen, *Van Dyck* (pl.450).

4244 Virgin and Child with St. Rosalie (kneeling) and SS. Peter and Paul (Christ is crowning Rosalie with a flower wreath), by Anthony van Dyck, 1629. KM, Vienna; Larsen, *Van Dyck* (pl.232).

4245 St. Rosalia in adoration (crowned with a flower wreath by an angel), by Anthony van Dyck. Palermo, Museo Nazionale; Bentley, *Calendar*.

4246 St. Rosalia freeing Palermo from the plague (she kneels among the dead and sick, as an angel overhead sheaths a sword), etching and engraving by Pietro Del Po. Illus. Bartsch; *Ital. Masters of the 17th Cent.* (Vol.45).

4247 Saint Rosalia (looking up, right hand holding crucifix resting on a skull, left hand on chest) by Francesco Solimena. Coll. Pisani, Naples; RA, *Painting in Naples.*

4248 St. Rosalie of Palermo (holding a cross), pine wood retable with water-based paints, gesso, att. to José Benito Ortega, c. 1875–90. Taylor Museum for Southwest Studies, CO; Wroth, *Images of Penance.*

Rose of Lima, first New World saint, d. 1617 (Aug. 30)

4249 St. Rose of Lima, by Giambattista Tiepolo. Venice, Chiesa dei Gesuati; Coulson, *Saints.*

4250 Virgin and Child with St. Dominic and St. Rose de Lima (Virgin gives her a rosary) by Giovanni Antonio and Francesco Guardi. Budapest, Museum of Fine Arts; Garas, *Musée.*

Rose of Viterbo, Franciscan tertiary, d. 1252 (Mar. 6)

4251 St. Rose crowned by the Virgin, ceiling fresco by Baldi, c. 1671. Rome, S. Maria sopra Minerva; Waterhouse, *Roman Baroque.*

4252 Madonna with Saints Rose, Catherine of Siena (wearing a crown of thorns), and Agnes, by Giambattista Tiepolo. Venice, Chiesa dei Gesuati; Morassi, *Catalogue* (pl.102).

Rufina, sister of St. Secunda; beheaded; mart. 3rd cent. (July 10 or 19)

4253 Martyrdom of Saints Secunda and Rufina (one is already decapitated, and executioner prepares to strike again), by Giovan Battista Crespi, Pier Francesco Mazzucchelli, and Giulio Cesare Procaccini, c. 1620–25. Brera, Milan; Book of Art, *Ital. to 1850*; McGraw, *Encyclo.* (Vol.XI, pl.452); Newsweek, *Brera*; Puppi, *Torment.*

4254 St. Rufina, carrying her pottery, by Francisco de Zurbaran. Fitzwilliam Museum, Cambridge; Bentley, *Calendar*; Coulson, *Saints*; Gállego, *Zurbaran.*

4255 St. Rufina (in a brocade dress, holding a book) by Francisco de Zurbaran, 1641–58. Hispanic Society of America, New York; Gállego, *Zurbaran.*

Rufinus or Rufino, first bishop of Assisi, mart. 240 (Aug. 11)

4256 St. Rufinus (standing in bishop's robes, giving a blessing), fresco in the Umbro-Roman tradition, early 14th cent. San Francesco, Assisi; Kaftal, *Central & So. Ital.*

4257 Martyrdom of St. Rufinus (Asprasio, Prefect of Assisi, orders him to be placed in an outside burning oven, which is stoked by two men; St. Rufinus is unharmed); two peasants find Rufinus drowned in the river Chiasio; funeral of St. Rufinus; predella from a triptych by Niccolò da Foligno, 1460. Assisi, Cathedral; Kaftal, *Central & So. Ital.*

Rusticus *see* **Fermus and Rusticus**

Sabinus, Bishop of Faenza, patron of Siena; scourged to death; mart. 4th cent. (Oct. 30)

4258 St. Sabinus and two deacons before the Roman governor of Tuscany, altar panel by Pietro Lorenzetti, c. 1342. Nat'l Gallery, London; Dunkerton, *Giotto to Dürer.*

4259 The martyrdom of St. Sabinus (clubbed to death between four pillars) by Carlo Caliari. Private coll., Novara, Italy; New Int'l Illus. *Encyclo.*

Saintin *see* **428**

Sallustius, Patriarch of Jerusalem

4260 Saint Sallustius, patriarch of Jerusalem, fresco, c. 1176–80. Patmos; Kominis, *Patmos* (p.89).

Satyrus, brother of St. Ambrose, layman, d. 379 (Sept. 17)
4261 The shipwreck of St. Satyrus (rescued from the water by an angel on a cloud), by Giambattista Tiepolo. Milan, S. Ambrogio; Morassi, *Catalogue* (pl. 144).
See also 3514

Sava, archbishop and patron of Serbia, d. 1237 (Jan. 14)
4262 SS. Sava and Simeon Nemanja by a Serbian painter, 15th cent. Belgrade, National Museum; Knopf, *The Icon* (p.198).
4263 St. Sava before the governor (he preaches against war), by Pietro Lorenzetti. Nat'l Gallery, London; Bentley, *Calendar.*
4264 Serbian Saints Sava and Simeon Nemanja with scenes from their lives, by Kozma, 1645. Moraca Monastery, Montenegro; Knopf, *The Icon* (p.371).
See also 207

Savin or Savinus, bishop of Piacenza
4265 Saint Savin before the Emperor Maximus, fresco c. 1100. Vienna, Saint Savin sur Gartempe; New Int'l Illus. *Encyclo.* (see French).
4266 St. Savin (in purple surcoat and yellow mantle), stained-glass window from Cathedral of Sens, c. 1294. Walters Art Gallery, Baltimore.
4267 Scenes from the life of St. Antoninus: St. Savinus instructs men to dig for the body of St. Antoninus; St. Savinus translates the body of St. Antoninus to the Basilica of St. Vittore; St. Savinus and six bishops officiate at the funeral of St. Antoninus; predella panels by the Emilian School, 1420–30. Piacenza, S. Antonio; Kaftal, *North East Italy.*
See also 429

Savin and Cyprien, brothers; partially flayed and broken on the wheel; mart. 5th cent.
4268 Martyrdom of Saints Savin and Cyprien (flayed with hooks), fresco by an unknown 12th cent. artist. Saint-Savin-sur-Gartempe (near Poitiers); Puppi, *Torment.*

Savvatii Solovetskii, Russian monk, founded Northern Solovetskii Monastery
4269 St. Zosima and St. Savvatii Solovetskii, holding rolled-up scrolls and giv-

ing a blessing, embroidered funeral shrouds, Solychegodsk, 1660 and 1661. State Russian Museum, St. Petersburg.

Scholastica twin sister of St. Benedict, 6th cent. (Feb. 10)
4270 Funeral of St. Scholastica (priests pray at her deathbed), fresco by the Umbrian School, 14th–15th cent. Subiaco, Sacro Speco; Kaftal, *Central & So. Ital.*
4271 St. Benedict dines with his sister Scholastica; she prays that he will spend the night and a storm breaks overhead, fresco by the Central Italian School, 14th–15th cent. Subiaco, Sacro Speco; Kaftal, *Central & So. Ital.*
4272 St. Benedict sees the soul of his sister Scholastica rising to heaven (he looks from a window, as two angels carry the soul in the guise of a bird), fresco by the School of Umbria and the Marches, 15th cent. Sacro Speco, Subiaco; Batselier, *Benedict.*
4273 St. John the Evangelist, St. Scholastica (in nun's habit) and St. Benedict, by Master of Liesborn, c. 1465. Nat'l Gallery, London; Poynter, *Nat'l Gallery.*
4274 St. Scholastica in nun's habit, holding a crosier and reading a book, from "Crucifixion" by School of Master of Liesborn, c. 1465. Nat'l Gallery, London; Coulson, *Saints.*
4275 St. Scholastica (in nun's habit, clasping hands in prayer), from an altarpiece by Benozzo Gozzoli. Pisa, Museo Civico; Kaftal, *Tuscan.*
4276 Ippolita Sforza (kneeling) with SS. Scholastica, Agnes, and Catherine of Alexandria, fresco by Bernardino Luini. Milan, Monastero Maggiore; Ricci, *Cinquecento.*
4277 Death of St. Scholastica (she dies in another nun's arms, who holds a crucifix), by Jean II Restout, 1730. Tours, Musée des B/A; Larousse, *Painters.*
4278 St. Scholastica (holding a crosier and the rules of the Benedictine order), polychromed lindenwood statue by Ignaz Günther, c. 1755. Los Angeles County Museum of Art, CA; *Handbook.*
See also 690, 696, 4070, 4110

Sebaldus or Sebald, or Sinibaldus, son of the King of Dacia, Patron of Nuremberg, hermit pilgrim, 8th cent. (Aug. 19)
4279 St. Sebaldus in a gateway, holding a model of a church, woodcut att. to

Albrecht Dürer, from a History of St. Sebald, c. 1514. Geisberg, *Single-Leaf*; Strauss, *Woodcuts* (p.659).
4280 SS. Valentine (blessing a plague victim) and Sebald (in pilgrim's dress, holding a church), after Lucas Cranach the Elder, c. 1520. Annabeg, St. Anne's Church, Saxony; Friedländer, *Cranach*.
See also 4901

Sebastian, Roman knight, one of the 14 Holy Helpers, protector against plague; beaten to death after being shot full of arrows, mart. 287 (Jan. 20)
4281 St. Sebastian (standing between two archers), from the Berthold Missal, ms. 710, fo.78, c. 1200-35. Pierpont Morgan Library, NY; Swarzensski, *Berthold Missal* (pl.XVII).
4282 Martyrdom of St. Sebastian (tied high on a post, filled with arrows shot by several men with striped bows), by Giovanni del Biondo, mid-1370's. Florence, Museo dell'Opera del Duomo; Offner, *Corpus* (Sect.IV, Vol.IV, part I, pl.XXX).
4283 Martyrdom of St. Sebastian (he stands, tied to a tree, wearing a hat, before a brick wall and a wall painted with coats of arms), from the "Boucicaut Hours" painted by the Boucicaut Master, ms.2,fo.21v. Jacquemart-André Museum, Paris; Meiss, *French Painting*.
4284 Martyrdom of St. Sebastian (tied high on a post, he is filled with arrows shot by executioners with short, striped bows; an angel descends with a martyr's crown), fresco by Agnolo Gaddi. Florence, S. Ambrogio; Kaftal, *Tuscan*.
4285 St. Sebastian, standing in a short, dagged houppelande, holding a staff and with his left hand on his sword, with four arrows in his chest, panel from the Retable de Thouzon by an unknown Provencal painter, c. 1410-15. Louvre, Paris; Laclotte, *L'Ecole d'Avignon*.
4286 Martyrdom of St. Sebastian (tied to a tree, shot with arrows, while God points down from fiery clouds), min. by the Rohan Master from a Book of Hours, ms. Latin 9471, f.221, c. 1415-16. BN, Paris; *Rohan Master* (pl.101).
4287 St. Sebastian (in a houpelande, holding a bow and an arrow), by J. Mates, c. 1425. Barcelona, Museo d'Art de Catalunya; McGraw, *Encyclo.* (Vol.XII, pl.367).
4288 St. Sebastian, shot full of arrows,

depicted with two prayers against the plague, one of the earliest dated woodcuts, 1437. ON, Vienna; Oxford, *Medieval Europe*.
4289 St. Sebastian, tied to a tree, full of arrows, by Upper Rhenish School, c. 1450. Rijksmuseum, Amsterdam; *Paintings*.
4290 The emperor restores the spurs to St. Sebastian (as two courtiers look on); Sebastian exhorts the emperor to renounce the idols; Sebastian in prison; wall mural by an unknown artist. Celliac, Eglise Saint-Sébastien; *Peintures Murales*.
4291 Saint Sebastian, tied to a Roman column, by Andrea Mantegna. Louvre, Paris; Coulson, *Saints*; Gowing, *Paintings*; Lightbown, *Mantegna*.
4292 Martyrdom of St. Sebastian (tied to a broken column, he is shot full of arrows by four archers, while a tiny angel descends with a palm), by Vincenzo Foppa, c. 1459. Sforza Castle, Milan; Fiorio, *Le Chiese di Milano*; McGraw, *Dict.*; New Int'l Illus. *Encyclo.*
4293 St. Sebastian, tied to a pillar of an arch, filled with arrows (and an arrow in his forehead), by Andrea Mantegna, 1459-80. KM, Vienna; Bentley, *Calendar*; Book of Art, *Ital. to 1850*; Janson, *History* (colorpl.56); Lightbown, *Mantegna*; Newsweek, *Art History Museum*; Praeger, *Great Galleries*; Puppi, *Torment*.
4294 St. Sebastian (full of arrows; armored soldier stands behind him) by Cosimo Tura, c. 1460. Picture Gallery, Dresden; *Old Masters*; Ruhmer, *Tura*.
4295 St. Sebastian, dressed as a nobleman, standing with a bow and an arrow, by Jaime Huguet, 1464-65. Private Coll.; Larousse, *Ren. & Baroque*.
4296 St. Sebastian (tied to a tree, full of arrows, looking up), by Carlo Crivelli. Poldi Pezzoli Museum, Milan; Zampetti, *Crivelli*.
4297 St. Sebastian serving Emperor Diocletian (he kneels at the emperor's side, accepting a staff); St. Sebastian beaten with chains (as the emperor looks on); predellas from an altarpiece by Urbani, 1474. Recanati, Cathedral; Kaftal, *Central & So. Ital.*
4298 St. Sebastian standing on a tree trunk, pierced with arrows, by Sandro Botticelli, 1474. Picture Gallery, Berlin; *Catalogue*; Lightbown, *Botticelli*; Redslob, *Berlin*.

4299 St. Sebastian in a rocky landscape, with Saints Jerome, Anthony Abbot and Christopher (in background), by Marco Zoppo, c. 1475-78. Courtauld Inst. of Art, London; *Catalogue*.

4300 St. Sebastian, tied to a post in the middle of a plaza, standing on a checkered floor, by Antonello da Messina, c. 1475. Picture Gallery, Dresden; Berenson, *Ital. Painters*; Hartt, *Ital. Ren.*; Levey, *Giotto to Cézanne*; Picture Gallery, *Old Masters*.

4301 The martyrdom of St. Sebastian (some soldiers load crossbows) before a landscape, by Antonio and Piero Pollaiuolo, c. 1475. Nat'l Gallery, London; Book of Art, *Ital. to 1850*; Hartt, *Ital. Ren.*; *Int'l Dict. of Art*; Piper, *Illus. Dict.* (p.94); Praeger, *Great Galleries*; Rowling, *Art Source Book*; Wilson, *Nat'l Gallery*.

4302 St. Sebastian (filled with arrows, holding a crown in his right hand, as two angels put a crown on his head), by Matteo di Giovanni. Nat'l Gallery, London; Edgell, *Sienese Paintings*; Poynter, *Nat'l Gallery*.

4303 Martyrdom of St. Sebastian, stained-glass window after a design att. to the Master of the Housebook, Middle Rhine, c. 1480. Württembergisches Landesmuseum, Stuttgart; McGraw, *Encyclo.* (Vol.XIII, pl.174).

4304 St. Sebastian (sitting in left profile, with a book on his lap and an arrow in his right hand), panel by the Venetian School, 15th cent. Coll. Cini, Venice; Kaftal, *North East Italy*.

4305 The martyrdom of St. Sebastian, tied to a tree one hand above his head, the other below, a city in the background, by Hans Memling, late 15th cent. Brussels, Musées Royaux des B/A; *Peinture Ancienne*.

4306 St. Sebastian (tied to a pillar, looking down at an archer; a second archer and a swordsman walk up), by Vincenzo Foppa, c. 1489. Brera, Milan; McGraw, *Encyclo.* (Vol.V, pl.357); Newsweek, *Brera*.

4307 St. Sebastian (in armor) before Diocletian and Maximian (enthroned) by Master of St. Sebastian, end of 15th cent. Hermitage, St. Petersburg; Eisler, *Hermitage*; Hermitage, *Old Master*; Hermitage, *Peinture Francaise*.

4308 Virgin and Child enthroned, with St. Jerome (in cardinal's robes, holding a model of a church) and St. Sebastian (with a sword, holding an arrow), by Carlo Crivelli, c. 1490. Nat'l Gallery, London; Dunkerton, *Giotto to Dürer*.

4309 Virgin and Child enthroned, with SS. Francis of Assisi (with a tiny kneeling nun at his feet) and Sebastian (filled with arrows), by Carlo Crivelli, 1491. Nat'l Gallery, London; Dunkerton, *Giotto to Dürer*.

4310 St. Sebastian (in the sky) interceding for the plague-stricken in a city (as a plague victim is being buried, gravedigger is struck down by the illness), by Josse Lieferinxe. Walters Art Gallery, Baltimore.

4311 St. Sebastian (tied to a tree), painted terracotta statuette by Matteo Civitale, c. 1492. NGA, Washington DC.

4312 St. Sebastian destroying the idols (as Sebastian and a monk are knocking small idols off the pedestals, he turns to look at the deathbed of the prefect Polycarpe, who is greeted by a descending angel that accepts his soul) from the Retable of St. Sebastian by Josse Lieferinxe, 1495-1505. Philadelphia Museum of Art, PA; Laclotte, *L'Ecole d'Avignon*; Larousse, *Ren. & Baroque*.

4313 Martyrdom of St. Sebastian (an archer and a crossbowman draw on him), woodcut by Albrecht Dürer, 1494. Basel, Kunstmuseum; Strauss, *Woodcuts* (pl.15).

4314 St. Sebastian (one-half view, with an arrow in his throat), by Perugino, 1495. Hermitage, St. Petersburg; Eisler, *Hermitage*; Piotrovsky, *Hermitage*.

4315 St. Sebastian, filled with arrows, holding a crown, by Guidoccio Cozzarelli, 1495. Siena, Pinacoteca Nazionale; New Int'l Illus. *Encyclo.* (see Sienese).

4316 Death of Saint Sebastian (as he lies on the ground, they are beating him with clubs), from the Altarpiece of St. Sebastian att. to Josse Lieferinxe, 1497-98. Philadelphia Museum of Art, PA; Laclotte, *L'Ecole d'Avignon*; Snyder, *Northern Ren.*

4317 Intervention of St. Sebastian during the plague in Rome (as men are dying while disposing of plague victims at the steps of the church, St. Sebastian, kneeling before God in the sky, pleads for help), from the St. Sebastian altarpiece by Josse Lieferinxe, 1497-98. Philadelphia Museum of Art, PA; *L'Ecole d'Avignon*.

4318 Martyrdom of St. Sebastian (he is

tied to a tree before a landscape with a mountain in background; the archers are shooting him with longbows and cross-bows), from the Altarpiece of St. Sebastian by Josse Lieferinxe, 1497-98. Philadelphia Museum of Art, PA; *L'Ecole d'Avignon.*

4319 Mourners at the tomb of St. Sebastian (cripples and the sick approach St. Sebastian's tomb, inside of a church), from the St. Sebastian altarpiece by Josse Lieferinxe, 1497-98. Philadelphia Museum of Art, PA; *L'Ecole d'Avignon.*

4320 Martyrdom of St. Sebastian (approached by angels as bowmen draw their arrows), by Pietro Perugino from "Hours of Bonaparte Ghislieri," Yates Thompson ms.29, fo.132v, c. 1500. BM, London; BL, *Ren. Painting in MS.*

4321 Martyrdom of St. Sebastian, woodcut by school of Albrecht Dürer, Dresden, c. 1500. Geisberg, *Single-Leaf.*

4322 St. Matthew and St. Sebastian (in a brocaded cloak, holding a black arrow), by Cristoforo Caselli. Detroit Inst. of Art, MI.

4323 St. Sebastian (half-view, in a fleuried coat and a jeweled headband, holding an arrow), by Giovanni Antonio Boltraffio. Pushkin Museum, Moscow; *Old Master.*

4324 St. Sebastian (tied to a tree) and St. Francis of Assisi (holding a crucifix), by workshop of Lorenzo di Credi. Walters Art Gallery, Baltimore.

4325 St. Sebastian (tied to a tree, bleeding from wounds), wooden sculpture att. to Gregor Erhart, c. 1500. Allentown Art Museum, PA; *Samuel H. Kress.*

4326 The martyrdom of St. Sebastian (one archer shoots at him while the other loads a crossbow), woodcut by Thomas Anshelm, 1501. Geisberg, *Single-Leaf.*

4327 St. Sebastian (in armor, draped in a black cloak, holding three arrows and a bow), by Gerard David, c. 1502. KM, Vienna; Miegroet, *David.*

4328 St. Sebastian (tied to a column before an archway, with an arrow in his chest and one in his arm), by Pietro Perugino. Louvre, Paris; Berenson, *Ital. Painters;* Gowing, *Paintings.*

4329 St. Sebastian (one-third view, holding an arrow), by Raphael, c. 1504. Carrara Academy, Bergamo; Raphael, *Complete Works* (1.40).

4330 St. Sebastian (tied to a tree, filled with arrows), by Monaldo, c. 1505.

Walters Art Gallery, Baltimore; *Italian Paintings* (Vol.I).

4331 St. Sebastian (tied to a tree, with a kneeling woman donor and her three children), by Antonio Rimpatta, c. 1505. Walters Art Gallery, Baltimore; *Italian Paintings* (Vol.I).

4332 St. Sebastian, sitting on wall carved with reliefs, three arrows in his body, by Amico Aspertini. NGA, Washington DC; Ferguson, *Signs;* Shapley, *15th-16th Cent.;* Walker, *NGA.*

4333 Saint Sebastian (filled with arrows, strings of red beads in upper corners of panel) by Andrea Mantegna, c. 1506. Ca' d'Oro, Venice; Lightbown, *Mantegna;* McGraw, *Encyclo.* (Vol.IX, pl.325); New Int'l Illus. *Encyclo.* (see Ren.).

4334 St. Sebastian (tied to a tree, inside an archway), by Marco d'Oggiono, c. 1506. Poldi-Pezzoli Museum, Milan; Sedini, *Marco d'Oggiono* (p.31).

4335 Martyrdom of St. Sebastian (archer in furred collar draws his bow) woodcut by Hans Baldung Grien, Bamberg, c. 1508. Geisberg, *Single-Leaf.*

4336 Martyrdom of St. Sebastian (archers string their bows in a city with a "tiled" pavement), square majolica plate by Master of the Resurrection, c. 1510. Florence, Museo Nazionale; McGraw, *Encyclo.* (Vol.III, pl.148).

4337 Martyrdom of St. Sebastian, diptych by Master of St. Sebastian Diptych, c. 1510. Picture Gallery, Berlin; *Catalogue.*

4338 SS. Sebastian (tied to a tree) and John the Baptist flank the Virgin in "Virgin Annunciate and Saints" by Timoteo Viti, c. 1510. Brera, Milan; Burckhardt, *Altarpiece.*

4339 St. Sebastian (tied to a tree, leaning toward an angel that appears in a cloud), att. to Marco d'Oggiono. Picture Gallery, Berlin; Sedini, *Marco d'Oggiono* (p.194).

4340 St. Sebastian (tied to a tree, standing on one leg), by Cesare da Sesto. Sforza Castle, Milan; Sedini, *Marco d'Oggiono* (p.194).

4341 St. Sebastian (untied from the tree by cherubs, who also remove the arrows), woodcut by Hans Baldung Grien, Berlin, 1512. Geisberg, *Single-Leaf.*

4342 St. Sebastian (with arrows in his side and his neck, reaching up for a palm given him by an angel), copy after Fra

Bartolommeo. Fiesole, San Francesco; Fischer, *Fra Bartolommeo* (fig.229).

4343 St. Sebastian tied to a tree in a landscape, by Antonio Pirri, early 16th cent. Walters Art Gallery, Baltimore; *Ital. Painting* (Vol.I).

4344 St. Sebastian (half-view, tied to a tree, stuck with four arrows; below, they throw his wrapped body in a well), illum. by Jean Bourdichon from the Great Book of Hours of Henry VIII, 1514-18. Coll. Duke of Cumberland; *Great Hours.*

4345 St. Sebastian (tied to a tree, full of arrows), woodcut by Hans Baldung Grien, Munich, 1514. Geisberg, *Single-Leaf.*

4346 Martyrdom and death of St. Sebastian (a man wielding a club steps on his belly), min. by the Master of Claude from a Prayer Book of Queen Claude of France, fo.34r, c. 1515-16. Coll. H.P. Kraus, NY; Sterling, *Master of Claude.*

4347 Martyrdom of St. Sebastian (with a mustache); man in yellow and man in red shoot at him as others look on, by Hans Baldung-Grien. Germanisches Nationalmuseum, Nuremberg; McGraw, *Dict.*

4348 St. Sebastian (standing on a pedestal apart from the pillar, though pinned to it by a long arrow) from the Isenheim Altarpiece by Matthias Grüne-wald. Colmar, Musée d'Unterlinden; McGraw, *Encyclo.* (Vol.VII, pl.87).

4349 St. Sebastian (tied to a tree, filled with arrows; he points with his right hand), by Giuliano Bugiardini, 1517-20. Isaac Delgado Museum of Art, New Orleans LA; *Handbook*; Shapley, *15th-16th Cent.*

4350 Healing of St. Sebastian (Irene pulls his head out of the sewer water), by Albrecht Altdorfer, c. 1518. Städelsches Kunstinstitut, Frankfurt; Keller, *20 Centuries.*

4351 Martyrdom of St. Sebastian (shot by archers as crowd watches from a bridge), from polyptych of St. Florian by Albrecht Altdorfer, 1518. Monastery of St. Florian, near Linz, Austria; Guillaud, *Altdorfer.*

4352 St. Sebastian (half view, holding a pair of arrows and a palm, looking up; he has short hair), contemporary copy after a lost original by Andrea del Sarto. Bob Jones Univ. Art Gallery, Greenville, SC; Pepper, *Ital. Paintings.*

4353 St. Sebastian before the judge

(enthroned), from the polyptych of St. Florian by Albrecht Altdorfer, 1518. Monastery of St. Florian, near Linz, Austria; Guillaud, *Altdorfer.*

4354 St. Sebastian is beaten, from polyptych of St. Florian by Albrecht Altdorfer, 1518. Monastery of St. Florian, near Linz, Austria; Guillaud, *Altdorfer.*

4355 The body of St. Sebastian is retrieved from the gutter water, from polyptych of St. Florian by Albrecht Altdorfer, 1518. Monastery of St. Florian, near Linz, Austria; Guillaud, *Altdorfer.*

4356 Martyrdom of St. Sebastian (the crossbowman reloads, as others look on), woodcut by Hans Schaufelein. Strauss, *The Illus. Bartsch* (Vol.11, no.39).

4357 St. Sebastian (tied with his right hand above his head, with an arrow in his leg) flanked by SS. Roch and Margaret, by Giovanni Cariani, 1520-21. Marsiglia, Musée des B/A; Pallucchini, *Cariani.*

4358 St. Sebastian, tied to a tree as landesknecht soldiers shoot arrows into his side, panel of the Altarpiece of the Trinity by the studio of Quentin Metsys. Munich, Pinacoteca; Bosque, *Metsys.*

4359 St. Sebastian (tied to a tree by his elbows, with one arrow in his side), from the Resurrection polyptych by Titian, c. 1522. Brescia, SS. Nazaro e Celso; Burck-hardt, *Altarpiece.*

4360 St. Sebastian (holding an arrow) and a Franciscan saint, by Pietro Perugino, 1523. Nantes, Musée des B/A; Cousseau, *Musée.*

4361 St. Sebastian, tied to a tree, an arrow through his throat and leg, looks up as an angel descends, by Sodoma, 1525-26. Pitti Palace, Florence; Denvir, *Art Treasures*; *Int'l Dict. of Art*; Murray, *Art & Artists*; Praeger, *Great Galleries.*

4362 St. Sebastian, polychromed wooden statue by Pedro Berruguete, 1529-32. Valladolid, S. Gregorio Museum; Larousse, *Ren. & Baroque* (pl.352).

4363 Martyrdom of St. Sebastian (flanked by two archers at a distance in lower corners; flanked by two angels above his head) by follower of Lorenzo di Credi. Fitzwilliam Museum, Cambridge; *Catalogue, Italian.*

4364 St. Sebastian (half view, with his left hand above his head and an arrow in his right shoulder), by the Italian School, first half of the 16th cent. Mauritshuis, The Hague; *Catalogue.*

4365 Martyrdom of St. Sebastian (high up in a tree above the archers, as God and angels look down on scene) by Girolamo Genga, c. 1535. Uffizi, Florence; New Int'l Illus. *Encyclo.*

4366 St. Sebastian (tied to a tree, his left arm above his head, shot by two arrows, with a third stuck in the trunk), by Bastarolo, c. 1538. Ferrara, Pinacoteca Nazionale; Frabetti, *Manieristi.*

4367 Saint Sebastian (hands tied above his head, against a peach tree) by Dosso Dossi, c. 1540. Brera, Milan; Newsweek, *Brera*; Praeger, *Great Galleries.*

4368 St. Sebastian (nude, hands tied above his head) in a landscape before castle ruins, by Jan Van Scorel, 1542. Boymans–Van Beuningen Museum, Rotterdam; Maison, *Art Themes.*

4369 St. Sebastian (right arm above his head, right leg on a barrel), copy after Titian. Epinal, Musée Départmental des Vosges; Wethey, *Titian* (pl.238).

4370 Martyrdom of St. Sebastian (they lay him on his back, enchained, in a crowded room), by Paolo Veronese. Venice, S. Sebastiano; Rearick, *Veronese.*

4371 St. Sebastian, bound to a column and pierced with arrows, by Zaganelli, 16th cent. Nat'l Gallery, London; Poynter, *Nat'l Gallery.*

4372 St. Sebastian tied to a tree, filled with arrows, by Titian, c. 1570. Hermitage, St. Petersburg; Eisler, *Hermitage*; *Western European*; Piotrovsky, *Hermitage Old Master.*

4373 Martyrdom of St. Sebastian (tied to a pillar, shot by a single archer), by Jacopo Bassano, 1574. Dijon, Musée des B/A; Georgel, *Musée des B/A.*

4374 St. Sebastian (kneeling on a rock, one arrow in his side, one arm tied to a tree) by El Greco, 1576–79. Palencia Cathedral, Spain; Gudiol, *El Greco*; McGraw, *Encyclo.* (vol.VI, pl.458).

4375 Martyrdom of St. Sebastian before Emperor Diocletian and counselors, by Santa Croce, late 16th cent. Picture Gallery, Berlin; *Catalogue.*

4376 Martyrdom of St. Sebastian (archers draw their bows as cherub descends with palm and flower wreath), att. to Hans Von Aachen. Helen Foresman Spencer Museum of Art, Lawrence KS; *Handbook.*

4377 Madonna of St. Sebastian (Madonna and Child above, with angels, look down toward Sebastian at left, tied to a tree, and two other saints), by Correggio. Picture Gallery, Dresden; Burckhardt, *Altarpiece*; Freedberg, *Circa 1600.*

4378 St. Sebastian (executioners are busy tying his leg to a tree, as a cherub descends to comfort him), by Joachim Wtewael, c. 1600. Nelson-Atkins Museum, Kansas City MO; *Collections*; Lowenthal, *Wtewael.*

4379 St. Sebastian (tied to a tree, as a cherub descends with a palm), by Bartholomaus Spranger, 1601–02. Prague, St. Thomas Church; Kaufmann, *School of Prague.*

4380 St. Sebastian tied to a tree, oval painting by El Greco, 1603–07. Bucharest, Royal Palace; Gudiol, *El Greco.*

4381 St. Sebastian, tied to a tree, by El Greco, 1608–14. Prado, Madrid; Gudiol, *El Greco.*

4382 Martyrdom of St. Sebastian (executioners are tying his feet while he looks up at angels bearing a crucifix), by Wenceslas Coeberger. Nancy, Musée des B/A; *Musée*; Pétry, *Musée.*

4383 Saint Sebastian thrown into the Cloaca Maxima (after he is dead, soldiers unroll his body from a white cloth), by Ludovico Carracci. J. Paul Getty Museum, Malibu CA; *Age of Correggio*; Freedberg, *Circa 1600*; Met Museum, *Caravaggio*; Puppi, *Torment.*

4384 St. Sebastian (sitting back, holding an arrow buried in his side), by Carlo Saraceni, 1610–15. Prague Castle; Neumann, *Picture Gallery.*

4385 St. Sebastian (three-quarters view, tied to a tree with his hands over his head, pierced by three arrows), by Nicolas Régnier, 1610's. Hermitage, St. Petersburg; Eisler, *Hermitage.*

4386 The burial of St. Sebastian (friends lower him into a grave) by Il Passignano, 1612. Capodimonte, Naples; Met Museum, *Caravaggio.*

4387 Martyrdom of St. Sebastian (they are tying him to a tree; one man has a hand on his left shoulder), by Anthony van Dyck, c. 1615–17. Louvre, Paris; Larsen, *Van Dyck* (pl.61).

4388 St. Sebastian (tied to the tree with his hands above his head, and two arrows in his chest), by Guido Reni, c. 1615–16. Rosso Palace, Genoa; *Guido Reni.*

4389 St. Sebastian (tied to a tree filled with arrows, a quiver of arrows at his feet, by P.P. Rubens, 1616–17. Picture

Gallery, Berlin; *Catalogue*; *Masterworks*; Redslob, *Berlin*.

4390 Martyrdom of St. Sebastian (as one man ties his leg, he is looking at a soldier on horseback), by Anthony Van Dyck, c. 1617. Alte Pinakothek, Munich; Larsen, *Van Dyck* (pl.67).

4391 St. Sebastian (half-view, with two arrows in his side; two soldiers look up from the left in distress), by Hendrick Goltzius, 1617. Nantes, Musée des B/A; Cousseau, *Musée*.

4392 St. Sebastian (looking at horsemen as his leg is tied to a tree), by Anthony van Dyck, 1617. NGS, Edinburgh; Larsen, *17th Cent. Flemish*; Larsen, *Van Dyck* (pl.62); NGS, *Illustrations*.

4393 St. Sebastian (with his hands tied behind his back, one arrow in his side), by Guido Reni, c. 1617–18. Prado, Madrid; *Guido Reni*.

4394 Martyrdom of St. Sebastian (he looks down as one man ties his leg and another puts a hand on his head), by Anthony van Dyck, c. 1619–20. Chrysler Museum, Norfolk VA; Larsen, *Van Dyck* (pl.70).

4395 Martyrdom of St. Sebastian (Sebastian is practically unidentifiable in a wide view with people gathered before a ruined building; in foreground a man pulls a bow), drawing by Jacques Callot. Crocker Art Gallery, Sacramento CA; *Catalogue*.

4396 St. Sebastian (leaning forward from the tree, an arrow in his chest), by Guido Reni. Ponce, Museo de Arte; Held, *Catalogue*.

4397 Martyrdom of St. Sebastian (tied to a tree, he is lit by a heavenly light as angels descend with a flower wreath), by Horace Le Blanc. Rouen, Musée des B/A; *La Peinture d'Inspiration*.

4398 St. Sebastian (Irene is pulling an arrow from his side, as her servant supports him), by Jan van Bylert, 1624. Coll. The Counts Harrach; Cooper, *Family Collections*.

4399 St. Sebastian (tied to a post, shot with three arrows), by Giovanni Battista Caracciolo, c. 1625. Fogg Art Museum, Cambridge MA; Spear, *Caravaggio*.

4400 St. Sebastian (standing on one leg, draped over a tree, with a quiver of arrows at his feet), by Massimo Stanzione, after 1625. Nelson-Atkins Museum of Art, Kansas City MO; *Handbook*.

4401 Bust of St. Sebastian, arrow in

his throat, by Francesco Furini. NGS, Edinburgh; *Illustrations*.

4402 The martyrdom of St. Sebastian (angel is pulling an arrow from his left side), by Anthony van Dyck, c. 1630–31. Sabauda Gallery, Turin; Larsen, *Van Dyck* (pl.247).

4403 The martyrdom of St. Sebastian (cherub is pulling an arrow from his right side), by Anthony van Dyck, c. 1630–31. Louvre, Paris; Larsen, *Van Dyck* (pl.245).

4404 The martyrdom of St. Sebastian (cherub is pulling an arrow from his right side), by Anthony van Dyck, c. 1630–31. Schelle Parochial Church; Larsen, *Van Dyck* (pl.248).

4405 The martyrdom of St. Sebastian (he is succored by three angels), by Anthony van Dyck, c. 1630–32. Brussels, Musées Royaux des B/A; Larsen, *Van Dyck* (pl.250).

4406 St. Sebastian (leaning forward from a tree, full of arrows), by Francisco de Zurbaran, 1631–40. Private Coll., San Sebastián; Gállego, *Zurbaran*.

4407 St. Sebastian (tied to a tree, looking heavenward, before he is shot with arrows), by Guido Reni, c. 1638–40. Bologna, Pinacoteca Nazionale; *Guido Reni*.

4408 Martyrdom of St. Sebastian (before a walled city, Sebastian is collapsed against the tree, with an arrow in his chest and two in his leg, as executioners walk away), by Johann Heinrich Schönfeld, 1639–48. Marianella (Naples), House of Sant'Alfonso de'Liguori; Puppi, *Torment*.

4409 St. Sebastian (half-view, tied to a tree with one arrow in his chest, in right profile), by Guercino. Ponce, Museo de Arte; Held, *Catalogue*.

4410 St. Sebastian (lying unconscious on the ground still tied to a tree, while two angels contemplate his wounds), by Claude Vignon the Elder. Ponce, Museo de Arte; Held, *Catalogue*.

4411 St. Sebastian (sitting next to his armor, with a hand tied above his head), by Guercino. Wadsworth Atheneum, Hartford CT; *Handbook*.

4412 St. Sebastian (eyes closed, supported by a tree trunk), marble sculpture by Gianlorenzo Bernini. Thyssen-Bornemisza Coll., Lugano; McGraw, *Encyclo.* (Vol.II, pl.272).

4413 St. Sebastian (half view in right

profile with arrow in his chest) by north Italian school, c. 17th cent. Mauritshuis, The Hague; Hoetink, *Mauritshuis.*

4414 St. Sebastian, tied to a tree, filled with arrows, half view, att. to Juan Carreño de Miranda. Rijksmuseum, Amsterdam; *Paintings.*

4415 St. Sebastian (sitting against a tree, with his hands tied above his head, filled with arrows and lit by a celestial light), by Mattia Preti, c. 1657. Rome, Museo Diocesano; *Tresori d'Arte.*

4416 St. Sebastian (sitting, hands tied, bathed in celestial light), by Mattia Preti, c. 1657. Capodimonte, Naples; RA, *Painting in Naples*; Yale Univ., *Taste* (fig.37).

4417 Martyrdom of St. Sebastian (lying down, right hand on his chest, arrows in his side and leg), sculpture by Antonio Giorgetti, 1660–70. Rome, S. Sebastiano; Larousse, *Ren. & Baroque* (pl.910).

4418 Martyrdom of St. Sebastian (nude, tied to a post, hands above his head, his armor behind him), sculpture by Pierre Puget, c. 1663. Genoa, Sta. Maria di Carignano; Boone, *Baroque*; Larousse, *Ren. & Baroque* (pl.911); McGraw, *Encyclo.* (Vol.II, pl.170).

4419 St. Sebastian consoled by the angels (one unties his ankle, another pulls an arrow from his side, while a third points to heaven; cherubs descend with palm and laurel wreath), by Pierre Thys the Elder. Ghent, Museum voor Schone Kunst; Hairs, *Sillage de Rubens.*

4420 St. Sebastian, martyr, helped by the angels (one unties his ankle while another pulls an arrow from his side) by Thomas Willeboirts Bosschaert. Coll. Mlle. C. Leegenhoek; Hairs, *Sillage de Rubens.*

4421 St. Sebastian (tied to a column of an archway, full of arrows), by David Teniers the Younger after an original by Mantegna in the KM, Vienna. Courtauld Inst. of Art, London; *Catalogue.*

4422 St. Sebastian (tied to a tree, looking up at a celestial light), by Giuseppe Maria Crespi, c. 1685–90. Coll. Gabrielle Kopelman, New York; Merriman, *Crespi.*

4423 The apotheosis of St. Sebastian, by Sebastiano Ricci, c. 1693–94. Sforza Castle, Museo d'Arte Antica, Milan; Daniels, *Ricci.*

4424 St. Sebastian, right hand tied to a tree (he leans on a broken branch), bronze statue by Francois Coudray, 1712. NGA, Washington DC; Walker, *NGA.*

4425 The martyrdom of St. Sebastian

(archers come running up; he has an arrow in one arm), by Giambattista Tiepolo, 1739. Diessen, Convent Church; Cleveland, *European, 16th–18th Cent.*; Morassi, *Catalogue* (pl.119).

4426 The martyrdom of St. Sebastian (archers come running up; he has an arrow in one arm), modello for the altarpiece at Diessen by Giambattista Tiepolo, 1739. Cleveland Museum of Art, OH; *European, 16th–18th Cent.*; Morassi, *Catalogue* (pl.116).

4427 St. Sebastian (leaning against a pillar, found by Irene), by Gustave Moreau. Clemens-Sels-Museum, Neuss; Hahlbrock, *Gustave Moreau.*

4428 St. Sebastian (tied to a tree, with an arrow in his leg and arm, looking down while riders approach from the city), by Gustave Moreau, c. 1870. Private Coll., Switzerland; Moreau, *Gustave Moreau.*

4429 St. Sebastian (comforted by an angel), chalk drawing by Gustave Moreau, c. 1876. Gustave Moreau Museum, Paris; Mathieu, *Aquarelles*; Mathieu, *Musée.*

4430 St. Sebastian (still tied to a tree, he holds up a crucifix; in background, soldiers appear to stand about, watching him), by Gustave Moreau, c. 1875. Gustave Moreau Museum, Paris; Mathieu, *Musée.*

4431 St. Sebastian (tied to a tree) by Odilon Redon, 1910–12. NGA, Washington DC; Walker, *NGA.*

See also 219, 446, 449, 597, 777, 890, 1087, 1343, 1423, 1424, 1617, 1930, 1932, 1933, 1934, 1935, 2100, 2179, 2416, 2448, 2473, 2474, 2747, 2748, 2749, 2750, 2751, 2752, 2753, 2754, 2755, 2756, 2757, 2758, 2759, 2760, 2761, 2762, 2763, 2764, 2765, 2766, 2826, 2828, 3325, 3423, 3800, 3809, 4169, 4180, 4184, 4187, 4189, 4192, 4197, 4211, 4517, 4760, 4921

Seconda, Roman knight, patron of Turin; beheaded; mart. 257 (July 10)

4432 St. Seconda (in armor, holding a model of a city), fresco by the Piedmontese School, 15th cent. Sale San Giovanni, Capella al Cimitero; Kaftal, *North West Italy.*

See also 2531, 4253

Senatore, Bishop of Milan, d. 475 (May 28)

4433 Virgin and Child with SS. John the Baptist, Euphemia, Senatore,

Catherine of Alexandria, and three angels playing music, by Marco d'Oggiono, c. 1510. Milan, Church of S. Euphemia; Sedini, *Marco d'Oggiono* (p.165).

Senatro, Abbot
4434 St. Senatro Abbot (looking over his left shoulder and gesturing to a city in left background), etching by Teresa Del Po. Illus. Bartsch; *Ital. Masters of the 17th Cent.* (Vol.45).

Sennen *see* **Abdon and Sennen**

Seraphina *see* **Fina**

Serapion, member of Mercerdarios Calzados, mart. 1240
4435 St. Serapion, standing and sleeping, his arms chained to the wall, by Francisco de Zurbaran, 1628. Wadsworth Atheneum, Hartford CT; Gállego, *Zurbaran*; *Handbook*; Held, *17th & 18th Cent.*; Janson, *History* (pl.669); Murray, *Art & Artists*; Puppi, *Torment*; United Nations, *Dismembered Works*.

Sergius of Radonezh, founded monastery of the Holy Trinity at Makovka, d. 1392 (Sept. 25)
4436 St. Sergius, 7th cent. mosaic. Salonika, St. Demetrios, Greece; McGraw, *Encyclo.* (Vol.XII, pl.367).
4437 St. Sergius riding a horse (carrying a banner), by an Italian artist working at Sinai, 13th cent. Sinai, St. Catherine's Monastery; Knopf, *The Icon* (p.232).
4438 St. Sergius of Radonezh (in black cloak), silk embroidery by school of Moscow, 1422-24. Zagorsk, Museum of History and Art; McGraw, *Russia*.
4439 Enthroned Mother of God with St. Michael and St. Sergius, icon, c. 1425-50. Moscow, State Historical Museum; McGraw, *Russia*.
4440 The birth of St. Sergius of Radonej, with Emperor Andronicus enthroned in foreground (sheet 38, v.12,9 x 11,8); Grand Duke Dmitri Donskoi visiting St. Sergius who prostrates himself before the Duke (sheet 241, v.12,8 x 11); from "Life of St. Sergius," ms.5/19, 16th cent. Lenin USSR State Public Library; Georgyevsky, *Old Russian Min.*
4441 St. Sergius settling down in the heart of the forest (sheet 121, v.12,5 x 11,8); St. Sergius and the wild beasts of the forest (sheet 81, v.12,3 x 11,7); from

"Life of St. Sergius," ms.5/19, 16th cent. Lenin USSR State Public Library; Georgyevsky, *Old Russian Min.*
4442 St. Sergius building his cell and a church (sheet 61, v.12,3 x 11,6); the raising of a pale (wooden fence) around St. Sergius' monastery (sheet 93, f.12,7 x 11,8); St. Sergius digging the ground to sow vegetables (sheet 154, v.12,5 x 11,7); St. Sergius choosing the site for building his monastery (sheet 61, v.12 x 11,8); from "Life of St. Sergius" ms. 5/19, 16th cent. Lenin USSR State Public Library; Georgyevsky, *Old Russian Min.*
See also 567, 3848

Sernin of Toulouse, Bishop of Toulouse, missionary, tied to a bull and dragged out of a temple, mart. 3rd cent. (Nov. 29)
4443 St. Sernin of Toulouse (giving a blessing), anon. 14th cent. Bilbao, Provincial Museum of Fine Arts; Bentley, *Calendar*.

Servatius
4444 St. Servatius (sleeping, approached by an eagle); St. Urban I (about to be decapitated); St. Petronilla (at the table); St. Erasmus (his entrails wound on a windlass); St. Boniface (about to be clubbed); St. Vitus (boiled in a cauldron); St. Quirico (before the emperor); woodcuts by Günther Zainer from "Leben der Heiligen, Sommerteil," Augsburg, 1472. The Illus. Bartsch; *German Book Illus.* (Vol.80, pp.83–85).

Seven Sleepers of Ephesus, Roman knights, hid from Decius in a cave and slept for 100 years (June 27 & July 27)
4445 The Seven Sleepers of Ephesus (the bishop is led to the seven sleepers after they are awakened in the cave; the Emperor Theodosius II kneels before the seven sleepers, and thanks God for the miracle); frescoes by the School of the Alto Adige, early 15th cent. Bolzano, Cathedral; Kaftal, *North East Italy*.

Severinus or Severino, Benedictine monk, d. 481
4446 St. Severinus greets Maximus of Norica, who is brought to the cloister by a bear; St. Severinus exorcises a possessed woman (posthumous miracle); predella from an altarpiece by the Master of St. Severino. Naples, SS. Severino e Sosio; Kaftal, *Central & So. Ital.*

See also 4478

Severinus of Austria, Bishop and patron of Sanseverino, apostle of Bavaria and Austria, d. 543 (Jan. 8)
4447 St. Severinus (in bishop's regalia, holding a model of the city of Sanseverino), panel of a polyptych by Vittore Crivelli. San Severino Marche, Pinacoteca Civica; Kaftal, *North East Italy*.
4448 Madonna and Child with SS. Anthony Abbot, Sebastian, Mark, and Severino (kneeling with crosier and fruit), by Lorenzo da Sanseverino, c. 1491. Cleveland Museum of Art, OH; *European before 1500*.
See also 1511, 4085

Severus, Bishop of Naples and Ravenna, patron of drapers and upholsterers, d. 409 (Feb. 1 & Apr. 30)
4449 St. Severus (enthroned, in bishop's regalia, giving a blessing), from an altarpiece by the Master of St. Severino. Naples, SS. Severino e Sosio; Kaftal, *Central & So. Ital.*
4450 St. Severus (as a bishop, going up some steps, with two people weaving in the foreground), by Pieter Coeck. Coll. Georges Peltzer, Verviers; Marlier, *Coeck.*
See also 2499, 3726

Siffrein
4451 St. Siffrein (standing in bishop's regalia, giving a blessing), by an unknown Provencal painter, c. 1460-70. Petit Palais, Avignon; Laclotte, *L'Ecole d'Avignon.*

Sigismund, King of Burgundy; beheaded and body thrown into a well; mart. 524
4452 St. Sigismund (standing in an ermine-trimmed cloak, wearing a crown, holding an orb), fresco by the School of the Veneto, 14th cent. Bassano, S. Antonio; Kaftal, *North East Italy.*
4453 Madonna and Child with St. Anthony Abbot (and his pig) and St. Sigismund, by Neroccio de'Landi, c. 1495. NGA, Washington DC; Bentley, *Calendar*; Pope-Hennessy, *Sienese*; Shapley, *Samuel H. Kress.*
4454 St. Sigismund (standing in royal robes, holding a staff and a host), from an altarpiece by Andrea di Niccolò, 1498. Casole, Colle di Val d'Elsa; Kaftal, *Tuscan.*

See also 11, 2531, 3718

Silvester I *see* **Sylvester I**

Simeon, bishop of Jerusalem, cousin of Christ (Feb. 18)
4455 St. Simeon with the Christ Child, by Petr Brandl, c. 1730. Prague, Nat'l Gallery; National Gallery, *Baroque.*

Simeon Nemanja *see* 4262, 4264

Simeon Stylites, first Stylite, pillar hermit, d. 459 (Jan. 5)
4456 St. Simeon Stylites (half of his body seen atop a pillar), from the Menologion of Basil II, ms.cod.vat.gr.1613, fo.2, late 10th cent. Vatican Library; McGraw, *Encyclo.* (Vol.XII, pl.372).
4457 St. Simeon Stylites (his upper body showing atop a pillar), fresco, 1192. Church of Panagia tou Arakou, near Lagoudera; Stylianou, *Painted Churches* (p.173).
4458 St. Simeon Stylites on a pillar, mosaic, 12th-13th cent. Venice, S. Marco; Kaftal, *North East Italy.*
4459 St. Simeon Stylites (in a tower with clouds beneath the summit, giving a blessing), icon from a Deisis tier–icon screen–tempera on wood by Simeon, c. 1502. State Russian Museum, St. Petersburg.
4460 St. Simeon Stylites, painting by Frank Brangwyn. Venice, Galleria Internazionale d'Arte Moderna; Coulson, *Saints.*

Simeon the Pious
4461 St. Simeon the Pious, bust portrait icon, mid-16th cent. Tretyakov Gallery, Moscow; Knopf, *The Icon* (p.300).

Simon Stock, Simon the Englishman, Carmelite, d. 1265 (May 16)
4462 The Virgin gives the chasuble to Simon Stock, by Nicholas Mignard, 1644. Calvert Museum, Avignon; Rocher, *Carmels de France.*
4463 Virgin with Saints Simon Stock and Anthony of Padua, by Giuseppe Maria Crespi, c. 1690. Bergantino Parochial Church; Merriman, *Crespi.*
4464 Madonna and Child with St. Simon Stock and Teresa, by Sebastiano Ricci, c. 1708. Dubrovnik, The Carmine Church, Yugoslavia; Daniels, *Ricci.*
4465 St. Simon Stock visited by angels

in a graveyard, by Giovanni Battista Tiepolo. Brera, Milan; Coulson, *Saints.*
4466 St. Simon Stock, by Giovanni Battista Tiepolo. Brera, Milan; Book of Art, *Ital. to 1850.*

Simonino, boy martyr, protector of children; murdered, 1475 (Mar. 23)
4467 Martyrdom of St. Simonino (his eyes are put out, and the blood is collected in a bowl by four men), colored woodcut. Ravenna, Biblio. Classense; Puppi, *Torment.*

Sinibaldus *see* **Sebaldus**

Sirus
4468 St. Sirus (in bishop's robes) and St. Paul, altar panels by Vincenzo Foppa. Minneapolis Inst. of Art, MN; *European Paintings.*

Sisimos
4469 Saints Sisimos and Phibamon on horseback, frescoes in the monastery of Bawit (Egypt), 5th–6th cent. Bawit, Egypt; Boucher, *20,000 Years.*

Sixtus I, Pope, r. 115–125 (Apr. 6)
4470 St. Sixtus I, fresco by school of Botticelli in the Sistine Chapel. Vatican Museums; Brusher, *Popes.*

Sixtus II, Pope; beheaded; mart. 258 (Aug. 6 & 7)
4471 St. Sixtus II (wearing a pallium, holding a book and a palm), from a triptych by Spinello Aretino. Pisa, S. Francesco; Kaftal, *Tuscan.*
4472 St. Sixtus II standing in a niche, fresco by Sandro Botticelli, 1481. Sistine Chapel, Vatican; Lightbown, *Botticelli.*
4473 St. Sixtus II (surrounded by knights ushering him out of a room) dismisses St. Lawrence, by Michael Pacher. Osterreichische Galerie, Vienna; Bentley, *Calendar.*
4474 SS. Stephen, Sixtus II, and Lawrence, woodcut by Albrecht Dürer, Berlin, c. 1504. Geisberg, *Single-Leaf*; Strauss, *Woodcuts* (pl.87).
See also 3255

Sol the Abbot
4475 St. Sol the Abbot (riding a mule); St. Fabian (beaten with clubs); St. Vincent (roasted on a gridiron); St. John Chrysostom (nude, crawling in the wilderness); St. Julian (about to be decapitated with a sword); St. Bridget of Sweden; St. Ignatius of Antioch (kneeling between two lions); St. Agatha (put to the flames); woodcuts by Günther Xainer from "Leben der Heiligen," 1471. The Illus. Bartsch; *German Book Illus.* (Vol.80, pp.68–72).

Sophia, Roman martyr; mother of SS. Hope, Faith and Charity, mart. 120 (Aug. 1)
4476 St. Sophia (in nun's habit, kneeling and pointing to a model of a city, which she holds), from an altarpiece by Giovanni Santi, 1484. Gradara, Casa Comunale; Kaftal, *Central & So. Ital.*

Sosius or Sosio, follower of St. Gennaro, mart. 303 (Sept. 19)
4477 San Gennaro embracing San Sosio, fresco by an assistant after a design by Domenichino, 1635–37. Naples Cathedral; Spear, *Domenichino.*
4478 SS. Sosius (wearing a dalmatic, holding a palm and a book) and Severinus (in black robe, hands clasped, holding a crucifix on a staff), from an altarpiece by the Master of St. Severino. Naples, SS. Severino e Sosio; Kaftal, *Central and So. Ital.* (fig. 685).
See also 2350

Soter, Pope, r. 167–175 (Apr. 22)
4479 St. Soter (holding an unrolled scroll), fresco by Sandro Botticelli in the Sistine Chapel, 1481. Vatican; Bentley, *Calendar*; Brusher, *Popes*; Lightbown, *Botticelli.*

Speciosa *see* **1857**

Spiridonius or Spyridon, Bishop of Tremithus, 4th cent. (Dec. 14)
4480 Saint Spiridonius, holding a burning tile and a scroll, fresco, early 16th cent. Kourdali, Church of the Dormition of the Mother of God; Stylianou, *Painted Churches* (p.148).
4481 Saint Spiridonius, wearing a basket cap and holding a burning tile which dripped water and left a clod of earth in his hand, fresco of 1514. Galata, Church of the Archangel or Panagia Theotokis; Stylianou, *Painted Churches* (p.93).
4482 St. Spiridonius, standing, holding a scroll, fresco, 1564. Church of Pan-

agia Amasgou, near Monagri; Stylianou, *Painted Churches* (p.245).

See also 874

Spyridon *see* **Spiridonius**

Stanislaus Kotska, Jesuit novitiate, d. 1568 at age 18 (Nov. 13)
4483 Stanislaus Kotska kissing the feet of the Infant Jesus (while angels hold a book, and give flowers to the Virgin), by Andrea Pozzo. Nantes, Musée des B/A; Cousseau, *Musée.*
4484 Saints Ignatius of Loyola, Luigi Gonzaga (in ecstasy) and Stanislaus Kotska (holding the Infant Christ), by Giuseppe Maria Crespi, c. 1726–27. Modena, San Bartolomeo; Merriman, *Crespi.*
4485 Ecstasy of St. Stanislaus Kotska (supported by angels), by Giuseppe Maria Crespi, 1727–30. Ferrara, Chiesa del Gesù; Merriman, *Crespi.*
4486 Virgin with Saints Luigi Gonzaga and Stanislaus Kotska (both saints are about to be crowned by angels carrying flower wreaths), by Giuseppe Maria Crespi, c. 1730. Parma, Galleria Nazionale; Merriman, *Crespi.*
See also 2011

Stanislaus of Cracow, Bishop and patron of Cracow; beheaded and limbs torn off; mart. 1079; canon. 1253 (May 7)
4487 Martyrdom of Stanislaus of Cracow (he is decapitated, and two men flourish limbs torn from his body), fresco by the School of Giotto, early 14th cent. S. Francesco, Assisi; Kaftal, *Tuscan.*
4488 St. Stanislaus of Cracow, raising up a dead man who will attest to the innocence of an accused man, fresco by school of Giotto, early 14th cent. San Francesco, Assisi; Coulson, *Saints*; Kaftal, *Tuscan*; McGraw, *Encyclo.* (Vol.VI, pl.347).
4489 Punishment of unfaithful wives (men take their babies and suckle them on a dog, then make the dog's puppies suckle the women), from the triptych of St. Stanislaus by the Cracow school, early 16th cent. Wawel Castle, Poland; Szablowski, *Collections.*

Stephen, deacon, protomartyr; stoned to death; mart. c. 35 (Dec. 26)
4490 Stoning of St. Stephen, fresco from Church of St. Germain, Auxerre,
9th cent. Paris, Musée des Monuments Francais; Boucher, *20,000 Years* (287).
4491 Stoning of St. Stephen (as a hand in the cloud blesses him), from a Salzburg Lectionary, ms.780, fo.6v, 11th cent. Pierpont Morgan Library, NY; Harrsen, *Central European.*
4492 Stoning of St. Stephen (three men follow him throwing stones, as a hand from heaven blesses him), wall painting from Sant Joan de Boi, 11th cent. Barcelona, Museo d'Art de Catalunya; Lasarte, *Catalan.*
4493 St. Stephen as a deacon, silver on wood base reliquary with colored stones, France, 12th cent. Hermitage, St. Petersburg; Piotrovsky, *Hermitage.*
4494 The protomartyr Stephen (in white, holding a chasuble and an incense urn), icon, early 13th cent. Sinai, Monastery of St. Catherine; Manafis, *Sinai.*
4495 Initial with the stoning of St. Stephen, from ms.R.I.6, fo.73. Este Library, Modena; Salmi, *Ital. Miniatures.*
4496 Birth of St. Stephen, from "Chronica de Gestis Hungariorum," ms. Cod. 405, fo.19. Vienna, National Library; Salmi, *Ital. Miniatures.*
4497 St. Stephen (half-view, dressed in ecclesiastical robes, holding a red book) panel by Giotto di Bondone, c. 1315–25. Coll. Fondazione Horne, Florence; Andres, *Art of Florence* (Vol. I, pl.95); McGraw, *Encyclo.* (Vol.VI, pl.205).
4498 Stoning of St. Stephen (at left, he is condemned; at right, he is stoned as Christ looks on from upper corner), fresco by Bernardo Daddi, c. 1330. Santa Croce, Florence; Andres, *Art of Florence* (Vol.I, pl.103).
4499 Madonna and Child enthroned, with SS. John the Baptist and Thomas apostle at left, and SS. Benedict and Stephen at right, polyptych by Luca di Tommè and Niccolò di Ser Sozzo Tegliacci, 1362. Siena, Pinacoteca; Hills, *The Light.*
4500 St. Stephen (half-length, holding a book and a palm, with two rocks on his head), panel by Giovanni del Biondo. Santa Croce, Florence: Offner, *Corpus* (Sect.IV, Vol.IV, part I, pl.XVI).
4501 St. Stephen (holding a banner) enthroned with angel, by Rossello di Jacopo Franchi from ms. Cod. D, fo.48v. Prato, Cathedral Museum; Eisenberg, *Monaco* (pl.326).
4502 The martyrdom of St. Stephen

(stoned from behind; magistrates watch in front of him), att. to Lorenzo di Niccolo, c. 1400. Arkansas Arts Center, Little Rock; Shapley, *Samuel H. Kress.*

4503 The stoning of St. Stephen in the presence of Saul, from the "Boucicaut Hours," painted by the Boucicaut Master, ms.2,fo.19v. Jacquemart-André Museum, Paris; Meiss, *French Painting.*

4504 The funeral of St. Stephen, drawing by Fra Filippo Lippi. Cleveland Museum of Art, OH; *Selected Works.*

4505 St. Stephen preaching in a city, before a group of women sitting on the ground and the Jewish council, fresco by Fra Angelico called "Lives of St. Stephen and St. Lawrence," 1447–49. Vatican, Chapel Nicholas V; Jacobs, *Color Encyclo.*; Piper, *Illus. Dict.* (p.90); Random House, *Paintings* (109).

4506 The expulsion and stoning of St. Stephen, fresco by Fra Angelico in the Chapel of Nicholas V. Vatican Museums; McGraw, *Encyclo.* (Vol.I, pl.270).

4507 The ordination of St. Stephen (he is given communion by another saint), fresco by Fra Angelico in the Chapel of Nicholas V. Vatican; Pope-Hennessy, *Fra Angelico.*

4508 Etienne Chevalier with St. Stephen, by Jean Fouquet, c. 1450. Picture Gallery, Berlin; Janson, *History of Art* (pl.562); Klessmann, *Berlin Gallery*; *Masterworks.*

4509 Martyrdom of St. Stephen (he kneels, looking up at God, as two men prepare to hurl stones at him), illum. by Jean Foucquet from the Hours of Etienne Chevalier, c. 1453. Condé Museum, Chantilly; Fouquet, *Hours*; Lassaigne, *Fifteenth Cent.*

4510 St. Stephen and Etienne Chevalier before the Virgin (they kneel on a checkered floor, while angels play musical instruments), illum. by Jean Foucquet from the Hours of Etienne Chevalier, c. 1453. Condé Museum, Chantilly; Fouquet, *Hours.*

4511 Birth of St. Stephen (an angel comes into the room), by Fra Filippo Lippi, 1452-64. Prato Cathedral; Lavin, *Narrative.*

4512 Funeral of St. Stephen (lying on a couch inside a colonnaded hall, surrounded by dignitaries), fresco by Fra Filippo Lippi, 1460. Prato Cathedral; Kaftal, *Tuscan*; McGraw, *Encyclo.* (Vol.IX, pl.145); Murray, *Art & Artists.*

4513 St. Stephen martyr in red robe with blue lower sleeves, by Domenico Ghirlandaio. Budapest, Museum of Fine Arts; Garas, *Musée.*

4514 St. Stephen with a bloody head, kneeling in prayer, stones on the floor, by Francesco Francia, 1475. Borghese Gallery, Rome; Denvir, *Art Treasures.*

4515 St. Stephen (holding a rock), by Hans Memling, c. 1479-80. Cincinnati Art Museum, OH; *Handbook*; *Masterpieces.*

4516 St. Stephen (holding three stones in the folds of his garment), polychromed wooden statue by the Master of Kloster-Neuberg, c. 1480. Joslyn Art Museum; *Paintings & Sculpture.*

4517 Madonna and Child flanked by Stephen and James on the left, and John Evangelist and Sebastian on the right, polyptych by Pietro Alemanno, late 15th cent. Bob Jones Univ. Art Gallery, Greenville, SC; Pepper, *Ital. Paintings.*

4518 St. Stephen (holding a bag of rocks), colored woodcut from the "Missale Pataviense of 1503," ms. Holl. 89, by Lucas Cranach the Elder, 1502. Picture Gallery, Berlin; Schade, *Cranach.*

4519 St. Stephen (standing with hands clasped, looking at a rock on his right shoulder), by Marco d'Oggiono. Hearst Coll., St. Simeon CA; Sedini, *Marco d'Oggiono* (p.75).

4520 Martyrdom of St. Stephen (stoned as angels push clouds away in the upper right, so Jesus can watch), tapestry by Raphael. Vatican Museums; Boschloo, *Carracci.*

4521 Martyrdom of St. Stephen (kneeling, as crowd throws rocks at him), woodcut by Hans Baldung Grien, Munich, c. 1508. Geisberg, *Single-Leaf.*

4522 St. Stephen, painted lindenwood statue by Tilmann Riemenschneider, c. 1510. Cleveland Museum of Art, OH; *Selected Works.*

4523 Madonna and Child with Saints Stephen and Catherine of Alexandria, by Girolamo Mocetto. Organo, Verona, Santa Maria; New Int'l Illus. *Encyclo.*

4524 The ordination of St. Stephen (by St. Peter) on exterior staircase outside the walls of Jerusalem, by Vittore Carpaccio, 1511. Picture Gallery, Berlin; *Catalogue.*

4525 Preaching of St. Stephen (to several turbaned listeners, before a white city), by Vittore Carpaccio. Louvre,

Paris; Gowing, *Paintings*; Levey, *Giotto to Cézanne*; McGraw, *Encyclo.* (Vol.III, pl.75).

4526 St. Stephen preaching (in a gazebo), by Vittore Carpaccio. Brera, Milan; Book of Art, *Ital. to 1850*; Newsweek, *Brera*; Praeger, *Great Galleries.*

4527 The stoning of St. Stephen (as the Trinity looks down from above), by Giulio Romano. Genoa, Santo Stefano; Raphael, *Complete Works* (2.91).

4528 Legend of St. Stephen in three parts: before the tribunal; taken away from the tribunal; the stoning of St. Stephen (as he prays on his knees, men throw stones from behind his back; two men lean on their halberds in discussion, left foreground), by Lorenzo Lotto, 1516. Carrara Academy, Bergamo; Berenson, *Lotto.*

4529 St. Stephen with two bishops (and the coat of arms of Virgil Froeschel, Bishop of Passau), woodcut by Master HF, 1518. Strauss, *The Illus. Bartsch* (Vol.13, no.1).

4530 Stoning of St. Stephen, drawing by Pieter Coeck. Hessiches Landesmuseum, Darmstadt; Marlier, *Coeck.*

4531 Martyrdom of St. Stephen (in a forest outside the city, three men throw stones at him), by Battista Dossi. Coll. Nottebohm, Hamburg; Gibbons, *Dossi.*

4532 St. Stephen (standing, holding a book and a palm, with a rock on his head and a rock on his shoulder), by Giovanni Cariani, 1528-30. Carrara Academy, Bergamo; Pallucchini, *Cariani.*

4533 Saint Stephen (holding rocks; a rock hits him in the head) panel from an altarpiece by Master of Messkirch, c. 1530-43. Philadelphia Museum of Art, PA.

4534 The stoning of St. Stephen as God looks on from above, by Benvenuto da Garofalo, c. 1530-40. Picture Gallery, Berlin; *Catalogue.*

4535 Virgin and Child (in the clouds) with St. Stephen (holding up a rock) and John the Baptist (with a donor at left putting his chin on Stephen's knee), by Parmigianino, 1539-40. Picture Gallery, Dresden; Briganti, *Ital. Mannerism.*

4536 Stoning of St. Stephen (he kneels, stripped to the waist, while men are about to throw stones, before a landscape with a walled city; the Trinity look on from above), by Jan Van Scorel. Douai, Municipal Museum; Bentley, *Calendar.*

4537 Triptych with the stoning of St. Stephen and the legend of the discovery of his tomb, by the Utrecht school, 1554. Rijksmuseum, Amsterdam; *Paintings.*

4538 The martyrdom of St. Stephen (they stone him as he prays), by Juan de Juanes called Lorenzo Lotto, c. 1570. Prado, Madrid; Book of Art, *German & Spanish.*

4539 Burial of St. Stephen (commoners lower him into a stone vault), by Juan de Juanes, called Lorenzo Lotto. Prado, Madrid; McGraw, *Encyclo.* (Vol.XIII, pl.143).

4540 Stoning of St. Stephen (he kneels as a man holds his sleeve, other arm raised with a stone), by Titian, c. 1570-75. Lille, Musée des B/A; Wethey, *Titian* (pl.198).

4541 The martyrdom of St. Stephen (before a castle wall, as he kneels in prayer; boy stands above him holding rock in both hands), by Annibale Carracci. Louvre, Paris; Gowing, *Paintings*; New Int'l Illus. *Encyclo.*

4542 Stoning of St. Stephen (he is kneeling, surrounded by a crowd with stones raised above their heads), by Giorgio Vasari. Vatican Museums; Freedberg, *Circa 1600.*

4543 The throwing of the body of St. Stephen into the town sewer, by Ludovico Carracci, c. 1600. Private Coll.; Rowling, *Art Source Book.*

4544 The stoning of St. Stephen (dressed in ecclesiastical garments) by Adam Elsheimer, 1602-05. NGS, Edinburgh; Jaffé, *Rubens and Italy*; Met Museum, *Caravaggio*; NGS, *Illustrations*; Rowling, *Art Source Book.*

4545 The stoning of St. Stephen (before a walled city, as the Trinity looks on from a cloud), drawing, study for the painting in the Condé, by Domenichino, 1605-07. Uffizi, Florence; Spear, *Domenichino.*

4546 The stoning of St. Stephen (before a walled city, as the Trinity looks on from a cloud), by Domenichino, c. 1605-07. Condé Museum, Chantilly; Spear, *Domenichino.*

4547 St. Stephen (sitting with a palm, and his elbow on a book, with stones in his lap), by Domenico Fetti. Rochester Memorial Art Gallery, NY; *Handbook.*

4548 The martyrdom of St. Stephen (looking up at angels as he is being stoned), central panel of a triptych painted for abbey church of St. Amand by P.P. Rubens,

1612-15. Valenciennes, Musée des B/A; Baudouin, *Rubens.*

4549 Stoning of St. Stephen (he looks up as an angel descends with a wreath), chalk drawing by P.P. Rubens, 1615. Hermitage, St. Petersburg; Piotrovsky, *Hermitage.*

4550 The stoning of St. Stephen (he looks up at an angel descending with a wreath), oil sketch by P.P. Rubens, c. 1615. Brussels, Royal Palace; Held, *Oil Sketches.*

4551 The stoning of St. Stephen (outside a city, while a sitting soldier goads them on), by Domenico Zampieri. Nat'l Gallery, London; Poynter, *Nat'l Gallery.*

4552 The stoning of St. Stephen (one of the men is about to hit him with a huge rock as a cherub descends with a flower wreath), by Anthony van Dyck, c. 1623. Coll. Earl Egerton, Tatton Park, England; Larsen, *Van Dyck* (pl.159).

4553 St. Stephen (half view, holding a rock and a palm), by Francisco de Zurbaran, 1625-30. Private Coll., Madrid; Gállego, *Zurbaran.*

4554 Stoning of St. Stephen (a crowd hurls stones, as the emperor watches from a horse), by Rembrandt, 1625. Lyon, Musée des B/A; Durey, *Musée.*

4555 Lapidation of St. Stephen (he is lying on the ground while men stand above him with stones; angels descend while the Trinity looks on), by Pietro da Cortona, 1660. Hermitage, St. Petersburg; Eisler, *Hermitage.*

4556 Martyrdom of St. Stephen (men are throwing large stones at him, as cherubs descend with palms), by Filippo Lauri. Burghley House, Northamptonshire, England; DiFederico, *Trevisani.*

4557 Martyrdom of St. Stephen (as he is stoned, he is lit by celestial light, and cherubs watch from clouds), by Francesco Trevisani, c. 1680's. Corsini Palace, Rome; DiFederico, *Trevisani.*

4558 St. Stephen before the idol (as he prays, the idol bursts with a flash of light, and the soldiers shy away), by Giuseppe Chiari. Rome, S. Silvestro in Capitre; DiFederico, *Trevisani*; Waterhouse, *Roman Baroque.*

See also 4, 777, 1849, 2327, 2806, 3239, 3242, 3259, 3314, 3625, 3707, 3794, 4474

Stephen I, Pope; beheaded; r. 254-257 (Aug. 2)
4559 St. Stephen I (in papal robes, holding his own decapitated head), from a reliquary by Antonio Vivarini and Gio-

vanni d'Alemagna, 1443. Venice, S. Zaccaria; Kaftal, *North East Italy.*

4560 St. Stephen I looking down at a closed book, fresco by Sandro Botticelli in the Sistine Chapel, 1481. Vatican; Brusher, *Popes*; Lightbown, *Botticelli.*
See also 3504

Stephen of Hungary, King of Hungary, d. 1038, canon. 1087 (Aug. 16, Sept. 2, and Nov. 4)
4561 Patron Saints of Hungary (SS. Stephen, Ladislas, and Emmerich) woodcut by Hans Sebald Beham. Geisberg, *Single-Leaf.*
See also 3221

Stephen of Muret, founded order of Grandmont, d. 1124 (Feb. 8)
4562 Sick, wounded, and prisoners praying at the tomb of Saint Stephen of Muret, by Anonyme Rouennais, 1610-15. Roncherolles-sur-le-Vivier Church; *La Peinture d'Inspiration.*

Stephen of Perm, Bishop, translated scriptures for Eastern Russians, d. 1396 (Apr. 26)
4563 The travels of St. Stephen of Perm (passing St. Sergius's monastery on a sledge in the summertime), from "Life of St. Sergius" ms. 5/19, sheet 213 v.12,1 x 11,8. Lenin USSR State Public Library; Georgyevsky, *Old Russian Min.*

Stephen the King (Uros III)
4564 St. Stephen the King Uros III and scenes from his life, icon by Longin, 1577. Serbia, Monastery of Decani; Knopf, *The Icon* (p.344).

Susanna of Rome, niece of Pope St. Caius; beheaded; mart. 295 (Aug. 11)
4565 St. Susanna (kneeling with a cross, wearing a crown), min. by the Master of Claude from a Prayer Book of Queen Claude of France, fo.48r, c. 1515-16. Coll. H.P. Kraus, NY; Sterling, *Master of Claude.*

4566 St. Susanna, marble statue by Francois Duquesnoy, 1629-33. Rome, S. Maria di Loretto; Gowing, *Biog. Dict.*; Held, *17th & 18th Cent.*; Murray, *Art & Artists*; New Int'l Illus. *Encyclo.*

Sylvester I or Silvester I, Pope, converted Emperor Constantine to Christianity, d. 335 (Dec. 31)
4567 St. Sylvester, Pope, in an illumi-

Symeon 226

nated D, from the Berthold Missal, ms. 710, fo.76v, c. 1200–35. Pierpont Morgan Library, NY; Swarzensski, *Berthold Missal* (pl.XLIV).

4568 Messengers prostrate themselves before Sylvester I, fresco, mid-13th cent. Rome, SS. Quattro Coronati; Coulson, *Saints*; McGraw, *Encyclo.* (Vol.XI, pl.360).

4569 St. Silvester and Emperor Constantine (he baptizes the Emperor); fresco by Maso di Banco. Santa Croce, Florence; McGraw, *Encyclo.* (Vol.IX, pl.370).

4570 St. Sylvester resuscitating two deceased Romans (and holding closed the mouth of the dragon who killed them), fresco by Maso di Banco, c. 1340. Santa Croce, Florence; Andres, *Art of Florence* (Vol.I, pl.111); Gowing, *Biog. Dict.*; Hartt, *Ital. Ren.*; *Int'l Dict. of Art*; McGraw, *Encyclo.* (Vol.IX, pl.370); Murray, *Art & Artists*; New Int'l Illus. *Encyclo.* (see Maso); Piper, *Illus. Dict.*

4571 Miracle of St. Sylvester (released from prison after the man who sentenced him collapsed at his dinner table), by Francesco Pesellino, c. 1450. Doria Pamphili Palace, Rome; Cooper, *Family Collections*; Kaftal, *Tuscan.*

4572 St. Sylvester overcomes the dragon and resuscitates two pagan priests that were killed in the dragon's den, predella panel from an altarpiece by Francesco Pesellino, c. 1450. Doria Pamphili Palace, Rome; Kaftal, *Tuscan.*

4573 St. Sylvester resuscitates a bull that was killed by the Jewish priest; Sylvester baptizes the Jewish magician; Sylvester overcomes the dragon that was devastating the country (he holds its mouth shut); from an altarpiece by the School of the Abruzzi, 15th cent. Mutignano, S. Silvestro; Kaftal, *Central & So. Ital.*

4574 St. Sylvester revives the bull killed by St. Helena's Jewish priest (in the presence of Constantine and St. Helena), predella panel from an altarpiece by Francesco Pesellino, c. 1450. Worcester Art Museum, MA; *Handbook*; Kaftal, *Tuscan.*

4575 SS. Lawrence (in his deacon's robes), Sylvester I (in papal robes) and Francis of Assisi (receiving the stigmata) from Madonna and Child altarpiece by Carlo Crivelli. Massa Fermana, SS. Lorenzo, Silvestro e Rufino; Zampetti, *Crivelli.*

4576 St. Sylvester I enthroned with angels, fresco in the Raphael Rooms by Giulio Romano. Vatican Museums; Brusher, *Popes.*

4577 St. Sylvester showing the portraits of SS. Peter and Paul to Constantine, by Garzi, after 1675. Rome, S. Croce in Gerusalemme; Waterhouse, *Roman Baroque.*

4578 St. Sylvester baptizing Constantine, by Passeri, c. 1711. Rome, S. Luca Academy; Waterhouse, *Roman Baroque.*

See also 1519, 1520, 1521, 2614, 4139, 4905

Symeon *see* **Simeon**

Symmachus, Pope, r. 498–514 (July 19)
4579 St. Symmachus, mosaic. Rome, St. Paul-Outside-the-Walls; Brusher, *Popes.*

Symphorian, martyred at Autun, c. 200 (Aug. 22)
4580 The martyrdom of St. Symphorian (led away by a crowd of Romans), by Jean-Auguste-Dominique Ingres, 1834. Autun Cathedral; Wildenstein, *Ingres.*
4581 Martyrdom of St. Symphorian, by Jean Auguste Dominique Ingres, 1865. Philadelphia Museum of Art, PA.

Symphorosa and her seven sons; killed by Emperor Hadrian, date unknown (July 18)
4582 St. Symphorosa (thrown into the ocean); St. Leo I (approaching kneeling armored men); St. Felicity and her sons; St. Alexis (under the stairs); St. Praxedes (in bed, as an angel appears to her); St. Christina of Bolsena (about to be shot with an arrow), woodcuts by Günther Zainer from "Leben der Heiligen, Sommerteil," Augsburg, 1472. The Illus. Bartsch; *German Book Illus.* (Vol.80, pp.86–87).
See also 4582

Syrus, First Bishop of Padua, 2nd or 3rd cent. (Aug. 31 & Dec. 9)
4583 St. Syrus (wearing a pallium, giving a blessing), fresco by the Lombard School, 13th cent. Pavia, S. Giovanni Dominarum; Kaftal, *North West Italy.*
4584 St. Syrus (enthroned) and other saints, by Ambrogio Bergognone, 1490–95. Pavia, Certosa; Burckhardt, *Altarpiece.*

Taurinus
4585 Saints Hippolytus, Taurinus, and Herculanus, by Antonio Gonzalez Velazquez, 1746-52. Boston Museum of Fine Arts.

Telephorus, Pope, r. 125-138 (Feb. 22)
4586 St. Telephorus, fresco by Sandro Botticelli in the Sistine Chapel, 1481. Vatican; Brusher, *Popes*; Lightbown, *Botticelli.*

Terentianus or Terentius, Roman knight, patron of Pesaro; killed with lance or dagger; mart. 247 (Sept. 24)
4587 St. Terentius (standing, holding a book and a palm), painted lid of his wooden coffin, by the Marchigian School, 1447. Pesaro, Cathedral; Kaftal, *Central & So. Ital.*
4588 St. Terentius (standing with a banner, holding a model of the city), panel of a polyptych by Antonio Vivarini, 1464. Vatican; Kaftal, *North East Italy.*
4589 St. Terentianus (on a pedestal, holding a banner and a model of a city), predella of the Coronation of the Virgin altarpiece by Giovanni Bellini. Pesaro, Museo Civico; Goffen, *Bellini*; McGraw, *Encyclo.* (Vol.II, pl.254).

Terentius *see* **Terentianus**

Teresa of Avila, founder of Barefooted Carmelites, d. 1582 (Oct. 15)
4590 Saint Teresa of Jesus (with dove in upper right corner), by Fray Juan de las Miserias, 1562. Seville, Convento de las Carmelitas Descalzas; Smith, *Spain.*
4591 St. Teresa of Avila inspired by the Holy Spirit (as she is writing) by the Spanish school, 16th cent. Carmelites of Beaune; Rocher, *Carmels de France.*
4592 St. Teresa, hands clasped in prayer, medallion portrait by the Spanish school, 16th cent. Carmel de l'Incarnation, Clamart; Rocher, *Carmels de France.*
4593 St. Teresa, polychromed wood statue by Alonso Cano, c. 1629. Seville, Santa Maria del Buen Suceso; Wethey, *Alonso Cano* (pl.29).
4594 St. Teresa intercedes for souls in purgatory, oil sketch by P.P. Rubens, c. 1630-33. Wuyts Van Campen Museum, Lier; Held, *Oil Sketches.*
4595 St. Teresa (writing at a table, with Holy Spirit in upper left corner), by

Francisco de Zurbaran, 1641-58. Seville, Cathedral; Gállego, *Zurbaran.*
4596 Ecstasy of St. Teresa, marble and bronze sculpture by Gianlorenzo Bernini, c. 1645-53. Rome, Santa Maria Della Vittoria; Gardner, *Art thru Ages*; Gowing, *Hist. of Art* (p.699); Held, *17th & 18th Cent.*; McGraw, *Encyclo.* (Vol.IV, pl.428); New Int'l Illus. *Encyclo.*; Piper, *Illus. Dict.* (213); Pischel, *World History*; Random House, *Paintings* (191); Rowling, *Art Source Book.*
4597 Louis XIII and Anne of Austria pray to St. Teresa to intercede for the birth of the Dauphin, by the French School, 1646. Jouy-le-Moutier Church; Rocher, *Carmels de France.*
4598 St. Teresa of Avila blessing Anne de St. Barthélemy, by the Spanish School, 17th cent. Carmelites of Pontoise; Rocher, *Carmels de France.*
4599 St. Teresa of Avila covering the Carmelites with her mantle, by the French School, 17th cent. Carmelite Collection; Rocher, *Carmels de France.*
4600 The Holy Spirit appearing to St. Teresa (as she kneels in prayer) by the French school after Le Brun, 17th cent. Carmelite Collection; Rocher, *Carmels de France.*
4601 St. Teresa of Avila placating the anger of God (she sends an angel to heaven), by Domenico Maria Canuti. Bologna, Santa Maria degli Alemanni; Merriman, *Crespi.*
4602 Christ crowns St. Teresa of Avila (He reaches out of a cloud as she prays at an altar), by the French School, 17th cent. Carmelite Collection; Rocher, *Carmels de France.*
4603 Christ feeds St. Teresa of Avila (he serves her at the table), by the French School, 17th cent. Carmelite Collection; Rocher, *Carmels de France.*
4604 Christ gives St. Teresa a rose (as an angel crowns her with a flower wreath), by the French School, 17th cent. Carmelite Collection; Rocher, *Carmels de France.*
4605 St. Teresa of Avila and St. Catherine of Siena worship the infant Jesus, by the French School, 17th cent. Carmelite Collection; Rocher, *Carmels de France.*
4606 St. Teresa of Avila praying for the souls in purgatory (their heads appear below her as she kneels), by the French School, 17th cent. Carmelite Collection; Rocher, *Carmels de France.*

4607 The Virgin giving a rosary to St. Teresa (as they sit in the clouds), by the French School, 17th cent. Gray, Notre-Dame Church; Rocher, *Carmels de France.*

4608 The death of St. Teresa of Avila (martyrs look on as Christ crowns her from above), by the French School, 17th cent. Carmelite Collection; Rocher, *Carmels de France.*

4609 The transverberation of St. Teresa of Avila (she sits as an angel comes up behind her, pointing an arrow at her chest), by the French School, 17th cent. Carmelites of Clamart; Rocher, *Carmels de France.*

4610 The transverberation of St. Teresa of Avila (she stands as an angel descends with an arrow; scenes from her life in the borders), by the French School, 17th cent. Carmelite Collection; Rocher, *Carmels de France.*

4611 The transverberation of St. Teresa of Avila (supported by angels; one angel holds an arrow), by the French school, late 17th cent. Carmelite Collection; Rocher, *Carmels de France.*

4612 The transverberation of St. Teresa of Avila with the Holy Family (Jesus shoots arrows at her, while an angel crowns her with a flower wreath), anon. Carmelite Collection; Rocher, *Carmels de France.*

4613 Ecstasy of St. Teresa (uplifted by angels), by Sebastiano Ricci, c. 1690. Vicenza, S. Girolamo degli Scalzi; Daniels, *Ricci.*

4614 The vision of St. Teresa (she has a vision of angels escorting her to heaven), by Jean Jouvenet. Rouen, Musée des B/A; Schnapper, *Jouvenet.*

4615 The glory of St. Teresa (raised to heaven by angels), ceiling fresco by Giambattista Tiepolo, 1720-25. Venice, Chiesa degli Scalzi; Morassi, *Tiepolo.*

4616 Madonna and the Great Nuns, with St. Teresa (wearing a crown of thorns), Clare (holding the Child), and Catherine of Siena, by Giambattista Tiepolo. Venice, Chiesa dei Gesuati; De Bles, *Saints in Art*; Morassi, *Catalogue* (pl.102).

4617 Vision of St. Teresa (she kneels, looking up at the Trinity and a host of angels), by Sebastiano Conca. Ponce, Museo de Arte; Held, *Catalogue.*

4618 Ecstasy of St. Teresa (an angel pierces her heart with a flaming arrow, as Teresa leans back in a trance), by Pompeo Batoni, c. 1743. Private Coll., Genoa; Clark, *Batoni.*

4619 Apparition of St. Teresa to Queen Maria I (Teresa appears on a cloud above the enthroned queen with kneeling nuns; the saint is surrounded by angels carrying her attributes), by Pompeo Batoni, 1784. Lisbon, Basilica of the Estrela; Clark, *Batoni.*

See also 3171, 4464

Thaïs, Egyptian courtesan, converted by St. Paphnutius, penitent, d. 348 (Oct. 8)

4620 St. Thaïs in meditation, engraving by Parmigianino. McGraw, *Encyclo.* (Vol.IV, pl.428); Strauss, *The Illus. Bartsch* (vol.32, no.10).

See also 3947

Thecla of Iconium, follower of Paul the apostle; beheaded, mart. 1st cent. (Sept. 3 & 23)

4621 Saint Thecla (holding a palm) and Saint Paul, from reliquary of St. Thecla. Tarragon Cathedral, Spain; New Int'l Illus. *Encyclo.* (see Gothic).

4622 St. Thecla (standing, holding a palm), panel of a polyptych by Paolo Veneziano and workshop. Arbe, Cathedral; Kaftal, *North East Italy.*

4623 Saint Thecla praying for the plague-stricken, sketch for the altarpiece at Este by Giovanni Battista Tiepolo, 1758-59. Met Museum; Morassi, *Tiepolo.*

4624 St. Thecla delivers the city of Este from the plague, by Tiepolo, 1758-59. Este, Chiesa delle Grazie; Held, *17th & 18th Cent.*; McGraw, *Encyclo.* (Vol.XIV, pl.62); Morassi, *Tiepolo*; Murray, *Art & Artists.*

4625 St. Thecla (holding a crucifix and a lily, looking up at angels), by Franz Anton Maulbertsch. Picture Gallery, Lvov; *Old Master.*

4626 Une Martyre (Saint Thecla) in left profile before a painted cross, holding a palm, by Sarah Paxton Ball Dodson, 1891. Smithsonian Institute, Washington DC; Zellman, *300 Years.*

See also 2744, 4890

Theodora, sister of Hermes; beaten and executed; mart. 117 (Apr. 1)

4627 Martyrdom of St. Theodora (executioner is drawing his sword), by Giambattista Tiepolo. Coll. Falck, Milan; Morassi, *Catalogue* (pl.153).

Theodore Stratelates, general of Licinius; patron of Venice; crucified, mart. 319 (Feb. 7 & 8, July 8, Nov. 9)

4628 St. Peter with his hand on the shoulder of St. Damian, and St. Theodore (holding a crown), mosaic, c. 530. Rome, SS. Cosma e Damiano; Oakeshott, *Mosaics of Rome.*

4629 The Virgin between St. Theodore and St. George, Encaustic icon, 6th cent. Sinai, Monastery of St. Catherine; Manafis, *Sinai.*

4630 St. Theodore Stratelates (astride a horse, killing a demon), pen and ink drawing, ms. Vat. Copto 66, fol. 210v, 9th–10th cent. Vatican Library; McGraw, *Encyclo.* (Vol.III, pl.457).

4631 St. Theodore in chain-maille, holding a spear and shield, statue c. 1215–20. Chartres Cathedral; Gardner, *Art thru Ages.*

4632 Icon of St. Theodore spearing the dragon, cloisonné and champlevé enamels on copper, 12th cent. Hermitage, St. Petersburg; Bank, *Byzantine* (pl.194).

4633 Saint George and St. Theodore on horseback, by a French artist working in the Holy Land, 1250–1300. Sinai, St. Catherine's Monastery; Knopf, *The Icon* (p.220).

4634 St. Theodore Stratelates, mosaic icon from Byzantium, first third of the 14th cent. Hermitage, St. Petersburg; Piotrovsky, *Hermitage.*

4635 St. Theodore (in blue, with flames in lower right corner), possibly a self-portrait by Master Theodoric, c. 1367. Karlstejn, Church of Holy Cross; Murray, *Art & Artists*; Stejskal, *Charles IV.*

4636 Saints Theodore (with an unsheathed sword) and George (with a spear and a sheathed sword), both wearing patterned hose, fresco from 2nd half of 14th cent. Kakopetria, St. Nicholas of the Roof Church; Stylianou, *Painted Churches* (p.73).

4637 Saint Theodore (in armor) stone statue by Pierpaolo dalle Masegne, active 1383–1403. Venice, Ducal Palace; New Int'l Illus. *Encyclo.* (see Venetian Art).

4638 St. Theodore Stratelates with scenes from his life, c. 1500. Novgorod, Museum of Art & History; McGraw, *Encyclo.* (Vol.XII, pl.373).

See also 1612, 4644

Theodore Tyro or Theodorus, Roman knight; patron of Venice; burned at the stake, mart. 306 (Feb. 7 & 8, Nov. 9)

4639 Saint Theodore the Tiro (in armor, with a shield and an empty scabbard), fresco, c. 1200. Patmos; Kominis, *Patmos* (p.132).

4640 St. Theodore Tiron, fresco from central Greece, c. 1296. Pyrghi, Euboea, Church of the Transfiguration; Knopf, *The Icon* (p.166).

4641 St. Theodore and his (kneeling) monks (he holds one of their hands) from "Mariegola of the Order of St. Theodore," ms. IV, 21, fo.52v. Correr Museum, Venice; Salmi, *Ital. Miniatures.*

4642 St. Theodorus (roasted on a gridiron); St. Euphrosinos (speaking to a hermit); woodcuts by Günther Xanier from "Leben der Heiligen, Winterteil," Augsburg, 1471. The Illus. Bartsch; *German Book Illus.* (Vol.80, p.76).

4643 St. Theodore Tyro (astride a horse, in armor, holding a banner), from a triptych by the South Italian School, c. 1500. Laino Bruzio, S. Teodoro; Kaftal, *Central & So. Ital.*

4644 Saints Theodore Tyron and Theodore Stratelates (standing side by side), c. 1614. Dobursko, SS. Theodore Tyron and Theodore Stratelates; Paskaleva, *Bulgarian Icons.*

See also 466

Theodorus, Bishop of Pavia, d. 778 (May 20)

4645 Scenes from the life of St. Theodorus: elected bishop of Pavia; cures the sick and crippled on his way to Rome; confirmed by Pope Leo IV; cures the paralyzed son of the widow from Castronuovo; replaces the severed hand of a Jew, who is converted; expels the French from Pavia; defends Pavia from a siege by the French, all alone; frescoes by Bernardino Lanzoni. Pavia, S. Teodoro; Kaftal, *North West Italy.*

4646 Scenes from the life of St. Theodorus: the nephew of King Charles of France shoots an arrow at St. Theodorus during the siege, but the arrow turns back on him and kills him; the king begs him to restore his nephew to life, and Theodorus agrees; he raises the water of the Ticino river, and the French abandon the siege; frescoes by Bernardino Lanzoni. Pavia, S. Teodoro; Kaftal, *North West Italy.*

Theodosia, inspired a Christian rebellion against the heretic Patriarch of Constantinople; decapitated; mart. 8th cent. (May 29)
4647 Saint Theodosia (holding a cross, giving a blessing), icon, early 13th cent. Sinai, Monastery of St. Catherine; Manafis, *Sinai.*
See also 1850, 3697

Theodosius Cenobiarch, hermit, d. 529 (Jan. 11)
4648 Saint Theodosius the Cenobiarch, icon fresco of 1514. Galata, Church of the Archangel or Panagia Theotokis; Stylianou, *Painted Churches* (p.94).
4649 Saints Theodosius Cenobiarch, Arsenius, Hilarion, and Onophrius, icon fresco, second decade of the 16th cent. Church of the Transfiguration of the Savior, Palaeochorio; Stylianou, *Painted Churches* (p.272).
4650 St. Theodosius Cenobiarch (standing before his monastery, holding a scroll), icon by Maître Longin, 1572. Decani (Kosovo), Monastery; Bentley, *Calendar.*

Thomas Aquinas, Dominican Theologian, co-patron of Naples, called Doctor Communis or Angeicus, d. 1274, canon. 1323 (Mar. 7)
4651 St. Thomas Aquinas submitting his office to the Pope, predella panel att. to Taddeo di Bartolo, late 14th cent. Philadelphia Museum of Art, PA.
4652 SS. Thomas Aquinas (holding a blazing book), Augustine, Nicholas of Bari, and Mary Magdalene, altar panels by Simone Martini. Pisa, Gallery; Edgell, *Sienese Painting.*
4653 Glorification of St. Thomas Aquinas (he sits with an open book, surrounded by saints holding books open toward him), by an unknown artist of the 14th cent. Pisa, S. Caterina; Kaftal, *Tuscan*; Meiss, *Traini.*
4654 Temptation of St. Thomas Aquinas (two angels place the girdle of chastity around his hips, chasing away a courtesan sent to seduce him), by Bernardo Daddi, 1338. Picture Gallery, Berlin; *Catalogue*; Kaftal, *Tuscan.*
4655 Apotheosis of St. Thomas Aquinas (encircled by saints holding scrolls), by Francesco Traini, mid-14th cent. Pisa, S. Caterina; Burckhardt, *Altarpiece*; McGraw, *Encyclo.* (Vol.XII, pl.375).

4656 St. Thomas Aquinas receiving a book from God, from Strozzi altarpiece by Orcagna or Andrea di Cione. Florence, S. Maria Novella; Coulson, *Saints*; Offner, *Corpus* (Sect.IV, Vol.I, pl.1).
4657 Christ in glory (in the center) with SS. Michael, Catherine of Alexandria, the Virgin, and a kneeling Thomas Aquinas (handing Him a book) at left, and a kneeling Peter, John the Baptist, Lawrence, and Paul at right, polyptych by Andrea Orcagna, 1357. Florence, S. Maria Novella; Hills, *The Light.*
4658 St. Thomas Aquinas (holding a book), right wing of the Coronation of the Virgin altarpiece by Giovanni del Biondo. San Donato in Poggio, Parish Church; Offner, *Corpus* (Sect.IV, Vol.IV, part I, pl.XXXIV).
4659 St. Thomas Aquinas studies in the school of St. Albert the Great at Cologne; Fra Bonfilio sees a star come through the window, in the sick room of St. Thomas; a man miraculously brings sardines to the sickbed of St. Thomas, when none were obtainable; funeral of St. Thomas; the monks hide the body of St. Thomas in the chapel of St. Stephen in the monastery; Fra Paul of Aquila's vision of the soul of St. Thomas received into heaven; frescoes by the Abruzzi School, late 14th cent. Loreto Aprutino, S. Maria del Piano; Kaftal, *Central & So. Ital.*
4660 St. Thomas Aquinas saved from temptation by angels (who wrap a girdle around his loins), panel by the Venetian School, late 14th cent. Kunstmuseum, Zurich; Kaftal, *North East Italy.*
4661 Pope Alexander IV approves the writings of Thomas Aquinas at Anagni, from "The Triumph of St. Thomas" by Benozzo Gozzoli, 15th cent. Louvre, Paris; Brusher, *Popes thru the Ages*; Gowing, *Paintings*; John, *Popes.*
4662 A vision of St. Thomas Aquinas (Christ on the crucifix speaks to him), altarpiece by Sassetta, c. 1423-26. Vatican Museums; Christiansen, *Siena*; De Campos, *Vatican.*
4663 St. Thomas Aquinas before the altar of the Virgin, by Sassetta, c. 1426. Budapest, Museum of Fine Arts; Christiansen, *Siena*; Edgell, *Sienese Painting*; Garas, *Musée*; Verdon, *Christianity.*
4664 St. Thomas Aquinas confounding Averroes (as he preaches, one man sleeps on the floor), by Giovanni di Paolo, 1445-50. St. Louis Art Museum, MO.

231 Thomas Becket

4665 St. Thomas Aquinas (sitting in a black robe, holding an open book), fresco by Andrea Bonaiuti da Firenze. Florence, S. Maria Novella; Kaftal, *Tuscan.*

4666 St. Thomas Aquinas converting heretics (some of them rip pages from their books, some hold their ears), fresco by Andrea Bonaiuti da Firenze. Florence, S. Maria Novella; Kaftal, *Tuscan.*

4667 St. Thomas Aquinas teaching, from "Hours of Etienne Chevalier" by Jean Foucquet, c. 1450. Condé Museum, Chantilly; Porcher, *Medieval Fr. Min.*

4668 St. Thomas Aquinas, fresco by Fra Angelico in the chapel of Nicholas V. Vatican Museums; Boudet, *Rome.*

4669 St. Thomas Aquinas (standing, with an open book), by the school of Sano di Pietro, 1480. Univ. of Arizona Museum of Art, Tucson AZ; *Paintings & Sculpture.*

4670 St. Thomas writing in his cell (a scroll with words comes from the mouth of the crucified Christ), from a destroyed ms. illum. from the "Turin Hours" by Master H. Châtelet, *Early Dutch* (pl.28).

4671 St. Thomas Aquinas (reading, holding a crucifix and a lily), by Marco d'Oggiono. Blois, Musée des B/A; Sedini, *Marco d'Oggiono* (p.99).

4672 St. Thomas Aquinas (holding a church), by Giovanni Battista Bertucci, c. 1512-16. Houston Museum of Fine Arts, TX; *Guide to the Coll.*

4673 Stained glass portrait of St. Thomas Aquinas by Ghirlandaio. Florence, S. Maria Novella; Hallam, *Four Gothic.*

4674 The Sudermann Altarpiece with Saint Thomas (reading) and St. Ursula (reading, holding arrows), by Barthel Bruyn the Elder, 1525-30. Kimbell Art Museum, Fort Worth TX; *Handbook.*

4675 Fra Lorenzo da Bergamo portrayed as St. Thomas Aquinas, by Lorenzo Lotto, 1542. Walters Art Gallery, Baltimore.

4676 Apotheosis of St. Thomas Aquinas (stands on a cloud in discussion with other saints), by Francisco de Zurbaran, 1631. Seville, Museum of Fine Arts; Gállego, *Zurbaran.*

4677 The temptation of St. Thomas Aquinas (angels hold him as a woman runs away), att. to Alonso Cano or Velazquez, c. 1638-44. Orihuela, Museo Dio Cesano; Brown, *Velazquez*; Gudiol, *Velazquez.*

4678 St. Francis of Assisi and St. Thomas Aquinas appear to Fray Lauterio with Our Lady Mary Queen of the Angels to discuss a point of doctrine, in "The Vision of Fray Lauterio" by Bartolomé Esteban Murillo. Fitzwilliam Museum, Cambridge; Catalogue; *Dutch.*

4679 St. Thomas Aquinas (standing, holding a book), by Subleyras. Pinacoteca, Munich; *Subleyras.*

4680 St. Thomas Aquinas (holding a scepter, giving a blessing), pine wood retable with water-based paints, gesso, by the Quill Pen Follower, 1871-80. Taylor Museum for Southwest Studies, CO; Wroth, *Images of Penance.*

See also 94, 483, 895, 1661, 4089

Thomas Becket, Benedictine Archbishop of Canterbury; murdered at the altar, head cleaved with a sword; d. 1170, canon. 1173 (Dec. 19 & 29)

4681 St. Thomas à Becket (holding a book, giving a blessing), 12th cent. mosaic. Sicily, Monreale Cathedral; Read, *Great Art.*

4682 Martyrdom of St. Thomas Becket (he drops his crosier as his head is severed), wall painting, late 12th cent. Tarrasa, Santa Maria d'Egara; Lasarte, *Catalan*; Lassaigne, *Spanish.*

4683 Entombment of St. Thomas of Canterbury, wall painting in an apse of the Church of Santa Maria, Tarrasa, end of 12th cent. Barcelona, Museo d'Art de Catalunya; Souchal, *Early Middle Ages.*

4684 Martyrdom of Becket, from John of Salisbury, "Letters of St. Thomas Becket," MS Cotton Claud. B II, fo.34lr., late 12th cent. BM, London; DeHamel, *Illum. MS.*; Lewis, *Paris.*

4685 Murder of Becket, from a Psalter, MS Harl 5102, f.37 or f.52r., c. 1200. BM, London; Deuchler, *Gothic Art*; Lewis, *Paris*; New Int'l Illus. Encyclo. (see Illum.).

4686 Becket leaves for England after his exile; Becket arrives at Sandwich, from "Life of St. Thomas of Canterbury," c. 1230-40. Private Coll.; Hallam, *Plantagenet.*

4687 Thomas Becket crowning young King Henry, from the "Life of St. Thomas of Canterbury," c. 1230-40. Private Coll.; Besant, *Medieval London*; Fraser, *K. & Q. of England*; Gillingham, *Richard*; Hallam, *Plantagenet.*

4688 Thomas Becket leaving Henry II

of England and Louis VII of France, from "Life of St. Thomas of Canterbury," c. 1230–40. Private Coll.; Hallam, *Plantagenet*; Larousse, *Medieval History*.

4689 Martyrdom of St. Thomas of Canterbury, from Matthew Paris, "Chronica Majora" MS 26, p.263. CCC, Cambridge; Lewis, *Paris*.

4690 Martyrdom of Thomas Becket as he faces assailants, from "Psalter and Hours," cat. 40, f.145v, 13th cent. Walters Art Gallery, Baltimore; Randall, *Manuscripts*.

4691 Becket being appointed chancellor of England; Becket promoted to the see of Canterbury; Becket arguing with King Henry II; Becket's flight from England; all from MS Royal 2 B vii. BM, London; Strutt, *Regal*.

4692 Henry II arguing with Thomas à Becket, illum. from MS Cotton Claud. D. II 70, fol. 70. BM, London; Besant, *Medieval London*; Strutt, *Regal*.

4693 Murder of Becket, from MS Cotton Julius A. XI. BM, London; Strutt, *Regal*.

4694 St. Thomas Becket (enthroned, wearing a pallium, holding a book and giving a blessing), fresco by the Roman School, c. 1300. Subiaco, Sacro Speco; Kaftal, *Central & So. Ital.*

4695 St. Thomas of Canterbury and a kneeling monk donor, by Vitale da Bologna. Bologna, S. Salvatore; Gnudi, *Vitale*.

4696 Scenes from the life of St. Thomas Becket: he is driven from court by Henry II; he sails to France; he is greeted by Pope Alexander III; predella panels att. to Stefano di Sant'Agnese. Venice, S. Zaccaria; Kaftal, *North East Italy*.

4697 Martyrdom of St. Thomas of Canterbury (one man sinks an axe in his head, while another monk tries to defend him with a crucifix), from the "Boucicaut Hours" painted by the Boucicaut Master ms.2,fo.24v. Jacquemart-André Museum, Paris; Meiss, *French Painting*.

4698 Martyrdom of St. Thomas à Becket (he looks back at his murderers, head covered with blood), from the "English Pilgrimage Altar" by Master Francke, 1424. Hamburg, Kunsthalle; Bentley, *Calendar*; *Int'l Dict. of Art*; New Int'l Illus. *Encyclo.*

4699 The mocking of St. Thomas of Canterbury (as he rides away on a white horse), from the English Pilgrimage Altar by Master Francke, after 1424. Hamburg, Kunsthalle; Book of Art, *German & Spanish*.

4700 Martyrdom of St. Thomas à Becket (attacked by four men), by the Master of the First Prayer Book of Maximilian, from the Hours of William Lord Hastings, add. ms.54782, fo.55v, late 1470's. BM, London; BL, *Ren. Painting in MS*.

4701 Funeral of St. Thomas Becket (inside the church, as he lies on a bier surrounded by churchmen, angels descend with a scroll), by Michael Pacher. Landesmuseum, Graz; Gaunt, *Pictorial Art*.

4702 The murder of Thomas à Becket, woodcut from "Golden Legend," Westminster, c. 1484–85. Hind, *Woodcut*.

4703 The murder of Becket, woodcut from Mirk's "Festial," Oxford, 1486. Hind, *Woodcut*.

4704 Funeral of St. Thomas Becket (he lies on a litter, while an archbishop officiates at the funeral), by Giuseppe Vermiglio, c. 1652. Milan, Santa Maria della Passione; Fiorio, *Le Chiese di Milano*.

4705 St. Thomas à Becket in red Episcopal robe, holding a crosier, by Benjamin West, 1797. Toledo Museum of Art, Ohio; Staley, *West*.

4706 Death of Thomas Becket, by John Cross. Canterbury Cathedral; Parrott, *British*.

See also 4085

Thomas More, Chancellor of England under Henry VIII; beheaded, mart. 1535, canon. 1935 (June 22)

4707 Portrait of Sir Thomas More, by Hans Holbein, 1527. NPG, London; Hayes, *NPG*; Piper, *Genius*; Stone, *Mary I*; Sunderland, *Painting*; Williams, *Henry VIII*.

4708 Sir Thomas More and his family at their home in Chelsea, att. to Hans Holbein. Coll. Lord St. Oswald; Milestones, *Expanding*; Williams, *Henry VIII*.

4709 Sir Thomas More and his family, by Rowland Lockey, 1593. NPG, London; Auerbach, *Hilliard*; Hayes, *NPG*.

4710 Sir Thomas More, pen drawing from "Memoriaux" of Antoine Succa,

233 *Tryphon*

4711 Sir Thomas More and his daughter, by John Rogers Herbert, 1844. Nat'l Gallery, London.
See also 3130

Thomas of Hereford or Thomas Cantelupe, Chancellor of England, Bishop of Hereford d. 1282, canon. 1320 (Oct. 3)
4712 St. Thomas of Hereford (standing in a small room, in bishop's robes), ms. illum. by Master of Louthe, ms. A2, fol. 113v. Louvain-la-Neuve University Cathedral; Dogaer, *Flemish Min.*

Thomas of Villanova, Archbishop of Valencia, d. 1555, canon. 1688 (Sept. 22)
4713 St. Thomas of Villanova giving alms to the poor, by Juan de Valdés Leal, 1650's. El Paso Museum of Art, TX; Eisler, *European Schools*; El Paso, *Kress.*
4714 St. Thomas of Villanova giving alms to a cripple (from a pouch), by Francisco de Zurbaran, 1658–64. Private coll., Madrid; Gállego, *Zurbaran.*
4715 St. Tommaso da Villanova distributing alms (in bishop's miter), by Luca Giordano, c. 1658. Naples, S. Agostino degli Scalzi; RA, *Painting in Naples*; Yale Univ., *Taste* (fig.9).
4716 Death of St. Thomas of Villaneuva (falls into the arms of monks, as angels descend), by Lippo Vanni, 1665. Ariccia, Collegiata; Waterhouse, *Roman Baroque.*
4717 St. Thomas of Villanova (in bishop's robes with a cross), polychromed wooden statue by František Ignác Weiss, 1741–43. Prague, St. Catherine's Church; Štech, *Baroque Sculpture.*
4718 St. Thomas of Vilaneuva (as a child) dividing his clothes among the beggar boys (he hands over his cloak, and is about to remove his pants), by Bartolomé Esteban Murillo, 1664–67. Cincinnati Art Museum, OH; *Masterpieces.*

Tibalt
4719 St. Tibalt (in deacon's robes, holding a book), wooden sculpture, late 17th cent. Huy, Couvent des Croisiers; *Tresors.*

Tiburtius or Tiburzio, brother of Valerian, Roman knight; mart. 229 (Apr. 14 & Dec. 15)

See also 4803

Titian *see* **Tiziano**

Tiziano or Titian, Bishop of Lodi, d. 476 (May 4)
4720 St. Tiziano (in bishop's regalia, holding a book and giving a blessing), fresco by the Lombard School, 14th cent. Lodi Vecchio, S. Bassiano; Kaftal, *North West Italy.*
4721 St. Tiziano (in bishop's robes, standing in right profile), by School of Titian, c. 1550–70. Lentiai Parish Church (Belluno); Wethey, *Titian* (pl.232).
4722 Madonna and Child with Saints Andrew and Tiziano (in bishop's robes) and Titian as donor, by Titian and workshop, c. 1560. Pieve di Cadore Parish Church; Wethey, *Titian* (pl.47).

Toribio *see* **Turibius**

Torpes, Roman knight, protomartyr and patron of Pisa; beheaded; 1st cent. (May 17)
4723 Virgin and Child enthroned, with SS. Raniero and Torpes, altarpiece by Turino Vanni, 1347. Pisa, S. Paolo a Ripa d'Arno; Kaftal, *Tuscan.*

Transpadano
4724 St. Transpadano (standing before a wall, holding a palm, with cherubs above his head), etching by Teresa Del Po. Illus. Bartsch; *Ital. Masters of the 17th Cent.* (Vol.45).

Trond *see* **Trudo**

Trudo or Trond, missionary, Abbot, d. 698 (Nov. 23)
4725 St. Trudo and St. Amand, holding the monasteries dedicated to them, in "The Annunciation" triptych by Jean Bellegambe, c. 1516–17. Hermitage, St. Petersburg; Nikulin, *Soviet Museums.*

Tryphon, Roman child martyr, patron of Cattaro (Feb. 3 & Nov. 10)
4726 St. Tryphon called to exorcise the daughter of Emperor Gordian (as the court looks on from the porch, Tryphon exorcises the demon who appears in the shape of a dragon), by Vittore Carpaccio, c. 1508. Venice, S. Giorgio degli Schiavoni; Kaftal, *North East Italy.*
4727 Saint Tryphon, holding a scythe,

with the Dragoman Christophakis and his family, fresco, 1747. Church of St. George of Arpera, near Tersephanou; Stylianou, *Painted Churches* (p.442). *See also* 3697

Turibius Alphonsus de Mogrovejo or Toribio, bishop of Lima, Peru; d. 1606, canon. 1726 (Apr. 27)
4728 St. Turibius (reading, surrounded by angels), by Francesco Trevisani, c. 1726. Rome, S. Anastasia; DiFederico, *Trevisani*; Waterhouse, *Roman Baroque*.

Tuscana, widow nurse of the Order of the Knights Hospitallers of St. John of Jerusalem in Verona, d. 1142 (July 14)
4729 Scenes from the life of St. Tuscana: aiding the sick (she prays at the bedside); she feeds the poor; three youths who mean to assault her fall dead as they find her in prayer; the parents beg her forgiveness and she prays to raise them to life; three thieves steal her cloak and find their hands paralyzed; from an altarpiece by Liberale da Verona. Verona, S. Toscana; Kaftal, *North East Italy*.
4730 St. Tuscana (dressed as a nun, wearing a Maltese cross, holding beads and a book), from an altarpiece by Liberale da Verona. Verona, S. Toscana; Kaftal, *North East Italy*.

Ubaldo, Bishop of Gubbio, patron of masons, d. 1160, canon. 1192 (May 16)
4731 St. Ubaldo (holding a mason's tool), fresco by Ottaviano Nelli, c. 1409. Gubbio, S. Francesco; Kaftal, *Central & So. Ital.*
4732 St. Ubaldo (in bishop's regalia, holding a book), from a triptych by Giovanni Martino Spanzotti. Sabauda Gallery, Turin; Kaftal, *North West Italy*.
4733 St. Ubaldo (standing in bishop's regalia, holding a book, thrusting his crosier into a demon), fresco by the School of Parma, 15th–16th cent. Parma, S. Sepolcro; Kaftal, *North East Italy*.
4734 Saints Ubaldo and Carlo Borromeo (coronation of the Virgin above their heads) by Alessandro Turchi, 1620's. Camerino, S. Venanzio, Italy; McGraw, *Dict.*

Ulfrid or Wolfred, bishop, killed by pagans in Sweden, mart. 1209 (Jan. 18)
4735 St. Ulfrid (reading a book, dressed as a bishop, holding an axe), panel of a

polyptych by Antonio Rosso. Jacquemart-André Museum, Paris; Kaftal, *North East Italy*.

Ulrich, Bishop of Augsburg, d. 973, canon. 993 (July 4)
4736 St. Ulrich (enthroned, holding a fish), fresco by the School of the Alto Adige, 1403. Bolzano, S. Martino; Kaftal, *North East Italy*.
4737 Ulrich, in bishop's regalia, holding a fish, woodcut by Johann Bälmer from "Buch der Natur," Augsburg, 1475. The Illus. Bartsch; *German Book Illus.* (Vol.80, p. 292).
4738 SS. Nicholas of Bari, Ulrich, and Erasmus, woodcut by Albrecht Dürer, Munich, c. 1504. Geisberg, *Single-Leaf*; Strauss, *Woodcuts* (pl.88).
4739 St. Ulrich (standing in bishop's robes, holding a fish), by Hans Burgkmair the Elder, 1518. Picture Gallery, Berlin; *Gemäldegalerie*; *Master Works*; McGraw, *Encyclo.* (Vol.XII, pl.374).
4740 St. Ulrich (with a Bishop's crosier, holding a fish) and St. Barbara (holding a chalice with a host), wings of an altarpiece by Hans Burgkmair, c. 1518. Picture Gallery, Berlin; *Gemäldegalerie*.
See also 4080

Umiltà see **Humility**

Urban I, Pope, d. 230 (May 25)
4741 Pope Urban I, limewood bust by Alstian, c. 1500. Picture Gallery, Berlin; Coulson, *Saints.*
4742 St. Urban I enthroned with angels, fresco by Giulio Romano in the Raphael Rooms. Vatican Museums; Brusher, *Popes.*
See also 4444

Ursicinus, 26th bishop of Ravenna, founded church of St. Apollinare in Classe, 6th cent. (Sept. 9)
4743 St. Ursicinus, standing in an archway, holding a book, mosaic, mid-6th cent. Ravenna, S. Apollinare in Classe; Kaftal, *North East Italy*.
4744 St. Ursicinus (with a short beard), mosaic, c. 650. Rome, S. Apollinare in Classe; Oakeshott, *Mosaics of Rome* (pl.93).
4745 SS. Petronius, Ambrose, and Ursicinus bless one of the crosses of the four boroughs of Bologna; fresco by Giovanni da Modena. Bologna, S. Petronino; Kaftal, *North East Italy*.

Ursula, Virgin; killed with arrows along with her 11,000 virgins; mart. 5th cent. (Oct. 21)

4746 Christ crowning St. Ursula, initial from ms. Cor.12, fo.71, 13th cent. Bologna, Pinacoteca Nazionale; Salmi, *Ital. Miniatures.*

4747 Arrival of St. Ursula and her 10,000 virgins in Basle (they approach the coast in their boats), by Bernardo Daddi, c. 1327. J. Paul Getty Museum, Malibu CA; *Catalogue*; *Western European.*

4748 Martyrdom of St. Ursula and her companions (she stands in the midst of them as they are hacked to pieces before a castle), by the workshop of Bernardo Daddi. Schweizerisches Landesmuseum, Zurich; Offner, *Corpus* (Sect.III, Vol. VIII, pl.X).

4749 St. Ursula's leave-taking, from Life of St. Ursula fresco cycle by Tommaso da Modena, 1349–66. Treviso, Museo Civico; McGraw, *Encyclo.* (Vol.VI, pl.361); New Int'l Illus. *Encyclo.*

4750 St. Ursula (enthroned) with her 10,000 virgins, head of a bier by the Pisan School, 14th cent. Pisa, Museo Civico; Kaftal, *Tuscan.*

4751 St. Ursula (in a green robe, holding two arrows), from the Altar of Berenguer by the Master of Los Marti de Torres, before 1443. Valencia, San Carlos Museum; Lassaigne, *Spanish.*

4752 St. Ursula (in a brocaded cloak, holding a book), by Giovanni di Paolo. Houston Museum of Fine Arts, TX; Christiansen, *Siena.*

4753 St. Ursula with angels (holding a brocaded cloth behind her) and a donatrice, by Benozzo Gozzoli, c. 1455. NGA, Washington DC; Shapley, *Samuel H. Kress.*

4754 St. Ursula holding two arrows, limewood statue by Hans Multscher, 1456–59. Unserer Lieben Frau im Moos, Sterzing; Snyder, *Northern Ren.*

4755 St. Ursula, her maidens, and Pope Ciriacus are massacred by soldiers (and their souls are carried to heaven by angels), fresco by the Neapolitan school under Umbrian influence, 15th cent. Naples, S. Maria Donnaregina; Kaftal, *Central & So. Ital.*

4756 St. Ursula shrine, gilded and painted wood by Hans Memling. Memling Museum, Bruges; Lloyd, *1773 Milestones* (p.135); McGraw, *Encyclo.* (Vol.IX, pl.461).

4757 Martyrdom of St. Ursula (dressed in a sideless surcoat, she is pierced in the chest with an arrow), min. from "Book of Hours of Queen Anne of Brittany" by Jean Bourdichon. BN, Paris; Bentley, *Calendar*; New Int'l Illus. *Encyclo.* (see French).

4758 Martyrdom of St. Ursula (armored man draws his bow, as they stand before several white pavilions), from the shrine of St. Ursula, gilded and painted wood, painted by Hans Memling, 1489. Hospital of St. John, Bruges; Erlande-Brandenburg, *Gothic Art*; Snyder, *Northern Ren.*

4759 Dream of St. Ursula (she is sleeping in a canopy bed, as an angel enters the room), by Vittore Carpaccio, 1490–96. Accademia, Venice; Berenson, *Ital. Painters*; Craven, *Art Master*; Goffen, *Bellini*; Hartt, *Ital. Ren.*; Rowling, *Art Source Book.*

4760 St. Sebastian, St. Ursula and St. Christopher, from thirteen panels of a polyptych, by Guidoccio Cozzarelli, 1490. Philbrook Art Center, Tulsa OK; Shapley, *Samuel H. Kress.*

4761 St. Ursula and the prince taking leave, from the Life of Saint Ursula cycle by Vittore Carpaccio, 1490–95. Accademia, Venice; Denvir, *Art Treasures*; New Int'l Illus. *Encyclo.* (see Venetian Art).

4762 The arrival of St. Ursula at Cologne (at the quai before the bell tower), by Vittore Carpaccio, 1490. Accademia, Venice; McGraw, *Encyclo.* (Vol.III, pl.73); New Int'l Illus. *Encyclo.*

4763 The meeting of St. Ursula with the pope in Rome (surrounded by Cardinals), by Vittore Carpaccio, 1490. Accademia, Venice; Denvir, *Art Treasures*; McGraw, *Encyclo.* (Vol.III, pl.78).

4764 The martyrdom and funeral of St. Ursula, by Vittore Carpaccio, 1493. Accademia, Venice; Denvir, *Art Treasures*; Lloyd, *1773 Milestones* (p.106).

4765 St. Ursula announces her pilgrimage to the court of her father, by the Master of the Legend of St. Ursula, 1490–1500. Louvre, Paris; Gowing, *Paintings.*

4766 The angel appearing to St. Ursula (angel has wings of white, brown, and red feathers) from St. Ursula cycle by Master of St. Severin, c. 1500. Wallraf-Richartz Museum, Cologne; Praeger, *Great Galleries*; Snyder, *Northern Ren.*

4767 St. Ursula Martyr (bust portrait in left profile, with an arrow through her neck), by Brescianino, 1506-27. Bordeaux, Musée des B/A; *Peinture Ital.*

4768 Martyrdom of the eleven thousand virgins (in a harbor scene) att. to Cristovao de Figueiredo, c. 1520. Lisbon, Monastery of Madre de Deus; New Int'l Illus. *Encyclo.*

4769 St. Ursula (towering over the other maidens, who kneel at her feet), by Jan de Beer. Orléans, Musée des B/A; O'Neill, *L'Ecole Francaise.*

4770 The martyrdom of St. Ursula and the eleven thousand virgins, by a Brussels Master, c. 1520. Esztergom Christian Museum; *Christian Art in Hungary* (pl.XVI/413).

4771 Saint Ursula, holding three arrows, in ermine-trimmed dress, by Hans Holbein the younger, 1522. Karlsruhe, Galerie Grand Ducale; Classiques, *Holbein.*

4772 Martyrdom of St. Ursula (boiled in a cauldron), majolica plate by Nicola Pellipario, Urbino, 1528. Florence, Museo Nazionale; Raphael, *Complete Works* (pl.XLIX).

4773 St. Ursula and her virgins (before a bishop; silhouettes of ships in background), by Tintoretto. Venice, S. Lazzaro dei Mendicanti; Tietze, *Tintoretto.*

4774 St. Ursula (towering over her companions), by Bartholomaus Spranger. Nárdoni Galerie, Prague; Kaufmann, *School of Prague.*

4775 St. Ursula Altar (she kneels amidst her companions, who are being murdered), by Ludovico Carracci. Bologna, Pinacoteca Nazionale; Freedberg, *Circa 1600.*

4776 The martyrdom of St. Ursula and her companions, oil sketch by P.P. Rubens, c. 1602. Mantua, Ducal Palace; Held, *Oil Sketches*; Jaffé, *Rubens and Italy.*

4777 Saint Ursula with her companions, Pope Cyriacus, and St. Catherine of Alexandria (under a pyramid with an eye), by Bartolomeo Cavarozzi, 1608. Rome, S. Marco; Met Museum, *Caravaggio.*

4778 The martyrdom of St. Ursula and the 11,000 maidens (they lie in a pile, as executioners drive swords into her chest), oil sketch by P.P. Rubens, 1615-20. Kimbell Art Museum, Fort Worth TX; *Pursuit of Quality.*

4779 The martyrdom of St. Ursula (she holds her breast, which has just been pierced with an arrow) by Caravaggio, 1616. Banca Commerciale Italiana, Naples; Met Museum, *Caravaggio*; RA, *Painting in Naples.*

4780 The martyrdom of St. Ursula (she and her companions are attacked) copy att. to Frans Francken II after P.P. Rubens. BS, Munich; Held, *Oil Sketches* (Vol.I).

4781 The martyrdom of St. Ursula and her companions (men come after them with daggers), oil sketch by P.P. Rubens, c. 1620. Brussels, Musées Royaux des B/A; Baudouin, *Rubens*; Held, *Oil Sketches*; *Peinture Ancienne.*

4782 St. Ursula (half-view in contemporary dress, holding an arrow), by the Florentine School. Walters Art Gallery, Baltimore; *Italian Paintings* (Vol.II).

4783 SS. Ursula (kneeling with a banner), Lucy (holding a plate with eyes) and other saints, adoring the crucified Christ (who stands above the crucifixion scene, holding his cross), by Bernardo Castello. Genoa, Chiesa di S. Maria delle Vigne; Frabetti, *Manieristi.*

4784 Embarkation of St. Ursula (coming down the steps toward waiting gondolas) by Claude Lorrain, 1641. Nat'l Gallery, London; Gowing, *Biog. Dict.*; McGraw, *Dict.*; McGraw, *Encyclo.* (Vol.IX, pl.205); Nat'l Gallery, *London.*

4785 St. Ursula (holding an arrow pointing away from her), by Francisco de Zurbaran, 1641-58. Strasbourg Fine Arts Museum; Gállego, *Zurbaran.*

4786 St. Ursula (in a brocade dress, holding an arrow pointed at her heart), by Francisco de Zurbaran 1641-58. Private Coll., Paris; Gállego, *Zurbaran.*

4787 St. Ursula, holding an arrow pointed at her head, by Francisco de Zurbaran, 1641-58. Bianco Palace, Genoa; Gállego, *Zurbaran.*

4788 St. Ursula with a banner, by Cerrini, 1642. Rome, S. Carlo alle Quattro Fontane; Waterhouse, *Roman Baroque.*

4789 Martyrdom of St. Ursula (men with daggers murder her companions, while Ursula stands in white with a banner), by Lorenzo Pasinelli, c. 1685. Bologna, Pinacoteca Nazionale; *Age of Correggio.*

4790 Martyrdom of St. Ursula (she and her companions are murdered as angels descend with flower wreaths), by

follower of Lorenzo Pasinelli, c. 1700. Walters Art Gallery, Baltimore; *Italian Paintings* (Vol.II).
See also 54, 198, 609, 1054, 3544, 3718, 3947, 4674

Vaast *see* **Vedastus**

Valentine, Roman priest; companion of St. Marius; beheaded; mart. 269 (Feb. 14)
4791 Scenes from the life of St. Valentine: he agrees to cure the son of the rector Croton, who is doubled over by some strange disease; the child cured, Croton is baptized; Valentine is scourged because he refuses to worship idols; Valentine led to execution; frescoes by Master of Bussolengo. Bussolengo, S. Valentino; Kaftal, *North East Italy*.
4792 St. Barbara and St. Valentine with Caspar von Laubenberg and his sons, by an anon. South German artist of the mid-15th cent. North Carolina Museum of Art, Raleigh; *Intro. to the Coll.*
4793 St. Valentine (giving bread to a beggar) and St. Louis of Toulouse, by the school of Master of the Martyr Apostles, c. 1490. Esztergom Christian Museum; *Christian Art in Hungary* (pl.XI/221).
4794 St. Valentine in bishop's miter holding a crosier, statue by Tilman Riemenschneider, c. 1500. Picture Gallery, Berlin; Book of Art, *German & Spanish*.
4795 St. Valentine (in bishop's dress) with kneeling donors, by Lucas Cranach the Elder, 1502. Akademie der Bildenden Künste, Vienna; Friedländer, *Cranach*; Schade, *Cranach*.
4796 St. Valentine (blessing a plague victim), drawing by Lucas Cranach the Elder, 1510. Staatliche Graphische Sammlung, Munich; Schade, *Cranach*.
See also 4280

Valerian, husband of St. Cecilia, brother of St. Tiburtius (or Tiburzio), Roman knight, mart. 229 (Apr. 14 & Dec. 15)
4797 St. Peter and St. Valerian, mosaic, c. 800–25. Rome, Sta Cecilia in Trastevere; Oakeshott, *Mosaics of Rome* (pl.131).
4798 Wedding feast of St. Cecilia and St. Valerian, panel painting by Master of St. Cecilia, early 14th cent. Uffizi, Florence; McGraw, *Encyclo.* (Vol.VIII, pl.183).

4799 Saints Cecilia and Valerian (sitting on a long bench, she urges him to convert) from a predella by Bernardo Daddi. Pisa, Museo Civico; McGraw, *Encyclo.* (Vol.IV, pl.105).
4800 St. Valerian (holding a palm), fresco by the Piedmontese School, c. 1450. Marentino, S. Maria Assunta della Madonna dei morti; Kaftal, *North West Italy*.
4801 St. Valerian, holding a sword and wreath of flowers, by Master of the Braunschweig Diptych, c. 1490. Rijksmuseum, Amsterdam; *Paintings*.
4802 SS. Cecilia and Valerian (as he enters the room, an angel descends with a circlet of flowers for each of them), by Lelio Orsi. Borghese Gallery, Rome; Briganti, *Ital. Mannerism*; Denvir, *Art Treasures*.
4803 The martyrs Valerian, Tiburzio, and Cecilia (the three saints look up at an angel that descends with a palm and flower wreath), by Orazio Gentileschi and studio. Bob Jones Univ. Art Gallery, Greenville, SC; Pepper, *Ital. Paintings*.
See also 1265, 1278, 1289

Valéry
4804 St. Valéry appearing to King Hugh Capet (as he sleeps), from "Grandes Chroniques" illus. by the Boucicaut Master, ms.Cotton Nero E.II,I,fo.29. BM, London; Meiss, *French Painting*.

Vedastus or Vaast, Bishop of Arras, d. 539 (Feb. 6)
4805 St. Vaast (greeting a wild animal before a small building), woodcut by Günther Xanier from "Leben der Heiligen, Winterteil," Augsburg, 1471. The Illus. Bartsch; *German Book Illus.* (Vol.80, p.72).
See also 468

Venantius, Roman knight, patron of Camerino and Fabriano; beheaded; mart. 250 (May 18)
4806 St. Venantius (standing with a palm and a book), fresco by the School of Giotto, 1337. Bargello, Florence; Kaftal, *Tuscan*.
4807 St. Venantius of Camerino (standing with a palm and holding a banner), from a polyptych by A. Nuzi. Fabriano, Pinacoteca; Kaftal, *Central & So. Ital.*
4808 St. Venantius (holding a banner

and a model of the city), panel of a polyptych by Paolo Veneziano. San Severino Marche, Pinacoteca Civica; Kaftal, *North East Italy*.

4809 St. Venantius of Camerino (standing with a banner, and holding a model of a city), from a polyptych by Giovanni Boccati, 1468. Belforte Sul Chienti, S. Eustachio; Kaftal, *Central & So. Ital.*

4810 St. Venantius (standing before a landscape, holding a banner and a model of a castle), by Girolamo da Santacroce. Nat'l Gallery, London; Bentley, *Calendar*.

4811 Martyrdom of St. Venantius of Camerino (about to be decapitated in a landscape before a castle), by Scarsellino, c. 1595. Sarah Campbell Blaffer Found., Houston, TX; *Age of Correggio*.

Venceslav *see* **Wenceslas**

Veranus, Bishop of Cavaillon
4812 St. Veranus curing the insane (they wait in a crowd, inside of Notre Dame Cathedral), min. by Jean Foucquet from the Hours of Etienne Chevalier, c. 1453. Wildenstein Found., NY; Fouquet, *Hours*.

Verecundius
4813 St. Verecundius gives the habit of his order to St. Giles in the wilderness, from an altarpiece by the school of Lorenzo da Viterbo. Orte, Cathedral; Kaftal, *Central and So. Ital.*

Victor, Roman knight, patron of Osimo, Otricoli & Vallerano; patron of prisoners; beheaded after torture; mart. 178 (May 8 & 14)
4814 St. Victor of Siena (with a sword and a palm) and St. Catherine of Alexandria (with a crown and a palm), altarpiece panels by an unknown Sienese painter, c. 1340. Royal Museum of Fine Arts, Copenhagen; Van Os, *Sienese Altarpieces* (Vol.I pl.97 & 98).

4815 St. Victor (holding a sword), fresco by the Veronese School, late 14th cent. Sommacampagna, S. Andrea; Kaftal, *North East Italy*.

4816 St. Victor (standing, holding a sword and an olive branch), by Lippo Memmi. Copenhagen Fine Arts Museum; Kaftal, *Tuscan*.

4817 St. Victor (riding a horse, dressed in armor), from a breviary by the Boucicaut

workshop, ms.2, fo.237, before 1415. Châteauroux, Biblio. Municipale; Meiss, *French Painting*; Sterling, *Peinture Médiévale*.

4818 St. Victor (standing, holding a banner with the arms of Feltre, and holding a book), fresco by the School of the Veneto, c. 1450. Vittorio Veneto, S. Lorenzo; Kaftal, *North East Italy*.

4819 St. Victor (in armor, holding a banner and a shield) and a donor, by the Master of Moulins, 1480-1500. Glasgow Art Gallery; Gaunt, *Pictorial Art*.

4820 Madonna and Child with Saints John the Baptist, Victor, Bernard, and Zenobius, by Filippino Lippi, 1485-86. Uffizi, Florence; Newsweek, *Uffizi*.

4821 St. Victor (in armor, with a banner and holding a palm), by Bernardo Zenale, c. 1490-95. Grenoble, Musée de Peinture et de Sculpture; Chiarini, *Tableaux Italiens*; Kaftal, *North West Italy*.

4822 St. Victor (standing with a banner, holding a model of the city of Vallerano), panel of a triptych by Gabriele di Francesco. Vallerano (Viterbo), S. Andrea; Kaftal, *Central & So. Ital.*

4823 St. Victor brought before judge Sebastian (and his court); St. Victor tied to a trestle-board and beaten with clubs; panels by Pietro di Giovanni Ambrogi. Vatican Museums; Kaftal, *Tuscan*.

4824 Martyrdom of St. Victor (he kneels, in armor, as executioner is about to strike), by Giulio Cesare Procaccini. Milan, San Vittore al Corpo; Fiorio, *Le Chiese di Milano*.

4825 Martyrdom of St. Victor (about to be decapitated, as a Roman commander looks on), by Giambattista Tiepolo. Milan, S. Ambrogio; Morassi, *Catalogue* (pl.143).
See also 206, 207

Victor I, Pope, r. 189-199 (July 28)
4826 St. Victor I, fresco by Ghirlandaio in the Sistine Chapel. Vatican Museums; Brusher, *Popes*.

Victoria or Vittoria, patron of Pisoniano, stabbed thru the heart (Dec. 23)
4827 St. Victoria (standing with a banner, holding a palm), fresco by Marchigian School, 15th cent. Patrignone, Parish Church; Kaftal, *Central & So. Ital.*

4828 Martyrdom of Saint Victoria (exe-

cutioner pulls her forward by the hair, while brandishing a dagger), by Giovanni Antonio Burrini, c. 1682-83. Château du Compiègne; *Age of Correggio.*

Victorinus or Vittorino, Bishop of Assisi, roasted in a furnace and beheaded
4829 St. Victorinus (standing in bishop's robes, giving a blessing), fresco in the Umbro-Roman tradition, 1330-40. San Francesco, Assisi; Kaftal, *Central & So. Ital.*
4830 Martyrdom of St. Vittorino (he is tied to a table and beaten with sticks), by the school of Sassetta. Vatican Museums; Edgell, *Sienese Painting.*

Vincent, deacon of Saragossa; drowned with millstone around his neck; mart. 304 (Jan. 22)
4831 Scenes from the life of St. Vincent: preaching; tortured by fire; Vincent in prison; ascending to heaven; his body protected by foxes from the ravens; body sinks into the sea weighted with a millstone; detached from the rack; stained-glass window from Abbey of Saint-Germain-des-prés, c. 1245. Walters Art Gallery, Baltimore.
4832 St. Vincent (standing in left profile, holding a palm and a millstone), panel of a polyptych by the Bolognese School, early 15th cent. Bologna, Collezioni Communali d'Arte; Kaftal, *North East Italy.*
4833 The veneration of Saint Vincent, with King Alfonso V of Spain, six panels by Nuño Goncalves, 1450-71. Lisbon, Museu Nacional de Arte Antiga; Bentley, *Calendar*; Erlande-Brandenburg, *Gothic Art*; European Painting, *15th Cent.*; Gaunt, *Pictorial Art*; New Int'l Illus. *Encyclo.* (see Portuguese).
4834 Saints Eustace (in a red robe, holding a book and palm), James (with a staff) and Vincent (holding a palm), from St. Miniato Altarpiece by Antonio del Pollaiuolo, 1460's. Uffizi, Florence; McGraw, *Dict.*; McGraw, *Encyclo.* (Vol.XI, pl.182).
4835 Ordination of Saint Vincent, by Jaime Huguet. Barcelona, Museo d'Art de Catalunya; New Int'l Illus. *Encyclo.*
4836 St. Vincent (blessing two men in armor, as ecclesiastics look on), by Nuño Goncalves. Lisbon, Museu Nacional de Arte Antiga; Larousse, *Painters.*
4837 Martyrdom of St. Vincent (tied to a cross leaning against a table, flogged, burned with brands), black ink drawing by an unknown artist, Est. Hennin, n.11148, t.126. BN, Parish; Puppi, *Torment.*
4838 St. Vincent, in mantle of deacon, stands behind kneeling donatrice, from altarpiece by Gerard David, c. 1509. Met Museum; Jules S. Bache, *Catalogue*; Miegroet, *David.*
4839 St. Vincent (kneeling in the wilderness with his attributes, looking up at the Virgin in the clouds), by Ludovico Carracci. Bologna, Palazzo Magnani; Freedberg, *Circa 1600.*
4840 Saint Vincent in a dungeon (with a millstone around his neck, flanked by Peter and another saint, before a window showing the boat carrying his body out to sea), by the School of Ribalta. Hermitage, St. Petersburg; Eisler, *Hermitage.*
See also 185, 4475

Vincent de Paul, d. 1660, canon. 1737 (July 19)
4841 St. Vincent de Paul, copy of a portrait by Simon Francois of Tours, 1660. Lazarist Motherhouse, Paris; Coulson, *Saints.*

Vincent Ferrer, Dominican priest, mart. 1419, canon. 1455 (Apr. 5)
4842 St. Vincent Ferrer (holding an open book, with a cleaver in his head), fresco by Lazzaro Vasari. Arezzo, S. Dominico; Boase, *Vasari.*
4843 St. Vincent Ferrer (holding a lettered scroll which loops around his head), by Jacomart. Valencia Cathedral; Book of Art, *German & Spanish.*
4844 St. Vincent Ferrer preaching outside of a church; in 1410, St. Vincent exorcises a possessed woman; two men who try to murder St. Vincent find their arms paralyzed; St. Vincent resuscitates a child who was cut up and cooked by its mother, who wanted to serve it to its father and Vincent; from an altarpiece by the Sicilian School, 15th cent. Castelvetrano, S. Domenico; Kaftal, *Central & So. Ital.*
4845 St. Vincent Ferrer resuscitates a dead woman at her funeral; St. Vincent multiplies 15 loaves of bread to feed 2000 men; St. Vincent cures a crowd of cripples; St. Vincent stops a thunderstorm; funeral of St. Vincent; St. Vincent saves a child who drowned in a well (post-

humously); from an altarpiece by the Sicilian School, 15th cent. Castelvetrano, S. Domenico; Kaftal, *Central & So. Ital.*

4846 Scenes from the life of St. Vincent Ferrer, from the Griffoni Altarpiece by Ercole de Roberti. Vatican Museums; McGraw, *Encyclo.* (Vol.XII, pl.155).

4847 St. Vincent Ferrer in black cloak and white robe, holding an open book in left hand and pointing up with right hand, standing on a red-draped pedestal, from the dismembered Griffoni polyptych by Francesco del Cossa, c. 1473. Nat'l Gallery, London; Bentley, *Calendar*; Dunkerton, *Giotto to Dürer*; Wilson, *Nat'l Gallery*; United Nations, *Dismembered Works.*

4848 The miracles of St. Vincent Ferrer, by Francesco Cossa, 1473. Vatican Collection; Berenson, *Ital. Painters*; Lloyd, *1773 Milestones* (p.107).

4849 Scenes from the life of St. Vincent Ferrer: he converts and baptizes infidels; a mad woman cuts up her child and serves him to the saint; Vincent brings the infant back to life; while preaching at Murcia, he stops galloping horses, who would have trampled his brethren; from a polyptych by Bartolomeo degli Erri, c. 1475. KM, Vienna; Kaftal, *North East Italy.*

4850 Scenes from the life of St. Vincent Ferrer: his father brings him as a child to join the Order; the devil tempts him to leave the Order, but he is saved by the Virgin; he preaches at Avignon in the presence of Pope Benedict XIII; he falls ill, but Jesus appears at his bedside and cures him; Benedict XIII sends him out to preach the Gospel; from a polyptych by Bartolomeo degli Erri, c. 1475, KM, Vienna; Kaftal, *North East Italy.*

4851 St. Vincent Ferrer resuscitates a Spanish jewess (killed by a falling portico), predella panel by Francesco del Cossa and Ercole de'Roberti, 1475-77. Vatican; Kaftal, *North East Italy.*

4852 Posthumous miracles of St. Vincent Ferrer: he resuscitates a drowning woman; he saves a woman and child from a crumbling building; he saves an infant from a burning building and puts the fire out; he saves a man from execution; predella panels by Giovanni Bellini. Venice, SS. Giovanni e Paolo; Kaftal, *North East Italy*; New Int'l Illus. *Encyclo.* (see Venetian Art).

4853 St. Vincent Ferrer (pointing up with his right hand), by Fra Bartolommeo. Florence, San Marco; Fischer, *Fra Bartolommeo* (fig.113).

4854 St. Vincent Ferrer in glory (raised to heaven on a cloud, open book in hand, pointing upward), by Lorenzo Lotto. Recanati, S. Domenico; Berenson, *Lotto.*

4855 St. Vincent Ferrer (pointing up), by Francisco de Zurbaran 1631-40. Guillermo Bernstein, Madrid; Gállego, *Zurbaran.*

4856 St. Vincent Ferrer (holding a book and a lily, pointing up to a horn in upper left corner), by Giambattista Tiepolo. Coll. Venier, Milan; Morassi, *Catalogue* (pl.173).

See also 597, 3409, 4095, 4857

Vincent the Martyr

4857 St. Vincent the Martyr (tied to a cross) and St. Vincent Ferrer (refusing to allow a man entry into a building) by Bernardo Martorell, 1437-52. Hermitage, St. Petersburg; *Old Master.*

4858 St. Vincent Martyr worshipping the Madonna and Child (he points toward an urn filled with coals, kneeling in the wilderness), by Ludovico Carracci, c. 1584. Coll. Credito Romagnolo, Bologna; *Age of Correggio.*

Vitalis, Roman knight; beaten to death or buried alive after tortures; 2nd cent. (Apr. 28)

4859 Saint Vitalis holding a mace, panel from a dismembered altarpiece att. to Niccolo di Segna, c. 1340. Atlanta Art Assoc. Galleries, Atlanta GA; Shapley, *Samuel H. Kress.*

4860 The martyrdom of St. Vitalis (as a cherub comes down from a cloud), by Federico Barocci, 1583. Brera, Milan; Book of Art, *Ital. to 1850*; Boschloo, *Carracci.*

4861 Martyrdom of St. Vitalis (they throw him into a pit), chalk drawing after Federigo Barocci by P.P. Rubens, c. 1605. Wilton House, Salisbury; *Catalogue*; Jaffé, *Rubens and Italy.*

4862 St. Gregory the Great and St. Vitalis interceding for souls in purgatory, by Sebastiano Ricci, c. 1730-34. Paris, St. Gervais et St. Protais; Daniels, *Ricci.*

See also 2531

Vittoria *see* **Victoria**

Vittorino *see* **Victorinus**

Vitus, patron saint of dancers and actors, patron of Paestum; invoked against epilepsy and against "St. Vitus dance"; beheaded, mart. 300 (June 15)
4863 Scenes from the life of St. Vitus: he restores his pagan father's sight, after the father tried to offer a bull to Jupiter; he is accused of being a Christian, with his nurse Crescentia; he is put in a boiling cauldron; nails are driven into his head; panels by the Provincial Tuscan School, 15th cent. Vatican Museums; Kaftal, *Tuscan.*
4864 St. Catherine of Alexandria (in a houpelande) and St. Vitus with Anna von Frieberg and her daughters, by an unknown German artist of the mid-15th cent. North Carolina Museum of Art, Raleigh; *Intro. to the Coll.*
4865 St. Vitus (standing, dressed as a young nobleman, holding a palm, with a dog at his feet), fresco by Antoniazzo Romano, 1483. Rome, SS. Vito e Modesto; Kaftal, *Central & So. Ital.*
4866 Bust of St. Vitus, embossed silver, partly gilt, c. 1484. Prague, St. Vitus Cathedral; Korejsi, *Ren. Art in Bohemia.*
4867 St. Vitus in a caldron of oil (he is immersed to his waist, and clasps his hands), linden wood sculpture by Veit Stoss, 1520. Germanisches Nationalmuseum, Nuremberg; Met Museum, *Gothic Art.*
4868 St. Wenceslas (in armor) and St. Vitus (with orb and palm), by Bartholomaus Spranger. Zámecká Galerie, Duchcov; Kaufmann, *School of Prague.*
4869 St. Vitus (standing on a rock with lions), statue on Charles Bridge by Ferdinand Maximilian Brokoff, 1714. Prague; Štech, *Baroque Sculpture.*
4870 St. Vitus (with a rooster, holding a book), statue by Andreas Philip Quitainer, 1720-21. Prague, St. Thomas Church; National Gallery, *Baroque*; Štech, *Baroque Sculpture.*
See also 9, 3710, 4444, 4882, 4884

Viviana *see* **Bibiana**

Walburga *see* **Walpurgis**

Walpurgis or Walburga
4871 St. Amandus (reading) and St. Walburga, study for the "Raising of the Cross" altarpiece, oil sketch by P.P. Rubens, 1609. Dulwich College Picture Gallery, London; Murray, *Catalogue*; Rowlands, *Rubens, Drawings.*

4872 Saint Walpurgis in a nun's habit, reading, panel from an altarpiece by Master of Messkirch, c. 1530-43. Philadelphia Museum of Art, PA.
4873 St. Walburga (standing with a crosier, reading), statue. Eichstatt Cathedral, Germany; Bentley, *Calendar.*
4874 The miracle of St. Walburga (rescues a boat about to be lost in a tempest), by P.P. Rubens, 1610-11. Leipzig, Museum der Bildenden Künste; White, *Rubens.*
See also 131, 2531, 4902

Wandregisil or Wandrille, founded abbey of Fontenelle, d. 668 (July 22)
4875 Scenes from the "Life of St. Wandregisil" (he is approached by an angel before the king), from ms.764, f.9, 10th cent. Saint-Omer Library; Porcher, *Medieval French Min.* (fig.7).

Wandrille *see* **Wandregisil**

Wenceslas or Venceslav, King and Patron of Bohemia; stabbed with lance; mart. 929 or 935 (Sept. 28)
4876 St. Wenceslas bakes the hosts and carries them away, from the cycle of the legend of St. Wenceslas frescoes by Master Oswald, 1360-61. Karlstejn Castle; Stejskal, *Charles IV.*
4877 St. Wenceslas' body being taken to Prague (on a litter), fresco soon after 1360. Karlstejn Castle; Bachmann, *Gothic Art.*
4878 The Virgin and St. Wenceslas, preparatory drawing by Master Oswald, c. 1360. Stockholm, Biblio. Royale; Stejskal, *Charles IV.*
4879 St. Wenceslas (with spear and shield), polychromed limestone statue, 1373. Prague, St. Vitus Cathedral; Kutal, *Gothic Art*; Stejskal, *Charles IV.*
4880 Wenceslaus of Bohemia, holding his heraldic shield, marble sculpture by the Brothers Parler, 1373. Prague, St. Wenceslaus; Coulson, *Saints.*
4881 King Wenceslas and Sophia of Bavaria (enthroned), from the Wenceslas Bible, c. 1390-95. Vienna, National Library; Bachmann, *Gothic Art.*
4882 SS. Wenceslas (holding a banner and a sword and shield), and Vitus (holding a palm and an orb), panel from the altarpiece from Dubeček, c. 1405. Prague, Nat'l Gallery; Bachmann, *Gothic Art.*

4883 Bust of St. Wenceslas embossed silver, before 1487. Prague, St. Vitus Cathedral; Korejsi, *Ren. Art in Bohemia.*

4884 St. Wenceslas receiving the relic of St. Vitus's arm from the emperor, from the Master of the Leitmeritz altarpiece, c. 1510. Prague, St. Vitus Cathedral; Bachmann, *Gothic Art.*

4885 Portrait of a man as St. Wenceslas (in armor, his back to the viewer, pointing out the window to the Virgin and Child), by Lorenzo Lotto. Tadini Gallery, Lovere; Berenson, *Lotto*; Pallucchini, *Cariani.*

4886 Equestrian statue of St. Wenceslas (holding a banner), by Johann Georg Bendl, 1678–80. Prague; Štech, *Baroque Sculpture.*

4887 St. Wenceslas (looking heavenwards), statue from Charles Bridge in Prague by Ottavio Mosto, c. 1698. Prague, Nat'l Museum; Štech, *Baroque Sculpture.*

4888 St. Ludmilla with St. Wenceslas, sculpture by Matthias Bernard Braun, 1710. Charles Bridge, Prague; Štech, *Baroque Sculpture.*

4889 Martyr's death of St. Wenceslas (he grabs a doorknocker while executioner holding dagger grabs his back), sculpture by the workshop of Matthias Bernard Braun. Stará Boleslav, Chapter Church; Štech, *Baroque Sculpture.*
See also 3485, 4868, 4890

Wendelin
4890 St. Wendelin (with a herd of sheep); St. Euphemia (stabbed through the thigh); St. Maurice (and the Thebian Legion); St. Thecla (standing before a fire); SS. Cosmas and Damian (hung by their arms wrapped over a post); St. Wenceslas (decapitated); woodcuts by Günther Zainer from "Leben der Heiligen, Sommerteil," Augsburg, 1472. The Illus. Bartsch; *German Book Illus.* (Vol.80, pp.92–93).

Widoc
4891 St. Widoc (standing with a pilgrim's staff, reading from a book), ms. illum. by the School of Lieven van Lathem, ms. Douce 381, fol. 83r, c. 1468. Bodleian Library, Oxford; Dogaer, *Flemish Min.*

Wilfrid, Celtic monk, d. 709 (Oct. 12)
4892 St. Wilfrid, statue, 15th cent. Ripon Minster, Yorkshire; Coulson, *Saints.*

William of Aquitaine or William of Gellone, Duke of Aquitaine, Benedictine, founded monastery at Gellone, d. 812 (May 28)
4893 St. William of Gellone (standing in the wilderness holding a helmet) from the "Boucicaut Hours" painted by the Boucicaut Master, ms.2,fo.43v. Jacquemart-André Museum, Paris; Meiss, *French Painting.*

4894 Madonna and Child (enthroned under an arch) with Saints John the Baptist and St. William of Aquitaine (in Gothic armor), by Ercole di Giulio Cesare Grandi. Nat'l Gallery, London; Poynter, *Nat'l Gallery.*

4895 Coronation of the Virgin with Saints Augustine and William of Aquitaine, by Giovanni Lanfranco. Louvre, Paris; Gowing, *Paintings.*

4896 Investiture of St. William of Aquitaine (as Holy Family looks on) by Guercino. Bologna, Pinacoteca Nazionale; Merriman, *Crespi.*

4897 St. William of Aquitaine (wearing a helmet, standing barefoot next to a fallen banner), by Francisco de Zurbaran, 1641–58. Private Coll., Paris; Gállego, *Zurbaran.*
See also 4898

William of Bourges, Archbishop, d. 1209 (Jan. 10)
4898 St. William, Archbishop of Bourges, and St. William of Aquitaine (holding a banner) in "The Annunciation" triptych by Jean Bellegambe, c. 1516–17. Hermitage, St. Petersburg; Nikulin, *Soviet Museums.*

William of Gellone *see* **William of Aquitaine**

William of York, William Fitzherbert, Archbishop of York, d. 1154 (June 8)
4899 St. William of York, mural painting, early 14th cent. Hertfordshire, St. Albans Cathedral; Bentley, *Calendar*; Coulson, *Saints.*

William the Hermit
4900 Apparition of the Virgin to St. William, Hermit (he reacts in surprise when he sees her, and an angel supports him), by Pierre Thys the Elder. Koninklijke Museum, Antwerp; Hairs, *Sillage de Rubens.*

Willibald, West Saxon bishop of Eichstätt, d. 786 (June 7)
4901 St. Willibald (watching the construction of his abbey); St. Cyriacus (they are pouring hot lead on his head); St. Hippolytus (tied to a tree and flayed); St. Sebaldus (joining the hands of two youths); St. Louis IX (washing a man's feet); St. Giles (with the hind); woodcuts by Günther Zainer from "Leben der Heiligen, Sommerteil," Augsburg, 1472. The Illus. Bartsch; *German Book Illus.* (Vol.80, pp.89–90).
4902 SS. Willibald and Walpurgis adored by Gabriel von Eib, Bishop of Eichstätt, by Lucas Cranach the Elder, 1520. Bamberg, Staatsgalerie; Friedländer, *Cranach.*
4903 St. Bavo (at center, slightly elevated) flanked by SS. James the Greater and Willibald (holding a book with a naked infant), by the school of Lancelot Blondel, c. 1569. Bruges, State Museum; Pauwels, *Musée Groeninge.*

Winebald, English pilgrim, founded double monastery with St. Walburga at Heidenheim, d. 761 (Dec. 18)
4904 St. Winebald (holding a crosier, reading a book), statue. Eichstatt Cathedral; Bentley, *Calendar.*
4905 St. Winebald (before a castle); St. Sylvester (facing St. Helena); Erhard (baptizing another saint); St. Makarios (nude, stung by a bee); St. Felix (about to be beheaded with a cleaver); St. Maurus the Abbot (before the monastery); St. Marcellus I (blessing a woman); St. Anthony Abbot (beaten by demons); woodcuts by Günther Xainer from "Leben der Heiligen, Winterteil," 1471. The Illus. Bartsch; *German Book Illus.* (Vol.80, pp.68–70).

Wolfgang, Bishop of Regensburg, d. 994, canon. 1052 (Oct. 31)
4906 St. Wolfgang forces the devil to hold his prayer-book, panel from Altar of the Fathers of the Church by Michael Pacher, c. 1481. Alte Pinakothek, Munich; Bentley, *Calendar*; Book of Art, *German & Spanish*; Gardner, *Art thru Ages*; New Int'l Illus. *Encyclo.* (see German).
4907 Saint Wolfgang praying for a miracle (his face in his hands) as an angel puts a tabernacle on an altar, from "The Fathers of the Church" altarpiece by Michael Pacher, c. 1483. Alte Pinako-

thek, Munich; New Int'l Illus. *Encyclo.*; Snyder, *Northern Ren.*
4908 St. George (with his foot on the dragon's face) and St. Wolfgang (in bishop's robes, holding a model of a church and an axe) by the Master of the Hasbuch, late 15th cent. Nelson-Atkins Museum of Art, Kansas City MO; *Handbook.*
4909 Saint Wolfgang holding a model of a cathedral, woodcut by Albrecht Dürer from the "Salus Animae" of 1503. Strauss, *Woodcuts* (pl.72).
4910 St. Wolfgang (in bishop's robes, holding a crosier, a model of a church, and a hatchet), woodcut by Hans Sebald Beham, Coburg, c. 1525. Geisberg, *Single-Leaf.*
See also 3726

Wolfred *see* **Ulfrid**

Yrieix
4911 Reliquary head of St. Yrieix, from the church of St. Yrieix, Limoges, silver with cabochons, 13th cent. Met Museum; Hibbard, *Met Museum.*

Yves *see* **Ives**

Zacharias *see* **Zachary**

Zachary or Zacharias, Pope, d. 752 (Mar. 15)
4912 Annunciation to St. Zachary (angel with a scroll appears to him at mass), wall mural by unknown artist. Embrun, Eglise des Cordeliers; *Peintures Murales.*
4913 Saint Zacharias, stone statue by Vittoria, c. 1599. Venice, S. Zazzaria; New Int'l Illus. *Encyclo.*

Zeno, of Verona, Bishop of Verona, wrote earliest Latin homilies still in existence, 4th cent. (Apr. 12)
4914 St. Zeno of Verona (in bishop's regalia, giving a blessing), from "Three Saints" by Bartolommeo Mantegna. Nat'l Gallery, London; Bentley, *Calendar.*

Zenobius, patron and bishop of Florence, d. 4th cent. (May 25)
4915 St. Zenobius in bishop's robes, giving a blessing, marble statue by workshop of Arnolfo di Cambio, 1296–1310. Florence, Museo dell'Opera del Duomo; Andres, *Art of Florence* (vol.I, fig.35).

4916 St. Zenobius (enthroned, flanked by two priests) with scenes from his life (in one scene, he exorcises a youth), fresco by the Bigallo Master. Florence, Museo dell'Opera del Duomo; Hills, *The Light*; Kaftal, *Tuscan.*

4917 St. Zenobius raising a child crushed under a cart; the funeral of St. Zenobius, miniature taken from a choir book by the Master of the Dominican Effigies. Coll. M. Salmi, Rome; Salmi, *Ital. Miniatures.*

4918 Silver and silver gilt reliquary bust of St. Zenobius, by Andrea Arditi, c. 1330. Florence Cathedral; New Int'l Illus. *Encyclo.* (see Reliquary).

4919 St. Zenobius (half-view, in left profile, in bishop's robes), by an assistant of Daddi. York City Art Gallery; *Catalogue.*

4920 St. Zenobius (enthroned, with kneeling deacons), by Giovanni del Biondo. Florence Cathedral; Meiss, *Painting in Florence* (pl.70).

4921 Meeting of St. Zenobius and St. Ambrose (with SS. Sebastian and Apollonia looking on), by Neri di Bicci. Coll. R. M. Hurd, NY; Kaftal, *Tuscan.*

4922 Miracle of the dead body, from the shrine of St. Zenobius, bronze sepulcher by Lorenzo Ghiberti, after 1436. Florence Cathedral; Andres, *Art of Florence* (Vol.I, pl.283).

4923 A miracle of St. Zenobius (praying in a city street, over the body of a man bleeding from the head) by Domenico Veneziano, before 1438. Fitzwilliam Museum, Cambridge; Catalogue, *Italian*; United Nations, *Dismembered Works.*

4924 Sacra Conversazione, with Madonna and Child and Saints Francis of Assisi, John the Baptist, Zenobius and Lucy, by Domenico Veneziano. Uffizi, Florence; Andres, *Art of Florence* (Vol.I., pl.356); Janson, *History* (colorpl.52); McGraw, *Dict.*; New Int'l. Illus. *Encyclo.* (see Domen.).

4925 Madonna and Child enthroned, flanked by SS. Zenobius, John the Baptist and kneeling Jerome at left, and SS. Peter, Dominic, and kneeling Francis of Assisi at right, by Benozzo Gozzoli, 1461. Nat'l Gallery, London; Hall, *Color and Meaning.*

4926 St. Zenobius raising a boy from the dead, by Benozzo Gozzoli, 1461-62. Picture Gallery, Berlin; *Catalogue.*

4927 St. Zenobius (in bishop's regalia,

holding a crosier and a book, with a kneeling donor), by Gerini. Florence, Cathedral; Kaftal, *Tuscan.*

4928 Early life and first miracle of St. Zenobius (baptized, made into a bishop), by Sandro Botticelli, c. 1500-05. Nat'l Gallery, London; Dunkerton, *Giotto to Dürer*; Kaftal, *Tuscan*; Lightbown, *Botticelli.*

4929 Three miracles of St. Zenobius (exorcising the sick, restoring a dead child, saving an injured man), by Sandro Botticelli, c. 1500-05. Nat'l Gallery, London; Dunkerton, *Giotto to Dürer*; Kaftal, *Tuscan*; Lightbown, *Botticelli.*

4930 Ninth miracle and death of St. Zenobius, by Sandro Botticelli, 1503. Picture Gallery, Dresden; *Old Masters*; Lightbown, *Botticelli*; New Int'l Illus. *Encyclo.*

4931 Three miracles of St. Zenobius (curing the sick, raising the dead), by Sandro Botticelli. Met Museum; Lightbown, *Botticelli*; McGraw, *Encyclo.* (Vol.II, pl.332).

4932 Madonna and Child (standing on a pedestal), flanked by SS. Jerome (reading a book) and Zenobius (hands clasped in prayer), by Mariotto Albertinelli. Augustinian Museum, Toulouse; McKillop, *Franciabigio.*

4933 Translation of the body of St. Zenobius, by Ghirlandaio, 1517. Uffizi, Florence; Ancona, *Garden* (fig.44); Murray, *Art & Artists.*

4934 San Zenobius restoring life to a dead child, by Jacopo da Empoli. Nat'l Gallery, London; Poynter, *Nat'l Gallery.*
See also 3507, 4820

Zenophon
4935 Bust of St. Zenophon, fresco, 1176-80. Patmos; Kominis, *Patmos* (p.87).

Zephyrinus, Pope, r. 199-217 (Aug. 26)
4936 St. Zephyrinus, fresco by Fra Diamante in the Sistine Chapel. Vatican Museums; Brusher, *Popes.*

Zita, Italian servant, patron of servants, d. 1278 (Apr. 27)
4937 St. Zita (holding a rosary and a bunch of keys), roodscreen by Cornelius Jansson Walter Winter, 1865. Norwich Castle Museum; Bentley, *Calendar.*

Zosima *see* 4269

Zosimus, Pope, r. 417–418 (Dec. 26)
4938 St. Zosimus, portrait att. to Antonello da Messina. Syracuse Cathedral, Sicily; Brusher, *Popes thru the Ages.*
4939 St. Mary of Egypt receiving communion from St. Zosimus, fresco by Puccio Capanna. Pistoia, S. Francesco; Kaftal, *Tuscan.*
See also 3655

Index of Artists

of: Assassination of St. Peter Martyr 3984; St. Jerome in his study (London) 2853

Bellini, Jacopo: St. Chrysogonus 1436; St. Francis receiving the stigmata (drawing) 2111; St. Hubert 2680; St. Jerome (Berlin) 2791

Bembo, Bonifacio: St. Ambrose chastises the Arians with his whip 151; SS. Mark and Gregory I 2551

Bembo, Gianfrancesco del (or Giovan Francesco or Gian Francesco): Madonna with SS. Cosmas and Damian 1557; St. Roch and St. Peter 4174

Benati, C.: St. George and the dragon 2470

Bendl, Johann (or Ignaz) Georg: Equestrian statue of St. Wenceslas 4886; St. Gregory I 2581

Benefial, Marco: Death of St. Margaret of Cortona 3572

Bensell, George Frederick: St. Genevieve of Brabant in the forest 2340

Benvenuti, Giovanni Battista (or Ortolano): St. Sebastian, St. Roch, and St. Demetrius 1617

Benvenuto da Garofalo (or Garofalo): Catherine of Alexandria 1111; St. Lucy 3463; St. Nicholas of Tolentino reviving the birds 3841; Stoning of St. Stephen 4534; Vision of St. Augustine 525

Benvenuto da Garofalo, att. to: St. Catherine of Alexandria 1109

Benvenuto di Giovanni: St. Catherine of Siena leads Pope Gregory XI out of Avignon 1223; St. John Gualbertus and the crucifix 3137

Bergognone, Ambrogio (or Ambrogio da Fossano or Il Bergognone): Alms of St. Benedict 707; Birth of St. Ambrose 149; Prayer, miracle of the sieve, and departure of St. Benedict 709; St. Ambrose con-

secrated as bishop; St. Ambrose preaching 152; St. Ambrose with SS. Gervase, Protase, Marcellina, and Satyrus 3514; St. Augustine and Peter Martyr with donors 509; St. Syrus and Saints 4584; SS. Epiphanius, Liberata, Luminosa, and Speciosa 1857

Bergognone, Bernardino, att. to: Mystical marriage of St. Catherine of Alexandria 1057

Berlinghieri, Bonaventura (or Berlinghieri, Berlinghiero): St. Francis talking to the birds 2020

Bermejo, Bartolomé de Cardenas (or Rubeus): Pieta of Canon Lluis Desplà with St. Jerome 2848; St. Engracia 1853; Santa Engracia apprehended upon entering Zaragoza, Spain 1852; Santo Domingo de Silos 1721

Bernard Van Orley see **Orley, Bernard Van**

Bernardino di Mariotto: Mystic marriage of St. Catherine 1114

Bernini, Gianlorenzo (or Gian Lorenzo): Ecstasy of St. Teresa 4596; St. Augustine 544; St. Bibiana (NGA) 856; St. Bibiana (Rome) 855; St. Cajetan 962; St. Jerome (Siena) 3057; St. Jerome kneeling before the crucifix (Louvre) 3060; St. Longinus (Rome) 3351; St. Sebastian 4412

Bernini, Giovanni: Head of St. Jerome 3058; St. Longinus (Cambridge) 3352

Berruguete, Pedro: St. Dominic and the Albigenses burning books 1683; St. Dominic in Auto de fé 1684; St. Peter Martyr and the crucifix 3978; St. Sebastian 4362; Sermon of St. Peter the Martyr 3979

Bertoldo di Giovanni: St. Benedict between two angels 697

Bertolino dei Grossi, att. to: Martyrdoms of St. Christopher 1364; Scenes from the life of St. Catherine of Alexandria 1013

Bertucci, Giovanni Battista: St. Thomas Aquinas 4672

Bertucci, Jacopo: Madonna with Saints Gregory and Maglorio 3503; St. Jerome 2929

Bevilacqua: SS. Romanus and Babylas 566

Biagio di Antonio: St. Sebastian and St. Roch 4169

Bicci, Neri di: Bernardino of Siena and the story of the pagan fount 816; Martyrdom of St. Apollonia (Claremont) 443; Martyrdom of St. Apollonia (Washington, D.C.) 438; Meeting of St. Zenobius and St. Ambrose 4921; St. Anthony Abbot 269; St. Felicity altarpiece 1947; St. Felicity and the martyrdom of her sons 1948; St. John Gualbertus surrounded by monks 3134; St. Leonard prays for the queen 3326; Virgin giving her girdle to St. Thomas and other saints 483

Bicci di Lorenzo: Martyrdom of St. Eulalia 1880; Nicholas of Bari and the miracle of the three children 3771; Pilgrims at the grave of St. Nicholas of Bari 3772; St. Anthony feeding the poor 248; St. Anthony of Padua serves dinner to noblemen 354; St. Eulalia 1882; St. Francis at the deathbed of the miser of Celano 2068; St. Hippolytus 2665; St. Hippolytus tied to the tails of wild horses 2666; St. John Gualbertus watches a flood remove a monastery 3135; St. Nicholas of Tolentino 3825; SS. Anthony and Stephen, and SS. John the Baptist and Miniato 3707; Stigmatization of St. Francis (Cleveland) 2069

Boschi, Fabrizio: St. Antoninus of Florence overturning a gaming-table 348
Bosschaert, Thomas Willeboirts: St. Sebastian helped by the angels 4420
Botticelli, Sandro (or Alessandro di Mariano Filipepi): Coronation of the Virgin with SS. Augustine, Jerome, Eligius 1801; Early life and first miracle of St. Zenobius 4928; Extraction of the heart of St. Ignatius 2710; Last communion of St. Jerome 2855; Miracle of St. Eligius 1802; Ninth miracle and death of St. Zenobius 4930; St. Augustine in his study (Ognissanti) 508; St. Augustine writing in his cell (Uffizi) 511; St. Augustine's first vision of St. Jerome 512; St. Calixtus I 970; St. Cornelius 1530; St. Dominic 1685; St. Dominic preaching (St. Petersburg) 1682; St. Evaristus 1927; St. Jerome (St. Petersburg) 2851; St. Jerome and St. Augustine 517; St. Jerome in penitence (Florence) 2845; St. Lucius 3431; St. Marcellinus 3515; St. Marcellus I 3516; St. Sebastian 4298; St. Sixtus II 4472; St. Soter 4479; St. Stephen I 4560; St. Telephorus 4586; Three Miracles of St. Zenobius (London) 4929; Three Miracles of St. Zenobius (New York) 4931
Botticelli, Sandro, School of: St. Pontian 4077; St. Sixtus I 4470
Boucicaut Master: Death of St. Augustine 481; Marshal in prayer before St. Catherine 1011; Martyrdom of St. Denis and his companions (Châteauroux) 1631; Martyrdom of St. Lawrence 3244; Martyrdom of St. Pancras 3893; Martyrdom of St. Sebastian 4283; Martyr-

dom of St. Thomas of Canterbury 4697; Preaching of St. Denis near Paris 1632; Roasting of St. Lawrence 3241; St. Anthony Abbot 242; St. Augustine 479; St. Bridget 916; St. Christopher 1355; St. Denis 1628; St. George killing the dragon 2368; St. Honoratus 2676; St. Jerome 2786; St. Leonard with two prisoners 3317; St. Martin and the beggar (Châteauroux) 3608; St. Martin and the beggar (Paris) 3606; St. Nicholas reviving three men 3758; St. Peter Martyr 3961; St. Valéry appearing to King Hugh Capet 4804; St. William of Gellone (Aquitaine) 4893; Saints Catherine, Margaret, Martha, Christine, and Barbara 1342; Stigmatization of St. Francis 2063; Stoning of St. Stephen 4503; Veneration of the supposed St. Denis 1634
Boucicaut Master, School of: Martyrdom of St. Denis and his companions 1630; St. Anthony Abbot and the devils 244; St. Christopher 1361; St. Victor 4817
Bourdichon, Jean (or Jehan): Catherine of Alexandria and the broken wheel 1077; Martyrdom of St. Ursula 4757; Mass of St. Gregory 2568; St. Adrian martyred in the presence of his wife 20; St. Anthony of Padua and the miracle of the mule (Paris) 385; St. Anthony of Padua and the mule (England) 384; St. Barbara murdered by her father 600; St. Christopher leaving his master 1410; St. Claudius raises a man from the dead 1481; St. Genevieve and the miracle of the candle 2335; St. Jerome in the wilderness 2895; St. Margaret

herding sheep 3550; St. Nicholas giving the dowry to three poor girls 3798; St. Sebastian 4344; Stigmatization of St. Francis 2134; Temptation of St. Anthony 301
Bouts, Dirck (or Thierry or Dieric): Martyrdom of St. Erasmus 1859; Martyrdom of St. Hippolytus 2669; St. Hubert 2682
Bouts, Dirck, School of: St. Christopher in The Pearl of Brabant 1376
Boyermans, Theodore (or Boeyermans, Theodoor): St. Julienne de Cornillon 3196; Vows of St. Luigi Gonzaga 3489
Braccesco, Carlo di Giovanni (or Carlo da Milano): St. Maurice 3678
Brandi, Giacinto: St. Erasmus in glory 1872; St. Paul the Hermit and the raven 3938; St. Roch received into heaven 4204
Brandl, Petr (or Brandel, Peter): St. Simeon with the Christ Child 4455
Brangwyn, Frank: St. Simeon Stylites 4460
Braun, Anton, att. to: St. Adalbert 13; St. Procopius 4096
Braun, Matthias Bernard (or Braun von Braun, Matthias): St. Ivo 2774; St. Ludmila with St. Wenceslas 4888; St. Lutgard at the foot of the cross 3496
Braun, Matthias Bernard, School of: Martyr's death of St. Wenceslas 4889
Brea, Ludovico (or Louis): St. Bridget of Sweden 912; Scenes from the life of St. Margaret 3542
Brea, Ludovico, att. to: Martyrdoms of St. Erasmus 1863
Brescian Master: St. Margaret of Hungary receiving the stigmata 3576
Brescianino: St. Ursula Martyr 4767
Breu, Georg (or Jörg) the Elder: St. Bernard praying 773; St. George and the dragon 2441

Brokoff, Ferdinand Maximilian: St. Cajetan 963; St. Francis Borgia 2012; St. John Nepomucen 3146; St. Vincent Ferrer and St. Procopius 4095; St. Vitus 4869; SS. John of Mathy, Felix of Valois, and Ivan 1955
Brokoff, Michael Johann Josef: St. Adalbert 12
Bromley, William: Insolence of Dunstan to King Edwy 1757
Bronzino, Agnolo (or Angelo di Cosimo di Mariano): Martyrdom of St. Lawrence 3272
Bronzino, Agnolo, School of: Portrait of a lady as St. Catherine 1125
Brosamer, Hans: St. Jerome 2954
Brother Luke: St. Peter of Alcantara 4011
Bru, Anye: Martyrdom of Cucufas 1578
Bruegel (or Brueghel), Jan: St. Eustace 1914; St. Norbert preaching against the heresy of Tanchelin 3853
Bruegel (or Brueghel), Pieter the Elder: Landscape with the penitence of St. Jerome 2959; Temptation of St. Anthony 317
Bruyn, Barthel the Elder: St. Helena with relic of the true cross 2623; Sudermann Altarpiece with SS. Thomas and Ursula 4674
Büchler, Heinrich: St. Christopher and St. Peter 1380
Bugiardini, Giuliano: St. Sebastian 4349
Burgkmair, Hans: St. George (etching) 2442; St. George (woodcut) 2429; St. Helen, St. Brigitte, and St. Elizabeth 914; St. John's Altarpiece, with SS. Erasmus and Martin of Tours 1868; St. Onophrius 3875; St. Radiana 4134; St. Ulrich 4739; St. Ulrich and St. Barbara 4740
Burne-Jones, Edward: Leg-

end of St. Frideswide 2318; St. Aidan 86; St. Cecilia 1305; SS. John the Baptist, Cosmas and Damian 1562
Buron, Romain: Beheading of St. Faith 1940
Burrini, Giovanni (or Gian) Antonio: Martyrdom of St. Victoria 4828; Virgin Immaculate with SS. Petronius and Dionysius the Areopagite 4037
Buys, Cornelius: Death of St. Alexis 112
Bylert, Jan van: St. Sebastian 4398
Cades, Giuseppe: Levitation of St. Joseph of Copertino 3178
Cadore School: St. Florian saving a burning city 1980
Caffà (or Cafà), Melchiorre: St. Catherine in ecstasy 1254
Calabrese, Il see **Preti, Mattia**
Caliari, Carlo (or Veronese, Carlo): Martyrdom of St. Sabinus 4259
Callego, Fernando, School of: The mass of St. Gregory 2550
Callot, Jacques: Martyrdom of St. Sebastian 4395
Calvaert, Denis (or Denys or Dionisio Fiammingo): St. Francis receiving the Christ Child from the Virgin 2188
Camilo, Francisco: St. Francis of Paola 2281
Campagnola, Domenico: Baptism of St. Justina 3208
Campanian School: Crispin and Crispinian 1571; Pope Innocent III dreams of St. Dominic 1653
Campeche, Jose: Vision of St. Philip Benizi 4053
Campi, Antonio: Martyrdom of St. Lawrence 3275; Visit of the Empress Faustina to St. Catherine in prison 1133
Campi, Giulio: Burial of St. Agatha 43; Martyrdom of St. Agatha 44
Candido, Pietro (or Candid, Peter or Witte, Pieter de):

Mystical marriage of St. Catherine 1139
Cano, Alonso: Apparition of St. Dominic in Soriano 1713; Death of St. Francis (Madrid) 2248; St. Agnes (Berlin) 80; St. Agnes (destroyed) 79; St. Anthony of Padua (Madrid) 408; St. Anthony of Padua (Murcia) 407; St. Anthony of Padua holding the Christ Child (Granada) 412; St. Benedict's vision of Glory 735; St. Diego de Alcalá 1646; St. Dominic's miraculous portrait at Soriano 1709; St. Francis Borgia 2009; St. Isidore and the miracle of the well 2767; St. John Capistrano and St. Bernardino of Siena 3112; St. Theresa 4593; San Diego de Alcalá 1645; Vision of St. Anthony of Padua (Madrid) 403; Vision of St. Anthony of Padua (Munich) 404; Vision of St. Bernard 788
Cano, Alonso, att. to: Temptation of St. Thomas Aquinas 4677
Cano, Alonso, School of: Apparition of the Virgin to St. Felix of Cantalice 1954; SS. Clara and Louis of Toulouse 3428
Cantarini, Simone (da Pesaro): SS. Anthony of Padua and Francis of Paola 2276
Canuti, Domenico Maria: St. Teresa of Avila placating the anger of God 4601
Capanna, Puccio: St. Mary of Egypt receiving communion from St. Zosimus 4939
Capella, Francesco: Holy Family with Saints Francis of Paola and Aloysius Gonzaga 3493
Capitelli, Bernardino: St. Bernardino of Siena in Milan 847; St. Bernardino of Siena reviving a child 848; St. Paul Aretio 3922; St. Sebastian cured of his wounds 2752
Caporali, Bartolommeo: St.

with SS. Francis and Sebastian 2100; St. Anthony of Padua 364; St. Augustine 503; St. Bernard 768; St. Bernardino of Siena (Esztergom) 837; St. Bernardino of Siena (Paris) 829; St. Bonaventura (Berlin) 882; St. Bonaventura (Esztergom) 887; St. Catherine of Alexandria, from Virgin and Child Altarpiece 1053; St. Dominic (Amsterdam) 1677; St. Dominic (Esztergom) 1681; St. Dominic (New York) 1659; St. Francis of Assisi 2092; St. George 2406; St. George and the dragon (Boston) 2405; St. George and the dragon (London) 2414; St. James of the March 2775; St. Jerome (London) 2827; St. Jerome (NGA) 2861; St. Jerome in Madonna della Rondine altarpiece (London) 2826; St. Lucy (London) 3453; St. Nicholas of Bari 3785; St. Onophrius 3871; St. Peter Martyr (London) 3972; St. Roch 4168; St. Sebastian (Milan) 4296; SS. Anthony Abbot and Lucy 3451; SS. Augustine and Jerome 502; SS. Bernardino of Siena and Catherine of Siena 828; SS. Bernardino of Siena and Clare 1466; SS. Catherine and Jerome 1028; SS. Lawrence and Sylvester in Madonna and Child altarpiece 4575; SS. Louis of Toulouse, Jerome, and Peter Apostle 3418; SS. Paul, John Chrysostom, and Basil 627; Virgin and Child giving the key to St. Peter, with other Saints 1847; Virgin and Child with SS. Francis and Sebastian 4309; Virgin and Child with SS. Jerome and Sebastian 4308

Crivelli, Carlo, School of: St. Nicholas of Tolentino 3831

Crivelli, Vittore (or Vittorio):

St. Benedict 712; St. Bonaventura (Amsterdam) 884; St. Bonaventura (Cambridge) 886; St. Bonaventura and St. John the Baptist with a donor 885; St. Francis receiving the stigmata (El Paso) 2118; St. Francis receiving the stigmata (New York) 2093; St. Julian the Hospitaller 3185; St. Louis of France (Amsterdam) 3387; St. Louis of France and St. Francis of Assisi 3388; St. Louis of Toulouse 3420; St. Severinus 4447

Croce, Santa: Martyrdom of St. Sebastian before Emperor Diocletian 4375

Cross, John: Death of Thomas Becket 4706; Edward the Confessor leaving the crown to Harold 1783

Da Asolo, Giovanni *see* **Giovanni da Asolo**

Da Besozza, Michelino *see* **Michelino da Besozza**

Da Bologna, Andrea *see* **Andrea da Bologna**

Da Bologna, Monte *see* **Monte da Bologna**

Da Bologna, Vitale *see* **Vitale da Bologna**

Da Brescia, Moretto *see* **Moretto da Brescia**

Da Carpi, Girolamo *see* **Girolamo da Carpi**

Da Cemmo, Giovanni Pietro *see* **Giovanni Pietro da Cemmo**

Da Como, Guido *see* **Guido da Como**

Da Conegliano, Cima *see* **Cima da Conegliano**

Da Cortona, Pietro *see* **Pietro da Cortona**

Da Crevalcore, Antonio Lionelli *see* **Antonio Lionelli da Crevalcore**

Da Empoli, Jacopo *see* **Chimenti, Jacopo**

Da Fabriano, Antonio *see* **Antonio da Fabriano**

Da Fabriano, Gentile *see* **Gentile da Fabriano**

Da Feltre, Morto *see* **Morto da Feltre**

Da Ferrara: St. Jerome in the desert 2823

Da Ferrara, Bono *see* **Bono da Ferrara**

Da Firenze, Andrea Bonaiuti *see* **Andrea Bonaiuti da Firenze**

Da Foligno, Niccolò *see* **Abate, Niccolò dell'**

Da Forlì, Ansuino *see* **Ansuino da Forlì**

Da Forlì, Asuino *see* **Asuino da Forlì**

Da Gaeta, Giovanni *see* **Giovanni da Gaeta**

Da Garofalo, Benvenuto *see* **Benvenuto da Garofalo**

Da Lanciano, Polidoro *see* **Polidoro da Lanciano**

Da Lodi, Gian Giacomo *see* **Gian Giacomo da Lodi**

Da Marone, Giovanni *see* **Giovanni da Marone**

Da Messina, Antonello *see* **Antonello da Messina**

Da Milano, Giovanni *see* **Giovanni da Milano**

Da Modena, Barnaba *see* **Barnaba da Modena**

Da Modena, Giovanni *see* **Giovanni da Modena**

Da Modena, Michele di Matteo *see* **Michele di Matteo da Modena**

Da Modena, Tommaso (Thomaso) *see* **Tommaso da Modena**

Da Montepulciano, Pietro *see* **Pietro da Montepulciano**

Da Panicale, Masolino *see* **Masolino da Panicale**

Da Pavia, Leonardo *see* **Leonardo da Pavia**

Da Pesaro, Giovanni *see* **Giovanni di Antonio da Pesaro**

Da Ponte, Jacopo *see* **Bassano, Jacopo**

Da Pontormo, Jacopo *see* **Jacopo da Pontormo**

Da Pordenone, Giovanni Antonio *see* **Pordenone, Giovanni Antonio da**

Da Rimini, Lattanzio *see* **Lattanzio da Rimini**

Da Roma, Mariano di Matteo *see* **Mariano di Matteo da Roma**

Da San Leocadio, Paolo *see* **Paolo da San Leocadio**

Fiammingo, Francesco *see* **Duquesnoy, Francois**

Figueiredo, Cristóvão de: Martyrdom of the eleven thousand virgins, with St. Ursula 4768

Finelli, Giuliano, att. to: St. Eusebius 1893

Finoglia, Paolo Domenico: St. Augustine 534; St. Benedict with a raven and angels 732

Finson, Louis (or Ludovicus Finsonius): San Gennaro 2341

Fiorenzo di Lorenzo: Miracle of San Bernardino 835; St. Mustiola 3724; SS. Roch and Romanus 4219

Fisen, Engelbert: St. Benedict destroying the statue of Apollo 741

Flach, Martin: St. Jerome in the wilderness 2832

Flemish School: A count of Hainault with St. Ambrose 154; Madonna and Child with SS. Barbara and Catherine of Alexandria 599; St. Bernard receiving the stigmata from the Virgin 772

Flipart, Charles-Joseph: Surrender of Seville to St. Ferdinand 1958

Florentine School: Conversion of St. John Gualbertus 3132; Martyred St. Catherine with angels 1091; St. Anthony of Florence 344; St. Dominic raises Napoleone Orsini 1654; St. Ignatius of Antioch 2707; St. Julian carries a pilgrim across the river 3182; St. Nicholas of Bari 3796; St. Paula 3941; St. Ursula 4782; Scenes from the life of St. Francis 2021; Scenes from the life of St. Reparata 4159; Temptation of St. Francis of Assisi 2136

Foggini, Giovanni Battista: Miracle of St. Andrea Corsini 194

Fontana, Prospero: Madonna in Glory with the four patron saints of

Bologna 4033; St. Alexis giving alms 113

Fontebasso, Francesco: Apparition of the Virgin to St. Anthony of Padua 422; Madonna and Child with SS. Anthony Abbot, Elizabeth, and others 1835; St. Francis of Paola with a brother 2292

Foppa, Vincenzo: Martyrdom of St. Peter Martyr 3968; Martyrdom of St. Sebastian 4292; Miracle of St. Peter Martyr at Narni 3969; Scenes from the life of St. Peter Martyr 3970; St. Anthony of Padua 363; St. Francis receiving the stigmata 2103; St. Sebastian 4306; St. Sirus and St. Paul 4468; SS. Augustine and Ambrose 150; SS. Clare and Bonaventura 883; Virgin and Child flanked by SS. Faust and Giovita 1942

Foucquet (or Fouquet), Jean: Consecration of St. Nicholas 3780; Estienne Chevalier with St. Stephen 4508; Martyrdom of St. Apollonia 441; Martyrdom of St. Catherine 1025; Martyrdom of St. Stephen 4509; Meeting of St. Margaret and the Prefect Olybrius 3536; St. Bernard teaching 767; St. Hilary at a council convened by Pope Leo 2657; St. Margaret 3537; St. Martin and the beggar 3615; St. Stephen and Etienne Chevalier before the Virgin 4510; St. Thomas Aquinas teaching 4812; St. Veranus curing the insane 4667

Fra Angelico *see* **Angelico, Fra**

Fra Bartolommeo *see* **Bartolommeo, Fra**

Francanzano, Francesco: A miracle of St. Gregory of Armenia 2598; St. Catherine of Alexandria 1184; St. Gregory of Armenia thrown into the well 2599

Franceschini, Baldassarre

(or Il Volterrano): St. Catherine of Siena 1256

Francesco de Mura *see* **Mura, Francesco de**

Francesco dei Franceschi: St. Mamas 3511; Scenes from the life of St. Mamas 3509; Soldiers flee as they try to arrest St. Mamas 3510

Francesco del Cossa *see* **Cossa, Francesco del**

Francesco di Gentile: St. Adrian 17

Francesco di Giorgio (Martini): St. Benedict tormented 706; St. Dorothy and the Infant Christ 1746

Francesco di Sercenni: Martyrdom of Saints John and Lawrence 3237

Francia, Francesco (or Francesco di Marco di Giacomo Raibolini): St. George and the dragon 2432; St. Stephen 4514

Franciabigio (or Francesco di Cristofano Bigi): Canonization of St. Nicholas of Tolentino 3837; Mystic marriage of St. Catherine 1070; St. Nicholas of Tolentino healing the sick (Oxford) 3839; St. Nicholas of Tolentino performing miracles (Arezzo) 3840

Francken, Frans II (or Franken II the Younger), att. to: Martyrdom of St. Ursula 4780

Francken, Hieronymus: Martyrdom of St. Crispin and St. Crispinian 1576

Franco, Giovanni Battista: Jerome in solitude 2912

Francois, Simon of Tours: St. Vincent de Paul 4841

Franconian School: Miraculous mass of St. Martin 3614

Franken II the Younger *see* **Francken, Frans II**

Frankfurt Master: Legend of St. Romuald 4234

Freeman, Miss Mary Winefride: Dedication of St. Edward the Confessor 1784

Fremiet, Emmanuel: Equestrian statue of Joan of Arc 3099; Joan of Arc 3102

with St. Louis of Toulouse 3422; Madonna and Child with Saints Apollonia and Sebastian 449; Pope Clement reading a book 1492; Pope confirms St. Francis in his rule 2108; Pope Honorius confirms the rule of St. Francis 2107; St. Ambrose 147; St. Christopher 1382; St. Cletus 1505; St. Eutychian 1926; St. Felix I 1952; St. Francis resuscitating a child of the Spini family 2109; St. Hyginus 2704; St. Jerome in his study 2830; St. Marcellus I 3517; St. Pius I 4067; St. Rosalie of Palermo 4237; St. Stephen martyr 4513; St. Victor I 4826; Scenes from the life of St. Fina 1971; Stained glass portrait of St. Thomas Aquinas 4673; Translation of the body of St. Zenobius 4933

Ghirlandaio, School of: Martyrdom of St. Clement I 1489

Giacomo dal Ponte *see* **Bassano, Jacopo**

Giambono, Michele: St. Chrysogonus 1437; St. Philip Benizi 4042

Giampietrino (or Giovanni Pedrini): Madonna and Child between SS. Catherine and Jerome 1069; St. Catherine of Alexandria 1090

Gian Giacomo da Lodi: St. Placidus 4072; Scenes from the life of St. Bernardino of Siena 833

Gianfrancesco del Bembo *see* **Bembo, Gianfrancesco**

Giaquinto, Corrado: Emperor Constantine presented to the Holy Trinity by St. Helena 1526; Glory of St. John Calibrita 3141; Madonna and Child with SS. Abercius, Stephen, Benedict 4; St. Cecilia 1301

Gillot, Claude: Temptation of St. Anthony 334

Gimignani, Giacinto: Martyrdom of SS. Marius, Martha, Audifax and Ambachum 3587

Giolfino, Niccolò: Death of St. Philip Benizi 4044

Giordano, Luca: Apparition of the Virgin to St. Francis 2258; Glorification of St. Andrew Corsini 193; Martyrdom of St. Januarius 2349; Martyrdom of St. Lawrence 3297; St. Barbara 619; St. Dominic 1714; St. Gennaro frees Naples from the plague 2348; St. Nicholas in glory 3815; St. Sebastian cured by St. Irene 2764; St. Tommaso da Villanova distributing alms 4715; Virgin appearing to St. Bernard of Clairvaux 792

Giorgetti, Antonio: Martyrdom of St. Sebastian 4417

Giorgione (or Giorgio or Zorzi) da Castelfranco: Enthroned Madonna with St. Liberalis and St. Francis 3344; Madonna and Child with SS. Anthony of Padua and Roch 376

Giotto di Bondone *see* **Bondone, Giotto di**

Giovan Francesco Surchi *see* **Dielaì**

Giovannetti, Matteo: SS. Hermagoras and Fortunatus 1989; Scenes from the life of St. Martial 3667

Giovanni Andrea de Ferrari *see* **Ferrari, Giovanni Andrea de'**

Giovanni Battista d'Angeli: Martyrdom of St. Justine 3209

Giovanni da Asolo: The Virgin with SS. Louis IX and Elizabeth of Hungary 1827

Giovanni da Gaeta: St. Bernardino of Siena flanked by SS. Louis of Toulouse and Clare 815

Giovanni da Marone: SS. Barbara and Roch 583

Giovanni da Milano: Martyrdom of St. Catherine 993; St. Anthony Abbot

236; St. Francis of Assisi 2062

Giovanni da Modena: SS. Petronius, Ambrose and Ursicinus bless a cross of Bologna 4745; Scenes from the life of St. Petronius 1979

Giovanni d'Agnolo di Balduccio: Mass of St. Donatus 1729

Giovanni dal Ponte (or Giovanni del Ponte or Giovanni di Marco): Mystical marriage of St. Catherine of Alexandria 1015; St. Anthony Abbot 251; St. Anthony of Padua 355; St. George 2384; St. Jerome and St. Francis (Cambridge) 2075; St. John the Baptist and St. Anthony Abbot 252; SS. Geminianus and Francis of Assisi 2332

Giovanni de Lutero *see* **Dossi, Dosso**

Giovanni del Biondo: Coronation of the Virgin with SS. Anthony and Louis of Toulouse 233; Four church-fathers of 1363 137; Funeral of St. Benedict 675; Madonna and Child with SS. Augustine, Lawrence, Anthony Abbot 3238; Martyrdom of St. Sebastian 4282; Mystical marriage of St. Catherine 1002; Posthumous scenes of St. Donnino 1735; Presentation in the temple with St. Benedict 670; St. Benedict leaving for the desert; Benedict receiving food 671; St. Benedict restores life to a young monk 672; St. Benedict's vision of the whole world 673; St. Catherine of Alexandria 1000; St. Donnino 1737; St. Stephen 4500; St. Thomas Aquinas 4658; St. Zenobius 4920; Scenes from the life of St. Donnino 1736

Giovanni del Biondo, att. to: St. Jerome 2781

Giovanni di Antonio da Pesaro: St. Blaise with a

John the Baptist 2807; Madonna and Child with SS. Zenobius, Dominic, Francis, Jerome 4925; Pope Alexander IV approves the writings of Thomas Aquinas 4661; St. Augustine given to the grammar master 496; St. Bernardino of Siena (Montefalco) 814; St. Bonaventure 880; St. Dominic resuscitates Napoleone Orsini 1676; St. Fortunade 1991; St. Francis before Arezzo 2097; St. Jerome leaves Rome 2805; St. Monica (S. Gimignano) 3714; St. Monica (S. Gioniguiano) 3716; St. Scholastica 4275; St. Ursula with angels 4753; St. Zenobius raising a boy from the dead 4926; Scenes from the life of St. Augustine 495; Scenes from the life of St. Francis 2096

Gramatica (or Grammatica), Antiveduto: Death of St. Romuald 4235; St. Cecilia 1282

Granacci, Francesco: St. Apollonia 448; St. Francis holding a book, in a niche 2138

Grandi, Ercole: Madonna and Child with SS. John the Baptist and William 4894

Greco, El (or Domenico Theotocopuli): Apparition of the Virgin to St. Hyacinth 2701; Julián Romero de las Azañas and St. Julian 3193; Julian Romero kneeling before St. Louis 3395; Madonna with SS. Martina and Agnes 77; Martyrdom of St. Maurice 3684; Portrait head of St. Francis (New York) 2163; St. Anthony of Padua (Madrid) 395; St. Augustine 529; St. Benedict 727; St. Bernard (unknown) 781; St. Bernardino 845; St. Catherine of Alexandria 1155; St. Dominic in prayer (Bos-

ton) 1694; St. Dominic in prayer (Madrid) 1690; St. Dominic in prayer (Newport) 1691; St. Dominic in prayer (Toledo) 1696; St. Francis (Chicago) 2161; St. Francis (El Escorial) 2168; St. Francis and Brother Leo in prayer (Milan) 2165; St. Francis and the lay brother (Madrid) 2181; St. Francis and the lay brother (Monforte) 2146; St. Francis and the lay brother (Zurich) 2182; St. Francis in ecstasy (Madrid) 2170; St. Francis in ecstasy (Pau) 2169; St. Francis in meditation (Barcelona) 2156; St. Francis in meditation (Canada) 2184; St. Francis in meditation (Valencia) 2155; St. Francis in prayer (Joslyn) 2151; St. Francis kneeling in meditation (Bilbao) 2147; St. Francis receiving the stigmata (Baltimore) 2166; St. Francis receiving the stigmata (Cadiz) 2167; St. Francis receiving the stigmata (Geneva) 2143; St. Francis receiving the stigmata (Madrid) 2147; St. Francis venerating the crucifix 2162; St. Ildefonso (Escorial) 2733; St. Ildefonso (Illecas) 2734; St. Ildefonso (NGA) 2735; St. Jerome (NGA) 2991; St. Jerome (New York) 2977; St. Jerome in penitence (NGS) 2983; St. John of Avila 3155; St. Lawrence's vision of the Virgin 3273; St. Louis, king of France 3394; St. Martin and the beggar 3629; St. Sebastian (Bucharest) 4380; St. Sebastian (Palencia) 4374; St. Sebastian (Prado) 4381; Saints Andrew and Francis 2171; The Virgin with St. Inés and St. Thecla 2744

Greco-Venetian School: St. George and the dragon 2465

Grien, Hans Baldung *see* **Baldung-Grien, Hans**

Gröninger, Johann Mauritz: St. Ambrose 168; St. Augustine 546; St. Gregory I 2582; St. Jerome 3056

Grossaert, Jan: St. Jerome penitent 2880

Grünewald, Matthias (or Mathis Nithardt): Meeting of St. Anthony and the Hermit Paul 302; Meeting of Saints Erasmus and Maurice 1867; St. Cyriacus curing the mad daughter of Diocletian 1589; St. Elizabeth of Hungary 1826; St. Lawrence 3266; St. Lucy 3460; St. Sebastian 4348; Temptation of St. Anthony 303

Guardi, Francesco: Miracle of St. Hyacinth 2703; Virgin and Child with St. Dominic and St. Rose de Lima 4250

Guariento: St. Justina of Padua 3202; St. Martin dividing his cloak 3602; Scenes from the life of St. Augustine 485

Guarino (or Guarini), Francesco: St. Agatha 50; St. George 2479

Guercino (or Giovanni Francesco Barbieri): Anthony of Padua 391; Burial of St. Petronilla 4027; Investiture of St. William of Aquitaine 4896; Madonna and Child with St. Lawrence 3280; St. Anthony of Padua 405; St. Augustine meditating on the holy trinity 542; St. Chrysogonus glorified 1438; St. Francis in ecstasy and St. Benedict 731; St. Francis meditating in a landscape 2246; St. Jerome (Georgetown) 3006; St. Sebastian (Hartford) 4411; St. Sebastian (Ponce) 4409; SS. Bernardino of Siena and Francis kneeling in prayer 846; Vision of St. Francesca Romana 2005; Vocation of San Luigi Gonzaga 3488

Jacopo da Pontormo: Martyrs of the Theban Legion 3682
Jacopo da Valenza: St. Jerome in the wilderness 2842
Jacopo de Barbari see **Barbari, Jacopo de'**
Jacopo del Casentino: St. Lucy 3437; St. Prosper 4108; San Miniato Altarpiece 3706
Jacopo del Sellaio: St. Jerome and St. Francis 2101; St. Jerome in the desert 2824
Jan de Beer: St. Ursula 4769
Jan de Beer, att. to: Conversion of St. Hubert 2686
Jan Sanders Van Hemessen see **Hemessen, Jan Sanders Van**
Jansz, Jacob: St. Bavo 648
Jaquerio, Giacomo: St. Blaise visited by wild animals 864; St. Denis 1629; St. Quentin 4113
Joan the Painter: Mass of St. Martin 3595
Jordaens, Jacob: Martyrdom of St. Apollonia (Antwerp) 453; Martyrdom of St. Apollonia (drawing) 454; Miracle of St. Dominic 1704; Mystical marriage of St. Catherine of Alexandria 1177; St. Christopher 1432; St. Ives, patron of lawyers 2773; St. Martin healing a possessed man 3636; Vision of St. Bruno 947
Jorhan, Christian the Elder: SS. George and Florian 1987
Joseph Van de Kerkhove: Ecstasy of St. Catherine of Siena 1258
Jouvenet, Jean (or Jean III): Death of St. Francis 2259; Last communion of St. Louis 3400; Martyrdom of St. Ovid 3889; St. Louis visiting the wounded after the battle of Mansourah 3401; Vision of St. Teresa 4614
Jouvenet, Jean, School of: Blanche of Castile show-

ing St. Louis religion, faith, and piety 3399; St. Bruno praying on his knees (Dijon) 953; St. Bruno praying on his knees (Lyon) 951; St. Bruno praying on his knees (Stockholm) 952
Juan de Flandes: St. Francis and St. Michael 2125
Juan de Juanes (or Vicente Juan Masip): Burial of St. Stephen 4539; Consecration of St. Eligius 1807; Martyrdom of St. Stephen 4538
Juan de la Abadia: St. Anthony Abbot 272; St. Catherine's ordeal of the wheels 1041
Juan de la Miserias, Fray: St. Teresa of Jesus 4590
Juan de Roelas: St. Ignatius of Loyola 2711
Juan de Valdés Leal see **Valdés Leal, Juan de**
Julien, Simon: Martyrdom of St. Hippolytus 2672
Justus van Ghent (or Joos van Gent): Albert the Great 95; St. Augustine 506; St. Gregory I (Urbino) 2556; St. Gregory the Great (Rome) 2552
Keirincx, Alexander: Woodland scene with St. Anthony and St. Paul the Hermit 3929; Woodland scene with the meeting of SS. Anthony and Paul the Hermit 327
Kern, Antonín: St. Agatha 56
Kohl, Johann Friedrich: St. Nicholas 3818
Kolyvas, Ioannis: St. Phanourius 4040
Kozma Serbian: SS. Sava and Simeon Nemanja 4264
Kulmbach, Hans Suess (or Süss) von: St. Catherine converted by a picture of the Virgin and Child 1079
Kunchov, Dimiter: St. George with scenes from his life 2488
La Hyre (or La Hire), Laurent: Pope Nicholas V opening the tomb of St. Francis 2220

La Hyre, Laurent, att. to: St. Francis giving the cordon of the Third Order to Louis XIII 2213
La Tour, Etienne de: St. Alexis 116
La Tour, Georges de: Discovery of the body of St. Alexis 115; Finding of St. Sebastian 2759; Penitence of St. Jerome (Grenoble) 3027; Penitence of St. Jerome (Stockholm) 3024; St. Francis in ecstasy 2239; St. Jerome reading 3020; St. Sebastian tended by St. Irene (Kansas City) 2756; St. Sebastian tended by St. Irene (Louvre) 2757
La Tour, Georges de, copy after: St. Sebastian tended by Irene (Rouen) 2760
Laib, Konrad: St. Hermes 2651
Lanfranco, Giovanni: Coronation of the Virgin with SS. Augustine and William of Aquitaine 4895; Ecstasy of St. Margaret of Cortona 3573; Madonna and Child with SS. Charles Borromeo and Bartholomew 1321; St. Cecilia 1287; St. Charles Borromeo praying 1322
Langetti (or Langhetti), Giovanni Battista: Vision of St. Jerome 3052
Lanino, Bernardino: St. George and the dragon 2393
Lanzoni, Bernardino: St. Anthony Abbot before the city of Pavia 282; Scenes from the life of St. Theodorus of Pavia 4645
Latium School: St. Francis of Assisi 2018
Lattanzio da Rimini: St. Martin and the Beggar 3620
Lauri, Filippo: Martyrdom of St. Lawrence 3296; Martyrdom of St. Stephen 4556
Lazio, School of: St. Ansanus 216
Lazzarini (or Lazarini), Gregorio: Alms of St. Laurence Justinian 3226

and Luke 577; SS. Matthew, Catherine of Alexandria, and John the Evangelist 1020
Lockey, Rowland: Sir Thomas More and his family 4709
Loechener, Stephan *see* **Lochner, Stephan**
Lomazzo, Giovanni Paolo: SS. Bartholomew, Francis and Bernardino 2148
Lombard School: Ecstasy of St. Francis of Paola 2284; Mass of SS. Faust and Giovita 1942; St. Agatha 30; St. Albert of Trapani 90; St. Alexander 99; St. Bassian 641; St. Elzéar 1844; St. Francis prostrates himself before St. Angelo 201; St. Giles of Rome 2522; St. Glisente 2527; St. Glisente milking a doe 2528; St. Nicholas of Tolentino altarpiece 3833; St. Peter Celestine 3953; St. Syrus 4583; St. Tiziano 4720; SS. Clare and Francis of Assisi 1451; SS. Quirico and Julitta 4119; Scenes from the life of St. John Damascene 3124; Scenes from the life of St. Patrick 3920
Lombardelli, Giovanni Battista: Scenes from the life of St. Anthony Abbot 323
Longhi, Pietro: St. Anthony Abbot, Pope Cornelius, Mary Magdalene and donor 1531
Longin (or Longino): St. John Climacos and communion of St. Mary of Egypt 3125; St. Nicholas enthroned, with one of his miracles 3808; St. Stephen the King Uros III and scenes from his life 4564
Lorentino d'Angelo: Scenes from the life of St. Anthony of Padua 367
Lorenzetti, Ambrogio: Charity of St. Nicholas of Bari 3748; Consecration of St. Nicholas 3753; St. Catherine of Alexandria

988; St. Dorothy 1741; St. Elizabeth of Hungary 1814; St. Louis of Toulouse and his companions before Boniface VIII 3416; St. Nicholas elected bishop of Myra 3749; SS. Francis and Mary Magdalene 2055; SS. Nicholas and Proculus 4098; Two scenes from the legend of St. Nicholas of Bari 3750
Lorenzetti, Ambrogio, School of: St. Dominic clothed by angels 1655
Lorenzetti, Pietro: Crucifixion with SS. Clare and Francis 1445; Madonna and Child with St. Nicholas and Elijah 3747; St. Benedict, St. Catherine, and St. Margaret 3526; St. Catherine of Alexandria (New York) 987; St. Catherine of Alexandria (Wash. DC) 1024; St. Clare 1450; St. Donatus 1727; St. Lucy 3436; St. Sabinus before the governor 4258; St. Sava before the governor 4263; SS. Afra and Margaret 25; SS. Catherine of Alexandria and Agnes 63; Stigmatization of St. Francis 2054; Two scenes from the legend of St. Humility 2699
Lorenzetti, Pietro, School of: Madonna and Child with SS. John the Baptist and Bernardino 800; St. Anthony Abbot 234; Scenes from the life of St. Helena 2619
Lorenzetti, Ugolino *see* **Ugolino-Lorenzetti**
Lorenzo da San Severino (or Lorenzo d'Alessandro da Severino): Madonna and Child with SS. Anthony, Sebastian, Severino, and Mark 4448; Mystic marriage of St. Catherine of Siena 1622
Lorenzo da Viterbo, School of: St. Giles 2517; Verecundius gives the habit to St. Giles 4813; Scenes from the life of St. Giles 2516

Lorenzo di Bicci: SS. Luke and Christopher 1352
Lorenzo di Credi *see* **Credi, Lorenzo di**
Lorenzo di Niccolò: Posthumous scenes from the St. Fina cycle 1969; Scenes from the life of St. Fina 1970; Scenes from the life of St. Lawrence 3239
Lorenzo di Niccolò, att. to: Martyrdom of St. Stephen 4502
Lorenzo di Pietro *see* **Vecchietta, Lorenzo**
Lorenzo Monaco (or Piero di Giovanni): Annunciation with Anthony Abbot and three other saints 4100; Beheading of St. Catherine of Alexandria 1007; Death of St. Benedict 685; Funeral of St. Francis of Assisi 2067; Incidents from the life of St. Benedict of Nursia (London) 686; Monte Oliveto Altarpiece with SS. Benedict, Thaddeus, and others 683; Rescue of St. Placidus and St. Benedict's visit to St. Scholastica 4070; St. Benedict raises a young monk 684; St. Caius 958; St. Jerome (Florence) 2785; St. Jerome in his study (Amsterdam) 2788; St. Nicholas of Bari rescuing a storm-tossed ship 3762; St. Placidus in St. Benedict's Altarpiece 688; St. Romuald (Florence) 4228; St. Romuald (Tulsa, OK) 4230; Scenes from the life of St. Benedict (Florence) 687; Scenes from the life of St. Onophrius 3870; Stigmatization of St. Francis 2065
Lorenzo Monaco, School of: Funeral of St. Francis 2064; Martyrdom of St. Lawrence 3247; St. Benedict in the Sacro Speco 689; St. Lawrence enthroned, with SS. Ansanus and Margaret 3248; St. Margaret and the prefect 3533
Lorenzo Veneziano: Mystic

Mignard, Nicholas: Virgin gives the chasuble to Simon Stock 4462
Mignard, Pierre-Francois: The mystical marriage of Catherine 1191
Mildert, Hans van: St. Norbert overcoming Tranchelm 3852
Miranda, Juan Carreño de *see* **Carreño de Miranda, Juan**
Mocetto, Giramo (or Girolamo): Madonna and Child with Saints Stephen and Catherine 4523
Mola, Pier Francesco: Ecstasy of St. Bruno (Doria Pamphili) 933; St. Jerome 3032; Vision of St. Bruno (Vatican) 923
Monaco, Lorenzo *see* **Lorenzo Monaco**
Monaldo: St. Anthony Abbot 296; St. Sebastian 4330
Montagna, Bartolomeo: Madonna with St. Jerome and St. Sebastian 2828; St. Bernard and a holy bishop 778; St. Jerome 2860; Ursula and saints with Madonna and Child enthroned 3718
Montagna, Benedetto: St. Benedict instructing his order 708; St. George 2411
Monte da Bologna: Scenes from the life of St. Julian the Hospitaller 3181
Montecassino School: Martyrdom of St. Pantaleon 3900
Morandini, Francesco (or Il Poppi): St. Helena 2626
Morazzone, Pier Francesco *see* **Mazzuchelli, Pier Francesco**
Moreau, Gustave: St. Cecilia and angel musicians 1306; St. Elizabeth of Hungary 1836; St. Helena 2638; St. Sebastian (Neuss) 4427; St. Sebastian (Paris) 4429; St. Sebastian (Paris) 4430; St. Sebastian (Switzerland) 4428; Temptation of St. Anthony 342
Morelli, Domenico: Temptation of St. Anthony 341

Moretto da Brescia (or Alessandro Bonvicino): Four Great Virgins of the Church, with SS. Agnes, Lucy, Cecilia 75; Madonna and Child, with SS. Hippolytus and Catherine of Alexandria 2671; St. Anthony of Padua with SS. Anthony Abbot and Nicholas 396; St. Bernardino of Siena with other saints 843; St. Jerome in the wilderness 2916; St. Justina 3207; St. Nicholas of Bari presenting four children to the Virgin 3804
Morone, Francesco: St. Francis receiving the stigmata 2119
Morto da Feltre: Madonna and Child with Saints Vitus and Modestus 3710
Moscow School: St. Sergius of Radonezh 4438
Mosto, Ottavio: St. Wenceslas from Charles Bridge 4887
Multscher, Hans: St. Ursula 4754
Mura, Francesco de: Leo IX 3310; St. Carloman dons the Benedictine habit 976
Muratori: SS. Prassede and Pudenziana gathering the bones of martyrs 4084
Murillo, Bartolomé Esteban: Death of St. Clare 1478; Elizabeth of Portugal washing a beggar's hair 1839; John of God curing a cripple 3162; St. Alphonsus Rodriguez 122; St. Elizabeth of Hungary cures a leper 1834; St. Francis and St. Thomas Aquinas appear to Fray Lauterio 4678; St. Francis Xavier 2312; St. Ildephonso receives the chasuble from the Virgin 2741; St. Thomas of Vilanueva dividing his clothes among the beggar boys 4718; Vision of St. Anthony of Padua 413
Muziano, Girolamo (or Girolamo Bressano or Bresciano): St. Francis receiving the stigmata 2145

Naiveu, Matthijs: St. Jerome 3062
Nanni (d'Antonio) di Banco: St. Eligius 1797
Napoletano, Jilippo *see* **Angeli, Filippo**
Nardo di Cione: St. Christina of Bolsena 1340
Nardo di Cione, School of: Madonna and Child with SS. Gregory I and Job 2543; St. Anthony Abbot 237; St. Benedict 674; St. Romuald's vision of St. Apollinaris 4227; Trinity with SS. Romuald and John the Evangelist 4226
Naselli, Francesco: Madonna in glory with SS. John the Baptist, Bonaventure and Sebastian 890; St. Monica puts the black habit on St. Augustine 3721
Naselli, Francesco, att. to: Madonna and Child with SS. Roch and Sebastian 4189
Neapolitan School: Martyrdom of St. Ursula 4755
Nebbia, Cesare: Pilgrimage of St. Charles Borromeo to the Sacred Mount of Varalio 1311
Nelli, Ottaviano: Death of St. Monica 3717; St. Ambrose baptizes St. Augustine 145; St. Augustine arrives in Carthage 500; St. Ubaldo 4731; SS. Jerome and John the Baptist appear to St. Augustine 499
Nelli, Ottaviano, School of: St. Anthony Abbot blessing the camels sent by the king 225
Neri, Pietro Martire, att. to: St. Jerome 3046
Neri de Bicci *see* **Bicci, Neri di**
Neroccio de'Landi (or Neroccio di Bartolomeo di Benedetto de'Landi): Holy Saints offer the robe to St. Catherine of Siena 1230; Madonna and Child with St. Anthony Abbot and St. Sigismund 4453; St. Benedict receiving Totila 700; St. Bernardino of

Madonna and Child with St. Charles Borromeo 1329; Madonna and Child with St. Philip Neri 4057; Martyrdom of SS. Faust and Giovita 1944; St. Augustine in glory 551; St. Eustace refuses to worship the idols (Bordeaux) 1917; St. Eustachio refuses to worship the idols (Munich) 1918; St. Jerome (Rimini) 3068; St. Jerome and St. Peter of Alcantara 3073; St. Prosdocimus baptizing St. Daniel 1601; St. Roch (Rovigo) 4205; SS. Jerome and Peter of Alcantara 4014; Triumph of St. Francis of Sales 2299

Platzer, Ignác (or Ignaz) František: St. Alexander 107; St. Barbara 620; St. Nicholas 3820

Pleydenwurff, Hans, School of: St. Leonard 3322

Pleydenwurff, Wilhelm: Mystic Marriage of St. Catherine 1044

Poccetti, Bernardino (or Barbatelli): Death of St. Alexis Falconieri at Monte Senario 117; Martyrdom of St. Catherine of Alexandria 1138; St. Philip Benizi converting two wicked women at Todi 4051; Youthful St. Antoninus kneeling before a crucifix in Orsanmichele 351

Podesta, Giovanni Andrea: St. Francis with the bread changed to roses 2251

Polidoro da Lanciano: Madonna and Child with St. Jerome 2955

Pollaiuolo, Antonio (Benci): Head of St. Jerome 2821; Martyrdom of St. Sebastian 4301; Saints Eustace and Vincent from St. Miniato Altarpiece 4834

Pontormo, Giacomo (or Jacopo Carucci): Virgin and Child with SS. Elizabeth, Anthony of Padua and John 394; Virgin and Child with SS. Jerome and Francis 2947

Pordenone, Giovanni Antonio da: St. Christopher bearing the Christ Child 1422; St. Laurence Justinian in Glory, surrounded by saints 3225; St. Martin and St. Christopher 3628; SS. Prosdocimus and Peter 4106

Pordenone, Studio of: St. Christopher 1411

Porte, Adams: St. Henry the emperor 2640

Portigiani: Antonius of Florence 350

Pourbus, Frans: Martyrdom of St. George 2464

Pourbus, Pieter: Baptism of St. Eustace 1911

Poussin, Nicolas: Landscape with St. Jerome 3028; Martyrdom of St. Erasmus 1871; Martyrdom of St. Lawrence 3281; Miracle of St. Francis Xavier 2311; Mystic marriage of St. Catherine 1168; St. Cecilia 1292; St. Margaret 3565; St. Rita of Cascia 4160

Pozzo, Andrea, Fra: Stanislaus Kotska kissing the feet of the Infant Jesus 4483; Triumph of St. Ignatius of Loyola 2724

Preiss, Franz: St. Francis Seraphicus 2304

Preti, Mattia (or Il Calabrese): Decollation of St. Gennaro 2343; Empress Faustina visits St. Catherine of Alexandria in prison 1173; Martyrdom of Catherine of Alexandria 1187; St. Catherine disputing with the doctors 1188; St. Catherine visited in prison by the Empress 1178; St. Nicholas of Bari (Naples) 3813; St. Nicholas of Bari (Rouen) 3814; St. Paul the Hermit (Cleveland) 3937; St. Paul the Hermit (Toronto) 3936; St. Peter Celestine in glory 3955; St. Sebastian (Naples) 4416; St. Sebastian (Rome) 4415

Preudhomme, Jerome: St. Benedict presents the

rules of his order to the Pope 752

Procaccini, Camillo: Birth of St. Francis of Assisi 2173; Dispute between SS. Ambrose and Augustine 159; St. Francis resuscitating a dead youth 2177

Procaccini, Giulio Cesare: Madonna and Child with St. Francis and St. Dominic 1698; Martyrdom of St. Justina 3213; Martyrdom of St. Victor 4824; Mystic marriage of St. Catherine (Milan) 1152; Mystical Marriage of St. Catherine (St. Petersburg) 1166; St. Charles Borromeo in glory 1317; Virgin and Child with SS. Latinus and Charles Borromeo 3224

Provence School: St. Agricolus in the Retable of Boulbon 85

Provoost (or Prevost), Jan: Dispute of St. Catherine 1056; Holy Virgin with SS. John the Baptist and Jerome 2872; St. Godelieve with a donor 2529; St. Nicholas of Bari with a donor 3801; SS. Benedict and Bernard in Coronation of the Virgin 771

Puccinelli, Angelo: St. Catherine and an anonymous bishop saint 1003; SS. Gervasius and Protasius 2506; SS. Leonard and Sebastian 3325

Puccini: St. Brigid in glory 915

Puccio di Simone: Madonna and Child with SS. Lawrence, Onophrius, James Major 3868

Pucelle, Jean: Miracle of the breviary brought to St. Louis in prison 3364

Puget, Pierre: Blessed Alessandro Sauli as St. Augustine (St. Louis) 549; Martyrdom of St. Sebastian 4418; St. Alessandro Sauli (Aix) 108; St. Charles Borromeo praying for the end of the plague in Milan 1333

Puligo, Domenico: Vision of St. Bernard 779

Salimbeni, Ventura: Sermon of St. Bernardino 838
Salzillo, Francisco: St. Jerome 3075
Samacchini, Orazio: Madonna and Child with SS. Mary Magdalen and Jerome 2968; Mystic marriage of St. Catherine 1122
Sambach, Caspar Franz: St. Charles of Borromeo administering the sacrament 1337
Sano di Pietro (or Ansano di Pietro di Mencio): Gesuati Polyptych with SS. Augustine, Jerome, Dominic, and Francis 489; Madonna and Child between SS. Jerome and Bernardino (Cambridge) 818; Madonna and Child with SS. Jerome and Bernardino of Siena (Esztergom) 2796; Madonna and Child with SS. Mary Magdalene and Nicholas of Bari 3774; Martyrdom of St. Quirinus 4122; Possessed woman is exorcised near St. Bernardino's deathbed 803; St. Augustine 504; St. Benedict 705; St. Bernardino (Museo dell'Opera, Siena) 806; St. Bernardino of Siena (Fine Arts Acad., Siena) 811; St. Bernardino of Siena (Palazzo Pubblico) 821; St. Bernardino preaching before the church of San Francesco 804; St. Bernardino resuscitates a dead child 805; St. Blaise saves a poor woman's pig 863; St. Bonda Polyptych with SS. Lawrence, Benedict, Stephen, John 3259; St. Christina of Bolsena 1341; St. Francis receiving the stigmata 2106; St. George baptizes the king of Silena 2400; St. George preaching to the king of Silena 2401; St. George slaying the dragon 2388; St. Jerome and St. Catherine of Siena 1227;

St. Jerome and the lion 2797; St. Jerome appears to Sulpicius Severua and St. Augustine 490; St. Jerome before a crucifix 2798; St. Quirinus 4123; SS. Cosmas and Damian Altarpiece 1551; Stories of St. Jerome 2799; Torture of St. Agatha 36; Virgin appears to St. Dominic 1675
Sano di Pietro, School of: St. Dominic 1678; St. Thomas Aquinas 4669
Santacroce, Girolamo da: St. Venantius 4810
Sant'Agostino, Agostino *see* Agostino Sant'Agostino
Santi, Giovanni: St. Sophia 4476
Saraceni, Carlo: Martyrdom of St. Cecilia (London) 1272; Martyrdom of St. Eugene 1877; St. Leocadia in prison 3311; St. Martin and the beggar 3630; St. Roch and the angel 4200; St. Sebastian (Prague) 4384
Saraceni, Carlo, att. to: Martyrdom of St. Cecilia (New York) 1271; St. Cecilia 1273
Sardinian School: Episodes from the life of St. Eligius 1804; Martyrdoms of St. Pantaleon 3905; St. Pantaleon 3906
Sassetta (or Stefano di Giovanni): Death of St. Anthony 253; Four patron saints: Victor, Ansano, Savino, and Crescenzio 207; Funeral of St. Francis 2077; Madonna della Neve Altarpiece, with Francis of Assisi 2074; Meeting of St. Anthony and St. Paul 260; St. Anthony beaten by devils (New Haven) 256; St. Anthony beaten by devils (Siena) 275; St. Anthony distributing his wealth to the poor 257; St. Anthony leaving his monastery 258; St. Anthony tempted by the devil in the guise of a

woman (Yale) 259; St. Francis before the crucifix 2084; St. Francis before the Sultan 2082; St. Francis holds the paw of a wolf, from Sansepolcro Altarpiece 2078; St. Francis in ecstasy, from Sansepolcro Altarpiece 2083; St. Francis prepares to walk through the fire before the Sultan 2079; St. Francis renounces his earthly father 2080; St. Francis's betrothal with my lady poverty 2085; St. Martin sharing his cloak with the beggar 3612; St. Thomas Aquinas before the altar of the Virgin 4663; SS. Ambrose, Jerome, Augustine, and Gregory I 139; Vision of St. Thomas Aquinas 4662; Whim of young St. Francis to become a soldier 2081
Sassetta, att. to: St. Anthony Abbot at mass 255
Sassetta, School of: Martyrdom of St. Vittorino 4830
Sassoferrato (or Giovanni Battista Salvi): St. Catherine of Siena receiving the crown of thorns from Christ 1252; St. Francis of Paola kneeling before the Madonna and Child 2279
Saturnino de'Gatti: St. Antonia of Florence 427; St. Eusanius with scenes of his life 1891
Savoldo, Giovanni Girolamo: Temptation of St. Anthony 304
Scacco, Cristoforo: St. Honoratus 2677
Scarsella (or Scarsellino), Ippolito: Betrothal of St. Catherine 1146; Martyrdom of St. Venantius of Camerino 4811
Schaufelein, Hans Leonhard: Martyrdom of St. Catherine 1086; Martyrdom of St. Sebastian 4356; St. Jerome 2871; St. Roch and St. Sebastian 4180
Schedel, Hartmann: St. Margaret subduing the dragon 3535

Vouet, Simon: Apotheosis of St. Eustace and his family 1915; St. Jerome and the angel 3012; St. Peter visiting St. Agatha in prison 46; Temptation of St. Francis 2231

Vrancke van der Stockt *see* Stockt, Vranck van der

Vroylinck, Ghislain: Martyrdom of SS. Crispin and Crispinian 1577

Wale, Samuel: St. Austin preaching Christianity to King Ethelbert 557

Waterhouse, John William: St. Cecilia 1304

Weiss, František Ignác: St. Adalbert 14; St. Thomas of Villanova 4717

Werff, Pieter van der: St. Jerome 3067

West, Benjamin: St. George destroying the dragon 2487; St. Margaret of Scotland 3581; St. Thomas a'Becket 4705

Weyden, Gossen van der, School of: St. George blesses the poison cup before the Emperor 2445

Weyden, Rogier van der: Nativity with SS. Francis and Bavo 645; St. George killing the dragon 2381; St. Ivo 2770; St. Margaret of Antioch and St. Apollonia of Alexandria 437

Weyden, Rogier Van der, School of: Exhumation of St. Hubert 2679; Pietà with St. Jerome 2802; St. Catherine 1022

Wheelright, J. Hadwen: Assassination of Edward the Martyr 1787

Willmann, Michael Leopold: St. Jerome and the recording angel 3059

Winter, Cornelius Jansson Walter: St. Zita 4937

Wittewael, Joachim *see* Wtewael, Joachim Anthonisz

Witz, Konrad (or Conradus Sapientis): St. Christopher (Basel) 1367

Witz, Konrad, School of: St. Christopher (Berlin) 1371

Wolgemut, Michael: St. Margaret rejecting the

prefect; Margaret killing the dragon 3543

Wtewael (or Wittewael), Joachim Anthonisz: St. Sebastian (Kansas City) 4378

Yañez de la Almedina, Fernando: St. Catherine 1099

Yoan of Chevindol: St. George on horseback with scenes from his life 2482

Yoan of Samokov: St. John of Rila with scenes from his life 3166

Yselin, Heinrich: St. Margaret with the dragon 3538

Ysenbrant, Adriaen *see* Isenbrandt, Adriaen

Zaganelli, Bernardino: Virgin and Child with SS. Jerome, Catherine, Cecilia, and Michael 1270

Zaganelli, Francesco: St. Catherine 1092; St. Sebastian 4371

Zahariev, Krustyu: St. Pachomius the Great 3891

Zainer, Günther: St. Remigius and other saints 3313

Zampieri, Domenico *see* Domenichino

Zanchi, Antonio: Martyrdom of St. Daniel 1600; Miracle of St. Julian 3195

Zeitblom, Bartholomeus: St. Cyprian of Carthage 1587

Zenale, Bernardo (or Bernardino): St. Ambrose on horseback 156; St. Louis of Toulouse 1603; St. Victor 4821

Zenale, Bernardo, att. to: St. Catherine of Alexandria 1051

Zick, Januarius: St. Charles Borromeo giving communion to the plague-stricken 1338; St. Jerome 3076

Zingaro, Lo *see* Solario, Antonio

Zoppo, Marco: Christ in the sepulchre between saints John the Baptist and Jerome 2810; Dead Christ with SS. John the Baptist and Jerome 2820; St. Francis receiving the stigmata 2099; St. Jerome in penitence 2816; St. Sebas-

tian with SS. Jerome, Anthony, and Christopher 4299

Zuccari (or Zuccaro), Federico: Virgin and Child appear to SS. Damasus, Lawrence, Peter and Paul 1598; Vision of St. Eustace 1912

Zuccari Brothers (Federico and Taddeo): St. Gregory VII pardons the excommunicated Emperor Henry IV 2592

Zurbarán, Francisco de: Apotheosis of St. Jerome 3029; Apotheosis of St. Thomas Aquinas 4676; Apparition of the Virgin to St. Dominic 1705; Apparition of the Virgin to St. Peter Nolasco 4004; Birth of St. Peter Nolasco 3995; Burial of St. Catherine on Mount Sinai 1169; Communion of St. Mary of Egypt 3662; Coronation of St. Catherine 1179; Death of St. Bonaventura 894; Death of St. Dominic 1706; Death of St. Peter Nolasco 4005; Departure of St. Peter Nolasco 3996; Entombment of St. Catherine 1174; Miracle of St. Hugo 2697; Miraculous communion of St. Peter Nolasco 4001; Mystical marriage of St. Catherine of Siena 1251; Our Lady bestowing the habit on St. Peter Nolasco 4002; Pope Urban II and St. Bruno 934; St. Agatha (Bilbao) 52; St. Agatha (Montpellier) 48; St. Agnes (Seville) 81; St. Ambrose 163; St. Ambrose of Siena 176; St. Anselm 220; St. Anthelm 224; St. Anthony Abbot (Florence) 328; St. Anthony Abbot (Lima) 329; St. Anthony of Padua (Cadiz) 399; St. Anthony of Padua (São Paulo) 400; St. Anthony of Padua holding the Infant Christ 409; St. Apollonia 455; St. Arthold 460; St. Augustine (Bar-

Index of Attributes and Events

The entries in this index are given as either attributes associated with the saints, or as key words associated with an event in the piece. For instance, one may find entries such as *Intercession* or *Praying*. Also, for a piece in which the saints surround the Madonna and Child, look under *Madonna and Child with*; in this index you will find references to most of the Biblical saints who were excluded from the entries. Headings such as *Mary Magdalene with* or *John the Baptist with* have been used. When further explanation is necessary, a descriptive phrase after the saint's name is included.

A few potential entries have been excluded because too many pieces contained the object. For example, the *Palm* is the universal symbol of martyrdom — any saint holding a palm was martyred. The *Book* and the *Pen,* symbols of learning, were excluded, though *Reading and Writing* are included. *Cherubs* and *Angels* were excluded because they were nearly always present during a miracle; *Angel musicians* has been included. Also excluded are *Mitre* and *Crosier,* which identify all bishops or sometimes abbots.

Accused, Accusing: Edward the Confessor accusing Earl Godwine of his brother's murder 1774; John Damascene falsely accused 3128; Martin accused of cowardice 3599; Mitre accused of stealing 3709; Quirico and Julitta accused of being Christians 4118; Vitus accused of being a Christian 4863

Adore *see* **Worship**

Alms, giving: Anthony Abbot 257, 278; Anthony of Florence 349; Benedict 707; Bruno 940; Cecilia 1279, 1302; Charles Borromeo 1334; Donnino 1736; Eligius 1804; Elizabeth of Hungary 1832; Francesca Romana 2006; Francis Regis 2301; Giles 2516; John the Almsgiver 3175; John the Hospitaller 3176; Laurence Justinian 3226; Lawrence 3239, 3253, 3284; Louis IX 3389, 3396; Lucy 3477; Onobono 3867; Poten-

tiana 4080; Raniero 4138; Roch 4198; Thomas of Villanova 4713, 4714, 4715

Anchor: Clement I 1489, 1494, 1495, 1496

Andrew the Apostle with: Francis of Assisi 2171; Jerome 2960; Leonard 3324; Longinus 3349; Louis IX 3393; Monica 3718; Prosper 4109; Tiziano 4722

Angel musicians with: Anthony of Padua 402; Anthony Abbot 606; Benedict 731; Catherine of Alexandria 1119, 1160; Cecilia 1267, 1273, 1281, 1282, 1298, 1300, 1304, 1306; Dominic 1682; Francesca Romana 2005; Francis of Assisi 2193, 2206, 2208, 2212, 2222, 2223, 2262, 2264, 2265; George 2402; Jerome 2964; Prosdocimus 4107; Senatore 4433; Stephen 4510

Annunciation with: An-

thony Abbot 4100; Catherine of Alexandria 1014; Cosmas 1536; Emidius 1846; Maurelius 3671; Zachary 4912

Anvil: Adrian 18, 19, 20; Eligius 1802, 1805, 1806, 4080

Apostatize, refusing to *see* **Idols, refusing to worship**

Apotheosis of (*see also* **Ecstasy of; Glory of**): Andrea Corsini 193; Augustine 551; Benedict 743; Bernard 797; Bernardino of Siena 810; Bruno 943; Cajetan 967; Camille de Lellis 972; Catherine of Alexandria 1162; Emmerich 3221; Eustace 1915; Hermenegild 2649; Jerome 3029; John Nepomucen 3154; Louis IX 3404; Martin 3616; Rita 4160; Roch 4191; Rosalie 4238; Sebastian 4423; Thomas Aquinas 4655, 4676

Apparition of *see* **Vision of**

Armor: Achatius 6; Adrian

bread of Innocent IV 1455, 1462; Claude 1480; Cleridonia 1504; Cyril Belozerskii 1591; Dominic 1652; Endoxus 1851; Fabian 1930, 1932; Fidentius 1967; Francis of Assisi 2022; blesses a dead youth 2177; Francis of Paola blessing a child 2283; George blesses the poisoned cup 2445; Heracleidius 2642; Isicus blesses St. Arigius 458; John Capistrano blesses the army against the Turks 3109; Julitta 4119; Leo II 3303; Leopardus 3334; Louis of Toulouse 3411; Macarius of Egypt 3499; Marcellus I blessing a woman 4905; Marziale 3665; Medardus blesses St. Radegund 3696; Nicholas of Bari 3790; blesses the three children 3771; Nicholas of Tolentino blesses cripples 3839; Pantaleon 3902, 3906; Peter Celestine 3953; Peter Nolasco blessing a donor 4003; Petronius 4032; Phevronia 4041; Photius 4066; Polychronius 4076; Radegonde 4131; Roch blessing the plague-stricken 4196; Rufinus 4256; Sernin of Toulouse 4443; Siffrein 4451; Simeon Stylites 4459; Syrus 4583; Teresa blessing Anne de St. Barthélemy 4598; Theodosia 4647; Thomas Aquinas 4680; Thomas Becket 4681, 4694; Tiziano 4720; Ursicinus blesses one of the crosses of Bologna 4745; Valentine blessing a plague victim 4280, 4796; Victorinus 4829; Vincent blessing two men in armor 4836; Zeno of Verona 4914; Zenobius 4915; Zosima 4269

Blood: Agatha 35, 50; Barbara 621; Bernard 787; Blaise 866; Charles Borromeo 1316; Christopher 1363; Dominic 1668;

Erasmus 1860; Gennaro 2344; Grata 2533; Gregory I 2573; James of the March 2776; Peter Martyr 3968, 3970, 3971, 3973; Praxedes 4082, 4083; Simonino 4467; Stephen 4514; Thomas Becket 4698

Boar *see* **Pig**

Boat (*see also* **Ship**): Antoninus 429; Augustine 500; Christopher 1400; Clement I 1488; John Nepomucen 3150; Julian 3194; Nicholas of Bari 3750; Peter Martyr 3960; Peter Nolasco 4000, 4007; Ursula 4747; Vincent 4840; Walpurgis 4874

Brazen Bull, tortured in: Eustace 1900, 1901, 1903; George 2357

Bread: Albinus 98; Anthony Abbot 267, 302, 330, 3925, 3927, 3928, 3931; Basil the Great 633, 634, 635, 636, 637, 638; Benedict 666, 707; Bernard 763; Bernardino of Siena 833; Charles Borromeo 1311, 1312; Clare 1455, 1462; Dominic 1667; Elizabeth of Hungary 1819, 1822, 1823; Elizabeth of Thuringia 1840; Francesca Romana 2000; Francis of Assisi 2251; Margaret 3313; Nicholas of Bari 3744; Nicholas of Tolentino 3833; Paul the Hermit 3936, 3937, 3938; Roch 4167, 4170, 4181, 4182; Valentine 4793; Vincent Ferrer 4845

Breasts: Agatha 29, 31, 32, 33, 35, 36, 38, 41, 48, 49, 52, 56, 60, 75; Anatolia 187; Barbara 572; Julitta 4118; Justina 3203; Lucy 3434; Reparata 4159; Ursula 4779

Brothel, sent to: Agatha 29, 32, 33; Agnes 66, 82

Build: Barbara, building her tower 575, 580; Benedict instructs monks how to build their abbey 720; Edmund the Martyr supervises the building of

an abbey 1769; Four Crowned Martyrs refusing to build a pagan temple 1995; Galganus instructed by Michael the Archangel where to build a hermitage 2320; Sergius of Radonezh building his cell and a church 4442

Bull: Bernardino of Siena 848; Eustace 1910; George 2355; Gregory of Armenia 2598; Sylvester I 4573, 4574; Vitus 4863

Burial of (*see also* **Funeral of; Tomb**): Agatha 43; Catherine of Alexandria 1169; Cosmas 1542; Hermagoras 2648; Lucy 3468; Monica 3713; Petronilla 4027; Roch 4172; Sebastian 4386; Stephen 4539

Burned (*see also* **Gridiron; Oven**): Agatha 4475; Agnes 83; Anastasia burned at the stake 4085; Catherine of Alexandria 1018; Christina of Bolsena burned 1339; Dominic with burning book 1665, 1672, 1683; Eustace, burned in a brazen bull 1910; Florian saves burning castle 1977, 1980; Francis Xavier burned 2313; Joan of Arc tied to a stake 3083; Julitta, burning pitch poured on her 4117; Lawrence 3237, 3251; Regina burned with torches 3340; Lucy with burning oil and pitch poured on her 3444; Lucy burned 3442, 3447, 3456, 3482; Margaret burned with brands 3521, 3542; Prisca burned at the stake 4089; Reparata put to the flames 4158; Rufinus placed in a burning oven 4257; Spiridonius holding a burning tile 4480, 4481; Thomas Aquinas holding a blazing book 4652; Vincent burned with brands 4837; Vincent Ferrer saves an infant from burning building 4852

Candle (*see also* **Torch**): Agatha 45, 46; Anthony Abbot 253; Benedict 739;

Blaise 857, 862; Bridget of Sweden 913; Charles Borromeo 1326; Clare 1471; Donatus 1730, 1733; Erasmus 1865; Francis of Assisi 2071; Genevieve 2334, 2335, 2336; Giovita 1942; Jerome 2906, 2951, 3019; John Lampadistis 3143; Leocadia 3311; Lucy 3459; Peter Nolasco 4001; Phanourius 4039

Canonization of: Catherine of Siena 1216; Francis of Assisi 2071; Luigi Gonzaga 3490; Nicholas of Tolentino 3837

Captured: Joan of Arc 3084; John Damascene 3126

Cauldron, baptized in: Constantine 1520; Pelagia 3947

Cauldron, boiled in: Ansanus 215; Anthony of Padua rescues infant from 358; Crispin 1568, 1573; Erasmus 1863; George 2357; Lucy 3442, 3697; Margaret 3521; Quirico 4116; Ursula 4772; Vitus 4444, 4863, 4867

Cave: Anthony Abbot 247, 301, 333; Benedict 663, 666, 668, 671, 689, 724, 725, 736, 740; Bernardino of Siena 825; Blaise 864; Clement of Volterra 1502; Cleridonia 1504; Francis of Assisi 2112, 2183, 2201, 2204, 2205; George 2396; Giles 2514; Jerome 2834, 2840, 2841, 2860, 2864, 2892, 2895, 2897, 2917, 2946, 2961, 2972, 2998, 3034, 3072; Margaret 3550; Seven Sleepers of Ephesus 4445

Chains: Anthony Abbot 336, 337; Anthony of Padua 377; Bernard 780; Catherine of Alexandria 1145; Bernard 1607; John of Mathy 1955; George 2489; Joan of Arc 3092; Leonard 3316, 3317, 3322, 3327, 3329, 3726; Metronius 3705; Polycarp 4074; Quentin 4111; Sebastian 4297, 4370; Serapion 4435

Chain Maille: Bacchos 567; Theodore Stratelates 4631

Chalice: Agatha 39; Anthony of Padua 384, 385; Barbara 588, 589, 590, 592, 596, 601, 602, 603, 4740; Donnino 1740; Gregory I 2573; Hugh of Lincoln 2693, 2694, 2695; Nicholas of Bari 3756; Nicholas of Tolentino 3832; Conrad 3888; Louis of Toulouse 3888; Pontianus 4079

Chasuble: Apollinaris of Ravenna 430; Faust 1942; Ildefonso 2731, 2736, 2738, 2739, 2740, 2741, 2742

Choking: Blaise 866; Four Crowned Martyrs are scourged, while devils strangle the tribune Lampadius 1996; Godelva 2530

Chopped *see* **Dismembered**

Christ *see* **Jesus**

Circlet *see* **Crown**

Cleaver: Felix 4905; Peter Martyr 3963, 3981, 3991; Vincent Ferrer 4842

Club, Clubbed (*see also* **Beaten**)**:** Boniface about to be clubbed 4444; Meinrad about to be clubbed from behind 3697; Protus and Hyacinth pursued by men bearing clubs 3513

Coals, placed on: Agatha 34

Coffin (*see also* **Funeral of; Tomb**)**:** Eleutherius of Tournai 1790; John Chrysostom 3113; Louis IX 3386; Martin 3592

Comforted by angels *see* **Consoled by angels**

Communion: Arigius 458; Benedict 737, 751; Bonaventure 893, 898; Catherine of Siena 1209, 1214, 1225, 1249; Charles Borromeo 1324, 1327, 1337, 1338; Denis 1624, 1635; Francis of Assisi 2159, 2203; Jerome 2855, 2857, 2978, 2995, 2996, 3065, 3070; Louis IX 3400; Lucy 3467, 3470, 3479, 3480, 3481; Macaire of Ghent 3497; Mary of Egypt 3125, 3655, 3659,

3662, 4939; Peter Nolasco 4001; Petronilla 4028; Stephen 4507

Condemned: Catherine of Alexandria 1033; Cecilia 1278; Edmund the Martyr 1766; Maurelius 3672; Stephen 4498

Confession: John Nepomucen 3145, 3151; John of the Cross 3171; Margaret of Cortona 3572; Roch 4181

Consecration of: Ambrose 152; Augustine 507; Clare 1464; Edmund of Abingdon 1760; Eligius 1804, 1807; Hermagoras 2648; Martin 2660; Marziale 3667; Nicholas of Bari 3753, 3780, 3803, 3805; Norbert 3856; Peter Martyr 3966; William of Aquitaine 4896

Consoled by angels: Catherine of Alexandria 1126, 1148; Francis of Assisi 2183, 2193, 2255; Roch 4194; Sebastian 4378, 4419, 4429

Construction: Clotilde 1509; Edward the Confessor 1778; Francis of Paola 2294; Willibald 4901

Contemplation *see* **Meditation**

Conversion: Bavo converted 129, 651, 652; Augustine converted 488, 3722; Catherine of Alexandria converts the philosophers 1013; converts the Empress 1036; Catherine of Alexandria converted 1079; Cecilia urges Valerian to convert 4799; Christopher converts two courtesans 1364; converts soldiers 1375; Clement I converted 1493; Eustace converted 1896, 1897, 1899; George converts Athanasius 2355; converts the Queen 2356; converts the king and court 2410; Grata converts her father 2533; Hippolytus converted by Lawrence 2667, 2668, 3251, 3255; Hubert converted 2684, 2686, 2688;

4350; Lawrence 2668, 3255; Leu 3341; Louis IX 3398; Martin 3636; Maurus 3692; Nicholas of Bari 3750, 3772, 3808; Nicholas of Tolentino 3839, 3840; Pantaleon 3907; Patrick 3920; Philip Benizi 4046, 4047; Roch 4166, 4202; Stephen of Muret 4562; Theodorus 4645; Tuscana 4729; Valentine 4791; Vincent Ferrer 4845; Zenobius 4929, 4931
Curry Comb: Blaise 861, 866, 867, 870, 871
Dacian (Roman Emperor) with: George 2355, 2356, 2357
Dagger _see_ **Knife**
Death of: Alexis 112; Alexis Falconieri 117; Andrew of Ireland 197; Anthony Abbot 253, 263; Augustine 481; Benedict 677, 685; Bonaventure 894; Bruno 937; Catherine of Siena 1208, 1217; Cecilia 1275; Clare 1443, 1448, 1459, 1478; Dominic 1666, 1706; Edmund the Martyr 1766; Efriam the Syrian 1788; Elizabeth of Hungary 1824; Fina 1970, 1971; Francis of Assisi 2021, 2053, 2058, 2164, 2248, 2259; Gregory I 2585; Hildebrand 2661; Jerome 2799, 2857, 3069; John Damascene 3128; John Gualbertus 3133; John of the Cross 3172; Louis IX 3357, 3377, 3378, 3385, 3397; Margaret of Cortona 3572; Monica 3717; Nicholas of Bari 3778; Nilus 3849; Omobono 3866; Pancras 3895; Paul the Hermit 3939, 3940; Peter Nolasco 4005; Petronilla 4028; Philip Benizi 4044; Romuald 4235; Scholastica 4277; Teresa 4608; Thomas of Villanova 4716; Zenobius 4930
Decapitated _see_ **Beheaded**
Deer: Calogerus 971; Catherine of Vadstena 1261; Eustace 1899, 1905, 1907,

1909, 1913; Giles 1384, 2513, 2514, 2515, 2518, 4901; Hubert 2684, 2685, 2686, 2687, 2688
Demons _see_ **Devil**
Departure: Augustine 3713; Benedict 709, 715; Florian 1984; Louis IX 3361; Mary of Egypt 3654; Paula 3945; Peter Nolasco 3994, 3996; Thomas Becket 4686
Desert: Ansanus 209; Anthony Abbot 285; Benedict 671; Jerome 2813, 2818, 2823, 2824, 2840, 2903, 2970, 3051, 3072, 3074; Mary of Egypt 3663
Devil (or demons), assaulted by: Abbâ Macarius 1, 2; Anthony Abbot 239, 241, 244, 256, 259, 275, 276, 288, 291, 323; Benedict 706; Bernard 767; Brandon 906; Dominic 1714; Four Crowned Martyrs 1996; Julian 3181, 3190; Francesca Romana 2001; Margaret 3565; Nicholas of Bari 3340; Romuald 4225; Vincent Ferrer 4850
Devil, conquering (_see also_ **Exorcising):** Albert Siculus 90; Basilius 640; Benedict 678, 682, 692; Bernard 780, 1607; Brandon 907; Christopher 1378; Dunstan 1756; Eligius 1805; Francis of Assisi 2096; Lawrence 3236; Nicholas of Tolentino 3836; Peter Martyr 3970; Wolfgang 4906
Dictating: Catherine of Siena 1218
Digging: Anthony Abbot buries St. Paul with the help of lions who dig a grave 254; Savinus instructs men to dig for the body of Antoninus 429, 4267; Helena with men digging for the three crosses 2613; Sergius of Radonezh digging the ground to sow vegetables 4442
Dinner of _see_ **Supper of**
Diocletian (Roman Emperor) with: Cyriacus

1589; Four Crowned Martyrs 1994, 1995; Sebastian 4297, 4307, 4375
Discovery _see_ **Finding of**
Disembarking: Nicholas of Bari 3776; Ursula 3947
Dismembered (_see also_ **Beheaded; Severed):** Euphemia 1887; George 2357; Hippolytus 2669, 2670; Maurice 3686; Quirinus 4126; Ursula 4748; Vincent 4849
Distributing wealth to the poor _see_ **Alms, giving**
Doctrine: Ambrose 159; Augustine 487, 494; Basil 631; Francis of Assisi 4678
Doe _see_ **Deer**
Dog: Christopher Kynokephalos 1434; Dominic 1711; Donnino 1737, 1738, 1740; Eustace 1912; Hubert 2687; Jerome 2885; Julian 3192; Justin Martyr 3201; Livinus 3347, 3348; Quirinus of Neuss 4126; Roch 4166, 4167, 4170, 4179, 4181, 4182, 4207, 4209; Stanislaus of Cracow 4489; Vitus 4865
Dove: Ambrose 148; Ambrose of Siena 176; Cecilia 1266; Colomba the Dominican 1514; Eulalia 1880; Francis of Sales 2295; Glisente 2528; Gregory I 137, 2543, 2580; Margaret 3521; Remigius of Rheims 4148; Teresa 4590
Dragon: Anthony Abbot 266, 285; Florentius 1975; Francesca Romana 2001; George 100, 1397, 2351, 2358, 2360, 2361, 2362, 2363, 2365, 2367, 2368, 2369, 2370, 2371, 2372, 2374, 2376, 2378, 2381, 2383, 2384, 2388, 2391, 2392, 2393, 2394, 2395, 2396, 2397, 2398, 2399, 2401, 2403, 2404, 2405, 2408, 2410, 2411, 2412, 2413, 2414, 2416, 2417, 2419, 2420, 2421, 2422, 2423, 2424, 2425, 2427, 2428, 2430, 2432, 2433, 2434, 2435, 2437, 2438, 2439, 2440, 2441, 2442, 2443, 2444, 2446, 2452,

Roch 4166; Thomas More 4708, 4727
Father of (*see also* **Parents of):** Alexis 110; Augustine 501; Barbara 580, 598, 600, 616; Christina of Bolsena 1347; Dagobert 1597; Dympna 1759; Emmerich 1849; Francis of Assisi 2050, 2080; Grata 2533; John Gualbertus 3133; Julian 3190; Vincent Ferrer 4850; Vitus 4863
Feet cut off: Adrian 16, 21, 22, 23; Anthony of Padua healing the young man's foot 356, 379, 418, 419; Eligius shoeing the detached foot of a diabolical horse 1802, 1805, 1806; Euphemia 1887; Peter Martyr replacing a man's foot 3969
Fetters *see* **Manacles**
Finding of: Alexis 111, 115, 116, 118; Genevieve of Brabant 2339; Donatus, praying at the grave of a penitent's wife, to discover hidden money 1732; Edward the Confessor recovers a ring from a pilgrim 1775; Florian, his body recovered 1986; Helena finds the True Cross 2611, 2613, 2616, 2619, 2624, 2628, 2633, 2635, 2637; Irene finds St. Sebastian 2759; Gratus finds the head of John the Baptist 3179; Jerome, his lion recovers the stolen donkey 2797; Julian finding his parents in his bed 3181, 3190; Leopold finding the veil 3337; Louis IX recovering the remains of the Christians massacred at Sidon 3362; Norbert receiving the saint hosts and church vessels recovered from Tankhelm 3855; Peter Nolasco recovering the image of the Virgin 3999; Rufinus 4257; Stephen's tomb 4537
Fire *see* **Blazing; Burned; Flame**
Fish: Anthony of Padua

367, 375; Brandon 906; Christopher 1352, 1418; Ulrich 4736, 4737, 4739, 4740
Flagellant with: Anthony Abbot 281
Flagellation *see* **Beaten**
Flail: Barbara 582; Dominic 1668; Gregory I 2558; Jerome 3024, 3027
Flame (*see also* **Blazing; Burned):** Agatha holding a flaming staff 42; Anthony Abbot standing in a circle of flames 242; Anthony of Padua standing in flames 353; holding a flame 355; Antonia of Florence with a divine flame around her head 427; Augustine holding a flaming heart 3407; Catherine of Alexandria with an angel holding a flaming sword 1194; Conrad holding a flaming chalice 3888; Elias holding a flaming sword 1792; Ephesus put into an oven, but the flames turn on his persecutors 1856; Francis of Sales hands a flaming heart to SS. Mary and Anne 2299; Illuminata of Todi holding a flaming vase 2743; Lucy holding a flaming urn 3436, 3437, 3438, 3445; unharmed by the flames 3444; Teresa, an angel pierces her heart with a flaming arrow 4618; Theodore Stratelates with flames in lower right corner 4635
Flayed; Coloman 3947; Crispin 1576, 3947; Hippolytus 4901; Julitta 4117, 4120; Proculus 4101; Savin and Cyprien 4268
Floating *see* **Raising**
Flogged *see* **Beaten**
Flood: Camille de Lellis 975; Elizabeth of Hungary 1824; John Gualbertus 3135
Flowers (*see also* **Lily, Rose):** Agatha 40, 56; Alphonsus Rodriguez 122; Anthony of Padua 363, 3268; Apollinaris of Ravenna 430; Bernard

789; Bonaventure 879; Bruno 931; Casilda 979; Catherine of Alexandria 1171, 1186; Catherine of Siena 1253; Cecilia 1286, 1294, 1295, 1298; Crispin 1577; Daniel 1600; Diego de Alcalá 1643; Dorothy 1579, 1741, 1743, 1747, 1748, 1751, 1753; Elizabeth of Hungary 1814; Elizabeth of Portugal 1838; Fina 1970; Florian 1978; Francis of Assisi 2206, 2228; Francis Xavier 2309; Grata 2533; Hippolytus 2672; Lawrence 3293, 3296; Lucy 3452; Luigi Gonzaga 4486; Nereus 1723; Prosper 4109; Rosalie 4237, 4239, 4244, 4245; Sebastian 4376, 4397; Stanislaus Kotska 4483; Stephen 4552; Teresa 4604, 4612; Ursula 4790; Valerian 4801, 4802, 4803
Flying (*see also* **Raising):** Bernardino of Siena 803; Francis of Assisi 2109; Gennaro 2344, 2345; Nicholas of Bari 3766, 3781
Foretelling *see* **Predicting**
Forgiving: Dagobert forgiven by his father 1597; Gregory VII pardons the excommunicated Emperor Henry IV 2592; John Damascene forgives the emperor 3128; Tuscana forgiving three youths who assault her 4729
Founding: Alto and the founders of the Mariamünster 123; Anthony of Florence founding the congregation of the Buonomini di S. Martino 346; Ignatius of Loyola receives permission to found the Society of Jesus 2723; Joan of Valois founds the Order of the Annunciation 3105; Marziale founding churches 3667
Fount or Fountain (*see also* **Spring):** Bernardino of Siena 816; Clotilde 1509
Freeing (or Releasing):

Roch 4173, 4189; Rosalie 4244; Rose of Lima 4250; Sebastian 219, 1343, 4308, 4309, 4377; Severinus of Austria 4448; Simon Stock 4464; Stephen 4517, 4535; Tiziano 4722; Vincent 185; Vincent the Martyr 4858; Wenceslas 4885; William of Aquitaine 4894; Zenobius 4925, 4932

Manacles: Gervasius, exorcizing a demon from a shackled woman 2507; John of Mathy 1955; Leonard 3318, 3324, 3325

Mark the Apostle with: Augustine 526; Barbara 577; Benedict 729; Peter Martyr 1549; Gregory I 2551; Hermagoras 2648; Severinus of Austria 4448

Marriage: Edward the Confessor 1777; Louis IX 3377; Margaret of Scotland 3583

Marriage, Mystical: Catherine of Alexandria 198, 985, 989, 998, 999, 1002, 1005, 1014, 1015, 1016, 1026, 1027, 1031, 1032, 1034, 1035, 1038, 1043, 1044, 1057, 1058, 1067, 1070, 1071, 1076, 1078, 1081, 1083, 1087, 1095, 1096, 1100, 1113, 1114, 1119, 1120, 1122, 1123, 1124, 1136, 1137, 1139, 1146, 1151, 1152, 1156, 1159, 1160, 1161, 1162, 1166, 1168, 1171, 1177, 1182, 1189, 1191, 1197, 1199; Catherine of Ricci 1200; Catherine of Siena 1202, 1204, 1205, 1210, 1219, 1239, 1240, 1241, 1251, 1622; Francis of Assisi 2035, 2085

Mary Magdalene with: Anthony Abbot 1531; Catherine of Alexandria 1067, 1144; Catherine of Siena 1232; Cecilia 1268; Cornelius 1529; Edward the Confessor 1782; Francis of Assisi 2055; Jerome 2839; Lucy 3459, 3465; Margaret 3332, 3539; Mary of Egypt 3658; Odile 3859; Philip Neri 1895; Thomas Aquinas 4652

Mass: Ambrose 135; Anthony Abbot 255; Basil the Great 633, 634, 635, 636, 637, 638; Bonaventure 893; Catherine of Siena 1225, 1249; Clement I 1487; Donatus 1729; Edward the Confessor 1774; Faust 1942; Francis of Sales 2295; Giles 2514, 2519; Gregory I 2545, 2550, 2558, 2561, 2563, 2565, 2566, 2567, 2568, 2569, 2570, 2571, 2572, 2573; Hubert 2683; Ildefonso 2732; John Capistrano 3109; John Damascene 3128; Joseph of Copertino 3178; Leu 3340; Margaret of Hungary 3576; Martin 3591, 3595, 3604, 3614, 3616, 3635, 3639; Narcissus 3726; Nicholas of Bari 3749; Nicholas of Tolentino 3840; Omobono 3866; Philip Neri 4058; Zachary 4912

Matthew the Apostle with: Catherine of Alexandria 1020, 1156; Francis of Assisi 2076, 2175; Hilarion 2653; Hugo 2696; Sebastian 4322

Maxentius (Roman Emperor) with: Catherine of Alexandria 1029, 1050; Constantine 1523

Meal of see **Supper of**

Meditation: Augustine 485, 542; Charles Borromeo 1336; Cyril of Constantinople 1596; Dominic 1711; Francis of Assisi 2146, 2147, 2155, 2156, 2182, 2184, 2194, 2195, 2209, 2227, 2232, 2238, 2242, 2244, 2246, 2247, 2249; Jerome 2860, 2958, 2989, 3018, 3046; Onophrius 3879; Peter of Alcantara 4009; Roch 4206; Rosalie 4239; Thaïs 4620

Meeting: Alexis meets his father 110; Anthony Abbot meeting St. Paul 260, 3929; Nilus meets emperor Otto III 3849; Ursula 4763

Mermaid: Brandon 906; Christopher 1398, 1414, 1415

Millstone (see also Drown): Blaise 865, 869; Calixtus 3313; Christina of Bolsena 1339, 1340, 1346; Clement I 1488, 1490; Crispin 1568; Florian 1985; Pantaleon 3905; Quirinus 4122; Vincent 4831, 4832, 4840

Mocking of: Thomas Becket 4699

Model of a church (holding): Cunegund, with a model of Bamberg Cathedral 1580; Francis of Assisi 2332; Geminianus with a model of St. Gimignano 2333; Hilary Martyr 2659; Jerome 502, 2829, 4308; Leopold 3335; Louis IX 3380; Malo 3506; Sebaldus 4279; Wolfgang 4909, 4910

Model of a city (holding): Adrian 17; Daniel of Padua, with model of Padua 1602; Emidius with a model of Ascoli 1846; Fortunade 1992; Liberalis 3342; Nicholas of Tolentino with a model of Empoli 3825; Petronius 4032; Seconda 4432; Severinus of Austria with a model of Sanseverino 4447; Sophia 4476; Terentianus 4588, 4589; Venantius 4808, 4809; Victor with a model of Vallerano 4822

Mother of (see also Parents of): Augustine 155, 501; Bernardino of Siena 833; Catherine of Siena 1211; Constantine 1526, 2607; Crispin 1567; Eligius 1794; Fina 1970; Gennaro 2344; Giles 2516; Louis IX 3364, 3368, 3376, 3399; Lucy 3433; Nicholas of Bari 3738; Robert 4163

Mouse see **Rat**

Mule: Anthony of Padua 367, 370, 384, 385, 392, 401; Germanus 3504; Sol the Abbot 4475

Multiplication of: Clement of Volterra multiplying grain 1500; Francesca Romana multiplying loaves 1999, 2000; Nicholas of Bari multiplies corn 3770;

thony of Florence 349; Anthony Pecherskii 425; Anthony the Roman 426; Athanasius 462; Averkius 565; Basil the Great 623, 625, 629; Brigid 917; Catherine of Siena 1228; Cyril Belozerskii 1591; David 1604; Elzéar 1844; Francis of Assisi 1451, 2059; Giles 2514, 2519; Gregory Nazianzen 2595; Hermes 2651; Ives 2768; Jerome 2787, 1343, 2980, 2999, 3003, 3021; John Capistrano 3109; John Chrysostom 3121; John of Rila 3163, 3165; Leonard 3331; Macarius of Egypt 3498; Margaret of Hungary 3578; Monica 3711, 3722; Nicholas of Tolentino 3825; Pachomius 3891; Paraskeva 3912; Paula 3941, 3942; Primus 4086; Savvatii Solovetskii 4269; Soter 4479; Spiridonius 4480, 4482; Theodosius Cenobiarch 4650; Thomas Aquinas 4655, 4670; Vincent Ferrer 4843; Zachary 4912

Scythe: Abbâ Macarius 2; Romuald 4235; Tryphon 4727

Serpent: Anatolia 187; Anthony Abbot 256; Christina of Bolsena 1339; Fina 1970; Francesca Romana 2001; Francis of Sales 2298; Jerome 2811, 2970; Julian 3185, 3187; Pantaleon with donor wrapped in a serpent's coils 3906; Patrick 3919; Priminus 4085

Severed (*see also* **Beheaded; Dismembered**): Adrian, executioner holds up the hand he has just severed 23; Agatha holding her severed breast 31; Anthony of Padua restores the severed foot of a man 367, 379, 417, 418, 419; Crescenzio holding his own severed head 207, 1563; Donnino carries his own severed head across the river 1735; Eligius

holding a horse's severed leg 1803; Felix, Regula and Exuperantius hold their severed heads in their hands 1928; Felicity holding a sword with her seven sons' severed heads 1949; Gennaro pointing to a severed head 2341; Julian holding the severed heads of his parents 3186; Theodorus replaces the severed hand of a Jew 4645

Sewer: Bernardino of Siena 822; Irene 2748; Sebastian 4350; Stephen 4543

Ship (*see also* **Boat; Ship in Distress**): Anthony Abbot 289; Brandon 1494; Cuthbert 1582; Florian 1979; Louis IX 3383, 3386; Petronius 4031; Satyrus 4261

Ship in distress, saved by (*see also* **Ship**): Clare 1456, 1463; Dominic 1657, 1660; Fina 1969; Giles 2515; Nicholas of Bari 3743, 3744, 3754, 3761, 3762, 3766, 3781, 3786, 3810; Walpurgis 4874

Shovel: Fiacre 1964

Sick *see* **Curing the sick**

Siege (*see also* **Battle**): Joan of Arc 3084, 3088, 3100; Louis IX 3372; Marinus 3586; Nicholas of Tolentino 3832

Skinned alive *see* **Flayed**

Skull: Bruno 932, 936, 939; Catherine of Siena 1256; Francis Borgia 2008; Francis of Assisi 2136, 2146, 2151, 2161, 2170, 2181, 2184, 2194, 2195, 2197, 2204, 2209, 2222, 2223, 2227, 2229, 2233, 2236, 2237, 2238, 2242, 2244, 2250, 2261, 2265; Jerome 2864, 2902, 2908, 2914, 2919, 2920, 2921, 2922, 2925, 2937, 2938, 2943, 2944, 2958, 2964, 2981, 2989, 2990, 3009, 3022, 3036, 3040, 3048, 3056; Luigi Gonzaga 3492; Macarius of Egypt 3500; Onophrius 3878; Paul the Hermit 3934;

Peter of Alcantara 4009; Rosalie 4239, 4247

Sleeping: Ambrose 135; Benedict instructs sleeping monks 720; Catherine of Alexandria 1013; Cecilia 1304; Cosmas and Damian heal a sleeping man 1534; Dagobert 1597; Francis of Assisi 2183; Jerome 2936, 2951; Martin 2660, 3642; Mary of Egypt 3663; Nicholas of Bari with the impoverished nobleman and daughters (sleeping) 3787; Roch 4178; Romuald 4225, 4233; Serapion 4435; Servatius 4444; Seven Sleepers of Ephesus 4445; Ulrich 4080; Ursula 4759

Soldiers with: Agatha 44; Ansanus 214, 215; Anthony Abbot 284; Blaise 860; Christopher 1375, 1381; Clement I 1489; Demetrius 1619; Denis 1626; Donnino 1736; George 2364; Gervasius 2508; Mamas 3510; Maurice 3684; Peter Martyr 3959, 3983; Polycarp 4074; Sebastian 4294, 4301, 4358, 4383, 4390, 4391, 4430; Stephen 4551, 4558; Ursula 4755

Sore: Roch 583, 1932, 1935, 4168, 4173, 4174, 4179, 4190

Soul: Barbara 580; Benedict 703; Bertin 851; Catherine of Siena 1208, 1224, 1245; Ephesus 1856; Eulalia 1880; Eustace 1901; Francesca Romana 1999; Gregory I 2586, 2587; Lawrence 3236, 3239; Mamas 3509; Pantaleon 3905; Peter Martyr 3960; Roch 4172; Scholastica 4272; Sebastian 4312; Teresa 4594, 4606; Thomas Aquinas 4659; Ursula 4755; Vitalis 4862

Snake *see* **Serpent**

Sparing *see* **Forgiving**

Spear (*see also* **Lance**): Bassus 642; Demetrius 1614, 1619, 1620; Dimitrii 1649; Eustathios 1920; George 2352, 2360, 2367,

Directory

Abbeville Museum: (Musée Boucher de Perthes), 24 Rue du Beffroi, F-80100 Abbeville, France
Aberdeen Art Gallery: (Aberdeen Art Gallery and Museums), Schoolhill, Aberdeen, AB9 1FQ Scotland
Accademia, Venice: Campo della Carità, Accademia, I-30121 Venice, Italy
Accademia Carrara, Bergamo: (Pinacoteca dell'Accademia Carrara), Piazza Carrara 81a, I-24100 Bergamo, Italy
Accademia de Bellas Artes, Madrid: (Museo de la Real Academia de Bellas Artes de San Fernando), Calle Alcala 13, Madrid, Spain
Accademia della Belle Arti, Florence: Biblioteca, Via Ricasoli 66, I-50122 Florence, Italy
Accademia Nazionale di San Luca, Rome: Piazza dell'Accademia di San Luca 77, I-00187 Rome, Italy
Ackland Art Museum: University of North Carolina, Chapel Hill, NC 27514
Acropolis Museum: The Acropolis, Athens, Greece
Aix-en-Provence, Museum. See Granet Museum
Akademie der Bilden Künste, Vienna. See Gemäldegalerie, Vienna
Albegna, Museo Diocesano: Albegna, Italy
Albertina, Vienna. See Graphische Sammlung Albertina
Albright-Knox Art Gallery: 1285 Elmwood Avenue, Buffalo, NY 14222
Aldobrandini, Frascati: I-00044 Frascati, Rome, Italy
Alençon, Bibliothèque Municipale: 312 Rue du Collège, F-61014 Alençon, France
Alençon Museum: F-61000 Alençon, France
Algiers, Musée des Beaux-Arts: El Hamma, Alger, Algeria
Alkmar, Stedelijk Museum: Doelenstraat 3, NL-1811 KX Alkmaar, Netherlands
All Souls' College Chapel: Oxford, OX1 4AL, England
Allen Memorial Art Museum: Oberlin College, Oberlin, OH 44074
Allentown Art Museum: PO Box 117, Allentown, PA 18105
Alost, St. Martin: Aalst, Belgium
Alte Pinakothek: 2 Barerstraβe 27, 8000 Munich, Germany
Ambrosian Library, Milan: Piazza Pio XI 2, 20123 Milan, Italy
Amiens, Musée des Beaux-Arts: (Musée de Picardie), 48 Rue de la République, F-8000 Amiens, France
Amsterdam Historical Museum: Kalverstraat 92, Nieuwezijds Voorburgwal 359, NL-1021 RM Amsterdam, Netherlands
Amsterdam Maritime Museum: (Rijksmuseum Nederlands Scheepvaart Museum), Kattenburgerplein 1, NL-1018 KK Amsterdam, Netherlands
Ancona, Museo Civico: (Pinacoteca Civica 'Francesco Podesti' e Galleria Comunale d'Arte Moderna) Palazzo Bosdari, via Pizzecolli 17, I-60100 Ancona, Italy
Angers, Musée des Beaux-Arts: 10 Rue du Musée, F-49000 Angers, France
Antikenmuseum, Basle: St. Albangraben 5, CH-405 Basel, Switzerland
Antikensammlungen, Munich: (Staatliche Antikensammlungen und Glyptothek) Karolinenplatz 4, D-8000 Munich 2, Germany
Antiker Kleinkunst Museum, Munich: Königsplatz 1, 8000 Munich 2, Bayern, Germany
Antiquarian Museum: Pompei Scavi, I-80040 Pompei, Naples, Italy
Anton Ulrich Museum. See Herzog Anton Ulrich Museum
Antwerp, Musée Royal des Beaux-Arts: Leopold de Waelplein, 2000 Antwerp, Belgium

319

Apostolica Biblioteca Vaticana: Porta San Anna, Cortile del Belvedere, 00120 Vatican City
Apostolico Palace: Piazza della Madonna, Loreto, Italy
Apsley House, Wellington Museum: 149 Piccadilly, Hyde Park Corner, London, W1V 9FA, England
Aquila, Museo Nazionale Paleocristiano: Piazza Monastero, I- 33051 Aquileia, Udine, Italy
Arbe Cathedral: Rab, Croatia
Archangel, Museum of Fine Arts: (Archangeliskij Oblastnoj Muzej izobrazitelnych iskusstv) nab im. Lenina, 79 Archangel'sk 61, Russia
Archbishop's Palace, Ravenna: I-48100 Ravenna, Italy
Archer Huntington Gallery: University of Texas at Austin, Art Building, 23d & San Jacinto Streets, Austin, TX 78712
Archives Générales du Royaume, Brussels: (Archives et Musée de la Littérature, Bibliothèque Royale Albert I), Boulevard de l'Empereur 4, B-1000 Brussels, Belgium
Archives of Toulouse: (Archives Départmentales de la Haute-Garonne, Service de Documentation Historique), 11 Boulevard Griffoul-Dorval, F-31400 Toulouse, France
Archivo de la Corona de Aragón, Barcelona: Condes de Barcelona 2, 08002 Barcelona, Spain
Archivo Histórico Nacional, Madrid: Museo Arqueológico Nacional, Calle Serrano 13, Madrid, Spain
Arcivescovile Gallery: Piazza Fontana 2, I-20122 Milan, Italy
Arezzo, Museo Civico Archeologico: Via Margaritone 10, I-52100 Arezzo, Italy
Arezzo, Pinacoteca Comunale (Museo Statale di Arte Medioevale e Moderna): Via San Lorentino 8, I-52100 Arezzo, Italy
Ariccia, Collegiata: Arriccia, Italy
Arkansas Arts Center: MacArthur Park, Little Rock, AR 72203
Armeria Reale, Turin: Piazza Castello 191, I-10122 Turin, Italy
Arouca, Monastery: Arouca, Portugal
Arras Library: (Bibliothèque Municipale) 20 Rue Paul-Doumer, F-62000 Arras, France
Arsenal Museum: 1 Rue de Sully, F-75004 Paris, France
Art Museum of the Socialist Republic of Romania: (Muzeul de Istorie al Republicii Socialiste Romania), Calea Victoriei 12, Bucharest, Romania
Aschaffenburg, Staatsgalerie: Schloβstraβe, Johannesburg, 8750 Aschaffenburg, Bayern, Germany
Asciano, Museo d'Arte Sacra: Chiesa di Santa Croce, I-53041 Asciano, Siena, Italy
Ascoli Piceno, Pinacoteca Comunale: Palazzo Comunale, Piazza dell'Aringo, Ascoli Piceno, Italy
Ashdown House: National Trust, 123 Victoria Street, London SW1E 6RE England
Ashmolean Museum of Art: Beaumont Street, Oxford, OX1 2PH, England
Assisi, Italy. See San Francesco, Assisi
Atri Cathedral or Atri, Cathedral of Atri, Italy
Augustinian Museum, Toulouse: 21 Rue de Metz, F-31000 Toulouse, France
Auschaffenburg Museum der Stadt: Schloβmuseum Schloβplatz 4, D-8750 Auschaffenburg, Germany
Avignon Museum: (Musée du Petit Palais), Palais des Archevêques, Place du Palais des Papes, F-84000 Avignon, France
Avranches Library: (Bibliothèque-Discothèque Municipale Edouard le Héricher) 11 place Saint-Gervais, F-50300 Avranches, France
Baas Museum of Art: 2100 Collins Ave., Miami Beach, FL 33139
Bagnères-de-Bigorre, Musée Salies: Boulevard des Thermes et de l'Hyperon, F-65200 Boulevard Bagnères-de-Bigorre, France
Bagnoregio, SS. Annunziata: Bagnoregio, Italy
Baltimore Museum of Art: Art Museum Drive, Baltimore, MD 21218
Bamberg, Staatsbibliothek: Neue Residenz, Dompl 8, 8600 Bamberg, Germany
Bamberg, Staatsgalerie: Neue Residenz, 8600 Bamberg, Bayern, Germany
Barber Institute of Fine Arts, Birmingham University: Edgebaston Park Road, Birmingham, B15 2TS, England

Barberini Palace, Rome: (Galleria Nazionale d'Arte Antica-Palazzo Barberini), Via delle Quattro Fontane 13, I-00184 Rome, Italy
Barcelona, Museo de Artes de Cataluna: (Museo d'Art de Catalunya), Palau Nacional, Parc de Montjuic, Barcelona 4, Spain
Barcelona Cathedral: c/o Claustro de la Catedral, Calle Obispo Irurita, Barcelona, Spain
Bardini Museum, Florence: (Museo Bardini e Galleria Corsi) Piazza dei Mozzi 1, I-50125 Florence, Italy
Bardo Museum: (Musée National du Bardo), 2000 Le Bardo, Tunis, Tunisia
Bargello Museum: Via del Proconsolo 4, I-50122 Florence, Italy
Bari, Pinacoteca Provincale: Palazzo della Provincia, Lungomare Nazario Sauro, Bari, Italy
Baron-Gerard Museum: F-14400 Bayeux, France
Barracco Museum: Corso Vittorio Emanuele 168, I-00186 Rome, Italy
Basel, Kunstmuseum: (Kunstsammlungen) St. Albangraben 16, 4051 Basel, Switzerland
Basel Historisches Museum: Barfuberplatz, CH-4051, Basel, Switzerland
Bassano, Museo Civico: Convent of San Francesco, Piazza Garibaldi, Bassano del Grappa, Italy
Bautzen, Stadtmuseum: (Museum für Kunst und Kulturgeschichte), Platz der Roten Armee 1a, DDR-86, Bautzen, Germany
Bayerische Staatsgemaldesammlungen: Meiserstraße 10, D-8000 Munchen 2, Germany
Bayeux, Musée Municipal: Ancien Évêché, F-14400 Bayeux, France
Beinecke Rare Book and Manuscript Library: Yale University, 121 Wall Sreet, POB 1603A, Yale Station, New Haven, CT 06520
Belgrade, Museum of Applied Arts: see Narodni Galerie, Prague
Bellomo Museum, Syracuse: Via GM Capodieci 14-16, I-96100 Syracuse, Italy
Benedictine Abbey, Salzburg: 5020 Salzburg, Austria
Berlin, Kupferstichkabinett der Staatlichen Museen: Neubau am Kemperplatz, D-1000 Berlin 30, Germany
Berlin, Nationalgalerie: Potsdamerstraße 50, D-1000 Berlin 90, Germany
Bern, Kunstmuseum: Hodlerstraße 8-12, CH 3011, Bern, Switzerland
Besançon, Bibliothèque Minicipale: 1 Rue de la Bibliothèque, F-25044 Besançon, France
Besançon Museum: (Musée des Beaux-Arts), 1 Place de la Révolution, F-25000 Besançon, France
Bethnal Green Museum of Childhood: Cambridge Heath Road, London, E2 9PA, England
Bianco Palace: Via Garibaldi 11, I-16124 Genoa, Italy
Biblioteca de Palacio Réal, Madrid: (Réal Biblioteca), Palacio de Oriente, Calle Bailén, Madrid, Spain
Biblioteca Trivulziana e Archivio Storico Civico: Castello Sforzesco, I-20121 Milan, Italy
Bibliothèque de l'Arsenal: 1 Rue de Sully, I-75004 Paris, France
Bibliothèque de Mejanes, Aix-en-Provence: Hotel de Ville, F-13616 Aix-en-Provence, France
Bibliothèque Historique de la Ville de Paris: Préfecture de Paris 24, Rue Pavée, F-75004 Paris, France
Bibliothèque Nationale, Paris: 58 Rue Richelieu, Cedex 02, F-75084 Paris, France
Bibliothèque Royale Albert I, Brussels: 4 Boulevard de l'Empereur, Mont des Arts, Brussels, Belgium
Bibliothèque Royale Estampes, Brussels: (Bibliothèque Royale Albert I), 1 Place du Musée, B-1000 Brussels, Belgium
Bilbao, Museum of Fine Arts: Parque de Da. Casilda Iturriza 3, Bilbao, Vizcaya, Spain
Birmingham City Art Gallery: Congreve Street, Birmingham, B33DH, England
Birmingham Museum of Art, AL: 2000 Eighth Avenue North, Birmingham, AL 35203
Blaye, Musée d'Histoire d'Art: Citadelle, F-33390 Blaye, France
Blois, Musée des Beaux-Arts: Château de Blois, F-41000 Blois, France
Bob Jones University Collection of Sacred Art: Greenville, SC 29614
Bode Museum, Berlin: (Gemäldegalerie) Bodestrasse 1-3, DDR-102 Berlin, Germany
Bodleian Library: Oxford, OX1 3BG, England
Bologna, Collezioni Communali d'Arte: Palazzo d'Accursio, Piazza Maggiore, Bologna, Italy

Bologna, Museo Civico: (Museo Civico del Primo e Secondo Risorgimento), Via dei Musei 8, I-40124 Bologna, Italy
Bologna, Pinacoteca Nazionale: Via Belle Arti 56, I-40126 Bologna, Italy
Bologna, San Domenico: Piazza San Domenico 13, Bologna, Italy
Bologna, San Petronio: Piazza Maggiore, I-40124 Bologna, Italy
Bologna University Library: Via Zamboni 35, I-40126 Bologna, Italy
Bonn, Universitätsbibliothek: Adenauerallee 39-41, D-5300 Bonn, Germany
Bonnat Museum: 5 Rue Jacques-Lafitte, F-64100 Bayonne, France
Bordeaux, Musée des Beaux-Arts: Jardin de la Mairie, Cours d'Albret, F-33000 Bordeaux, Gironde, France
Borghese Gallery: Piazzale Scipione Borghese 5, I-00197 Rome, Italy
Boston Museum of Fine Arts, 465 Huntington Ave, Boston, MA 02115
Boston Public Library: 666 Boylston St., Box 286, Boston, MA 02117
Boulogne Library: (Bibliothèque Municipale) Place de la Résistance, F-62200 Boulogne-sur-Mer, France
Bourg-en-Bresse, Musèe de Brou (Musèe de l'Ain): Prieure de Brou, Boulevard de Brou, F-01000 Bourg-en-Bresse, France
Bowes Museum: Barnard Castle, County Durham, England
Boymans-Van Beuningen Museum, Rotterdam: Mathenesserlaan 18-20, POB 2277, NL-3000 CG Rotterdam, Netherlands
Bradford Art Galleries and Museums: (Cartwright Art Gallery and Museum), Lister Park, Bradford, BD9 4NZ, England
Bratislava, Saint Martin: Bratislava, Slovak Republic
Bremen, Staatsbibliothek: (Staats- und Universitätsbibliothek), Bibliothekstraβe, Postfach 330160, D-2800 Bremen, Germany
Bremen Kunsthalle: Am Wall 207, D-2800 Bremen 1, Germany
Brera, Milan: Via Brera 28, Milan, Italy
Brescia, Museo Civico: (Museo Civico di Storia Naturale), Via Gualla 3/Via Ozanam 4, I-25100 Brescia, Italy
Brescia, Museo Romano: Via Musei 57a, I-25100 Brescia, Italy
Brescia, Pinacoteca Tosio Martinengo: Via Martinengo da Barco 1, I-25100 Brescia, Italy
Bressanone, Saint Giovanni: Bressanone, Italy
Bridgeport, Museum of Art, Science and Industry: 4450 Park Avenue, Bridgeport, CT 06604
Bristol City Art Gallery: Queen's Road, Bristol, BS8 1RL, England
British Library: 2 Sheraton Street, London, W1V 4BH, England
British Museum: Great Russell Street, London, WC1, England
Brooklyn Museum: 188 Eastern Parkway, Brooklyn, NY 11238
Brooks Memorial Art Gallery: Overton Park, Memphis, TN 38112
Bruges, State Museum: Balstraat 27, B-8000 Bruges, Belgium
Brukenthal Museum, Sibiu: Boulevard Republicii 4-5, Sibiu, Romania
Brussels, Musée d'Art Ancien: Rue de la Régence 3, B-1000 Brussels, Belgium
Brussels, Musées Royaux d'Art et d'Histoire: Avenue des Nerviens, 10 Parc du Cinquantenaire, Brussels 4, Belgium
Brussels, Musée Royaux des Beaux-Arts: 3 Rue de la Régence, Brussels, Belgium
Bucharest, Museum of Romanian Art: Strada Stirbei Vodă 1, Bucharest, Romania
Bucknell University: Lewisburg, PA 17837
Budapest, National Gallery: (Magyar Nemzeti Galeria), Szent György tér 2, H-1014 Budapest, Romania
Budapest, Reformed Church: (A Dunamelléki Református Egyházkerület Ráday Gyújteménye) 1092 Budapest, Ráday utca 28, Hungary
Budapest Museum: (Szepmuveszeti Muzeum), Dozsa György ut 41 24, POB 463, H-1134, Budrio, Pinacoteca: (Inzaghi Municipal Art Gallery) Via Mentana 9, Budrio, Italy
Bulgaria, National Archaeological Museum: Avenue Stambolisky 2, Sofia, Bulgaria
Bulgaria, National Art Gallery: Ninth of September Square, Sofia, Bulgaria
Burgherbibliothek, Bern: Munstergasse 63, 3000 Bern, Switzerland
Bury Art Gallery and Museum: Moss Street, Bury, Lancaster, England
Busch-Reisinger Museum: 29 Kirkland Street, Cambridge, MA 02138

Bussolengo, Saint Valentino: Bussolengo, Italy
Byzantine Museum, Athens: 22 Vassilissis Sofias Avenue, Athens, Greece
Cà d'Oro, Venice: (Galleria Giorgio Franchetti alla Cà d'Oro) Calle Cà d'Oro 3933,
 I-30173 Venice, Italy
Cabinet des Estampes, Bibliothèque Royale, Brussels. See Archives Générales du
 Royaume, Brussels
Cadiz, Provincial Museum of Fine Arts: Plaza de Mina, Cadiz, Spain
Caen, Musée des Beaux-Arts: Esplanade du Château, F-14000 Caen, France
Cagliari, Museum Capitolare: Via del Fossario, I-09100 Cagliari, Italy
Calahorra Cathedral: Logroño, Spain
Calvert Museum, Avignon: 65 Rue Joseph-Vernet, F-84000 Avignon, France
Cambrai Municipal Library: (Médiathèque Municipale), 37 Rue Saint-Georges, F-59400
 Cambrai, France
Campidoglio, Rome. See Capitoline Museum, Rome
Campo Santo, Pisa: (Camposanto e Museo dell'Opera), Piazza Duomo, I-56100 Pisa,
 Italy
Capitoline Museum, Rome: (Musei Capitolini), Piazza del Campidoglio, I-00186 Rome,
 Italy
Capodimonte, Naples: (Museo e Gallerie Nazionale di Capodimonte): Palazzo di
 Capodimonte, Naples I-80139, Italy
Carcassonne, Church of Saint Vincent: Carcassone, France
Cardiff National Museum of Wales: Amgueddfa Genedlaethol Cymru Cathays Park,
 Cardiff, CF1 3NP, Wales
Carlisle Museum and Art Gallery: Tullie House, Castle Street, Carlisle, CA3 8TP,
 England
Carlsruhe, Galerie Grand Ducale: (Baden Museum) Badisches Landesmuseum
 Karlsruhe, Schloß D-7500 Karlsruhe 1, Baden-Württemberg, Germany
Carlsruhe, Museum: (Badisches Landesmuseum Karlsruhe) Schloß D-7500 Karlsruhe,
 Germany
Carnavalet Museum, Paris: Hôtel Carnavalet, 23 Rue de Sévigné, F-75003 Paris, France
Carnegie Institute: 4400 Forbes Avenue, Pittsburgh, PA 15213
Carpentras, Bibliothèque Inguimbertine: 234 Boulevard Albin-Durand, F-84200
 Carpentras, France
Carrara Academy, Bergamo: (Pinacoteca dell'Accademia Carrara), Piazza Carrara 81a,
 I-24100 Bergamo, Italy
Casa di Buonarroti: Via Ghibellina 70, I-50122 Florence, Italy
Cassel, Gemäldegalerie. See Cassel, State Art Collections
Cassel, State Art Collections: (Staatliche Kunstsammlungen), D-3500 Cassel, Germany
Castel Sant'Angelo, Rome: Lungotevere Castello 50, I-00193 Rome, Italy
Castello da Porto Colleoni: Piazza Ferrarin, I-36016 Thiene, Vicenza, Italy
Castello di San Maria (Colleoni), Thiene: (Museo del Castello Colleoni), Porto, Piazza
 Ferrarin, I-36016 Thiene, Vicenza, Italy
Castello Sforzesco: 20121 Milan, Italy
Castelvecchio Museum, Verona: (Museo di Castelvecchio), Corso Castelvecchio 2,
 I-37100 Verona, Italy
Castelvetrano, Saint Domenico: Castelvetrano, Italy
Castiglione Fiorentino, Communal Picture Gallery: Piazza del Municipio 12, Castiglione
 Fiorentino, Italy
Cathedral of the Dormition, Zvenigorod: Zvenigorod, Ukraine
Cenacolo di Ognissanti: Piazza Ognissanti 42, Florence, Italy
Cenacolo di Santa Apollonia, Florence: Via XXVII Aprile 1, I-50100 Florence, Italy
Cento, Pinacoteca e Galleria d'Arte Moderna: Via Matteotti, I-44042 Cento, Ferrara,
 Italy
Certosa di Pavia, Pavia, Italy
Chartres, Musée Municipale: 29 Cloître Nôtre-Dame, F-28000 Chartres, France
Certosa Pavia: (Museo della Certosa), Palazzo Ducale, I-27012 Pavia, Italy
Chambéry, Musée des Beaux-Artes: Place du Palais-de-Justice, F-73000 Chambéry,
 France

Chartres Cathedral: Trésor de la Cathédrale, BP 131, F-28003 Chartres, Eure-et-Loire, France
Châteauroux, Bibliothèque Municipale, France: Maison de la Culture, Rue de la République, F-36004 Châteauroux, France
Cherbourg Museum: (Thomas Henry Museum) Hôtel de Ville, F-50100 Cherbourg, France
Chetham's Hospital and Library, Manchester: Long Mill Gate, Manchester, M3 1SB, England
Chiaramonti Museum, Braccio Nuovo: Musei Vaticani, Viale Vaticano, V-00120 Vatican City
Chicago Art Institute: Michigan Avenue & Adams Street, Chicago, IL 06063
Chigi-Saracini Palace: Via di Città 89, Siena, Italy
Chiusi, Museo Nazionale: (Museo Nazionale Etrusco), Via Porsenna, I-53043 Chiusi, Siena, Italy
Christ Church Picture Gallery: Canterbury Quadrangle, Oxford, OX1 1DP, England
Christ's College Library, Cambridge: Cambridge, CB2 3BU, England
Chrysler Museum: Mowbray Arch & Olney Road, Norfolk, VA 23510
Church of Panagia Phorbiotissa of Asinou: Cyprus
Cincinnati Art Museum: Eden Park, Cincinnati, OH 45202
Città di Castello, Pinacoteca Civica: Via della Cannoniera 22, I-06012 Città di Castello, Perugia, Italy
Civica Raccolta Stampe Bertarelli, Milan: (Civica Raccolta di Stampe Achille Bertarelli), Castello Forzesco, 20121 Milan, Italy
Cividale, Museo Cristiano: Piazza Duomo, I-33043 Cividale del Friuli, Udine, Italy
Clemens-Sels-Museum, Neuss: Am Obertor, D-4040 Neuss, Germany
Cleveland Museum of Art: 11150 East Boulevard, Cleveland, OH 44106
Cloisters Museum: Fort Tryon Park, New York, NY 10040
Cluny Museum: 6 Place Paul Painleve, Paris, France
Cognac-Jay Museum, Paris: 25 Boulevard des Capucines, F-75002 Paris, France
Cognac, Musée des Beaux-Arts: Boulevard Denfert-Rochereau, F-16100 Cognac, France
Colchester and Essex Museum: The Castle, Colchester, Essex, C01 1TJ, England
Colmar, Musée d'Unterlinden: 1 Place d'Unterlinden, F-68000 Colmar, France
Cologne Cathedral: Domschatzkammer, Dom, D-5000 Cologne, Nordrhein-Westfalen, Germany
Colonna Palace, Rome: Via della Pilotta, I-00187 Rome, Italy
Columbia Museum of Art, Missouri: University of Missouri, Columbia, MO, 65201
Columbia Museum of Art, South Carolina: 1112 Bull Street, Columbia, SC 29201
Como, Museo Civico: (Civico Museo Storico G. Garibaldi), Piazza Medaglie d'Oro, I-22100 Como, Italy
Compiègne, Château: 60200 Compiègne, Oise, France
Condé Museum: Château de Chantilly, F-60500 Chantilly, France
Conservatori Museum, Rome: Piazza Campidoglio, I-00186 Rome, Italy
Convent des Descalzas Reales, Madrid: (Monasterio de las Descalzas Reales), Plaza de las Descalzas 3, Madrid, Spain
Convento de las Carmelitas Descalzas, Seville: Plaza de las Descalzas 3, Madrid, Spain
Copenhagen, Statens Museum før Kunst: 1307 Solvgade, Copenhagen, Denmark
Copenhagen Nationalmuseet: Prinsens Palae D, Frederiksholms Kanal 12, DK-1220 Copenhagen, Denmark
Copenhagen Royal Library: (Det Kongelige Bibliotek), Christians Brugge 8, POB 2149, 1016 Copenhagen, Denmark
Coptic Museum: Masr Ateeka, Cairo, Egypt
Córdoba Cathedral: (Museo-Tesoro Catedralicio) Catedral, Córdoba Cathedral or Córdoba, Cathedral of Spain
Córdoba, Provincial Museum of Fine Arts: Plaza del Potro 2, Córdoba, Spain
Corpus Christi College Library, Cambridge: Cambridge, CB2 1RH, England
Corpus Christi College Library, Oxford: Oxford, OX1 4JF, England
Correr Museum: Piazza San Marco 52, I-30124 Venice, Italy
Corsini Palace, Rome: (Galleria Nazionale d'Arte Antica--Palazzo Corsini), Via della Lungara 10, I-00165 Rome, Italy

Cortona, Museo Diocesano: Gesu Church, Piazza del Duomo, Cortona, Italy
Council of Trent Chamber, Palazzo Farnese, Caprarola. See Farnese, Caprarola
Courtauld Institute of Art: 20 Portman Square, London, W1H 0BE, England
Courtrai, Musée des Beaux-Arts: (Museum voor Schöne Kunsten en Museum voor Oudheidkundi en Sierkunst), Broelkaai 6, B-8500 Kortrijk, Belgium
Cracow, National Museum: (Muzeum Narodowe w Krakowie) ul. Manifestu Lipcowego 12, PL-30-960 Cracow, Poland
Crawford Municipal Art Gallery: Emmet Place, Cork, County Cork, Ireland
Cremona, Museo Civico: Palazzo Affaitati, Via Ugolani Dati 2, Cremona, Italy
Cremona Cathedral: Cremona, Italy
Cristiano Museum, Vatican: Vatican City
Crocker Art Gallery: 216 O Street, Sacramento CA 95814
Cummer Gallery of Art: 829 Riverside Ave, Jacksonville, FL 32204
Czartoryski Museum, Cracow: Narodowe w Krakowie, ul. sw. Jana 19, Platz Cracow, Poland
Dallas Museum of Fine Arts: 1717 North Harwood, Dallas, TX 75201
Darmstadt, Landesmuseum: Friedensplatz 1, D-6100 Darmstadt, Germany
David and Alfred Smart Gallery of the University of Chicago: 5550 South Greenwood Ave, Chicago, IL 60637
Dayton Art Institute: Forest & Riverview Avenues, Dayton, OH 45401
Delft, Stedelijk Museum: Het Prinsenhof Agathaplein 1, NL-2611 HR Delft, Netherlands
Delphi Museum: (Archeological Museum of Delphi), Delphi, Phoecis, Greece
Dendermonde, Church of Notre Dame: Onze-Lieve-Vrouweparochie, Onze-Lieve-Vrouwekerkplein 7, B-9200 Dendermonde, Belgium
Denver Art Museum: 100 West 14th Avenue, Denver, CO 80204
Derby Museum and Art Gallery: The Strand, Derby, DE1 1BS, England
Detroit Institute of Fine Arts: 5200 Woodward, Detroit, MI 48202
Deutsche Barockgalerie, Augsburg: Städtische Kunstsammlungen Maximilianstraße 46, D-8900 Augsburg, Germany
Deutsche Staatbibliothek, Berlin: Breitestraße 32-34, 0-1020 Berlin, Germany
Diessen, Convent Church: Diessen, Netherlands
Dijon, Bibliothèque Municipale: 5 Rue de l'Ecole-du-droit, F-21000 Dijon, France
Dijon, Musée des Beaux-Arts: Palais des Ducs et des États de Bourgogne, F-21000 Dijon, France
District History Museum, Veliko Turnovo: (Okrǎžen istoričeski muzej) ul. Ivanka Boteva 1, BG Veliko Turnovo, Bulgaria
Dobrée Museum, Nantes: Place Jean Cinq, F-44000, Nantes, France
Dole, Municipal Museum: Pavillon des Officers, 85 Rue des Arènes, F-39100 Dole, France
Dommuseum, Halberstadt: Domplatz 36, 36 Halberstadt, Germany
Dordrechts Museum: Museumstraat 40, NL-3311 XP Dordrecht, Netherlands
Doria-Pamphili Gallery, Rome: (Galleria Doria Pamphili), Piazza del Collegio Romano 1a, I-00186 Rome, Italy
Douai, Musée de la Chartreuse: F-59500 Douai, Nord, France
Douai Library: (Bibliothèque Municipale) 117 Rue de la Fonderie, F-59500 Douai, France
Dresden Gallery. See Picture Gallery, Dresden
Dublin National Gallery: Merrion Square, Dublin 2, Ireland
Dubrovnik, The Carmine Church: Croatia
Ducal Palace, Mantua: (Galleria e Museo del Palazzo Ducale), Piazza Sordello 39, I-46100 Mantua, Italy
Duke of Alba Collection, Madrid: Palacio de Liria, Princesa 20, Madrid, Spain
Duke of Wellington Collection, Apsley House: 149 Piccadilly, Hyde Park Corner, London, W1V 9FA, England
Dulwich College Picture Gallery: College Road, Dulwich, London, SE21 7BG, England
Dumbarton Oaks Collection: 1703 32d Street, Washington, DC 20007
Dunkirk Museum: Place du Général de Gaulle, F-59140 Dunkerque, France
Duomo, Cefalù, Sicily: Mendralisca Museum, Via Mendralisca 15, Cefalù, Sicily
Duomo, Gaeta: Diocesan Museum, Piazza del Duomo, Gaeta, Italy
Düsseldorf, Municipal Museum of Art, Ehrenhof 5 und Schulstraße 5, 4000 Düsseldorf, Nordrhein-Westfalen, Germany

Edinburgh Central Public Library: Edinburgh City District Council, George IV Bridge, Edinburgh, EH1 1EG, Scotland

Edinburgh Univeristy Library: George Square, Edinburgh, EH8 9LJ, Scotland

Eidgenossische Technische Hochschule, Zurich: (Graphische Sammlung der Eidgenossischen Technischen Hochschule), Ramistrasse 101, CH-8092 Zurich, Switzerland

Eisenstadt Landesmuseum, Austria: Museumgasse 1-5, A-7000 Eisenstadt, Austria

El Escorial: El Escorial, Madrid, Spain

El Paso Museum of Art: 1211 Montana Street, El Paso, TX 79902

Elena, National Revival Museum: Văzroždendki Muzej 'Ilarion Makariopolski, ul. Dojčo Gramatik 2, BG Elena, Bulgaria

Eleusis Museum: (Archaeological Museum) Eleusis, Greece

Emmanuel College, Cambridge: Cambridge, CB2 3AP, England

Empoli, Galleria della Collegiata: Collegiata di Sant'Andrea, Empoli, Italy

Epinal, Musée de Vosges: Place Lagarde, F-88000 Epinal, France

Epinal, Musée Départmental des Vosges: Place Lagarde, 88000 Epinal, Vosges, France

Epinal Library: Bibliothèque Municipale, 2 Rue de Nancy, 88025 Epinal, France

Episcopal Museum, Vich, Spain: Antiquo Colegio de San José, Vich, Barcelona, Spain

Erzbischöfliches Dom- und Diözesanmuseum, Vienna: Stephansplatz 6/1, A-1010 Vienna, Austria

Escorial Monastery, Spain: Salas Capitulares del Monasterio, Monasterio de San Lorenzo, El Escorial, Madrid, Spain

Este Library, Modena. See Estense Library, Modena

Estense Gallery, Modena: Palazzo dei Musei, Piazza San Agostino, I- 41100 Modena, Italy

Estense Library, Modena: Galleria, Museo e Medagliere Estense, Piazza San Agostino, 337, Palazzo dei Musei, I-41100 Modena, Italy

Esztergom, Gallery of the Prince: (Vármúzeum) Bajcsy-Zsilinsky U-63, H-2500 Esztergom, Hungary

Esztergom Christian Museum: Berényi Zsigmond utca 2, Esztergom, Komárom Megye, Hungary

Eton College: Windsor, SL4 6DB, England

Etrusco Gregoriano, Vatican: Viale Vaticano, V-00120 Città del Vaticano, Vatican City

Etterbeek, St. Gertrude: Etterbeek, Belgium

Euboea, Saint Thekla: Euboea, Italy

Evora Museum: Largo Conde Vila Flor, 7000 Evora, Portugal

Fabré Museum, Montpellier: 13 Rue Montpelliéret, F-34000 Montpellier, France

Fabriano, Pinacoteca Civica e Museo degli Arazzi: Piazza Umberto di Savoia 2, I-60044 Fabriano, Ancona, Italy

Faenza, Pinacoteca: Town Hall, Piazza del Popolo, via San Maria dell'Angelo 2, Faenza, Italy

Faenza, Museo Internazione delle Ceramiche: Via Campidori 2, I-48018 Faenza, Ravenna, Italy

Farnese, Caprarola: Villa della Farnesina, Accademia Nazionale dei Lincei, Via della Lungara 230, I-00165 Rome, Italy

Farnese Palace: Palazzo Farnese, Via della Lungara 230, I-00165 Rome, Italy

Feltre, Museo Civico: Via Lorenzo Luzzo, Feltre, Italy

Fermo, Pinacoteca Civica: Palazzo del Comune, Fermo, Italy

Ferrara, Pinacoteca Nazionale: Palace of Diamonds, Corso Ercole d'Este 21, Ferrara, Italy

Ferrara Archaeological Museum: (Museo Nazionale Archeologico), Via XX, Settembre 124, I-44100 Ferrara, Italy

Ferrara Cathedral: Piazza Cattedrale, Ferrara, Italy

Ferrens Art Gallery: Queen Victoria Square, Hull, North Humberside, HU1 3RA, England

Fesch Museum, Ajaccio: (Musée-Palais Fesch), 50-52 Rue Cardinal Fesch, F-20000 Ajaccio, France

Fiesole, Museo Bandini: Via Giovanni Dupré, I-50014 Fiesole, Florence, Italy

Fitzwilliam Museum: Trumpington Street, Cambridge, England

Florence, Badia Church: 4 Via Condotta, Florence, Italy

Florence, Gabinetto Disegni e Stampe: Via della Ninna 5, I-50122 Florence, Italy
Florence, Museo Archeologico: Via delle Colonna 38, I-51021 Florence, Italy
Florence, Museo dell'Opera del Duomo: Piazzo Duomo 9, Florence, Italy
Florence, Museo Nazionale. See Bargello Museum
Florence, Or San Michele Church: 7 Via Tavolini, Florence, Italy
Florence, San Marco Museum: Via Cavour 56, I-50129 Florence, Italy
Florence, San Miniato al Monte: Viale Galileo, I-50125 Florence, Italy
Florence, Santa Croce: Piazza Santa Croce 16, I-50122 Florence, Italy
Florence, Santa Maria Novella, Palazza Santa Maria Novella, Florence, Italy
Florence Cathedral: Museo dell'Opera di Santa Maria del Fiore, Piazza del Duomo 9,
 I-50122 Florence, Italy
Florence National Central Library: Piazza dei Cavalleggeri 1A, I-50122 Florence, Italy
Fogg Art Museum: Harvard University, Cambridge, MA 02138
Folger Library: (Folger Shakespeare Library), 201 East Capitol Street, Washington DC
 20003
Fondazione Horne Collection, Florence: Via dei Benci 6, Florence, Italy
Fondi, Cathedral: Fondi, Italy
Fontainebleau: F-77300 Fontainebleau, France
Fossombrone, Saint Aldebrando: Fossombrone, Italy
France, National Archives: 29 Chemin de Moulin Detesta, 13090 Aix-en-Provence,
 France
Frankfurt, Museum für Kunsthandwerk: Schaumainkai 15, D-6000 Frankfurt 70,
 Germany
Frankfurt, Städelsches Kunstinstitut und Städtische Galerie: Dürerstraße 2, D-6000
 Frankfurt 70, Germany
Frankfurt, Stadtische Skulpturensammlung im Liebieghaus: Museum Alter Plastik
 Schaumainkai 71, D-6000 Frankfurt 1, Germany
Frans Hals-Museum, Haarlem: Groot Heilig Land 62, NL-2011 ES Haarlem,
 Netherlands
Frauenfeld, Thurgau, Kunstmuseum: (Canton Thurgau Historical Museum) Schloß,
 8500 Frauenfeld, Thurgau, Switzerland
Frejus Cathedral: Frejus, France
Frick Collection: 1 East 70th Street, New York, NY 10021
Fulda Public Library: (Heissische Landesbibliothek) Heinrich-von-Bibra-Platz-12,
 Postfach 665, W-6400 Fulda, Germany
Fürstenberg Collection, Donaueschingen: Karlsplatz 7, 7710 Donaueschingen, Baden-
 Württemberg, Germany
Fürstenbergische Gallery, Donaueschingen: Karlsplatz 7, 77100 Donaueschingen, Baden-
 Württemberg, Germany
Fürstliche Gemäldesammlung, Liechtenstein: (Sammlungen des Regierenden Fürsten
 von Liechtenstein), Schloß Vaduz, Fl-9490 Vaduz, Liechtenstein
Gaeta, Duomo: Piazza Duomo, I-04024 Gaeta, Latina, Italy
Galleria Nazionale d'Arte Antica, Palazzo Corsini, Rome: Via della Lungara 10, I-00165
 Rome, Italy
Gemäldegalerie, Pommersfelden: Schloß Weissenstein, D-8602 Pommersfelden,
 Germany
Gemäldegalerie, Vienna: (Akademie derBilden Künste), Schillerplatz 3, A-1010 Vienna,
 Austria
Geneva Museum of Art and History: 2 Rue Charles-Galland, CH-1211 Geneva 3,
 Switzerland
Genoa, Museo Navale: Piazza Bonavino, I-16156 Genoa, Italy
Georgetown University Art Collection: Box 2269 Hoya Station, Georgetown University,
 Washington DC 20057
Germanic National Museum, Nuremberg: Weinmarkt 1, D-8500 Nuremberg, Germany
Germanisches Nationalmuseum, Nuremberg: Weinmarkt 1, D-8500 Nuremberg, Germany
Gerona, Diocesan Museum: Plaza de España 2, Gerona, Spain
Gesuiti, Venice: Cannaregio 4885, I-30121 Venice, Italy
Getty Museum. See J. Paul Getty Museum

Ghent, Bibliothèque Centrale: (Rijksuniversiteit te Gent), Rozier 9, B-9000 Ghent, Belgium
Ghent, Museum of Fine Arts: Citadelpark, B-9000 Ghent, Belgium
Glasgow Art Gallery and Museum: Kelvingrove Park, Glasgow, Scotland
Goodwood House, Chichester, West Sussex, P018 0PX, England
Gotha, Schloßmuseum: Schloß Friedenstein, DDR-58 Gotha, Germany
Gouda, Musées Communaux (Stedelijk Museum Het Catharina-Gasthuis): Achter der Kerk 14, NL-2801 JX Gouda, Netherlands
Gradara, Casa Comunale: Castello e Rocca, I-61012 Gradara, Italy
Graeco-Roman Museum, Alexandria: 5 AL Mathaf Street, Alexandria, Egypt
Granada, Museo Provincial: Carrera del Darro 43, Granada, Spain
Granada, Palace of Charles V (Museo de Bellas Artes): Palacio de Charles V, Alhambra, Granada, Spain
Granet Museum, Aix-en-Provence: Place Saint-Jean-de-Malte, F- 3100 Aix-en-Provence, France
Graphische Sammlung, Munich: (Staatliche Graphische Sammlung), Meisterstraße 10, D-8000 Munich 2, Germany
Graphische Sammlung Albertina: Augustinerstraße 1, 1010 Vienna, Austria
Grasse, Cathedral: Place du Petit Puy, F-06130 Grasse, France
Graves Art Gallery, Sheffield: See Sheffield City Art Galleries
Greco Museum, Toledo: (Casa y Museo del 'Greco') Alamillos del Tránsito y Calle Samuel Levi, Toledo, Spain
Grenoble, Musée de Peinture et de Sculpture: Place de Verdun, F-38000 Grenoble, France
Grobet-Labadié Museum, Marseille: 140 Boulevard Longchamp, F-13001 Marseille, France
Groot Seminarie, Bruges: Potterierei 72, B-8000 Bruges, Belgium
Grottaferrata Abbey: 00046 Grottaferrata, Italy
Gubbio, Pinacoteca (Museo e Pinacoteca Comunali): Palazzo dei Consoli, I-60124 Gubbio, Perugia, Italy
Gubbio, San Francesco: Convento di San Francesco, I-06024 Gubbio, Perugia, Italy
Gustave Moreau Museum: 14 Rue de la Rochefoucauld, F-75009 Paris, France
The Hague, Royal Library: (Koninklijke Bibliotheek), Prins Willem Alexanderhof 5, 2595 EE s'Gravenhage, Netherlands
Hamburg Kunsthalle: (Hamburger Kunsthalle), Glockengießerwall 1, D-2000 Hamburg, Germany
Hampton Court Palace: Hampton Court, Middlesex, England
Hardwick Hall: Doelea, Derbyshire, S44 7QJ, England
Harvard University Library: Cambridge, MA 02138
Hatay Museum, Antakya: TR Antakya, Hatay Province, Turkey
Hatfield House: Hatfield, Hertfordshire, AL9 5NQ, England
Hearst Collection: PO Box 8, San Simeon, CA 93452
Heidelberg, Universitätsbibliothek: Plock 107-109, Postfach 105749, D-6900 Heidelberg, Germany
Helen Foresman Spencer Museum of Art: 1301 Mississippi Street, University of Kansas, Lawrence, KS 66045
Henry E. Huntington Library & Art Gallery: 1151 Oxford Road, San Marino CA 91108
Hermitage Museum: Saint Petersburg D-65, Dvoztzovaya Naberegnaia 34, Saint Petersburg, Russia
Herzog Anton Ulrich-Museum: Museumstraße 1, D-3300 Brunswick, Germany
Hessischen Landes und Hofschulbibliothek, Darmstadt: Kunstgeschichtliche Abteilung, Friedensplasse 1, 6100 Darmstadt, Germany
Hessisches Hauptstaatsarchiv, Wiesbaden: Mosbacherstraße 55, W-6200 Wiesbaden, Germany
Hessisches Landesbibliothek, Fulda: Heinrich-von-Bibra-Platz 12, Postfach 665, D-6400 Fulda, Germany
Hieronymite Monastery, Guadelupe: (Monasterio de Nuestra Señora de Guadelupe) Plaza Generalisimo Franco, Guadelupe, Cáceres, Spain
Higgins Armory: (John Woodman Higgins Armory), 100 Barber Avenue, Worcester, MA 01606

High Museum of Art: 1280 Peachtree Sreet, NE, Atlanta, GA 30309
Hirshhorn Museum & Sculpture Garden, Smithsonian Institution, Independence Avenue
 & 8th Street SW, Washington DC 20560
Hispanic Society of America: 613 West 155th Street, New York, NY 10032
Holyrood House: Palace of Holyroodhouse, Edinburgh, Scotland
Hospital de la Caridad, Illescas: Calle Cardenal Cisneros, 2, Illescas, Toledo, Spain
Hospital de la Caridad, Seville: Iglesja de San Jorge, Calle Temprado, 3, Seville, Spain
Houghton Library: Houghton College, Houghton, NY 14744
House of the Masks: Delos, Greece
Houston Museum of Fine Arts: 1001 Bissonet Street, Houston, TX 77005
Huize van de Kastelle, Zutphen: NL-7201 Zutphen, Netherlands
Huntington Library, San Marino: 1151 Oxford Road, San Marino, CA 91108
Hyde Collection, Glens Falls: 161 Warren Street, Glens Falls, NY 12801
Indiana University, Bloomington: Bloomington, IN 47405
Indianapolis Museum of Art: 1200 West 38th St., Indianapolis, IN 46208
Ingres Museum, Montauban: Palais des Evêques, 19 Rue de l'Hôtel de Ville, F-82000
 Montauban, France
Inguimbertine Library, Carpentras: 234 Boulevard Albin-Durand, F-84200 Carpentras,
 France
Innsbruck, Landesmuseum Ferdinandeum: (Tiroler Landesmuseum Ferdinandeum),
 Museumstraße 15, A-6020 Innsbruck, Austria
Instituto de Valencia de Don Juan, Madrid: Calle de Fortuny 43, Madrid, Spain
Instituto Nazionale di Previdenza Sociale, Rome: Via Ciro il Grande, I-00144 Rome, Italy
Isaac Delgado Museum of Art: Lelong Avenue, City Park, PO Box 19123, New Orleans,
 LA 70179
Isabella Stewart Gardner Museum, 2 Palace Rd, Boston, MA 02115
Istanbul Archaeological Museums: Sul Tanahmet, Istanbul, Turkey
Istanbul Museum: See Topkapi Palace Museum
J. Paul Getty Museum: 17985 Pacific Coast Highway, Malibu, CA 90265
Jacquemart-André Museum: 158 Boulevard Haussman, F-57008 Paris, France
Jena, Universitätsbibliothek: Goetheallee 6, D-6900 Jena, Germany
Jesi, Pinacoteca Comunale: Palazzo della Signoria, I-60035 Jesi, Ancona, Italy
Jihlava, St. James: Jihlava, Czech Republic
Joanneum Landesmuseum: Herrengasse 16, A-8010 Graz, Austria
Joe and Emily Lowe Art Museum: University of Miami, 1301 Miller Drive, Coral Gables,
 FL 33146
John Carter Brown Library, Providence: Box 1894, Providence, RI 02912
Joslyn Art Museum: 2218 Dodge Street, Omaha, NE 68102
Kakopetria, St. Nicholas of the Roof Church: Cyprus
Kansallismuseo, Helsinki: Kansallis-Osake-Pankki, Pohjolsesplanadi 29, SF-0010
 Kelsinki 10, Finland
Karlsruhe, Museum. See Carlsruhe, Museum
Karlstejn Castle: Karlstejn, Czech Republic
Kassel, Gemäldegalerie. See Cassel, State Art Collections
Kenwood House, London: The Iveagh Bequest, Hampstead Lane, London, NW3 7JR,
 England
Kharkov Art Museum: Kharkov, Ukraine
Kiev, Museum of Western and Eastern Art: (Kievskij Muzej Zapadnogo i Vostočnogo
 Iskusstva) ul. Repina, il, Kiev 4, Ukraine
Kimbell Art Museum: Will Rogers Road West, Fort Worth, TX 76107
Klagenfurt, Landesmuseum: Museumgasse 2, A-9010 Klagenfurt, Austria
Kobe Municipal Museum: 1-Chome Kunochi-cho, Fukiai-ku, Kobe, Hyogo, Japan
Kölnisches Stadtmuseum, Cologne: Seughausstraße 1-3, D-5000 Cologne, Germany
Kolomna, Saints Boris and Gleb: Kolomna, Russia
Königsfelden, Abbey Church: Königsfelden, Aargau, Switzerland
Koninklijk Kabinet van Schilderijen. See Mauritshuis Royal Picture Gallery
Koninklijk Museum voor Schöne Kunsten: Leopold de Waelplaats, Plaatsnijderstraat 2,
 B-2000 Antwerp, Belgium

Koninklijke Musea voor Schöne Kunsten, Brussels: Parc du Cinquantenaire 10, B-1040 Brussels, Belgium
Kononklikje Bibliothek, The Hague: Prins Willem Alexanderhof 5, 2595 BE The Hague, Netherlands
Kremlin, Cathedral of the Annunciation: Sobornaja Ploščad', Moscow, Russia
Kremlin Museums: Oružejnaja Palata, Gosudarstvennye Muzei Moakovoskogo Kremlija, Kremlin, Moscow, Russia
Krestner-Museum, Hanover: Trammplatz 3, D-3000 Hannover 1, Germany
Kroller-Müller Museum: Houtkampweg 6, NL-6730 AA Otterlo, The Netherlands
Kunsthistorisches Museum: Burgring 5, Vienna 1, Austria
Kunstmuseum, Bern: Hodlerstraße 12, CH-3011 Bern, Switzerland
Kunstmuseum, Zurich (Kunsthaus): Heimplatz 1, CH-8001 Zurich, Switzerland
Kunstmuseum der Stadt Düsseldorf: 4 Düsseldorf-Nord, Ehrenhof 5, Düsseldorf, Germany
La Coruña, Museo Provincale de Bellas Artes: Plaza Pintor Sotomayor, La Coruña, Spain
La Rochelle, Musée d'Orbigny Bernon: 2 Rue Saint-Come, F-17000 La Rochelle, France
La Salle College Art Museum: 20th Street & Olney Avenue, Philadelphia, PA 19141
Lady Lever Art Gallery: Port Sunlight, Cheshire, L62 5EQ, England
Lambeth Palace Library: London, SE1 7JU, England
Laon, Bibliothèque Municipale: Ancienne Abbaye Saint-Martin, Place Soeur Marie-Catherine, F-02011 Laon, France
Lateran Museum, Rome: (Profane Lateranense, Vatican), Viale Vaticano, V-00120 Vatican City
Lazaro Galdiano Museum, Madrid: Calle Serrano, 122 Madrid, Spain
Le Mans Museum. See Tesse Museum
Leamington Spa Art Gallery: Avenue Road, Leamington Spa, Warwickshire, CV31 3PP, England
Leeds City Art Gallery: Municipal Buildings, Leeds, LS1 3AA, England
Leicester Museum and Art Gallery, 96 New Walk, Leicester, LE1 6TD, England
Leipzig, Museum der Bildenden Künste: Georg-Dimitroff-Platz 1 701, Leipzig, Germany
Leipzig, Universitätsbibliothek: Beethovenstraße 6, D-7010 Leipzig, Germany
Lenin Library, Moscow: (Gosudarstvennya Ordena Lenina Biblioteka SSSR im. V.I. Lenina), Prospekt Kalinina 3, Moscow 101000, Russia
Library of Congress: Second Street & Independence Avenue, SE, Washington DC 20540
Lichtenstein Collection, Vaduz: (Sammlungen des Regierenden Fürsten von Liechtenstein), Schloss Vaduz, Fl-9490 Vaduz, Liechtenstein
Liège, Musée d'Art Religieux et d'Art Mosan: Basilique Saint-Martin, rue Mont-Saint-Martin, B-4000 Liège, Belgium
Liège, Musée de la Boverie: Parc de la Boverie 3, B-4020 Liège, Belgium
Liège, Saint Paul Cathedral: 6 Rue Bonne Fortune c/o Zeevaert, Sacristain 2a, Rue Saint Paul, B-4000 Liège, Belgium
Lille, Musée des Beaux-Arts: Place de la République, F-59000 Lille, France
Lindenau Museum, Altenburg: (Staatliche Lindenau-Museum) Ernst-Thälmann-Straße 5, DDR-74 Altenburg, Germany
Lisbon, National Archives, Amario dos Tratados: Servicio de Documentacão, Avenue Dr. António José de Almeida, 1, 1078 Lisbon, Portugal
Lisbon National Museum of Antique Art: Rua das Janelas Verdes, Lisbon, Portugal
Lodi Museum: Corso Umberto 63, I-20075 Lodi, Milan, Italy
London Guildhall Art Gallery: Corporation of London, King Street, London, EC2P 2ET, England
London Public Record Office and Museum: Chancery Lane, London, WC2A 1LR, England
Loreto, Apostolico Palace: Piazza della Madonna, Loreto, Italy
Los Angeles County Museum of Art: 5905 Wilshire Boulevard, Los Angeles, CA 90036
Louvain-La-Neuve, University Library: Place Cardinal Mercier 31, B-1348 Louvain-La-Neuve, Belgium
Louvre: (Musée National du Louvre), Palais du Louvre, F-75041 Paris, France
Lowrie Museum of Anthropology, University of California: 103 Kroeber Hall, Berkeley, CA 94720

331 *Directory*

Lubomirski Museum, Lemberg: (L'vovskij Istoriceskij Muzej), Pl. Rynok, 6, L'vov 6,
 Russia
Lucca, Museo Nazionale di Villa Guinigi: Via della Quarquonia, I-55100 Lucca, Italy
Lucca, Pinacoteca Nazionale: Piazza Napoleone, I-55100 Lucca, Italy
Lutherhalle, Wittenberg: (Staatliche Lutherhalle), Collegienstraße 54, DDR-46
 Wittenberg-Lutherstadt, Germany
Luxemburg, Musée d'Histoire et d'Art: 18 Avenue de l'Arsenal, Luxembourg
Lyons, Bibliothèque Municipale: 30 Boulevard Vivier-Merle, F-69431 Lyon, France
Lyons, Musée des Beaux-Arts: Palais Saint-Pierre, 20 Place des Terreaux, F-69001
 Lyons, France
M. H. de Young Memorial Museum: Golden Gate Park, San Francisco, CA 94118
Madrid, Academy of Fine Arts: Circulo de Bellas Artes, Alcalá 42, Madrid, Spain
Madrid, Monastery of Descalzes Reales: Plaza de las Descalzas 3, Madrid, Spain
Madrid, Museo Nacional de Arte Moderno: (Museo Español de Arte Contemporaneo),
 Avenida Calvo Sotelo 20, Madrid, Spain
Madrid, Museo Naval: Calle de Montalban 2, Madrid 14, Spain
Madrid, Royal Palace: Palacio Real, Madrid, Spain
Madrid National Library: Museo de la Bibliografia Española, Paseo de Recoletos 20,
 Madrid, Spain
Magnin Museum, Dijon: 4 Rue Bons-Enfants, F-21000 Dijon, France
Mainz Cathedral: Bischöfliche Dom- und Diözesanmuseum, Domstraße 3, D-6500
 Mainz, Rheinland-Pfalz
Malines, St. Rombaud: (Metropolitaanse Kerkfabriek Van de H. Rumoldus) Frederik de
 Merodestraat 18, B-2800 Mechelen, Belgium
Manchester City Art Gallery: Mosley Street, Manchester, England
Mantua, Ducal Palace: Piazza Sordello 39, I-46100 Mantua, Italy
Mappin Art Gallery. See Sheffield City Art Galleries
Marburg, Universitätsmuseum: Biegenstraße 11, D-3550 Marburg, Germany
Marciana Library: Libreria Vecchia, Piazza San Marco, Venice, Italy
Mariners' Museum, 100 Museum Drive, Newport News, VA 23606
Marseille, Musée des Beaux-Arts: Palais Longchamp, Place Bernex, F-13004 Marseille,
 France
Masséna Museum, Nice: 65 Rue de France, F-06000 Nice, France
Matelica, Museo Piersanti: Via Umberto I 11, I-62024 Matelica, Macerata, Italy
Maurcelliana Library, Florence: Via Cavour 43-45, I-50129 Florence, Italy
Mauritshuis Royal Picture Gallery: Plein 29, The Hague, Netherlands
Mayer van den Bergh Museum, Antwerp: Lange Gasthuisstraat 19, B-2000 Antwerp,
 Belgium
Meadows Museum, Dallas: Owen Fine Arts Center, Southern Methodist University,
 Dallas, TX 75275
Medicea Laurenziana Library: Piazza San Lorenzo 9, I-50123 Florence, Italy
Medici-Riccardi Palace, Florence. See Museo Mediceo e Palazzo Medici Riccardi
Memling Museum, Bruges: St. Janshospitaal, Mariastraat 38, B-8000 Bruges, Belgium
Memorial Art Gallery, Rochester: 490 University Avenue, Rochester, NY 14607
Meningen, Schloß: (Staatliche Museum, Schloss), Elisabethenburg, DDR-61 Meiningen,
 Germany
Messina, Museo Nazionale: Viale Libertà 465, I-98100 Messina, Italy
Metropolitan Museum of Art, 1000 Fifth Avenue, New York, NY 10028-0198
Milan, Museo Civico: Castello Sforzesco, I-20121 Milan, Italy
Milan, San Ambrogio: Piazza San Ambrogio 15, I-20123 Milan, Italy
Milan Cathedral: Museo del Duomo, Piazza Duomo 14, I-20122 Milan, Italy
Milwaukee Art Museum: 800 West Wells Street, Milwaukee, WI 53233
Minneapolis Institute of Arts: 201 East 34th Street, Minneapolis, MN 55404
Mint Museum of Art: 2730 Randolph Road, Charlotte, NC 28207
Modena, Pinacoteca Estense: See Estense Gallery, Modena
Montclair Art Museum: 3 South Mountain Avenue, Montclair, NJ 07042
Monte, Bologna: (Convento di San Paolo in Monte-Osservanza) Via dell'Osservanza 88,
 I-40136 Bologna, Italy

Monte Oliveto Maggiore: 53041 Asciano, Italy
Montepulciano, Pinacoteca Comunale: Via Ricci 15, I-53045 Montepulciano, Siena, Italy
Montreal Museum of Fine Arts: 3400 Avenue du Musée, Montreal, Quebec, H3G 1K3, Canada
Moraca Monastery, Montenegro: Yugoslavia
Moravian Gallery, Brno: Husova 14, CS-600 00 Brno, Czech Republic
Moritzburg: (Barockmuseum Scholoβ Moritzburg), 8105 Moritzburg, Germany
Moscow, State Historical Museum: (Gosudarstvennyj Istoriceskij Muzej), Krasnaja Pl., 1/2 Moskva 103012, Russia
Moulins, Biblio. Municipale: Avenue Maréchal de Lattre de Tassigny, F-03000 Moulins, France
Moulins Museum: 6 Place de l'Ancien Palais, F-03000 Moulins, France
Munich, Nationalmuseum: (Bayerisches Nationalmuseum), Prinzregentenstraβe 3, D-8000 Munich, Germany
Munich, Pinacoteca: (Neue Pinakothek) Barerstrasse 29, D-8000 Munich, Germany
Munich, Staatsgemäldesammlungen. See Bayerische Staatsgemäldesammlungen, Munich
Munich Staatsbibliothek: (Bayerische Staatsbibliothek), Ludwigstraβe 16, D-8000 Munich, Germany
Münster, Landesmuseum: Rothemburg 30, D-4400 Münster, Germany
Münster, Saint Martin: Katholisches Pfarramt Saint Martin 1- Martinikirchof 11, D-4400 Münster, Germany
Murcia, San Nicolás: Murcia, Spain
Musée de la Chartreuse, Douai: (Musée Municipal Ancienne Chartreuse), Rue des Chartreux, F-59500 Douai, France
Musée de la Légion d'Honneur et des Ordres de Chevalerie: 2 Rue de Bellechasse, F-75007 Paris, France
Musée de la Marine: Palais de Chaillot, Place du Trocadéro, F-75116 Paris, France
Musée de l'Ain, Bourg-en-Bresse: Prieuré de Brou, 65 Boulevard de Brou, F-01000 Bourg-en-Bresse, France
Musée de Richelieu: (Musée Municipal), Hôtel de Ville, F-37120 Richelieu, France
Museo del Prado. See Prado Museum
Museo Dio Cesano, Orihuela: de Arte Sacro, Catedral, Orihuela, Spain
Museo Mediceo e Palazzo Medici-Riccardi, Florence: Via Cavour 1, I-50129 Florence, Italy
Museo Nazionale Archeologico, Ferrara. See Spina Museum, Ferrara
Museo Vesuviano. See Pompeii Museum
Museum für Geschichte der Stadt Leipzig: Markt 1, 701 Leipzig, Germany
Museum of Art History, Vienna. See Kunsthistorisches Museum
Museum of the Plovdiv Metropolitanate: (Okrăžna Chudožestvena Galerija) ul. Vasil Kolarov 15, BG Plovdiv, Bulgaria
Nancy, Musée des Beaux-Arts: 3 Place Stanislas, F-54000, Nancy, France
Nancy, Musée Historique Lorrain: Grande rue, F-54000 Nancy, France
Nantes, Bibliothèque: 15 Rue de l'Héronnièré, F-44041 Nantes, France
Nantes, Musée des Beaux-Arts: 10 rue Georges Clemenceau, F-44000 Nantes, France
Nantes, Musée Municipal. See Dobrée Musée, Nantes
Naples, Bibliothèque Nationale: Palazzo Reale, I-80132 Naples, Italy
Naples, Certosa di San Martino. See Naples, Museo Nazionale
Naples, Museo Archeologico Nazionale: Piazza Museo Archeologico Nazionale, I-80135 Naples, Italy
Naples, Museo Civico Gaetano Filangieri: Piazetta Filangieri, Via Duomo 288, I-80138 Naples, Italy
Naples, Museo Nazionale: (Museo Nazionale di San Martino), Largo San Martino, I-80129 Naples, Italy
Naples, San Martino: (Museo Nazionale de San Martino) Largo San Martino 5, I-80129 Naples, Italy
Narodni Galerie, Prague: Hradcany, Jirsky Klaster, CS-11000 Prague, Czech Republic
Narodowe Krakowie Museum: Ul. Manifestu Lipcowego 12, Pl-30- 960 Cracow, Poland

Narodowe Warszawie Museum: Aleje Jerozelimskie 3, Warsaw, Poland
National Archeological Museum, Athens: 44 Patission Street, Athens 147, Greece
National Gallery, London: Trafalgar Square, London, WC2N 5DN, England
National Gallery of Art: 6th Sreet & Constitution Avenue, Washington DC 20565
National Gallery of Canada: Immeuble Lorne Bldg, Elgin Street, Ottawa, Ontario, K1A 0M8, Canada
National Gallery of Ireland: Leinster Lawn, Merrion Square, Dublin, Ireland
National Gallery of Scotland: The Mound, Edinburgh, EH2 2EL, Scotland
National Gallery of Victoria, Melbourne: 180 Street Kilda Rd., Melbourne, Victoria 3004, Australia
National Library of Scotland, Edinburgh: George IV Bridge, Edinburgh, EH1 1EW, Scotland
National Maritime Museum: Romney Road, Greenwich, London, SE10 9NF, England
National Monuments Record: Royal Commission on the Historical Monuments of England, Fortress House, 23 Saville Row, London, W1X 1AB, England
National Portrait Gallery, 2 Saint Martin's Place, London, WC2 0HE, England
Nelson-Atkins Museum of Art: 4525 Oak Street, Kansas City, MO 64111
Nessebur Museum: Gradski Archeologičeski Muzej, BG Nesebăr, Burgaski Okrăg, Bulgaria
Neue Pinakothek: Barerstraße 29, D-8000 Munich 40, Germany
New Orleans Museum of Art: Lelong Avenue, City Park, New Orleans, LA 70119
New York Public Library, 5th Avenue & 42nd Street, New York, NY 10018
Niedersächische Landesgalerie, Hannover: Am Maschpark 5, D-3000 Hannover 1, Germany
Nîmes, Musée des Beaux-Arts: (Musée d'Art et d'Histoire), Rue de la Cathédrale, F-3000 Nimes, France
Nonantola, Abbey: Nonantola, Italy
Nordiska Museet, Stockholm: Djurgarden, S-115, 21 Stockholm, Sweden
North Carolina Museum of Art, Raleigh: 107 East Morgan Street, Raleigh, NC 27611
Northampton, Smith College Museum of Art: Elm Street at Bedford Terrace, Northampton, MA 01060
Norton Simon Museum of Art, Pasadena: Colorado & Orange Grove Boulevards, Pasadena, CA 91105
Nottingham Museum: The Castle, Nottingham, NG1 6EL, England
Novgorod, Museum of Art & History: (Novgorodskij istoriko-chudožestvennyj i archilekturnyj muzej) Kreml' 11, Novgorod, Russia
Ny Carlsberg Glyptothek, Copenhagen: Dantes Plads, DK-1556 Copenhagen V, Denmark
Öffentliche Kunstsammlung-Kunstmuseum: Straße Albangraben 16, Ch-4010 Basel, Switzerland
Ohrid, St. Clement: Macedonia
Oldenburg, Landesmuseum für Kunst und Kulturgeschichte: Schloßplatz 1, D-2900 Oldenburg, Germany
Olympia Archaeological Museum: Olympia, Peloponnese, Greece
Oratorio Suardi: Trescore, Italy
Oriheula, Museo Dio Cesano: (Museo Diocesano de Arte Sacro), Cathedral, Orihuela, Spain
Orléans, Musée des Beaux-Arts: 1 Place de la République, F- 45000 Orléans, France
Orléans Library: 1 Rue Dupanloup, 45043 Orléans, France
Orte Cathedral: Orte, Italy
Orvieto Cathedral (Museo dell'Opera del Duomo): Piazza Duomo 29, Orvieto, Italy
Oslo National Museum: (Nasjonalgalleriet), Universitetsgata 13, Oslo, Norway
Ospedale Galleria degli Innocente: Piazza Della Sans Annunziata 12, Florence, Italy
Österreichische Galerie im Belvedere: Prinz Eugen Straße 27, 1030 Vienna, Austria
Österreichische Nationalbibliothek, Vienna: Josefsplatz 1, 1015 Vienna, Austria
Ostia Museum: (Museo Ostiense), I-00050 Ostia Antica, Rome, Italy
Padua, Church of the Eremitani: (Museo Civico Ermitani) Piazza Eremitani 8, I-35121 Padua, Italy

Padua, Museo Civico: Monastery of Saint Anthony, Piazza del Santo 10, Padua, Italy
Padua, Santa Giustina: Via Giuseppe Ferrari 2, I-35100 Padua, Italy
Palacio de Liria, Madrid: Princesa 20, Madrid, Spain
Palacio Real, Madrid: (Palacio Real de Madrid), Madrid, Spain
Palatina Galerie, Florence: Palazzo Pitti, Piazza Pitti, I- 50135 Florence, Italy
Palatine Library, Parma: Palazzo delle Pilotta, I-43100 Parma, Italy
Palazzo della Pilotta, Parma: (Galleria Nazionale Palazzo Pilotta), Via della Pilotta 4,
 I-43100 Parma, Italy
Palazzo Pubblico, Siena. See Siena Civic Museum
Palazzo Reale, Turin: Piazza Castello, I-10120 Turin, Italy
Palazzo Venezia, Rome: Via del Plebiscito, Rome, Italy
Palermo, Galleria Nazionale: Palazzo Abatellis, via Alloro 4, I-90133 Palermo, Italy
Palermo, Pinacoteca: (Galleria Regionale della Sicilia), Palazzo Abatellis, Via Alloro 4,
 I-90133 Palermo, Italy
Palermo Archaeological Museum: (Museo Archeologico Regionale), Piazza Olivella,
 I-90133 Palermo, Italy
Palma, Archaeological Museum: (Museo de Mallorca) Sección de Arqueologiá, Oficinas,
 Calle Lulio 5, Palma de Mallorca, Beleares, Spain
Palma de Mallorca Cathedral: Baleares, Spain
Panthéon, Paris: Université de Paris, Panthéon- Sorbonne Bibliothèque de l'Université,
 90 Rue de Tolbiac, F-75634 Paris, France
Paris, Bibliothèque de l'Ecole des Beaux-Arts, 17 Quai Malaquais, F- 75272 Paris, France
Paris, Ecole des Beaux-Arts: (Ecole Nationale Supérieure des Beaux-Arts – ENSBA), 17
 Quai Malaquais, 75272 Paris, France
Paris, Musée de d'Homme: Palais de Chaillot, F-75016 Paris, France
Paris, Musée des Monuments Français: Palais de Chaillot, aile de Paris, Place du
 Trocadéro, F-75116 Paris, France
Parma, Bibliothèque Palatina: Palazzo della Pilotta, I-43100 Parma, Italy
Parma, Pinacoteca: (Pinacoteca G. Stuard), Via Cavestro 14, I-43100 Parma, Italy
Parma Museum: (Camera di San Paolo), Via Melloni, I-43100 Parma, Italy
Parma National Gallery: Palazzo della Pilotta, Via della Pilotta 4, I-43100, Parma, Italy
Patmos, Monastery of Saint John the Theologian: Patmos, Italy
Pau, Musée des Beaux-Arts: Rue Mathieu-Lalanne, F-64000 Pau, France
Pedralbes Monastery: Avenida Generalisimo Franco, Barcelona, Spain
Pella Museum: (Archeological Museum of Pella), Pella, Macedonia, Greece
Pennsylvania Academy of Fine Arts: Broad & Cherry Streets, Philadelphia, PA 19102
Pepoli Museum: Via Pepoli 196, I-91100 Trapani, Italy
Perugia, Galleria Nazionale dell'Umbria: Palazzo dei Priori, Corso Vannucci, I-26100
 Perugia, Italy
Perugia, Museo del Duomo: Piazza IV Novembre 23, I-06100 Perugia, Italy
Perugia, Pinacoteca Vannucci: (Galleria Nazionale dell'Umbria) Palazzo dei Priori, Corso
 Vannucci, I-26100 Perugia, Italy
Pesaro, Museo Civico: Piazza Mosca 29, I-61100 Pesaro, Italy
Petit Palais, Avignon: Palais des Archevèques, Place du Palais des Papes, F-84000
 Avignon, France
Petit Palais, Paris: (Musée du Petit Palais), 1 Avenue Dutuit, F-75008 Paris, France
Pezzoli Museum, Milan: (Museo Poldi Pezzoli), Via Manzoni 12, I-20121 Milan, Italy
Philadelphia Museum of Art: Parkway and 26th Street, Philadelphia, PA 19130
Philbrook Art Center: 2727 South Rockford Road, Tulsa, OK 74114
Phillips County Museum: 623 Pecan Street, Helena, AR 72342
Phoenix Art Museum: 1625 North Central Avenue, Phoenix, AZ 85004
Piacenza, Museo Civico: (Galleria Alberoni) Gia Emila Parmense 77, I-29100 Piacenza,
 Italy
Piacenza, San Antonio: Annesso alla Basilica, Via Chiostro San Antonino 6, Piacenza, Italy
Piazza della Signoria. See Vecchio Palace
Picardy Museum. See Amiens, Musée des Beaux-Arts
Piccolomini Library, Siena: Palazzo Piccolomini Via Banchi di Sotto 52, I-53100 Siena,
 Italy

Picture Gallery, Berlin: (Gemäldegalerie der Staatlichen Museen), Arnimallee 23, D-1000 Berlin 33, Germany
Picture Gallery, Dresden: (Staatliche Kunstsammlungen, Gemäldegalerie Alte Meister), Semper Galerie Zwinger, DDR-6904 Dresden, Germany
Picture Gallery, Dresden: (Staatliche Kunstsammlungen, Gemäldegalerie Neue Meister, Dresden), Georg-Treu-Platz 3, Albertinum, DDR-801 Dresden, Germany
Picture Gallery, Lvov: Ul. Stefanika 3, L'vov, Russia
Pienza, Cathedral Museum: Via del Castello, I-53026 Pienza, Siena, Italy
Pierpont Morgan Library: 29 East 36th Street, New York, NY
Pinacoteca Ambrosiana, Milan: Piazza Pio XI, I-20123 Milan, Italy
Pinacoteca di Brera. See Brera, Milan
Pinacoteca Tosio-Martinengo, Brescia: Via Martinengo da Barco 1, I-25100 Brescia, Italy
Pinacoteca Vaticana. See Vatican Museums
Pio-Clementino Museum: Viale Vaticano V-00120 Vatican City
Piraeus Museum: (Archeological Museum), 38 Filellinon Street, Piraeus, Attica, Greece
Pisa, Museo Civico: (Museo delle Sinopie), Piazza Duomo 17, I-56126 Pisa, Italy
Pisa, Museo Nazionale di San Matteo: Lungarno Mediceo, I-56100 Pisa, Italy
Pisa Cathedral: Museo dell'Opera del Duomo, Piazza Archivescovado, I-56100 Pisa, Italy
Pitti Palace, Florence: Palazzo Pitti, Piazza Pitti, I-50125 Florence, Italy
Plantin-Moretus Museum, Antwerp: Vrijdagmarkt 22, B-2000 Antwerp, Belgium
Plessis-lès Tours Castle, Indre-et-Loire: France
Plymouth City Museum and Art Gallery: Drake Circus, Plymouth, PL4 8AJ, England
Poggibonsi, Saint Michele al Padule: Poggibonsi, Italy
Poitiers, Musée des Beaux-Arts: (Musée Sainte-Croix), 3 Bis. Rue Jean Jaurés, F-86000 Poitiers, France
Poitiers Library: 43 Place Charles-de-Gaulle, F-86000 Poitiers, France
Poldi-Pezzoli Museum: Via Manzoni 12, Milan, Italy
Poltava, State Museum: Ul. Dzerdzinskogo, 11, Poltava, Ukraine
Pomona College: Montgomery Gallery, 300 College Avenue, Claremont, CA 91711
Pompeii Museum: (Museo Vesuviano), Piazza Longo 1, I-80040 Pompei, Naples, Italy
Ponce, Museo de Arte: POB 1492, Ponce, Puerto Rico
Pordenone, Museo Civico Palazzo Ricchieri: Corso Vittorio Emmanuele, I-33170 Pordenone, Italy
Portland Art Museum: 1219 Southwest Park Avenue, Portland, OR 97205
Potsdam, Schloß Sanssouci: Park Sanssouci, 15 Potsdam, Germany
Potsdam Neues Palais: 15 Potsdam, Germany
Prado Museum: Paseo del Prado, Madrid, Spain
Prague, Municipal Museum: Mickiewiczova 2, CS Prague 6, Czech Republic
Prague National Gallery. See Nardoni Gallerie
Prato, Museo Comunale: Piazza del Comune, I-50047 Prato, Florence, Italy
Prato, Museo dell'Opera del Duomo: Piazza Duomo 49, I-50047 Prato, Florence, Italy
Pretenkabinet der Rijksuniversiteit, Leyde: Rapenburg 65, NL-2311 SK Leiden, Netherlands
Princeton University Art Museum: Princeton, NJ 08540
Princeton University Firestone Library: Princeton, NJ 08554
Pushkin Museum of Fine Arts, Moscow: Ul. Volchonka, 12, Moscow 121019, Russia
Pyrghi, Euboe, Church of the Transfiguration: Evvoia, Greece
Queen's College, Cambridge: Cambridge, CB3 9ET, England
Quimper, Musée des Beaux-Arts: Hôtel del Ville, Place Saint-Corentin, F-29000 Quimper, France
Ravenna, Archbishop's Palace: Piazza Arcivescovado 1, I-48100 Ravenna, Italy
Ravenna, Pinacoteca Comunale: Via Roma, I-48100 Ravenna, Italy
Ravenna, San Vitale: (Museo Nazionale), Via San Vitale 17, I-48100 Ravenna, Italy
Reading Public Museum and Art Gallery: 500 Museum Road, Reading, PA 19611
Recanti, Saint Domenico: Recanti, Italy
Reggio Calabria, Museo Nazionale: Piazza de Nava 26, I-89100 Reggio Calabria, Italy
René-Princeteau Museum, Libourne: Mairie de Libourne, F-33500 Libourne, Gironde, France

Rennes, Musée des Beaux-Arts et d'Archéologie: 20 Quai Emile Zola, F-35100 Rennes, France
Residenz, Würzburg: (Residenz mit Hofkirche und Hofgarten), c/o Schloß- und Gardenverwaltung Würzburg, Residenzplatz 2, D-8700 Würzburg, Germany
Rheims Museum: (Musée Saint-Denis), 8 Rue Chanzy, F-51100 Rheims, France
Rheinisches Landesmuseum, Trier: Ostallee 44, D-5500 Trier, Germany
Rhode Island School of Design: 224 Benefit Street, Providence, RI 02903
Rhodes Archaeological Museum: Street of the Knights, Rhodes, Greece
Riccardiana Library, Florence: via Ginori 10, I-50129 Florence, Italy
Rice University: Sewall Art Gallery Rice University, PO Box 1892, Houston, TX 77251
Rieti Church of the Crucifix: Rieti, Italy
Rijksmuseum, Amsterdam: Stadhouderskade 42, Postbus, 50673 (1007 DD) Amsterdam, Netherlands
Rijksmuseum Kroller-Muller, Otterlo: Houtkampweg 6, NL-6370 AA Otterlo, Netherlands
Rijksmuseum Meermanno-Westreenianum, The Hague: Museum Van het Boek, Prinsessegracht 30, NL-2514 AP 'S-Gravenhage (The Hague), Netherlands
Rila Monastery: Nacionalen Muzej 'Rilski Manastir', BG Rilski Manastir, Bulgaria
Rimini, Civic Museum: Tempio Malatestiano, I-40137 Rumini, Forli, Italy
Ringling Museum of Art: Sarasota, FL 33578
Rio de Janeiro, Museu Nacional de Belas Artes: Avenue Rio Branco 199, Rio de Janeiro, Brazil
Rochefort-sur-Mer, Musée Municipal: 63 Rue de l'Arsenal, F-17300 Rochefort, France
Rochester Memorial Art Gallery: 490 University Avenue, Rochester, NY 14607
Romantico Museum, Madrid: Calle San Mateo, 13 Madrid, Spain
Rome, Canonica di San Pietro: Nella 'Fortezzuola' di Villa Borghese, Rome, Italy
Rome, Casa Colonna: Via Pilotta 17, I-00187 Rome, Italy
Rome, Gabinetto Nazionale delle Stampe: Via della Lungara 230, I-00165 Rome, Italy
Rome, Galleria d'Arte Moderna: (Galleria Nazionale d'Arte Moderna-Arte Contemporanea), Viale delle Belle Arti 131, I-00197 Rome, Italy
Rome, Galleria Nazionale d'Arte Antica: Via delle Quattro Fontane 13, I-00184 Rome, Italy
Rome, Museum: Piazza di San Pantaleo 10, I-00186 Rome, Italy
Rome, National Library: Viale Castro Pretorio 105, I-00185 Rome, Italy
Rome, National Museum: (Museo Nazionale Romano), Piazza della Finanze, I-00185 Rome, Italy
Rome, San Andrea al Quirinale: 29 Via del Quirinale, Rome, Italy
Rome, San Bernardo alla Terme: 94 Via Torino, Rome, Italy
Rome, San Callisto: 16 Piazza San Calisto, Rome, Italy
Rome, San Carlo ai Catinari: 117 P. B. Cairoli, Rome, Italy
Rome, San Carlo alle Quattro Fontane: 23 Via del Quirinale, Rome, Italy
Rome, San Clemente Church: Via Labicana 95, I-00184 Rome, Italy
Rome, San Crisogono: 44 Piazza Sonnino, Rome, Italy
Rome, San Francesco de Paola: 10 Piazza San Francesco di Paola, Rome, Italy
Rome, San Lorenzo in Lucina: 16/A Via in Lucina, Rome, Italy
Rome, San Lorenzo in Miranda: 10 Via in Miranda, Rome, Italy
Rome, San Luigi dei Francesi: 5 Piazza San Luigi dei Francesi, Rome, Italy
Rome, San Marco: 48 Piazza San Marco, Rome, Italy
Rome, San Nicola da Tolentino: 17 Sal. Santa Nicola da Tolentino, Rome, Italy
Rome, San Paolo fuori le Mura (Saint Paul-Outside-the-Walls): 190 Via Ostiense, Rome, Italy
Rome, San Rocco: 1 Lg. San Rocco, Rome, Italy
Rome, San Silvestro al Quirinale: 10 Via XXIV Maggio, Rome, Italy
Rome, San Silvestro in Capite: Piazza San Silvestro, Rome, Italy
Rome, Santa Agnese in Piazza Navona: 30 Via Santa Maria Anima, Rome, Italy
Rome, Santa Anastasia: Piazza Santa Anastasia, Rome, Italy
Rome, Santa Bibiana: 154 V. G. Giolitti, Rome, Italy
Rome, Santa Caterina da Siena: 28 Via Latina, Rome, Italy

Rome, Santa Caterina dei Funari: Via dei Funari, Rome, Italy
Rome, Santa Cecilia: 22 Piazza Santa Cecilia, Rome, Italy
Rome, Santa Croce in Gerusalemme: 12 Piazza Santa Croce in Gerusalemme 8, Rome, Italy
Rome, Santa Francesca Romana: 15 Via Luigi Capucci, Rome, Italy
Rome, Santa Maria, Ara Coeli: 4 Piazza del Campidoglio, Rome, Italy
Rome, Santa Maria degli Angeli: 9 Via Cernaia, Rome, Italy
Rome, Santa Maria della Vittoria: 17 Via XX Settembre, Rome, Italy
Rome, Santa Maria di Loretto: Castelverde di Lunghezza, Rome, Italy
Rome, Santa Maria in Araceli: 4 Plaza del Campidoglio, Rome, Italy
Rome, Santa Maria in Transpontina: 15 Borgo San Angelo, Rome, Italy
Rome, Santa Maria in Vallicella: 134 Via del Governo Vecchio, Rome, Italy
Rome, Santa Maria Maggiore: 47 Via Carlo Alberto, Rome, Italy
Rome, Santa Maria sopra Minerva: 35 Via Beato Angelico, Rome, Italy
Rome, Santa Prassede: 9/a Via Santa Prassede, Rome, Italy
Rome, Sant'Onofrio: 2 Piazza Sant'Onofrio Onofrio, Rome, Italy
Rome, Sans Cosmas e Danian: 1 Via dei Fori Imperiali, Rome, Italy
Rome, Sans Nereo ed Achilleo: 28 Via Terme Caracalla, Rome, Italy
Rome, Sans Quattro Coronati: 20 Via SS. Quattro, Rome, Italy
Rome, Sans Vito e Modesto: 47 Via Carlo Alberto, Rome, Italy
Rouen, Bibliothèque Municipale: 3 Rue Jacques Villon, F-76043 Rouen, France
Rouen, Musée des Beaux-Arts: 26615 Rue Thiers, F-76000 Rouen, France
Rovigo, Accademia dei Concordi: Piazza Vittorio Emanuele, I-45100 Rovigo, Italy
Royal Academy of Arts: Burlington House, Picadilly, London, W1V 0DS, England
Royal Holloway and Bedford New College, University of London: Egham Hill, Egham, London, JW20 0EX, England
Royal Museum of Fine Arts, Brussels. See Koninklijke Musea voor Schöne Kunsten, Brussels
Royal Ontario Museum: 100 Queen's Park, Toronto, Ontario, Canada
Royal Palace, Madrid: (Palacio Real de Madrid), Madrid, Spain
Rubens House, Antwerp: (Rubenshuis), Wapper 9-11, B-2000 Antwerp, Belgium
Rumania, Art Museum of the R.P.R.: (Muzeul de Artă al Republicii Socialiste Romănia) Str. Stirbei Vedă, Bucuresti, Romania
Ruźicka-Stiftung Kunsthaus, Zurich: Heimplatz 1, CH-8001 Zurich, Switzerland
Sabauda Gallery, Turin: Via Accademia delle Scienze 6, I-10123 Turin, Italy
Saint-Germain-en-Laye Museum: (Musée des Antiquités Nationales de Saint-Germain-en-Laye), Château, F-78100 St. Germain-en-Laye, France
Saint-Lô Museum: Place du Général de Gaulle, F-50010 Saint-Lô, France
Saint Louis Art Museum: Forest Park, Saint Louis MO 63110
Saint-Omer Library: 40 Rue Gambetta, F-62500 Saint-Omer, France
Saint-Quentin Library: 9 Rue des Canonniers, F-02100 Saint Quentin, France
Sainte Geneviève Bibliothèque, Paris: Université de Paris, 10 Place du Panthéon, F-75005 Paris, France
Salerno, Museo del Duomo: Via Monterisi, I-84100 Salerno, Italy
Saltykov-Shchedrine Library, St. Petersburg: (Gosudarstvennaja Ordena Trudovogo Krasnogo Znameni Publicnaja Biblioteka im M.E. Saltykova-Shchedrina), Sadovaja ul., 18 St. Petersburg, Russia
Salzburg, Universitätsbibliothek: (Hauptbibliothek), Hofstallgasse 2-4, A-5020 Salzburg, Austria
Salzburger Barockmuseum: Mirabellgarten Orangerie, A-5020 Salzburg, Austria
Salzillo Museum, Murcia: Calle San Andrés, 1, Murcia, Spain
Sammlung Oskar Reinhart am Romerholz: Haldenstraße 95, CH-8400 Winterthur, Switzerland
San Diego Fine Arts Gallery: PO Box 2107, San Diego, CA 92112
San Francesco, Assisi: (Sacro Convento di San Francesco) Frati Minori Conventuali, I-06082 Assisi, Italy
San Francesco Museum, Montefalco: (Pinacoteca San Francesco), Via Ringhiera Umbra, I-06036 Montefalco, Perugia, Italy

San Francisco Art Institute Galleries, 800 Chestnut Street, San Francisco, CA 94133
San Francisco el Grande, Madrid: Plaza de San Francisco el Grande, Madrid, Spain
San Gimignano, Museo Civico: Piazza Duomo, I-53037 San Gimignano, Siena, Italy
San Luca Academy, Rome: Piazza dell Accademia di San Luca 77, I-00187 Rome, Italy
San Marco Monastery, Florence: Via Cavour 56, I-50129 Florence, Italy
San Marco Museum, Florence: Piazza San Marco, I-50121 Florence, Italy
San Martino Museum, Naples: (Museo Nazionale di San Martino) Largo San Martino 5, I-80129 Naples, Italy
San Severino Marche, Pinacoteca Civica: Palazzo Tacchi Venturi, Via Salimbeni 39, I-62027 San Severino Marche, Italy
Sansepolcro, Pinacoteca Comunale: Via Aggiunti 65, I-52037 Sansepolcro, Arezzo, Italy
Santa Barbara Museum of Art: 1130 State Street, Santa Barbara, CA 93101
Santa Cruz Museum, Toledo: Calle Cervantes 1, Toledo, Spain
Santa Sofia Museum, Istanbul: (Ayasofya Museum), Sultan Ahmet, TR Istanbul, Turkey
Santo Tomé, Toledo: (Museo Parroquial de Santo Tomé), Calle de Santo Tomé, Toledo, Spain
São Paulo Museu de Arte Assis Chateaubriand: Avenue Paulista 1578, São Paulo, Brazil
Sarah Campbell Blaffer Foundation, Houston: 4800 Calhoun, Houston, TX 77004
Schwabach, Evangelisch Lutheran Stadtpfarrkirche Sankt Martin: Schwabach, Germany
Schweizerisches Landesmuseum: Museumstraße 2, CH-8023 Zurich, Switzerland
Scottish National Gallery: The Mound, Edinburgh, Scotland Scottish National Portrait Gallery: 1 Queen Street, Edinburgh, Scotland
Seville Cathedral: Avenida Queipo de Llano, 41001 Seville, Spain
Seville, Museum of Fine Arts: (Museo de Bellas Artes), Plaza del Museo 9, Sevilla 1, Spain
Sforza Castle, Milan: Castello Sforzesco, I-20121 Milan, Italy
Sheffield City Art Galleries: Surrey Street, Sheffield, England
Siena, Biblioteca Comunale degli Intronati: Via di Città 73, Siena, Italy
Siena Cathedral. See Siena, Museo dell'Opera del Duomo
Siena, Museo dell'Opera del Duomo: Piazza del Duomo, I-53100 Siena, Italy
Siena, Palazzo Pubblico: Museo Civico, Piazza del Campi 1, I-53100 Siena, Italy
Siena, Pinacoteca Nazionale: 20 Via San Pietro 29, 53100 Siena, Italy
Siena, State Archive: (Museo dell'Archivio di Stato), Via Banchi di Sotto 52, I-53100 Siena, Italy
Siena Civic Museum; Piazzo del Campo, Siena, Italy
Sinai, Saint Catherine's Monastery: Sinai, Egypt
Skulpturensammlung, Dresden: Georg-Treu-Platz 1, 801 Dresden, Germany
Snite Museum of Art, Indiana: University of Notre Dame, Notre Dame, IN 46556
Society of Antiquaries of London: Burlington House, Picadilly, London, W1V 0HS, England
Soissons Museum: (Musée Municipal), 2 Rue de la Congrégation, F-02200 Soissons, France
Solvgade Museum of Fine Arts: DK-1307, Copenhagen K., Denmark
Sommacampagna, Santa Andrea: Italy
Sorrento, Museo Correale di Terranova: Via Correale 50, I-80067 Sorrento, Italy
Southampton Art Gallery: Commercial Road, Civic Center, Southampton, England
Spada Palace: Piazza Campo di Ferro 3, Rome, Italy
Sperlonga, Museo Archeologico Nazionale: Via Flacca, Sperlonga, Italy
Spina Museum, Ferrara: (Museo Nazionale Archeologico), Palace of Ludovic the Moor, Via XX, Settembre 124, Ferrara, Italy
Spinola Plaza: Piazza Pellicceria 1, Genoa, Italy
Staatliche Antikensammlung, Berlin: Schloßstraße 1, D- 1000 Berlin 19, Germany
Staatliche Antikensammlungen, Munich: und Glyptothek, Karoline-platz 4, D-8000 Munich 2, Germany
Staatliche Gemäldegalerie, Kassel: Schloß Wilhelmshöhe, D-3500 Kassel, Hessen, Germany
Staatliche Graphische Sammlung, Munich: Meierstraße 10, D-8000 Munich, Germany
Staatliche Kunsthalle, Karlsruhe: Hans-Thoma-Straße 2, D-7500 Karlsruhe, Germany
Staatliche Kunstsammlungen, Berlin. See Picture Gallery, Berlin

Staatliche Kunstsammlungen, Dresden. See Picture Gallery, Dresden
Staatliche Lindenau-Museum: Ernst-Thälmann-Straße 5, DDR-74 Altenburg, Germany
Staatliche Museen Pruessischer Kulturbesitz, Berlin-Dahlem: Berlin Museums, Stauffenbergstraße 41, 1000 Berlin 30 Germany
Staatliche Museen zu Berlin: State Museums, Berlin, Generaldirektion, Bodestraße 1-3, D-1020 Berlin, Germany
Staats- und Stadtbibliothek, Augsburg: Schaezlerstraße 25, Postfach 111909, D-8900 Augsburg, Germany
Staatsarchiv Schwerin: Graf-Schack-Allee 2, 2750 Schwerin, Germany
Städelsches Kunstinstitut und Stadtische Galerie, Frankfurt: Schaumainkai 63, D-6000 Frankfurt-am-Main 70, Germany
Stadtische Kunstsammlungen, Augsburg: Maximilianstraße 46, Schaezler-Palais, D-8900 Augsburg, Germany
Stanford University Museum of Art: Museum Way, Stanford, CA 94305
Staten Island Institute of Arts and Science: 75 Stuyvesant Place, Staten Island, NY 10301
Statens Historiska Museer, Stockholm: Narvavägen 17, Storgatan 41, Box 5405, S-114 84 Stockholm, Sweden
Stedelijk Museum voor Schöne Kunsten: Dijver 12, B-2000 Bruges, Belgium
Stedelijk Prentenkabinet, Anvers: Vrijdagmarkt 22, B-2000 Antwerp, Belgium
Sainte-Foy, Conques: Abbaye de Conques, F-12320 Conques, France
Sterling and Francine Clark Art Institute: PO Box 8, Williamstown, MA 01267
Stichting Pieter en Nelly de Boer: (Peter Stuyvesant Stichting) Drentsestraat 21, hoek De Boelelaan, Postbus 7400, NL-1007 JK Amsterdam, Netherlands
Stichting Teyler, Haarlem: Spaarne 16, NL-2011 CH Haarlem, The Netherlands
Stiftsmuseum, Klosterneuburg: Stiftsplatz 1, A-3400 Klosterneuburg, Austria
Stiftung Heylsof Kunsthaus, Worms: Stephansgaße 9, 6520 Worms, Rheinland-Pfalz, Germany
Stockholm, Bibliotèque Royale: Humlegarden, Box 5039, 102 41 Stockholm, Sweden
Stockholm Nationalmuseum: S.Blasieholmshamnen, Box 16176, S-103, 24 Stockholm, Sweden
Stockholm University Art Gallery: 106 91 Stockholm, Sweden
Strasbourg Fine Arts Museum: (Musée des Beaux-Arts or Musée de la Ville) Château des Rohan, c/o Musées Municipaux, 2 Place du Château, F-67000 Strasbourg, France
Stuttgart, Landesbibliothek: (Wurttembergische Landesbibliothek), Konrad-Adenauer-Straße 8, Postfach 769, D-7000 Stuttgart, Germany
Stuttgart, Staatsgalerie: Konrad-Adenauer-Straße 32, D-7000 Stuttgart 1, Germany
Suffolk Collection, Ranger's House, Blackheath: Chesterfield Walk, Blackheath, London, SE10 8QX, England
Sumu Museum: Bucharest, Romania
Sürmondt Museum, Aachen: (Suermondt-Ludwig-Museum), Wilhelmstraße 18, D-5100 Aachen, Germany
Svenska Porträttarkivet Nationalmuseum, Stockholm. See Stockholm Nationalmuseum
Sydney, National Gallery of New South Wales: Art Gallery Road, Domaine, NSW 2000 Sydney, Australia
Syracuse, Museo Archeologico Nazionale: Foro Italico, Piazza del Duomo 14, Syracuse, Sicily, Italy
Syracuse, Museo Bellomo: Via G. M. Capodieci 14-16, I-96100 Syracuse, Italy
Szépmuvezeti Muzeum, Budapest: Dózsa György ut 41 23 POB 463, H-1134 Budapest, Hungary
Tadini Gallery, Lovere: Via Tadini, I-24065 Lovere, Bergamo, Italy
Tallinn Art Museum: Vejcenberg 31, Tallinn 10, Russia
Taranto, Museo Archeologico Nazionale: Corso Umberto 54, I-74100 Taranto, Italy
Tarquinii, Museo Nazionale: (Museo Nazionale Archeologico), Palazzo Vitelleschi, Piazza Cavour 1, I-01016 Tarquinia, Viterbo, Italy
Tarragon Cathedral, Spain: (Museo Diocesano) Claustro Catedral, Tarragon, Spain
Tate Gallery: Millbank, London, SW1P 4RG, England
Tempio Malatestiano, Rimini: (Museo Civico), Tempio Malatestiano, I-41037 Rimini, Italy

Templice, Museum: Krajské Muzeum, Zámecké nám. 14, CS-415 01 Templice, Czech Republic
Terme Museum, Rome: Viale delle Terme, Rome, Italy
Termeno, Sans Quirico e Giulitta: Termeno, Italy
Tesse Museum: 2 Avenue de Paderborn, F-72000 Le Mans, France
Teyler's Museum: Spaarne 16, NL-2011 CH Haarlem, Netherlands
Thassos Museum: (Thassos Archaeological Museum), Thassos, Greece
Thomas-Henry Museum, Cherbourg: Hôtel de Ville, Place de la République, F-50100 Cherbourg, France
Thorvaldsens Museum: Porthusgade 2, DK-1213 Copenhagen K, Denmark
Thyssen Collection, Lugano, Switzerland: (Museo Civico di Belle Arti), Villa Ciani, CH-6900 Lugano, Switzerland
Tiflis, Museum of Art: Gosudarstvennyj Muzej Iskusstv GSSR, ul. Kecchoveli 1, Tbilisi, Georgia
Timken Art Gallery, San Diego: 1500 El Prado, Balboa Park, San Diego, CA 92101
Tiroler Landesmuseum Ferdinandeum, Innsbruck: Museumstraße 15, A-6020 Innsbruck, Austria
Toledo Cathedral: (Museo-Tesoro Catedralicio) Plaza Generalisimo, Toledo, Spain
Toledo Museum of Art, Ohio: PO Box 1013, Toledo, OH 43697
Topkapi Palace Museum: TR Istanbul, Turkey
Toronto Art Gallery: Grange Park, 317 Dundas Street West, Toronto, Ontario, Canada
Toulouse, Bibliothèque Municipale: 1 Rue de Périgord, 31070 Toulouse, France
Toulouse Museum. See Augustinian Museum, Toulouse
Tours, Musée des Beaux-Arts: 18 Place François Sicard, F-37000 Tours, France
Tower of London: The Armouries, H.M. Tower of London, London, EC3 4AB, England
Tretjakov Gallery, Moscow: Lavrusenskji per., 10, Moscow, Russia
Treviso, Museo Civico: Borgo Cavour 22, I-31100 Treviso, Italy
Trier, Stadtbibliothek: Weberbach 25, 5500 Trier, Germany
Trieste, Museo Civico di Storia e d'Arte: Via Cattedrale 15, I-34121 Trieste, Italy
Trinity College, Dublin: University of Dublin, Dublin 2, Ireland
Trondelag, Norway: (Trondelag Kunstgalleri), Trondhjems Kunstforening, Bispegt 7b, N-7000 Trondhjem, Norway
Troyes, Musée des Beaux-Arts: (Musée des Beaux-Arts et d'Archéologie), 21 Rue Chrétien-de-Troyes, F-10000 Troyes, France
Troyes, Library: 21 Rue Chrétien-de-Troyes, F-10042 Troyes, France
Turin, Biblioteca Nazionale Universitaria: Piazza Carlo Alberto 3, I-10123 Turin, Italy
Turin, Museo Civico d'Arte Antica: Palazzo Madama, Piazza Castello, Turin, Italy
Turin, Pinacoteca Nazionale: Palazzo dell'Accademia delle Scienze, Via Accademia delle Scienze 6, Turin, Italy
Udine, Museo Civico: Castello, I-33100 Udine, Italy
Uffizi, Florence: Loggiato degli Uffizi 6, I-50122 Florence, Italy
Ulster Museum Art Gallery, Belfast: Botanic Gardens, Belfast, BT9 5AB, Northern Ireland
University of Aberdeen: Aberdeen, AB9 1FX, Scotland
University of Arizona Museum of Art: Olive & Speedway, Tuscon, AZ 85721
University of Georgia, Athens: Jackson Street, North Campus, Athens, GA 30602
University of Glasgow: Glasgow, G12 8QQ, Scotland
University of Kansas, Lawrence: Spencer Museum of Art, 1301 Mississippi Street, Lawrence, KS 6045
University of London Library: Senate House, Malet Street, London, WC1E 7HU, England
University of Notre Dame Art Gallery: Suite Museum of Art, O'Shaughnessy Hall, Notre Dame, IN 46556
University of Wisconsin, Madison: Elvehjem Museum of Art, 800 University Avenue, Madison, WI 53706
Urbino, Galleria Nazionale delle Marche: Palazzo Ducale, Piazza Duca Federico 1, 61029 Urbino, Pesaro-Urbino, Italy
Urbino Ducal Palace: Piazza Duca Federico, Urbino, Italy
Utrecht, Centraal Museum: Agnietenstraat 1, NL-3500 GC Utrecht, Netherlands

Utrecht, Universiteitsbibliothek: (Rijksuniversiteit te Utrecht), Wittevrouwenstraeet 7-11, Postbus 16007, 3500 DA, Utrecht, Netherlands
Valencia Cathedral: (Museo Diocesano-Catedralicio) Plaza Almoyna, Valencia, Spain
Valencia, Museo de Bellas Artes: Calle San Pio V 9, Valencia, Spain
Valenciennes, Library: 26 Rue Ferrand, F-59300 Valenciennes, France
Valenciennes, Musée des Beaux-Arts: Place Verte, F-59300 Valenciennes, France
Valladolid Museum: Palacio de Fabio Nelli, Plaza de Fabio Nelli, Valladolid, Spain
Vassar College Art Gallery: Raymond Avenue, Poughkeepsie, NY 12601
Vatican, Galleria della Carte Geografiche: (Museo della Società Geografica Italiana), via Navicella 12, I-00184 Vatican City
Vatican Museums: (Musei Vaticani), Viale Vaticano, V-00120 Vatican City
Vecchio Palace, Florence: Piazza della Signoria, I-50122 Florence, Italy
Vela Museum, Ligornetto: CH-6853 Ligornetto, Switzerland
Venezia Palace, Rome: (Museo di Palazzo Venezia), Piazza Venezia 3, I-00184 Rome, Italy
Venice, Chiesa dei Gesuati: Cannaregio 4885, I-30121 Venice, Italy
Venice, Galleria Internazionale d'Arte Moderna: Palazzo Pesaro, Calle Longo, Venice, Italy
Venice, Saint Mark's: (Tesoro di San Marco e Museo della Basilica) Piazza San Marco, I-30124 Venice, Italy
Venice, San Rocco: Calle della Chiesa, Venice, Italy
Venice, Scuola Dalmata dei Sans Giorgio e Trifone: Calle dei Furlani, I-30233 Venice, Italy
Venice Ducal Palace: San Marco 1, I-30124 Venice, Italy
Vercelli, Museo Borgogna: Via Borgogna 1, I-13100 Vercelli, Italy
Verona, Biblioteca Civica: Via Cappello 43, I-37121 Verona, Italy
Verona, Municipal Museum: (Galleria Comunale d'Arte Moderna e Contemporanea) Palazzo Forti, Via A. Forti, I-37121 Verona, Italy
Versailles: (Musée National du Château de Versailles et de Trianon), Château, F-78000 Versailles, France
Vicenza, Pinacoteca Civica: Piazza Matteotti, I-36100 Vicenza, Italy
Vich, Museu Episcopal: Plaza Bispe Oliba, Vich, Barcelona, Spain
Victoria & Albert Museum: South Kensington Museum, South Kensington, London, SW7 2RL, England
Vienna, Academy of Fine Arts: Schillerplatz 3, A-1010 Vienna, Austria
Vienna, National Library. See Osterreichische Nationalbibliothek, Vienna
Villa Giulia, Rome: (Museo Etrusco di Villa Giulia), Piazzale Villa Giulia 9, I-00196 Rome, Italy
Virginia Museum of Fine Arts, Richmond: Boulevard & Grove Street, Richmond, VA 23221
Viterbo, Museo Civico: Piazza Crispi 2, I-01100 Viterbo, Italy
W. R. Hearst Collection: Hearst Art Gallery, Saint Mary's College, Moraga, CA 94575
Wadsworth Atheneum: 600 Main Street, Hartford, CT 06103
Walker Art Gallery: William Brown Street, Liverpool, L3 8EL, England
Walker Art Museum, Bowdoin College, Brunswick, ME 04011
Wallace Collection: Hertford House, Manchester Square, London, W1M 6BN, England
Wallraf-Richartz Museum, Cologne: Museum Ludwig An der Recht Schule, D-5000 Cologne, Germany
Walters Art Gallery: 600 North Charles Street, Baltimore, MD 21201
Washington University Art Gallery, Steinberg Hall, Forsyth & Skinker Campus, Saint Louis, MO 63130
Wellesley College: Jewett Arts Center, Wellesley College, Wellesley, MA 02181
Whitworth Art Gallery, University of Manchester: Whitworth Park, Manchester, M25 6ER, England
Wiesbaden, Gemäldegalerie: Friedrich-Ebert-Alee 2, D-6200 Wiesbaden, Germany
Wight Art Gallery, University of California: 1100 Gallery Building, 405 Hilgard, Los Angeles, CA 90024
Witte Memorial Museum: 3801 Broadway, San Antonio, TX 78209
Worcester Art Museum: 55 Salisbury Street, Worcester, MA 01508

Württembergisches Landesmuseum, Stuttgart: Altes Schloβ, Schillerplatz 6, D-7000 Stuttgart 1, Germany
Wuyts Van Campen Museum, Lier: Fl. Van Cauwenberghstraat 14, B-2500 Lier, Belgium
Yale University Art Gallery: 1111 Chapel Street, PO Box 2006, Yale Station, New Haven, CT 06520
York City Art Gallery: Exhibition Square, York, England
Zagorsk, Museum of History and Art: Zazorsk, Moskovskaja Obl., Russia
Zentralbibliothek, Zurich: (Kantons-Stadt-und Universitätsbibliothek), Zahringerpl 6, 8025 Zurich, Switzerland

For further information, see:

Museums of the World, Munich & New York, K.G. Saur, 1981.
World Guide to Libraries, Munich & New York, K.G. Saur, 1989.

Bibliography

The Ackland Art Museum. A Handbook. Chapel Hill, NC: The Ackland Art Museum, 1983.

The Age of Correggio and the Carracci: Emilian Painting of the Sixteenth and Seventeenth Centuries. Washington, DC: National Gallery of Art, 1986.

Allentown Art Museum. *The Samuel H. Kress Memorial Collection.* Allentown, PA: Allentown Art Museum, 1960.

Alpers, Svetlana. *The Art of Describing: Dutch Art in the Seventeenth Century.* Chicago: Univ. of Chicago Press, 1983.

Amaya, Mario. *Treasures from the Chrysler Museum at Norfolk and Walter P. Chrysler, Jr.* Norfolk: Chrysler Museum, 1977.

Andona, Mirella Levi D'. *The Garden of the Renaissance: Botanical Symbolism in Italian Painting.* Florence: Leo S. Olschki, 1974.

Andres, Glenn, John M. Hunisak, and A. Richard Turner. *The Art of Florence.* New York: Abbeville Press, 1988.

Argan, Giulio Carlo. *Botticelli.* Geneva: Editions d'Art Albert Skira, 1957.

Around 1610: The Onset of Baroque. London: Matthiesen Fine Art Ltd., 1985.

Art and Artists of All Nations. New York: Knight and Brown, 1898.

Art Association of Indianapolis. *Bulletin, Herron Museum of Art.* Art Association of Indianapolis, 1968.

The Art Institute of Chicago. *Paintings.* Art Inst. of Chicago, 1961.

_____. *100 Masterpieces.* Art Inst. of Chicago, 1978.

L'Art européen à la cour d'espagne au XVIII siècle. Paris: Réunion des Musées Nationaux, 1979.

Art Treasures from the Vienna Collection. Lent by the Austrian Government, Catalogue, 1949–50.

Art Treasures in Russia. New York: McGraw-Hill, 1970.

Ashelford, Jane. *A Visual History of Costume: The Sixteenth Century.* New York: Drama Bk. Pubs., 1983.

Ashley, Maurice. *The Life and Times of William I.* London: Weidenfeld and Nicolson, 1973.

Auchincloss, Louis. *J. P. Morgan: The Financier as Collector.* New York: Harry N. Abrams, 1990.

Auerbach, Erna. *Nicholas Hilliard.* London: Routledge and Kegan Paul, 1961.

Avermaete, Robert. *Rubens et son temps.* Brussels: Arcade, 1977.

Bache. *A Catalogue of Paintings in the Collection of Jules S. Bache.* New York, 1929.

Bachmann, Erich. *Gothic Art in Bohemia.* Oxford: Phaidon Press, 1977.

Bank, Alice. *Byzantine Art in the Collections of Soviet Museums.* Leningrad: Aurora Art Publishers, 1985.

Barbar, Richard. *The Reign of Chivalry.* London: David and Charles, 1980.

Barlow, Frank. *Edward the Confessor.* Berkeley: Univ. of California Press, 1984.

Batselier, Dom Pieter. *Saint Benedict: Father of Western Civilization.* New York: Alpine Fine Arts Collection, 1981.

Baudouin, Frans. *Peter Paul Rubens.* New York: Portland House, Bracken Books, 1989.

_____. *Pietro Paulo Rubens.* New York: Harry N. Abrams, 1977.

Baumstark, Reinhold. *Masterpieces from the Collection of the Princes of Liechtenstein.* New York: Hudson Hills Press, 1980.

Bayly Art Museum. *Selections from the Bayly Art Museum.* Charlottesville, VA: Univ. of Virginia, 1986.

Bazin, Germain. *The Loom of Art.* New York: Simon and Schuster, 1962.

Bean, Jacob. *15th and 16th Century Italian Drawings in the Metropolitan Museum of Art.* New York: The Metropolitan Museum of Art, 1982.

Benesch, Otto. *German Painting from Dürer to Holbein.* Geneva: Editions d'Art Albert Skira, 1966.

Bentley, James. *A Calendar of Saints: The Lives of the Principal Saints of the Christian Year.* New York: Facts on File, 1986.

Berenson, Bernard. *The Italian Painters of the Renaissance.* London: Phaidon Publishers, Inc., 1952.

————. *Lorenzo Lotto.* New York: Phaidon Publishers, 1956.

Berezina, Valentina N. *The Hermitage Catalogue of Western Painting: French Painting. Early and Mid-Nineteenth Century.* Florence: Giunti Martello Editore, 1983.

Bergot, Francois. *Le Musée des Beaux-Arts de Rouen.* Rouen: Musées et Monuments de France.

Bernardino Luini di Angela Ottino della Chiesa. Novara: Instituto Geografico de Agostini, 1956.

Besant, Sir Walter. *Medieval London.* London: Adam and Charles Black, 1906.

Birmingham Museum and Art Gallery. *Foreign Paintings.* 1960.

Blankert, Albert. *Ferdinand Bol, 1616–1680, Rembrandt's Pupil.* The Netherlands: Davaco Publishers, 1982.

Boase, T.S.R. *Giorgio Vasari: The Man and the Book.* Washington, DC: National Gallery of Art, 1979.

Boccazzi, Franca Zava. *Pittoni, L'Opera completa.* Venice: Alfieri Edizioni d'Arte, 1979.

Boone, Danièle. *L'Art baroque.* Neuchâtel, Switzerland: Ides et Calendes, 1988.

Bordeaux, Musée des Beaux-Arts. *Peinture italienne XV–XIX siècles.* Paris: Editions de la Réunion des Musées Nationaux, 1987.

Boschloo, A.W.A. *Annibale Carracci in Bologna: Visible Reality in Art After the Council of Trent,* Vol.II. The Hague: Government Publishing Office, 1974.

Bosque, Andrée de. *Mythologie et maniérisme.* Paris: Albin Michel, 1985.

————. *Quentin Metsys.* Bruxelles: Arcade, 1975.

Bosquet, Jacques. *Mannerism, the Painting and Style of the Late Renaissance.* New York: Braziller, 1964.

Boucher, Francois. *20,000 Years of Fashion.* New York: Harry N. Abrams.

Boudet, Jacques. *A History of Rome and the Romans.* New York: Crown Publishers.

Bowron, Edgar Peters. *North Carolina Museum of Art. Introduction to the Collections.* Chapel Hill: Univ. of North Carolina Press, 1983.

Bradfore, Ernle. *The Sword and the Scimitar.* New York: Putnam, 1974.

Briels, Jan. *Peintres flamands en Hollande au debut du siècle d'or.* Anvers: Fonds Mercator, 1987.

Briganti, Giuliano. *Italian Mannerism.* Rome; Editori Riuniti, 1962.

Brion, Marcel. *Masterpieces of the Louvre.* New York: Harry N. Abrams, Inc.

————. *The Medici, a Great Florentine Family.* New York: Crown, 1969.

British Library. *Renaissance Painting in Manuscripts.* New York: Hudson Hills Press, 1983.

Bromberg, Dr. Anne. *Dallas Museum of Art, Selected Works.* Dallas, TX: Dallas Museum of Art.

Brown, Jonathan. *Velázquez.* New Haven, CT: Yale Univ. Press, 1986.

Brusher, Joseph. *Popes Through the Ages.* Princeton, NJ: D. Van Nostrand, 1959.

Buchthal, Hugo. *Miniature Painting in the Latin Kingdom of Jerusalem.* Oxford at the Clarendon Press, 1957.

Burckhardt, Jacob. *The Altarpiece in Renaissance Italy.* Oxford: Phaidon Press Ltd., 1988.

Burlington Fine Arts Club. *Exhibition of Illuminated Manuscripts.* London: Burlington Fine Arts Club, 1908.

Burton, Anthony, and Susan Haskins. *The Victoria and Albert Museum (European Art)*. New York: The Viking Press, 1983.

Calvesi, Maurizio. *Treasures of the Vatican*. Geneva: Skira, 1962.

Canton, F. J. Sanchez. *Spanish Drawings*. Drawings of the Masters Series. Boston: Little, Brown, 1964.

Carnegie Institute Museum of Art. *Catalogue of Painting Collection*. Pittsburgh: Museum of Art, Carnegie Institute, 1973.

Castries, Duc de. *The Lives of the Kings and Queens of France*. New York: Alfred A. Knopf, 1979.

Caw, James L. *Scottish Painting, Past and Present, 1620–1908*. Edinburgh: T.C. and E.C. Jack.

Châtelet, Albert. *Early Dutch Painting*. New York: Rizzoli, 1981.

_____, and Jacques Thuillier. *French Painting*. Geneva: Editions d'Art Albert Skira, 1963.

Chiarini, Marco. *Grenoble, Musée de peinture et de sculpture: Tableaux italiens*. Musée de Grenoble, 1988.

Christiansen, Keith, Laurence Kanter, and Carl Brandon Strehlke. *Painting in Renaissance Siena, 1420–1500*. New York: Metropolitan Museum of Art; distributed by Harry N. Abrams, 1988.

Cincinnati Art Museum. *Handbook*. Cincinnati, OH: Cincinnati Art Museum, 1975.

_____. *Masterpieces from the Cincinnati Art Museum*. 1984.

City Art Gallery, Bristol. *Catalogue of Oil Paintings*. Bristol, 1957.

City of York Art Gallery. *Catalogue of Paintings, Foreign Schools 1350–1800*. York, England: City of York Art Gallery, 1961.

Clark, Anthony M. *Pompeo Batoni: A Complete Catalogue of His Works with an Introductory Text*. New York University Press, 1985.

Clark, Kenneth. *Piero della Francesca*. London: Phaidon Press Ltd., 1969.

Clay, Jean. *Romanticism*. Paris: Phaidon Press, 1980.

Cleveland Museum of Art. *European Paintings Before 1500*. Cleveland, OH: Cleveland Museum of Art, 1974.

_____. *European Paintings of the 16th, 17th, and 18th Centuries*. Cleveland, OH: Cleveland Museum of Art, 1982.

_____. *Selected Works*. Cleveland Museum of Art.

Cole, Bruce. *Agnolo Gaddi*. Oxford at the Clarendon Press, 1977.

Colombo, Alfredo, and Gaston Diehl. *Treasury of World Painting*. Tudor Publishing Co.

Columbia Museum of Art and Archaeology, Univ. of Missouri, Columbia. *Illustrated Museum Handbook*. Columbia, MO and London: Univ. of Missouri Press, 1982.

Cooper, Douglas. *Great Family Collections*. New York: MacMillan, 1965.

_____. *Great Private Collections*. London: Weidenfeld and Nicolson, 1963.

Coulson, John. *The Saints*. New York: Guild Press, 1958.

Courtauld Institute of Art. *Catalogue*. London: Courtauld Institute of Art, 1960.

Cousseau, Henry-Claude. *Le Musée des Beaux-Arts de Nantes*. Nantes: Musées et Monuments de France.

Cox-Rearick, Janet. *Dynasty and Destiny in Medici Art*. Princeton, NJ: Princeton Univ. Press, 1984.

Cracow. New York: Allanheld and Schram, 1977.

Craven, Thomas. *A Treasury of Art Masterpieces, from the Renaissance to the Present Day*. New York: Simon & Schuster, 1958.

Crocker Art Gallery. *Catalogue of Collections*. Sacramento, CA: E.B. Crocker Art Gallery, 1964.

Cummer Gallery of Art. *Handbook of the Permanent Collection*. Jacksonville, FL: Convention Press, Inc.

Cummings, Frederick. *Romantic Art in Britain*. Philadelphia: Philadelphia Museum of Art, 1968.

Cuzin, Jean-Pierre. *Raphael, His Life and His Works*. Secaucus, NJ: Chartwell Books, Inc., 1983.

Daniel, Howard. *Encyclopedia of Themes and Subjects in Painting.* New York: Harry N. Abrams, 1971.

Daniels, Jeffery. *Sebastiano Ricci.* Sussex, England: Wayland Publishers, 1976.

Dartmouth College. *Treasures of the Hood Museum of Art.* Hanover, NH: Trustees of Dartmouth College, 1985.

Davenport, Milla. *The Book of Costume.* New York: Crown, 1948.

Dawn of a New Era. Milestones of History Series. Newsweek Books, 1974.

Dayton Art Institute. *Fifty Treasures of the Dayton Art Institute.* Dayton, OH: Dayton Art Institute, 1969.

De Bles, Major Arthur. *How to Distinguish the Saints in Art.* New York: Art Culture Publications, Inc. 1925

De Campos, D. Redig. *Art Treasures of the Vatican.* Englewood Cliffs, NJ: Prentice-Hall, 1974.

De Hamel, Christopher. *A History of Illuminated Manuscripts.* Boston: David R. Godine, 1986.

Denver Art Museum. *Major Works in the Collection.* Denver, CO: Denver Art Museum, 1981.

Denvir, Bernard. *Art Treasures of Italy.* New York: Portland House, 1980.

Detroit Institute of Arts. *Treasures.* Detroit: Detroit Institute of Arts, 1966.

Deuchler, Florens. *Gothic Art.* New York: Universe, 1973.

————. Marcel Roethlisberger, and Hans Lüthy. *Swiss Painting, from the Middle Ages to the Dawn of the Twentieth Century.* Geneva: Editions d'Art Albert Skira, 1976.

DeWald, E.T. *Pietro Lorenzetti.* Cambridge: Harvard Univ. Press, 1930.

DiFederico, Frank R. *Francesco Trevisani: Eighteenth-Century Painter in Rome, A Catalogue Raisonné.* Washington, DC: Decatur House Press, 1977.

Disegni, Dipinti E. *Carlo Ceresa.* Bergamo: Monumenta Bergomensia, 1979.

Dogaer, Georges. *Flemish Miniature Painting in the 15th and 16th Centuries.* Amsterdam: B.M. Israël, B.V., 1987.

Drake, Maurice, and Wilfred Drake. *Saints and Their Emblems.* Philadelphia: Lippincott, 1916.

Dunkerton, Jill, Susan Foister, Dillian Gordan, and Nicholas Penny. *Giotto to Dürer: Early Renaissance Painting in the National Gallery.* New Haven and London: Yale Univ. Press, 1991.

Durey, Philippe. *Le Musée des Beaux-Arts de Lyon.* Lyon: Musées et Monuments de France, 1988.

Edgell, George Harold. *A History of Sienese Painting.* New York: Dial Press, 1932.

Edgerton, Samuel Y. *Pictures and Punishment: Art and Criminal Prosecution During the Florentine Renaissance.* Ithaca: Cornell Univ. Press, 1985.

Eight Centuries of European Painting: Art Collections in Belgian Museums. Brussels, Belgium: Arcade, 1975.

800 Yahre: St. Martini, Münster. Münster: Verlag Regensberg, 1980.

Eisenberg, Marvin. *Lorenzo Monaco.* Princeton, NJ: Princeton Univ. Press, 1989.

Eisler, Colin. *Paintings from the Samuel H. Kress Collection: European Schools Excluding Italian.* Oxford: Phaidon Press, 1977.

————. *Paintings in the Hermitage,* New York, Stewart, Tabori and Chang, 1990.

El Paso Museum of Art. *The Samuel H. Kress Collection.* El Paso, TX: El Paso Museum of Art, 1961.

Enciclopedia Bernardiniana. *Iconografia,* Vol. II. L'Aquila: Cento Promotore Generale, 1980.

Encyclopedia of World Art. New York: McGraw-Hill, Inc., 1972.

Erlande-Brandenburg, Alain. *Gothic Art.* New York: Harry N. Abrams, 1989.

Esztergom Christian Museum. *Christian Art in Hungary.* Budapest: Publishing House of the Hungarian Academy of Sciences, 1965.

Ettlinger, Leopold D., and Helen S. Ettlinger. *Raphael.* Oxford: Phaidon, 1987.

European Art in the Virginia Museum of Fine Arts, a Catalogue. Richmond: Virginia Museum of Fine Arts.

European Painting in the Fifteenth Century. London: Studio Books, 1961.

Evans, Joan. *The Flowering of the Middle Ages*. New York: McGraw-Hill, 1966.
Expanding Horizons. Milestones of History Series. Newsweek Books, 1974.
Eydoux, Henri-Paul. *St. Louis et son temps*. Paris: Librairie Larousse, 1971.
Faranda, Franco. *Ludovico Cardi Detto Il Cigoli*. Rome: De Luca Editore, 1986.
Ferguson, George Wells. *Signs and Symbols in Christian Art*. New York: Oxford Univ. Press, 1954.
Fiorio, Maria Teresa. *Le Chiese di Milano*. Milano: Electa, 1985.
Fischer, Chris. *Fra Bartolommeo: Master Draughtsman of the High Renaissance*. Rotterdam: Museum Boymans-Van Beuningen, 1990.
Fitzwilliam Museum, Cambridge. *Catalogue of Paintings: Dutch and Flemish*. Cambridge, 1960.
_____. *Catalogue of Paintings: Italian Schools*. Cambridge, 1960.
_____. *Catalogue of Paintings: British School*. Cambridge, 1960.
Fogg Art Museum, Harvard Univ. *Collection of Mediaeval and Renaissance Paintings*. Cambridge: Harvard Univ. Press, 1919.
Fouquet, Jean. *The Hours of Etienne Chevalier*. New York: George Braziller, 1971.
Fowler, Kenneth. *The Age of Plantagenet and Valois*. New York: Putnam, 1967.
Frabetti, Giuliano. *Manieristi a Ferrara*. Italy: Silvana Editoriale d'Arte.
Francia, Mons. Ennio. *Pinacotaeca Vaticana*. Milano: Aldo Martello Editore, 1960.
Fraser, Antonia. *The Lives of the Kings and Queens of England*. New York: Alfred A. Knopf, 1975.
Fredericksen, Burton B. *Catalogue of the Paintings in the J. Paul Getty Museum,* 1972.
Freedberg, S.J. *Circa 1600: A Revolution of Style in Italian Painting*. Cambridge: Harvard Univ. Press, 1983.
Friedländer, Max J., and Jakob Rosenberg. *The Paintings of Lucas Cranach*. New York: Tabard Press, 1978.
Friedrich, Carl. *The Age of Baroque, 1601–1660*. New York: Harper and Row, 1952.
Gaehtgens, Thomas W. *Versailles, de la résidence royal au musée historique*. Albin Michel, 1984.
Gállego, Julián, and José Gudiol. *Zurbaran, 1598–1664*. London: Secker and Warburg, 1977.
Garas, Klara. *Le Musée Des Beaux-Arts de Budapest*. Paris: Editions Somogy, 1973.
Gardner's Art Through the Ages. Harcourt Brace Jovanovich, 1976.
Garlick, Kenneth, ed. *British and North American Art to 1900*. New York: Grolier, 1965.
Garner, Grancois. *Le Langage de l'image au moyen age II (grammaire des gestes)*. Editions Le Léopord D'Or, 1988.
Gaunt, William. *Everyman's Dictionary of Pictorial Art*. London: J.M. Dent & Sons, Ltd., 1962.
Geisberg, Max. *The German Single-Leaf Woodcut: 1500–1550* 4 vols. New York: Hacker Art Books Inc., 1974.
The Gemäldegalerie, Berlin: A History of the Collection and Selected Masterworks. London: Weidenfeld and Nicolson, 1986.
Georgel, Pierre. *Le Musée des Beaux-Arts de Dijon*. Musée des Beaux-Arts de Dijon, 1985.
Georgetown University. *Catalogue of the Art Collection*. Washington, DC: Georgetown Univ., 1963.
Georgyevsky, G. *Old Russian Miniatures*. Moscow: Academia, 1934.
Gibbons, Felton. *Dosso and Battista Dossi: Court Painters at Ferrara*. Princeton Univ. Press, 1968.
Gillingham, John. *The Life and Times of Richard I*. London: Weidenfeld and Nicolson, 1973.
Gnudi, Cesare. *Vitale da Bologna*. Cassa di Risparmio in Bologna, 1962.
Goddard, Donald. *American Painting*. New York: Hugh Lauter Levin Associates, Inc. 1990.
Godfrey, Frederick M. *Christ and the Apostles: The Changing Forms of Religious Imagery*. London and New York: Studio Publications, 1957.
Goffen, Rona. *Giovanni Bellini*. New Haven, CT: Yale Univ. Press, 1989.
Gowing, Lawrence. *A Biographical Dictionary of Artists*. London: MacMillan, 1983.

————. *Paintings in the Louvre.* New York: Stewart, Tabori and Chang, 1987.
Great Book of Hours of Henry the Eighth, Illustrated by Jean Bourdichon of Tours. Privately printed, 1923.
Grote, Ludwig. *Dürer.* Geneva: Editions d'Art, Albret Skira, 1965.
Grousset, Réné. *The Epic of the Crusades.* New York: Orion, 1970.
Gudiol, José. *The Complete Paintings of El Greco, 1541-1614.* New York: Greenwich House, 1983.
————. *Velázquez, 1599-1660.* London: Secker & Warburg, 974.
Guide to the Prado. Consuelo Luca de Tena and Manuela Mena. Spain: Silex, 1987.
Guido Reni, 1575-1642. Bologna: Pinacoteca Nazionale di Bologna, 1988.
Guratzsch, Herwig. *Dutch and Flemish Painting.* New York: Vilo, 1981.
Gustave Moreau et le symbolisme. Kamakura: Musée d'Art Moderne, 1985.
Guth, Paul. *Histoire de la douce France.* Libairie Plon, 1968.
Hadley, Rollin van N. *Museums Discovered; the Isabella Stewart Gardner Museum.* Ft. Lauderdale, FL: Woodbine Books, 1981.
Hairs, Marie-Louise. *Dans le sillage de Rubens: Les Peintres d'histoire anversois au XVII siecle.* Université de Liège, 1977.
Hall, Marcia B. *Color and Meaning: Practice and Theory in Renaissance Painting,* Cambridge: Cambridge Univ. Press, 1992.
Hallam, Elizabeth. *Four Gothic Kings.* New York: Wiedenfeld and Nicolson, 1987.
————. *The Plantagenet Chronicles.* New York: Wiedenfeld and Nicolson, 1986.
Hammacher, A.M., ed. *Flemish and Dutch Art.* New York: Grolier, 1965.
A Handbook of the Museum of Art. Providence, RI: School of Design, 1985.
Hans Holbein le jeune. Paris: Librairie Hachette and Cie., 1912.
Haraszti-Takáca, Marianne. *The Masters of Mannerism.* Budapest: Corvina Press, 1968.
Harrsen, Meta. *Central European Manuscripts in the Pierpont Morgan Library.* New York: Pierpont Morgan Library, 1958.
Hartt, Frederick. *History of Italian Renaissance Art.* Englewood Cliffs, NJ: Prentice Hall, 1969.
Hay, Denys. *The Age of the Renaissance.* New York: McGraw-Hill, 1967.
Hayes, John. *National Portrait Galleries.* London: Studio Vista, 1979.
Held, Julius. *The Oil Sketches of Peter Paul Rubens, Vol. I & II.* Princeton Univ. Press: Published for the National Gallery of Art, 1980.
————, and Donald Posner. *17th and 18th Century Art: Baroque Painting, Sculpture, Architecture.* Englewood Cliffs, NJ: Prentice-Hall, 1972.
————, Rene Taylor, and James N. Carder. *Museo de Arte de Ponce, Catalogue.* Ponce, Puerto Rico: Museo de Arte de Ponce, 1984.
Helen Foresman Spencer Museum of Art. Handbook of the Collection. Lawrence, Univ. of Kansas, 1978.
Hendy, Philip. *The National Gallery, London.* London: Thames & Hudson, 1955.
Herald, Jacqueline. *Renaissance Dress in Italy, 1400-1500.* London: Bell and Hyman, 1981.
Hermitage (Musée de l'Ermitage). *Peinture francaise des XV-XVII siècles.* Leningrad: Editions d'Art Aurore, 1973.
Hermitage. *Western European Painting in the Hermitage.* New York: Harry N. Abrams, 1978.
The Hermitage Picture Gallery. Western European Painting. Leningrad: Aurora Art Publishers, 1979.
Hibbard, Howard. *The Metropolitan Museum of Art.* New York: Harper and Row, 1980.
Hibbert, Christopher. *London, the Biography of a City.* London: Longmans, Green, 1969
————. *Rome, the Biography of a City.* New York: Norton, 1985.
Hills, Paul. *The Light of Early Italian Painting.* New Haven and London: Yale Univ. Press, 1987.
Hind, Arthur M. *An Introduction to a History of Woodcut.* London: Constable, 1935.
Hoetink, H.R. *The Royal Picture Gallery, Mauritshuis.* New York: Harry N. Abrams, 1985.
Hogarth, Peter, and Val Clery. *Dragons.* New York and Middlesex: Penguin Books, 1979.

Hollander, Hans. *Early Medieval Art.* New York: Universe, 1974.
Horejsi, Jorina. *Renaissance Art in Bohemia.* London: Hamlyn, 1979.
Horizon Magazine. *The Horizon Book of the Middle Ages.* New York: American
 Heritage/Bonanza, 1968.
_____. *The Horizon Book of the Renaissance.* New York: American Heritage
 Publishing Co., Inc., 1961.
Houston Museum of Fine Arts. *A Guide to the Collection.* Houston: The Museum of
 Fine Arts, 1981.
_____. *A Permanent Legacy: 150 Works from the Collection of the Museum of Fine
 Arts. Houston.* New York: Hudson Hills Press, 1989.
Hubbard, R.H. *European Paintings in Canadian Collections—Earlier Schools.* Toronto,
 Oxford Univ. Press, 1956.
d'Hulst, R.A. *Jacob Jordaens.* London: Southeby Publications, 1982.
Huse, Norbert, and Wolfgang Wolters. *The Art of Renaissance Venice.* Chicago and
 London: Univ. of Chicago Press, 1990.
Huvenne, Paul. *Pierre Pourbus, peintre brugeois, 1524–1584.* Bruges: Crédit Communal,
 1984.
Huy. *Tresors d'art religieux.* Credit Comunal de Belgique, 1984.
The Icon. New York: Alfred A. Knopf, 1982.
The Illustrated Bartsch: Early Italian Masters Century. New York: Abaris Books, 1990.
The Illustrated Bartsch: Italian Masters of the Seventeenth Century. New York: Abaris
 Books, 1990.
International Dictionary of Art and Artists: Art. Chicago and London: St. James Press,
 1990.
Isabella Stewart Gardner Museum. *Catalogue of Exhibited Paintings and Drawings,*
 Boston, 1931.
The J. Paul Getty Museum. *Greek and Roman Antiquities, Western European Paintings,
 French Decorative Arts of the Eighteenth Century.* Malibu, CA: The J. Paul Getty
 Museum Publications, 1975.
Jacobs, Jay. *Color Encyclopedia of World Art.* New York: Crown Publishers, 1975.
Jaffé, Michael. *Rubens and Italy.* Oxford: Phaidon Press Ltd., 1977.
Janson, Anthony F., with A. Ian Fraser. *100 Masterpieces of Painting.* Indianapolis
 Museum of Art, 1980.
Janson, H.W. *History of Art.* New York: Harry N. Abrams, 1982.
_____. _____. 4th ed. New York: Harry N. Abrams, 1991.
_____, and Dora Jane Janson. *The Picture History of Painting.* New York: Harry N.
 Abrams, 1957.
John, Eric. *The Popes.* New York: Hawthorn, 1964.
Joslyn Art Museum. *Paintings & Sculpture from the European and American Collec-
 tions.* Nebraska: Joslyn Art Museum, 1987.
Jullian, Marcel, and Jacques Levron. *Histoire de la France et des français au jour le jour.
 Tome II, 1180–1408.* Libraire Academique Perrin et Libraire Larousse, 1979.
Kaftal, George. *Iconography of the Saints in Central and South Italian Schools of Paint-
 ing.* Florence: G. C. Sansoni, 1965.
_____. *Iconography of the Saints in the Painting of North East Italy.* Florence:
 G.C. Sansoni, 1978.
_____. *Iconography of the Saints in Tuscan Painting.* Florence: G. C. Sansoni, 1952.
_____. *West Italy.* Florence: Casa Editrice le Lettere, 1985.
Kaufmann, Thomas Da Costa. *The School of Prague; Painting at the Court of Rudolf
 II.* Chicago: Univ. of Chicago Press, 1988.
Keen, Maurice. *A History of Medieval Europe.* New York: Frederick A. Praeger, 1967.
Keller, Dr. Hiltgart, and Dr. Bodo Cichy. *20 Centuries of Great European Painting.* New
 York and London: Sterling Publishing Co., Inc., 1957.
Kent, Rockwell. *World Famous Paintings.* New York: Wise & Co., 1939.
Kermode, Frank, and John Hollander. *The Oxford Anthology of English Literature.*
 New York: Oxford Univ. Press, 1973.
Kettlewell, James K. *The Hyde Collection Catalogue.* Glen Falls, New York: The Hyde
 Collection, 1981.

Kidson, Peter. *The Medieval World.* New York: McGraw Hill, 1967.
Kimbell Art Museum. *Handbook of the Collection.* Fort Worth: Kimbell Art Foundation, 1981.
————. *In Pursuit of Quality, the Kimbell Art Museum, Ft. Worth.* New York: Harry N. Abrams, 1987.
Klessmann, Rudiger. *The Berlin Gallery.* London: Thames and Hudson, 1971.
Kominis, Athanasios D. *Patmos, Treasures of the Monastery.* Athens: Edkotike Athenon, 1988.
Konody, Paul G., and Maurice W. Brockwell. *The Louvre: Fifty Plates in Color.* London: T.C. and E.C. Jack, 1910.
Krasa, Josef. *The Travels of Sir John Mandeville.* New York: George Braziller, 1983.
Kunstmuseum, Basel. *150 Paintings, 12th–20th Century.* Basel: Bâloise-Holding, 1964.
Kutal, Albert. *Gothic Art in Bohemia and Moravia.* London: Hamlyn, 1971.
Laclotte, Michel. *L'Ecole d'Avignon.* Paris, Flammarion, 1960.
————, ed. *French Art from 1350 to 1850.* New York: Grolier, 1965.
————, and Dominique Thiébaut. *L'Ecole d'Avignon.* France: Flammarion, 1983.
Larousse Dictionary of Painters. London: The Hamlyn Publishing Group Ltd., 1989.
Larousse Encyclopedia of Ancient and Medieval History. Ed. by Marcel Dunan, New York: Excalibur Books, 1964.
Larousse Encyclopedia of Renaissance and Baroque Art. Ed. by Rene Huyghe. New York: Prometheus Press, 1964.
Larsen, Erik. *The Paintings of Anthony Van Dyck.* Germany: Luca Verlag Freren, 1988.
————. *Seventeenth Century Flemish Painting.* Luca Verlag Freren, 1985.
LaSarte, Joan Ainaud de. *Catalan Painting.* New York: Rizzoli Int'l Publications, Inc. 1990.
Lassaigne, Jacques. *The Fifteenth Century from Van Eyck to Botticelli.* New York: Skira, 1955.
————. *Spanish Painting from the Catalan Frescoes to El Greco.* Geneva: Albert Skira, 1952.
Latouche, Robert. *Caesar to Charlemagne, the Beginnings of France.* New York: Barnes and Noble, 1968.
Lauck, Rev. Anthony J., and Dean A. Porter. *Art Gallery, University of Notre Dame.* Notre Dame, IN: Univ. of Notre Dame Press, 1967.
Lavin, Marilyn Aronberg. *The Place of Narrative: Mural Decoration in Italian Churches, 431–1600.* Chicago: Univ. of Chicago Press, 1990.
Lecat, Jean-Philippe. *Le siècle de la toison d'or.* Paris: Flammarion, 1989.
Lejard, André. *French Tapestry.* Paris: Editions du Chene, 1947.
Lemoine, Serge. *Le Musée de Grenoble.* Paris: Musées et Monuments de France, 1988.
Lenz, Christian. *The Neue Pinakothek Munich.* London: Scala, 1989.
Levey, Michael. *A Concise History of Painting from Giotto to Cézanne.* New York: Oxford Univ. Press, 1962.
————. *Giambattista Tiepolo, His Life and Art.* New Haven: Yale Univ. Press, 1986.
————. *The National Gallery Collection.* London: National Gallery Publications, 1987.
Lewis, Suzanne. *The Art of Matthew Paris in the Chronica Majora.* Berkeley: Univ. of California Press, 1987.
Life's Picture History of Western Man. New York: Time Inc., 1951.
Lightbown, Ronald. *Mantegna.* Oxford: Phaidon/Christie's, 1986.
————. *Sandro Botticelli, Life and Work.* New York: Abbeville Press Publishers, 1989.
Lloyd, Christopher. *1773 Milestones of Art.* New York: Harrison House, 1979.
Lopez, Robert S. *The Birth of Europe.* New York: M. Evans, 1962.
Los Angeles County Museum of Art. *A Decade of Collecting, 1965–1975.* Malibu, CA: The J. Paul Getty Museum Publications, 1975.
————. *Handbook.* Los Angeles: Los Angeles County Musuem of Art, 1977.
Los Angeles Times Book of California Museums. New York: Harry N. Abrams, Inc., 1984.

Louvre. *Great Drawings of the Louvre*. 3 vols. New York: George Braziller, 1968.

Lowenthal, Anne W. *Joachim Wtewawl and Dutch Mannerism*. The Netherlands: Davaco Publishers, 1986.

M. H. de Young Memorial Museum. *European Works of Art*. Berkeley, CA: Diablo Press, 1966.

Maas, Jeremy. *Victorian Painters*. New York: G.P. Putnam's Sons, 1969.

McKendrick, Melveena. *Ferdinand and Isabella*. New York: Horizon Magazine/American Heritage, 1968.

McKillip, Susan Regan. *Franciabigio*. Los Angeles: Univ. of California Press, 1974.

Maclean, Fitzroy. *A Concise History of Scotland*. New York: Beekman House, 1970.

Maison, K.E. *Art Themes and Variations*. New York: Harry N. Abrams, Inc..

Majoana, Marina. *Valentin de Boulogne*. Milan: Eikonos Edizioni, 1989.

Malitskaya, K.M. *Great Paintings from the Pushkin Museum, Moscow*. New York: Harry N. Abrams.

Manafis, Konstantinos A. *Sinai: Treasures of the Monastery of Saint Catherine*. Athens: Edkotike Athenon, 1990.

Marck, Jan van der. *In Quest of Excellence*. Miami: The Center for the Fine Arts Association, 1984.

Marlier, Georges. *La Renaissance flamande: Pierre Coeck d'Alost*. Bruxelles: Editions Robert Rinck, 1966.

Masterworks of the Gemäldegalerie, Berlin. New York: Harry N. Abrams, 1985.

Mather, Eleanore Price, and Dorothy Canning Miller. *Edward Hicks, His Peaceable Kingdoms and Other Paintings*. East Brunswick, NJ: Associated Univ. Presses, Inc. 1983.

Matthiesen Fine Art Ltd. *Around 1610: The Onset of the Baroque*. London: Mathiesen Gallery, 1985.

Matthieu, Pierre-Louis. *Le Musée Gustave Moreau*. Paris: Editions de la Réunion des Musées Nationaux, 1986.

Mauritshuis, Illustrated General Catalogue. The Hague: Government Publishing Office, 1977.

Mauritshuis, The Hague. *Royal Picture Gallery*. New York: Harry N. Abrams, 1985.

Maurois, André. *Histoire de la France*. Hachette, 1957.

Maxon, John. *The Art Institute of Chicago*. New York: Harry N. Abrams, Inc. 1970.

Meiss, Millard. *Francesco Traini*. Washington, DC: Decatur House Press, 1983.

_____. *French Painting in the Time of Jean De Berry: The Boucicaut Master*. London: Phaidon Press, 1968.

_____. *Painting in Florence and Siena*. Princeton, NJ: Princeton Univ. Press, 1951.

Memorial Art Gallery of the University of Rochester. *Handbook*. Rochester, NY: The Case-Hoyt Corporation, 1961.

Mérot, Alain. *Eustache Le Sueur, 1616-1655*. Paris: Arthena, 1987.

Merriman, Mira Pajes. *Giuseppe Maria Crespi*. Milan: Rizzoli, 1980.

Metropolitan Museum of Art. *The Age of Caravaggio*. New York: Electa/Rizzoli, 1985.

_____. *Gothic and Renaissance Art in Nuremberg, 1300-1550*. Munich: Prestel-Verlag, 1986.

_____. *The Secular Spirit, Life and Art at the End of the Middle Ages*. New York: Dutton, 1975.

Micheletti, Emma. *Masterpieces of Pitti Palace*. Firenze: Bonechi Editore, 1973.

Miegroet, Hans J. Van. *Gerard David*. Antwerp: Mercatorfonds, 1989.

Minneapolis Institute of Arts. *European Paintings*. New York and London: Praeger Publishers, 1971.

Minney, R.J. *The Tower of London*. Englewood Cliffs, NJ: Prentice Hall, 1970.

Moir, Alfred. *Caravaggio*. New York: Harry N.Abrams, Inc. 1989.

Monteverdi, Mario, ed. *Italian Art to 1850*. New York: Grolier, 1965.

Morassi, Antonio. *A Complete Catalogue of the Paintings of G.B. Tiepolo*. London: Phaidon Publishers, Inc., 1962.

_____. *G.B. Tiepolo, His Life and Work*. London: Phaidon Press, 1955.

_____. *Titian*. Greenwich, CT: N.Y. Graphic Society, 1964.

Moreau, Gustave. *Gustave Moreau, Aquarelles*. New York: Hudson Hills Press, 1985.

Mortimer, Kristin A. *Harvard University Art Museums, a Guide to the Collections.* New York: Abbeville Press, 1986.

Munhall, Edgar. *Masterpieces of the Frick Collection.* New York: Viking Press, 1970.

Munro, Eleanor C. *The Golden Encyclopedia of Art.* New York: Golden Press, 1961.

Muraro, Michelangelo. *Paolo da Venezia.* University Park: Pennsylvania State Univ. Press, 1970.

————. *Treasures of Venice.* Albert Skira/Horizon Magazine. 1963.

Murray, Peter. *Dulwich Picture Gallery: A Catalogue.* London: Sotheby Parke Bernet, 1980.

————, and Linda Murray. *Dictionary of Art and Artists.* New York: Frederick A. Prager, 1965.

Musées Royaux des Beaux-Arts de Belgique. *Catalogue de la peinture ancienne.* 1953.

Museo Diocesani. *Tresori d'arte dei Musei Diocesani.* Rome: Umberto Allemandi, 1987.

Museum of Fine Arts, Boston. *Illustrated Handbook.* Boston, MA: Museum of Fine Arts, 1975.

Museum of Fine Arts, Houston. *A Permanent Legacy.* New York: Hudson Hills Press, 1989.

Myers, Bernard S., ed. *Dictionary of Art.* McGraw-Hill, 1969.

Nanteuil, Luc de. *Jacques-Louis David.* New York: Harry N. Abrams, 1985.

National Gallery of Ireland. *Illustrated Summary Catalogue of Paintings and Drawings.* Gill and MacMillan, 1981.

National Gallery of Scotland. *Illustrations.* Edinburgh, T. and A. Constable Ltd., 1980.

National Gallery, Prague. *Baroque in Bohemia: An Exhibition of Czech Art.* England: Arts Council, 1969.

Nelson-Atkins Museum of Art. *The Collections of the Nelson-Atkins Museum of Art.* New York: Harry N. Abrams, 1988.

Nelson Gallery of Art, Atkins Museum. *Handbook of the Collections in the William Rockhill Nelson Gallery of Art and Mary Atkins Museum of Fine Arts.* Vol. I. Kansas City, MO: W.R. Nelson Trust, 1973.

Neumann, Jaromír. *The Picture Gallery of Prague Castle.* Praha: Publishing House of the Czechoslovak Academy of Sciences, 1967.

New International Illustrated Encyclopedia of Art. New York: Greystone Press, 1968.

New Orleans Museum of Art. *Handbook of the Collection.* New Orleans Museum of Art, 1980.

Newsweek. Great Museums of the World Series. *Art History Museum, Vienna.* New York: Newsweek, 1969.

————. ————. *Brera, Milan.* New York, 1981.

————. ————. *El Escorial.* Ed. by Mary Cable. New York, 1971.

————. ————. *Hagia Sophia.* Ed. by Lord Kinross. New York, 1972.

————. ————. *Louvre, Paris.* New York, 1967.

————. ————. *The National Gallery Washington, D.C.* New York, 1968.

————. ————. *Pinakothek, Munich.* New York, 1969.

————. ————. *Uffizi, Florence.* ed. dir. Carlo Ludovice Ragghiant, New York, 1968.

Nicolson, Benedict. *The International Caravaggesque Movement.* Oxford: Phaidon, 1979.

Nikulin, Nikolai. *Netherlandish Paintings in Soviet Museums.* Leningrad: Aurora Art Publishers, 1987.

North Carolina Museum of Art. *Introduction to the Collection.* Chapel Hill: Univ. of North Carolina Press, 1983.

Novotny, Fritz. *Pelican History of Art, Painting and Sculpture in Europe, 1780–1880.* Penguin Books, 1960.

Novotny, Vladimir. *Treasures of the Prague National Gallery.* London: Batchworth Press.

Oakeshott, Walter. *The Mosaics of Rome.* London: Thames and Hudson, 1967.

Oberhuber, Konrad. *Poussin, the Early Years in Rome.* New York: Hudson Hills Press, 1989.

Offner, Richard. *Corpus of Florentine Painting: The Fourteenth Century.* Sect. III, Vol. V. New York: Institute of Fine Arts, 1947.
————. ————. Sect. III, Vol. VIII. New York: Institute of Fine Arts, 1958.
————. ————. Sect. IV, Vol. II. New York: Institute of Fine Arts, 1960.
Offner, Richard, and Klara Steinweg. *Corpus of Florentine Painting: The Fourteenth Century.* Sect. IV, Vol. I. New York: Institute of Fine Arts, 1962.
————. ————. Sect. IV, Vol. IV, Part I. New York: Institute of Fine Arts, 1967.
————. ————. Sect. IV, Vol. III. New York: Institute of Fine Arts, 1965.
Old Master Paintings in Soviet Museums. Leningrad: Aurora Art Publishers, 1989.
O'Meara, John J. *The Voyage of Saint Brendan; Journey to the Promised Land.* North America: The Dolmen Press, 1978.
O'Neill, Mary. *Les Peintures de l'ecole francaise des XVII et XVIII siècles.* Musée des Beaux-Arts d'Orléans, 1980.
Oprescu, G. *Great Masters of Painting in the Museums of Rumania.* Buchares: Eridians.
Oxford Illustrated History of Medieval Europe. George Holmes, ed. New York: Oxford Univ. Press, 1988.
Padovani, Serena. *Andrea Del Sarto.* Becocci, Scala, Firenze, 1986.
Pallucchini, Rodolfo, and Francesco Rossi. *Giovanni Cariani.* Bergamo: Credito Bergamasco, 1983.
Panofsky, Erwin. *Early Netherlandish Painting: Its Origins and Character.* Havard Univ. Press, 1964.
————. *The Life and Art of Albrecht Dürer.* New Jersey: Princeton Univ. Press, 1943.
Parrot, J. Edward. *The Pageant of British History.* London: Thomas Nelson, 1911.
Paskaleva, Kostadinka. *Bulgarian Icons Through the Centuries.* Sofia: Svyat Publishers, 1987.
Pauwels, Henri. *Musée Groeninge.* Bruges: Musée Communal des Beaux-Arts, 1963.
La Peinture d'inspiration religieuse à Rouen au temps de Pierre Corneille, 1606–1684. Rouen Eglise Saint-Ouen, 1984.
La Peinture flamande au Prado. Anvers: Fonds Mercator, 1989.
Peintures murales des Hautes-Alpes, XV–XVI siècles. Société d'études des Hautes-Alpes, Culture et Patrimoine en Provence-Alpes-Côte-d'Azur.
Pepper, D. Stephen. *Bob Jones University Collection of Religious Art, Italian Paintings.* Greenville, SC: Bob Jones Univ., 1984.
Perls, Klaus. *Jean Fouquet.* Paris: Editions Hyperion, 1940.
Pernoud, Regine. *Blanche of Castille.* New York: Coward, McCann and Geoghegan, 1975.
————. *Histoire du peuple français, origins–Middle Ages.* Paris: Nouvelle Librairie de France, 1951.
Pétry, Claude. *Le Musée des Beaux-Arts de Nancy.* Paris: Musées et Monuments de France.
Phoenix Art Museum. *Paintings, Drawings and Sculpture in the Phoenix Art Museum Collection.* 1965.
Picture Gallery, Berlin. *Catalogue of Paintings.* Gemaldegalerie, Berlin-Dahlem, 1975.
Picture Gallery, Dresden. *Old Masters.* Dresden: Staatlichekunstsammlungen, 1976.
Pierleoni, Paolo. *Denti e Santi: Il Moto di Apollonia.* Asclepio editrice.
Pierpont Morgan Library. *Mediaeval and Renaissance Manuscripts.* New York: Pierpont Morgan Library, 1974.
Piotrovsky, Boris. *The Hermitage, Its History and Collections.* Johnson Reprint Corporation, Harcourt Brace Jovanovich, Publishers, 1982.
Piper, David. *The Genius of British Painting.* London: Weidenfeld and Nicolson, 1975.
————. *The Illustrated Dictionary of Art and Artists.* New York: Random House, 1984.
————. *The Treasures of Oxford.* New York: Paddington Press, 1977.
Pirenne, Henry. *Histoire de Belgique.* La Renaissance du Livre, 1973.
Pischel, Gina. *A World History of Art.* New York: Simon & Schuster, 1968.
Plon, Eugene. *Leone Leoni et Pompeo Leoni.* Paris: Librairie Plon, 1887.
Ponce Art Museum. *Museo de Arte de Ponce: Fundación Luis A. Ferré, Catalogue.* Ponce, Puerto Rico: Museo de Arte de Ponce, 1984.

Pope-Hennessy, John. *Fra Angelico*. Ithaca, NY: Cornell Univ. Press, 1974.
————. *Sienese Quattrocento Painting*. Oxford and London: Phaidon Press Ltd., 1947.
Porcher, Jean. *Medieval French Miniatures*. New York: Harry M. Abrams, Inc.
Poynter, Sir Edward J. *The National Gallery*. London: Cassel and Co., 1899.
Praeger, Frederick A. *Paintings of the World's Great Galleries*. New York: Frederick A. Praeger, 1960.
————. *The Praeger Picture Encyclopedia of Art*. New York: Frederick A. Praeger, 1958.
Puppi, Lionello. *Torment in Art: Pain, Violence and Martyrdom*. New York: Rizzoli, 1990.
Pushkin Museum of Fine Art. *La Peinture francaise au Musée Pouchkine*. Leningrad: Editions d'Art Aurore, 1980.
Quarré, Pierre. *La Sculpture en Bourgogne à la fin du Moyen Âge*. Fribourg: Office du Livre SA, 1978.
Randall, Lilian M. *Medieval and Renaissance Manuscripts in the Walters Art Gallery: France, 875-1420*. Baltimore: Johns Hopkins Univ. Press, 1989.
Random House Library of Painting and Sculpture. Vol. 1, *Understanding Art: Themes, Techniques and Methods*. New York: Random House, 1981.
————. Vol. 2, *The History of Art, from the Beginnings to the Late 18th Cent.* New York: Random House, 1981.
Read, Sir Herbert. *Great Art and Artists of the World: Origins of Western Art*. New York: Franklin Watts, Inc., 1965.
Rearick, W.R. *The Art of Paolo Veronese, 1528-1588*. National Gallery of Art, 1988.
Redslob, Edwin, *The Berlin-Dahlem Gallery*. New York: Macmillan, 1967.
The Renaissance, Maker of Modern Man. National Geographic Society, 1970.
Rhode Island School of Design. *Handbook of the Museum of Art*. Providence: The Museum, 1985.
Ricci, Corrado. *North Italian Painting of the Cinquecento*. New York: Hacker Art Books, 1976.
Rickert, Margaret Josephine. *Painting in Britain: The Middle Ages*. London: Penguin Books, 1954.
Rijksmuseum. *Catalogue of All the Paintings of the Rijksmuseum in Amsterdam*. An illustrated catalogue, 1976.
Roberts, Jane. *Master Drawings in the Royal Collection*. London: Collins Harvill, 1986.
Rocher, Yves. *L'Art du XVII siècle dans les Carmels de France*. Paris: Musée du Petit Palais, 1983.
(Rochester) Memorial Art Gallery. *An Introduction to the Collection*. New York: Univ. of Rochester, 1988.
The Rohan Master: A Book of Hours. New York: George Braziller, 1973.
Rooses, Max. *L'Oeuvre de P.P. Rubens*. Anvers: Joseph Maes, 1886.
Rosenblum, Robert. *Jean-Auguste-Dominique Ingres*. Paris: Editions Cercle D'Art, 1968.
————, and H.W. Janson, *19th Century Art*. New York: Harry N. Abrams, 1984.
Rossi. *Art Treasures of the Uffizi and Pitti*. New York: Harry N. Abrams.
Rothe, Edith. *Medieval Book Illumination in Europe, the Collections of the German Democratic Republic*. New York: W.W. Norton and Co., 1966.
Rowlands, John. *Rubens, Drawings and Sketches, Catalogue of an Exhibition at the Department of Prints and Drawings in the British Museum, 1977*. London: British Museum Publications Ltd., 1977.
Rowling, Nick. *Art Source Book: A Subject-by-Subject Guide to Paintings and Drawings. A Compilation of Works from the Bridgeman Art Library*. New Jersey: Chartwell Books, 1987.
Royal Academy of Arts. *Exhibition of British Primitive Paintings, Twelfth to Early Sixteenth Century, Oct. and Nov. 1923*. Oxford Univ. Press, 1931.
————. *Exhibition of Italian Art Held in the Galleries of the Royal Academy, London, Jan.-Mar., 1930*. Oxford University Press, 1931.

_____. *Painting in Naples 1606-1705, from Caravaggio to Giordano*. Ed. by Clovis Whitfield and Jane Martineau. London: Weidenfeld and Nicolson, 1982.

Royal Museum of Fine Arts, Copenhagen. *Catalogue of Foreign Paintings*. Copenhagen, 1951.

Ruhmer, Eberhard. *Tura: Paintings and Drawings*. London: Phaidon Press, 1958.

Sachs, Samuel, II. *The Minneapolis Institute of Arts*. New York: Abbeville Press, 1981.

Salmi, Mario. *Italian Miniatures*. New York: Harry N. Abrams, Inc., 1954.

The Samuel H. Kress Collection. Birmingham Museum of Art, Birmingham, Alabama, 1959.

San Diego Fine Arts Gallery. *Master Works from the Collection of the Fine Arts Gallery of San Diego*. San Diego, CA: Arts and Crafts Printers, 1968.

Schade, Werner. *Cranach: A Family of Master Painters*. New York,: G.P. Putnam's Sons, 1980.

Schnapper, Antoine. *Jean Jouvenet, 1644-1717 et la peinture d'histoire à Paris*. Paris: Léonce Laget Libraire Éditeur, 1974.

Schönberger, Arno. *The Age of Rococo*. London: Thames and Hudson, 1963.

Schwartz, Gary. *Rembrandt, His Life, His Paintings*. Viking, 1985.

Sedini, Domenico. *Marco D'Oggiono*. Milan: Jandi Sapi Editori, 1989.

Shapley, Fern Rusk. *Paintings from the Samuel H. Kress Coll.: Italian Schools, 13th-15th Centuries* London, Phaidon Press, 1966.

_____. *Paintings from the Samuel H. Cress Collection: Italian Schools, 15th-16th Century*. London: Phaidon Press, 1968.

Shaw, J. Byam. *Paintings by Old Masters at Christ Church Oxford*. London: Phaidon Press, 1967.

Smalley, Beryl. *Historians in the Middle Ages*. London: Thames and Hudson, 1974.

Smart, Alastair. *The Assisi Problem and the Art of Giotto*. Oxford at the Clarendon Press, 1971.

Smith, Bradley. *Spain, a History in Art*. New York: Simon and Schuster, 1966.

Snite Art Museum. *A Guide to the Snite Museum of Art*. Notre Dame, Indiana, Univ. of Notre Dame.

Snyder, James. *Medieval Art: Painting, Sculpture, Architecture, 4th-14th Cent*. New York: Harry N. Abrams, 1989.

_____. *Northern Renaissance Art*. New York: Harry N. Abrams, 1985.

Souchal, François. *Art of the Early Middle Ages*. New York: Harry N. Abrams, 1968.

Spear, Richard E. *Caravaggio and His Followers* New York: Harper and Row, 1971.

_____. *Domenichino*. New Haven: Yale Univ. Press, 1982.

Stagni, Simonetta. *Domenico Maria Canuti*. Rimini: Luise Editore, 1988.

Staley, Helmut von Effra, and Allen Staley. *The Paintings of Benjamin West*. New Haven, CT: Yale Univ. Press, 1986.

Štech, V.V. *Baroque Sculpture*. London: Spring Books.

Steel, David H., Jr. *Baroque Paintings from the Bob Jones University Collection*. Raleigh, NC: North Carolina Museum of Art, 1984.

Stejskal, Karel. *L'Empereur Charles IV: L'Art en Europe au XIV siècle*. Paris: Gfünd, 1980.

Sterling, Charles. *The Master of Claude, Queen of France: A Newly Defined Miniaturist*. New York: H.P. Kraus, 1975.

_____. *La Peinture médiévale à Paris, 1300-1500*. Paris: Fondation Wildenstein, 1987.

Stone, J. M. *The History of Mary I, Queen of England*. New York: Dutton, 1901.

Strauss, Walter L. *Albrecht Dürer, Woodcuts and Wood Blocks*. New York: Abaris Books, 1980.

_____. *The German Single-Leaf Woodcut, 1550-1600*. New York: Abaris Books, 1975.

_____. *The Illustrated Bartsch*. New York: Abaris Books, 1981.

Strieder, Peter. *Albrecht Dürer: Paintings, Prings, Drawings*. New York: Abaris Books, 1981.

Strong, Roy. *Splendor at Court*. Boston: Houghton Mifflin, 1973.

Strutt, Joseph. *Regal and Ecclesiastical Antiquities of England*. London: Henry G. Bohn, 1862.

Stylianou, Andreas, and Judith Stylianou. *The Painted Churches of Cyprus.* London: Trigraph Ltd., 1985.

Subleyras 1699–1749. Paris: Ministère de las Culture et de la Communication, Editions de la Réunion des Musées Nationaux, 1987.

Sunderland, John. *Painting in Britain 1525–1975.* London: Phaidon, 1976.

Swarzenski, Hanns. *The Berthold Missal.* New York: Pierpont Morgan Library, 1943.

Szablowsli, Jerzy, *Collections of the Royal Castle of Wawel (Poland).* Warsaw: Arkady, 1975.

The Tate Gallery. *The Pre-Raphaelites.* London: Allen Lane, 1984.

Thompson, Henry Yates. *The Book of Hours of Joan II, Queen of Navarre.* London: The Chiswick Press, 1899.

Thubron, Colin. *The Venetians.* Alexandria, VA: Time-Life Books, 1980.

Tietze, Hans. *Tintoretto, the Paintings and Drawings.* New York: Phaidon Publishers, 1948.

The Timken Art Gallery. *European Paintings.* San Diego, CA: Putman Foundation, 1969.

Toledo Museum of Art. *A Guide to the Collections.* Toledo, OH: Toledo Museum of Art, 1976.

The Tretyakov Gallery, Moscow. *Russian Painting.* New York: Harry N. Abrams, Inc., 1979.

Treasures of the Philadelphia Museum of Art and the John G. Johnson Collection. Philadelphia: Philadelphia Museum of Art, 1973.

United Nations Educational, Scientific and Cultural Organization. *An Illustrated Inventory of Famous Dismembered Works of Art: European Painting.* Paris: UNESCO, 1974.

University of Arizona Museum of Art. *Paintings and Sculptures in the Permanent Collection.* Tuscon, AZ: Univ. of Arizona, 1983.

Valcanover, Francesco, and Terisio Pignatti. *Tintoretto.* New York: Harry N. Abrams, 1985.

Van Braam, Frederick A. *Treasures in the Benelux Countries,* Vol. 1. The Netherlands: Van Braam Publication.

Van Os, Henk. *Sienese Altarpieces, 1215–1460: Form, Content, Function, Volume I, 1215–1344.* The Netherlands: Bouma's Boekhuis bv Groningen, 1984.

_____. *Sienese Altarpieces, 1215–1460: Form, Content, Function, Volume II, 1344–1460.* The Netherlands: Egbert Forsten Groningen, 1990.

Vassar College Art Gallery. *Paintings, 1300–1900.* Poughkeepsie, NY: Vassar College Art Gallery, 1983.

Venturi, Lionello. *Italian Painting.* Geneva: Albert Skira.

Verdon, Timothy, and John Henderson. *Christianity and the Renaissance: Image and Religious Imagination in the Quattro-Cento.* New York: Syracuse University Press, 1990.

Vey, Dr. Horst, ed. *German and Spanish Art to 1900.* New York: Grolier, 1965.

Virginia Museum of Fine Arts. *Treasures in the Virginia Museum.* 1974.

Voltini, Franco. *Cremona, La Cattedrale.* Amilcare Pizzi Editore, 1989.

von Erffa, Helmut, and Allen Staley. *The Paintings of Benjamin West.* New Haven, CT: Yale Univ. Press, 1986.

Wadsworth Atheneum. *Handbook.* Hartford, CT: Wadsworth Atheneum, 1958.

Waetzoldt, Stephan. *Art Treasures in Germany.* New York: McGraw-Hill, 1970.

Walker, John, director. *National Gallery of Art, Washington D.C.* New York: Harry N. Abrams, 1984.

Walters Art Gallery. *Italian Paintings,* Vol., I & II. Ed. by Federico Zeri. Baltimore: Walters Art Gallery, 1976.

Waterhouse, Ellis. *The Dictionary of British 18th Century Painters in Oils and Crayons.* Woodbridge: Antique Collectors' Club Ltd., 1981.

_____. *Roman Baroque Painting.* Oxford: Phaidon Press, 1976.

Wehle, Harry B. *Art Treasures of the Prado Museum.* New York: Harry N. Abrams, 1954.

Weitzmann, George. *Late Antique and Early Christian Book Illumination.* New York: George Braziller, 1977.

Wethey, Harold E. *Alonso Cano: Painter, Sculptor, Architect.* New Jersey: Princeton University Press, 1955.

_____. *The Paintings of Titian.* Vol. 1: *The Religious Paintings.* London: Phaidon Press Ltd. 1969.

Weygand, General. *Histoire de l'armée françoise.* Ernest Flammarion, 1938.

White, Christopher. *Dürer, the Artist and His Drawings.* New York: Watson-Guptill Publications, 1971.

_____. *Peter Paul Rubens, Man and Artist.* New Haven and London: Yale Univ. Press, 1987.

Wildenstein, Georges. *Ingres.* London: Phaidon Press, 1954.

Williams, Neville. *Henry VIII and His Court.* New York: Macmillan, 1971.

Wilson, Michael. *The National Gallery, London.* New York: Crescent Books, 1977.

Wilton House, Salisbury-Wiltshire. *A Catalogue of the Paintings and Drawings in the Collection.* London: Phaidon, 1968.

Winthrop, Grenville L. *Retrospective for a Collector.* Cambridge, MA: Fogg Museum of Art, 1969.

Wood, Christopher. *The Dictionary of Victorian Painters.* 2d ed. Woodbridge, Suffolk, England: Antique Collector's Club, 1978.

Woodruff, Douglas. *The Life and Times of Alfred the Great.* Book Club Assoc., 1974.

Worcester Art Museum. *A Handbook to the Worcester Art Museum.* Worcester, MA: Worcester Art Museum, 1970.

Wright, Christopher. *Masterpieces of Reality: French 17th Century. Painting.* New Walk, Leicester: Leicestershire Museum and Art Gallery, 1985.

_____. *Poussin, Paintings: A Catalogue Raisonné.* London: Harlequin Books Ltd., 1985.

Wroth, William. *Images of Penance, Images of Mercy: Southwestern Santos in the Late Nineteenth Century.* Norman, OK: Univ. of Oklahoma Press, 1991.

Yale University Art Gallery. *A Taste for Angels: Neapolitan Painting in North America, 1650–1750.*

_____. *Paintings and Sculpture from the Yale University Art Gallery.* New Haven, CT, and London: Yale Univ. Press, 1972.

York City Art Gallery. *Catalogue of Paintings.* York: The Museum, 1961.

Zampetti, Pietro. *Carlo Crivelli.* Florence: Cassa di Risparmio di Fermo, 1986.

Zellman, Michael David. *300 Years of American Art.* Secaucus, NJ: The Wellfleet Press, 1987.

Zeri, Federico. *Italian Paintings in the Walters Art Gallery.* Baltimore: Walters Art Gallery, 1976.

Ziff, Norman. *Paul Delaroche.* New York: Garland Publishing Inc., 1977.